W9-CFO-393

MICHELANGELO
DRAWINGS: CLOSER TO THE MASTER

Hugo Chapman

Yale University Press

Few individual artists have had a greater impact in their own lifetime and subsequently than Michelangelo. BP is delighted to support this unique exhibition of over ninety drawings, gathered from three of the world's great collections. The exhibition includes preliminary studies for some of Michelangelo's most important creations including the Sistine chapel ceiling, the Medici chapel tombs and the *Last Judgement*. The drawings reveal his approach to the perfection of his finished works in sculpture, painting and architecture.

I hope you will enjoy this glimpse of a man at the peak of his creative genius.

Lord Browne of Madingley
Group Chief Executive, BP

First published in the United Kingdom in 2005 by
The British Museum Press
A division of The British Museum Company Ltd
38 Russell Square, London WC1B 3QQ
www.britishmuseum.co.uk

Published in 2005 in North America by
Yale University Press
P.O. Box 209040
302 Temple Street
New Haven, CT 06520-9040
www.yalebooks.com

Designed by Tim Harvey
Printed in Spain by Grafos SA, Barcelona

Library of Congress Control Number: 2005928827
ISBN 0-300-11147-9
10 9 8 7 6 5 4 3 2 1

jacket illustrations
(front) Exh. No. 11 **A seated male nude twisting around**, *c.* 1504–5. The British Museum, London;
(back) Exh. No. 30 Recto **Studies for Haman**, *c.* 1511–12. The Teyler Museum, Haarlem

Contents

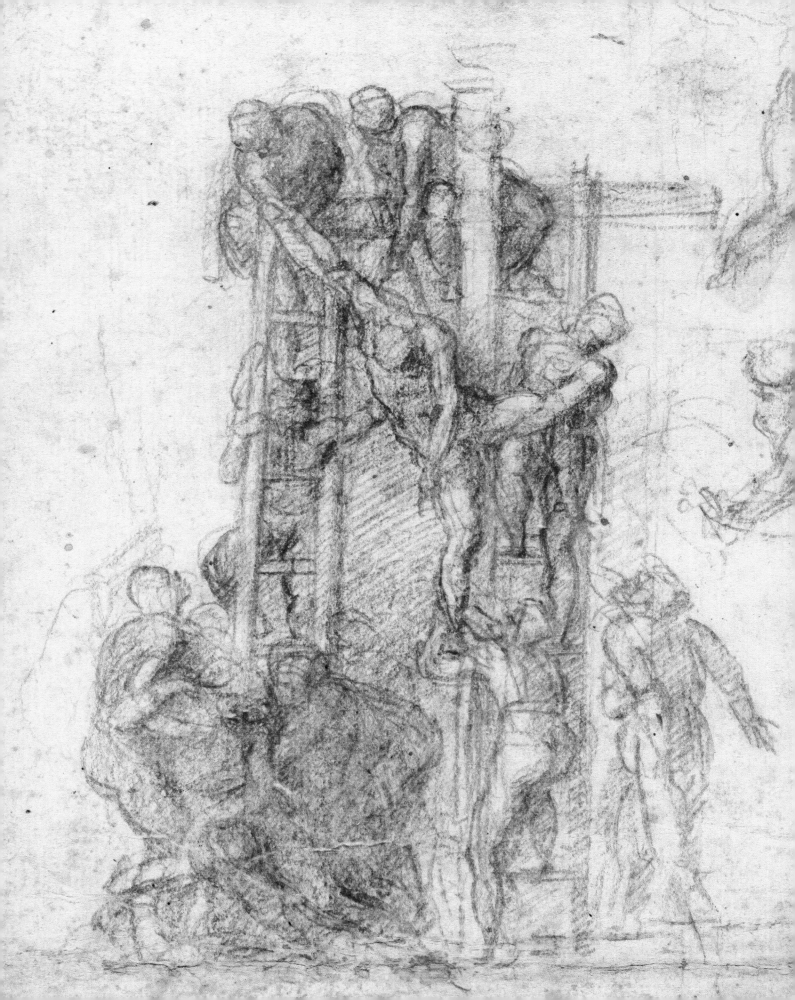

Foreword

Michelangelo is a giant. Even after almost five centuries his works communicate powerfully with us, perhaps because we subconsciously recognize the deeply human character that is fundamental to his art. The versatility of his artistic skill, even by the exalted standards of his own age, was exceptionally wide: apart from being a sculptor, painter and draughtsman, he was also an architect and a poet. In these artistic endeavours it is the beauty, perfection and virtuosity of the execution, as well as his willingness to take on projects of awesome scale, that still excite our admiration.

Michelangelo may be considered the first 'modern' artist. A commission for him was merely the beginning of an intensely creative process in which he developed revolutionary solutions to the formal problem of representing the required subject. His patrons never knew what they would receive or when, or indeed if the promised work would ever materialize. This very individual approach towards official commissions may help explain the magnetic effect of his art. The force of Michelangelo's character, and his innovative brilliance in addressing the timeless questions of human existence, retain their potency and relevance for a modern audience. Michelangelo's passionate nature continues to resonate in his work in all media, and as a result he is an artist about whom it is impossible to feel indifferent. One may admire or recoil, but no one can deny the overwhelming effect of his creations.

Michelangelo was already a legend in his own lifetime as witnessed by the sobriquet 'il divino' that was applied to him by his contemporaries. Uniquely, his supremacy in the fiercely competitive artistic world of Renaissance Rome lasted for more than four decades after Raphael's death in 1520. Contemporaries recognized that his genius raised him above all other artists, and his status has never since been eclipsed. On the contrary, some of his works have become icons for the modern world, and have been invested with new meaning. The detail of the ceiling of the Sistine chapel with the hand of God bringing Adam to life is ubiquitous globally as a symbol of communication, and the statue of *David* has been used to express various ideals of masculinity. Ironically for an artist who so fiercely guarded his own privacy, Michelangelo stands at the pinnacle of mass cultural fame and recognition, a position he shares with just a handful of others.

Michelangelo lived at a time and place of many new discoveries, and his work reflects these changes. The art and ideals of classical antiquity profoundly affected him, as is shown, for example, by his statue of *David*, the first colossal marble statue in Europe for more than a millennium. At the same time he was also greatly influenced by the medieval Christian legacy, and its renewal under pressure from the Protestant revolution in northern Europe at the beginning of the Counter-Reformation. Michelangelo was central to this transformation through his long employment by successive popes in Rome, a city that emerged in his lifetime

as the cultural capital of Europe. The sculptures of the *Pietà* and drawings of the *Crucifixion* at the end of his life are wonderful examples of Michelangelo's intensely felt spirituality. He lived during a period of great upheavals all over Europe, as different ideologies collided in the difficult and sometimes bloody birth of the modern world: his own life was touched and shaped by these conflicts, and by those who played leading parts in them – Lorenzo the Magnificent, Julius II, Francis I, Leonardo da Vinci and Raphael.

It is well known that Michelangelo burned many of his drawings, and he guarded jealously access to those that escaped the flames. Whether this destruction was prompted by diffidence, or because he wanted to prevent his fellow artists from seeing how much effort he had to put into the preparation of his finished works, is unclear. What is certain is that Michelangelo recognized that his exceptional talents set him apart from his contemporaries, and he tried throughout his life to advance his privileged status. Fortunately Michelangelo did not destroy all his drawings: of the many thousands that he must have made about six hundred sheets survive.

These drawings constitute the indispensable foundation for studying Michelangelo's art. A sketch with a preliminary design transports us back to the very moment of creation. Careful study of the drawings by generations of scholars has clarified much about the process of the making of Michelangelo's great commissions, such as the *Battle of Cascina* for the Hall of the Great Council in the Palazzo Vecchio, the frescoes of the Sistine chapel, and the architecture and sculptures for the Medici chapel in Florence. When comparing the drawings with the final results it seems as if Michelangelo had a clear notion from the beginning of the general effect he was aiming for. Such powers of conception are given to very few artists. In Michelangelo it was allied to an extraordinary capacity for hard work and concentration that drove him relentlessly to refine his ideas on paper, until he had found the most effective means of realizing his vision. Looking at his drawings is a voyage of discovery into the essence of his creativity, and in the process we cannot fail to marvel at his incomparable skills as a draughtsman, especially when he is describing the taut muscular beauty of the male form.

The present project began with a suggestion from the British Museum to the Teyler Museum that the two institutions should for the first time combine their holdings of Michelangelo drawings to mount an exhibition that would present these treasures to a new generation of the public in Holland and Britain. The last major showing of the British Museum's holdings of the artist was in 1975, and the magnificent sheets in the Teyler Museum have not been seen as a group since 2000. When planning the content we realized that there were critical drawings in the Ashmolean Museum in Oxford that completed the story told by those in London and Haarlem. We should like to thank our colleague, Dr Christopher Brown,

the Director, and the Visitors of the Ashmolean Museum for their most generous loans to the exhibition. As a result we are delighted and proud that the exhibition will contain nearly one sixth of all Michelangelo's surviving sheets, some of which have never been seen together since they left his studio. For the additional items lent to the London exhibition we would like to acknowledge the support and generosity of the British Library, the National Gallery, Sir John Soane's Museum, and the Victoria and Albert Museum. It is no accident that the drawings come from three museums which were all founded in the period of the Enlightenment: the Ashmolean Museum (1693), the British Museum (1753) and the Teyler Museum (1784).

The selection of drawings has been made in collaboration by our two institutions, but this catalogue is the work of Hugo Chapman of the British Museum, who has taken the opportunity to re-examine all the drawings and reinterpret their function in Michelangelo's creative process. This has led to his writing a narrative book rather than a conventional exhibition catalogue, and we wish to thank him for the enthusiasm and hard work that he has put into what has become a major project.

The cooperation between the Department of Prints and Drawings of the British Museum and the Cabinet of Art Collections of the Teyler Museum has been both smooth and happy. We should also like to thank Antony Griffiths, Carel van Tuyll van Serooskerken and his successor Michael Kwakkelstein for all their efforts. Any project of this kind demands much of the administrative team, and we would also like to acknowledge the work of Janice Reading in London, and Marijke Naber and Frank van der Velden in Haarlem.

This project would not have been possible without the generous support of several sponsors and funds. At the beginning Jean-Luc Baroni provided the funds to employ Daniel Godfrey as a research assistant. The very considerable costs of installation, transport and insurance have been met by BP in the British Museum and ING RE and HGIS Culture Programme in the Teyler Museum. We owe our warmest thanks to all these bodies for their enlightened sponsorship.

Neil MacGregor
The British Museum

Marjan Scharloo
The Teyler Museum

Acknowledgements

This book would not have been written without the help of many colleagues and friends who supported me during its progress. Writing about Michelangelo as a draughtsman, I am conscious of the debt I owe to Noël Annesley and Francis Russell who, during the ten years I spent at Christie's, taught me how to look at drawings. In their different ways they passed on to me their skills of connoisseurship, built up over long years of experience: how a good drawing can be distinguished from a lesser one, an original from a copy and so on. Unlike Michelangelo, who tried so hard to present himself as an autodidact, I am happy to acknowledge how much I learned from them both during my time in their King Street *bottega*. I am keenly aware too of the influence that another Christie's employee, David Ekserdjian, now head of the Art History department at the University of Leicester, has had on my thinking about the varying ways in which sixteenth-century artists used drawings to prepare their compositions. His books and articles on Correggio and Parmigianino have shown how an understanding of drawings can enrich our experience of the finished work, and he has been unfailingly generous in sharing his knowledge with me over the course of a friendship that stretches back more than twenty years. I would also like to take this opportunity of expressing my thanks to Tom Henry and Carol Plazzotta who shouldered so much of the burden of the recent Raphael exhibition at the National Gallery, allowing me to begin writing about the painter's great rival. In my solitary efforts to realize this book, I have often thought back wistfully to the pleasurable collaboration I enjoyed with such exemplary colleagues. The discussions we had about Raphael, and the possible ways of presenting his work in the exhibition, have shaped my thinking about the current project in numerous ways.

As a Michelangelo neophyte I have relied heavily on the kindness of specialists in the field. I was enormously fortunate in being able to call upon Caroline Elam and Paul Joannides to read through the manuscript. They saved me from many errors, and their suggestions and comments improved the text in countless ways. Paul Joannides graciously gave me access to his forthcoming catalogue of the Ashmolean's Michelangelo drawings, a work which proved an invaluable aid to this enterprise. I also benefited from the advice of colleagues who undertook to read various sections of the work: Antony Griffiths, Mark McDonald, Martin Royalton-Kisch, Dora Thornton and Jeremy Warren. I am very grateful to Michael Hirst's forbearance in putting up with my interruptions of his own work on Michelangelo to answer my queries (a favoured ambush site was the periodical stacks in the Warburg Institute on Saturday morning). The footnotes of this book attest to my reliance on both his and Paul Joannides' many publications on the artist, as well as to the superlative catalogues of Johannes Wilde and Charles de Tolnay. Daniel Godfrey, whose knowledge of Michelangelo is reflected in his entries on the artist's drawings in the British Museum's database, proved an

invaluable ally in the creation of this book. Thanks to Jean-Luc Baroni's generosity in sponsoring his post, I was able to employ him to track down and order the necessary illustrations, and he also drafted both appendices and the index. I am grateful to Laura Brockbank for guiding the book through production, to the copy editor Nancy-Jane Rucker, to Paul Goodhead for creating the map and to the designer Tim Harvey.

During the course of working on this exhibition my colleagues in the Department of Prints and Drawings took over many of my duties to allow me time to disappear off to libraries and printrooms. I would also like to acknowledge the support I have received from Marjan Scharloo, Carel van Tuyll van Serooskerken and Michael Kwakkelstein, Frank van der Velden, Robien van Gulik, Celeste Langedijk and Martijn Zegel from the Teyler Museum, and in Oxford from Christopher Brown, Caroline Newton, Catherine Whistler and Tim Wilson. I would also like to record my gratitude to the following for their help: Janet Ambers, Philip Attwood, Michelle Brown, Frances Carey, Charlie Collinson, Xenia Corcoran, Marzia Faietti, Sylvia Ferino-Pagden, Philip Fletcher, Sarah Frances, Laura Giles, Jeremy Harding, Duncan Hook, Caroline Ingham, David Jaffé, Elizabeth Kieven, Scot McKendrick, Sam Moorhead, Peta Motture, Laura Nuvoloni, Thorsten Opper, Roxanne Peters, Janice Reading, Elisa Reyes-Simpson, Margaret Richardson, Charles Saumarez-Smith, Margaret Schuelein, Nicolas Schwed, Sabrina Shim, Martin Sonnabend, Luke Syson, Paul Taylor, Francesca Tronconi, Rebecca Wallace, Leslie Webster, Dyfri Williams, Jonathan Williams and Paul Williamson. I am extremely grateful to the work done on the Michelangelo drawings and their mounts by Jenny Bescoby and her colleagues in the British Museum Department of Conservation, Documentation and Science. Special thanks are due to John Williams and Kevin Lovelock for digitally photographing the British Museum drawings, and to Ivor Kerslake for his assistance with the black and white photography for the comparative illustrations.

Finally I would like to thank my wife, Isabella Lodi-Fè, for her assistance in reading through the text and in deciphering the meaning of Michelangelo's letters. Both she and our three children – Oliver, Matthew and Mollie – patiently endured my virtual disappearance from family life for over a year to work on Michelangelo, and it is to them that I dedicate my labours.

H.C. June 2005

Note to Reader Technical and bibliographic details for all the works in the exhibition (denoted by 'Exh. No.') are to be found in Appendix I, pp. 284–93. Reference to 'r' or 'v' signifies recto and verso; the latter terms are only used in the captions when both sides are illustrated. Except where the recto and verso appear on the same opening, the captions include a reference to the page where the other side is illustrated. Details of which works are to be shown double-sided in the London exhibition are given in Appendix I. Measurements are given height before width. Dates for the majority of individuals mentioned in the main text (excluding those born after 1850) are given in the index.

Michelangelo: Significant dates

1475
6 March. Born in Caprese near Arezzo, the second of five sons born to the Florentine Lodovico di Leonardo Buonarroti Simoni and his wife, Francesca.

1481
Death of Michelangelo's mother.

1484
Death of Sixtus IV (della Rovere, elected 1471). Election of Innocent VIII (Cibo).

1487
Documented in the workshop of Domenico and Davide Ghirlandaio in Florence.

***c.* 1488/92**
Joins Medici household and studies in the Medici Garden under the tutelage of the sculptor Bertoldo. During this time carves *Madonna of the Stairs* and *Battle of the Centaurs* (Fig. 11).

1492
Death of Lorenzo de'Medici. Death of Innocent VIII. Election of Alexander VI (Borgia).

1493
In service of Piero de'Medici. Lost marble *Hercules*. Wooden *Crucifix*.

1494
French invasion of Italy. Expulsion of Piero de'Medici from Florence and establishment of first Florentine Republic. Michelangelo works in Bologna on figures for shrine of St Dominic.

1496
Arrives in Rome, aged twenty-one; commission for the *Bacchus* sculpture from Cardinal Riario.

1498
Contract for the marble *Pietà* (finished in 1500).

1500
Contract for the Piccolomini altar figures for Siena cathedral.

1501
Returns to Florence. Contract for the marble *David* (installed outside Palazzo Vecchio in 1504).

1502
Commission for bronze *David*.

1503
Death of Alexander VI. Election and death of Pius III (Piccolomini). Election of Julius II (della Rovere). Contract to carve twelve over-life size *Apostles* for Florence cathedral. First payment for *Bruges Madonna* (Fig. 19).

1504
Begins work on the *Battle of Cascina* cartoon. At work on the *Taddei* (Fig. 20) and *Pitti* marble tondos. *Doni Tondo* panel painting probably completed.

1505
Summoned to Rome by Julius II and commissioned to execute his tomb.

1506
Returns secretly to Florence. Begins and then abandons the marble *St Matthew* for Florence cathedral (Fig. 18). Sent to Bologna to produce a monumental bronze statue of Julius II for main portal of S. Petronio (destroyed in 1511).

1508
Julius summons Michelangelo to Rome to decorate the ceiling of the Sistine chapel (Fig. 33).

1510
Completion of first half of the ceiling, followed by a long break in the work while Julius is away fighting in northern Italy.

1511
August. Unveiling of half the Sistine ceiling.

1512
August/September. Fall of first Florentine Republic and restoration of Medici rule. October. Unveiling of the whole Sistine ceiling.

1513
Death of Julius II. Election of Leo X (Medici). New contract for the Julius tomb for which Michelangelo begins sculpting the *Dying* and *Awakening Slaves* (for the latter, Fig. 56) and the *Moses*.

1514
First contract for marble *Risen Christ*. First version abandoned.

1516
Third contract for the Julius tomb. Michelangelo, aged forty-one, returns to Florence. Leo X commissions façade of S. Lorenzo (Fig. 62).

1519
Second version of the *Risen Christ* begun (installed in Roman church of S. Maria sopra Minerva in 1521). Death of Leonardo da Vinci in Blois, France.

1520
Façade project abandoned, replaced by the Medici chapel project in S. Lorenzo. Death of Raphael in Rome.

1521
Death of Leo X.

1522
Election of Adrian VI (Florenszoon Boeyens or Dedal).

1523

Death of Adrian VI. Election of Clement VII (Medici).

1524

Intensive work in the Medici chapel begins (Fig. 65). Commission to build the Laurentian library (Fig. 80).

1527

The Sack of Rome. The Medici are expelled from Florence and second Florentine Republic established. Scheme for a pendant figure of *Hercules* or *Samson* for the marble *David*.

1528/9

Michelangelo oversees the fortifications of Florence.
July. Michelangelo's favourite brother Buonarroto succumbs to the plague.

1529

September. Flees to Venice before the siege of Florence by pro-Medici forces begins, but returns to Florence in November.

1530

August. Florence surrenders to the Imperial army and the Medici are restored to power. Michelangelo goes into hiding but is pardoned by Clement VII. He resumes work on Medici projects in Florence.

1531

Death of Michelangelo's father. *Leda* cartoon and panel completed and taken by Antonio Mini to France.

1532

Fourth contract for the Julius tomb.
August. A long visit to Rome and the beginning of his friendship with Tommaso de'Cavalieri.

1533

Returns to Florence and resumes working for the Medici.
November. Again in Rome.
Commissioned by Clement VII to paint the *Last Judgement* on the Sistine chapel altar wall (Fig. 94).

1534

August/September (?). Abandons Florence never to return, leaving the Medici chapel and the Laurentian library unfinished. Settles permanently in Rome.
September. Death of Clement VII.
October. Election of Paul III (Farnese).

1536

November. Begins the fresco of the *Last Judgement* (Fig. 94).

1536/8

Friendship with Vittoria Colonna begins.

1541

October. Unveiling of the *Last Judgement*.

1542

August. Fifth and final contract for the Julius tomb. Begins the two frescoes in the Pauline chapel (completed in 1550).

1544

Falls ill and is nursed to health by Luigi del Riccio in the Strozzi palace.

1545

The Julius II tomb erected in S. Pietro in Vincoli, Rome (Fig. 55).

1546

Takes over the construction of St Peter's and Palazzo Farnese.

1547

Death of Vittoria Colonna.

1549

Death of Paul III.

1550

Election of Julius III (del Monte). Pauline chapel frescoes completed. The first edition of Vasari's *Lives of the Artists* published in Florence, the biography of Michelangelo is the only one included of a living artist.

1552/3

Begins his last sculpture, the *Rondanini Pietà* (Fig. 121).

1553

Condivi's *Life of Michelangelo* published in Rome.

1555

Death of Julius III. Election and death of Marcellus II (Cervini). Election of Paul IV (Carafa).

1556

Death of Michelangelo's loyal assistant and servant Urbino.

1559

Death of Paul IV. Election of Pius IV (Medici). Michelangelo works on plans for S. Giovanni dei Fiorentini and for equestrian monument to Henry II of France.

1561

Contract for the Porta Pia.

1564

18 February. Michelangelo dies aged eighty-eight. Body taken back to Florence and buried in S. Croce.

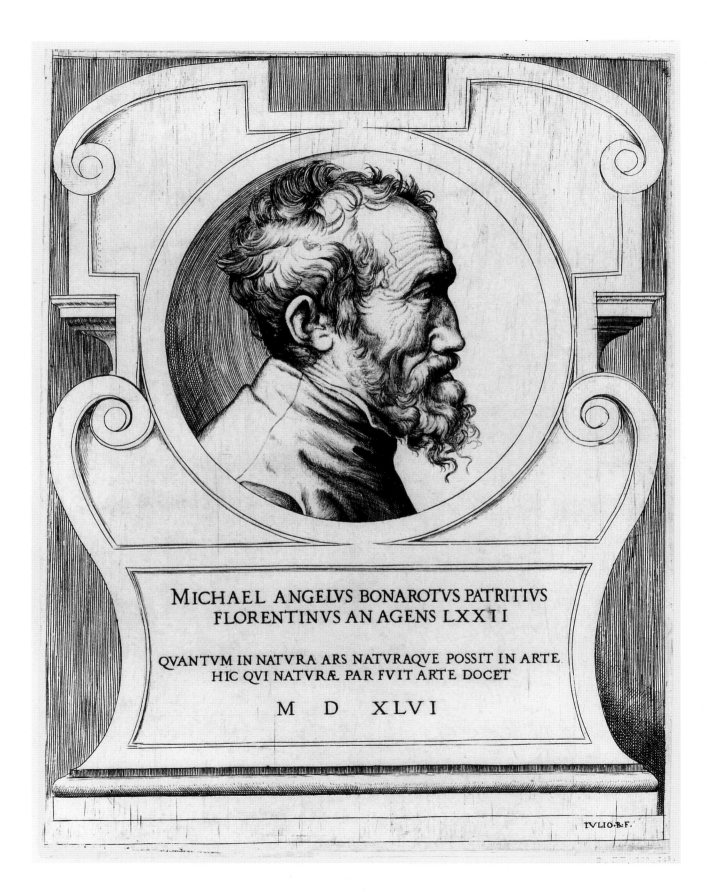

MICHAEL ANGELVS BONAROTVS PATRITIVS
FLORENTINVS AN AGENS LXXII

QVANTVM IN NATVRA ARS NATVRAQVE POSSIT IN ARTE
HIC QVI NATVRÆ PAR FVIT ARTE DOCET

M D XLVI

IVLIO·B·F·

1

Introduction

In a letter of September 1520 the Venetian painter Sebastiano del Piombo wrote from Rome to his friend Michelangelo in Florence that he wished to see him made 'imperator del mondo' ('emperor of the world'). All they needed to do was to wrest a share of the decoration of the Sala di Costantino in the Vatican palace from Raphael's pupils.[1] Michelangelo resisted these blandishments as he had no need of his friend's collaboration. His artistic supremacy had been assured that April by the death of his rival Raphael, at the age of thirty-seven. This event was an important one in Michelangelo's fortunes in Rome, a city which suffered many reverses during his long life. Yet in spite of two invasions and the rise of Protestantism north of the Alps, Rome's position as Europe's cultural capital grew ever stronger. The majestic ruins and antiquities of the ancient metropolis were tangible, evocative reminders of a lost civilization that enthralled the classically educated humanists and rulers of Renaissance Europe.

In the first decades of the sixteenth century a modern generation of artists and architects, led by Bramante, Michelangelo and Raphael, had been inspired by these remains of Rome's past greatness to create works that matched, or surpassed, the achievements of their ancient forebears. The most potent symbol of this confluence was the design of St Peter's which involved all of the aforementioned trio. This vast new basilica in the classical style was conceived on a scale that dwarfed even the greatest ruined temples and bath complexes of the ancient city. Its gradual construction was one of many ambitious and costly building projects that signalled the papacy's determination to transform Rome into a city befitting its status as the capital of Christendom.

A similar spirit of display was found among many of the cardinals and financiers at the court, expressed through the construction and decoration of grand palaces and chapels. The unrivalled scale of artistic patronage, and the dearth of a local school of painters and sculptors, attracted artists to Rome from all over Italy and far beyond, lured also by the opportunity of studying its ancient and modern treasures. It was in this highly competitive environment that Michelangelo, after Raphael's death, reigned supreme for more than four decades. His facility and originality as a sculptor, painter, architect and, in the private domain, as a poet, and his single-minded ambition and huge reserves of energy, sustained him at the pinnacle of papal favour until his death in 1564 at the great age of eighty-eight.

The near monopoly on Michelangelo's energies exerted by papal projects meant that he had little time to satisfy other demands for his work, however clamorous, and he refused to relieve the pressure by establishing a studio or workshop as Raphael had done. This was just one manifestation of his stubbornly independent nature which led to a fierce clash of wills with his first papal patron, Julius II. His lifelong determination to set himself apart from his artistic peers was also demonstrated by his refusal to turn his talent to portraying his patrons.

Exh. No. 1 Giulio Bonasone (c. 1510–76), **Portrait of Michelangelo**, 1546. Engraving, 23.8 × 17.6 cm. The British Museum, London

Only with Julius II did he relent. His only other concessions to a genre that was a stock-in-trade for his peers, even those as exalted as Leonardo, Raphael and Titian, was the creation of a few chalk drawings of individuals in his intimate circle (see Exh. No. 70). Michelangelo's perfectionism made his work rare and anything by him, even a drawing (a category hitherto largely ignored by most collectors), became a hugely desirable commodity. Some of the most influential figures of the day, from the king of France, Francis I, to the literary heavyweight Pietro Aretino, petitioned Michelangelo in vain to produce something for them. Such men were accustomed to having artists accede to their wishes. Aretino railed furiously, but fruitlessly against Michelangelo's refusal to send him a drawing. When Michelangelo told the newly elected Pope Paul III in 1534 that the backlog of unfinished commitments prevented him from taking on any new ones, the pontiff replied angrily that he had longed to employ the artist for thirty years and would not now be denied.[2] Paul III used Michelangelo's talents not only to celebrate his reign in the Vatican palace and at St Peter's, but also to bring lustre to a dynastic project with architectural designs for the Palazzo Farnese in Rome (see Exh. No. 103).

The near-unbroken favour of popes from Julius II onwards (the only exception being the short-lived Dutchman Adrian VI) was a record that none of his contemporaries could match. While this brought Michelangelo great wealth, and an unprecedented power to accept or decline outside commissions much as he pleased, the competing demands made by successive papal masters exacerbated his tendency not to complete works, and also prevented him from taking on projects that he yearned to fulfil.[3] For example, his long-held wish to carve a pendant to the colossal marble figure of *David* outside the Palazzo della Signoria in Florence was crushed by Pope Clement VII's dictat reported to him in 1525: 'Digli che io lo voglio tutto per me, e non voglio che e' pensi alle cose del pubrico, né d'altri ma alle mia' ('Tell him that I want him all for myself, and I don't want him thinking of public commissions nor of any others except mine').[4] The same pope, perhaps only half-jokingly, told the artist that he should fulfil any outstanding requests for paintings with a paintbrush held in his toes so that he could return to his rightful business of serving Clement.[5] Michelangelo remained in papal service until his death, rewarded by a stream of prestigious commissions and seventeen years as the architect in charge of St Peter's. There were, however, moments when he contemplated escape by leaving for France or even for Istanbul.[6]

The veneration that Michelangelo enjoyed is summed up by his early characterization as 'il divino', a sobriquet that played on the angelic connotations of his name. This tag was first used by Ariosto in the 33rd canto of the third edition of his epic poem *Orlando Furioso*, published in 1532. Such praise was not in itself novel because humanists and poets in the previous century had lauded exceptional artists before, notably Andrea Mantegna, Antonio Pisanello and from north of the Alps Jan van Eyck and Rogier van der Weyden. But the kind of far-reaching international fame first enjoyed by the German contemporary painter and print-maker Dürer was a recent phenomenon. In part this was due to the new technology of engraving which brought images of the works of artists like Raphael and later Michelangelo to a European-wide audience, where previously they had only been known to the courtly and urban elites which had commissioned them. This technological development quickened the growth of a new attitude towards artists on the part of patrons and intellectuals, and a concomitant rise in their social status. This was linked to a growing awareness that the success of a painter or sculptor had as much to do with the intellectual process as with the manual labour in making it.[7] Michelangelo played a huge part in this shift because his achievements over his long career marked him out so decisively from any artist who had come before him.

The sculptor's considerable gifts as a poet, and his profound knowledge of the writings of Dante and Petrarch, helped bridge the differences in education between him and some of the leading literary figures of the day. One example of this is Michelangelo's friendship with the exiled Florentine republican writer Donato Giannotti. In the latter's *Dialoghi* written in the 1540s Michelangelo is included as one of the participants in a discussion about the duration of Dante's sojourn in Hell and Purgatory. Another of Michelangelo's intellectual admirers was the Florentine historian, art theorist and writer Benedetto Varchi, who addressed the newly formed Florentine Academy on the relative merits of painting and sculpture (the so-called *paragone* or comparison). This early moment in the development of art criticism had been preceded the week before by a lecture on one of Michelangelo's sonnets, and Varchi published both texts in 1547.[8] It was Varchi who was later deputed to give the address at the elaborate memorial service accorded to Michelangelo in S. Lorenzo, his body having been returned to Florence after his death in Rome on 18 February 1564.[9] That the passing of an artist should be honoured in such a fashion, close in pomp and ceremony to that normally reserved for kings and princes, is a testament to the recognition of Michelangelo's genius, and to the elevation that he had helped effect in the status of his profession.

A measure of Michelangelo's renown can be gauged from the fact that no less than three biographies of him were written during his lifetime. The first was a brief account in Latin by the papal physician and bishop, Paolo Giovio, from the mid-1520s (unpublished until the eighteenth century).[10] This is of interest largely because of the author's evident distaste for Michelangelo's unsociable nature, but it is otherwise not very informative as regards his work. Quite different in every way is the biography written by the Arezzo-born painter Giorgio Vasari in his hugely influential history of Italian art, the *Lives of the Most Excellent Architects, Painters and Sculptors*, first published in Florence in 1550.[11] Vasari's account of the development of the arts in Italy (with a special emphasis given to the role played by artists from the author's native Tuscany) begins with Cimabue and culminates in Michelangelo, who is described as having been sent from heaven to bring perfection to the arts. In spite of the adulatory nature of the biography (the only one included of a living artist) Vasari unwittingly offended the thin-skinned Michelangelo by mentioning episodes that he would rather have suppressed, such as his apprenticeship with Ghirlandaio, and the description of so many works that had been left unfinished. More serious still was Vasari's rather cursory and muddled treatment of the tomb of Julius II, a hugely problematic and long drawn-out commission. Michelangelo was particularly anxious not to reignite the simmering resentment still felt by the dead pope's family over the much compromised monument, finally erected in the Roman church of S. Pietro in Vincoli five years before (Fig. 55).[12]

Michelangelo's discomfort at certain aspects of Vasari's treatment of his life probably prompted him to ask a young artist in his twenties, Ascanio Condivi, to write what would now be termed the 'authorized' biography.[13] Published in 1553, Condivi does not mention Vasari's name but the latter is plainly the target of his charge that previous writers had made errors through their lack of prolonged familiarity with Michelangelo. In fact Condivi's own friendship with Michelangelo, who was then in his mid-seventies, was of only a few years standing. The gulf of age between them and his understandable awe of Michelangelo, which is evident from the obsequious tone of his one surviving letter to the Florentine, made Condivi an ideal conduit for the sculptor's carefully crafted account of his career.[14] Michelangelo was particularly eager to show himself to have been powerless to avert the 'tragedy of the tomb', to borrow Condivi's much-quoted phrase of the long drawn-out history of the Julius II monument.

It is also noticeable that no mention is made of a number of other sculptural projects that had never been brought to completion. Despite the highly biased nature of Condivi's account, it is a rich source of information, particularly concerning Michelangelo's early career, an area that Vasari had covered poorly. This was probably because Vasari did not know the sculptor well, and the latter's close Florentine contemporaries were long dead. The readability of Condivi's prose is the result of significant editorial input on the part of his future uncle-in-law, the writer Annibale Caro, whose erudition is also discernible in the references to contemporary and classical authors.[15] Marginal notes by Tiberio Calcagni, Michelangelo's assistant in the last years of his life, in a copy of Condivi's biography, record the aged artist's pithy comments on the text, including criticisms of certain inaccuracies.[16] Nonetheless, it was Michelangelo and not Condivi who was largely responsible for the flattering image of his character and actions in the book. In a sense this idealized portrayal can be counted as one of his most important creations. Michelangelo repaid Condivi's efforts in the early 1550s with a 2-metre-high black chalk cartoon (from the Italian *cartone*, a big piece of paper), now in the British Museum (Exh. No. 95). This was intended as a guide for a panel painting by Condivi, an unfinished work of wretched quality now in the Casa Buonarroti (Fig. 110).

In the second edition of the *Lives*, published in 1568, Vasari included a much-enlarged biography of Michelangelo incorporating a great deal of Condivi's work. This borrowing was not acknowledged, and indeed Vasari's only mention of his rival's book omits the author's name and points out an inaccuracy. The only reference to Condivi is a disparaging comment on the painting made from Michelangelo's cartoon. Michelangelo's death four years earlier had enabled Vasari to interweave his own life story with that of his hero to suggest a far greater degree of intimacy between the two than was actually the case. The most shameless fabrication is perhaps Vasari's contention that as a child he almost became the pupil of Michelangelo, who personally delivered him instead to the studio of Andrea del Sarto, solicitously suggesting that he would prosper better there. Vasari could reasonably claim to know his subject better than he had when he wrote his first version. They had had dealings over Florentine-related commissions, such as the unrealized plans for the Roman church of S. Giovanni dei Fiorentini, a result of the elderly Michelangelo's accommodation with the rule of Vasari's patron, Duke Cosimo de'Medici. Vasari added to the second edition woodcut portraits heading the biographies, the one dedicated to Michelangelo portraying him in the patrician garb of a fur-trimmed brocade jacket (Fig. 1).[17]

Condivi's and Vasari's detailed hagiographies are supplemented by the primary evidence of Michelangelo's own words: his poetry, around 1,400 letters written by or addressed to him, as well as hundreds of notes (*ricordi*) of his expenses and financial transactions. The vast majority of these documents remain in Michelangelo's family archive at the Casa Buonarroti in Florence.[18] (Translations of thirteen letters selected from those acquired from the Buonarroti family in 1859 by the British Museum, now in the British Library, are included in Appendix II, pp. 294–8) The astonishing quantity of documentary material relating to Michelangelo, evidence of his adherence to the long-established Tuscan mercantile tradition of record keeping, makes him one of the best-documented artist of the period (by comparison, only two autograph letters by Raphael survive).[19] This wealth of material has given rise to hugely diverse and often highly speculative reading of his personality, behaviour, psychology, sexuality, artistic credos and the manner in which these are manifested in his art. Despite the access that these documents give to the minutiae of his daily life, and the torrent of words that have been written about him, we are perhaps no nearer deciphering some aspects of Michelangelo's character and motivations that puzzled his contemporaries.[20]

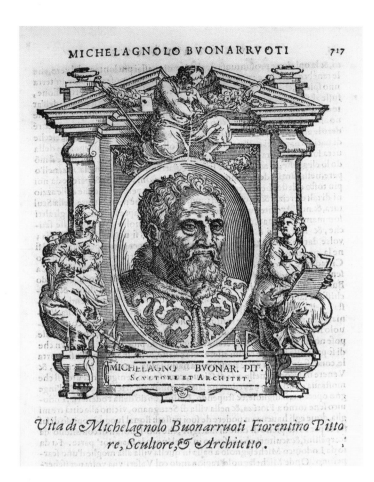

MICHELAGNOLO BVONARRVOTI 717

MICHELAGNO BVONAR. PIT.
SCVLTORE ET ARCHITET.

Vita di Michelagnolo Buonarruoti Fiorentino Pitto
re, Scultore, & Architetto.

Fig. 1 Cristoforo Coriolano
(b. *c.* 1530), **Portrait of
Michelangelo from Vasari's
*Lives of the Artists***, 1568.
Woodcut, 12.5 × 11 cm.
The British Museum, London

Michelangelo and *Disegno*

The Italian word *disegno* encompasses both the mental formulation of the idea, the design, and the drawing that was the result of this process.[21] The conceptual aspect of *disegno* was much emphasized by Renaissance artists and art theorists because it was such a vital part of the long-running argument that the occupation of painters, sculptors and architects should be counted among the liberal arts. One of the most active promoters of the intellectual and practical importance of drawing as the cornerstone of artistic excellence was Vasari, who was instrumental in the formation of the first art academy, the Florentine Accademia del Disegno, established in 1563 with Michelangelo as its honorary patron. Vasari also tirelessly extolled the primacy of *disegno* in his *Lives*, advancing the long-established Tuscan tradition of drawing as one of the principal reasons why artists from the region were, in his view, superior to all others. This is summed up in the anecdote included in the second edition of the *Lives*, in which Michelangelo confronted with the vaporous brushwork of Titian's *Danaë* (Galleria Nazionale di Capodimonte, Naples) is made to voice his regret that the Venetian had never learned to draw.[22]

Though we know little of Michelangelo's views on the theoretical aspect of drawing, he certainly shared Vasari's belief in its fundamental importance in artistic practice.[23] Perhaps Michelangelo's most famous expression of this credo is the inscription on a drawing in the British Museum from the mid-1520s (Exh. No. 59) directed to his pupil Mini: 'Draw Antonio

draw Antonio, draw and don't waste time'. The drawing in question is one of a handful (mostly included in this exhibition) that document Michelangelo's doomed, but touching attempts to teach his untalented pupils to draw by providing them with examples to copy, a traditional method of instruction adopted from his time in Ghirlandaio's workshop.[24] The inscription is not an isolated example of Michelangelo's insistence on the practical importance of drawing. He expressed much the same sentiments in a letter of 1518 to one of Mini's predecessors, Pietro Urbano, in which he urged him to work hard and 'not on any account to neglect to draw'.[25] The exhibition demonstrates Michelangelo's own lifelong dedication to the practice of drawing, which remained the wellspring from which his achievements in sculpture, painting and architecture flowed.

The Technique of Michelangelo's Drawings

The present exhibition provides a representative survey of the artist's drawing techniques, and one that reflects his changing preferences over the course of his career.[26] One technique that Michelangelo certainly practised in his youth was silverpoint, but no example by his hand in this medium survives. This is a method of drawing utilizing a stylus made of silver which leaves a deposit on paper or vellum coated with layers of ground.[27] It was an exacting technique because once a line had been drawn it could not be erased, except by scraping it off and reapplying the coating of ground-up bone. It was a method of drawing still in vogue in Florence during Michelangelo's youth (a virtuoso example from the mid-1470s is Leonardo's drawing of a warrior, Fig. 84), and it seems improbable that it did not feature in his training especially as his master Domenico Ghirlandaio was skilled in its use.[28] Michelangelo's boyhood friend and fellow student in Ghirlandaio's workshop, Francesco Granacci, certainly made drawings in silverpoint.[29] If Michelangelo did so as a boy, it was not a method to which he ever seems to have returned, probably because its delicate linearity was not suitable for the kind of exploration of the dynamic male form that was his preferred subject matter from the outset of his career. His rejection of it mirrors the general decline of silverpoint among artists at the beginning of the sixteenth century in favour of chalk, although Raphael was a notable exception to this trend, as he continued to use it until around the middle of the second decade.[30]

Michelangelo did make use of a stylus – a thin, sharpened iron point akin to that used for silverpoint drawings but one leaving no mark on the paper except for an indentation (for this reason it is sometimes known as a blind stylus). This instrument was widely used for underdrawing in the Renaissance, the indented lines acting as a guide when the artist took up his pen or chalk. The lines remain largely invisible allowing the artist to experiment freely without ruining the sheet of paper. Stylus underdrawing is often difficult to detect as the surface of the paper over time has been considerably flattened, and often stained and abraded. It is most easily seen in chalk drawings where the stylus has been pressed into the surface of the paper, the resulting deep groove causing the chalk to skip over the indentation. The indented marks then show up white against the surrounding chalk. This effect can, for example, be seen in Michelangelo's two studies for the *Flagellation* (Exh. Nos 32–3). With drawings in pen, stylus underdrawing is much harder to pick out because the indentations tend to be obscured by the ink. It is just discernible under raking light in some of Michelangelo's pen drawings, such as Exh. Nos 11 and 58, and it is more than likely that he used it with some frequency. Such difficulties detecting its use make it unwise to hazard any but the most general

comments, but there seem to be more examples of stylus underdrawing from the first half of Michelangelo's career; in the present group the *Fall of Phaeton* drawn in 1532 (Exh. No. 81) appears to be the latest example where it is observable, and it may be that he made less use of it later on. A possible explanation for this is Michelangelo's reportedly failing eyesight at the time of the *Last Judgement*, which prevented him from executing very detailed work at close range.[31]

Michelangelo's few secure studies drawn with leadpoint, a stylus made of lead, are identifiable through the thin, slightly lustrous quality of the line, although it is often hard to distinguish from black chalk. Leadpoint, unlike silverpoint, can be used directly on paper without any preparatory ground and the line can be easily erased. A few drawings in this selection, mainly from the first decade of the century, show definite traces of it in the underdrawing (Exh. Nos 11 and 18r). It is perhaps most easily visible in the figural studies partly obscured by the larger ones in red chalk on the versos of Exh. Nos 26–7, and in the underdrawing for the kneeling male nude on the left of Exh. No. 18r. Michelangelo certainly continued to make use of it at least until the 1530s, although the latest examples in the exhibition are the barely visible marks to the right of the doorway in the pen study of 1526 for a door in the Laurentian library (Exh. No. 58r).[32] As with stylus it may lurk undetected beneath further studies in pen, and careful examination may reveal further examples of his use of leadpoint underdrawing.[33]

Michelangelo's preferred medium for drawing at the beginning of his career was pen and ink. In Condivi's biography the aged artist is reported as describing how in his youth this was the only available drawing technique. His memory was at fault as black chalk had already gained acceptance among Florentine artists of the period, and red chalk was becoming more established after Leonardo's pioneering use of it in the 1490s. Michelangelo used, for example, the latter medium in one of his earliest surviving studies.[34] Nonetheless his remark is revealing of how much he associated his early years with this one technique.[35] The sort of pen that Michelangelo and his contemporaries used was one made by sharpening to a point the end of a feather quill, and then dipping this in ink. The natural springiness of the quill makes it highly responsive to the slightest change of pressure, the sharpened nib flexible enough to create straight and curved lines. The pen's qualities are well demonstrated in Michelangelo's study of a male nude of *c.* 1504–5 (Exh. No. 13r), the description of the form achieved through a combination of short multi-directional strokes to model the taut musculature of the torso with longer, more elastic contour lines. Some of the thicker lines, such as in the description of the flowing curls or the shadowed contour on the right side of his body, have been made by using the side of the sharpened point of the pen to drag the ink across the paper.

When Michelangelo made the drawing the colour of the ink was almost certainly nearly black: the familiar chocolatey brown tonality of almost all old pen studies results from chemical change to the iron oxides that are the principal constituent of the ink. Most inks of the period were made from an infusion of gallnuts, the fibrous tissue rich in tannins and gallic acid formed on the barks of oaks around eggs laid by certain insects, mixed with a solution of iron or copper sulphate.[36] The acidity of this irongall ink has resulted in the eating away of the paper in areas where it has been applied most thickly, such as the contour around the figure's raised arm in Exh. No. 13r. The same problem has affected the majority of the artist's pen studies (and indeed most Old Master drawings in the same medium), the seriousness of the damage governed by factors such as the particular acidity of the ink mixture and the relative thickness of the paper. Some of the artist's earliest pen studies, such as Exh. Nos 5 and 7, have been drawn using two different shades of ink, the lighter of which is more golden in tone.

Recent analysis undertaken at the British Museum of a small sample of Michelangelo's drawings has shown that the two inks used on Exh. No. 5r are both irongall inks. It is therefore uncertain whether the difference in tone between the two batches of ink would have been apparent when Michelangelo made the drawing. The investigation showed that Michelangelo did on occasion use slightly different types of ink on the same sheet: for example, the figure on the left of Exh. No. 18r was drawn with irongall ink and the three to the right in a now much darker ink that seems to be a mixture of carbon black and irongall ink.[37]

There is no evidence that Michelangelo made use of coloured papers except when he was producing a cartoon, such as Exh. No. 95, when he elected to use, like most of his contemporaries, thick bluish sheets now turned grey. Raphael's cartoon in the British Museum for the *Mackintosh Madonna* was likely drawn on similarly coloured paper, and the same shade was used by his pupil Giulio Romano.[38] There are only a handful of cases at the beginning of Michelangelo's career where he altered the tonality of the paper: either by rubbing crushed red chalk onto the surface, as he uniquely did in the pen study in the Louvre of around 1500 for one of the figures in the National Gallery *Entombment*, or by applying wash as is found on the verso of an early design for the Sistine vault in the British Museum (Exh. No. 17).[39] Such methods of colouring paper were widely used by earlier artists: the use in Florence of a red chalk ground to obtain a warm flesh-like hue for figure studies is exemplified by Botticelli's celebrated *Abundance* of the late 1470s or early 1480s in the British Museum.[40]

Michelangelo seems consistently to have preferred high grade cream or white paper (the tonality of which has often slightly yellowed over the years), although occasionally he drew on paper of inferior quality like the coarse, porridge-coloured sheet used to study the figure of *Leda* or *Night* and the *Head of a Child* (Exh. Nos 54 and 69). While paper was no longer such an expensive commodity as it had been for artists of earlier generations, Michelangelo was remarkably parsimonious in his use of it. He rarely left the reverse of a sheet of paper unused and, although his drawings on the front and back are usually from much the same date, on occasion he evidently went through his store of drawings in his studio to find one with a blank side. This seems to be the likely explanation for the roughly five-year gap (although some scholars favour an even greater interval) between the drawings on either side of a sheet in the British Museum (Exh. No. 5), and the twenty-year hiatus in the case of one of the Haarlem studies (Exh. No. 10). There are other examples of drawings with notes of expenses (as on the verso of Exh. No. 59), and drafts of letters and poems (such as Exh. Nos 15v, 62v and 102).

For a brief period in the middle of the first decade of the century, Michelangelo extended the tonal range of some of his pen drawing by using opaque lead white applied with a small brush as a highlight. It can be found on one of his nude studies for the *Bathers*, a section of the *Battle of Cascina* dating from around 1504–5 (Exh. No. 11); thereafter he abandoned it in favour of using untouched areas of paper as a highlight. Another means of indicating the fall of light was through the combination of pen and ink with wash (a more diluted solution of ink) applied with a brush. This was a technique widely used among Florentine draughtsman: Leonardo employed it with particular subtlety to create the effect of figures bathed in a crepuscular light in some of his drawings from the 1480s.[41] Michelangelo's use of this combination in his figure drawings was limited to a few sheets from the first decade of the sixteenth century. The first instance is in the large pen study of a twisting nude (Exh. No. 11), and he used pen and wash a few years later, arguably to better effect, to work out the structure and lighting of a vestment worn by one of the seated Sibyls in the Sistine chapel (Exh. No. 19r). After this date there are no further examples of his using pen and wash together

for figural drawings. He limited this combination for architectural designs, such as those relating to his work on fortifications for Florence from the late 1520s in the Casa Buonarroti; in his detailed studies for the Laurentian library; and on rare occasions after his return to Rome in 1534, as in his ground plan from the late 1550s for the Roman church of S. Giovanni dei Fiorentini.[42] The two techniques were often used in tandem by Renaissance sculptors to elucidate the designs of sculptural ensembles, a pattern followed by Michelangelo in some of his early finished drawings for the Julius tomb (Fig. 52).

The latest pen drawings in the exhibition are studies from the mid- to late 1520s, such as the designs for the Laurentian library (Exh. Nos 52v, 53v and on both sides of 58), and this accurately reflects the artist's near total renunciation of the medium in favour of black chalk in the last thirty years of his life.[43] His preference for black chalk even extended to architectural studies (such as Exh. Nos 103–4), a category of drawing that his contemporaries overwhelmingly preferred to make with the pen. Nowadays chalk is largely synthetic but the material used by Michelangelo, and indeed all draughtsmen until the late eighteenth century, was a natural substance found most commonly in three colours – black, red and white. Black chalk, a soft carbonaceous schist, was described as a 'certain black stone which comes from Piedmont' in a technical manual for artists written in the late fourteenth century by the Florentine painter Cennino Cennini.[44] However, it does not seem to have been widely used until the end of the fifteenth century when it was popularized by painters such as the Tuscan Luca Signorelli (see Fig. 27). Black chalk was sufficiently dense for it to be sharpened to a point, a quality that allowed Michelangelo to render detail with great precision in drawings, as can be seen in his 1537 design for a salt-cellar (Exh. No. 88). The density of black chalk meant that Michelangelo could press down hard on its sharpened tip to emphasize the torsion of muscle or register the density of bone, while the same stick of chalk could also create modulated hatching of the utmost delicacy, as in the British Museum *Crucifixion* drawn as a gift in the late 1530s or early 1540s (Exh. No. 91). The miraculously smooth transition of tone in the latter drawing was achieved through dextrous and time-consuming employment of a finger or a stump, a roll of leather or cloth with a domed point, in order to blend the modelled areas of chalks together seamlessly, a technique found in earlier studies such as the Haarlem *Bathers* study (Exh. No. 10r). In general in the second half of his career, in those studies destined to remain in the studio, such as those for the *Last Judgement* (Exh. Nos 83–7), Michelangelo's blending of tone is as telling as in the *Crucifixion*, but the execution is markedly more direct and immediate. The darkest shading in these same drawings is achieved by wetting the stick of chalk. Black chalk also varied naturally in tonality and density, as can be seen from comparing the dark, crayon-like viscosity of the outlines in one of the Sistine vault studies (Exh. No. 18v) with the sharply etched quality of the contours in the studies for *Christ Purifying the Temple* (Exh. Nos 97–9).

The majority of Michelangelo's black chalk studies are drawn in this medium alone, but the magnificent studies in Haarlem (Exh. Nos 9–10) for figures in the *Bathers* cartoon of 1504–5 include delicate traces of lead white applied with a brush.[45] This rather dainty application gives way to a broader more painterly approach in the study of Christ of 1516 (Exh. No. 33), although the white highlights are only dimly appreciable in this because the lead white has been affected by sulphur in the atmosphere and has discoloured. White heightening seems not to have been used by Michelangelo for roughly the next thirty-five years, until it reappears in a much more diluted form in his black chalk and brown wash architectural drawings from the 1550s and 1560s, like the additions made to a window design in the Ashmolean

(Exh. No. 103). In his later use of the medium it largely served as a means of covering-up parts of the drawing that Michelangelo was dissatisfied with. The once opaque liquid has gradually become transparent making some of his late architectural drawings, and to a lesser extent the *Crucifixion* studies from the same period (Exh. Nos 106–7), become like palimpsests, the cancelled contours now unintentionally visible through a misty haze of the white heightening.

In view of the remarkable fame and influence of Michelangelo's red chalk figure studies, most notably those for the Sistine chapel vault (for example Exh. Nos 25–30), it comes as something of a surprise to find how briefly he favoured it. Red chalk, an earth pigment formed from clay coloured by iron oxide, is one of the most ancient drawing media, but it did not become widespread in Italy until the early sixteenth century. Leonardo da Vinci was one of the first artists to use it extensively, employing it for his expressive studies of the apostles' heads for the *Last Supper* painted in Milan in 1495–7, and for the never completed *Battle of Anghiari* mural in Florence (1503–5).[46] Red, like black, chalk came in slightly different tones and densities, as can be seen from comparing the soft waxy quality of the line in Exh. No. 25r with the thinner, and more brittle contours in the two *Lazarus* studies (Exh. Nos 34–5). The variations in colour in some of the red chalk studies, such as the Haarlem drawing for the figure of Haman on the Sistine vault (Exh. No. 30), has led to suggestions that Michelangelo was adding accents in a stick of chalk of a darker shade. Even where it seems certain that Michelangelo was using a single stick of chalk, as with the two *Lazarus* studies, he masterfully varied the tone by pressing more heavily or lightly, darkening the line by moistening the tip and blending the areas of modelling with the tip of his finger or with a stump. The application of a wetted finger to create a tiny area of pinkish wash at the top of the cross in Exh. No. 71, a method much used by contemporary northern Italian artists like Correggio, seems to have been an experiment that was not repeated elsewhere in his red chalk drawings.

Although red chalk features in some of the artist's earliest drawing, his concentrated use of it dates from the period when he was painting the Sistine vault (1508–12). In the early stages of his work there he made studies in black chalk (for example, Exh. Nos 9v and 18v), and he also used it for some of the small figure sketches in the Ashmolean album related to the second half of the ceiling (Exh. Nos 22–3). The colour of red chalk naturally lent itself to the creation of figure drawing, especially when the glowing warmth of the tone matched that of the final work, as is the case with the bright hues of the frescoes on the vault of the Sistine chapel. Michelangelo continued to make use of red chalk in the second and third decades of the century (for example Exh. Nos 62–3, 67–8), but following his return to Rome in 1534 to work on the *Last Judgement* he used it only occasionally. In his final years Michelangelo, like Leonardo before him, favoured the smokier and more varied tonality of black chalk over the more sharply focused accents achievable in the more brittle medium of red chalk. An exception to this is a red chalk drawing from Oxford (Exh. No. 101), the dating of which is much contested but is here placed with works from the 1550s. This would make it the last known example of him using the medium.

The appearance of separate studies in black and red chalk on the same sheet is not uncommon in the first half of Michelangelo's career, as in Exh. Nos 46 and 66. More often than not it is impossible to fathom the logic of Michelangelo's choice of one colour over the other, and it may well be that sometimes he simply used the first stick of chalk that came to hand. However, occasionally the thought process underlying a particular selection can be tentatively guessed at, such as his use of black chalk for the study of Christ (Exh. No. 33),

although there is no way of corroborating such inferences. Examples of the artist deliberately combining red and black chalk in a single figure or composition is less common, although there are a few instances of it, such as the study of a head on the reverse of Exh. No. 5.[47] The cleaning of the Sistine frescoes has revealed Michelangelo to have been a bold and subtle colourist, but even so it seems doubtful that he ever followed Leonardo's lead in introducing further colour to drawings by the use of watercolour, or combining three or more coloured chalks.

Quantity of Surviving Drawings

There are roughly 600 surviving drawn sheets by Michelangelo. This means that the ninety or so works included in this exhibition represent just under a sixth of his graphic oeuvre (for simplicity's sake this calculation counts the many double-sided studies as a single work). This total is based on the one reached in Charles de Tolnay's four-volume *Corpus* (1975–80), the most complete catalogue of the artist's drawings. This includes 633 sheets (many of them drawn on both sides), but this number is whittled away if the works that the author lists as probable copies after lost drawings are excluded, along with those that scholars have subsequently questioned as being by Michelangelo.[48] To balance these depletions a surprising number of significant new additions have emerged over the last twenty-five years since the publication of the final volume of Tolnay's work. These include an elaborately worked *Holy Family with the Infant Baptist* first published by Michael Hirst; an early pen and ink study of a woman discovered by Julien Stock in an album at Castle Howard; Timothy Clifford's find of a black chalk and wash study of a candelabra among designs for light fittings in the Cooper Hewitt Museum, New York; a black chalk *Stoning of St Stephen* that came to light in a private foundation in Belgium; and most recently two black chalk studies of arms for figures in the *Last Judgement* spotted by Nicholas Turner among Michelangelo school drawings at the Prado in Madrid.[49]

In common with almost all his peers, Michelangelo never signed his drawings, even in the rare cases when he knew them to be destined for an existence outside his workshop, as is the case with Exh. Nos 70 and 91.[50] Consequently the judgement of whether a drawing is or is not by him is highly subjective (this thorny question is reviewed later on), and no two scholars agree on exactly how many drawings there are by Michelangelo's hand. Suffice it to say that the total arrived at by Tolnay is higher than that in all previous surveys, some of which number less than half as many. Many of the earlier catalogues excluded Michelangelo's strictly utilitarian drawings, such as the sheets in the Casa Buonarroti of measured diagrams of marble blocks drawn to guide the quarrymen and, more significantly, their compilers were guided by a much more restrictive view of Michelangelo's activities as a draughtsman. The modern standards of what constituted an 'authentic' Michelangelo drawing were first set by Bernard Berenson in his ground breaking *The Drawings of the Florentine Painters*, published in two volumes in 1903, and in an expanded form in 1938. Berenson was a brilliantly perceptive critic, and his essay on Michelangelo as a draughtsman remains a classic, but his approach to the sculptor's drawing was fundamentally flawed because aesthetic considerations counted above all else. While a hypercritical approach was valuable in whittling away the optimistic accretions that had built up around Michelangelo's name over the centuries, the pruning back to just over 220 sheets removed many drawings which had the most solid claim to be judged autograph.

In the latter category is a dismembered sketchbook now in the Ashmolean, Oxford, four of which are included in the exhibition (Exh. Nos 20–3). Its pages are filled with spontaneous, rapidly drawn ideas in pen and chalk for figures in the second half of the Sistine vault. Such scrappy studies fell far short of Berenson's ideal and he attributed them instead to an obscure assistant of the sculptor, Silvio Falconi, because his name was written on one of the sheets. As the drawings differed too greatly from the finished works to be copies, the logical conclusion of Berenson's demotion was that someone other than the Florentine should be credited with inventing figural ideas for perhaps his greatest commission. Michelangelo's much noted solitary working methods, and the related aversion he showed to having talented pupils around him to learn his style, added to the implausibility of Berenson's rejection. Even so, his negative view was shared by the German scholar Karl Frey in his unfinished three-volume catalogue of Michelangelo's drawings published from 1909 to 1911, and by Tolnay in his five-volume monograph on the artist published in 1945. It is only in the last fifty years that the critical tide has begun to turn in favour of accepting the authenticity of the Oxford sketchbook.[51] The absence of what could be termed a Michelangelo school, akin to the entourage of Raphael with assistants like Giulio Romano and Perino del Vaga who had been trained to work in their master's style, presented a serious problem to the ultra-purist school headed by Berenson, and in order to fill this lacuna the sculptor's few known students, such as Falconi and Antonio Mini, were deemed capable of drawing to a standard almost as high as that of their master. Berenson even invented a highly gifted, but entirely fictitious pupil 'Andrea di Michelangelo' (based on a misinterpretation of an inscription on Exh. No. 60r) to whom he assigned a number of the sculptor's most refined ideal heads, such as Exh. No. 66.[52]

Berenson's rejection of so many drawings that had been prized as Michelangelo's by eighteenth- and nineteenth-century connoisseurs was challenged by the post-war studies of the Budapest-born art historian Johannes Wilde.[53] His re-evaluation came about through his long study of the important Michelangelo holdings from the British Museum and the Royal Collection, begun when the two collections were taken to Wales to escape the threat of bombing in the Second World War. Wilde's profound knowledge of the artist's works and their documented histories, together with a piercing analytical eye for quality and style, brought him to appreciate that a sizeable number of drawings rejected by Berenson, Frey and other scholars were, in fact, critical in revealing the artist's unfolding process of thought. What emerged from Wilde's researches was a far more nuanced picture of Michelangelo's activities as a draughtsman, one that showed him to be far more flexible and versatile in his approach than had hitherto been allowed. His adaptability was no different from that shown by other Renaissance artists with sizeable numbers of surviving drawings such as Raphael, Andrea del Sarto, Fra Bartolommeo and Parmigianino. Wilde's new thoughts on Michelangelo first emerged in the section devoted to the artist that he contributed to the 1949 catalogue of the Italian sixteenth-century drawings in the Royal Collection. He followed this by his penetrating and wide-ranging study of the even richer Michelangelo holdings in the British Museum published in 1953, and an exhibition held the same year of the artist's drawings in English collections. The force of Wilde's arguments led his fellow Hungarian Tolnay to recant the ultra-cautious line he had taken towards the drawings in his monograph published between 1943 and 1960. The more expansionist view set out in Tolnay's four-volume *Corpus dei disegni di Michelangelo* which came out between 1975 and 1980, the last volume published a year before his death, is one accepted by most, but not all, modern authorities.[54]

The fact that so many fragile pieces of paper with studies by the artist have been preserved for more than half a millennium may seem little short of miraculous. Fortunately Michelangelo lived in an age when the appreciation and collecting of drawings was becoming more widespread, and his renown as a draughtsman ensured that his studies were highly prized. Vasari built up a celebrated collection of drawings stored in albums to document the development of art set down in his *Lives of the Artists*. Among these works was a drawing by the young Michelangelo, given to him by the sculptor's boyhood friend Francesco Granacci, which he says he venerated like a relic.[55] The sense of pride felt by Michelangelo's descendants also ensured that his drawings, letters and poems were preserved. Although the value attached to Michelangelo's drawings helped to ensure their preservation, it also led to collectors and dealers cutting a single sheet into two or more pieces to boost their holdings of his work. The majority of works in the present selection have certainly been the victims of such treatment, especially if one bears in mind that the measurements of the smallest standard size of paper of the period (the *rezzuta*) were 32 × 45 cm, according to a stone slab measure in the headquarters of the paper makers' guild in Bologna (a paper making centre from where Michelangelo is known to have made purchases).[56] Sometimes two or more drawings can be shown to have once been part of the same sheet, as is the case with the studies of the unrealized statue of an Apostle for Florence cathedral now divided between the British Museum and the Louvre (Exh. No. 15 and Fig. 29); or the composition of the Annunciation split into two separate figure studies both in the British Museum (Exh. Nos 93–4).

Old copies can sometimes show the original appearance of the artist's drawings. For example, a sixteenth- or early seventeenth-century pen and ink drawing in the British Museum (Fig. 2) suggests that Michelangelo's early figure studies at Haarlem (Exh. No. 6) once had a study of a male torso on the left side. The dismemberment of drawings was unfortunately a common fate for works by the most admired Renaissance draughtsman. In comparison with some of his contemporaries, most notably the inveterate pen doodlers Leonardo and Parmigianino, whose graphic musings have frequently been chopped down to studies of postage stamp-like proportions, Michelangelo's work has suffered fewer indignities.[57] At least in one instance among the exhibited works Michelangelo appears to have wielded the scissors on one of his own drawings, cutting away a central section of his 1550s compositional study of *Christ Purifying the Temple* (Exh. No. 99) and pasting in another piece of paper to replace it. This time-saving technique to avoid having to begin a new drawing was employed by many of his contemporaries including Raphael.[58]

The part that chance has played in shaping the boundaries of Michelangelo's corpus of drawings should not be underestimated (the same could be said for almost all of his contemporaries). This randomness is apparent from the fate of the sculptor's studies for the allegorical figures in the Medici chapel (Figs 71–2).[59] There are seven unequivocally related studies for *Day* (all of which are in the exhibition, Exh. Nos 46–7, 49–53), three for *Night* (one of which is on the verso of Exh. No. 46) and none for the two remaining sculptures. Similarly, no studies survive for his two greatest early sculptures, the *Pietà* (1498–1500) in St Peter's and the *David* (1501–4), while two preliminary sketches survive (one of them exhibited here, Exh. No. 14r) for the *Bruges Madonna* (Fig. 19), a much less significant commission of the same period.[60] Haphazard survival is not uncommon from drawings of the period, perhaps the best-known example being the preponderance of studies by Raphael for the *Disputa* rather than the *School of Athens* on the opposite wall of the Stanza della Segnatura in the Vatican palace.

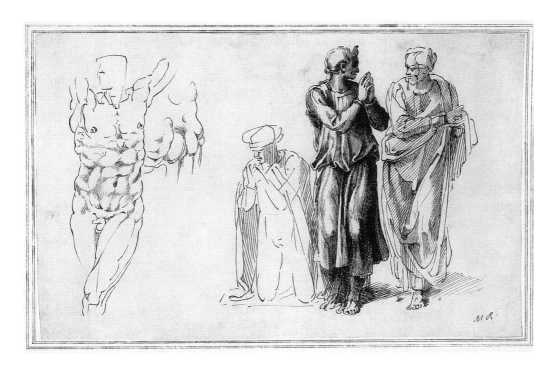

Fig. 2 Anonymous artist, **Figure studies**, after Michelangelo, c. 1550–80. Pen and brown ink, 24.8 × 38.1 cm. The British Museum, London

Random accident cannot, however, entirely explain the uneven coverage of Michelangelo's activities as a draughtsman. The worst documented period in terms of his drawings is, as with most artists, the first decade of his career before he had established himself as an independent artist with his own studio, and this requires no further explanation. Odder, however, is the poor survival rate of Michelangelo's drawings from the last thirty years of his life when compared with those from the period 1501 until his permanent transfer from Florence to Rome in 1534. (It has been calculated, counting recto and verso studies separately, that there are 360 figurative drawings from the period 1501–34 and just under 100 produced between 1534 and 1564).[61] This disparity is reflected fairly accurately in the present selection with two thirds of the exhibits dating from the years before Michelangelo's work on the *Last Judgement* in the Sistine chapel (1534–41). For the latter work, he must have made many hundreds of drawings to determine the poses of the protagonists in the densely packed composition, not to mention cartoons for the entire design. Not a single example of the latter category has survived, and only five studies of entire figures remain (all of which are exhibited here, Exh. Nos 83–7). Much the same is true of Michelangelo's preparatory work for his last work in fresco, the two murals painted in the Pauline chapel (1542–50), for which there are only two figure studies and a section of the cartoon, now in Naples, for the *Crucifixion of St Peter*.[62] The artist's increasing concentration on architecture in the last third of his life partly explains why there are fewer figural drawings, but again the number of surviving architectural studies for these years is far fewer than for those related to the Medici building projects in Florence that occupied him from 1516 to 1534. Just two elevation designs remain (one exhibited here, Exh. No. 104) to show the gestation of his thoughts for the dome of St Peter's, the crowning element of a building that he worked on for the last seventeen years of his life. In part this disparity is due to the absence of the Medici from Florence which meant that drawings were sent by Michelangelo to Rome and then returned to him, a proportion of them ending up in his archive. Once Michelangelo had moved to Rome he had less need to make

drawings as he could communicate his wishes on site, and those designs he committed to paper were probably less likely to return into his hands.

Another factor in the scarcity of Michelangelo's late drawings is that he destroyed them. As early as February 1518 Michelangelo's friend in Rome, Leonardo Sellaio, reported he had regretfully followed the artist's instructions to burn the *chartoni* left in his house.[63] The works consigned to the flames were most probably Michelangelo's cartoons for the Sistine vault, that is full-scale drawings made to transfer the design to the wall, although Vasari later records that a handful of these designs (now lost) were in private hands.[64] Word of this destructive practice clearly spread. Pietro Aretino, in his sustained but unsuccessful attempt to wheedle the gift of some drawings out of Michelangelo, mentions in letters to the artist written from Venice in 1538 and 1546 that he would be happy to accept works that might otherwise end up being burnt.[65] Leonardo, the artist's nephew and closest relative, reported that his uncle in his final days had burnt all the drawings in his Roman studio in two successive bonfires.[66] Following Michelangelo's death the painter Daniele da Volterra, who had been present at the sculptor's deathbed, reported to Vasari in Florence that apart from cartoons there were only two smaller drawings remaining in the house, an *Annunciation* and a *Christ in the Garden of Gethsemane*.[67] Both these highly finished designs (the class of drawings most prized by sixteenth-century collectors) were subsequently presented to Vasari's master, Duke Cosimo de'Medici. In view of the survival of late Michelangelo drawings, such as the moving series of Crucifixion studies bought from the artist's descendant in the early nineteenth century (Exh. Nos 106–7), the report of wholesale destruction was clearly exaggerated, probably to enable the Buonarroti to retain Michelangelo's drawings in the family's collection. Nonetheless Michelangelo evidently did destroy a large batch of his late drawings, and the few that have come down to us are precious records of his undiminished powers as a draughtsman.

Michelangelo left no word in his correspondence of his motivation for such acts of destruction, and it has been left to others to speculate. Vasari suggested in his 1568 biography that Michelangelo burnt his drawings because he wanted to obscure the effort that had gone into the creation of his masterpieces.[68] A less flattering interpretation of Michelangelo's behaviour is provided by the repeated injunction to his intimate circle not to allow outsiders to view his work. This intense dislike, if not paranoia, of unauthorized access to his creations is first expressed in a letter written in Rome in January 1506 to his father in Florence ordering him to hide away the *Bruges Madonna*.[69] Similarly, while Michelangelo was completing his work on the Sistine vault, he chided his father in a letter of 1511 for not having acknowledged his command that no one should touch his things (specifically mentioning his drawings), and in the same spirit he had the nearly completed marble figures for the Julius tomb stored behind a walled-up door in his house in Rome when he left the city for Florence in 1516.[70] It was when he returned there, on a short visit in January 1518 to tidy up his affairs, that Michelangelo most likely ordered the cartoons stored in the house to be burnt. If the *chartoni* were, as seems almost certain, those for the Sistine vaults, it would have been impractical to transport such an enormous quantity of large drawings to Florence. Michelangelo clearly preferred to destroy them to ensure that his artistic rivals could not possibly utilize his inventions, rather than leaving them in Rome unattended. (It is perhaps some consolation that even if Michelangelo had decided to spare them, they would most likely have perished when the Tiber burst its banks in 1530 and his house was flooded).[71]

If Michelangelo's destruction of his drawings was motivated by a dread of theft, his fears were realized when two young sculptors, Bartolommeo Ammannati and Nanni di Baccio Bigio, broke into his Florentine workshop just before the siege of the city in 1529 and took away fifty to sixty of his figure studies (including some for the Medici chapel), along with four sculptural models.[72] The crime went unpunished, according to Vasari, as it was recognized that the youthful perpetrators were fired by a love of Michelangelo's art not financial gain, and the drawings were soon returned. Nonetheless the two sculptors may well have had time to make copies of some of the drawings, and the circulation of these probably explains the spread of Michelangelo's figural inventions even to artists working in distant cities such as Bologna.[73]

Michelangelo may have boasted in Condivi's biography that he never repeated the pose of his figures, but this did not prevent his contemporaries wanting to copy or adapt his ideas for their own work. The contemporary taste for elegant imitation is exemplified by the incorporation of figures, copied from those in some of Michelangelo's elaborately finished drawings made as gifts for his friends (such as Fig. 92), in a painting of the *Battle of Montemurlo* (Palazzo Pitti, Florence) by the Venetian Battista Franco. Michelangelo's ardent admirer Duke Cosimo de'Medici commissioned the work in 1537–8, ironically to celebrate a victory over the Florentine republicans whose cause was tacitly supported by the sculptor (for his inconstancy in this regard see his 1547 letter in Appendix II, no. 8, p. 296). Michelangelo's jealous regard for his own uniqueness as an artist, and his protectiveness in not allowing his drawings to be seen or engraved (as had his rival Raphael in his fruitful collaboration with the engraver Marcantonio Raimondi), only increased the appetite of his contemporaries for his work.

The question of what percentage the total of 600 drawings represent of the entire number produced in Michelangelo's lifetime is unanswerable. When these are parcelled up between his seventy-seven years of recorded activity (1487–1564) it comes to a meagre total of less than eight a year. This is dwarfed by the corpus of more than 4,000 sketches and diagrams left by Leonardo (by far the largest of any sixteenth-century Italian artist), and also compares badly with the roughly 450 by Raphael from a career lasting little more than a quarter of a century. The present exhibition provides ample evidence of Michelangelo's natural fluency as a draughtsman, and it also underlines, perhaps most forcefully in the studies for the leg and shoulders of *Day* in the Medici chapel, how meticulously he worked out the details of his figures before taking up his chisel or paintbrush. With such sequences in mind it is clear that his known graphic corpus represents a fraction of the number of drawings he must have produced in his lifetime.

Identifying Michelangelo's Drawings

For almost all of Michelangelo's drawings there is no irrefutable way of ascertaining that they are by his hand, and the same could be said of any artist. Scientific analysis of a drawing's materials and paper can serve as helpful pointers to whether the work is from the right period, but such tests are rarely, if ever, conclusive as to authorship.[74] Knowledge of a drawing's history can also be invaluable, but in the case of Michelangelo even a provenance stretching back to the Casa Buonarroti does not, as will be discussed later, guarantee that the work is necessarily by him.[75] The lack of unanimity among Michelangelo scholars over the last century is reflected in the fact that almost all the drawings in this exhibition have at some time been doubted. Among the few that have not raised dissenting voices are three studies in

the British Museum: two pen and ink drawings related to the Julius tomb and the Medici chapel, and the black chalk *Fall of Phaeton* (Exh. Nos 38, 42 and 81). All three bear inscriptions in the artist's hand that directly relate to the drawings and were clearly written soon after. Cast-iron certainties of this kind are exceptionally rare with any Italian Renaissance draughtsman. Not even the presence of Michelangelo's handwriting on one side of the paper is any proof that the drawing on the other side is by him (an example being a sheet in the British Museum with a draft of a letter on the recto and a weak study by a pupil of Hercules and Antaeus on the verso).[76]

The first and the last drawings in this exhibition are separated by a gap of some sixty years, and not surprisingly they look very different. Taken in isolation they would be hard to accept as the work of the same artist, yet the ninety or so works between the two demonstrate the gradual evolution of his style over the course of his career. The chronology of Michelangelo's drawings is sometimes far from being straightforward, as his preoccupation with the male body made him return time and time again to explore analogous compositions and poses. This can be seen from the similarities between the organization of the action around a tightly compressed core of twisting figures in the studies of *Christ Purifying the Temple* (Exh. Nos 97–9) of around 1555–60, and a compositional study of *The Worship of the Brazen Serpent* (Exh. No. 75) executed for an unknown project some twenty-five years earlier. The latter drawing is also a good example of the vagaries of dating, because it has sometimes been thought in the past to be a study for the same scene painted on one of the pendentives on the altar wall of the Sistine vault (1511–12); to add to the confusion it also contains a figural motif of two men lifting up a third which is first found in studies (including Exh. No. 14r) from the period of Michelangelo's work on the *Bathers* back in 1504–5. Its present dating rests on stylistic analysis. The precise delineation of the figures and the neat parallel shading in the background of the Oxford sheet are not found in the only surviving compositional study for one of the Sistine pendentives, the *Judith and Holofernes* (Exh. No. 9v). A much more compelling comparison is provided by the British Museum compositional study for the *Last Judgement* dating from the beginning of the artist's work on the fresco, 1533–4 (Exh. No. 82r), and the Ashmolean *Brazen Serpent* must date from around the same period.

The study for the *Last Judgement* was drawn around the same period as Michelangelo made the highly polished black chalk portrait drawing as a gift for its subject, Andrea Quaratesi (Exh. No. 70), whose friendship with the artist can be traced through letters from the period 1530–2. Yet despite their closeness of date and comparable techniques, the two works look very unlike each other as they were made for completely different purposes. It is evident from the comparison that Michelangelo, like all artists, altered the way in which he drew to suit the requirements of the task in hand. A ready analogy for this is found in the way that we all routinely modify our writing style according to different circumstances, with the forms of expression, rules of syntax and punctuation (even ones as fundamental as the capitalization of proper nouns and the initial letter of a new sentence) changing between a business letter and an informal e-mail or text message. This kind of linguistic flexibility is so effortless and commonplace that we are rarely aware of it. Critics, both past and present, have often been reluctant to grant Michelangelo a similar versatility in the ways in which he drew. The artist capable of creating a male nude of such consummate perfection as Exh. No. 26r could also draw figures pared down to the barest essentials, such as those on the recto of Exh. No. 18. The tendency of collectors in the past to favour the artist's more finished drawings has meant that sketchy preliminary studies are rarer than his more finished

works, but proof that they are not exceptional is shown by similar examples from all periods of his career.

The pose of the twisting nude at the centre of the *Bathers* cartoon studied in one of Michelangelo's most celebrated works in the British Museum (Exh. No. 11r) developed out of a minuscule spidery outline drawing on the reverse of No. 15 (see Fig. 23). Fifty years or so later the artist was making similarly schematic figure drawings in the first stages of devising a pose, albeit in his favoured medium of his latter years, black chalk, as can be seen from the studies of Christ in the upper corner of Exh. No. 96 for a composition of *Christ Purifying the Temple*. The basic similarities between the two drawings, as with the earlier example of the two compositional studies for the *Brazen Serpent* and *Last Judgement*, stem from their origin at comparable stages of the preparatory process.[77] Comparison between these works from different periods show that while Michelangelo's drawing style changed, what remained constant was his dedication to the long established Florentine workshop routine of first working out the general compositional outline before moving on to studying individual figures.

In judging the correctness of any attribution to Michelangelo a number of factors have to be taken into consideration: whether it fits into the pattern of his working method and his use of techniques; comparisons made with examples from the same period; and the drawing's history and critical reception. Just as there are familiar correspondents whose identities are known to us from their handwriting on the envelope alone, individual artists can often be recognized by particular mannerisms in their way of drawing. One of the defining characteristics of Michelangelo's drawing is the vibrancy of the line, a quality discernible even in the most insignificant sketch: he is able to impart a sense of volume, and the underlying form, by dint of minutely lessening or increasing the pressure applied to the chalk or pen. The qualitative difference between Michelangelo's supremely responsive touch and that of even the most skilled copyist is apparent from comparing Exh. Nos 65–6 in the exhibition. The first, a black chalk drawing of the head of a warrior, the so-called *Count of Canossa*, is of sufficiently high quality that one recent critic has continued to champion its traditional attribution to Michelangelo.[78] It has many admirable qualities that recommend it – deftly controlled shading in the modelling, crisp outlines in the definition, such as the satyr mask on the breast, and even signs of the artist having changed his mind, as in the faint alterations to the profile defining the tip and bridge of the man's nose. Yet when the drawing is put side-by-side with Exh. No. 66 its deficiencies in the flatness and deadness of the handling are immediately highlighted. The tiny variations in pressure that darken or lighten almost imperceptibly the contours and shading of the autograph drawing give the female profile an animation lacking in the male one. The subtleties that the copyist (almost certainly Florentine and from the mid- to late sixteenth century) has been unable to capture are suggested by a comparison between the hard, unyielding textures of the description of the warrior's eye and his glassy stare, with the dreamy introspection of the woman's gaze, the soft tissue of her eyelid contrasted with the hard reflective sheen of the eye socket. The best test of any drawing is to look at it alongside works of comparable character by the same artist, and the present exhibition will hopefully help to resolve some of the outstanding questions of attribution (for example Exh. Nos 24 and 69).

There will be little reference here to the critical history of the various works as there would be little space left over for discussion of anything else. Those interested in such matters can consult the specialist catalogues of the three collections (a brief summary of recent critical literature for each of the exhibited works is given in Appendix I, pp. 284–93). But to give a flavour of the ebb and flow of drawing scholarship, and to underline how subjective a

judgement of quality can be, the critical history of one of the more debated works in the exhibition has been selected: a double-sided red chalk study in Haarlem related to the Sistine vault (Exh. No. 26). Along with the rest of the album of Michelangelo's work it had lain almost unnoticed in Haarlem until the visit of four German art historians in 1898, who had gone on an excursion to Haarlem from an international congress in Amsterdam. Their amazement at the calibre of the work they saw there led two of them, August Schmarsow, a professor at Leipzig University, and Adolf Bayersdorfer, a member of the board of the German Institute in Florence, to instigate the publication of these unknown Michelangelo works. Three years later high quality facsimiles of the drawings were published in Munich.[79] In the publication the life studies on both sides of the drawing were related to various figures on the Sistine vault, comparisons facilitated by the inclusion of black and white photographs of the related details of the fresco.

The Swiss art historian Heinrich Wölfflin in his 1901 review was willing to accept the authenticity of the verso studies but dismissed those on the other side as caricatures of Michelangelo's work, the forms 'conceived purely from the outside, without feeling for their relative values in the appearance as a whole'. Both sides were accepted as Michelangelo by Berenson and his positive view was shared by the great German scholars of Michelangelo of the early twentieth century: Ernst Steinmann in his 1905 publication on the Sistine chapel and Henry Thode in his three-volume critical edition of the artist's work (1908–13). An exception to this was their countryman Albert Erich Brinckmann, who in his 1925 catalogue of the drawings dismissed both sides as copies and Tolnay followed his lead by rejecting them in his 1945 publication on the Sistine vault. In his general retreat from his arch-sceptical position in his earlier writings Tolnay later accepted the Haarlem drawing in his *Corpus*. In Leopold Dussler's 1959 publication on Michelangelo's drawings, one generally inimical to Wilde's position, it is acknowledged that both sides of Exh. No. 26 and its companion No. 27 could not be copies of the fresco. Judging both to be insufficiently good to be by Michelangelo, Dussler gave them instead to some unknown artist in the Florentine's circle who had access to his drawings and cartoons for the Sistine vault. Despite the inclusion of Exh. No. 26 as autograph in the 1971 corpus compiled by the American scholar Frederick Hartt, the Swiss-born art historian Alexander Perrig has recently echoed Dussler's misgivings. In his 1991 book on Michelangelo's drawings Perrig suggests that both Haarlem drawings are 'most likely early examples of study forgeries' (i.e. false preparatory studies).

The Provenance of Michelangelo's Drawings in Haarlem, London and Oxford

An account tracing the journey of Michelangelo's drawings from his studio to three institutions in northern Europe must begin with the admission that it is a fragmentary one, especially as regards the early history of all but a handful of the works. The youngest of the three museums, the one founded in 1784 as part of the charitable foundation endowed by the Mennonite textile manufacturer and financier Pieter Teyler van der Hulst in his native Haarlem, was the first to possess drawings by the artist.[80] They came as part of the 1,700 or so drawings, mainly by Italian artists, acquired in Rome in 1790 on behalf of the museum by the Dutch connoisseur and collector Willem Anne Lestevenon. The collection was bought from Prince Livio Odescalchi, duke of Bracciano, whose family had owned it for almost a century

since its purchase by Don Livio Odescalchi in 1692 from the heirs of Queen Christina of Sweden who had died three years earlier.

Queen Christina was one of the most intriguing rulers of the Baroque age, her unconventionality confirmed by her decision in 1654 to renounce her throne after twenty-two years (Fig. 3). Her love of Italian art and her conversion to Catholicism led her to settle the next year in Rome, her palatial residence not far from the Tiber (Via della Lungara) transformed into a veritable private museum with a fabulous collection of Old Master paintings by Titian, Veronese, Raphael and Correggio, along with sculptures by her friend Bernini (one of the few contemporary artists she showed an interest in), antiquities, coins and medals, and a superb library.[81] Some notion of Christina's collection is supplied by a 1656 inventory list of her drawing volumes made in Antwerp prior to their shipment to Rome. This mentions three albums given over to drawings by single artists, namely Michelangelo, Raphael and the Dutch artist Goltzius, with a further three filled by a mixture of prints and drawings by Parmigianino and other miscellaneous masters. Once in Rome, Christina continued to add to her collection although details of her acquisitions are lacking. The queen is recorded as having bought drawings from her ambassador in The Hague, Pieter Spiering van Silfvercroon, in 1651, three years before her abdication. These may have been the two albums of drawings that the Dutch diplomat acquired in 1645 from the German painter and writer Joachim von Sandrart. The latter was a cosmopolitan figure who had travelled widely in Europe, spending a six-year sojourn in Rome (1629–35) where he had looked after the art collection of Vincenzo Giustiniani. Profiting from his patron's elevated position in Roman society, the German became acquainted with some of the most distinguished artists of the period: Claude Lorrain, Poussin, Pietro da Cortona and Andrea Sacchi; and it is probable that while in Rome he also took the opportunity of building up a collection of drawings by past and contemporary masters.

The young Swedish nobleman Nicodemus Tessin wrote that on a visit to Rome in 1688–9 he had been shown seven albums of Christina's drawings, and details of four of these (unfortunately not including the one with Michelangelo's works) are supplied by handwritten lists found in various locations summarizing their contents. These inventories, all written by the same hand, were probably made not long after Christina's death in April 1689 in connection with the dispersal of her collection. Cardinal Decio Azzolini was the queen's heir but he only outlived his benefactress by a few months, and it was his nephew, Marchese Pompeo Azzolini, who had to dispose of the inheritance to pay off the debts on the royal estate. To this end he sold Christina's library to the recently elected Pope Alexander VIII in 1690, and two years later Don Livio Odescalchi bought the rest of the collection. The drawings were part of this transaction, although they were ceded as a gift to Don Livio probably in order to avoid complications over Azzolini's removal of works from the queen's albums. The descriptions of the drawings given in the surviving inventories are frustratingly imprecise, but enough detail is given to prove that numerous studies now in the Teyler Museum once belonged to Queen Christina. Conversely they also show that some of the works listed were definitely not part of the group acquired by Haarlem in 1790, the missing items having been either sold or given away by Azzolini or by the Odescalchi. An added complication is that Don Livio was a considerable collector of drawings in his own right, although there is no evidence to suggest that he added any example by Michelangelo to the holdings acquired from Queen Christina.

Nothing is known for certain about the early history of the twenty-five Michelangelo drawings at Haarlem, although almost all of them have a late sixteenth- or early seventeenth-century pen inscription 'di Michel Angelo Bona Roti', or some close variant, and numbering in

Fig. 3 Giovanni Hamerani (1646–1705), **Portrait of Queen Christina of Sweden**, c. 1680. Wax and slate model for the obverse of a medal, diam. 4.5 cm. The British Museum, London

Fig. 4 **Details of the same inscription on Exh. Nos 31v, 47 and 93v**

a different hand (Fig. 4). Thirteen of the Haarlem drawings in the present selection have these inscriptions written on them (Exh. Nos 6v, 9r, 26r, 27v, 30v, 31v, 49v, 50v, 52v, 53v 72r, 84r and 89r). The same inscription is found on a number of other autograph Michelangelo drawings: seven at Windsor Castle; nine at Oxford (including Exh. Nos 16, 47r and 105v); three in the British Museum (including Exh. Nos 93v and 94r); and single sheets in the Louvre, the Ecole des Beaux-Arts, Paris, the Biblioteca Reale, Turin, and the Metropolitan Museum of Art in New York.[82] It is not an infallible guide to authenticity as the inscriptions are occasionally found on some drawings that are not by Michelangelo (for example the one by the Florentine sculptor Giovanni Bandini in Haarlem), but even so it is clear that whoever wrote the inscriptions had an extraordinary store of drawings by the artist.[83]

Almost all the Michelangelo drawings now in the Ashmolean and the British Museum arrived there more than half a century after the Teyler Museum's 1790 purchase. Both institutions owe their extraordinary holdings to the dispersal of the greatest of all English drawing collections, that of the portrait painter Sir Thomas Lawrence who died in 1830. Before the Ashmolean acquired a portion of Lawrence's unrivalled collection in 1846, the museum had nothing by Michelangelo's hand. In the case of the British Museum only one of the roughly eighty studies by Michelangelo now in the collection arrived there before the mid-nineteenth century – the black chalk study of the *Holy Family with the Infant Baptist* (Exh. No. 80) bequeathed by Richard Payne Knight in 1824. Other drawings from the same bequest, as well as some left to the museum in 1799 by the wealthy recluse the Reverend Clayton Mordaunt Cracherode, were also then believed to be by Michelangelo. This is revealed by an account of a visit to the Print Room in 1831 written by the Frankfurt-born Nazarene painter Johann David Passavant. The latter had come to England to research his pioneering monograph on Raphael,

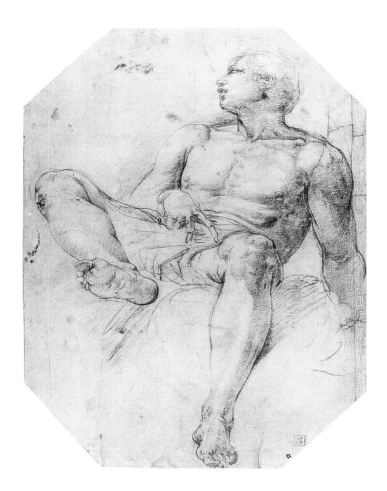

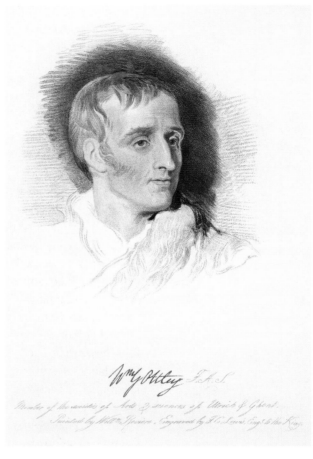

published eight years later in 1839, and this led him to study a considerable number of the country's greatest collections of paintings and drawings. Enterprisingly noting the absence of reliable modern guides to England's burgeoning art treasures, he published one in German in 1833 (including details of his tour of Belgium), and a translated version of the English section of this was published in London in 1836 as *A Tour of a German Artist in England*. Of the six drawings that Passavant was shown in Bloomsbury as being by Michelangelo only one, Exh. No. 80, is now regarded as autograph, the others classified as copies or works by contemporary admirers of the sculptor. These include two drawings from the Payne Knight collection: a study of a male nude in black chalk by the sixteenth-century Florentine sculptor Baccio Bandinelli which Passavant described as a study for Adam in the *Creation of Man* on the Sistine vault, and a work in the same medium by the Venetian painter Battista Franco (Fig. 5).[84] Passavant was particularly struck by the second of these, describing it as 'splendid drawing' by Michelangelo for the figure of Jonah on the Sistine vault.[85] Payne Knight almost certainly knew it to be by Franco as he kept it with other drawings by the same artist, but this knowledge was later ignored in the Museum. Michelangelo's name had been written on the backing by the seventeenth-century English collector William Gibson, perhaps recording the view of the painter Peter Lely, a pioneering collector of Old Master drawings in England who had owned it before him.

A cynic might interpret such long-established confusion over what constituted a genuine Michelangelo as an expression of the perennial over-optimism of collectors. In their defence, it

above left
Fig. 5 Battista Franco (*c*. 1510–61), **A seated nude youth**, *c*. 1552–61. Black chalk, 36.6 × 27.4 cm. The British Museum, London

above right
Fig. 6 Frederick Christian Lewis (1779–1856), **Portrait of William Young Ottley**, after Reviere, 1820–40. Stipple, 32 × 24 cm. The British Museum, London

should be said that in England, at least, they had relatively little to go on. Few genuine studies by Michelangelo can be traced back, through sale catalogues and collectors' marks, to the great English collectors of the seventeenth and eighteenth centuries. Among the Michelangelo drawings in the British Museum only two have an English provenance before 1800. Exh. Nos 7 and 25 are both said to have belonged to the painter Jonathan Richardson Senior, who died in 1745, although unlike the Michelangelo recently discovered at Castle Howard neither bears his collector's mark. It seems that authentic genuine examples of the sculptor's drawings were few in number and consequently there is some excuse for English collectors' ignorance of his style. In this regard it is significant that the only genuine Michelangelo drawings seen by Passavant in England were one in the British Museum, the superb group in the Royal Collection formerly owned by the Farnese family which is believed to have been bought by King George III's Italian agents in the late eighteenth century, and the *Epifania* cartoon (Exh. No. 95) then with the dealer Samuel Woodburn.[86] None of the other so-called Michelangelo studies that the German scholar admired in the collection of the duke of Devonshire at Chatsworth in Derbyshire, or in General Guise's collection at Christ Church, Oxford, is now considered to be authentic although the Christ Church collection is now reckoned to have four autograph examples.[87] The cartoon seen by Passavant was one of over a hundred drawings by Michelangelo from the cabinet of Sir Thomas Lawrence which had passed to his creditor, Samuel Woodburn, who was trying to arrange the sale of the collection. One can only conjecture how such an astute connoisseur as Passavant might have revised his view of Michelangelo's draughtsmanship, had Woodburn not meanly restricted him to seeing only Lawrence's collection of Raphael's work, deaf to his 'unremitting exertions' to be granted access to the rest.

In any event, within a few years the so-called study for Jonah at the British Museum was listed as a work by Franco (although it later reverted to its traditional and far grander attribution), the change almost certainly due to the arrival of William Young Ottley (Fig. 6) who had been appointed head, or Keeper, of the Department in 1833.[88] Ottley was one of the greatest authorities on prints and drawings of the age, but sadly by the time he took the job he was sixty-two and in ill health. He achieved little during his three-year tenure of the post before his death in 1836, his time largely taken up in disputes with the museum's Director and Trustees. However, his significance for the Michelangelo holdings in London (and in Oxford) extended far beyond his ability to spot a misplaced Franco, for he was instrumental in bringing back the first significant group of the Florentine sculptor's drawings to England since the cache at Windsor Castle.

Ottley was the son of a family made prosperous by the ownership of Jamaican sugar plantations. His interest in art led him to study at the Royal Academy where he became a talented amateur draughtsman in the neo-classical mould (Lawrence later flatteringly compared the delicacy of his pen studies to those of Franco). Like many young men of means with a taste for the arts he left for Italy. He was to remain there from 1791 to 1799, and it was during this period, spent mainly in Rome and Florence, that he acquired his profound knowledge of Italian art and also amassed his astonishing collection of drawings and prints. Works on paper were relatively inexpensive and he could only afford a small but choice selection of paintings. Fortunately for him the timing of his stay coincided with the French invasion of Italy in 1796, a period of upheaval that brought unrepeatable buying opportunities, as owners of works of art were confronted with the unenviable choice between selling at a reduced price or running the risk of their collection being looted by the invading army.

During his time in the peninsula Ottley is known to have bought drawings and prints from a number of distinguished sources, including the Neapolitan royal family; a superb collection of Parmigianino studies from descendants of the great Venetian eighteenth-century collector, Antonio Maria Zanetti; and a group of more than a hundred drawings mysteriously released from the Uffizi in Florence. Ottley funded his collecting by dealing and it appears that he was not over-scrupulous as to the source of the material offered him – as is shown by his acquisition of a superb collection of drawings stolen in 1799 from the French painter Jean-Baptiste Wicar, a former pupil of the revolutionary artist Jacques-Louis David, who had himself profited from Napoleon's Italian invasion.

Wicar had been resident in Florence between 1787 and 1793 and had returned to Italy with the French army to serve as a commissioner, advising on the removal of the country's greatest art treasures for the Musée Napoléon in Paris. At some time, probably during the late 1780s, Wicar is reported to have befriended his fellow radical Filippo Buonarroti and was able to acquire from him drawings by his illustrious ancestor taken from the family archive in the Casa Buonarroti in Florence, by far the largest collection of the artist's work. The core of the Casa Buonarroti's holdings were the studies left by the artist in Florence when he moved to Rome in 1534, augmented by those gleaned from his Roman studio after his death. (The archive includes letters both to and from the artist throughout his life, so it is clear that Leonardo Buonarroti gathered together his uncle's papers in 1564; among these must have been drawings by Michelangelo and his pupils made on the same sheets of paper as correspondence, financial accounts and drafts of poems.) Leonardo's son, Michelangelo the Younger, took over the Casa Buonarroti on his father's death in 1593, and he was largely responsible for turning the house into the shrine to his great-uncle that we know today. He commissioned paintings from the leading contemporary Florentine artists to depict key moments from the artist's life and, as a writer and poet himself, he was also keen to promote his namesake's literary gifts. It was he who published a heavily bowdlerized edition of Michelangelo's poetry in 1623. He also sought to add to the collection, purchasing sheets of drawings from the Florentine architect Bernardo Buontalenti or his heirs who had poetic drafts by his ancestor (among them Exh. Nos 14, 41 and 42). His familial piety was also rewarded by the donation of works, such as the return by the then duke of Florence, Cosimo II, of the early marble relief of the *Madonna of the Stairs* and the black chalk presentation drawing of Cleopatra.[89] Not all the works added to the family holdings during Michelangelo the Younger's lifetime were by his namesake, and this explains why a Casa Buonarroti provenance is not a certain proof of a drawing being an authentic work by the sculptor or his circle.

It seems that only a few of Wicar's substantial collection of Michelangelo drawings were among the stolen works that ended up with Ottley in 1799, and the Englishman must have found other sources through which to acquire works by the artist.[90] Four auctions held in London between 1803 and 1814 have been identified as sales of Ottley's drawing collection, and all but the first of these include substantial groups of studies by Michelangelo, many of which were described as coming from Italian sources. It is extremely hard to be precise as to how many of the sculptor's drawings Ottley owned, because unsold groups of drawings from one auction would often be grouped in different ways and with an amended description in the next one. In the last of the series held in June 1814, a marathon lasting fifteen days, there were almost seventy claimed to be by Michelangelo of which as many as twenty-four may have come from the Casa Buonarroti. Ottley may have acquired these legitimately from Filippo Buonarroti; but the Casa Buonarroti was certainly not the Englishman's only source for

The Private Sitting Room of Sir Tho.s Lawrence

the sculptor's drawings. There are scattered references in the various sales catalogues to Michelangelo's works having been in the possession of families such as the Martelli in Florence, the Spada in Rome, as well as from Roman sculptor and dealer Bartolommeo Cavaceppi (who had bought, probably in the 1760s, a part of the cache of Michelangelo studies assembled by the Florentine Filippo Cicciaporci) and from the Florentine collector Lamberto Gori. Ottley clearly was not willing to let such treasures go cheaply, and the high reserves he set on his finest drawings meant that following the 1814 sale he still retained most of them in his collection. This policy was vindicated when in 1823 he sold his drawings *en bloc* for £10,000 to a relatively new collector of Old Master drawings.[91]

The purchaser of Ottley's cabinet was the fashionable portrait painter Sir Thomas Lawrence (Figs 7 and 8) who, in the course of a single decade, succeeded in gathering together one of the greatest collections of drawings ever formed. The sizeable price paid to Ottley for his drawings may well have included a retainer to act as a consultant to advise on future acquisitive ventures; Lawrence's respect for his knowledge is clear from his recommendation to his executors that Ottley was a person 'particularly competent' to arrange his various works for sale.[92] The painter certainly had cause to admire Ottley's taste for Michelangelo because the 1823 purchase brought some superb examples by his hand, including leaves from a sketchbook with studies for the Sistine vault (Exh. Nos 20–3), the red chalk *Adam* for the same project (Exh. No. 25), a preliminary sketch for part of the *Last Judgement* (Exh. No. 82) and the magnificent pen and wash window design for the Palazzo Farnese (Exh. No. 103). These were soon joined by more examples by the same artist, as Lawrence's principal agent, Samuel Woodburn, scoured Europe to acquire notable collections. The greatest prize was brought about by Wicar's decision to sell part of the superb collection that he had built up after the disappearance of his first. After tough negotiations in Rome, Woodburn secured the sale early in 1823 for Lawrence's much richer rival, the banker Thomas Dimsdale.

The latter had bought from Woodburn two years earlier the fine collection of another Frenchman, the marquis de Lagoy, which included Michelangelo's study for the *Fall of Phaeton* now in the British Museum (Exh. No. 81). Dimsdale had little time to savour his new purchases for he died that April, and Woodburn bought from his heirs his Italian drawings and sold them on to Lawrence for £5,500.

Lawrence's insatiable passion for Old Master drawings coincided with a period of unrivalled opportunity, thanks to Napoleon's destruction of the old European order. The painter's reckless extravagance in pursuit of the choicest pieces resulted in large debts, but a collection of unequalled magnificence. He had hoped that it would be preserved intact, yet this proved impossible when he died unexpectedly in 1830. Lawrence's generous offer to various representatives of the nation, among them the British Museum, to acquire the collection of over 4,000 drawings and seven albums, including two by Michelangelo's Florentine contemporary Fra Bartolommeo, for the price of £18,000 was turned down. Although a substantial sum, this was probably less than half what the painter had expended on collecting it. After the negotiations had failed, Samuel Woodburn, the painter's major creditor, bought the whole lot for £16,000 and he set about selling it off. He organized a series of ten exhibitions between 1835 and 1836 in his gallery in St Martin's Lane in London, each one with a selection of around a hundred drawings. The last in the series was devoted to the pick of Lawrence's Michelangelo drawings with thirty-seven of the drawings exhibited here included in that show. Woodburn still hoped that sections of his friend's collection would be kept together (the banker William Esdaile, for example, acquiring Lawrence's Rembrandt and Titian drawings), but he did not find any takers ready to buy *en bloc* the contents of the most valuable parts: the ninth and tenth exhibitions devoted to Raphael and Michelangelo respectively. His hopes were partially realized when in 1839 the future King William II of Holland acquired sixty drawings from the exhibition in two transactions, as well as a substantial group of works by Correggio, Leonardo, Raphael and the complete series of the Florentine Andrea del Sarto, for a sum over £21,500.[93] A little more than a decade later, Woodburn was able to reacquire a substantial number of these drawings when they were auctioned at the posthumous sale of King William's drawings held in The Hague in the summer of 1850.

The 1839 transaction with the Dutch king seems to have given Woodburn renewed vigour to pursue his campaign for the preservation of the remaining portions of Lawrence's Michelangelo and Raphael holdings (some 270 works in all) by a sale to the Oxford University Galleries at a preferential rate of £10,000. The principal champion of Woodburn's plan was the Revd Dr Henry Wellesley, the Principal of New Inn Hall and a distinguished collector of drawings in his own right, who showed the tenacity of his kinsman, the duke of Wellington, in persuading his university colleagues of the merits of trying to raise such a large sum of money for the purchase of Italian drawings. The appeal launched in 1841 was successfully concluded the following year, largely thanks to the earl of Eldon giving £4,000 and Woodburn responding with great public spiritedness by reducing the asking price by £3,000. Thanks to this campaign the Ashmolean acquired 104 drawings then believed to be by Michelangelo, of which 57 are catalogued as autograph in Paul Joannides' forthcoming catalogue of the museum's holdings.

Oxford's triumph may possibly have caused the authorities at the British Museum to reconsider their neglect of Italian Old Master drawings. And it is perhaps not coincidental that the nineteen additions to this area of the museum's collection in the first half of the century were all acquired in the 1840s. However, the Department's ignorance of the field is

Fig. 8 Samuel Cousins (1801–87), **Sir Thomas Lawrence**, 1830. Mezzotint, 43.1 × 32.6 cm. The British Museum, London

also signalled by the return of Franco's *Jonah* (Fig. 5) among the Michelangelo drawings where Gustav Waagen, the tireless German scholar and director of the Berlin Royal Gallery, described it admiringly as being the best example there after a visit during his tour of England in 1850.[94] Significantly, it was an outsider, Sir Charles Eastlake, the first Director of the National Gallery and a Trustee of the British Museum from 1850, who instigated the acquisition of a group of Michelangelo drawings in 1859. The purchase came about when the collateral descendant and namesake of the artist, Michelangelo Buonarroti, showed Sir Charles and Lady Eastlake on a visit to the ancestral family villa in Settignano in October 1858 a group of drawings and letters, as well as three sculptural models (two attributed to Michelangelo, Exh. Nos 44–5, and one by Giambologna).[95] Despite the dubious circumstances surrounding the items' removal from the material kept in the Casa Buonarroti, a collection which had been donated to the city of Florence the previous year on the death of Michelangelo's cousin Cosimo Buonarroti and of which the seller was now custodian, Eastlake was so keen to secure such precious material for the British Museum that he personally paid the asking price of over £100. This first batch of material secured in May 1859 was followed by the purchase the following month of a larger group of drawings and manuscripts for the sum of £400. Fifteen of the thirty-six drawings acquired from Michelangelo's descendant are included in the present selection, including the marvellous series of black chalk studies for the Medici tombs (Exh. Nos 39–41).

A year later in 1860, the posthumous sale of the stock held by Samuel Woodburn, who had died seven years earlier, was sold by Christie's, and the Government of the day, in belated recognition of the importance of Lawrence's collection, offered a Treasury grant for the British Museum to make purchases at the sale. Sixty ex-Lawrence drawings by Michelangelo were included in the sale, most of the finest of which were those that Woodburn had bought back at William II's sale in 1850. The Museum was fortunate that the glut of so many superb drawings on the market severely depressed the prices, and it was able to buy the exceptional red chalk *Three Crosses* (Exh. No. 71) for just over £26 – less than a tenth of the sum asked for it by Woodburn at the time of the 1836 Lawrence Gallery exhibition. The British Museum secured eight drawings at the sale (all but one of which is included in this selection) for the expenditure of just over £300, and two more immediately afterwards (Exh. Nos 34–5). Further Michelangelo drawings from the Lawrence–Woodburn sale were later acquired – such as Exh. No. 86 bought from J.P. Heseltine in 1886 for £200 – or presented to the Department, as with the five examples given in 1887 by Henry Vaughan (four of which are included in the exhibition, Exh. Nos 11, 13, 19 and 77).

Another purchaser at the 1860 sale was the great connoisseur Sir John Charles Robinson, since 1852 the superintendent of the art collections of the new South Kensington Museum (later the Victoria and Albert Museum). Robinson was astonishingly wide-ranging in his interests and blessed with a keen eye for quality, his acumen reflected in the quality of the ceramics, metalwork, manuscripts and sculpture that he bought for the museum in Italy and Spain (he was among the first English admirers of El Greco). He also built up his own collection and acted as an advisor for rich collectors of the day (a conflict of interest with his official duties that was a factor in the abolition of his post in 1867 and his leaving South Kensington). In the Lawrence–Woodburn sale Robinson was buying for the Scottish laird John Malcolm of Poltalloch (Fig. 9), whose inherited fortune, based on estates in Argyll and sugar plantations in Jamaica, had been increased by successful land speculations in south Australia; the same year Robinson sold Malcolm his entire collection of drawings.[96] Robinson had a

Fig. 9 T.L. Atkinson (1817–89/90),
John Malcolm of Poltalloch,
after W.W. Ouless, *c.* 1860.
Mezzotint, 35.2 × 30.2 cm.
The British Museum, London

particular taste for the Italian Renaissance, and his collection's greatest treasures were the thirteen sheets attributed to Leonardo da Vinci, the twenty-three to Michelangelo and the thirteen to Raphael. The two last-named artists were the focus of his pioneering catalogue, *A Critical Account of the Drawings by Michel Angelo and Raffaello in the University Galleries, Oxford*, published in 1870. This established new standards of scholarship in the study of drawings, innovatively using the new technology of photography as an aid to finding finished works related to the studies, and analysing the drawings with great rigour even to the extent of analysing hitherto overlooked details: such as the watermarks found on some of the papers used by the two artists.

Robinson encouraged Malcolm to make further acquisitions, and two ex-Lawrence Michelangelo drawings (one attributed to Sebastiano) of the *Flagellation* (Exh. Nos 32–3) bought from William II's sale were among the 135 lots, mainly by Dutch seventeenth-century artists, purchased at the Gerard Leembruggen sale in Amsterdam in March 1866. Three months later Malcolm bought over eighty lots – one of which was the ex-Casa Buonarroti *Ideal head of a Woman* (Exh. No. 66) at the posthumous sale of the hero of the Oxford Michelangelo purchase, Henry Wellesley, whose collection curiously was not bequeathed to the Ashmolean. In May 1875 Malcolm and his devoted friend the print collector William Mitchell attended the Paris sale of Emile Galichon, the former editor of the *Gazette des Beaux-Arts*. Malcolm's purchases in the sale concentrated on rarities by Italian printmakers but he also added two ex-Lawrence black studies by Michelangelo, the *Fall of Phaeton* and a

rare study for the *Last Judgement* (Exh. Nos 81–2). Sidney Colvin, the wily Keeper of the Department of Prints and Drawings at the end of the nineteenth century, had assiduously courted Malcolm and when he died, aged eighty-eight, in the spring of 1893 the Museum acted quickly. The collector's son, John Wingfield Malcolm, was persuaded to deposit the collection in the Department in June of that year, and at the same moment he also presented to the Museum the *Epifania* cartoon (Exh. No. 95) that Robinson had bought from the Lawrence–Woodburn sale for the bargain price of just over £11. Two years later the collection of over 1,000 drawings, 22 of them by Michelangelo, and more than 400 prints was acquired for the favourable price of £25,000. The quality of the Michelangelo drawings in Malcolm's collection is testament to his determination to buy only the best examples, and he was fortunate that he was able to find superlative drawings on the market from the final dispersal of Lawrence's unique holdings (seventeen of the twenty-two previously belonged to the artist).

The arrival of the Malcolm drawings established the British Museum as one of the greatest repositories of Michelangelo's drawings, a position consolidated by the purchase at auction the following year of a black chalk *Lamentation* from the collection of the Earl of Warwick at a cost of £1,500 (Exh. No. 90). The only significant twentieth-century additions were the marvellous red chalk *Adam* for the Sistine vault (Exh. No. 25), one of the Michelangelo drawings bought from Ottley by Lawrence, presented in 1926 by the National Art Collections Fund and the splendid double-sided figure drawing (Exh. No. 83) for the *Last Judgement* that was accepted in lieu of tax on the estate of the fourth Lord Methuen of Corsham Court in 1980.[97] The Museum's very limited acquisition budget has meant that it could merely observe the recent high-profile sales of Michelangelo drawings, but its holdings have been increased in recent years by the inclusion among the drawings accepted in lieu from the estate of Dr and Mrs Alfred Scharf in 1993 of two tiny block diagrams.[98] Both have stamps in red sealing wax and accompanying inscriptions, dated 1852, written by Cosimo Buonarroti certifying them as authentic works by his illustrious ancestor 'Gran Michelangelo'. These tiny scraps, their elaborate presentation eerily reminiscent of the neatly tagged fragments of the True Cross and of saintly bones and teeth in dusty collections of church relics, must be among the last works taken from the much-reduced family archive before Cosimo bequeathed it, and the artist's house in the via Ghibellina, the Casa Buonarroti, to the city of Florence on his death in 1858. It is now a public museum and still holds numerically the largest collection of Michelangelo drawings.

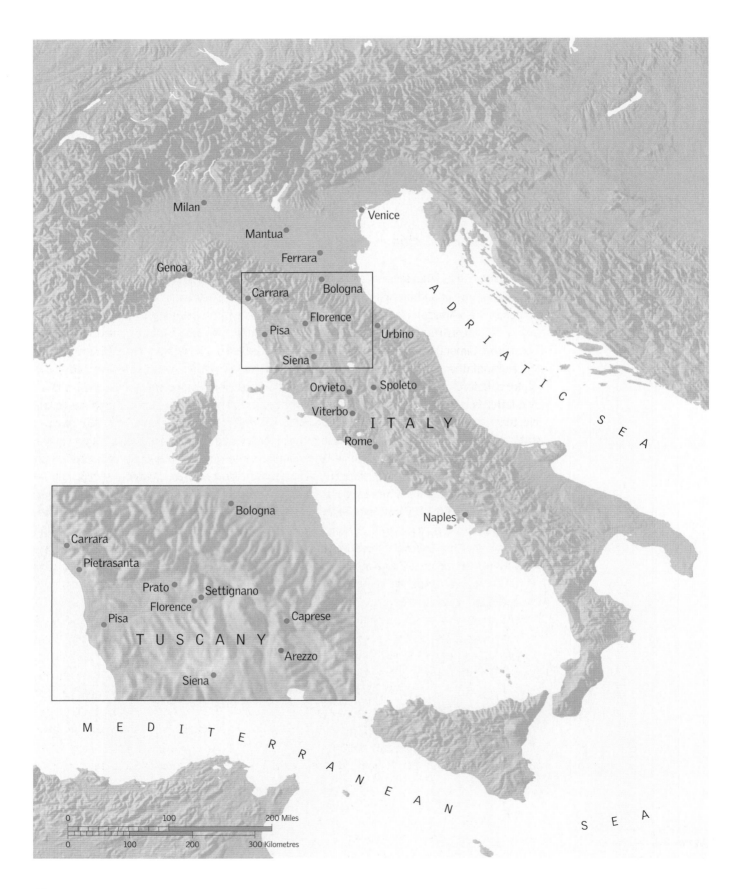

2

Early Formation: Florence and Rome 1475–1501

Family and Education

Michelangelo was the second of five sons born to the Florentine Lodovico di Leonardo Buonarroti Simoni and his wife, Francesca. He was born in March 1475 in the small town of Caprese, near Arezzo, where his father was employed for three months as *podestà* (the governor/administrative representative of the Florentine state). His family, the Simoni (or Buonarroti Simoni), had once enjoyed far greater political distinction since Michelangelo's great-grandfather had been elected three times to Florence's central political body, the Signoria, before his death in 1405. The artist was well aware of these past glories, as is shown by a letter written to his nephew in 1547 telling him how he had read an old Florentine chronicle that had mentioned their ancestors.[1] But by the time of the artist's birth the family's status and wealth had markedly declined.[2] The artist's father, Lodovico, who died aged eighty-seven in 1531, lived on a meagre inheritance and a share of the proceeds from a small farm jointly owned with his brother at Settignano, a small town outside Florence, augmented by occasional employment in low-ranking administrative positions for the Florentine state.[3]

In reaction to his father's resigned acceptance of his straitened circumstances, Michelangelo was driven by a fierce ambition to elevate the status of the Buonarroti. His large earnings from his artistic output coupled with a domineering personality meant that his family, none of whom showed any aptitude for business, looked to him from an early age for support. Michelangelo's correspondence bears testimony to the considerable efforts he expended to this end. An enormous number of his letters are taken up with financial transactions connected in some way to his family in Florence: bank transfers, urban and rural property purchases, the loan of funds to support his brothers' ill-fated business ventures and the like. He had to endure undeserved complaints from his father and siblings that he had left them short of money, a charge that would sometimes trigger Michelangelo to write furious, witheringly sarcastic denunciations of his family's ingratitude at his efforts to help them.[4] (For an example of the artist's epistolary gift in this vein see Appendix II, no. 5, p. 296.) Michelangelo's sensitivity to the standing of his family, and his disappointment at their shortcomings, is well illustrated in a letter he wrote from Rome in 1546 to his nephew Leonardo in Florence, one of many taken up with the search for a suitable Florentine property for the family:

> You should seek to buy an imposing house for fifteen hundred or two thousand *scudi*, if possible in our quarter [i.e. S. Croce]. And as soon as you have found something suitable, I'll have the money paid to you there. I say this because an imposing house in the city redounds much more to one's credit, because it is more in evidence than farm lands, since

we are, after all, citizens descended from a very noble family. I have always striven to resuscitate our house, but I have not had brothers worthy of this. So strive to do what I tell you and get Gismondo [Michelangelo's youngest brother] to return to live in Florence, so that it should no longer be said here, to my great shame, that I have a brother at Settignano who trudges after oxen.[5]

Michelangelo's sense of his family's distinction was perhaps further heightened by an entirely fallacious belief that the bourgeois and unremarkable Buonarroti Simoni were related to the celebrated Canossa family. Condivi includes this fiction in his biography, and Vasari in the second edition of his *Lives* repeats it, albeit with no great conviction. It is a mark of Michelangelo's fame that the originator of this invention may have been Count Alessandro of Canossa himself. He wrote to the artist in 1520 inviting him to come and visit the family castle, the letter addressed to 'my much loved and honoured kinsman messer Michelangelo de Canossa' (for the full text in translation see Appendix II, no. 4, p. 295).[6] Michelangelo made an imaginary portrait of one of his supposed ancestors, a drawing known only through a contemporary copy (Exh. No. 65). The sculptor was susceptible to this fantasy because he felt keenly, not without reason, that his background put him in a higher social class than his fellow artists. This famously led him to demand in a letter to his only nephew Leonardo in 1548 that correspondence should no longer be addressed to him in Rome as 'Michelangelo sculptor', tartly observing that he had never lowered himself to running a workshop.[7] Leonardo had been similarly castigated the previous year because he had sent his uncle a brass measuring rod in response to a request to supply details of the standard measures used in Florence. As Michelangelo explained in his letter, ownership of this humble object had affronted his dignity because he felt it implied he needed to carry it around like a builder or carpenter, and he had given it away rather than cause him shame.[8] Paradoxically Michelangelo's relationships with stonemasons and quarrymen, the very class that he was so anxious to distance himself from, were generally warm and unaffected. His correspondence with these artisans at the time of his work in S. Lorenzo (1516–34) is free of the peevish snobbery that he so often displayed in his later letters to his nephew.[9]

Michelangelo's vision of his imaginary Canossa ancestor as an ideal of martial vigour could not be more different from the realities of his parentage. His father's querulous, anxious nature is evident from the correspondence with his son. Their often thunderous disagreements (see, for example, Appendix II, no. 5, p. 296) are balanced by more tender expressions of solicitude, such as Lodovico's concerned letter of 1506 to his son in Rome warning him of the dangers of washing himself and of eating wind-inducing food, and the sculptor's poem lamenting the death of his father and favourite brother Buonarroto ('ancor che 'l cor già mi premesse tanto').[10] Late in life Michelangelo had forgiven the exasperation that his father had caused him, describing him in kindly terms in Condivi's life as a good and religious man, if somewhat old-fashioned.[11] The artist and his biographers are silent on his mother, Francesca, who died when he was six after having given birth to five children in eight years. Although much has been read into this loss by some commentators, the high mortality rates associated with childbirth meant that Michelangelo's near motherless upbringing was a relatively common one.[12]

The time he can have spent with his mother would have been short, for like most Florentine children of rank he had been sent by his parents to be brought up for the first years of his life by a wet nurse. As he later joked, he owed his skill as a sculptor to his nurse's milk as her father and husband were both stonemasons in the *macigno* quarries in Settignano, the

grey, or sometimes greenish blue, sandstone for which the locality was famed.[13] The long stone-working tradition of the area, exemplified by the fifteenth-century sculptor Desiderio da Settignano, was to prove important to Michelangelo as he may well have observed the basics of his future trade in the quarries and stone-carving workshops in the locality. His local knowledge also proved invaluable when he was assembling a team of skilled artisans to help him in the large-scale quarrying and carving connected with his Florentine architectural projects in S. Lorenzo, a large proportion of whom came from Settignano and must have been known to him from childhood.[14]

Michelangelo's boyhood was divided between Settignano and the family's house in the S. Croce quarter in Florence. He was educated in the city at a school of grammar run by a certain Francesco da Urbino where he would have been taught to read and write Latin. His biographers make clear that Michelangelo's nascent interest in becoming an artist made him a poor pupil, his neglect of his studies and stubborn refusal to give up his chosen career supposedly earning him beatings from his father and uncle. Michelangelo seems to have gained only a rudimentary grasp of Latin, and he taught himself to write a beautiful hand (examples of which can be found on a number of drawings reproduced here and in the letters included in the London exhibition).[15] During his youth he formed a lifelong passion for the poetry of Dante and Petrarch. Condivi records that Michelangelo almost knew their work by heart, and their influence resounds in his own Petrarchan poetry and in the inspiration he took from Dante's *Inferno* in his conception of the *Last Judgement*. An indication of the way in which his mind reverberated with Tuscan poetry is given by examples of him writing a phrase or stray line from Petrarch while working on a drawing.[16]

Michelangelo's Early Works

From Michelangelo's biographies and from other documentary sources it is evident that a number of key works from his early career have been lost, and similarly our knowledge of his development as a draughtsman during these years is hampered by the destruction of all but a handful of drawings. The lack of precision in the dating of the works included in this section of the exhibition is a consequence of this gap in our knowledge. As is well known, Michelangelo tried via Condivi's biography to deny that he had ever been apprenticed in the studio of Domenico and Davide Ghirlandaio, as had been stated in Vasari's *Life* written three years earlier in 1550. Condivi's disparaging remarks about Domenico's son falsely claiming that his father's teaching had been responsible for Michelangelo's genius was rebuffed by Vasari's publication, in his second edition, of a formal contract of April 1488 for a three-year apprenticeship between the sculptor's father and the Ghirlandaio brothers. The document that Vasari cited has disappeared but there is no reason to doubt its validity. Michelangelo was clearly already an assistant by June 1487, when he is recorded as having collected money due to his master for his work on the nearly completed altarpiece of the *Adoration of the Magi* in the Ospedale degli Innocenti, Florence. Vasari states that Michelangelo was encouraged to enter Ghirlandaio's studio because of the presence there of his friend Francesco Granacci who had grown up in the same quarter of the city. Condivi also mentions that Granacci took Michelangelo to visit Ghirlandaio's studio and encouraged his friend by supplying him with suitable models to copy, such as the engraving of the *Temptation of St Antony* (Fig. 12) by the famous contemporary Germany printmaker Martin Schongauer. The copy on panel that Michelangelo is supposed to

Fig. 11 *Battle of the Centaurs*, 1491–2. Marble, 80 × 90.5 cm. Casa Buonarroti, Florence

have made of the print has disappeared, but the survival of a comparable work from the same period, perhaps by a fellow pupil in Ghirlandaio's studio, suggests that Schongauer's animated model was a familiar part of a Florentine workshop training.[17]

How long Michelangelo remained there is uncertain, but perhaps as early as 1488 he may have abandoned his apprenticeship to study in the loggias of the Medici Garden the collection of antiquities and works of arts. Inspired by what he saw there Michelangelo carved a head of a faun (now lost), the quality of which brought him to the attention of Lorenzo de'Medici (Lorenzo the Magnificent) the *de facto* ruler of the nominally republican state of Florence. Condivi gives Michelangelo's age as between fifteen or sixteen (1490–1) when he was invited by Lorenzo to become a member of his household, while Vasari states that he was in the Medici palace for four years before the death of his patron in 1492. Michelangelo's earliest surviving works, the unfinished marble reliefs of the *Madonna of the Stairs* and the *Battle of the Centaurs* (both now in the Casa Buonarroti), were created during his time as a member of the Medici entourage, and in the case of the second work (Fig. 11), probably specifically for Lorenzo, although they remained in the artist's possession.[18]

During the brief period in power of Lorenzo's son Piero de'Medici (1492–4) Michelangelo carved a marble figure of Hercules of about 4 *braccia* high (roughly 2.45 metres or just under 8 feet high). Condivi concocted a story that Michelangelo carved this as an independent venture from a weathered piece of marble after Lorenzo's death. He did so probably to disassociate Michelangelo from Piero whose swift fall from power was an embarrassment to later

generations of the family. Michelangelo's lost work represented a mythical classical hero long regarded in Florence as a model of courageous virtue. Piero had grown up in a palace which had three giant paintings by Antonio and Piero Pollaiuolo, commissioned in 1464 by his grandfather, Piero di Cosimo de'Medici, and depicting some of Hercules' Labours. The suggestion that Piero commissioned Michelangelo's marble, perhaps prompted by a wish to renew his family's identification with Hercules, has been verified with the discovery of a document recording its restitution to Michelangelo from the confiscated Medici collection in August 1495.[19] At some later date Michelangelo either sold or gave the sculpture to the Strozzi, a banking family second only to their Medici rivals in wealth and influence, with whom he was to retain links throughout his career (see his letter of 1547, Appendix II, no. 8, p. 296). The *Hercules* is recorded from 1506 as standing in the courtyard of the Strozzi palace in Florence.[20] In 1529 Filippo Strozzi presented it to the ardent republican and francophile Battista della Palla who was gathering an art collection for the French king, Francis I.[21] In France it was placed in the gardens of the royal palace of Fontainebleau but it seems to have been destroyed there at some point in the early eighteenth century.[22]

In the 1490s Michelangelo's biographers record that he carved and painted a wooden Crucifix for the high altar of the Augustinian monastery of S. Spirito in Florence. This was apparently made as a gift in gratitude for the prior having provided him with corpses and a room so that he could make dissections to study anatomy. No anatomical drawings from this period survive to validate this story, but the superbly naturalistic rendering of Christ's body in his marble *Pietà* of 1498-1500 strongly suggests that he had at least observed such dissections. The wooden Crucifix was long assumed to have been lost, but most scholars now agree that it is the work rediscovered in a storeroom in S. Spirito in the early 1960s.[23] The choice of wood as a material and its polychrome surface are traditional for works of this kind, and Michelangelo's figure can be compared with examples by earlier Florentine sculptors such as Brunelleschi, Donatello and Benedetto da Maiano.

Condivi records that Michelangelo was part of Piero's household for a couple of months, but the sculptor's connection with the unpopular ruler was probably a great deal closer than that implied in Condivi's and Vasari's accounts. A clue to this is provided by Condivi's mention in his narrative that the invitation to return to the Medici palace followed on from Piero calling on Michelangelo to build a snowman in the courtyard. This can be dated to late January 1493 when a contemporary diarist recorded the rare occurrence of a heavy snowfall in the city. Michelangelo's stay at the palace probably continued for almost two years until his hurried departure from Florence in October 1494. Around the same period Michelangelo probably attended some of the fiery apocalyptic sermons in Florence cathedral given by Girolamo Savonarola, the Ferrarese prior of the Dominican monastery of S. Marco. Michelangelo never became a Savonarola disciple like his older brother, but he later admitted to Condivi that he retained an affectionate memory of the preacher and still in old age could recall his voice.[24] The influence of the friar's fierce condemnation of the worldliness and corruption of contemporary society can perhaps be felt in Michelangelo's poem bitterly decrying the impiety he encountered in Rome: 'Qua si fa elmi di calici e spade' ('Here from chalices helmets and swords are made').[25]

The Dominican friar's hold over Florence was immeasurably strengthened when his doom-laden prophecies of impending conflict and punishment of the ungodly seemed to be realized, as, at the beginning of September 1494, the French monarch Charles VIII and his large army crossed the Alps and entered Italy. News of the invasion caused Michelangelo to flee from

Florence (the first of a number of flights from real or imagined dangers during his lifetime). Condivi reports that the artist's exit was prompted by an ominous vision of the Medici's fall told to him by another member of the household.[26] Piero is said to have taken Michelangelo's desertion badly, but the following month he and his brother Giovanni and cousin Giulio de'Medici were forced to follow suit.[27] The Medici's domination was broken thanks to Piero's ill-judged opposition to the invasion of the French, historically Florence's ally and a nation with whom the city had crucial commercial links. As Piero had no means to withstand Charles' army invading Florentine territory, his resistance quickly turned to craven capitulation. As a result of this show of weakness the key strategic port of Pisa declared independence from Florence, and it was this loss that so enraged the Florentines that the Medici had to vacate the city to avoid their fury.

When the Medici departed, Michelangelo was already in Bologna, and he then moved even further northward to Venice for a brief spell. As an unknown and inexperienced artist Michelangelo's chances of finding work in a foreign city were slim, and, running short of money, he retraced his steps south. Condivi tells how through a providential meeting on his way back through Bologna, Michelangelo came to be employed for just over a year by Giovan Francesco Aldrovandi, one of the city's most influential citizens. This stroke of luck may also have owed something to Michelangelo's connections with Piero de'Medici, a debt that the sculptor in his later years may well have preferred to overlook. The Aldrovandi were closely allied with the ruling Bolognese dynasty, the Bentivoglio, who had shown their support for the fleeing Medici by providing them temporary refuge.[28] In Bologna Michelangelo was commissioned to complete the four remaining small marble figures for the much-venerated shrine of St Dominic in S. Domenico. He managed to carve in a year three figures for the monument: two male saints, *St Petronius* and *St Proclus*, and a kneeling angel (all still *in situ*).[29] Michelangelo and his patron are said to have shared a love of poetry, and Aldrovandi is reported to have taken pleasure in hearing the works of Dante, Petrarch and Boccaccio being read aloud with the correct Tuscan intonation by their countryman.

Towards the end of 1495 Michelangelo returned to Florence; Condivi explained his departure from Bologna as a consequence of the jealousy of an unnamed Bolognese sculptor towards him winning such a prestigious commission. The story may well be true, as resentment between native artists and those imported from outside was not uncommon, and Bolognese artists were well known for their animosity to foreigners.[30] Michelangelo may also have felt he stood a better chance of advancement in Florence now that the city had settled down after the expulsion of the Medici. On his return he found a new Medici patron, Lorenzo di Pierfrancesco de'Medici, who, together with his brother Giovanni, had opposed the rule of their cousin Piero and had been exiled to their estates outside Florence as a consequence.[31] On their return to the city the brothers demonstrated their allegiance to the new republican regime by adopting the name Popolani ('of the people'). Michelangelo's readiness to serve two warring wings of the same family may strike modern observers as opportunistic, but political loyalty was not a quality necessarily expected of Renaissance artists.[32] Michelangelo's new patron had mixed with the sophisticated literary and philosophical humanist circle of his cousin Lorenzo the Magnificent. The latter became the guardian of the two boys after the death of their father in 1476 (a position which allowed him to embezzle their money to keep the Medici bank afloat). Lorenzo di Pierfrancesco's upbringing in this erudite environment is shown in his patronage of the poet Agnolo Poliziano and of Botticelli. His collection included some of Botticelli's most famous and poetical works, including the *Primavera*, the *Birth of*

Venus (both Uffizi, Florence) and his illustrations of Dante now divided between the Vatican Library and Berlin. In 1495 or early 1496 he commissioned from Michelangelo a marble of the youthful Baptist, a lost work included in a 1498 inventory of the superb art collection in the family's Florentine palace.[33]

It was Lorenzo di Pierfrancesco who advised Michelangelo to age artificially a *Sleeping Cupid* that he had recently carved in marble, so that it could be sent to Rome and sold for a better price as an antique work. The demand for antiquities which grew ever stronger during the course of the fifteenth century had inevitably spawned the production of forgeries, and even highly experienced collectors of the period, such as Lorenzo the Magnificent, could sometimes be duped.[34] All the artist's biographers, including Giovio, relate the curious incident of this now lost statue. The sources universally characterize Michelangelo as an innocent party to the fraud who had not set out deliberately to make a fake. On the other hand, such a deception would not have been entirely out of character as Condivi reports that Michelangelo was an adept forger of drawings. He is said to have borrowed an old drawing of a head for which he then substituted his own work, making the paper look old and discoloured through smoke, so that he could retain the original.[35] Condivi is again careful to make clear that Michelangelo was moved by nothing more sinister than youthful playfulness, and the discovery of the trick only won praise for his astonishing fidelity as a copyist. Whether created to deceive or not, Michelangelo's marble was sufficiently convincing to allow the banker Baldassare del Milanese, a Florentine neighbour of Lorenzo di Pierfrancesco, to sell it for a high price to the cardinal of S. Giorgio, Raffaele Riario, a wealthy collector of antiquities.[36] The cardinal soon learnt that he had been fooled, and after returning the piece to Milanese he was sufficiently intrigued to send an agent to Florence to investigate the sculptor who had tricked him. Michelangelo was invited to come to Rome while his *Cupid* was put back on the market. It eventually ended up with Isabella d'Este in Mantua, and was one of the works shipped to England when King Charles I bought the Gonzaga collection (the family of Isabella's husband) in the 1620s. The *Cupid* was most probably burnt in the fire that destroyed the palace of Whitehall in 1698.

Michelangelo's arrival in Rome can be dated to 25 June 1496 thanks to a letter he wrote the following week to Lorenzo di Pierfrancesco who had supplied him with a letter of introduction.[37] Despite the assurances he had received from the cardinal's agent, probably the Roman banker Jacopo Gallo (Galli), Michelangelo must surely have felt some trepidation as to his reception. In the event Riario received him warmly and in the letter Michelangelo goes on to describe how the initial meeting quickly led to the purchase of a piece of marble for him to sculpt a life-size figure: the *Bacchus* (Museo Nazionale del Bargello, Florence).[38] This was completed by July 1497. The finished work evidently did not please Riario and he rejected it, the marble ending up in Gallo's collection. The fleshy sensuality of Michelangelo's divine drunkard, his inebriated state brilliantly conveyed by his staggering unbalanced pose and unfocused glassy stare, may well have repelled a patron expecting a classicizing work in the same vein as the *Sleeping Cupid*. Michelangelo took belated revenge for this humiliation by telling Condivi that the cardinal was someone who had little understanding, or enjoyment, of sculpture and Gallo is credited as the patron of the *Bacchus*.

The Roman banker was a loyal supporter of the Florentine, commissioning from him another classically inspired subject, a marble *Cupid*. This is probably the damaged sculpture that has recently come to light in Manhattan.[39] From a letter written to his father it is known that in the summer of 1497 Michelangelo was also involved in an abortive commission for a

marble sculpture for the exiled Piero de'Medici. At the same period he purchased a panel, perhaps the one used for the unfinished painting of the *Virgin and Child with the Infant Baptist and Angels*, known as the *Manchester Madonna* (National Gallery, London).[40] While in Rome, Michelangelo also supplied a drawing for a barber-artist in Riario's household (perhaps Piero d'Argenta who later worked as Michelangelo's assistant) to paint a *Stigmatization of St Francis* in tempera for an altarpiece in the Roman church of S. Pietro in Montorio. The composition of this lost work is recorded in a diminutive seventeenth-century pen copy.[41]

Despite promising his father in a letter of August 1497 that he would soon return home, Michelangelo remained in Rome. He may have been dissuaded from leaving because of a summer outbreak of plague in Florence, as well as the political instability caused by Savonarola's recent excommunication. His caution was rewarded not long after by a major commission from a French cleric, Cardinal Jean de Bilhères-Lagraulas, to sculpt a life-size marble group of the Pietà for his burial place in the church of S. Petronilla at the south side of old St Peter's. This is the famous sculpture now in a chapel on the north side of the nave of the new St Peter's.[42] The choice of subject was most probably determined by the patron because it was one commonly found in Northern Europe, and it had a particular resonance for its intended destination in a mortuary chapel. Mindful perhaps of the imperfections in the marble used for the *Bacchus*, Michelangelo determined to select his own block and he left Rome in the autumn of 1497 for the quarries at Carrara, north-west of Florence. He remained there until the following spring, apart from a trip to see his family in December.[43] This was the first of many such visits to marble quarries made during the course of his life. Michelangelo's unmatched mastery in carving the stone was rooted in an extensive first-hand knowledge of the material, garnered from studying it in its natural state and talking to the workmen skilled in its extraction. The near flawless block that he eventually selected did not actually arrive in his Roman studio until August 1498. The same month a contract was drawn up, with Gallo as a guarantor, in which Michelangelo promised to complete the work within a year. Whether he fulfilled this testing deadline is not known, and it is also uncertain whether his patron saw the completed piece as he died in August 1499. The marble was certainly finished by July 1500 when Michelangelo, then aged twenty-five, received his final payment. The *Pietà* marked Michelangelo's coming of age as a sculptor, and not coincidentally it is his only signed sculpture. The technical brilliance of the carving is matched by a startling originality in the conception of the group. Turning away from the established tradition of highly emotive treatments of the Pietà, Michelangelo achieved an understated, but no less profound, pathos from the reticence of the beautiful young Virgin who gazes down meditatively at the almost unmarked, near naked, body of her son. The sculpture was moved to St Peter's within twenty years of its completion when S. Petronilla was destroyed to make way for the construction of the new basilica.

Michelangelo remained in Rome during the Jubilee Year of 1500, unmoved to return home even by one of his father's splenetic laments on the failings of his children. ('I have five grown up sons and find myself, thanks be to God, at the age of fifty-six and none of them could provide me even with a glass of water').[44] The commission preventing his homecoming was for a painted altarpiece for the funerary chapel in the Roman church of S. Agostino of Giovanni Ebu, the deceased bishop of Crotone in southern Italy. A payment of sixty ducats from the Augustinian friars is recorded in Michelangelo's Roman bank account in September 1500. He gradually repaid this sum over the next couple of years when he failed to deliver the work before his move to Florence in the spring of 1501.[45] The unrealized altarpiece is most

probably the unfinished *Entombment* now in the National Gallery in London, a painting whose subject is more accurately described in a seventeenth-century inventory as Christ's body being transported to the tomb.[46] Michelangelo's highly ritualized rendering of the theme has the Dead Christ at the centre of the composition, his body solemnly carried towards his sepulchre to the right. The frontal representation of Christ's body in the London panel, a traditional manner of representation that imposed severe formal limitations, was one that Michelangelo explored with very different results in drawings forty or more years later (see for example Exh. No. 101).

Michelangelo and Ghirlandaio

Fig. 12 Martin Schongauer
(1435/50–91), ***The Temptation***
of St Antony, *c.* 1470–5.
Engraving, 31.4 × 23 cm.
The British Museum, London

Domenico Ghirlandaio, with the help of his less gifted brother Davide, ran one of the most successful workshops in Florence. Their efficiency and solid, good quality workmanship was rewarded by a string of commissions for altarpieces and large-scale fresco decorations in the 1470s and 1480s. Domenico's virtues are summed up by an anonymous commentator of the time charged by the duke of Milan to advise on the best available Florentine painters; in the letter he is described as 'an expeditious man and one who gets through much work'.[47] Ghirlandaio's status as one of Florence's most promising young artists had been confirmed by the invitation in the early 1480s, along with contemporaries such as Botticelli, to work in the recently constructed chapel of Sixtus IV (the Sistine chapel). Following his return to Florence two years later, Ghirlandaio completed the decoration of the Sassetti chapel in S. Trinita, a cycle of scenes from the life of St Francis which highlighted his talent for weaving together sacred narrative with compellingly realistic portraits, inspired by Flemish painting, of his patrician patrons and their circle. The gravity and sculptural solidity of Ghirlandaio's figures, as well as his gift for lucid story telling, deliberately harkened back to Giotto and Masaccio, the founding fathers of Florentine painting. Ghirlandaio discreetly updated this tradition by introducing more modern elements, such as his insertion of classical architectural and decorative details taken from his studies of antiquity in Rome.[48] Ghirlandaio's reverence for Giotto and Masaccio was passed down to his pupil Michelangelo. It is generally agreed that Michelangelo's earliest surviving drawing (*c.* 1490) is a sensitive pen copy, now in the Louvre (Fig. 13), after two figures from Giotto's *Ascension of St John the Evangelist* fresco in the Peruzzi chapel in S. Croce.[49] From much the same period Michelangelo made a more interpretative copy in the same medium after the figure of St Peter in Masaccio's *Tribute Money* in the Brancacci chapel in S. Maria del Carmine. This same chapel was the scene for the infamous incident in which the sculptor Pietro Torrigiani broke Michelangelo's nose, angered by the criticism of his drawn copies after Masaccio.

By the time Michelangelo was in Ghirlandaio's studio, the commission for the Sassetti chapel had been completed and work was underway on the five-year task of painting an even more ambitious fresco cycle in the choir chapel in the Dominican church of S. Maria Novella, Florence. The scenes illustrating episodes from the lives of the Virgin and St John the Baptist on the chapel walls, along with an altarpiece, had been commissioned in 1485 by Giovanni Tornabuoni, a kinsman of the Medici, and, like Ghirlandaio's earlier patron, Francesco Sassetti, a senior figure in the Medici bank. The young Michelangelo almost certainly assisted in painting these frescoes, and perhaps also in the production of altarpieces that continued to flow out of the well-organized studio run by the brothers. Examination of Michelangelo's two unfinished

panel paintings in the National Gallery for its 1994–5 exhibition, *The Young Michelangelo*, revealed how much they depended in their execution on Ghirlandaio's practice.[50] Michelangelo's technical debt was shown most clearly in the green earth pigment used as underpaint for areas of flesh, and in the choice of egg tempera technique in the *Manchester Madonna*. Ghirlandaio's influence on his pupil persisted more than a decade after he had left his studio, as can be seen in the palette and the method of fresco painting he used on the vault of the Sistine chapel.

Domenico Ghirlandaio's importance for Michelangelo was not confined to painting alone, because in time-honoured Florentine tradition much of his apprentices' activities would have centred on drawing.[51] It was precisely Domenico's qualities as a designer that underpinned his maintenance of high standards and stylistic coherence in the many works produced under his supervision. Michelangelo would have had first-hand experience of this in the Tornabuoni chapel frescoes where Ghirlandaio directed the project through his responsibility for the design process. This encompassed the rough compositional sketches and ended in the production of detailed cartoons for the principal figures. The outlines of these same-size drawings were transferred to the unpainted plaster of the chapel in two ways. The most commonly used was pouncing, the technique of laboriously pricking the contours of the cartoon with a pin and then dusting ground chalk through the holes. This method is identifiable through the dots of chalk (*spolveri*) visible beneath the painted outlines. In the later sections of the wall decorations, as the deadline for completion loomed, Ghirlandaio's studio switched to the quicker, more direct, but less precise, method of placing the sheet with the design against the wall and incising the outlines with a sharp instrument through to the wet plaster of the wall below.[52] Michelangelo later employed both these methods with his own cartoons in the Sistine chapel. The cartoons were the final part of Domenico's rigorous, highly disciplined design process, which can be partly reconstructed on the basis of three drawings in the British Museum relating to the Tornabuoni chapel (Exh. Nos 2–4). They are included here as a reminder of Ghirlandaio's considerable talents as a draughtsman, and to underline his importance to Michelangelo's development.

The differing styles of the three drawings demonstrate Ghirlandaio's flexibility, and how he varied his handling of graphic media, in the case of the British Museum works, exclusively pen and ink, depending on the needs of the particular task in hand.[53] The earliest of the three in the design sequence is the forceful study for the *Birth of the Virgin* (Exh. No. 2 and Fig. 14). This must have been drawn at a very preliminary stage in the gestation of the scene, although there must have been earlier, now lost, studies in which the complex architectural interior was first established. This did not prevent Ghirlandaio from coming up with alternative ideas for the interior while working on the drawing, such as the addition of a doorway brusquely penned in at the top of the stairs to the left. He continued to refine the architectural setting in subsequent designs, as comparison with the fresco shows he avoided the awkward division of the arch in the background of the drawing by moving the foremost pilaster to the right. The artist's principal aim in the drawing was the arrangement of the figures, and in particular the means of linking the sacred figures on the right with the approaching Tornabuoni retinue. In the drawing this has been achieved by the simple means of a serving girl gesturing towards the newborn infant, while in the fresco the two groups are connected in a subtler and more naturalistic manner by the turn of the head of one of the nursemaids curious to scrutinize the fashionable visitors. The artist began the drawing by laying in the setting, and once this had been completed he added the figures in a few rapid strokes of the pen. The notational simplicity

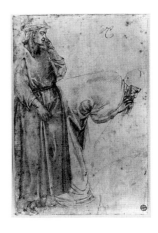

Fig. 13 **Study after a figure in Giotto's *Ascension of St John the Evangelist*, Peruzzi Chapel, S. Croce, Florence**, *c.* 1490. Pen and brown ink, 31.8 × 20.5 cm. Musée du Louvre, Paris

Fig. 14 Domenico Ghirlandaio
(*c.* 1448/9–94), ***The Birth
of the Virgin***, *c.* 1485–90. Fresco.
S. Maria Novella, Florence

Exh. No. 2 Domenico Ghirlandaio
(*c.* 1448/9–94), ***The Birth
of the Virgin***, *c.* 1485–90.
Pen and brown ink, 21.5 × 28.5 cm.
The British Museum, London

Fig. 15 **Detail of Exh. No. 71**
(***The Three Crosses***), *c.* 1521–4.
Red chalk, h. 12 cm

of Ghirlandaio's description of figures is at its most extreme in the classicizing battle relief behind the bed. A similar directness is revealed in the artist's spare but telling depiction of the poses and costumes of the women. Ghirlandaio's graphic shorthand, which reduced his figures to a spindly body with knobbly blobs to signify hands and topped by a blank oval for a head, is strikingly similar to Michelangelo's in some of his preliminary compositional sketches, for example in the red chalk study from the 1520s of a Crucifixion in the British Museum (Fig. 15; detail of Exh. No. 71).

The subsequent stage in Ghirlandaio's graphic preparation can be illustrated by two draw-ings that relate to scenes of John the Baptist's life on the opposite wall of the chapel. In the study for the *Naming of St John* (Exh. No. 3) the artist omitted the architectural setting and concentrated entirely on the poses and the narrative interaction of the figures. The key char-acter in the Biblical drama is the bearded elderly figure of Zacharias, seated on the left, who initially opposed the divine call to name his son John and has been consequently struck dumb in punishment. The drawing illustrates the moment he accepts God's will by writing his son's name on a tablet. Reaction to his submission is registered in differing ways by the assembled company: the bearded man to his right cranes forward as though to double-check he read the old man's script correctly, while one of the women to the right joyfully throws up her hands in delight. The variety of finish in the detailing of the figures is related to their importance in the composition, with the artist concentrating most keenly on the group immediately surrounding Zacharias and his newborn son. The importance of animated, three-dimensional folds of drap-ery in the finished work is already in the artist's mind, hence his careful description of the young man's garments on the left and, in slightly less detail, those of Zacharias. In these more considered passages Ghirlandaio employed a more extensive range of strokes, the variety in their length and direction also extending to a limited use of crosshatching in the areas of deepest shadow. This repertoire was to be dramatically expanded by Michelangelo in his

pursuit of a more nuanced description of form, and yet echoes of Ghirlandaio's swift simplification of draped figures can be seen in some of his early pen drawings, such as Exh. No. 6.

When Ghirlandaio had settled on the form and general poses of the figures in the composition, he proceeded to make more detailed individual studies, like that for a young member of the Tornabuoni circle, depicted in the centre of the *Birth of the Baptist* (Exh. No. 4). This is the only one of the three drawings made from life. The painter had already resolved her pose in a previous study and the drawing's function was to record precisely and rapidly the folds and structure of the luxurious dress. The all-important decorative touches of the costume are also punctiliously noted, such as the leaf-like decoration running vertically down the side of the garment and the gathering of material that billows out from a lining on the underside of the sleeve. The artist was probably drawing from a dress temporarily lent to him by the unidentified woman portrayed in the fresco, who doubtless was eager to be shown in the latest fashion. Ghirlandaio did not bother to individualize the features of the person, since the model in the drawing was most likely a studio assistant deputized to wear the dress to allow his master to study its folds and cut. He would have made a separate portrait study of the woman's head, and married the two in the creation of the final cartoon.

The three drawings powerfully convey a sense of Ghirlandaio's practical and highly structured approach to the task of designing a large-scale commission. Michelangelo must have seen many hundreds of drawing of this kind during his couple of years in the workshop, and

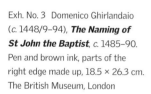

Exh. No. 3 Domenico Ghirlandaio (*c.* 1448/9–94), ***The Naming of St John the Baptist**, c.* 1485–90. Pen and brown ink, parts of the right edge made up, 18.5 × 26.3 cm. The British Museum, London

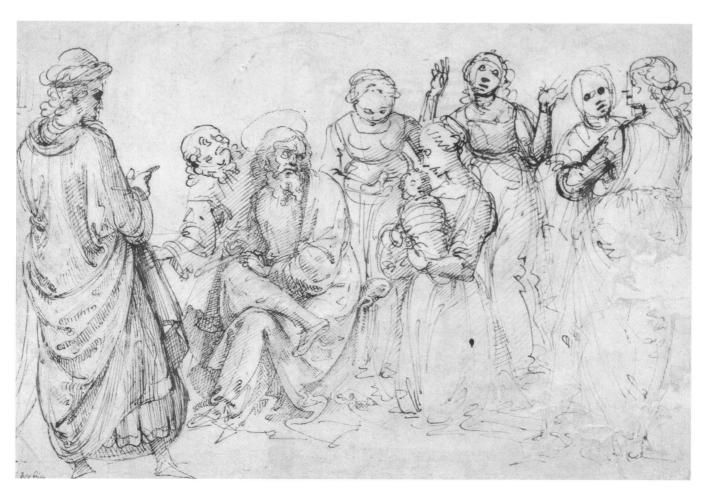

his master's dedication to the virtues of the Florentine *disegno* tradition was one that he would uphold for the rest of his career. It is clear, despite his denials, that his time in Ghirlandaio's studio was a formative one, and that aspects of his style and working methods, both as a painter and draughtsman, can be traced back to that period. This influence is demonstrated by comparing the three Ghirlandaio drawings with the earliest two studies by Michelangelo in the selection, generally dated to the period 1495–1500: the Haarlem *Three Figures in Adoration* and the so-called *Philosopher* in the British Museum (Exh. Nos 6r–v and 5r).[54]

The figures on the recto of the Haarlem drawing (Exh. No. 6) have their hands joined in prayer, while those on the verso are shown advancing to the right with their shoulders bowed. An old drawn copy of the recto in the British Museum (Fig. 2) perhaps indicates that the sheet once had a study of a male torso on the left, but this is of no help in working out the drawing's narrative. The most plausible suggestion is that the figures are adoring the newly born Christ Child, the strongest evidence for this being the downward gaze of the kneeling figure on the left. The old-fashioned flat hat of the kneeling figure is reminiscent of the head-gear associated with the Medici's patron saints, Cosmas and Damian, but the drawing seems too fluid to be a copy of an existing prototype. The manner in which the central figures have been worked up to a higher level of finish, and the somewhat caricature-like characterization of the two figures on the verso do, however, recall one of Michelangelo's best-known copies, the pen drawing in the Albertina, Vienna, inspired by a lost fresco by Masaccio.[55] The changes made in darker ink to the initial study executed in a lighter toned ink, most visible in the alterations to the position of his feet and the addition of hair rather than a close-fitting skull cap on his head, show beyond doubt that the composition is Michelangelo's own invention. The way in which Michelangelo began by drawing the central figure and then proceeded to sketch in broadly the figures on either side recalls Ghirlandaio's study for the *Naming of St John* (Exh. No. 3). Although there are echoes of Ghirlandaio's draughtsmanship in the Haarlem sheet it also highlights Michelangelo's development five or more years after leaving the painter's studio. This is clear from the vivid animation of his figures that contrasts strongly with the lifeless mannequins that inhabit the periphery of Ghirlandaio's composition.

The use of two tones of ink in the central figures on both sides of the Haarlem drawings recurs in the London study (Exh. No. 5r), as it does in other early drawings such as Exh. No. 7. In Exh. No. 5 Michelangelo employed a brown and then a greyish irongall ink. Changes over time to the tonality of the ink make it impossible to be sure what effect he intended, but it is perhaps an early instance of his trying to extend the tonal range of pen drawings that would within a few years lead him to experiment with white heightening and wash as in Exh. No. 11. The lighter ink was largely reserved for areas of shadow and it clearly followed on from the brown ink, since in some parts, such as the far outline of the figure's beard and hat, it has been used to make corrections to the outline. The way in which the two tones complement each other in the modelling of the central area of the drapery proves that this interaction was planned from beginning, and was not, as sometimes suggested, a result of Michelangelo taking up an unfinished study and reworking it at a later date. It has been remarked that Michelangelo's use of the blank paper as a highlight (an effect dulled by the yellowing of the paper) in the figure's draperies is reminiscent of the polished sheen of marble.[56] It is also possible that he was seeking to emulate the intense contrasts of lighting in the painting of drapery in some of Ghirlandaio's panel paintings.[57]

The three-dimensional volume that Ghirlandaio sought through combining varied shading and firm outline in his figure drawing (Exh. No. 4) is pushed to a new level in Michelangelo's

Exh. No. 4 Domenico Ghirlandaio
(c. 1448/9–94), **Standing woman**,
c. 1485–90. Pen and brown ink,
24.1 × 11.7 cm. The British Museum,
London

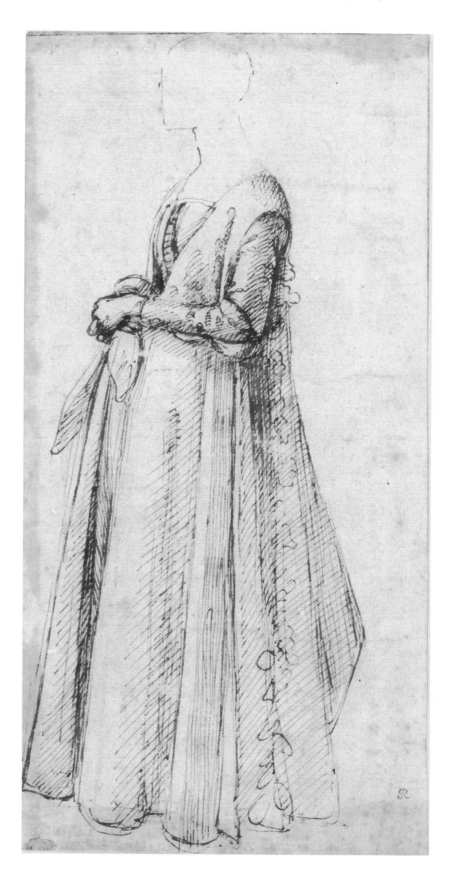

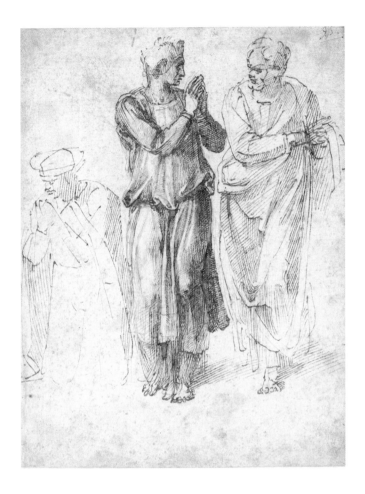

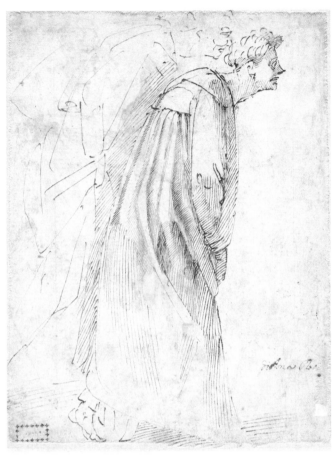

study. The overwhelming solidity of the form, akin to the weighty gravity of Masaccio's figures, is achieved by dense crosshatching, a laborious method of modelling that was employed sparingly by Ghirlandaio in his drawings and by Schongauer in the engraving (Fig. 12). The object held in the figure's left hand has been variously identified as a globe, a ball or a skull. Its flat bottom and domed top most closely resemble a casket.[58] The possibility that he is one of the Three Magi bearing a gift certainly fits his hat, loosely modelled in the detail of the peaked brim on the one worn by the Byzantine emperor John Palaeologus during his visit to Italy in 1438–9. Such headgear became a much-used device in Florentine paintings to give an authentic Eastern touch to representations of Greek or Eastern figures.[59] The figure has also been identified as a Greek philosopher on the basis of his pensive attitude, but this does not fit the scallop shell on the side of his hat that signifies he is a pilgrim. The function of such a highly worked drawing is uncertain; Michelangelo certainly retained it in his studio as he reused the blank verso for a head study eight or so years later (Exh. No. 5v).

The Medici and the Medici Garden

Michelangelo's contact with Florence's ruling dynasty began sometime around 1488–90 when he began to frequent the Medici Garden near S. Marco. This marked the beginning of Michelangelo's troubled but enduring relationship with a family who nurtured his talent, and

Exh. No. 6 Recto **Three figures in adoration**, *c.* 1495–1500. Pen and brown ink, over black chalk, 26.9 × 19.4 cm. The Teyler Museum, Haarlem

Exh. No. 6 Verso **Two figures leaning forward**, *c.* 1495–1500. Pen and brown ink, 26.9 × 19.4 cm. The Teyler Museum, Haarlem

opposite
Exh. No. 5 Recto **An old man wearing a hat (*Philosopher*)**, *c.* 1495–1500. Pen and brown ink, 33.1 × 21.5 cm. The British Museum, London (verso illustrated on p. 117)

2 Early Formation: Florence and Rome, 1475–1501

2 Early Formation: Florence and Rome, 1475–1501

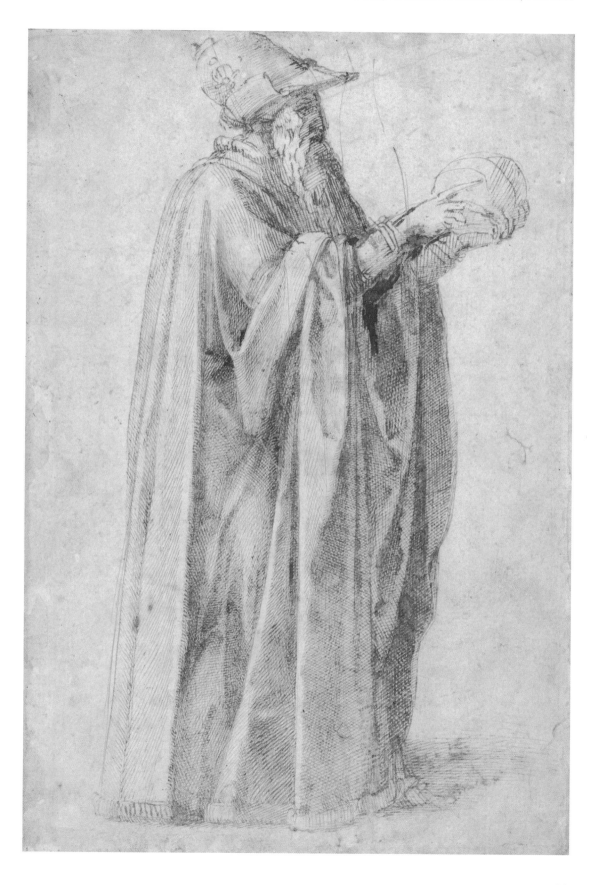

gave him some of his greatest commissions, but whose rule he grew to resent and oppose. He was an unwilling and at times rebellious servant of the family, yet his unique talent ensured that his disloyalty was always forgiven. Michelangelo's decision to be buried in Florence after thirty years of self-imposed exile meant that Duke Cosimo I was at last able to celebrate his family's relationship with the great Florentine. These connections were further enhanced in the second edition of the artist's biography written by his devoted courtier Giorgio Vasari published four years later in 1568.

The sculptor's association with this informal academy is demonstrated by a description of him in a letter of 1494 as 'Michelangelo ischultore dal giardino' ('Michelangelo the sculptor from [or at] the garden').[60] Both Vasari and Condivi concur that Michelangelo went to the garden with his friend Granacci, yet they differ over the circumstances that brought them to study there. Michelangelo's desire to create an image of himself as an autodidact is reflected in Condivi's account that tells how, after an initial visit with Granacci, he decided to dedicate himself to studying and copying the antique sculptures he found there independent of any master. Vasari's perspective on the events was very different; as a Medici loyalist, he gives credit to Lorenzo the Magnificent for inviting Domenico Ghirlandaio to send his brightest pupils – Granacci and Michelangelo – to study in the garden where they were taught by Bertoldo, a member of the Medici household. Vasari furnishes a little more detail of the garden and of Bertoldo's role in his 1568 biography of Michelangelo's assailant Pietro Torrigiani. He describes how Bertoldo, a pupil of Donatello, instructed the arts of design ('l'arti del disegno') to young painters, sculptors and well-born students of the arts with the help of the sculptures in the garden and many drawings, cartoons and models in the Medici collection, including works by Donatello, Brunelleschi, Masaccio and Uccello.[61] Varchi, in his oration at Michelangelo's memorial, gave even greater prominence to the importance of the Medici Garden in setting the young sculptor on the way to greatness.[62]

Vasari's self-interest in promoting the importance of the Medici Garden led some historians in the past to doubt its very existence, but more recent studies, in particular an article written in 1992, proved beyond doubt, on the basis of documentary and visual evidence, that such a site did exist opposite S. Marco.[63] The first mention of it as a place of artistic instruction is given in an anonymous biography of Leonardo from the late 1530s or early 1540s. This relates how Lorenzo financially supported Leonardo ('dandoli provisione') to study in the garden.[64] Exactly when this occurred is unknown but the most likely date would be the mid-1470s when the garden is first mentioned in contemporary records, and Leonardo, then in his mid-twenties, would still fit the description of him as *giovane*. According to Vasari, Lorenzo's later initiative in the late 1480s to set up a kind of informal academy was prompted by the absence of Florentine sculptors as excellent as the city's painters. He goes on to explain that Lorenzo was keen, both for his own and the city's honour, to encourage artistic excellence.

In reality Lorenzo's patronage of the arts was much less extensive than that of his grandfather Cosimo. His main enthusiasm was for architecture, of which he was a discerning and well-informed patron.[65] His fascination with the classical past was reflected in his scholarly pursuits, including the collection of a notable library and the acquisition of ancient gems, cameos and *objets d'art*. This same taste is manifested in his favouring Bertoldo, whose small-scale bronzes and medals were intimate pieces to be handled and studied at close quarters alongside their antique counterparts. But this was not the limit of his sculptural patronage. Lorenzo had grown up surrounded by examples of his grandfather's inspired support for Donatello, manifested both in public commissions, like the sculpted decorations in the old

sacristy in the family church of S. Lorenzo, and private ones such as the bronze figures of *David* and *Judith and Holofernes* set up respectively in the courtyard and the garden of the Medici palace.[66] After Donatello's death in 1466, Lorenzo and his brother Giuliano had been able to call on the services of Andrea del Verrocchio, a sculptor of almost comparable inventiveness and range. Lorenzo utilized Florence's artistic excellence as a diplomatic tool to win favour: as can be seen in his recommendation of the architect Giuliano da Maiano to the rulers of Naples; and the dispatch of a team of Florentine painters to decorate the Sistine chapel as a gesture of goodwill to his erstwhile enemy Pope Sixtus IV. For this reason Lorenzo may, as Vasari suggested, have been moved to revive the Medici Garden as a cradle for youthful talent, perhaps prompted by Verrocchio's death in 1488 which left Florence without a sculptor of real note.

Little is actually known of the antiquities that were in the garden as it was ransacked by an anti-Medicean mob after Piero's fall in 1494. It is unlikely that the antique marbles in the garden were of the highest quality because the best pieces, such as the statue of Marsyas that Verrocchio is recorded as having restored, were on display in the Medici palace.[67] It is possible that Michelangelo gained experience of marble carving by being allowed to restore some of the timeworn classical statuary in the garden. The much-debated question of how Michelangelo learnt to work marble is one that could be asked of other Renaissance sculptors, not least Verrocchio, whose skills as a stone carver cannot have been acquired from his training as a goldsmith.[68] Clearly blessed with enormous reserves of natural talent, Michelangelo may have benefited from some basic instruction in marble carving from Bertoldo. The latter is known for his classically inspired statuettes and medals in bronze (his skills in metalworking were based on a training in Donatello's workshop in the mid-1460s), but he is known to have carved wooden figures.[69] By the time Bertoldo was instructing pupils in the garden he was, in Vasari's words, 'so old that he could no longer work', but as his birth date is unrecorded there is no way of knowing his age at his death in Lorenzo's villa of Poggio a Caiano at the end of 1491. The recent discovery that his mother was still alive at his death casts doubt on Vasari's description of his age.[70] His connection with Lorenzo can be traced back to 1478 when he made a medal commemorating his patron's survival from the Pazzi conspiracy that year. The warm relationship between the two can be seen from Bertoldo's celebrated letter to his patron, written in the summer of 1479, in which he jokingly threatened to give up sculpture to become a cook.[71] Bertoldo was a prized member of Lorenzo's household with his own room in the Medici palace, and it seems likely that students who came to the garden were also granted access through his privileged position to the family's collection.

The influence of Bertoldo and the experience of studying the Medici collection can be seen in the two unfinished marble reliefs the young Michelangelo produced in the early 1490s. In the earlier of the two, the *Madonna of the Stairs*, probably carved around 1490, he paid homage to Donatello in the use of a low-relief technique, as well as in the monumental form of the impassive figure of the Virgin seen in profile. Michelangelo would unquestionably have been inspired by Donatello's example even if he had never entered Lorenzo's circle, and the influence of the quattrocento master continued well after his departure from the palace.[72] Yet Michelangelo's choice of model was also well chosen to flatter the descendant of Donatello's greatest patron, the Medici's collection numbering superlative examples of low reliefs by the quattrocento sculptor like the *Donation of the Keys* now in the Victoria and Albert Museum. He may also have had in mind his own lineal descent from the sculptor through Bertoldo who proudly described himself as Donatello's disciple.[73] Bertoldo's own work was influential for

Michelangelo's development too, and his bronze relief over a fireplace in the Medici palace based on a damaged Roman marble in the Campo Santo in Pisa served as a source for Michelangelo's own interpretation of such a classical composition in his *Battle of the Centaurs* (Fig. 11).[74] The wiry energy of Bertoldo's small-scale bronze figures was a quality that Michelangelo sought to emulate in his early marbles like the *Bacchus* and, to an even greater degree, in the Manhattan *Cupid*.[75]

After having won Lorenzo's favour by carving a copy of an antique head of a faun in the Medici Garden, Michelangelo was invited to follow in Bertoldo's footsteps and lodge in the palace. Michelangelo's father was, according to Condivi, appalled by the news of his son's success, as he was unable to grasp the difference between his son's aspiration to be a sculptor and the relatively lowly profession of the artisan stonemasons working in Settignano. His doubts at his son's choice of profession were quelled by an interview with Lorenzo who later rewarded his acquiescence with a job in the Florentine customs office. Lorenzo is said to have treated Michelangelo like a son, granting him a good room in the palace and inviting him to eat at the same table as the family.[76] Michelangelo's protector was a poet and intellectual as well as a statesman, and his love of learning was reflected in his precious library and his support for literary and philosophical endeavour. His circle included some of the leading humanists of the age, including the dazzlingly polyglot scholar Giovanni Pico della Mirandola and the poet and philologist Poliziano. Condivi relates that the latter befriended the young artist and made suggestions for possible subjects for his sculptures including the idea of treating the theme of battling centaurs. Condivi misidentified the subject of the relief as the Rape of Deianira, while it actually depicts the other well-known centaur story: Lapiths battling centaurs at the wedding feast of Pirithous. The relief (Fig. 11) was later described as having been made for a 'gran signore', the most likely candidate being Lorenzo, whose death in 1492 may explain its having been left unfinished.[77] Contact with such learned company must have widened Michelangelo's intellectual horizons, and his admiration for Dante and Petrarch may well have been strengthened by his patron's emulation of them in his own poetry. The once widely accepted notion that Michelangelo was profoundly influenced by the recondite Neo-Platonic doctrines of Lorenzo's early intellectual mentor Marsilio Ficino is now down-played, as the references to this philosophy in his art and poetry do not suggest more than a broad generalized understanding of its basic tenets. He could well have picked up this knowledge while living in the Medici household.[78]

A more practical and tangible benefit of his time in the Medici palace was his introduction to two of his most important future papal patrons: Lorenzo's second son Giovanni, the future Leo X, and his illegitimate nephew Giulio who later became Clement VII. Giovanni's ecclesiastical career had begun at the age of eight and was already well advanced by the early 1490s. Thirty years later Sebastiano related to Michelangelo in a letter of October 1520 how Leo had talked of the artist almost tearfully as though they were brothers, explaining how the two of them had been brought up together ('nutriti insiemi').[79] He went on to say that the pope had admitted that in spite of liking Michelangelo he was frightened of him, and this perhaps underlies his earlier preference for the courtly Raphael.

The bookish and reserved Giulio de'Medici was, by contrast, a far more sympathetic patron of Michelangelo, and his appreciation and respect for the sculptor are readily apparent from the voluminous correspondence that passed between Rome and Florence when the sculptor was working in S. Lorenzo. The intimacy of the bond between the two is revealed by Clement's extraordinary breach of protocol in personally adding an encouraging postscript to

a letter pledging his unfailing support for the artist. He signed this with his own Latinized name – I[ulius] – rather than the one he had adopted on his elevation to the papacy.[80] Michelangelo's own feelings towards Clement were complicated by his pro-republican political sentiments; his sympathies were most clearly expressed in his active support of the Florentine Republic's doomed attempt to resist the re-establishment of the family's rule in 1527–30. Michelangelo was swiftly forgiven this disloyalty by Clement and put back to work on the Medici chapel and library. For the rest of his life the sculptor avoided any risk to his family, and the considerable investment in property he had made in Florence and the surrounding region, by suppressing his opposition to the Medici. (The artist's awareness of the political realities of Florentine rule is well illustrated by two of his letters from 1512 and 1547 included in the London exhibition, see Appendix II, nos 2 and 8, pp. 295–6). Michelangelo steadfastly turned down all of Duke Cosimo and his courtiers' invitations for him to return home after his move to Rome in 1534 (see Appendix II, no. 11, p. 297), but he maintained cordial relations with Florence through his involvement in various Medicean architectural projects, including his acceptance of the duke's request in October 1559 to supply designs for the Florentine church in Rome – S. Giovanni dei Fiorentini.[81] The tensions of Michelangelo's fruitful, yet uneasy, relationship with the Medici were glossed over in Vasari's biography and in the obsequies honouring the artist.

Michelangelo and the Antique

The impact of classical art and architecture on Michelangelo's development is a vast topic and one that can only be touched on here in reference to his drawings.[82] Study of his work shows that he took inspiration from a wide variety of antique sources ranging from large-scale marbles like the *Apollo Belvedere* (Fig. 26), the *Torso Belvedere* (Fig. 41) and the *Laocoön* (Fig. 54; the last of which he was one of the first to see after its excavation in Rome in January 1506) to exquisitely worked pieces from the famous collection of ancient cameos collected by the Medici.[83] The idealization and the expressive vocabulary of gesture and pose that he encountered in classical art shaped his focus on these same themes in his own work. On a formal level, antique sculpture provided an enormously rich store of figural and composi-tional motifs that remained an enduring and stimulating source of inspiration for Michelangelo. This process can be seen in his reworking of the pose of the *Apollo Belvedere* (Fig. 26) for the figure study in the British Museum from the period of the *Battle of Cascina* (Exh. No. 13r).

The admiration on the part of Renaissance artists for classical art also had a competitive edge. Vasari reflects this in his repeated claims for Michelangelo's supremacy over artists of all previous periods, and he specifically mentions how his marble *David* had vanquished Rome's most revered monumental antique sculptures, such as the *Horse Tamers* on the Quirinal.[84] The works of Michelangelo (as well as those of his rival Raphael) had attained the status of modern classics well within his lifetime, and were copied and admired alongside the masterpieces of ancient Rome. This can be seen in a double-page opening (Fig. 16) from a sketchbook dating from the 1530s by the Bolognese artist Amico Aspertini that freely juxta-poses figures taken from the sculptor's *Battle of Cascina* cartoon with studies of ancient marbles.[85] The sense of rivalry that Michelangelo and other artists of the period experienced in their study of classical art was one that could work in favour of their patrons. Cardinal

Riario is described in the sculptor's letter of 1496 as first encouraging him to look around his superb collection of ancient marbles in his Roman palace, and then the next day asking if he had sufficient spirit to attempt his own figure ('mi domandò se mi bastava l'animo di fare qualchosa di bello').[86] Michelangelo certainly did not lack spirit for such a contest, as is shown by his later readiness to take on a gigantic block of marble from which he carved the *David*, or his youthful and unfulfilled dream, admitted to Condivi, to carve an even greater colossus out of one of the mountains near the quarries of Carrara.

Michelangelo had come to the attention of the antiquarian cardinal, as he had earlier done with Lorenzo de'Medici, precisely because of his precocious ability to imitate classical marbles. Unfortunately neither the *Head of a Faun* nor the *Sleeping Cupid* survives to demonstrate this skill, although his command of antique carving methods can be seen in his bold use of the drill, a favoured instrument of classical sculptors, in the *Bacchus*.[87] His study of antique sculpture in Florence was probably not just confined to works belonging to the Medici. Florentine patrician families, such as the Capponi and the Soderini, had smaller collections, and there were also antique sarcophagi on display around the Baptistery and in some of Florence's churches.[88] The classical detailing in the background decoration of the Tornabuoni frescoes suggests that Ghirlandaio must have assembled in Rome a model-book or sketchbook of antique details and ornament, akin to the one sometimes associated with his circle in the Escorial in Madrid, the so-called Codex Escurialensis.[89] A sketchbook by Ghirlandaio is mentioned in Condivi, who says that the older artist jealously prevented the teenage Michelangelo from studying its contents, described as drawings of 'shepherds with their sheep and dogs, landscapes, buildings, ruins and such things'.[90] Vasari in his life of Ghirlandaio also records that he had heard tell of an album of freehand but highly accurate drawings of ancient architecture.[91]

Michelangelo's vast visual memory mentioned by Condivi and Vasari, as well as his long residency in Rome, meant that he had no need to assemble a similar compendium of classical motifs. On occasion he does seem to have made drawings of antique sculptures for future reference. These include a headless torso of Venus studied from a variety of angles in black chalk on a sheet from the early 1520s, now divided in four between the Casa Buonarroti and the British Museum (Fig. 17).[92] Michelangelo's interest in the sculpture may have been part of his preparation for *Dawn* and *Night* in the Medici chapel, his first sculptures of female nudes.[93] He also made three red chalk studies of a recumbent figure from a lost relief of *Amor and Psyche*, known as the *Bed of Polycleitus*, which had been passed down from the collection of the famous early Renaissance sculptor Lorenzo Ghiberti. Michelangelo later used the pose of the sleeping god as a source of inspiration for his *Dead Christ* drawing in the Louvre.[94]

These examples show that Michelangelo's interest in classical art was driven by the practical concerns of an artist wishing to record a sculptural figure, and not that of a scholarly antiquarian. As such they differ in character from drawings like Raphael's meticulous and measured red chalk study after one of the Quirinal horses (National Gallery of Art, Washington), a work probably made *c*. 1516–17 as part of the artist's ambitious plan to reconstruct the appearance of ancient Rome.[95] Although Michelangelo was not inclined to make such painstaking records himself, he is known to have made use of such drawings. This was when he needed hurriedly to extend his knowledge of classical architecture at the time of his successful attempt to win the commission to design the façade of S. Lorenzo in 1516. To this end he copied from a pattern-book of classical architectural studies by the Florentine

architect Bernardo della Volpaia (Exh. No. 37).⁹⁶ This volume was bought by John Soane from the 1818 sale of his fellow architect Robert Adam, and before that it was part of the famed 'Paper Museum', a hugely ambitious encyclopaedic scheme to record all the traces of the natural and artificial world, including Roman civilization, conceived by the seventeenth-century Roman scholar Cassiano dal Pozzo and continued after his death in 1657 by his brother Carlo Antonio.⁹⁷ James Adam, Robert's younger brother, had negotiated the sale of dal Pozzo's collection from Cardinal Albani in 1762 for George III, and from this purchase the Scotsman retained certain items, like the Codex, which were of particular interest. Volpaia's pen and ink drawings in the album are based on copies of architectural studies made by fellow members of the antiquarian circle around the Lombard architect Bramante and members of the Sangallo family. The majority of the buildings featured in the Codex are ancient but a few are of recent construction, such as the works of Bramante and the enormous palace built by Michelangelo's patron Cardinal Riario now known as the Cancelleria. The Codex is organized thematically, beginning with plans, perspectival elevations and sections and lastly architectural details. The latter category includes detailed and generally rather decorative cross-section and profile views of architraves (Exh. No. 37); capitals (Fig. 60); columns (Fig. 61); cornices; doorframes and the like. The end of each section was marked by a blank page, some of which were later filled by two seventeenth-century draughtsmen when the Codex was owned by Cassiano dal Pozzo.⁹⁸

Fig. 16 Amico Aspertini (1474/5–1552), **Sketchbook opening with studies after antique sculptures and Michelangelo**, 1530s. Pen and brown ink with watercolour heightened with lead white, 21.9 × 15.9 cm (each page). The British Museum, London

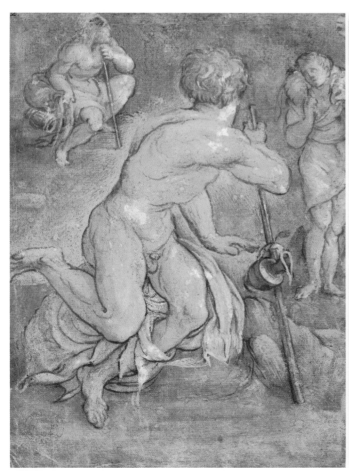
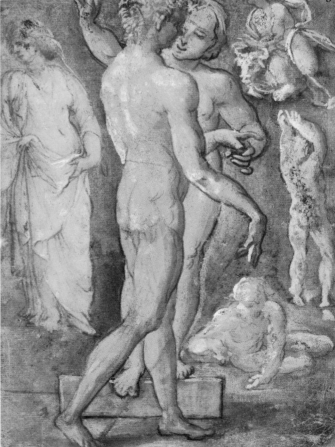

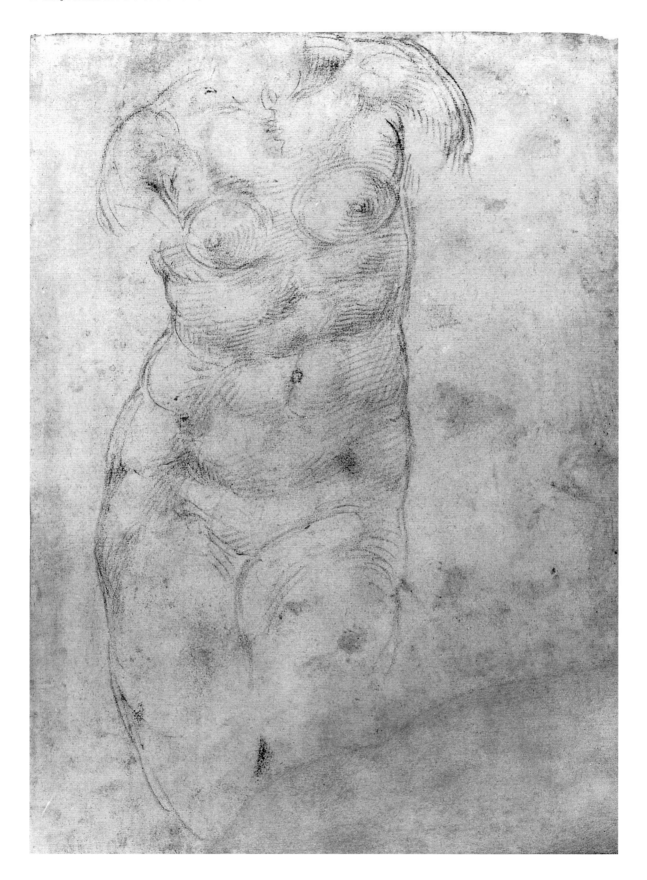

Michelangelo made freehand and much simplified red chalk copies from this album on six sheets of paper, now divided between the Casa Buonarroti and the British Museum, which were originally folded together to form a gathering of twenty-four pages of which twenty-two have been used.[99] The sculptor picked out from each page of the Codex the parts that would be of greatest practical importance to him. He was able, by excluding repetitions and by recording only details that were significantly different from those he had already noted down, to compress the salient details of four or more pages of Volpaia's pattern-book onto a single page. This process of distillation can be witnessed by comparing his copy with one of the pages of Volpaia's album (Exh. Nos 36–7).[100] Significantly Michelangelo did not bother to transcribe Volpaia's notes on the antique source of the fragments or their measurements, and true to his dictum that grace and harmony were dependent on artistic judgement rather than the ruler, he also freely altered the proportions of their parts.[101] Perhaps the most direct influence of his study of the Soane volume is the unusual form of the windows in the lunettes in the Medici chapel that are slightly wider at the bottom than the top. This tapering form was inspired by an opening in the interior of the Temple of Vesta in Tivoli that Michelangelo noted in one of the Casa Buonarroti copies after the Codex Coner.[102]

Michelangelo's inventive interpretation of classical forms and canons was to lead to attacks from purists on some of his architecture, such as the criticism levelled against his highly sculptural conception of the cornice crowning the Farnese palace in Rome that he designed in the late 1540s.[103] James Ackerman's observation that Michelangelo's interpretative drawn copies after Roman architecture were used as 'a spark for explosions of fancy' could also be extended to include some of his drawings inspired by antique sculpture.[104] A hitherto overlooked early example of this kind of drawing is in the British Museum (Exh. No. 7). This was again executed in two slightly different shades of ink (darker at the top and lighter towards the bottom half), and shows a figure with his head in profile to the left. The paper has clearly been cut and it is impossible to determine if the present bust-length representation is what Michelangelo intended. It is generally, although not universally, dated to c. 1500–5 because the description of form through an intricate grid of parallel and crosshatched shading is similar to that in some of the studies associated with the *Battle of Cascina*, such as Exh. No. 13r.[105] The youth's flame-like curls and fiercely concentrated gaze led to the figure being described as Satan in the 1860 Christie's sale catalogue of the Lawrence-Woodburn collection, while Wilde was more inclined to identify it in his 1953 British Museum catalogue as a representation of a satyr. Neither identification is satisfactory: neither Lucifer nor satyrs are normally represented with a loop of drapery over one shoulder, and the interpretation of the prominent strands of hair as either devilish or goatish antlers ignores the fact that similar shaped curls recur in studies of children of much the same period (like the one on the verso of Exh. No. 14).[106] The parallels in the figure's unkempt hair and straggly beard, as well as his costume and the turn of his head, with a first-century AD portrait bust in the British Museum of an unknown youth in the guise of a Greek philosopher (Exh. No. 8) may suggest that Michelangelo had in mind a similar marble which he had seen either in Florence or Rome.[107] The connection must remain a tentative one, since in the drawing Michelangelo has gone far beyond any classical source. The observation of the bulging sinews in the figure's neck, his prominent collarbone and the wide-eyed stare are so particular that it seems likely that Michelangelo was working from a live model.

Fig. 17 **Study of an antique torso of Venus**, c. 1524. Black chalk, made up section of the paper at the lower right, 25.6 × 18 cm. The British Museum, London

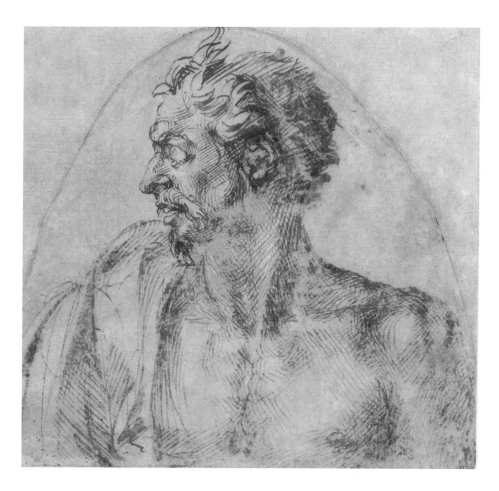

Exh. No. 7 **Head of a man in profile**, *c.* 1500–5. Pen and brown ink, cut at the top to a half-oval and later made up to a square, 13 × 13 cm. The British Museum, London

The British Museum drawing is not an isolated example of the acute powers of imagination and visualization which allowed Michelangelo to blend his experience of life drawing with figural studies inspired by classical statues. A comparable example of this process is found in his transformation in a study now in Chantilly of a fragmentary marble figure of Apollo. The statue was displayed in the niche in the courtyard of the Sassi palace in Rome, with the figure facing backwards as the front was damaged; Michelangelo turned the slender form of the god into a curvaceous female nude, with broad hips and swelling buttocks.[108] Michelangelo's ability to vivify ancient marbles must have been facilitated by his own experience of starting work on highly idealized sculpted figures by making life drawings.

Exh. No. 8 **Portrait bust of a bearded man dressed in classical Greek attire**, Antonine, *c.* AD 130–150. Marble, h. 66 cm. The British Museum, London

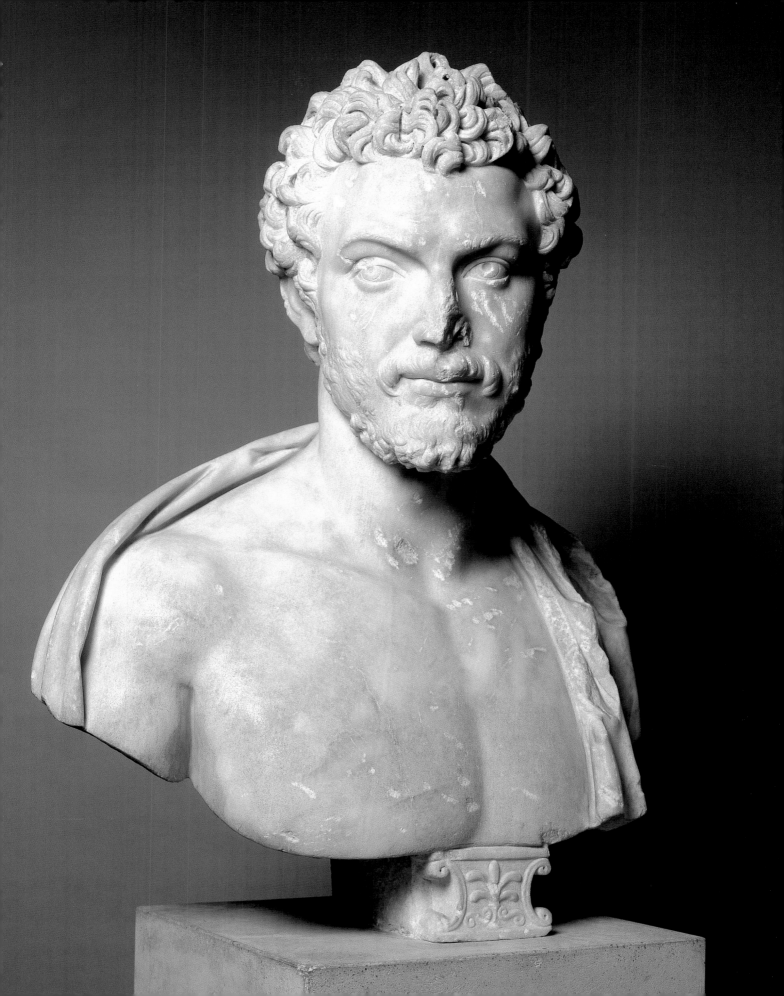

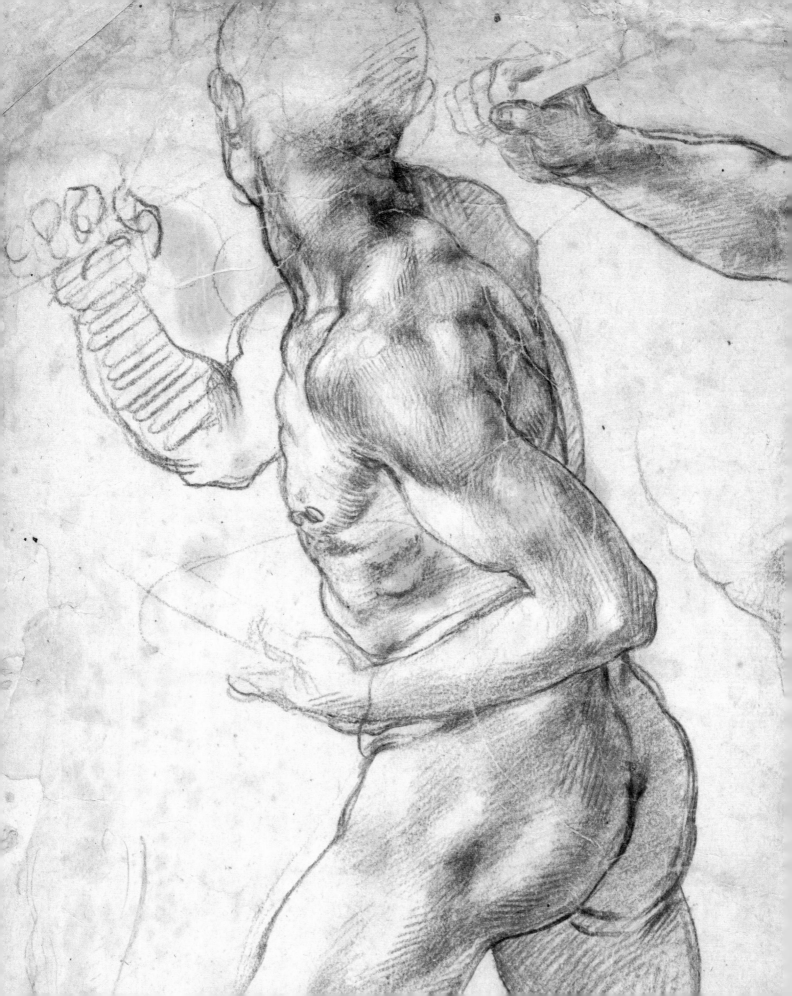

3
Florence
1501–1505

Michelangelo returned home from Rome in the spring of 1501 fresh from the triumphant success of the marble *Pietà*.[1] The political situation in Florence had changed considerably since his last brief visit there to see his family at the end of 1497. In the intervening period the bitter struggle between Savonarola's supporters (nicknamed by their detractors the *piagnoni*, 'snivellers') and his critics (the *arrabbiati*, 'enraged') had led to the trial and subsequent execution of the preacher in May 1498. The Dominican's fate had been sealed by his ill-judged conflict with the papacy resulting from his condemnation from the pulpit of the notorious Borgia pope Alexander VI.[2] Even after his death, sympathizers loyal to his theocratic aims could still be found in the Great Council, the principal organ of republican government, whose formation Savonarola had enthusiastically endorsed.[3] This body consisted of more than 3,000 male Florentines who met in the Hall of the Great Council (Sala del Maggior Consiglio) erected on the eastern side of the Palazzo della Signoria (now more commonly known as the Palazzo Vecchio). This chamber was built with astonishing speed. The first assembly held there in early 1496 took place less than a year after the decision had been made to build.[4] The practical problems of maintaining consistent policies with so many eligible officeholders, especially in the key areas of diplomacy and external relations, was addressed in 1502 by the election of a lifetime head of state, the *Gonfaloniere a vita*.[5]

Piero Soderini, who was elected by the Great Council to this post, came from a wealthy and influential patrician family which had formerly enjoyed close ties with the Medici.[6] His appeal to the polarized members of the ruling body was that he did not belong to any faction (his activities as a diplomat meant that he was largely absent from Florence during Savonarola's ascendancy), and his contemporaries were divided in their interpretation of his political views. The problems confronting him were formidable. The Florentine state was militarily weak, and the hire of mercenary aid to counter the threat of invasion was made difficult by the reluctance of the Great Council to impose new taxes. Florence's steadfast loyalty to the French had not yet delivered any tangible benefit apart from the removal of the Medici, and without Gallic help the Pisans were stubbornly beating off their attempts to recapture the city.

The turbulent politics of the period and the fledgling republic's precarious position was the backdrop for the five years that Michelangelo spent in Florence between 1501 and 1505. This was to prove one of the most active and productive periods of his career, and his experience of the city without the Medici controlling its government was to mark his political sympathies for the rest of his life. What probably prompted his return from Rome was the lure of working on a colossal block of Carrara marble owned by the powerful Opera del Duomo (the Committee of Works of Florence cathedral). In 1464 the committee had commissioned the Florentine sculptor Agostino di Duccio to sculpt from the stone a figure to stand at

Exh. No. 10 Recto **A male nude** (detail), *c.* 1504–5. Black chalk, heightened with lead white, the upper corners made up, 40.4 × 25.8 cm. The Teyler Museum, Haarlem

the top of one of the cathedral's buttresses. The scale of this work (4.1 metres or just over 13 feet high) was far larger than anything attempted since antiquity, and both Agostino di Duccio and Antonio Rossellino, who had been called in to revive the commission in 1476, were defeated by the magnitude of the task. Their botched attempts to rough out a figure had left the marble in a wretched state, and it was abandoned in the Opera's courtyard for almost forty years.[7] In July 1501 the cathedral authorities decided to resurrect the project and the block, referred to for the first time as a *David*, was lifted upright. Rumours of the revival of this ambitious project probably precipitated Michelangelo's abrupt departure from Rome leaving unfinished the S. Agostino *Entombment* altarpiece (now in the National Gallery, London), and a quantity of marble from Carrara perhaps related to a recent contract for Siena with the Piccolomini (for which see below).[8] He beat off the competition of Andrea Sansovino to secure the commission, and the contract was drawn up in August with Michelangelo agreeing to finish the work within two years – a demanding deadline he succeeded in meeting.

The statue, commonly known as the *gigante* (the 'giant'), was begun in September 1501 and must have been substantially completed by midsummer 1503, when the wooden palisade in the cathedral workshop behind which the sculptor had worked was taken down to allow the figure to be viewed.[9] Although the sculpture was intended to be for the cathedral, it was eventually decided after much deliberation to place it in an even more prominent position, outside the entrance of the Palazzo della Signoria. This was after soundings had been taken in January 1504 from eminent artists, sculptors and goldsmiths, including Botticelli, Davide Ghirlandaio, Filippino Lippi, Leonardo, Perugino and Andrea Sansovino.[10] The palace was the seat of government where Soderini and, to the horror of some conservatives, his wife resided. David's divinely inspired victory over Goliath, a more powerful foe who threatened to enslave the Jewish people, had long been seen as a symbol of Florence's own survival as an independent city state threatened on all sides by mightier rivals. David's valiant resolution had a particular resonance at a time when the city was struggling to maintain its newfound freedoms. The giant figure took four days in May 1504 to transport from the cathedral workshop; on the first night of the journey across the city the sculpture was pelted with stones by four youths. This attack has sometimes been seen as the work of anti-republicans since the assailants all came from families with ties to the Medici. However, as none of them seem to have been particular allies of the ruling family on its subsequent restoration, their actions may simply have been motivated by vandalism (occurrences of other attacks on art in Florence at the time are known).[11] The sculpture was set up on the marble base in September, and the following month there are records of payments for the gilding of the supporting tree stump, the strap of his sling and the creation of a gilt garland to hide the figure's genitals.[12]

Michelangelo's triumph in creating such a memorable image of heroic athleticism was even more remarkable because he had overcome the problems of the relatively narrow block having already been worked on. His success in meeting the deadline resulted in a deluge of commissions which meant he could seldom work in future with such single-minded determination on an individual project. Even before he had begun the *David*, Michelangelo had committed himself in Rome to producing for Cardinal Francesco Todeschini-Piccolomini fifteen smaller than life-size sculptures to embellish a large-scale marble altar in Siena cathedral that the Lombard sculptor Andrea Bregno and his studio had completed in 1485. The contract for this work was signed by Michelangelo in June 1501 with his Roman patron Gallo once more, as he had for the *Pietà*, guaranteeing the work's completion. The commission was a prestigious one, as the Sienese cardinal was the great-nephew of a pope (Pius II) and a future

Exh. No. 15 Verso **Capitals,
smaller studies and lines from
a sonnet**, *c.* 1503–4. Pen and
brown ink, 18.3 x 18.6 cm.
The British Museum, London
(recto illustrated on p. 74)

pontiff himself, although his reign as Pius III lasted less than a month before his death in
October 1503. In the event Michelangelo produced only four somewhat lacklustre figures,
probably in the period 1503–4. The death of the patron and the advent of more appealing
commissions than one circumscribed by an existing structure meant that Michelangelo never
delivered on his promise. Such breaches of contract were commonplace in the period, and the
only remarkable aspect of Michelangelo's failure to complete it was that he managed to retain
for so long the 100 ducats advance paid to him in 1501. The Piccolomini heirs were repaid the
money only after the sculptor's death more than sixty years later. It has been plausibly
suggested that Michelangelo was responsible for designing the handsome classical niches at
the lower tier of the Piccolomini altar, although there is no mention of this in the contract.[13]
This would mark the artist's first experience as an architect and would explain the appearance
in drawings of 1503–4 of pen studies of classically inspired capitals, such as on the verso of
Exh. No. 15, of a type not unlike those created for the altar.

Soderini, whom Condivi describes as a 'great friend' of the artist, was almost certainly
responsible for Michelangelo being assigned two further major public commissions which
deflected his progress from the Sienese project. Michelangelo was on close terms with the
Soderini family, and the relationship endured after Piero and his wife had been banished from
Florence to exile in Rome in 1512. This is demonstrated in a warmly worded letter of recom-
mendation written by Soderini's wife, Argentina Malaspina, to her brother to facilitate
Michelangelo's extraction of marble in Carrara in July 1516. The artist was, in turn, unusually

Exh. No. 15 Recto **A battle-scene; two figures**, c. 1503–4. Pen and brown ink, 18.6 × 18.3 cm. The British Museum, London (verso illustrated on p. 73)

obliging to his old patron, and supplied a design two years later for a tabernacle for the head of St John the Baptist (Florence's patron saint) in the Roman church of S. Silvestro.[14] The fact that Piero's nephew Niccolò asked Michelangelo to be godfather to his son in October 1523 underlines his continued link with the family.[15] Soderini's much remarked equanimity is shown by his having forgiven Michelangelo for not completing any of the Florentine government's commissions.

The earlier of the two projects commissioned by the Signoria was intimately related to the city's foreign policy. In August 1502 Michelangelo was asked to cast a bronze figure of *David* 2¼ *braccia* high (just over 1.4 metres or just over 4 feet) as a gift for an influential member of the French court, Pierre de Rohan. The Frenchman had accompanied Charles VIII during his stay in the city in 1494 after Piero de'Medici's flight, and five years later the Republic rewarded his support by the despatch of some antique sculptures from the Medici collection. Two years later in June 1501, Rohan relayed through the Florentine ambassadors in Lyon (one of whom was Michelangelo's former patron Lorenzo di Pierfrancesco de'Medici) his continuing adherence to the alliance, and his wish for a copy of Donatello's bronze *David*, which had been in the courtyard of the Palazzo Medici when he had stayed there in 1494.[16] Rather than sending a copy, the Signoria commissioned a new figure from Michelangelo. The necessary bronze was acquired in August 1501 and a contract drawn up with the sculptor a year later. To Soderini's embarrassment, the artist's burden of commitments, not least from 1505 onwards to Pope Julius II in Rome, meant that progress was extremely slow and the

Fig. 18 **St Matthew**, 1506. Marble, h. 263 cm. Galleria dell'Accademia, Florence

Fig. 19 **_Bruges Madonna_**, c. 1503–4/5. Marble, h. 128 cm. Church of Notre Dame, Bruges

figure had to be completed by Benedetto da Rovezzano. The finished figure was not sent off to France until 1509, and such was the delay that its recipient was not Rohan, who had fallen out of favour and withdrawn from court four years earlier, but Florimond Robertet, the treasurer and secretary of Louis XII. He, like Rohan, had profited from his royal master's intervention in Italian politics to build up a fine art collection which included Leonardo's lost _Madonna of the Yarnwinder_ and a painting by the Bolognese artist Lorenzo Costa.[17] Michelangelo's sculpture later vanished, and the most certain clue to its appearance is provided by the artist's quick pen sketch for the figure in the Louvre. This shows that his initial conception was for a lithe nude figure in the mould of Donatello's bronze.[18] Michelangelo also failed to finish the other Soderini project, the _Battle of Cascina_ painting (discussion of which follows below). He managed to complete only a section of the cartoon before his summons to Rome in spring 1505.

Even before the _David_ had left the cathedral workshop Michelangelo had undertaken in April 1503 to carve twelve larger than life-size Apostles for the cathedral, at the rate of one finished statue per year. The Opera clearly wanted to retain the services of the sculptor, but they were again to be disappointed. A drawing in the British Museum (Exh. No. 15r) records Michelangelo's initial thoughts (c. 1503–4) for one of the Apostles, but recent archival discoveries reveal that he began work on the series a few years later. The block used for the only figure on which Michelangelo began work, the unfinished _St Matthew_ (Fig. 18; Galleria dell'Accademia, Florence), is now known to have reached Florence in March 1506.[19] He must have worked on the marble during the time in Florence between his flight from Rome in April 1506 and departure to Bologna the following November. The Apostle's pose in the marble is very different from that of the figure in the drawing (perhaps, but not certainly, a study for the same sculpture), and this can be explained by the influence of a newly discovered antique work.[20] The Apostle's twisting motion depends on the pose of the central figure in the _Laocoön_ (Fig. 54; Vatican Museums, Rome), a celebrated classical work depicting the eponymous Trojan priest and his sons struggling against a giant serpent that Michelangelo saw soon after its excavation in Rome in January 1506.

Inexplicably, the only sculptural commission that Michelangelo completed apart from the _David_ during this intensely busy period was a smaller than life-size marble of the _Madonna and Child_ commonly known as the _Bruges Madonna_ (Fig. 19). This was ordered by the Mouscron, a family of rich Flemish cloth merchants, and placed by them above an altar in the church of Notre Dame in Bruges where it remains to this day.[21] The sculptor was paid in two instalments for this work in December 1503 and October 1504, but the marble was not shipped to Flanders until October 1506.[22] A spare pen outline study of the two figures in the British Museum (Exh. No. 14r) is one of two studies unquestionably related to the commission (the other in the Uffizi is illustrated in Fig. 28). During the same period Michelangelo was also working on two circular (_tondo_) marble reliefs of the _Virgin and Child with the Infant Baptist_ now known after their Florentine owners: the _Taddei Tondo_ created for Taddeo Taddei (now in the Royal Academy of Arts, London, Fig. 20) created for Taddeo Taddei and the _Pitti Tondo_ (Museo Nazionale del Bargello, Florence) owned by Bartolomeo Pitti.[23] Despite the similarity of format the two works are markedly different in effect. The explosive movement and dramatic narrative of the London marble contrast with the contained meditative calm of the Bargello relief. Both sculptures were abandoned in an unfinished state, perhaps because there was insufficient depth of stone in either to accommodate Michelangelo's changes to the composition. His predilection for making radical alterations to the poses of his figures midway through carving

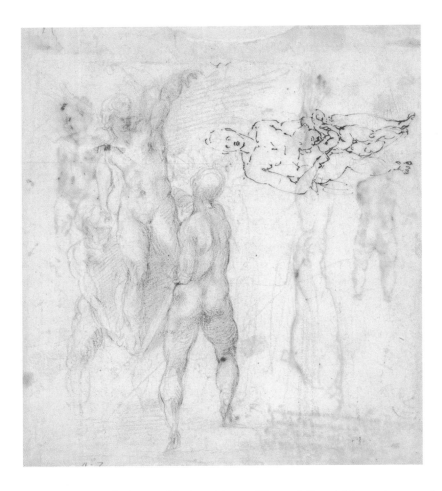

Exh. No. 14 Recto **A group of three nude men; the Virgin and Child**, *c.* 1504–5. Black chalk (the nudes); pen and brown ink over leadpoint (the Virgin and Child), made up section of paper at centre of upper edge, 31.5 × 27.8 cm. The British Museum, London (verso illustrated on p. 91)

them was virtually impossible to achieve with a relief, and this perhaps explains why he never attempted the form again. His inventive exploration of the traditional *tondo* form also extended to painting a highly artificial composition of the Holy Family for the Florentine merchant Agnolo Doni, the so-called *Doni Tondo* (Uffizi, Florence). The compact group of sacred figures in the painting's foreground, ingeniously adapted to fit the circular form, is set against a barren landscape populated by a group of naked men. Similar figures, perhaps symbolizing the sensual pagan age that Christ's ministry would overcome, are found in the background of a *tondo* of the *Virgin and Child* (Uffizi, Florence) painted in the 1480s by the Tuscan artist Luca Signorelli, probably at the behest of Lorenzo de'Medici.[24] Signorelli anticipated Michelangelo's fascination with the dynamics of the male form in extreme *contrapposto*, and he is one of the few artists of the preceding generation whose work inspired his admiration.

The complexity of Michelangelo's career during his time in Florence, as he shifted between separate workshops in the city to work on different projects, is well illustrated by his drawings from 1501–5. Some studies show Michelangelo's mind turning from one commission to another in rapid succession. The design for one of the Apostle sculptures is drawn over a preliminary idea for a cavalry mêlée in the background of the *Battle of Cascina* fresco (Exh. No. 15r); another sheet has a study of a figure from that battle-piece on the recto and various quick sketches of ideas for the pose of the Infant Baptist in the *Taddei Tondo* relief on the verso (Exh. No. 13). It is a mark of Michelangelo's inventiveness that, despite the intense creative pressure that he was under at this period, there is no evidence of his borrowing ideas,

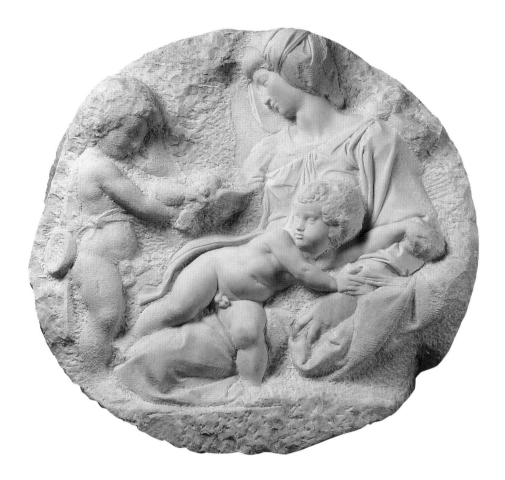

Fig. 20 **Taddei Tondo**, c. 1503–6. Marble, diam. 106.8 cm. The Royal Academy of Arts, London

even rejected ones, from one work to furnish another. His work from these Florentine years is exceptional for its expressive and dramatic range: he is equally adept at depicting the exertions of the Florentine soldiers in the *Bathers*, as well as the solemn pathos of the Christ Child slipping free of his mother's hand to take his first steps in the *Bruges Madonna*.

The Battle of Cascina

Seven years after the decision had been taken in 1495 to construct the Hall of the Great Council its walls remained undecorated.[25] The vast room, over 60 metres long, 22 metres wide and almost 12 metres high, was not completely bare. In 1498 the talented wood carver and architect Baccio d'Agnolo had been given the responsibility of making the furnishings, including the frame for the unexecuted altarpiece commissioned from Filippino Lippi, the panelling embellished with classical motifs designed with the help of Lippi, and a tribune for Soderini and eight priors.[26] The first move to progress further in the decoration was the commission given in June 1502 to Andrea Sansovino to carve a marble statue of Christ as Saviour. The choice of subject echoed Savonarola's proclamation of Christ as 'King of Florence', and it may also have been intended as a reminder that the Medici had been expelled on St Saviour's Day (9 November). Further impetus came with Soderini's appointment in November 1502, for he was quick to realize that the embattled Florentine Republic could

simultaneously promote its legitimacy and its hoped-for permanency by harnessing the talents of its native artists and architects along the lines of earlier Medicean patronage. He was encouraged in this by the presence in the city of Leonardo, whose engineering skills had been called on to devise a way of depriving Pisa access to the sea by diverting the course of the River Arno. This impractical project was much favoured by the Florentine politician and theorist Niccolò Machiavelli. Leonardo had returned from an extended period at the Milanese court (1481–99), and he had quickly reaffirmed his position as the city's most brilliant and original talent by the creation of a fabled, and now lost, cartoon depicting the Virgin and Child with the Infant Baptist and St Anne.[27]

Soderini was so anxious to utilize Leonardo's talents that, according to Vasari, even before he had taken office he had put forward the painter as a candidate to sculpt the *David*. It is not known exactly when he was finally able to secure Leonardo's services to paint the *Battle of Anghiari* on one of the long walls of the Great Council (whether it was for the east or west wall is still disputed).[28] The first notice of Leonardo's involvement in the project dates from October 1503, when the artist was given keys to the Sala del Papa and adjacent rooms off the cloister of the church of S. Maria Novella so he could make a cartoon for the work. The following January he began to prepare the composition, his progress on it interrupted on the 25th when he was on the committee to advise on the location of Michelangelo's *David*. Soderini must have been a guiding influence in the placement of the sculpture directly outside the seat of government, and it is almost certain that he was also responsible for commissioning Michelangelo in the summer of 1504 to fresco a companion battle-scene, the *Battle of Cascina*, on the left-hand side of the same wall. In September 1504 Michelangelo was assigned the Sala Grande in the Ospedale dei Tintori in S. Onofrio as a studio space for the creation of his cartoon.[29] The following month the paper arrived from Bologna, and by the end of the year the work of gluing the sheets together had come to an end.[30]

The exciting prospect of pitting the two greatest Florentine artists of their respective generations in direct competition with each other unfortunately ended in failure. Michelangelo's contribution never went further than the creation of the *Bathers* cartoon for the central section of his part of the wall (Fig. 21). He later claimed that he had finished this before his summons to Rome by Pope Julius in February 1505.[31] This seems to be confirmed by the payment he received on the 28 February. Leonardo abandoned his section when he left Florence for Milan in May 1506, although he had progressed further than his younger rival, having begun to paint part of the composition. He had unwisely elected to experiment with oil-based pigments, as he had done so disastrously a decade or so earlier in Milan with the *Last Supper*. The results were no more successful, and his damaged and unfinished mural was covered over when Vasari remodelled the room in the 1560s.[32]

The subjects chosen for Leonardo and Michelangelo's works had particular relevance to Florence's contemporary struggles. The Florentines were known for their skills as merchants and bankers and not as warriors, and this is reflected in the fact that the Anghiari engagement in 1440 painted by Leonardo had been the city's last major victory. The central motif of Leonardo's fresco of the furious clash of cavalrymen battling for possession of the Milanese standards recalled the fact that the Palazzo della Signoria housed these treasured relics of military success. Michelangelo's work celebrated the 1364 triumph over the Pisans, a victory the Florentines were desperately keen to replicate. Just as Leonardo's *Battle of the Standard* elevated an episode that contemporary chroniclers of the battle had described only in passing, so the central narrative scene in Michelangelo's work, the so-called *Bathers*, occurred on the

Fig. 21 Bastiano (Aristotile) da Sangallo (1481–1551), **Bathers (section of the Battle of Cascina)**, after Michelangelo, 1542. Oil on panel, 76.4 × 130.2 cm. Holkham Hall, Norfolk

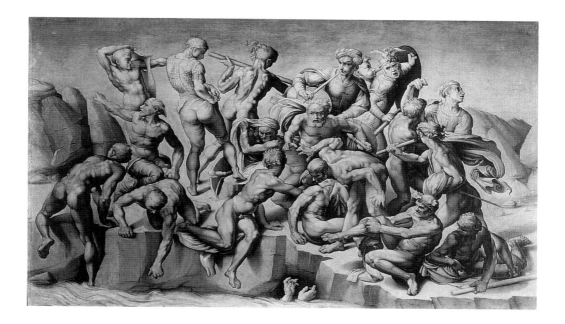

eve of the battle, according to the account given by Filippo Villani. The fourteenth-century Florentine chronicler tells how his compatriots had taken off their armour in the summer heat to take a dip in the Arno. At this moment their captain, Manno Donati, chose to test their readiness by shouting out that the enemy was approaching. His initiative is compared favourably in Villani's account to the negligence of the non-Tuscan mercenary captain of the Florentine army Galeotto Malatesta. In the battle itself, the Pisan army led by the English *condottiere* John Hawkwood was defeated when Donati took command.[33] The same incident was recounted with a slightly different emphasis in the Latin history of the Florentine people written by Leonardo Bruni, which would have been available to Michelangelo in an Italian translation.[34] In Bruni's version, the Florentine army's bathing and relaxation was interrupted by a real surprise attack on their camp that they succeeded in repulsing.[35] It seems more likely that Michelangelo's fresco was inspired by Bruni's more heroic version of events.

At a time when Florence was in dire need of comparable feats of arms, Michelangelo's *Bathers* celebrated a famous victory over Pisa which had been won through the superiority of Florentines fighting for their homeland. This was a topical issue at that time because Machiavelli had just begun to canvass opinion regarding the formation of a native militia, in the hope of overcoming the city's reliance on mercenaries.[36] If the two frescoes had been completed, their stirring narratives and huge scale (rough estimates of the space suggest that they would have measured around 18 × 7 metres or 19 × 48 feet) would have served as vivid reminders to the Great Council of their forebears' courage and fortitude, qualities that were sorely needed if the Florentine Republic was to survive.

Michelangelo's cartoon of the *Bathers*, the only part of the Cascina commission to have even approached its final preparatory stage, was reported to have been destroyed a decade or so after its completion by the very artists who flocked to study it.[37] The startlingly original composition of over life-size figures drawn in black chalk or charcoal with white highlights was hugely influential. The sculptor Benvenuto Cellini was one of many young Florentines who went to study Michelangelo's and Leonardo's cartoons when they had been put on public display, and in his autobiography, begun in the late 1550s but not published until the eighteenth

century, he described them as a 'school for all the world'.[38] Michelangelo's customary impulse to restrict access to his drawings and cartoons failed in this instance because he was away from Florence so frequently after 1505. Knowledge of the cartoon spread through various painted (Fig. 21), drawn (Figs 16, 25 and 31) and engraved copies (Fig. 24), the majority of which record only part of the composition. The best-known representation of the entire work is the grisaille panel belonging to the earl of Leicester at Holkham Hall in Norfolk (Fig. 21). This is generally identified as the work mentioned by Vasari as having been painted at his suggestion by the Florentine painter and architect Bastiano (known as Aristotile) da Sangallo from a drawing (*cartonetto*) he had made in his youth.[39] The painting is an invaluable guide to Michelangelo's composition, but it has to be admitted that Sangallo's limited skills as a painter were severely tested by the effort of transcribing his drawing into paint and his effort is disappointingly stilted. Fortunately, a more reliable idea of the cartoon's electrifying impact is provided by Michelangelo's large-scale figure studies for the composition, three of which are included here (Exh. Nos 9–11).[40]

What is perhaps most striking about the Holkham painting is the singular oddity of Michelangelo's composition. The cartoon was intended as part of a much larger whole, and the fragmentary nature of the work adds to its disjointed quality. The nude figures form a dense semi-circular scrum that pulsates with movement in all directions. The complex motion and poses of the individual soldiers make it impossible to take in the composition at a glance. This is particularly true in the right half, where the concentration of figures is so dense that it sometimes requires considerable effort to work out which limb belongs to which body. The disorientating effect can be seen as a narrative device to convey to the viewer something of the Florentines' desperate rush to prepare themselves for battle, as well as a means of coercing the viewer to focus on each individual figure. Michelangelo's wish that each figure should be studied in isolation is underlined by the manner in which the majority do not interact with one another, an exception to this being the soldier studied in Exh. No. 9r, who is engaged with helping his companion put on his armour. The composition is structured to encourage the viewer to persevere in this attentive study, as the figures on the left side are more widely spaced and fewer in number.

In the only surviving study for the entire composition (Fig. 22; Uffizi, Florence), drawn in soft black chalk, the balance of the design is in reverse to that of the final one. The drawing also shows that Michelangelo contemplated a much more co-ordinated sense of figural movement, with the eye directed backwards into pictorial space by the movement of one of the soldiers on the left being pulled out of the river. This impetus is then taken up in the charge of two others behind them towards the unfolding battle faintly visible in the background. It has been noted that the artist's move away from a literal interpretation of the narrative can be seen in the revision to the pose of the twisting soldier, the same figure studied in Exh. No. 11.[41] In the Uffizi study, Michelangelo began by drawing the figure with his head turned towards the soldier to his right who is shown bending down towards him, as though the two were in conversation. This link was broken with Michelangelo's subsequent alteration to the position of the seated figure's head to face in the opposite direction as in Exh. No. 11. The sketchy Uffizi drawing was generally placed in the earliest phase of the design, but this has recently been questioned.[42] When the composition is compared to Sangallo's copy it is apparent that it is only the left-hand section that differs markedly from the finished design, and, not coincidentally, this is the one section of the drawing which has freely executed underdrawing in stylus beneath the chalk. This signifies that Michelangelo must have already worked out the right

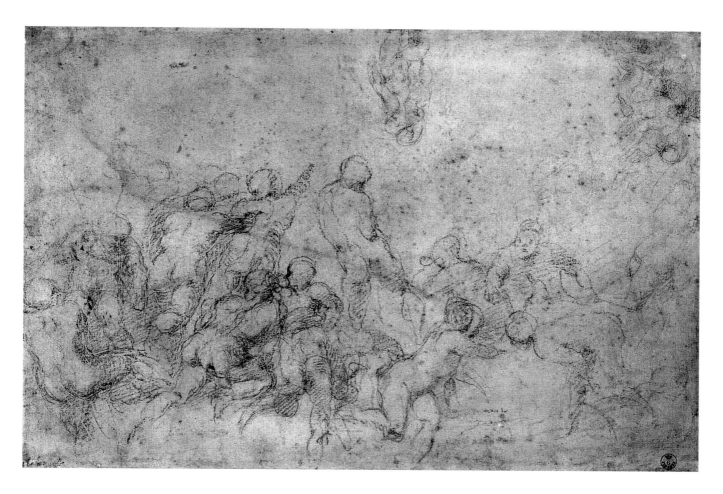

Fig. 22 **Study for the *Battle of Cascina***, *c.* 1504. Black chalk over stylus, 23.5 × 35.6 cm. Galleria degli Uffizi, Florence

half of the composition in previous, and now lost, studies, and this explains the absence of a preliminary stylus underdrawing in this part of the Uffizi drawing.

Even though the Uffizi drawing was evidently executed at a fairly advanced stage, neither of the two figures studied in the drawings in Haarlem appear in it. Michelangelo's invention of them must, therefore, belong to an even later stage in the design. Both of them are life studies for two soldiers on the right side of the group: Exh. No. 10r for the one with the billowing cloak striding to his left, and Exh. No. 9r for the figure almost immediately behind him who faces in the opposite direction. The similarities of the two drawings in technique and style suggest that they were executed in quick succession. Both are notable for his use of two shades of black chalk: a stick of a lighter shade was used first, another of a velvety black shade – its dark tonality probably enhanced by oil – to emphasize some of the outlines, and for internal modelling in the most shaded areas. The darker accents are most discernible in the modelling of the buttocks of the figure in Exh. No. 10r and around the groin of the nude in the other study. These two studies probably remained together in the possession of Michelangelo's friend Daniele da Volterra. His ownership of the Haarlem drawings is indicated by the appearance of figures based on the studies in two paintings executed by members of his studio in the 1560s.[43]

Michelangelo must have had a clear idea of the overall design before embarking on such detailed life drawings for individual figures. This is revealed by the way in which he did no more than outline the left calf of the figure studied in Exh. No. 10r because he knew this area

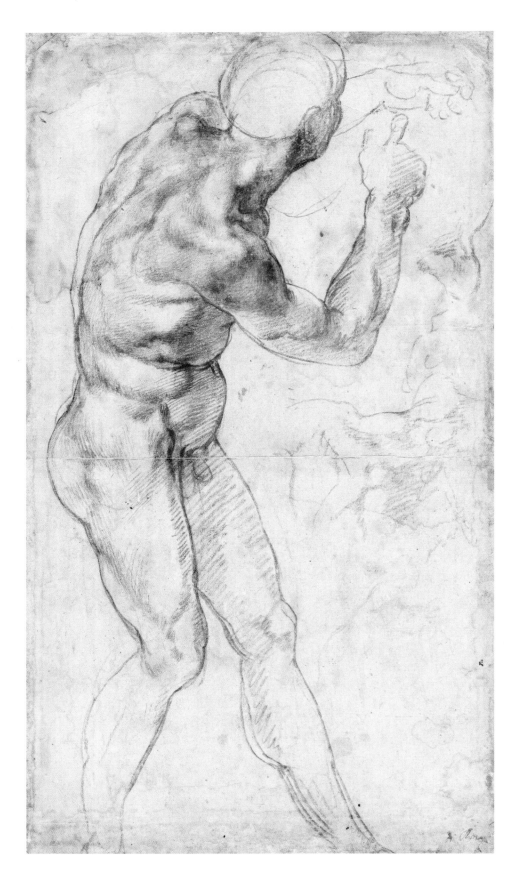

Exh. No. 9 Recto **A male nude**,
c. 1504–5. Black chalk, heightened
with lead white, the corners
made up, 40.4 × 22.5 cm.
The Teyler Museum, Haarlem
(verso illustrated on p. 110)

opposite
Exh. No. 10 Recto **A male nude**,
c. 1504–5. Black chalk, heightened
with lead white, the upper corners
made up, 40.4 × 25.8 cm.
The Teyler Museum, Haarlem
(verso illustrated on p. 165)

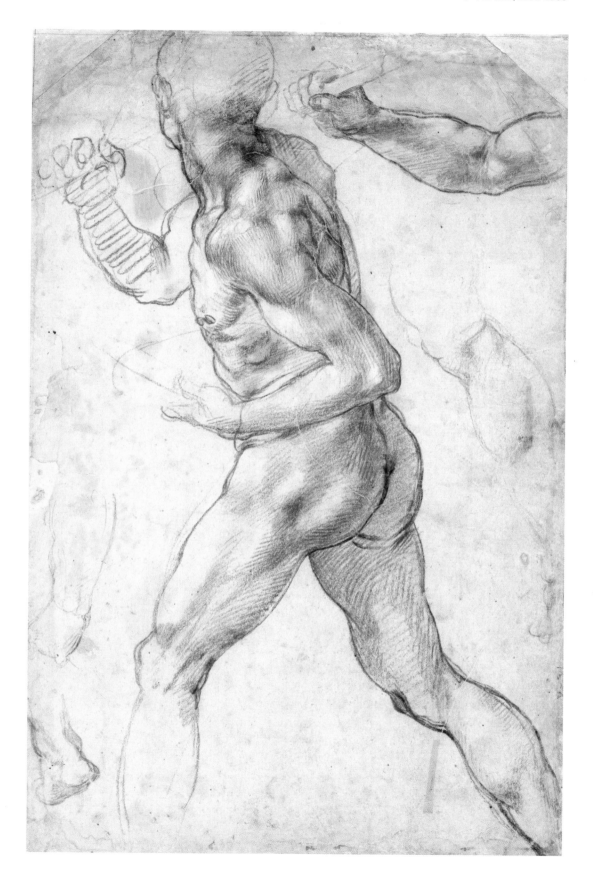

would be hidden by an overlapping figure. He had also clearly already decided that the figure would have part of his cloak bunched on his left forearm, but, as his aim in the drawing was to refine the pose and the details of lighting from a nude model, he simply reminded himself of this detail by drawing the rough outline of the cloak with an elliptical chalk line. As the material obscured the figure's left hand clutching a sword, he did not waste time on detailing an area that would not be visible in the finished work. Michelangelo must have already fixed the basic pose (one loosely inspired by one of the colossal antique *Horse Tamers* on the Quirinal in Rome), and as a consequence the contour outlining the form is firm and almost unbroken.[44] The only exception to this is the outline of the back below the figure's dramatically enlarged shoulder blades, where changes were made to add further emphasis to the rotating motion of the upper body.

The pose of the corresponding figure in the Holkham grisaille shows that Michelangelo made few changes apart from an adjustment to the left elbow. This was moved to prevent it disrupting the flowing line of the contour of the shaded right side of the body. An alternative study of the left arm, with the sword facing backwards as in the final design, was one of the subsidiary designs that the artist lightly drew in the areas of paper left free around the main one. His reworking perhaps indicates that Michelangelo already intended to change the pose in this area. It is impossible to know if the sheet has been seriously trimmed around the edges, but an indication that it is more or less intact is suggested by the way in which Michelangelo drew the right arm in a most summary fashion. He may have done so because he had left himself insufficient room on the paper to draw it in a more extended pose, and he then proceeded to make a more detailed study of the limb in the upper right. The use in the two Haarlem drawings of the space around the main study to make smaller sketches focused on a particular detail recurs throughout his career (see for example Exh. Nos 29r and 30r). This practice was already well established, as is shown by the delicate subsidiary studies surrounding the Ashmolean silverpoint study by Perugino of two studio assistants for the figures of the Archangel Raphael and Tobias for the Certosa altarpiece of about 1499–1500.[45] The boldness and energy of Michelangelo's marginal studies of figural details were far more dynamic, and it was these qualities that encouraged his contemporaries, like Raphael, to follow suit in their life drawings.[46]

The combination in both Haarlem drawings of black chalk with a little white heightening brushed on in the most highlighted areas was ideal for a fresco that Sangallo's copy shows was intended to deploy starkly opposing tonal contrasts. Michelangelo's use of light to model the straining bodies of the soldiers and to impart a strong sense of three-dimensional form is perhaps even more emphatic in the second Haarlem Cascina drawing (Exh. No. 9r). This figure was to be behind the one studied in Exh. No. 10r and, as with the other life drawing, Michelangelo only sketched in outline the parts of the body he knew would be covered up in the finished work. An earlier pen study of the same figure in the Albertina, Vienna, shows that the artist had intended to show him in profile, a pose that would have blocked the sense of motion set up by the striding figure studied in the other Haarlem sheet.[47] The artist's principal focus was again to make a detailed study of the twisting form of the model's upper body and of the lighting. The shape and density of the muscles and bones of the back and shoulders are described through a combination of the swelling contours outlining their forms, and internal modelling with a variety of differently weighted and directed strokes. In the shaded areas on the right side of the body Michelangelo again used a darker stick for emphasis and, more so than in the other study, smudged the surface tones of the chalk with his finger or a stump to

Fig. 23 **Preliminary sketch for Exh. No. 11, a detail from Exh. No. 15 verso** (illustrated on p. 73). Pen and brown ink, h. 4.4 cm

Exh. No. 11 **A seated male nude twisting around**, *c.* 1504–5. Pen and brown ink, brown and grey wash, heightened with lead white (partly discoloured) over leadpoint and stylus, 42.1 × 28.7 cm. The British Museum, London

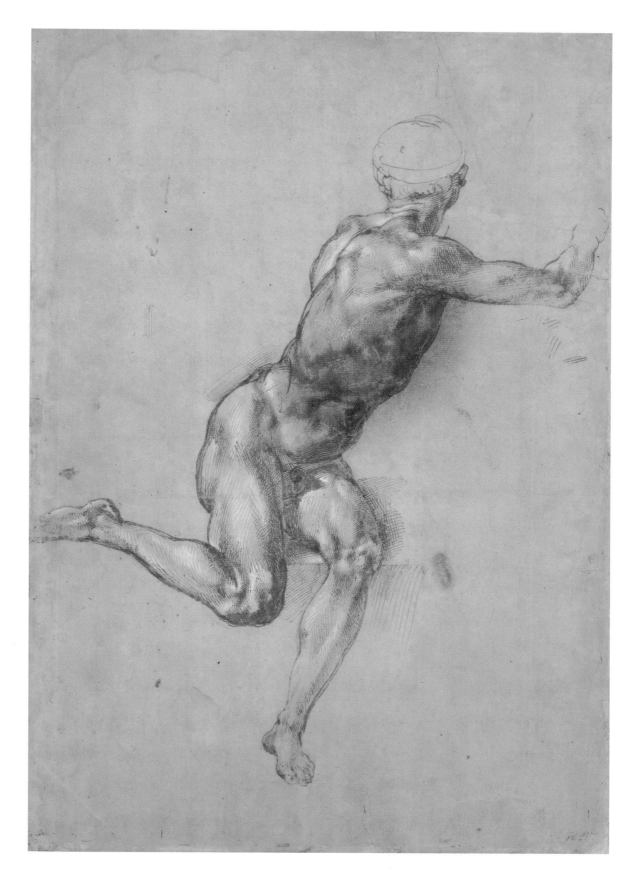

blend the modelling of the form. This is particularly evident in the description of the shoulders where Michelangelo's masterly use of the untouched surface of the paper, sometimes with a touch of white heightening, adds an even greater subtlety to his mapping of the body's undulating surface. The tactile, sensual quality of Michelangelo's modelling of the flesh in both drawings gives an indication of the appearance of the final cartoon. The physical presence of the figures in the lost work would have been even more powerful because of their larger scale.

The preparatory study in the British Museum for the central figure in the foreground of the *Bathers* (Exh. No. 11) differs from the Haarlem drawings in the use of ink and brown and grey wash (a technique used in no other study for the composition). The sharpened nib of the quill was well suited to the task of describing in great detail the plastic swelling forms of the straining muscles. Michelangelo added delicate brushstrokes of lead white and utilized the blank areas of paper to give an impression of a glistening sheen of sweat coating the model's form. Less successful was Michelangelo's attempts to use wash for the gradation of tone in the shaded area of the body on the right side. The shift from dark to light in this area is not nearly as subtle as in comparable passages in the black chalk drawings. The difficulties he experienced with wash in realizing the extremely precise observation of *chiaroscuro* modelling that he required to draw the final cartoon, might possibly have led him to switch to the more easily controllable medium of chalk and white heightening for the other *Bathers* figure studies.[48] Although Exh. No. 11 may mark the end of Michelangelo's use of wash for such highly detailed studies (there are no other surviving examples in a similar technique), he continued to use it for broader effects, as in the drapery study for one of the Sistine chapel Sibyls (Exh. No. 19r) and in his architectural studies such as Exh. No. 103.

The figure studied in the British Museum is of crucial importance because its turning upper body in the central foreground directs attention to the press of bodies behind it. Like

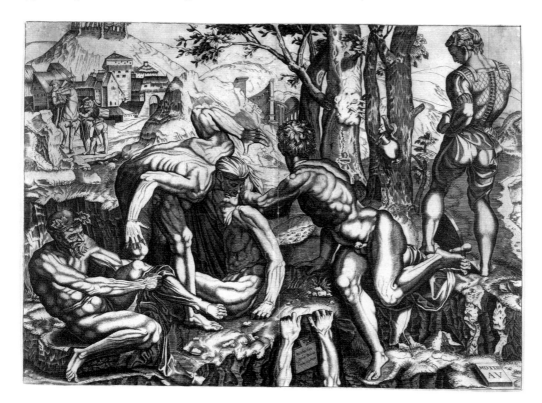

Fig. 24 Agostino Veneziano (*c.* 1490– after 1536), **Figures from the *Bathers* (section of the *Battle of Cascina*)**, after Michelangelo, 1524. Engraving, 32.4 × 43.4 cm. The British Museum, London

Exh. No. 12 **Maiolica plate with figures after the *Bathers* and the arms of Cardinal Bembo**, Urbino, *c.* 1539–47, diam. 27.2 cm. The British Museum, London

the two Haarlem drawings, it is taken from a posed model whose hair was covered by a cap. (It is one of the curiosities of Michelangelo's life drawing that he habitually ignored the cranial region: see for example the study on the recto of Exh. No. 27.) His remarkably three-dimensional rendering of the figure's body is so compellingly realistic that it is easy to overlook the unnaturalness of the pose. This is particularly true of the spiralling torsion of the upper body which has been pushed to impossible limits. Similarly the figure's prominently projecting shoulder blades should by rights lie flat as his arms are extended, but Michelangelo preferred to amend nature in this detail, as he had done with the model in Exh. No. 10r, because the shoulders are so expressive in conveying an impression of the model's physical exertion and strain. The position of the left arm is not indicated, perhaps because Michelangelo felt he did not need to do so as it was largely hidden by the model's torso.

The London drawing exemplifies Michelangelo's conceptual genius which allowed him to blend together seamlessly an abstract ideal of the pose with observations taken from life drawing. He was not an artist like Leonardo whose creative imagination was founded on observation of the people and landscapes around him; instead his inventions and artistic ideas were generated within his own imagination. These ideal forms were then modified through a relentless process of analysis on paper and in certain instances by making small-scale three-dimensional models (see Exh. Nos 44–5). Michelangelo's first thought for the pose, one of the most influential and sublime creations of his early career, almost certainly survives in a thumbnail pen study on the verso of a drawing in the British Museum for the background of

the *Battle of Cascina* (Fig. 23).[49] The passage from the spidery sketch to the grandeur of the final drawing is one of the most startling demonstrations of Michelangelo's transforming artistic brilliance. The impact of Michelangelo's dynamic invention can be gauged by the fact that the figure was copied by Raphael in a drawing in the Vatican Library and selected for inclusion in Agostino Veneziano's engraving (Fig. 24). This print was, in turn, used as a source for a superb maiolica dish in the British Museum (Exh. No. 12) bearing the arms of the Venetian churchman and poet, Cardinal Pietro Bembo. The cartoon's legacy is a subject worthy of a study in itself; the continuing stimulus of Michelangelo's work is attested by the drawing in the British Museum made by the Florentine painter Lodovico Cigoli in the 1590s (Fig. 25).[50] Cigoli's free copy of the right foreground section, and his experimental use of the twisting pose for the seated figure of the Infant Christ studied on the same sheet with the paper turned upside down, must have been based on a copy of Michelangelo's design, as the original cartoon had been destroyed more than fifty years earlier.

When Michelangelo made the Uffizi compositional drawing (Fig. 22) the figure studied in Exh. No. 11 had not yet been placed in the commanding central position it occupies in the cartoon. Other changes indicate the artist's readiness to eliminate figures even after having invested considerable time in working out their poses. This pitiless self-editing can be seen in the disappearance from the final cartoon of a charging soldier seen from behind with one arm outstretched. This figure was included in the Uffizi design, and his pose was studied in a celebrated pen drawing in the Casa Buonarroti.[51] Other figure studies which may have been conceived for the *Bathers* and then discarded, include a gesturing figure whose pose would be suited to a sentry alerting his companions to the approach of the Pisan army.[52] A double-sided drawing in the British Museum has on the recto a quickly penned study of such a figure (Exh. No. 13r) drawn over some sketches in black chalk, including one of a right leg. The figure's pose, with his left arm extended and his boyish frame and mass of curls, are reminiscent of the *Apollo Belvedere* (Fig. 26), a famous antique marble that Michelangelo must have studied earlier in the collection of Cardinal Giuliano della Rovere in Rome. The elegant stasis of the classical prototype is replaced in the drawing by a sense of precarious, unsustainable equilibrium with the figure seemingly on the brink of toppling backwards. The word *barba* (beard) written to the right of the figure may suggest that Michelangelo intended further to distinguish his figure from the beardless god represented in the sculpture.[53]

On the other side of the sheet (Exh. No. 13v) Michelangelo drew in pen a series of ideas for male infants which obscure some faint black chalk designs he had made, including one of the seated Virgin reaching down to her child. Leonardo was the inspiration for this kind of quickly realized sheet containing a variety of studies of a related theme. Michelangelo and Raphael at much the same period were moved by Leonardo's example to experiment with this improvisational method of drawing that could yield a host of potential figural and compositional ideas.[54] Michelangelo's chubby infants certainly show evidence of his observation of children, yet his naturalism is never as pronounced, nor as lyrical, as that of Leonardo because in his representation of figures it is secondary to the expression of the emotional and inner state of mind through gesture and pose. The bunched shoulder muscles of the Christ Child in the study at the lower right are not, for example, those of a child; yet it is through this muscular tension that Michelangelo signals the infant's fearful recoil from his cousin. He probably began the sheet with the outline sketches at the bottom before turning the sheet 90 degrees to the right to make more detailed studies (the central one overlaps one of his earlier efforts), and then he rotated the paper a further 180 degrees to m ake the slightly larger-scale figure

Fig. 25 Lodovico Cigoli (1559–1613), **Copies and derivations from the *Bathers***, *c.* 1594. Pen and brown ink, 41.7 × 28.5 cm. The British Museum, London

Fig. 26 ***Apollo Belvedere:*** **a Roman marble version, possibly after a Greek original of the fourth century** BC **by Leochares**, Hadrianic, *c.* AD 117–38. Marble, h. 224 cm. Vatican Museums, Vatican City

opposite
Exh. No. 13 Recto **A youth beckoning; a right leg**, *c.* 1504–5. Pen and brown ink; black chalk, 37.5 × 23 cm. The British Museum, London (verso illustrated on p. 90)

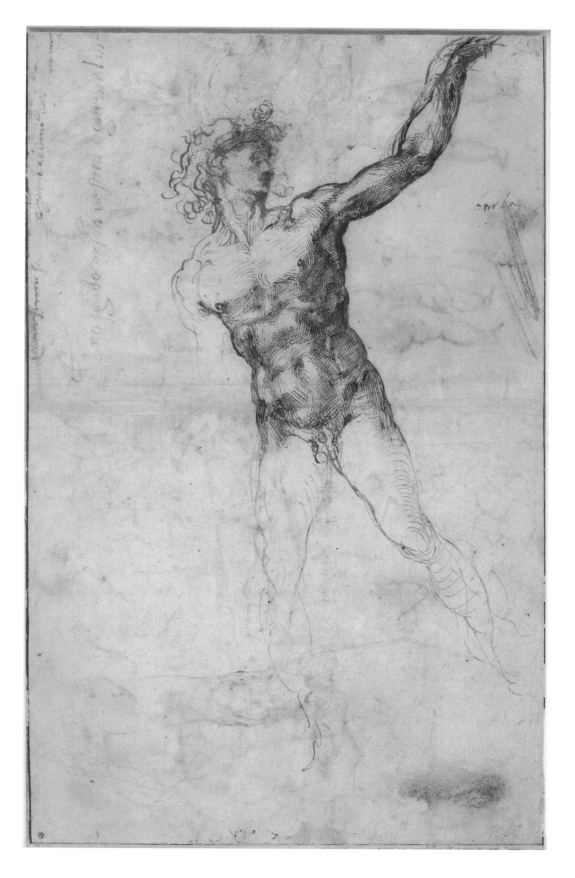

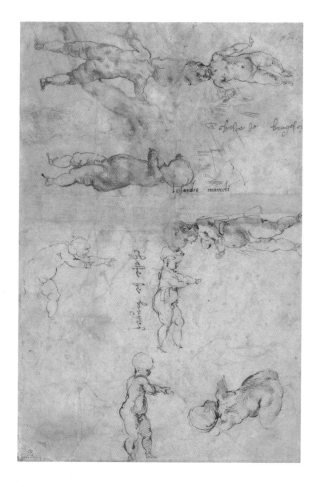

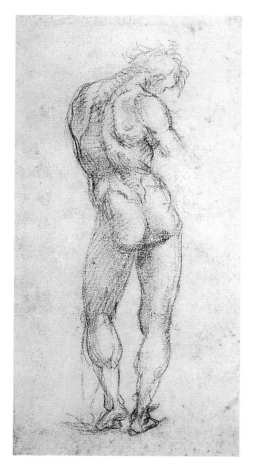

drawings at the top left. The studies of infants are preliminary ideas for the two children in the *Taddei Tondo* (Fig. 20), and the pose developed in the two central studies in the lower part of the sheet, with the Infant Baptist extending his left arm with his right hand beneath it, corresponds closely to that adopted for the corresponding figure in the *tondo* where he holds out towards his cousin a goldfinch, a traditional symbol of Christ's Passion. The narrative of the Baptist frightening his cousin in some way was clearly already in Michelangelo's mind, yet none of the variations of the Infant Christ's pose on the sheet comes close to his propulsive motion in the marble. Two of the studies, at the top left and bottom right, show that Michelangelo was even toying with the idea of having the Christ Child with his back to the viewer, a motif used in his youthful *Madonna of the Stairs*. His willingness to explore different narrative possibilities is demonstrated by the outline sketch of the Baptist scaring his cousin by reaching out his arms in a menacing fashion, while in the top right study Christ is depicted calmly reaching out his hand and perhaps even holding the bird. Similar pen studies of a child seen from the front and rear are on the verso of Exh. No. 14, but neither of the poses relates to the Royal Academy marble.

A modified version of the figure inspired by the *Apollo Belvedere* studied on the recto of Exh. No. 13 was used for the central figure in a trio of soldiers probably destined, but then rejected for the *Bathers*. The motif of two soldiers lifting up a third was studied in two quick black chalk drawings on both sides of Exh. No. 14. The springy contours, energetic black chalk hatching and the intense physical vitality of the figures strongly recall studies in the same

above left
Exh. No. 13 Verso **Studies of infants**, *c.* 1504–5. Pen and brown ink over black chalk, four infants not finished in pen and ink, 37.5 × 23 cm. The British Museum, London (recto illustrated on p. 89)

above right
Fig. 27 Luca Signorelli (*c.* 1441–1523), **Male nude from rear**, late 1490s. Black chalk, 27 × 13.6 cm. The British Museum, London

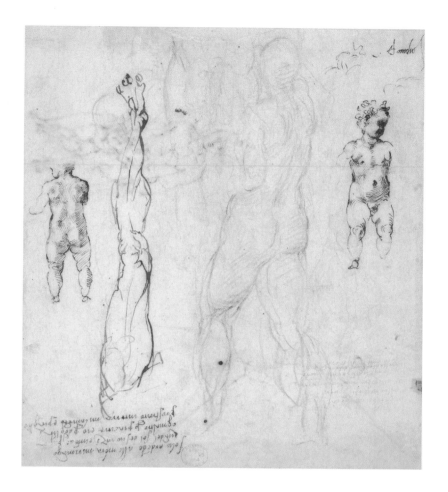

medium by Luca Signorelli (Fig. 27). Signorelli's black chalk study in the British Museum from
the late 1490s of a male nude in an exaggerated *contrapposto* pose is the kind of drawing
that inspired Michelangelo.[55] The two artists are known to have had dealings later in Rome
(Michelangelo lent money to the older painter in 1513 after he had failed to find work at Leo
X's court), but this is unlikely to have been their first encounter.[56] The impact of Signorelli's
work in the Cascina cartoon would suggest that Michelangelo had met his fellow Tuscan in
Orvieto in 1501 on his journey northwards from Rome. Signorelli was in the hilltop town work-
ing on his celebrated depictions of the Apocalypse in the Cappella Nuova in the cathedral, a
work that later influenced Michelangelo's treatment of the theme in his *Last Judgement*
fresco in the Sistine chapel.

A black chalk study by Michelangelo of the right-hand member of the trio studied in Exh.
No. 14 is found on a sheet of studies in the Uffizi (Fig. 28), and a more polished and detailed
study of the group in the same medium is in the Louvre.[57] The combination of the three figures
in Exh. No. 14r is uneasy. The right-hand figure, who holds a scabbard in his left hand and
points with his right, barely supports the gesturing lookout. Equally, the cupped hands of the
left-hand soldier are not positioned beneath the right foot of the central one. The clumsiness
of the grouping might be explained by the suggestion that Michelangelo began by drawing
the rightmost soldier with no thought of making him part of a group, but then with rapid
improvisation used his crocked elbow to support the sentry and added a third man on the left
to complete the group.[58] Turning over the paper, he proceeded to make a rapid sketch in black

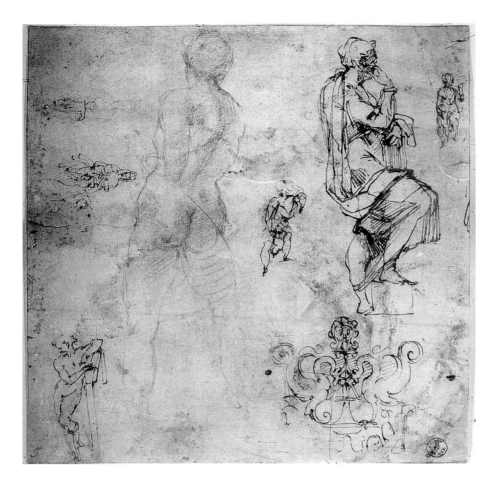

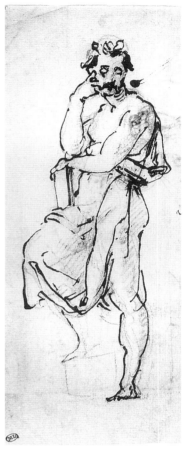

chalk (Exh. No. 14v) of two of the trio on a larger scale; the subsequent cutting down on the paper is shown by the fact that the upper half of the gesturing lookout has disappeared.

To the right of the *Bathers* study on the recto of Exh. No. 14 is a miraculously economical outline study in pen and ink over leadpoint for the Bruges *Madonna and Child*, one of a number of commissions he was working on in 1504. The idea of having the Christ Child standing between the legs of his mother can be traced back to some of the diminutive studies for the sculpture in leadpoint and pen in the Uffizi (Fig. 28), a sheet that contains ideas for three commissions. Following traditional Florentine practice, the figure of the Virgin in the London sheet is both nude, to allow the body to be studied without the encumbrance of drapery, and male, although in the present instance it is unlikely that such a spare outline drawing was drawn from life. The only suggestion of drapery is in the area around the Virgin's right thigh and beneath Christ's leg to indicate that he is standing on his mother's drapery, and stretching the material tight. The conception of the two figures in the drawing is more static than in the marble, where the Infant Christ is just about to step down from the rock on which his mother's raised left leg rests (Fig. 19). The turn of the Christ Child's upper body in the study was given greater emphasis in the sculpture where mother and son are united by their joined hands, a bond about to be broken by his downward step. The Virgin in the drawing is shown looking animatedly to the left (towards the direction of the nave in the church), while in the finished work she gazes impassively downward as though pondering the significance of her son's independence.[59]

above left
Fig. 28 **A male nude; studies of Apostles; the Virgin and Child; and a capital**, *c.* 1504–5. Black chalk; pen and brown ink; pen and brown ink over leadpoint (the Virgin and Child), the lower right corner made up, 27.2 × 26.2 cm. Galleria degli Uffizi, Florence

above right
Fig. 29 **An Apostle holding a book**, *c.* 1504–5. Pen and brown ink over black chalk, 20.1 × 78 cm. Musée du Louvre, Paris

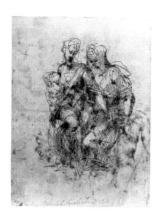

Fig. 30 **The Virgin and Child with St Anne**, *c.* 1501–5. Pen and brown ink, 25.7 × 17.5 cm. The Ashmolean Museum, Oxford

Fig. 31 Anonymous Artist, **Bathers (section of the *Battle of Cascina*)**, after Michelangelo, *c.* 1570. Pen and brown ink over black chalk, the upper corners made up, 45.8 × 89 cm. The British Museum, London

The sentry group studied in the drawing was just one idea to extend the action beyond the central group of the *Bathers*, who it is reckoned would have filled less than half the width of the wall to be painted. From Michelangelo's drawings of the period it seems likely that he intended to fill part of the remaining space with a cavalry engagement.[60] Partial confirmation of this can be gained from Vasari's remark that the composition included fighting figures on horseback, although he must have known this from hearsay or from copies of the cartoon, since he never saw the original. The much damaged pen copy of the *Bathers* in the British Museum (Fig. 31) also includes in the left background a group of horsemen, but they are not engaged in battle. The drawing cannot be taken as a reliable source because stylistically it seems a work of the latter part of the sixteenth century, and it must therefore be based on a copy made after the cartoon.[61] Pen sketches by Michelangelo in the British Museum and in the Ashmolean (Exh. Nos 15r and 16) provide the best evidence for what Michelangelo had in mind for the background of the *Bathers*. The drama of the Florentine soldiers' headlong rush to ready themselves for battle in the foreground was to be intensified by a fierce engagement of infantrymen and mounted warriors unfolding behind them.

This kind of cavalry combat was precisely what Leonardo was planning in his representation of the Battle of Anghiari on the same wall, and Michelangelo's drawings demonstrate his debt to his older rival as well as his desire to better him. The sculptor's general indifference to the work of his artistic contemporaries does not hold true for Leonardo, and his interest can be traced back to his return to Florence in 1501, when he evidently went to look at the painter's cartoon of the *Virgin and Child with the Infant Baptist and St Anne* which had caused such a stir the previous year. His interpretation of the now lost work (its composition is recorded in preparatory studies and in copies) survives in a pen drawing in the Ashmolean (Fig. 30). This retains the basic structure of the cartoon with the intricate, if improbable conceit of the Virgin perched on her mother's knee, but Michelangelo's version does not

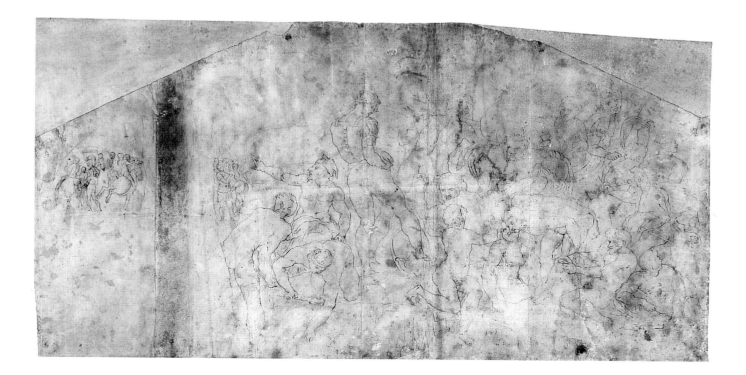

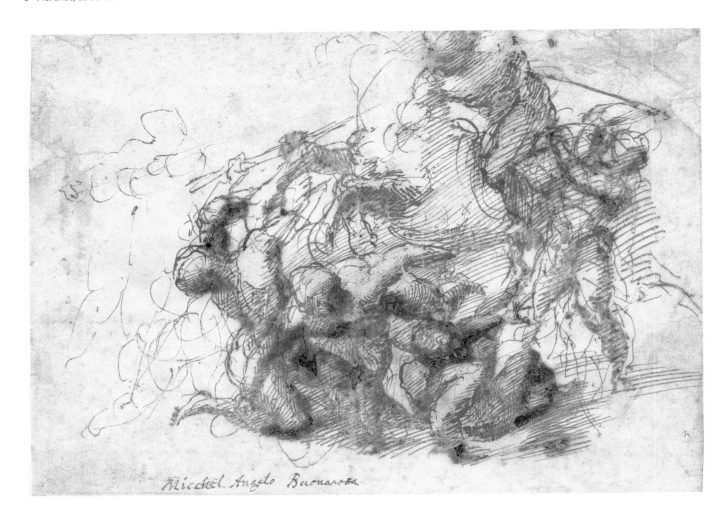

Exh. No. 16 **A battle-scene**, c. 1504. Pen and brown ink, made up sections at left and right edges, 17.9 × 25.1 cm. The Ashmolean Museum, Oxford

include the Baptist. In his rendition of the design Michelangelo also introduces a jagged disso-nance in the block-like arrangement of the figures, at odds with the harmonious interplay that guided Leonardo's composition.[62] Michelangelo must also have had some access to Leonardo's pen drawings, for he adopted his practice of using curved modelling lines to follow the contours of the body. This development in his style can be seen by a comparison with the cross or parallel hatching found in pre-1501 drawings (such as Exh. No. 6) with that used for the description of the figures on both sides of Exh. No. 13. As Wilde observed, Michelangelo also experimented with using Leonardo's contour hugging hatching in his black chalk drawings of the period such as those on the rectos of Exh. Nos 9–10.[63]

Comparison between Michelangelo's two putative studies for the background of the *Battle of Cascina* (Exh. Nos 15r and 16) and one by Leonardo for his commission (Fig. 32) underline the extent to which he was trying to rival the savage ferocity of the older man's vision of combat. Perhaps mindful that Leonardo was a master of superbly naturalistic depic-tions of horses, after having laboured for over a decade on a gigantic equestrian monument in Milan in the 1490s, Michelangelo followed his lead in making studies of the animals from life, one of which survives.[64] In the beautiful, but much damaged, pen drawing in the Ashmolean, the lucid observations of the flanks and hindquarters of a horse are enlivened by a small sketch of a horseman desperately fending off an assault by a group of infantrymen, an idea

Fig. 32 Leonardo da Vinci (1452–1519), **Battles studies**, *c.* 1504–5. Pen and brown ink, 8.3 × 12 cm. The British Museum, London

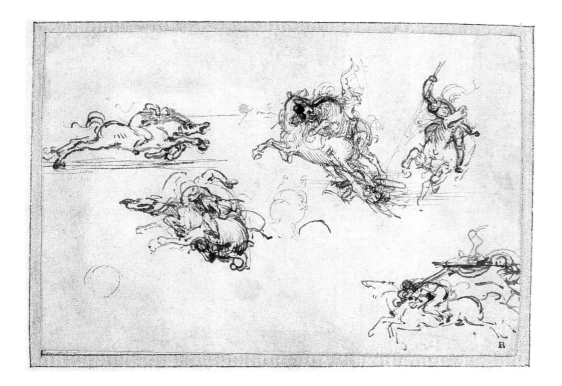

found in a more developed form in Exh. No. 16. A similar engagement is depicted on one side of a drawing in the British Museum (Exh. No. 15r, illustrated on p. 74). All the studies on the sheet must date from the summer of 1504 when Michelangelo began work on the Cascina commission since it has a wiry outline sketch of the central twisting soldier in the *Bathers* (Fig. 23) on the verso. Above this sketch is one in a comparable style of an Apostle holding a book, a figure whose pose was developed in greater detail on the other side of the sheet. The pared down study of the skirmish on the recto preceded the two Apostle drawings because the one on the left, the earlier of the two, is drawn over it. The fact that Michelangelo showed the Apostle in profile in this and a related drawing in the Uffizi (Fig. 28) led Wilde to suggest that this was the projected main view for the sculpture. This was puzzling as in the gloom of the cathedral it would have been difficult to make out the figure from the nave in this position, with his head turned inwards and his features partly obscured by his hand held to his face. The recent discovery in the Louvre of a study of the Apostle on a piece of paper cut from the top of Exh. No. 15 resolved the matter (Fig. 29). It showed that Michelangelo was working out the secondary profile view in the Uffizi and British Museum studies, in spite of the fact that the back part of the sculpture would have been invisible in the niche, but that the marble was intended to face outwards as in the Louvre drawing.[65] It is an early example of Michelangelo's ability to picture in his mind a pose from all angles, a necessary skill for a sculptor as can be seen in his studies for *Day* in the Medici chapel (pp. 180–5). Drafts of poems on this sheet 'molti anni fassi qual felicie in una/ brevissima ora si lame[n]ta e dole' ('one person passes many years in happiness, and in a single fleeting hour is brought to misery and grief') and on the verso of Exh. No. 14: 'sol io arde[n]do all ombra mi rima[n]go' ('I alone remain burning in the shadows') are some of Michelangelo's earliest literary efforts.[66]

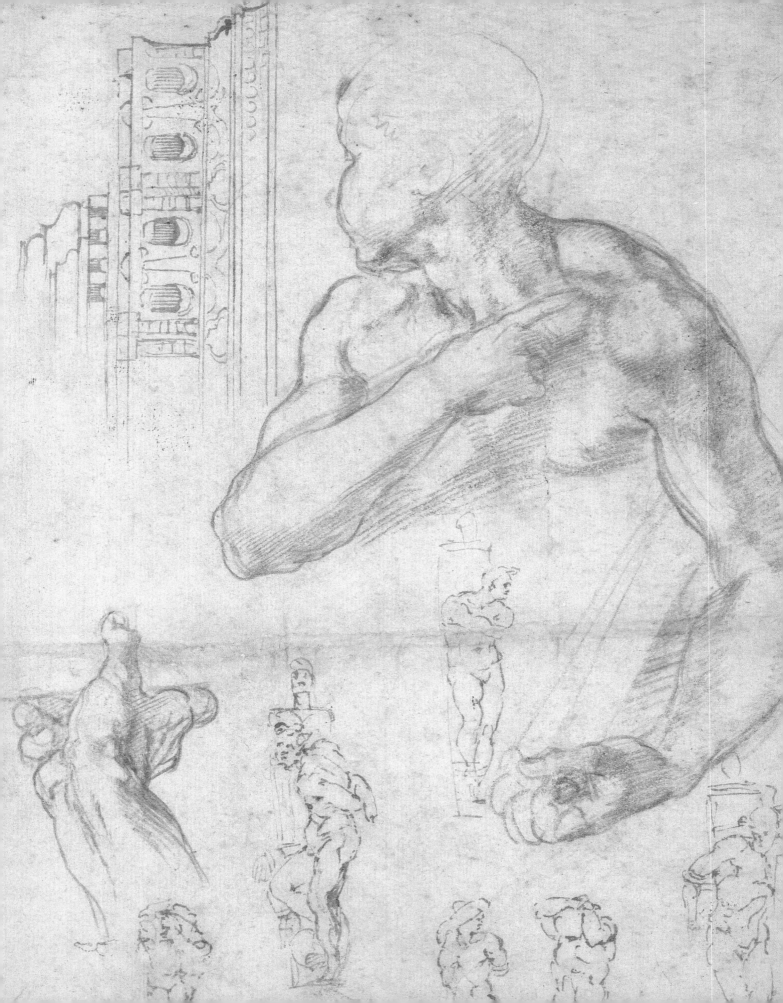

4

The Second Roman Period
1505–1516

By the end of March 1505 Michelangelo was in Rome where he had been summoned by Julius II to sculpt his tomb. This move marked the beginning of his employment at the papal court which was to endure almost without interruption, although not always in Rome itself, until his death almost sixty years later. The artistic and financial opportunities open to him there far exceeded anything his native city could offer. The largesse of his new patron was underlined at the end of February by the gift of a sizeable sum to cover his moving costs. The patrons of the works that Michelangelo left unfinished when he left Florence received no such remuneration. The greatest loser from the artist's departure was undoubtedly Soderini. The decoration of the Hall of the Great Council of the Palazzo della Signoria had barely begun, and the Republic's embarrassment over the bronze *David* was still unresolved. As the Florentine banker Alamanno Salviati, one of Soderini's political opponents, is known to have recommended Michelangelo to Pope Julius, this discomfort may not have been entirely accidental.[1]

Michelangelo's employer was Giuliano della Rovere who two years earlier had been elected Pope Julius II.[2] The new pontiff, who had followed his uncle, Francesco della Rovere, into the Franciscan Order, came from a noble but impoverished family from Liguria in the north-west of Italy. A glittering ecclesiastical career was assured when his uncle became Pope Sixtus IV in 1471. Giuliano, along with his cousin Pietro Riario, were made cardinals soon after. This was the beginning of thirteen years of papal nepotism that saw his appointment to a succession of lucrative ecclesiastical benefices.[3] His income allowed him to indulge in lavish displays of his wealth and position, such as the construction of palaces adjoining his two newly renovated titular churches in Rome, S. Pietro in Vincoli and SS. Apostoli. The building constructed around the latter church was by far the grander of the two because Giuliano inherited the unfinished project from his spendthrift cousin Pietro Riario on his death in 1474. At the rear of the church was a two-storey *palazzina* that Giuliano during the course of the 1480s richly embellished in a classical style with marble doorways, windows and fireplaces decorated with his coats of arms. These fittings were complemented by the classicizing frescoes he commissioned from Pinturicchio, the highly fashionable and much sought after Umbrian painter.[4] The palace of SS. Apostoli was also where Giuliano displayed yet another mark of his distinction: his superb collection of antique inscriptions, vases and statues. One of his most famous pieces was the marble *Apollo Belvedere* (Fig. 26) which had been excavated on one of his estates. When he became pope he moved it from the palace's garden to the Vatican where it served as one of the centrepieces of the statue court he established there.[5]

When his uncle died in 1484 Giuliano commissioned from the Florentine sculptors Antonio and Piero Pollaiuolo an elaborate bronze tomb to honour him, and it was perhaps his experience of the nine years that it had taken to complete this work that spurred him to order

Exh. No. 28 **Studies for the Libyan spandrel and the Slaves for the Julius tomb** (detail), *c.* 1511–12 (red chalk), *c.* 1512–13 (pen and ink), 28.5 × 19.4 cm. The Ashmolean Museum, Oxford

his own monument from Michelangelo while in his late fifties, and only a few years after his election. Giuliano was not in Rome to witness the completion of Sixtus' tomb in 1493 because of the election of his great rival Rodrigo Borgia as Pope Alexander VI the previous year. To escape Alexander's murderous reach, Giuliano removed himself from Rome to the safety of his fortress at Ostia designed by the Florentine Giuliano da Sangallo, his favourite architect, and the following year exiled himself to France, where he encouraged the French king Charles VIII to invade Italy. For two years (1495–6) Sangallo joined his patron in France, and at this time planned the façade of the Palazzo della Rovere in the family's ancestral seat of Savona, a small town south of Genoa. Sangallo later returned to Florence, where he acted as witness to Michelangelo's 1503 contract for the series of the Apostles for Florence cathedral. He was also one of the experts on the committee appointed to decide on the location of the *David*, and, according to Vasari, helped to devise the harness that ensured the marble's safe passage across the city.

In 1505 Sangallo moved to Rome, probably in the expectation of winning further commissions from his former patron. Both Francesco da Sangallo, Giuliano's son, and Vasari credit Giuliano with having encouraged the newly elected Julius to employ Michelangelo to create his tomb.[6] The two Florentines were certainly on excellent terms. Giuliano's son later recalled the sculptor as a frequent visitor to his father's house, and remembered accompanying the two of them to examine the newly excavated marble *Laocoön* group (Fig. 54) in January 1506. Michelangelo's lifelong preference for orthogonal elevations in his architectural and sculptural studies, first seen in his early designs for the Julius tomb, probably depends on his study of Sangallo's drawings at this period.[7] Sangallo's friendship with his temperamental compatriot meant that he was used as a mediator when the sculptor fled from Rome in 1506 after falling out with his notoriously fiery papal patron.[8] After the two had been reconciled, Julius called on Giuliano again in the winter of 1508 when Michelangelo threatened to give up work on the Sistine vault because his frescoes had developed mildew. The architect resolved this problem by advising his friend to make the plaster mix less watery.

Both Florentines resented the success of the veteran painter turned architect Donato Bramante, who had been in Rome since 1499 after the French conquest of Milan. Born in Urbino sometime in the early 1440s, Bramante was in his mid-sixties when Julius commissioned him in 1505 to design three colossal courtyards flanked by covered porticoes, to link the Vatican palace with the Belvedere villa on the hill above it. The Belvedere project was just the beginning of the grandiose plans that Julius and Bramante devised to transform the Vatican and St Peter's. The centrepiece of this vision was the replacement of the early Christian basilica with a gigantic new structure begun in April 1506. Bramante seized this opportunity to work on a monumental scale, his only models to guide him in the organization of such vast schemes being the brick vestiges of the massive ruined temple and bath complexes of ancient Rome. Faced with such competition Sangallo's Roman career stalled. The tide in papal favour against him became overwhelmingly evident when his plans for the new St Peter's were rejected in favour of Bramante's.

Michelangelo had his own reasons for disliking Bramante, stemming from his conviction that the architect was scheming against him.[9] The astonishingly rapid rise of the youthful Raphael at the papal court following his move to Rome in 1508 fuelled Michelangelo's suspicions further, as the painter was a compatriot and, according to Vasari, a relation of Bramante (although no evidence to substantiate this claim has ever been found). Both Condivi and Vasari's biographies include allegations that the two plotted against Michelangelo. The

latter's *Life* contains the implausible suggestion that Bramante tried to persuade Julius to substitute Raphael to complete the second half of the Sistine vault.[10] Decades after the death of Bramante (1514) and Raphael (1520) Michelangelo still felt certain that they were behind his troubles with Julius. This long simmering resentment was aired in a postscript to a 1542 letter defending his financial probity in the still unresolved saga of the papal tomb: 'all the disagreements that arose between Pope Julius and me were due to the envy of Bramante and of Raphael of Urbino'.[11] It is perhaps more likely that it was Michelangelo who was envious of Bramante's influence with Julius over artistic matters. He later extended this hostility to Raphael, an artist whose organizational brilliance in the running of his productive studio and his social ease, stemming from his courtly upbringing in Urbino, were completely opposed to Michelangelo's own essentially solitary temperament.[12] Bramante may well have grown to dislike Michelangelo over the latter's scathing criticism to Julius of his design for the scaffolding for the Sistine ceiling. This apparently led to the Florentine's much more economical design being adopted.[13] Michelangelo is known to have pointed out to Julius Bramante's personal and artistic flaws on at least one other occasion, but his antipathy did not entirely cloud his appreciation of the architect's talents.[14] When appointed architect of St Peter's in 1546 he described his long-dead rival in a letter of 1546 as 'talented in architecture as anyone since the ancients', adding 'whoever has departed from that order of Bramante has departed from the truth'.[15]

The Tomb of Julius II

Michelangelo's hostility to Bramante was probably linked to his early problems with Julius' tomb, a commission that proved ill fated almost from the outset. The protracted and highly complex history of the project from its beginnings in 1505 as a monument of unprecedented magnificence intended for old St Peter's, to its completion in a much reduced form in the Roman church of S. Pietro in Vincoli forty years later, will only be touched on here because only a few works in the exhibition relate to the commission (Exh. Nos 10v, 28, 31, 38 and 41v). An outline story of the 'tragedy of the tomb', to borrow Condivi's phrase, is, however, a necessity in dealing with Michelangelo's career. For much of his life the discontent of Julius' heirs, and their attempts to pressure him to complete work that he had been handsomely paid for, remained an ever present, if sometimes distant, threat.[16] The sculptor could never entirely escape his obligation to the powerful and influential della Rovere family, as he had successfully managed to do with the unfulfilled Piccolomini commission. While papal projects thrust on him by Julius' successors played a large part in his repeated failure to meet his contractual deadlines for the work, Michelangelo was far from blameless in the affair. He was responsible for a design that was overly ambitious, especially in view of his marked reluctance to delegate, and he infuriated his patrons by repeatedly agreeing to contractual deadlines that proved impossible to meet. An instance of his wildly optimistic estimates is contained in a letter of December 1518 sent to his friend Leonardo Sellaio (Leonardo the Saddler) in Rome. In it he reported that he would soon have a workshop in Florence that would allow him to progress with twenty statues at a time ('io potrò rizare venti figure per volta').[17] Michelangelo was, despite his repeated denials, guilty of retaining substantial sums for work that he never delivered.

Although the commission certainly enriched Michelangelo (Condivi's claim that he ended up out of pocket is duplicitous), he paid for its failure in other ways. The gradual disintegration

of a project that would have been his crowning achievement as a sculptor, not to mention the lurking dread that the heirs might physically harm or ruin him, caused him periods of intense mental anguish. The corrosive long-drawn out anxiety can be gauged from two of the many letters devoted to his travails with the commission. The earlier of the two, a letter of November 1526, was written to Giovan Francesco Fattucci, a canon at Florence cathedral who served as his spokesman at the papal court in the tortuous renegotiating of the contract with the della Rovere. Against a backdrop of deepening political and financial crisis for the papacy, Michelangelo admits in the letter his 'great fear' that Julius' family, whom he admits have good reason to hate him, will bankrupt him through a threatened lawsuit, and begs Fattucci to ascertain if he can still rely on Pope Clement's protection. His fear that the pope would no longer be able to shield him from the wrath of Francesco Maria della Rovere, duke of Urbino, is clear from his repeated injunctions to his friend to give him news, and the letter ends with Michelangelo admitting that the situation had driven him mad ('ò perduto el cervello interamente').[18] Sixteen years later in 1542 Michelangelo was still desperately battling to bring the project to a close, and in the autumn of that year he described how the anxious wait for news of whether the final contract had been accepted by Francesco Maria's son, Guidobaldo II della Rovere, had reduced him to a state of 'great desperation'.[19] This prevented him from beginning work on the Pauline chapel because, as he memorably described in another letter of the same period, he could not concentrate while weighed down with anxieties over the tomb: 'si dipigne col ciervello et non con le mani' ('one paints with the brain and not with the hands').[20]

The beginning of the commission is described in a draft of a letter of December 1523, addressed once again to Fattucci, in which Michelangelo mentions that he started work by submitting many designs to Julius before one was selected.[21] The most plausible candidates for such rejected ideas are the black chalk, pen and wash design for a wall tomb in the Metropolitan Museum of Art, New York, and a fragmentary drawing on the verso of two figure studies in the Louvre that once formed a single sheet.[22] The New York drawing shows a relatively modest structure embellished with fourteen sculptures and two reliefs. Michelangelo seems to have recycled some elements of this rejected design – such as two angels lifting up the upper body of the deceased pope – into that later agreed between patron and artist. Condivi's unusually detailed account suggests that he must have had access to a copy of the lost contract for the work, or a measured drawing still in the artist's possession. The tomb was planned as a free-standing three-storey rectangular block of gigantic size (roughly 59 × 23 feet or 10 × 7 metres).[23] The lowest level of this structure, inside which was to be Julius' sepulchre, was to have niches filled with statues separated by herms. Captive figures symbolizing the Liberal Arts were intended to stand on projecting plinths (Vasari interpreted these differently as representing the church provinces that had been subjugated and brought to order by the bellicose Julius). Four large seated figures, one of them a Moses, were to be placed on the tier above. At the top level was to be a sculpture of the deceased flanked by two angels, one weeping from sadness at his loss to the world while the other rejoiced at his acceptance in heaven. Condivi counted forty figures not including those in the bronze reliefs illustrating episodes from Julius' rule. It was agreed that the tomb should be finished in five years for a price of 10,000 ducats.[24]

After the design had been agreed Michelangelo left Rome for Carrara in April 1505 to select suitable marble. In November he signed a contract for a shipment of the stone to be sent to Rome, and the following month reached an agreement for more to be quarried and despatched to him there. By the end of the year the sculptor was back in the papal city where

he had been assigned a workshop behind the no longer extant church of S. Caterina delle Cavallerotte close to old St Peter's. In a letter sent to his father in Florence at the end of January 1506, he complained how the bad weather had prevented one barge unloading and that he had not yet been able to start work.[25] Despite such setbacks, large quantities of marble were reaching his studio in Rome and minor architectural elements of the project seem to have been begun at that time.[26] Condivi described the piles of marble stacked in the piazza outside St Peter's, and how they attracted the attention of Julius who would come to the studio to monitor progress. During the early months of 1506 the pope was also contemplating Bramante's plan to build St Peter's. Julius' decision to proceed with this clearly infuriated Michelangelo as the unprecedented cost of the new building threatened the funding of his own work.

Michelangelo's reaction to Bramante's triumph was to flee Rome for Florence on 17 April 1506, on the eve of Julius' laying of the foundation stone for St Peter's. Later that month Giuliano da Sangallo was instructed to write to his friend to convey the pope's displeasure at Michelangelo's sudden departure. The architect's letter is lost but Michelangelo's reply from 2 May survives.[27] He explained that his flight was prompted by the news that the pope had been heard to say that he would not spend any more money on marble. Furthermore Michelangelo alleged that his attempts to gain access to Julius to ask for money necessary for work on the tomb had been rebuffed for four days, and on the fifth he was expelled from the palace. As he had already received a sizeable sum to cover his expenses, of which half remained unspent, it is unclear why he should have needed more at this point, unless he was deliberately seeking an excuse to escape the city. Michelangelo must have known that Julius would be unlikely to accept his offer to continue work on the tomb in Florence. Moreover, from a letter to Michelangelo written by the master mason Pietro Rosselli reporting events at the papal court, it is clear that Julius was already contemplating employing him to paint the Sistine chapel vault, not withstanding Bramante's apparent attempts to dissuade him.[28] Michelangelo made use of his six-month stay in Florence to begin work on the marble figure of *St Matthew* (Fig. 18) intended for Florence cathedral, abandoning it in an unfinished state when he left the city in November.

Michelangelo in Bologna, 1506–1508

The artist's refusal to heed Julius' order to return to Rome was problematic for Soderini and his government, as the Republic had no wish to antagonize the pope. In the summer of 1506 Julius was leading an army to expel the Bentivoglio family from the papal city of Bologna, and it was his closest aide Francesco Alidosi, recently appointed cardinal of Pavia, who negotiated the artist's return.[29] Alidosi was already known to Michelangelo because, as part of his official duties as papal treasurer, he had arranged payment to fund the artist's move from Florence to Rome in February 1505, and later transferred money back to Florence to fund the purchase of marble from Carrara.[30] From a letter written by Soderini in July 1506 it seems that Michelangelo, fearful of Julius' reception, had requested Alidosi to write him a letter of safe conduct.[31] Only after several more letters had passed between Florence and Rome did the sculptor agree in late November 1506 to meet the triumphant pope in Bologna after the expulsion of the Bentivoglio. Michelangelo's dread of confronting Julius was so great that, according to Condivi, he considered accepting an offer to work in Istanbul to

design a bridge for the Turkish sultan Bayezid II, but was dissuaded from doing so by Soderini. Michelangelo later confirmed the veracity of this story, adding that he had gone so far as to make a model.[32]

Michelangelo's letters of recommendation from Soderini and the assurances of Alidosi and of the cardinal of Volterra, Soderini's brother, offered him some measure of protection, but they did not guarantee him a friendly reception from his volcanic papal patron. Almost twenty years later Michelangelo evidently still felt a bitter resentment at what he perceived as his humiliation, a feeling expressed by his metaphorical description of his having been made to go to Bologna like a criminal, with a 'rope around my neck' to ask the pope's forgiveness.[33] In the event Julius swiftly pardoned his behaviour, as his artistic skills were too precious for any patron to lose. The pope wanted his victory over the Bentivoglio to be commemorated by his portrayal in a colossal bronze statue to be placed above the main portal of Bologna's cathedral, S. Petronio. In the circumstances Michelangelo had no choice but to accept this undertaking despite his lack of experience of large-scale bronze casting. A series of letters to his family back in Florence between December 1506 and February 1508 relate the discomforts of Bologna: his difficulties in commissioning a dagger from a local craftsman as a favour for a wealthy Florentine; the failings of the mainly Florentine metalworkers he had hired to assist him with the statue; and the problems of casting such a large figure which were only resolved at the second attempt.[34] He had already left Bologna when the seated figure of the pope was installed in mid-March 1508. This sculpture, one of the largest of the period, remained *in situ* for just three years before being torn down and wrenched apart when the Bentivoglio briefly returned to power in December 1511. The bronze fragments were bought by Alfonso d'Este, duke of Ferrara, at that time engaged in a desperate struggle to prevent Julius' efforts to unseat him. Alfonso used the metal to cast a cannon, mischievously christened 'la Giulia', to add to his famed artillery batteries. The duke is said by Vasari to have preserved the statue's head, but today not even this fragment remains of Michelangelo's bronze colossus.

The Sistine Chapel, 1508–1512

At the end of Michelangelo's stay in Bologna he sent his brother Buonarroto two letters addressed to Francesco Alidosi that he instructed should be sent on directly to Rome.[35] Neither letter survives but it is likely that part of their contents concerned Julius' wish to decorate the ceiling of the Sistine chapel, a project first mooted in 1506. The sculptor arrived back in Florence at the beginning of March, and during that month he acquired a plot of land with three small houses on the via Ghibellina and paid a year's rent on the studio that the Opera del Duomo had constructed for him to sculpt the Apostle statues. His plans to resume work on his unfinished Florentine projects, such as the *Hercules* statue, had to be abandoned when he was summoned to Rome by Julius.[36] He must have obeyed this promptly as he was back in Rome by 27 March when he reopened his bank account.[37] A little over a month later he agreed to paint the Sistine vault. The actual contract for this work signed between Alidosi and Michelangelo has disappeared, but in a note made by the artist on 10 May 1508 he recorded having received 500 of the promised 3,000 ducats and his undertaking to begin work as of that day.[38] Three days later the artist wrote to a monk at the Florentine monastery of S. Giusto alle Mura e i Gesuati to request supplies of fine quality mineral azurite, a natural blue pigment, to be sent to him in Rome.[39] Michelangelo's tendency to call on his Florentine

contacts can also be seen in his request to his old friend Francesco Granacci to hire experienced fresco painters in the city to assist him.[40]

The Sistine chapel where Michelangelo was to spend the next four years is known after its patron Sixtus IV, a nomenclature that became firmly established before the end of his nephew Julius II's rule as pope in 1513.[41] Construction of the chapel began in 1477, six years after Sixtus' election, and it was substantially finished, along with its decoration, by the time of his death in August 1484. The explanation for the building's speedy erection became apparent during its recent restoration, when it was revealed that behind the outer brick shell it incorporated the foundations and much of the walls of an earlier medieval chapel (the *capella magna*).[42] The new building's rectangular form (measuring roughly 40.93 × 13.41 metres) and its proportions, three times as long as it is wide and half as high as it is long, in accordance with the dimensions given in the Bible of Solomon's Temple in Jerusalem (I Kings VI.2) were determined by the previous structure. The new building differed from its predecessor in a number of ways, most notably in its increased height and the replacement of the wooden ceiling with a lunette vault. The chapel's defensive location on the side of a hill caused it to suffer from subsidence. A crack opened up at the centre of the ceiling in the spring of 1504, and the need to repair this fissure prompted Julius to contemplate redecorating the vault. Chains were installed that year to hold the walls together at the top and bottom, but they did not prevent the collapse of the architrave over the entrance door on Christmas Day 1522. Two papal guards were killed and the fifteenth-century frescoes on the end wall were destroyed.

The interior decoration of the chapel was shaped by its function as a place of worship for the pope and his court, the Papal Chapel (*Capella papalis* or *Cappella Pontificia*). Beside the pope and the College of Cardinals, this group numbered the heads of monastic and mendicant orders, patriarchs and visiting archbishops, as well as leading members of the curial bureaucracy and of the pope's household, such as chamberlains, secretaries and notaries. Lay members of this elite included the senator and conservators of the city of Rome, the diplomatic corps and visiting princes. The papal calendar decreed that the Papal Chapel should meet together fifty times a year. Eight of these services, such as the Christmas and Easter masses, had to take place in St Peter's while the rest occurred in the chapel. Individual popes could increase this number by adding services of personal importance to them. The Papal Chapel, perhaps numbering around 200 people during Sixtus' period, occupied around half of the space of the Sistine chapel at the altar end. This space was demarcated by a marble choir screen (still extant but not in its original position) that separated the Papal Chapel from less privileged worshippers in the other half of the building. In addition to religious services the chapel was, and remains to this day, the location for the conclaves of cardinals which elected the pope.

The Sistine chapel's regular shape with the lower part of the wall free of interruption up to a height of ten metres, except for a small gallery for the papal choir on one side, meant that it was ideally suited to mural decoration (Fig. 33). (The placement of the windows at such a high level was to preclude them having to be walled up at conclaves when tradition decreed that all apertures up to a height of nine metres had to be filled in to isolate and protect the cardinals.) The chapel's side walls had been painted in the early 1480s by an imported team of Florence's brightest talents – Cosimo Rosselli, Sandro Botticelli, Domenico Ghirlandaio and the Umbrian Perugino, a Florentine by adoption as he had trained in Verrocchio's workshop.[43] All of the artists had links with Lorenzo the Magnificent and their coming to Rome in 1481 was probably part of his diplomatic efforts to cement peace with

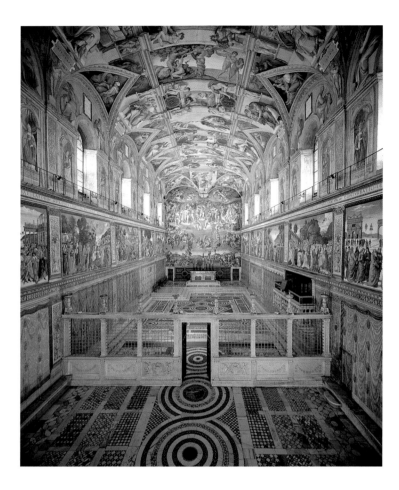

Fig. 33 **The interior of the Sistine chapel towards the** *Last Judgement*

Sixtus. These artists and their studio hands like Pinturicchio, as well as additional painters called in to assist, such as the Tuscan artist Luca Signorelli, completed the fresco decoration of the walls within two years. Their work included the pairs of portraits of popes standing in niches between the windows, and, on the level below, sixteen brightly coloured and lavishly gilded scenes running from the altar to the entrance wall illustrating episodes from the life of Moses on one side and the life of Christ on the other. The lowest section of the wall was decorated with fictive wall hangings liberally adorned with acorns in honour of the chapel's patron (della Rovere means 'of the oak tree'). The chapel was dedicated to the Assumption of the Virgin, and this subject was depicted in the altarpiece painted in fresco by Perugino. This was destroyed when Michelangelo painted the *Last Judgement*, but its composition with the kneeling Sixtus witnessing the Virgin's ascension is recorded in a drawing.[44]

The unity of the fifteenth-century decoration was marred by the destruction of the two Biblical frescoes on the entrance wall in 1522 (these were later replaced by depictions of the same subjects at the end of the sixteenth century), and permanently wrecked by the replacement of all the murals on the altar wall by Michelangelo's *Last Judgement*. The huge fresco entailed the eradication of Perugino's two fresco paintings – *The Finding of Moses* to the left of the altarpiece and *The Nativity of Christ* to the right – which were the starting point for the cycle (Fig. 34). The evident similarity in subject matter of the two narratives established the governing principle of the programme with each episode from the life of Moses, bearer of the 'Law', prefiguring and finding fulfilment in a corresponding scene on the opposite wall

from the life and ministry of Christ. The typological link between the paired Old and New Testament paintings was underlined, with the exception of the opening scenes, by similarly worded Latin titles placed above each fresco. The sophistication of this programme, as well as the recondite nature of some of the episodes related in the sometimes multi-layered narratives of the paintings, reflected the learned nature of the chapel's Franciscan patron, Sixtus, and of the well-educated and theologically well-versed congregation that worshipped there. The cycle lauded the supreme authority of the papal office by tracing its authority right back to Christ and his disciple St Peter, the first pope, whose body was buried in the nearby basilica. The continuity between the Christian age, established through the teachings and sacrifice of Christ, and the modern era was underscored in the New Testament narratives by the inclusion of now unidentifiable portraits of individuals from Sixtus' court.

How the chapel was decorated above the levels of the windows before Michelangelo's intervention remains unclear, although it is generally agreed that the appearance of the original vault is recorded in a drawing by Piermatteo d'Amelia in the Uffizi, Florence.[45] This shows it to have been painted with a stylized simulation of a starry night sky consisting of golden stars against a dark blue background. This was a well-established conceit for the decoration of a chapel vault, and it was one well suited to the gloomy upper region of the Sistine chapel which never received any direct sunlight.[46] The plainness of the ceiling was in stark contrast to the gilded magnificence of the frescoes below, and this may have been a factor in Julius II's decision to leave his mark on his uncle's building by commissioning Michelangelo. With the loss of the May 1508 contract it is impossible to know exactly what was originally agreed for the vault's decoration, but according to Michelangelo's later recollection it consisted of twelve Apostle figures in the spandrels (the 'V' shaped area between the windows) with the remaining space divided into painted panelled compartments. The accuracy of his memory is borne out by the two earliest studies for the commission, respectively in the British Museum (Exh.

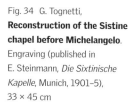

Fig. 34 G. Tognetti,
Reconstruction of the Sistine chapel before Michelangelo.
Engraving (published in
E. Steinmann, *Die Sixtinische Kapelle*, Munich, 1901–5),
33 × 45 cm

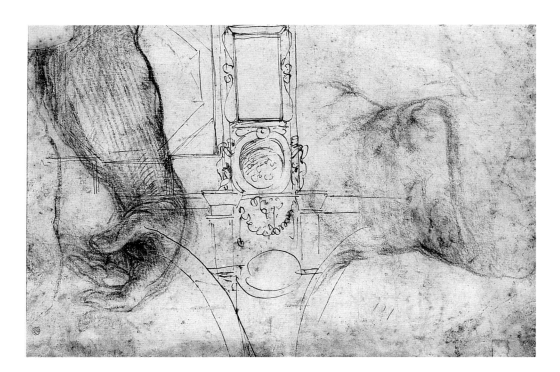

Fig. 35 **Scheme for the Sistine chapel ceiling; studies of arms and a male torso**, *c.* 1508. Pen and brown ink over stylus (ceiling scheme); black chalk (arm studies), top left corner made up, 25 × 36 cm. The Detroit Institute of Arts, City of Detroit Purchase

below
Exh. No. 17 **Scheme for the Sistine chapel ceiling; studies of arms**, *c.* 1508. Pen and brown ink over leadpoint and stylus (main study); black chalk (arm studies), 27.5 × 38.6 cm. The British Museum, London

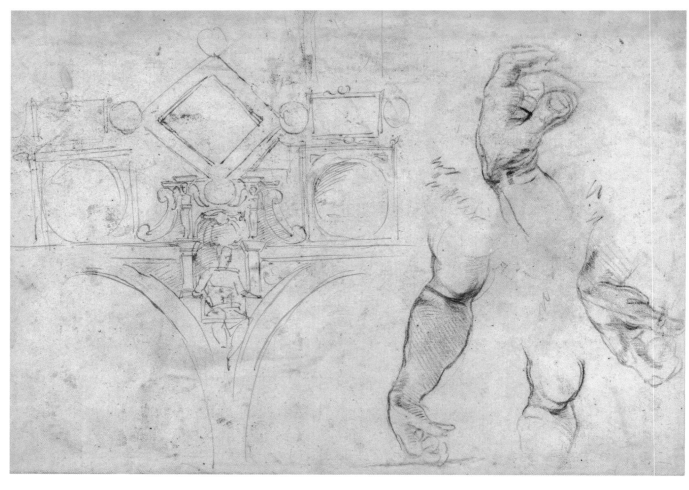

Fig. 36 Bernardino Pinturicchio (c. 1452–1513), **Ceiling decoration with the *Coronation of the Virgin**, c. 1509–10. Fresco. S. Maria del Popolo, Rome

No. 17) and in the Detroit Institute of Arts (Fig. 35).[47] This scheme fitted with the genealogical bent of the earlier frescoes that traced papal authority back to Biblical times, and on a practical level the number of Apostles coincided with the chapel's twelve spandrels (five on each side and one at either end). The simplicity of the decoration also suited the awkward form of the vault due to the interruption of eight severies or groins, the concave triangular forms shaped like an arrowhead which cut into the vault above the window lunettes on the two long walls with a further pair at each corner, that broke up the central field.

The British Museum sheet (Exh. No. 17) is likely to have been drawn just prior or soon after the contract was signed, when Michelangelo was trying to establish the basic design of a single bay which could then be repeated along the side walls. It is a rough working study briskly drawn with the pen over some preliminary leadpoint and stylus underdrawing. It must have been drawn at an early stage because the inaccuracy of the architecture suggests that it was made from memory, and not from recent observation of the site. In the drawing the severies on either side of the Apostle are shown as arches, while in reality their triangular form made the spaces between them narrower at the base and wider at the top precluding the snug fit of the seated figure that Michelangelo envisaged.[48] The scratchily drawn and stylized figure of an Apostle in the study is dwarfed by the imposing bulk of the throne embellished with a shell niche behind his head, and above him winged herms and scrolled brackets on either side.[49] The throne is ingeniously incorporated into the surrounding architectural framework. It seems to project forward from the fictive cornice running above the top of the

severies, while the upper part of the structure is amalgamated with the circular decoration at the tip of the diamond shaped panel at the centre of the vault. The repetition of these circular and rectangular elements within the larger lozenge compartment would have created a strong central spine for the decoration which would have linked the two Apostles at either end.

The compartments decorating the central section of the vault studied on the recto were to be decorated, according to Michelangelo's later testimony, with 'un certo partimento ripieno d'adornamenti chome s'usa' ('a certain arrangement full of ornament as is usual').[50] By this he meant the classically inspired decoration in fresco and stucco in the Domus Aurea (the Golden House of Nero) that had been uncovered in the 1480s, a style known as *grottesche* because the building had been buried so that it was like entering a cave or grotto. The embellishment of the walls and ceilings of the villa with animated, brightly coloured friezes of frolicking animals and putti among stylized vegetation had spawned a vogue for similar decoration. The most successful exponent of grotesque work was the Perugian painter Bernadino Pinturicchio whose patrons in Rome in the 1490s included Sixtus IV's nephews, Giuliano and Domenico della Rovere, and Alexander VI, who commissioned him to paint his living quarters in the Vatican. An idea of the decorative effect that Michelangelo had in mind for the vault is given by Pinturicchio's vault of the chancel of the Roman church of S. Maria del Popolo commissioned in 1509/10 by Julius II (Fig. 36).[51] The adoption of this style of ornament for the Sistine vault was highly practical because it would have been far easier to master than the art of foreshortening figures in a convincing fashion on the curved surface of the vault (a skill for which Michelangelo had no experience, as Bramante had reportedly rightly observed). Moreover the repeated patterns in this kind of decorative work could be more easily delegated to the trained fresco painters that his friend Granacci was then recruiting in Florence.[52]

Exh. No. 17 is a good example of Michelangelo's frugality: the blank area to the right was used to make studies of an arm and a hand in black chalk with the paper turned ninety degrees to the right (this rotation can be determined by the direction of the right-handed shading). The circular object visible in the figure's hand in two of the studies is perhaps the end of a handle of a staff or pole to allow the model to keep his arm outstretched for long periods. A black chalk academy in the British Museum by Polidoro da Caravaggio, a pupil of Raphael, gives a clearer example of a model using such a support to sustain the pose (Fig. 37).[53] In Michelangelo's work the arm and hand were studied from one position in the three lower drawings, and then the model was asked to face the other way and raise his other arm so that the artist could make the topmost drawing. The position of the hand in the last of these bears some similarity to that of Adam in the *Creation of Adam* (Fig. 48), but a direct connection between the two can be discounted as the sideways position of the bicep in the previous two studies shows that Michelangelo had in mind a pose with the elbow bent.[54] Wilde was inclined to date the black chalk studies on stylistic grounds to a year or so later than the pen vault design. Such a gap seems unlikely as a study of an arm in a similar pose is to be found on a sheet in Detroit that is also related to the earliest stage of Michelangelo's work in the chapel (Fig. 35).[55] Instances of Michelangelo's reuse of a blank side of an earlier sheet are not uncommon (such as the *Bathers* and Sistine chapel studies on the recto and verso of Exh. No. 9), but it seems highly unlikely that he would have selected another early Sistine study from among the mass of drawings in his studio to continue his examination of the motif. Far more plausible is the scenario that both sheets were close by in the studio, having recently been finished, when Michelangelo utilized the unused areas of paper to study a model's arm.

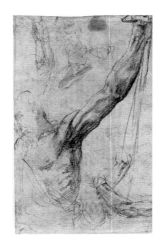

Fig. 37 Polidoro da Caravaggio (*c.* 1499–1543), **Figure studies**, *c.* 1537–40. Black chalk, 20.3 × 13.2 cm. The British Museum, London

The Detroit study for a single bay must, in any case, have followed on closely from Exh. No. 17 as the two designs are so alike in style, technique and purpose. It is if anything more hurried in execution than the London work, with the artist not even bothering to draw a figure occupying the niche. The general conception of the decoration shows little change, except that the lozenge-shaped compartments have been eliminated and the spandrels on either side of the chapel have been bound together by a lateral rectangular compartment framed at either end by a roundel flanked by putti. These axial ribs break the vault into a progression of large open bays occupied by an octagonal panel over the severies, and smaller closed ones above the pendentives. This division of the space is close to that finally adopted, although Michelangelo made numerous refinements to individual elements in the design. Another development in the Detroit drawing relates to the cornice that has been raised above the level of the severies; this reduced the central section of the vault while expanding the space around the spandrels. This expansion may have encouraged Michelangelo to conceive the figures in this space on a far more monumental scale, a development that ultimately led to the memorable creation of Prophets and Sibyls that replaced the original cast of Apostles.

For all the advances made towards the final form of the vault in the Detroit drawing, the adoption of an octagonal compartment in the large bays between the ribs would have been compromised at the shorter end bays where the space was constricted by two severies at each corner. Had the design sketched out in the Detroit study been adopted, the irregularity would have resulted in the truncation of the octagon at either end of the chapel. Michelangelo resolved this problem in the fresco by the simple means of leaving an interval between the cornice and the end rib, the gap between these architectural elements painted blue so that it seems as if a sliver of sky is visible. Unfortunately the subsequent evolution of the design is impossible to follow as no further drawings survive.

The only other study for the fictive architectural framework is a slight and rather scruffy diagrammatic sketch in black chalk of the central section on the verso of Exh. No. 19 (for this detail see Fig. 38). This must have been executed after Michelangelo had already formulated the final arrangement of this area. Partly obscured by a slightly later study of a hand for Noah's daughter-in-law in the *Sacrifice of Noah*, the ceiling design shows the rectangular cornice running around the central area of the ceiling. The five cigar-shaped forms outside this perimeter indicate the position of the Prophets and Sibyls in the spandrels.[56] In a very irregular

Fig. 38 **Detail of vault scheme on Exh. No. 19 verso** (illustrated on p. 119). Black chalk, approx. length 18 cm

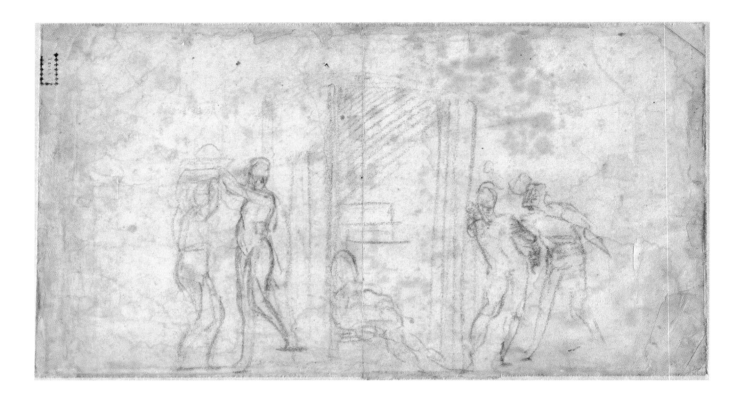

Exh. No. 9 Verso **Judith and Holofernes**, c. 1508. Black chalk, the corners made up, 22.5 × 40.4 cm. The Teyler Museum, Haarlem (recto illustrated on p. 82)

fashion he also roughly marked the position of the narrative scenes painted on each of the transverse sections, sometimes adding a circle within the box to show the location of the bronze roundels in the fresco (he distractedly placed one of these above the line). The one feature of the drawing that does not tally with the final scheme is the oval compartment in the centre. This suggests that Michelangelo toyed with the notion of differentiating the middle bay from the two on either side.

The transformation of the design was preceded by a no less radical change in its subject matter. The initial plan to paint the twelve Apostles was replaced by a far more elaborate programme. This change is entirely in keeping with what had occurred in the tomb project a few years earlier, and it is clear that Julius was a patron who needed little encouragement to endorse such expansion. In one of the two drafts of a much-quoted letter of 1523 to his friend Fattucci concerning his dealings with Julius, Michelangelo described how his criticism of the original scheme as a 'poor affair' led the pope to instruct him to continue work as he liked, and to paint the vault down to the level of the narrative frescoes.[57] This is one of a number of instances in the letter where Michelangelo's recollections of events can be shown to be unreliable, as it is improbable that the destruction of the papal portraits was ever considered. Similarly, his contention that he alone was responsible for deciding what was to be painted on the vault of such an important location seems highly doubtful.[58] A strong argument in favour of one or more of the theologians at the papal court having a hand in the planning is the inclusion of Biblical narratives rarely previously depicted.[59] These include the *Sacrifice of Noah* (a subject misidentified by Condivi and Vasari in the second edition of the *Lives*) and the series of roundels illustrating scenes from the Book of Maccabees.[60] (The martial nature of the latter text clearly appealed to Julius as he later had Raphael paint an episode from it in the Stanza d'Eliodoro in the Vatican palace.)

Michelangelo's use of woodcut illustrations in an Italian vernacular Bible (the Malermi Bible) as a source of inspiration for his Biblical depictions on the vault, as well as the compositional changes visible in his studies and in some cases on the ceiling itself, indicate that he was responsible for translating any guidance he had been given on the overall programme into pictorial form.[61] An example of this creative latitude is his representation in one of the pendentives at the entrance wall of the Jewish heroine Judith's assassination of Holofernes (Exh. No. 9v). This was painted at the entrance end of the chapel where Michelangelo began the fresco, and his rough black chalk compositional study in Haarlem must have been drawn in the summer months of 1508 prior to his commencing work on painting the vault. As in the slightly earlier studies in London and Detroit, the artist's description of the architecture is far from accurate as the 'V' shaped pendentive is represented as a semi-circular lunette. This can perhaps be attributed to Michelangelo's inexperience in architectural decoration. The corresponding fresco, perhaps the first of the entrance wall corner areas to have been executed, demonstrates a similar lack of sophistication with the figures confined to the upper part of the composition, and the lower section drably painted to resemble bare earth (Fig. 39).

In the centre of the drawing is the headless body of Holofernes seen through the doorway of a stylized tented pavilion. The parallel lines at the top, and the box-like structure in the background, perhaps indicate Michelangelo's intentions from the outset to add a curtained bed as in the final work. The bed was a key element in the story as it was where Judith wooed and then decapitated the sleeping Assyrian general. To the left of the doorway Judith reaches

Fig. 39 **Judith and Holofernes**, c. 1508–10. Fresco. Corner pendentive, first bay of the Sistine chapel ceiling

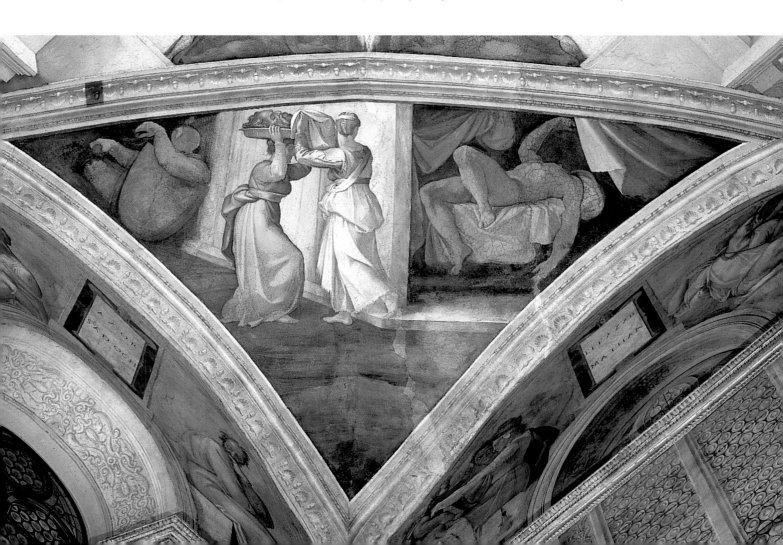

up to place Holofernes' head on a platter carried by her maid. The abbreviated forms of the women, like those of the soldiers to the right, strikingly recall those in Domenico Ghirlandaio's compositional studies (compare Exh. Nos 2–3). The two female figures in the fresco are modelled closely on those in the study, although Michelangelo made a slight but telling alteration to the position of Judith's head. In the finished work her face is no longer visible, as it would have been had the pose of the drawing been followed, so the viewer has to imagine how she might have reacted to the grisly carnage she had just caused. In the drawing Michelangelo seems to have originally shown her in profile, and sketched in her features as she looks back over her shoulder. On the far right of the drawing is a pair of figures, perhaps Assyrian soldiers debating whether to investigate the disturbance in their commander's tent. These figures were eliminated from the fresco in favour of the tented interior with Holofernes' body lying on a bed, the position of his corpse made less dramatic than in the drawing by turning it so that his severed neck is no longer seen from the front. The sleeping soldier resting on his shield in the upper left of the fresco does not appear in the drawing and must have been an improvised addition to fill the space, as the absence of incising or underdrawing on the surface of the wall shows that he did not feature in the cartoon either.[62] The Haarlem sheet must have been one of the works that Michelangelo took with him, or had sent, from his Florentine workshop, as the drawing on the other side of the sheet is a study for a figure in the *Battle of Cascina* (Exh. No. 9r). It may have been included in the parcel of drawings that Michelangelo asked his father in a letter to send to Rome at the end of January 1506.[63]

For over a century a scholarly debate has raged over the underlying theological and philosophical ideas articulated in Michelangelo's vault, and how these differing interpretations affect a coherent reading of the whole scheme. No consensus has been reached on this issue, but there is a general agreement on the identification of the subject matter. The main elements are: nine longitudinal narrative scenes taken from Genesis beginning with the *Separation of Light from Darkness* at the altar end and concluding with the *Drunkenness of Noah* at the entrance wall; four Old Testament miracles of the salvation of the Jewish people in the pendentives; seven Prophets and five Sibyls (ancient Greek prophetesses) seated in the spandrels and identified by their names on tablets below them; ten medallions coloured to look like gilded bronze with Old Testament scenes kept upright by drapery swags held by pairs of male nudes; and the forty ancestors of Christ named in St Matthew's Gospel depicted in the lunettes and the severies, with the series originally beginning at the altar wall (these were later destroyed to make space for the *Last Judgement*). The decision to have the vault's main narratives depict scenes from the first book of the Bible was logical, as the creation of the world and man's earliest history in the first stage of history before the Law of Moses preceded those shown in the fifteenth-century scenes below. In addition, the vault was intended for a congregation attuned to interpreting the Old Testament, and indeed the pagan past, in the light of Christ's birth and ministry recounted in the New Testament. This accounts for the inclusion of the Sibyls who were believed to have prophesied the coming of the Messiah. The clearest example of the typological connection between the Old and New Testament is the placement of the Prophet Jonah coming out of the mouth of the whale above the altar. Christ himself had compared his resurrection after being dead three days and nights with Jonah's emergence after the same period in the whale's belly (Matthew XII.40). The celebration at every mass of Christ's conquest over death would have been reiterated by the gigantic figure of Michelangelo's Jonah gazing upwards towards Heaven to give thanks for his salvation.

The Scaffolding and Chronology of the Vault

According to Michelangelo's biographers, Julius commissioned Bramante to build a scaffold for the Sistine chapel and he duly designed one suspended from the ceiling by ropes.[64] Michelangelo reportedly quizzed Bramante on how the resulting holes in the vault were to be filled, and when he did not receive a satisfactory answer he gained permission from the pope to erect scaffolding after his own design. The form this took is known from a diagrammatic representation of it in the corner of a sheet of Sistine figure studies in the Uffizi, Florence.[65] This shows it to have been a wooden structure stepped at the side, following the curve of the vault and with a flat platform at the top, a design based on the scaffolding used to support vaults while they were under construction. It rested on the ends of wooden beams placed in holes on the lateral walls, invisible from the chapel floor, situated at the top of the cornice above the portraits of popes. These holes were discovered during the cleaning of the ceiling when a platform much like Michelangelo's was employed. This new knowledge disproved the theory, encouraged by a statement in one of the artist's letters, that the lunettes and corner pendentives were painted from a separate scaffold after the main vault has been finished.[66] In reality the lowest part of the scaffold was at the level of the lunettes, while from the stepped sides and the platform at the top the artist could reach the vault standing upright. Michelangelo drew a self-portrait of himself painting standing up beside a draft of a wryly amusing poem addressed to his friend Giovanni da Pistoia describing the discomforts of working with his head tilted backwards.[67] The artist must have had to work by lamplight as the scaffold blocked out the small amount of natural light that filtered through the top part of the windows. The unpleasantness of spending all day in the dark was alluded to in a poetic fashion in the same sonnet: 'passi senza gli occhi muovo invano' (I take steps in vain without seeing).[68]

Construction of the scaffolding by the mason Pietro Rosselli took place between May and the end of July 1508. He was also responsible for repairing the damage to the vault and applying the first coat of plaster or *arriccio*.[69] At this time the ridges of the vaults at the corners were probably chiselled out to create single unified fields for the pendentives. The chapel remained in use throughout the time that the vault decoration was in progress, but during this initial phase of the work worship became difficult. In a diary entry made on 10 June 1508 Paris de Grassis, the papal master of ceremonies, complained how the incessant noise of the workman on the scaffold and great quantity of dust raised by their labours had upset the vigil of Pentecost.[70] Rosselli's scaffolding would have allowed Michelangelo his first glimpse of the vault's uneven surface and allowed him a better understanding of its shape, features which were difficult, if not impossible, to appreciate from the chapel's floor. Access to the vault would also have allowed him to make accurate measurements of the spaces to be painted.

The information gained from the recent cleaning of the vault regarding the scaffold and the plotting of Michelangelo's *giornate* (the area of plaster he frescoed in a single day) demonstrate that the artist began at the entrance wall and then moved bay by bay towards the altar end.[71] Michelangelo's starting point was most likely the *Flood*, the nearest of the large-scale narratives to the entrance wall. Part of this fresco and others in the near vicinity had to be repainted by Michelangelo when his first efforts were attacked by mould. He resolved this by reducing the amount of water in the plaster, and by minimizing the application of pigment after the surface had dried. The first stage of Michelangelo's work began in

the late summer or autumn of 1508 and ended in July or August 1510.[72] In mid-August Julius left Rome for Bologna to wage war against Alfonso d'Este, leaving the artist with insufficient funds to continue work. Michelangelo made two trips to Bologna to solicit more money in September 1510 and in midwinter of 1510–11. Some time in 1511, probably in the summer when Julius returned to Rome, Michelangelo resumed work and by the end of October 1512 the complete decoration was unveiled. Paris de Grassis reported in his diary that the ever impatient Julius had seen the first part of the ceiling without the scaffolding on 14 and 15 August 1511 when he attended services in the chapel, a month after his return from soldiering. It is now widely accepted that Wilde was right in contending that the break occurred after Michelangelo had finished the sixth bay (with Ezekiel and the Cumaean Sibyl at either end of the *Creation of Eve*).[73]

The dismantling of the scaffold in the summer of 1511 granted Michelangelo his first opportunity to gauge how the completed section looked like from the chapel floor, and it caused him to increase the scale of the figures for bolder effect. This enlargement can be seen plainly by comparing the *ignudi* on either side of the *Creation of Adam* with those nearer the altar (Fig. 48; the earlier pair is at the top of the illustration). The final four Prophets and Sibyls are similarly much bigger than those painted earlier, and in order to accommodate this shift in scale Michelangelo lowered the bases of their thrones and the position of the putti below. In the second part of the ceiling Michelangelo also experimented with more daring touches of figural foreshortening. His confidence in his skill in foreshortening is expressed in the figure of Jonah who defies the curve of the vault in appearing to recoil backwards.[74] The contrast between the explosive movement of this figure with the static, relief-like and much smaller figure of Zacherias at the other end of the chapel is perhaps the best demonstration of the dramatic and rapid evolution of Michelangelo's style that had occurred in the space of three years working in the chapel.

below left
Exh. No. 18 Recto **One kneeling and three seated nude men**, *c.* 1508. Leadpoint and pen and brown ink, 18.8 × 24.5 cm. The British Museum, London

below right
Exh. No. 18 Verso **A male torso**, *c.* 1508. Black chalk, 24.5 × 18.8 cm. The British Museum, London

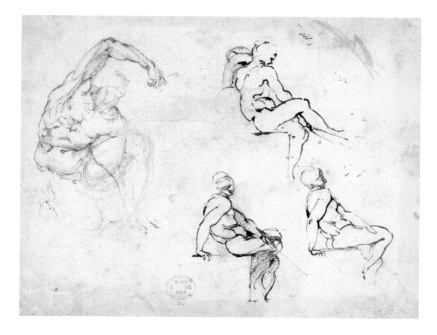

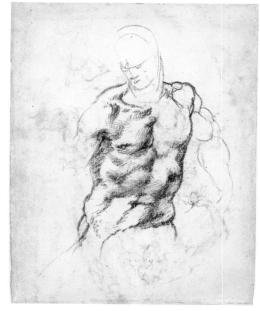

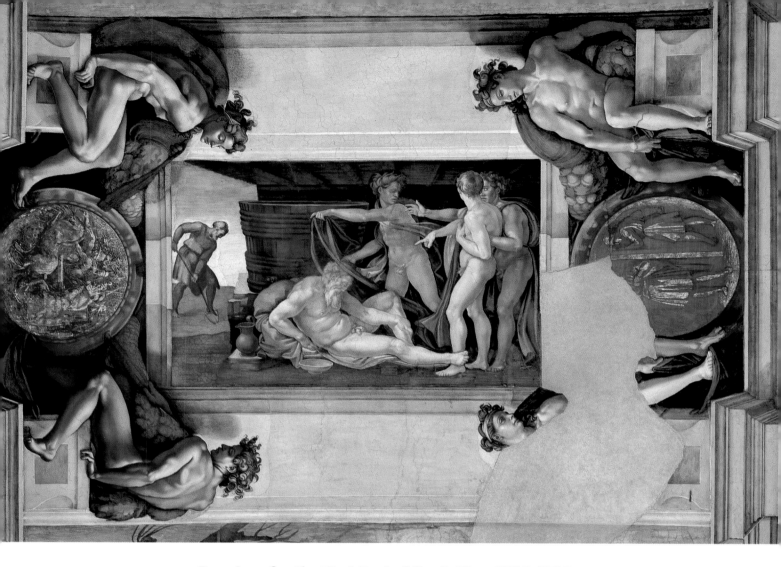

Fig. 40 **The Drunkenness of Noah**, c. 1508–10. Fresco. Second bay, Sistine chapel ceiling

Drawings for the First Part of the Ceiling, 1508–1510

Before Michelangelo began to paint the ceiling he needed to have finalized on paper how the decoration was to be structured. For this he required only to have worked out the design of the entrance wall and the two nearest lateral bays since these established the pattern for the rest of the ceiling. In all likelihood Michelangelo never made a detailed study of the entire vault before beginning work, preferring instead to design the next section in the course of executing the preceding one. Evidence of this sequential method of design is the fragmentary sketchbook in the Ashmolean (Exh. Nos 20–3) that relates exclusively to Michelangelo's work on the second section of the vault begun in 1511. This piecemeal approach is also indicated by the preparatory drawings, as even when he is developing poses of more than one figure on a sheet they will generally be for figures in the same bay or the successive one. This is true, for example, in the mix of studies for the *ignudi* painted in the eighth bay and for figures in the *Creation of Adam* in the previous one found on three drawings in Haarlem and London (Exh. Nos 25–7).

One of the design questions that Michelangelo needed to resolve in the first of the side wall sections was the placement of the nude youths or *ignudi*, the figures seated on plinths above the Prophets and Sibyls' thrones, holding swags which keep upright the bronze medallions (Fig. 42). Michelangelo demonstrates considerable inventiveness in devising different poses for each one of them, and they became one of the most admired and copied elements in

the design. Each *ignudo* in the two pairs nearest to the entrance wall matches his counterpart fairly closely (Fig. 40), and this suggests that Michelangelo did not originally envisage them to be so varied in pose. A drawing in the British Museum (Exh. No. 18r) most likely dates from the period before painting had commenced, when the artist was still deliberating on their basic pose. He probably began the sheet on the left with the leadpoint study from a live model leaning on his right knee, and his right arm raised above his head. Michelangelo slightly amended the pose when he went over the leadpoint in pen and ink, lightly indicating the position of the right thigh to show the figure kneeling on both legs. The artist may have rejected the idea of having the *ignudi* kneeling because it offered less scope for variety than a seated position. The greater range of artistic opportunities is underlined by the three studies of seated figures on the right side of the sheet, the outlines of their muscular forms expressively drawn in a slightly different shade of ink over faint traces of leadpoint. Seated on pedestals, taller than the ones shown in the vault, they nonchalantly hold up the swags with a fluid grace quite alien to the straining figure studied on the left. None of the poses corresponds directly with any of the *ignudi* on the vault, but their languorous sensuality does anticipate that found in the finished work.

Once the artist had settled on having the *ignudi* seated, he could turn his attention to the specific task of designing the first two pairs nearest the entrance wall. With this in mind he used the other side of the sheet to make a study of a powerfully muscled nude drawn in an unusually greasy black chalk. The drawing is related to the torso of the *ignudo* to the upper

below left
Fig. 41 ***Belvedere Torso*, signed by the sculptor Apollonios**, *c.* 50 BC. Marble, h. 159 cm. Vatican Museums, Vatican City

below right
Fig. 42 **The Erythraean Sibyl**, *c.* 1508–10. Fresco. Fourth bay, Sistine chapel ceiling

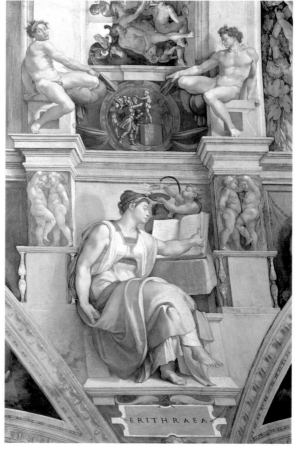

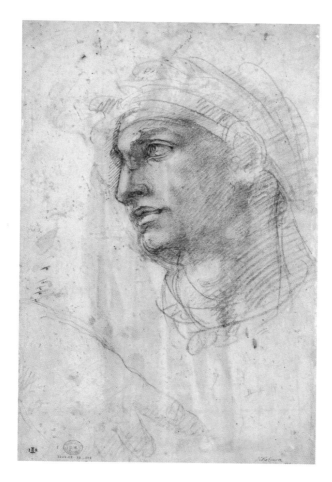

right of the *Drunkenness of Noah* (Fig. 40). His bull-like torso and the twisting motion of the hips and shoulders are inspired by the classical marble known as the *Torso Belvedere*, a model favoured by Michelangelo then belonging to the Colonna family in Rome (Fig. 41).[75] The figure in the fresco is less reminiscent of the marble, as he was turned into a more lithe and youthful type, and the rotation of his shoulders was made less emphatic. In the drawing Michelangelo concentrated on studying the model's upper body, always a key expressive area in his depiction of a figure, with the position of the limbs and head sketched in with a minimum of effort. This variety of finish is found in other life studies for the vault (see for example Exh. Nos 25r and 29), and he was to maintain this practice in drawings of a comparable type for the *Last Judgement* more than twenty years later (see Exh. Nos 83–4). Once he had finalized the pose Michelangelo almost certainly would have made a detailed study of the figure's head, like the one in black chalk in the Louvre for the *ignudo* above Esaias.[76] The study of a male head drawn in an unusually elaborate technique on the verso of Exh. No. 5 is similar in type to some of the *ignudi* on the first half of the ceiling, but it cannot be connected directly to any of the finished figures. If the head was drawn during the period that Michelangelo was working on the vault, it would signify that it was another one of the batch of drawings that had been taken from Florence to Rome, since on the recto is the so-called *Philosopher*.

A further insight into Michelangelo's meticulous preparation of the figures on the ceiling is supplied by a drapery study (Exh. No. 19r) for the Erythraean Sibyl in the fourth bay of the chapel (Fig. 42). We can infer from knowledge of fifteenth-century Florentine practice that

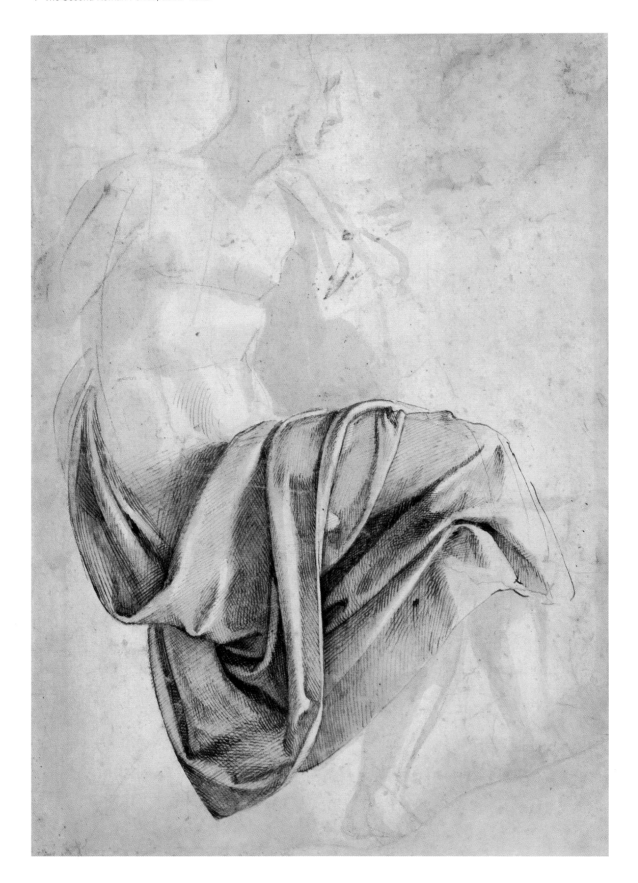

opposite
Exh. No. 19 Recto **The Erythraean Sibyl**, *c.* 1508–9. Black chalk, pen and brown ink and brown wash, made up section of the paper at the lower right corner, 38.7 × 26 cm. The British Museum, London

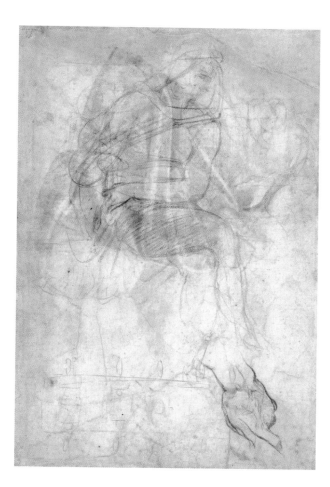

Exh. No. 19 Verso **Sistine vault scheme; hand study; and Sibyl**, *c.* 1508–9. Black chalk, made up section of the paper at the top right corner, 38.7 × 26 cm. The British Museum, London

Fig. 43 Fra Bartolommeo (1472–1517), **Drapery study for Christ**, before 1500. Brush and brown and white distemper on brown linen, 28.3 × 19.3 cm. The British Museum, London

this was drawn from a small-scale clay, wax or wooden mannequin over which was arranged cloth dipped in liquid clay that would harden when dry to preserve the shape of the folds.[77] Michelangelo's drawing is a quicker and less elaborate version of a well-established Florentine method of making studies in brush and tempera or distemper on linen, the best-known practitioners of which were the sculptor/painter Andrea del Verrocchio and his pupils Leonardo and Lorenzo di Credi.[78] Domenico Ghirlandaio is known to have executed similar studies on linen, and it is likely that he would have passed this method to his pupils.[79] These brush drawings were muted in their tonality with the focus on rendering the modelling of light to clarify the form of the figure beneath the drapery. A superlative example of this type of drawing is Fra Bartolommeo's study in the British Museum for the drapery of Christ (Fig. 43) in the fresco of the *Last Judgement* commissioned in 1499 for S. Maria Nuova in Florence. As with Michelangelo's study, this must have been executed when the final pose had been established and was intended as a guide for the creation of the cartoon. The black chalk or charcoal, with highlights in white chalk, used to draw cartoons was a technique well suited to reproducing the subtle tonal contrasts of the grey-brown and white distemper of the brush drawing. The manner in which Fra Bartolommeo lightly brushed in the slender form of the mannequin's torso is strikingly similar to Michelangelo's slightly later rendering of the figure in his own drawing.

Michelangelo began his study by blocking in the figure and the drapery folds with black chalk, and then followed this with brown wash applied with a brush. He also deftly exploited

the untouched areas of paper as highlights on the upper reaches of the ridges of cloth. The Sibyl's pose must already have been established in previous studies, an early example of which (differing greatly from the final result) is found on the other side of the drawing (Exh. No. 19v). The tonal range of the wash used for the drapery study on the recto is fairly restricted, with the artist preferring to use pen and ink to describe the drapery patterns. This manner of mapping out the folds with the pen harkens back in some respects to Michelangelo's early drawings in the medium, such as Exh. No. 5r, but the overall effect is lighter and more delicate. The configuration of the painted drapery is generally fairly close to that in the drawing, except for the simplification of the area of cloth stretched on her upraised knee and the lengthening of her dress to expose less of her bare legs. Michelangelo almost certainly made similar, now lost, studies for the draperies of the other Sibyls and Prophets on the vault, as well as for the Virgin and St Joseph in his earlier *Doni Tondo* painting now in the Uffizi, Florence.

The Use of Cartoons and the Question of Studio Assistance

After Michelangelo had refined the composition of the narrative scenes and the pose of the individual figures on paper, his finished designs would have been used to create a cartoon. These templates were drawn on numerous pieces of paper pasted together to form a huge sheet, which would then have been tacked to the wall of the studio and moistened to smooth out the wrinkles and creases. When the paper was dry Michelangelo could begin to draw the figure or composition in black chalk or charcoal on the basis of his previous preliminary drawings. The normal method of enlarging a preparatory design was by overlaying it with a grid of squared lines that facilitated the copying of its detail from the small square to one of a larger dimension on the paper of the cartoon.[80] There are no known examples of Michelangelo squaring his preparatory drawings so one can only assume that he copied them freehand.[81] To ensure that the cartoon was the right size the artist, or an assistant, would have previously taken measurements on the scaffold of the space it was to fill on the vault.[82] Unfortunately no cartoons for the vault have survived although Vasari tantalizing refers to Michelangelo giving away some of them to his friends.[83] The only clue to how they might have looked is a fragment in Haarlem (Exh. No. 30v) that has recently been identified as relating to the head of Haman in one of the pendentives on the altar wall (Fig. 53).[84]

Much information relating to Michelangelo's cartoons came to light during the recent cleaning, which revealed extensive evidence of the chalk dots (*spolveri*) beneath the pigment denoting his use of a pricked matrix as a guide.[85] He frequently strengthened the dotted lines in black pigment with a brush to make the contours clearer. While the cartoon was being dusted with the ground black chalk or charcoal contained in a pounce bag, it was held in place by nails. The holes these made are still visible on the surface of the vault, and some of the original nails used for this process were found in some of the severies. In the second campaign of work, when Michelangelo was clearly under pressure to finish, he made more use of tracing the design directly to the wall by following the outlines with a sharp point to produce an incised indentation on the freshly applied surface of the *intonaco*. This was a much speedier process because it did not require long hours minutely pricking the surface of the paper (a laborious task traditionally undertaken by workshop assistants), but the transmission of the cartoon's design was much more approximate. In the first part he had used incising for less detailed areas such as the drapery folds of the Sibyls and Prophets. Remarkably, the artist

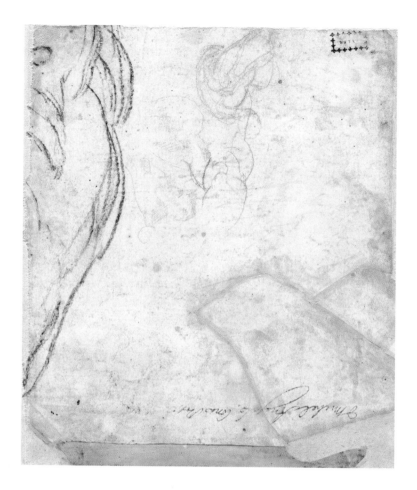

managed to paint some sections of the vault without making cartoons at all, most notably the series of Christ's ancestors in the lunettes. For these Michelangelo must have painted the figures by referring to his preparatory studies.

Despite the fact that Michelangelo's only formal artistic training was as a painter, he wrote to his father that painting was not his profession.[86] Michelangelo's anxiety about his lack of experience of mural painting (a feeling perhaps reinforced by his initial difficulties with the correct recipe for the *intonaco*) probably underlay his decision to ask Granacci to hire Florentine fresco painters from whom he could learn. A letter sent by the latter to Michelangelo in April 1508 relates his difficulties in finding suitable recruits in Florence.[87] Vasari names five of the artists, the majority of them trained in Domenico Ghirlandaio's workshop, and goes on to describe how Michelangelo soon decided that they were not good enough and locked them out of the chapel.[88] But Michelangelo remained on good terms with most of the artists mentioned by Vasari long after the period of the Sistine chapel commission, and indeed Granacci and Bugiardini could be counted among his most enduring friends, so that it seems likely that his break with them may have been more amicable than Vasari's dramatic account.

Opinion is divided over which, if any, parts of the ceiling can be attributed to assistants on stylistic grounds, but even the most expansive view of their involvement does not amount to much.[89] Michelangelo really does seem to have painted the vault single-handed, although he must have relied on his servants, at least one of whom – Pietro d'Argenta – was a painter, for

menial tasks such as grinding the colours and pricking the cartoons. The effects on Michelangelo of the unrelenting and physically demanding nature of the work – painting one section while preparing and designing the next – may be seen in the gloominess of his letters written to his family at this period. This may in part be explained by his perennial wish to discourage them from asking him for yet more money, but even so there seems no reason to doubt the genuineness of his lament to his brother Buonarroto in a letter written in the autumn of 1509: 'I am living here in a state of great anxiety and of the greatest physical fatigue; I have no friends of any sort and want none. I haven't even enough time to eat as I should. So you mustn't bother me with anything else, for I could not cope with another thing.'[90]

Studies for the Second Section of the Ceiling, 1511–1512

While Michelangelo was working on the first half of the chapel, his patron's aggressive foreign policy directed to restoring the church's power in Italy was proving successful. Julius had realized his ambition to wrest control of papal cities in Romagna in northern Italy from the Venetians through an alliance made at the end of 1508 (the League of Cambrai) with the Emperor Maximilian and the kings of France and Aragon. Venice's defeat had been celebrated in a ceremony in February 1510 which began by the city's ambassadors kissing Julius' feet and cheek under the portico of St Peter's, and ended with a service in the Sistine chapel. No sooner had the Venetians' power been curbed than Julius began to plot with them on the removal of French forces from Italian soil, a much greater and far riskier enterprise.

At the same time Julius was also trying to oust Alfonso d'Este as ruler of the papal city of Ferrara, and lack of progress led him to leave Rome in August 1510 to be nearer the action in Bologna. The papal forces were led by the mercenary captain Francesco Gonzaga, marquis of Mantua, who had little incentive to pursue the war with any great vigour because he was loath to antagonize the French by defeating their ally Alfonso. Julius' own commanders, his old friend the Francophile Cardinal Alidosi and his nephew Francesco Maria della Rovere, were equally ineffective because of their mutual hatred and jealousy.[91] The French exploited these difficulties by lending greater support to Alfonso to retake the territory he had lost to the papal armies, and by backing the Bentivoglio family's attempt to re-establish their dynastic rule in Bologna, a campaign aided by Alidosi's cruel and oppressive governorship of the city. Remarkably at this time of acute crisis, and with papal finances drained by warfare, Michelangelo managed in a trip to his beleaguered and ailing patron in Bologna in September 1510 to obtain more money that he regarded as payment for the part of the vault he had just finished. Michelangelo was less successful on a return visit some months later when the military situation had worsened. Bramante is said by Vasari to have sneakily taken advantage of Michelangelo's absence from the chapel to allow Raphael to study Michelangelo's paintings.[92] The painter famously paid homage to (or cheekily plundered) the originality of Michelangelo's ceiling by cutting out a section in the left foreground of his already finished *School of Athens* fresco in the Stanza della Segnatura to insert a seated figure of Heraclitus, a figure of such brooding presence that some believe it to be a portrait of the sculptor.[93]

Work in the Sistine chapel was halted by Julius' continuing absence in northern Italy. The pope had became so infuriated at the lack of progress in the war against Ferrara that, despite being in poor health, he braved freezing conditions personally to direct the successful siege of the town of Mirandola in January 1511. His physical resilience, remarkable for a man in his

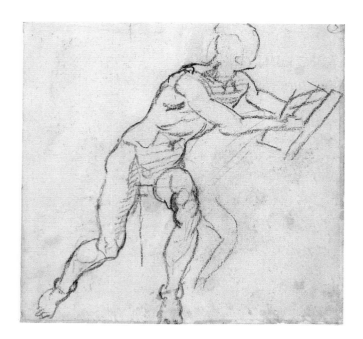

Exh. No. 23 Recto **Sistine
sketchbook**, *c.* 1511. Black chalk,
14 × 14.5 cm. The Ashmolean
Museum, Oxford

Exh. No. 23 Verso **Sistine
sketchbook**, *c.* 1511. Black chalk,
14 × 14.5 cm. The Ashmolean
Museum, Oxford

late sixties, amazed his contemporaries but his health was broken by the loss of Bologna to
the French in May 1511, in large part because of Alidosi and his nephew's refusal to co-oper-
ate in its defence. Soon after this humiliation Francesco Maria della Rovere fatally stabbed
Alidosi when the two encountered each other in Ravenna. This confirmed the papal nephew's
violent reputation established four years earlier by the murder of his sister's lover Giovanni
Andrea Bravo, another favourite of his uncle, along with one of her servants who had encour-
aged the relationship. Alidosi was widely reviled and few, apart from the grief-stricken pontiff,
mourned his death (one contemporary historian described him as a man of 'outrageous and
infinite vices').[94] Michelangelo may well have been an exception in regretting his demise, as
Alidosi's closeness to Julius made him a powerful ally at the papal court. The year before his
death Alidosi had shown his appreciation of Michelangelo by commissioning a fresco of the
Baptism of Christ for the chapel of his villa La Magliana.[95] Michelangelo's memory of what
had occurred at Ravenna helps to explain his extreme dread of being exposed to Francesco
Maria's wrath over his failure to finish Julius' tomb.

The return of Julius to Rome in June and the unveiling of the first half of the ceiling on 15
August 1511, the feast day of the Assumption of the Virgin, doubtless spurred Michelangelo to
resume work on the project. Thanks to the unique survival of eight leaves from a fragmentary
pocket sketchbook in the Ashmolean, four of which are included in the selection (Exh. Nos
20–3), it is possible to see the artist's initial thoughts for a number of the figures, most
notably the Ancestors of Christ, painted in the last part of the ceiling.[96] These diminutive
sheets of paper filled with minute sketches in pen or black chalk had already been removed
from the original sketchbook when Ottley acquired them while in Italy. The paper they are
drawn on must already have been slightly trimmed, as there are no marks of stitching from
the binding at the edges. It is clear that the leaves were once bound together as traces of
some of the black chalk studies have rubbed off over the years onto the surface of the facing
page. There is no way of knowing the number of pages in the sketchbook except that there
was at least one further leaf, since one of the offsets does not correspond to any of the

surviving black chalk studies. A clue to their dating is provided by the inscription 'di qui[n]dici sectebre' ('the fifteenth of September') written in Michelangelo's hand on one of the sheets not included in the present selection.[97] The year is not given, but 1511 seems most likely as this was around the time that Michelangelo resumed work on the ceiling. This would signify that Michelangelo had left the task of designing the second half to the last moment.

The attribution of these drawings to Michelangelo and their connection with the Sistine vault was recognized by Ottley and their subsequent owner Thomas Lawrence. The traditional view was cast aside by Bernard Berenson's imperious dismissal of them as 'scrawls' unworthy to be attached to Michelangelo's name, and this view was followed by the majority of critics (with the notable exception of Thode) until Wilde and then Parker, in his 1956 catalogue of the Ashmolean's Italian drawings, championed their authenticity.[98] It is hard to credit that exploratory studies of this kind, which differ so profoundly from the finished frescoes, could have been dismissed as copies, especially as comparably rapid first ideas for figures do occur on other sheets by Michelangelo – although admittedly never in such density (see Fig. 23). The sketchbook studies are far from being the artist's most prepossessing works, yet Michelangelo's remarkable qualities as a draughtsman are still discernible in his effortless creation of a figure possessed of volume and the potentiality of movement with a few rapid flicks of the pen. The embryonic pose of Jonah is, for example, clearly recognizable in the thumbnail sketch at the top left of Exh. No. 21r. The curved line to the left of the figure defining the boundary of the spandrel for which he was destined, and his pose – except the position of his head – correspond fairly well with the finished figure. Michelangelo's ability to pare down a pose to the barest essential can be seen in the summary study on the recto of Exh. No. 20 for the right-hand ancestor asleep and with his head turned away in the *Roboam–Abias* lunette (Fig. 44).

A number of the studies on the sheets cannot be linked to anything painted on the vault, evidence of the exacting editorial process to which Michelangelo submitted his own ideas. In other cases the evolution of the pose from the first idea was so profound that only tentative

Exh. No. 20 Recto **Sistine sketchbook**, *c.* 1511. Pen and brown ink, 14 × 14.2 cm. The Ashmolean Museum, Oxford

Exh. No. 20 Verso **Sistine sketchbook**, *c.* 1511. Pen and brown ink, 14 × 14.2 cm. The Ashmolean Museum, Oxford

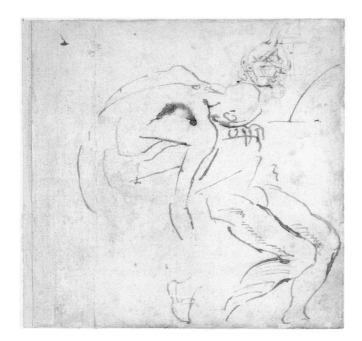

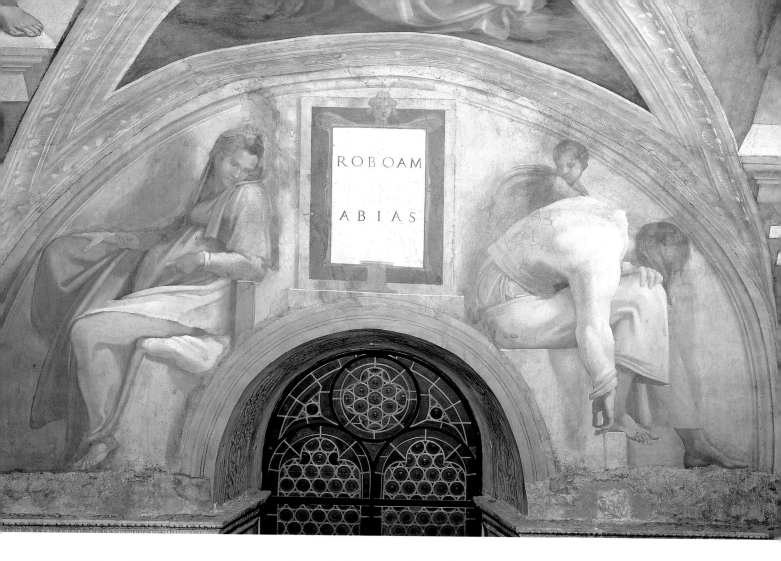

connections can be made. A case in point is the bending figure at the lower right of Exh. No. 21r that may be a first idea for the woman in the *Iesse–David–Salmon* lunette. The painted figure is posed differently and faces the other way, but the object in the drawing that looks like a music stand can be identified by reference to the fresco as a yarn winder. Similarly, the bearded man sketched above may be linked to the very differently posed figure of Booz seated facing the opposite direction in the *Salmon–Booz–Obeth* lunette. Both figures are dressed as itinerant carpenters, with wide brimmed hats on their backs and close fitting caps with earflaps on their heads.

The successive stage after the outpouring of ideas shown on both sides of Exh. No. 21 is shown by the black chalk study, perhaps made from life, of a sleeping male nude on the recto of Exh. No. 22. The first idea for his pose is found in a thumbnail pen sketch in the centre of the verso of Exh. No. 21, and Michelangelo went on to use a reversed version of this sleeping figure in the destroyed *Phares–Esron–Aran* fresco, one of the two lunettes on the altar wall destroyed by Michelangelo but recorded in an engraving made after a lost drawing published by William Young Ottley in 1827 (Fig. 45). The male nude studied in the very similar black chalk study on the recto of Exh. No. 23 is related to the left-hand Ancestor in the lost *Abraam–Isaac–Iacob–Iudas* lunette known through Ottley's print. Perhaps the most pictorial of the black chalk drawings in this group is on the verso of Exh. No. 22. This is a study for Naason's wife who is shown in the fresco gazing into a mirror on the left-hand side of the *Naason* lunette. In the fresco her pose with her arms leaning on her raised left knee, a posture

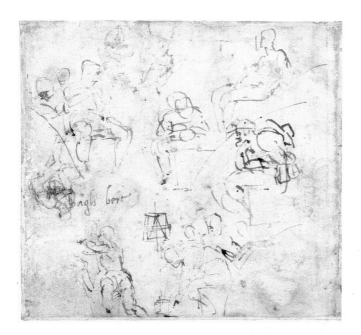

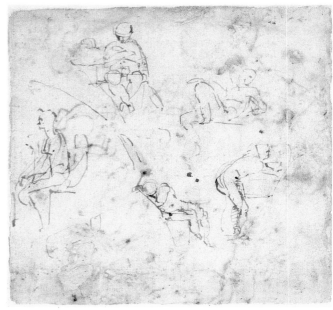

probably inspired by antique sculpture, is close to that in the drawing, and the greatest difference between them is the exclusion of the child resting on the arched frame in the foreground.[99]

The next stage in the development of the Ancestors is shown by a red chalk drawing in the Ashmolean for the figure of Josophat on the left of the *Asa–Iosophat–Ioram* lunette in the seventh bay (Exh. No. 24), a pose studied at the top right of Exh. No. 20r. This is a controversial drawing that a number of Michelangelo specialists in recent times have rejected, but it is included here as an autograph work. Wilde borrowed it for his 1953 Michelangelo exhibition at the British Museum, but John Gere and Nicholas Turner excluded it from their monographic show in 1975.[100] The drawing poses intriguing questions as it is certainly not a copy after the painted figure since there are a number of differences in detail between the two, most notably in the facial type and the angle of the left leg. Another possibility is that it is a copy after a lost drawing, but the changes in pressure in the handling of the chalk and the rough, energetic hatching do not tally with the usually even toned, mimetic character of such works. There are also alterations to the outlines which suggest that the draughtsman was adjusting the pose while in the course of making the drawing. These changes include the slight shift in the position of the head with the line of the chin and the mouth placed higher, and the addition of a lightly sketched quill in his right hand so that the figure is shown writing on, rather than

Exh. No. 21 Recto **Sistine sketchbook**, *c.* 1511. Pen and brown ink, 13.8 × 14.3 cm. The Ashmolean Museum, Oxford

Exh. No. 21 Verso **Sistine sketchbook**, *c.* 1511. Pen and brown ink, 13.8 × 14.3 cm. The Ashmolean Museum, Oxford

Fig. 45 William Young Ottley (1771–1836), **The destroyed lunettes on the Sistine chapel altar wall: Phares–Esron–Aran and Abraam–Isaac–Iacob–Iudas**, 1827. Etching after a lost pre-1534 drawing, 48.8 × 37.8 cm. The British Museum, London

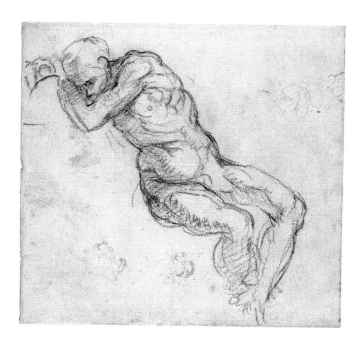

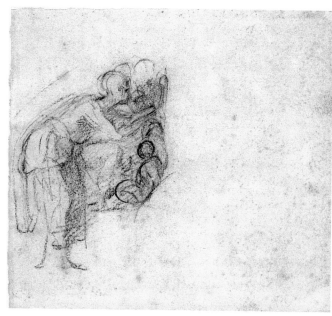

Exh. No. 22 Recto **Sistine sketchbook**, *c.* 1511. Black chalk; pen and brown ink, 14 × 14.5 cm. The Ashmolean Museum, Oxford

Exh. No. 22 Verso **Sistine sketchbook**, *c.* 1511. Black chalk, 14 × 14.5 cm. The Ashmolean Museum, Oxford

merely reading, the piece of paper balanced on his knee. The shading used to show the fall of light and to isolate the tubular drapery folds is admittedly broad and lacking in subtlety. Yet at the same time it is also extremely effective in imparting the essential information of the lighting that Michelangelo would have needed to guide him in painting the figure freehand on the wall. (The majority of the lunettes were painted in three *giornate* beginning with the central tablet and a day for each of the figures on either side.) There are some precedents for the gracelessness of the draughtsmanship from this period such as the study on the verso of Exh. No. 19.[101] The quality of Exh. No. 24 is perhaps most evident in the expressive description of the features, the figure's scholarly mien shown by his hollowed cheeks, downturned mouth pursed in concentration and his lowered gaze focused on the paper on his knee. The economy of this highly effective characterization has to be weighed against passages that appear atypical of the artist, most notably the smooth background hatching.[102] The opportunity afforded by the exhibition to examine it alongside other red chalk studies unquestionably by Michelangelo from the same period may help to resolve the issue.

Whereas Michelangelo had predominantly used black chalk for his studies for the first part of the vault, the use of red chalk in the Ashmolean study would be typical of his preference for this medium in the second campaign of work. Too much should not be read into this shift as there are a number of examples where Michelangelo switched between black and red chalk on the same sheet, for example on the reverse of the two Haman studies (Exh. Nos 29 and 30). Nevertheless the greater sharpness of detail and chromatic intensity of red chalk were qualities well suited to the shift in the second half of the ceiling towards brighter colours and more sharply defined contrasts between light and shade, changes designed to make the figures more visible in the gloom of the chapel. His red chalk drawings from this period must rank among his greatest creations, and they mark the highpoint of Michelangelo's intensely sensual glorification of the divinely fashioned perfection and beauty of the male form. The most famous encapsulation of this supremely positive view of mankind's creation and nature (one enunciated in contemporary sermons preached in the same chapel) was, aptly enough,

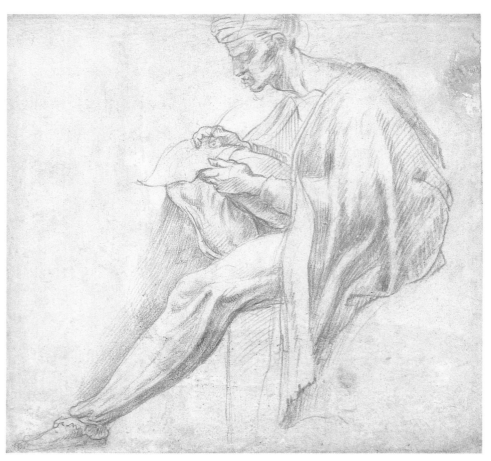

Exh. No. 24 **Josophat (Iosaphat)**,
c. 1511–12. Red chalk,
20.5 × 21.2 cm. The Ashmolean
Museum, Oxford

Fig. 46 **The Asa, Iosaphat and
Ioram lunette**, *c.* 1511–12. Fresco.
Seventh bay, Sistine chapel ceiling

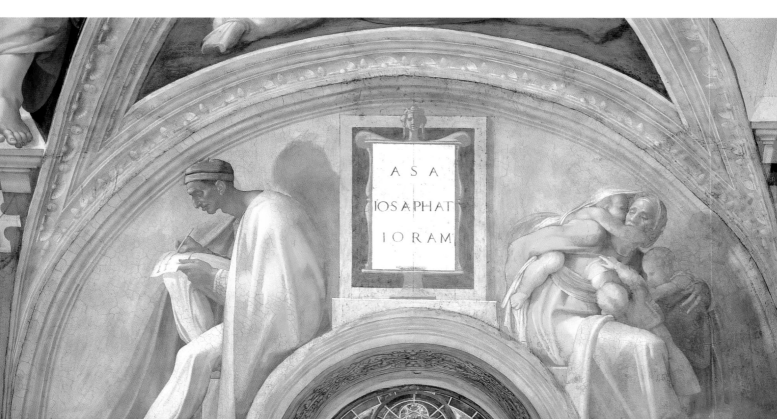

Michelangelo's *Creation of Adam* (Fig. 48). The languorous figure of Adam in the fresco is the subject of a life study in the British Museum (Exh. No. 25r). As with the earlier Cascina figure studies, the fact that Michelangelo was drawing from a model did not prevent him from adjusting the forms for artistic effect. The figure's stretching motion appears so persuasive because of the naturalness of the observation, while in reality it depends on a wholly contrived dislocation of the upper body. The sculptor's unrivalled skill in blurring the boundaries between artifice and the realities of the human frame underlie the remark attributed to him in a 1551 study of the Tuscan language by the Florentine hosier-turned-champion of Dante and of the spoken and written vernacular, Giovanni Battista Gelli: 'Michelangelo was wont to say that only those figures were good from which one had removed the effortful labour, that is, produced with such skill that they appeared the result of nature rather than art.'[103] The description of Adam's body in the fresco is much simplified in comparison with the drawing, particularly in the nuances of the contour. Michelangelo only indicated the outline of the head, as this would have been the subject of a specialized study, and the hands are sketched in for the same reason. The tricky foreshortening of the right arm is drawn rather hurriedly on the right side of the sheet, while the remaining space around the main figure is taken up with a study of the left hand and wrist raised at a less acute angle, and a more considered examination of the clenched right fist.

below

Exh. No. 25 Recto **Study for Adam**, *c.* 1511. Red chalk, made up sections at lower edge, 19.3 × 25.9 cm. The British Museum, London (verso illustrated on p. 130)

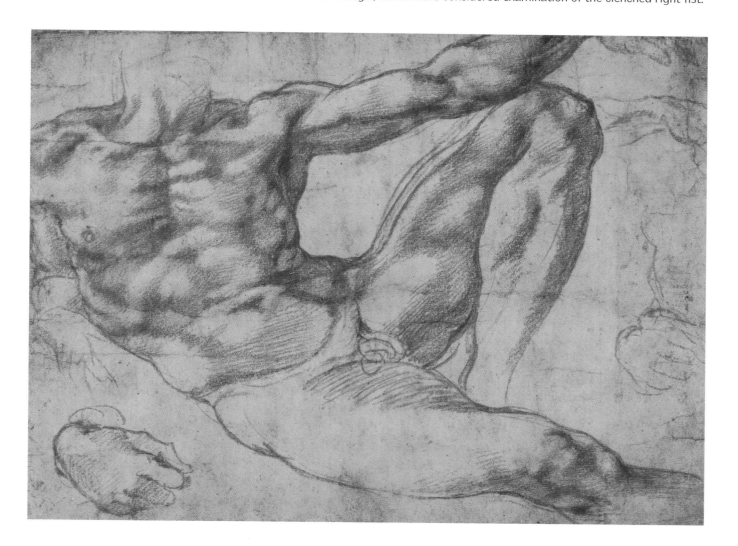

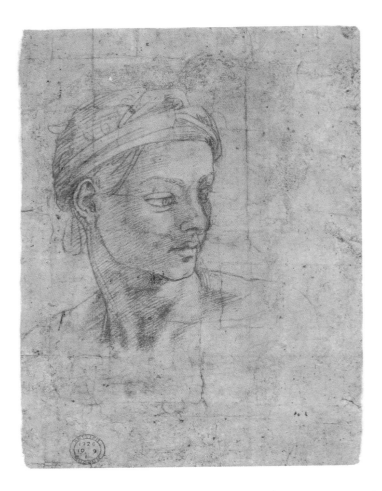

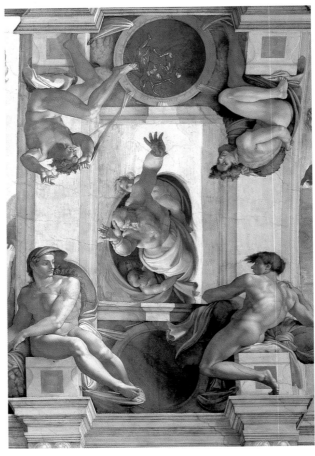

On the back of the paper Michelangelo drew a young man's head in the same medium (Exh. No. 25v) related to one of the *ignudi* in the following bay (Fig. 47). The quality of this study has long divided critics.[104] The hatching and the outlines of the head certainly lack the vibrancy of the nude on the recto, but it is conceivably a tracing of a previous, and now lost, study for the head, taking advantage of the relatively thin paper. (If so it must have been traced before the study for Adam was made on the other side.) He certainly traced studies from recto to verso (see for example Exh. Nos 30 and 89), probably by holding the paper on a sheet of glass up to the light, and it is possible he did so on occasion to transfer a motif from one sheet to another. Some of the contours of the head in the British Museum sheet have been incised with a sharp point, and this would indicate that Michelangelo (or another artist) copied the outlines to another sheet.

The British Museum drawing is the only surviving study for Adam, but almost certainly Michelangelo would have made a number of further drawings to refine the pose of such a key figure in the scheme before the production of the cartoon. A clue to how such lost drawings might have looked can be gained from two magnificent red chalk figure studies, almost certainly once a single sheet, related to the *Creation of Adam* and some of the *ignudi* in the successive bay (Exh. Nos 26–7).[105] The directness and immediacy of the observation in the Adam life study contrast strongly with the polished metallic brilliance of finish in the modelling in the Haarlem life study (Exh. No. 26) for an *ignudo* beside the *Separation of the Waters* (Fig. 47). The study's remarkable chromatic richness is achieved through a

above left
Exh. No. 25 Verso **Youthful head**, *c.* 1511. Red chalk, the contours traced with a stylus, made up sections at lower edge, 25.9 × 19.3 cm. The British Museum, London (recto illustrated on p. 129)

above right
Fig. 47 **The Separation of the Waters**, 1511–12. Fresco. Eighth bay, Sistine chapel ceiling

opposite
Exh. No. 26 Recto **A seated male nude**, *c.* 1511. Red chalk heightened with lead white, the corners made up, 27.9 × 21.4 cm. The Teyler Museum, Haarlem (verso illustrated on p. 134)

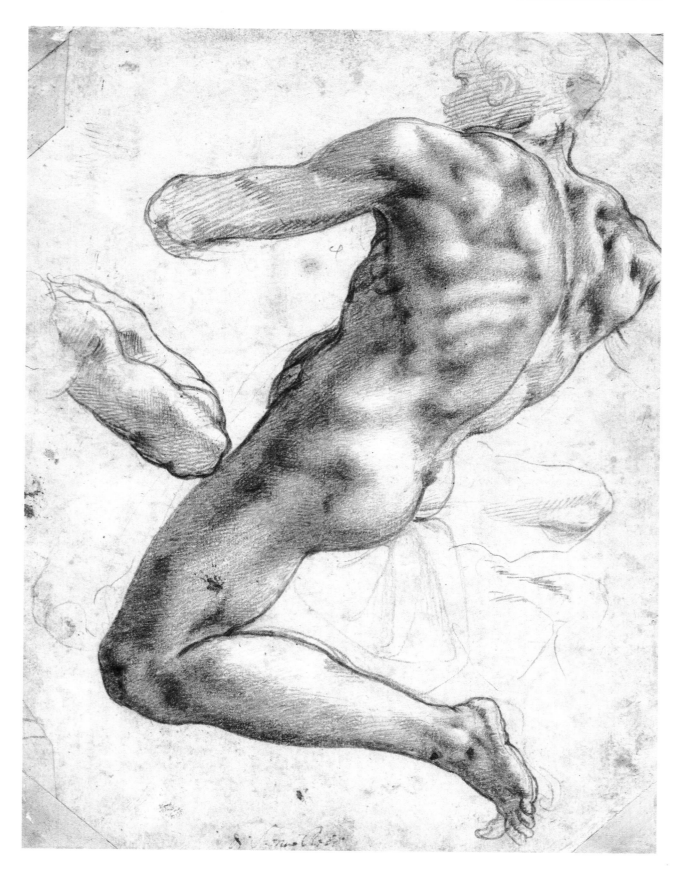

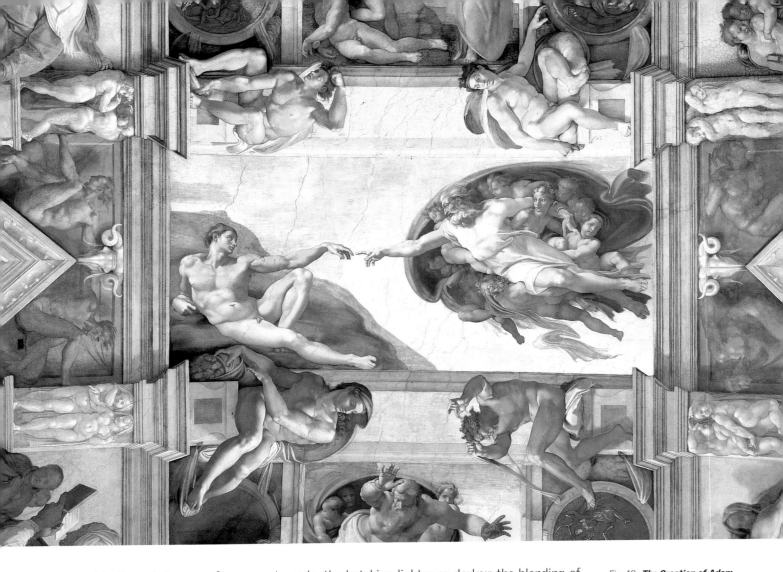

Fig. 48 **The Creation of Adam**, *c.* 1511–12. Fresco. Seventh bay, Sistine chapel ceiling

combination of changes of pressure to make the hatching lighter or darker; the blending of areas of shading, as in the shadows in the hollows between the ribs, by stumping; darkening the chalk by moistening it to create more accented contours or pools of shadow; and the discreet use of white heightening applied with a fine brush both in the main study (it is most noticeable on the figure's calf and left buttock) and in the subsidiary one devoted to the right arm. Michelangelo's main focus was the study of light, but he also made slight changes to the outlines of the calf and the belly, and comparison with the finished figures demonstrates that he continued to make small adjustments, such as to the angle of the foot, in the cartoon. The small squiggle of chalk beneath the figure's arm may have been an *aide-mémoire* to show the darkest area, and it may be a less developed progenitor of the notations found in slightly later studies (Exh. Nos 29–30). The delicate nuances of lighting would have been impossible to translate into the more limited tonal spectrum of black chalk or charcoal of the cartoon, and it is possible that Michelangelo would have referred to detailed drawings like this while painting the fresco. The nude's startled expression in the fresco, his mouth open and his eye straining to glance over his shoulder, was the subject of a study on the recto of Exh. No. 27, originally on the left side of the same sheet. Surrounding the head are studies for the legs of God the Father in the *Creation of Adam* (Fig. 48), the upper two drawn with the paper turned on its side, as is shown by the direction of the hatching beginning at the upper right hand and slanting diagonally downwards to the left, typical of a right-handed draughtsman.[106]

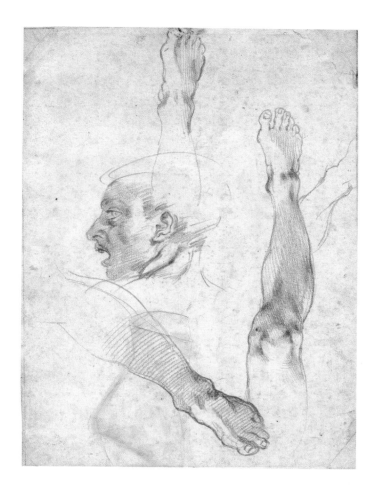

Exh. No. 27 Recto **A male head in profile; studies of limbs**, *c.* 1511. Red chalk, the corners made up, 29.6 × 19.5 cm. The Teyler Museum, Haarlem (verso illustrated on p. 135)

The complex overlapping forms of God and his attendant angels and putti must already have been established in earlier drawings, as the studies on Exh. No. 27r focus only on the parts of their bodies visible in the fresco. The crossed leg pose of the Deity is lightly indicated in the right-hand study, and the details of the right foot and ankle show only the parts not concealed by the other leg in the final work. The irregular area of damage visible in the ankle is due to the study of the hand of God on Exh. No. 27v having been cut out later by some collector (two segments above and below were probably trimmed off during this operation). This detail was pasted to the recto of Exh. No. 30 and was only restored to its rightful position in 1952. Prior to making the red chalk drawings Michelangelo had used the once single verso of Exh. Nos 26 and 27 to make small leadpoint sketches of figural ideas for the *ignudi*. These probably date from the early stages of Michelangelo's work on the ceiling, while the red chalk studies must date from around three years later (*c.* 1511) when Michelangelo resumed work on the ceiling. Apart from the knee studied at the lower left of the verso of Exh. No. 27 that is related to the *ignudo* on the lower left of Fig. 47, all the remaining red chalk studies on the two versos are for figures in the *Creation of Adam*. Perhaps the first to be executed was the summarily drawn seated figure to the right of centre on the verso of Exh. No. 26 (illustrated on p. 134). This is related to the epicene figure, identified by some scholars as Eve, beneath God's left arm in the fresco.[107] A study of the same figure's right shoulder and upper arm was begun and then abandoned at the lower left of the sheet. This was followed by the studies to establish the position of God's right and left

arms, the ones in the upper left made with the sheet turned upside down. The drawing of a young man at the bottom is for the angel above God's shoulder.

The three main life studies on the verso of Exh. No. 27 all relate to the angels below God the Father in the fresco. The change in scale between the two on the right and the central figure probably reflects the fact that the former were intended for the small child-angels clinging to the front of God's body, while the larger one is for the more grown-up angel shown flying horizontally beneath the Creator and supporting his legs. In the course of studying the nude model on the left Michelangelo decided to increase dramatically the rotation of the lower angel's upper body. This spiralling motion is registered in the fresco in the turn of the neck and head that almost totally obscures the angel's left shoulder. To accommodate this sudden change of mind, Michelangelo transformed what was originally the line of the figure's spine into the left-hand outline of his back. His first idea for this contour is lightly indicated further to the left. Before abandoning the drawing altogether he summarily indicated the position of the head to indicate his new thinking on the pose. The responsiveness of Michelangelo's handling of chalk to his impulsive change of mind is apparent from the dynamic contours and slashing hatchings that define the form. Similar verve is also discernible in the speedy revisions in the study of the knee below. The sensitivity and vivacity of touch is highlighted by contrasting the original with a seventeenth-century copy in Windsor made after some of the studies on the sheet (Fig. 49).[108]

The pose of the putto holding the scroll to the left of the Libyan Sibyl in the chapel's penultimate bay (Fig. 50) was the subject of the main study in red chalk on a sheet in the Ashmolean (Exh. No. 28). The finished figure is closely modelled on the drawing, and the only significant area of difference is the slight lifting of his left shoulder to reduce the swelling

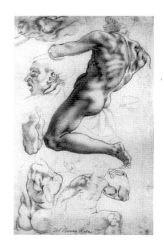

Fig. 49 Anonymous artist, **Copies after Sistine chapel studies (Exh. Nos 26–7)**, c. 1630. Red chalk, 39 × 23.5 cm. The Royal Collection, Windsor Castle

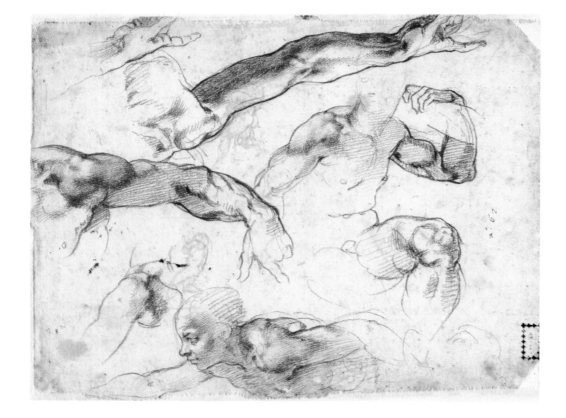

Exh. No. 26 Verso **Studies for God the Father and attendant angels**, c. 1511. Red chalk; lead-point, the corners made up, 21.4 × 27.9 cm. The Teyler Museum, Haarlem (recto illustrated on p. 131)

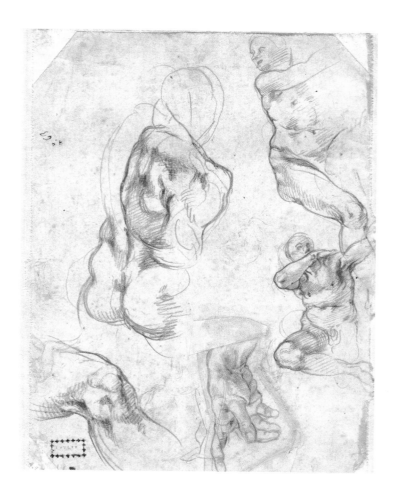

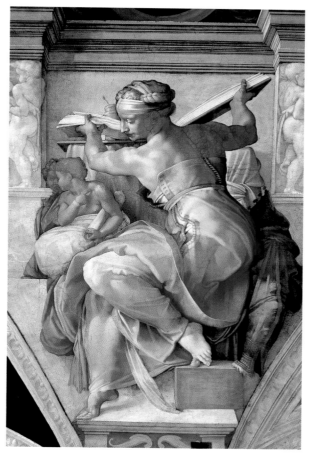

muscle that Michelangelo perhaps judged too conspicuous to be included in the depiction of a child-angel. The drawing of the right hand is related to that of the swivelling figure of the Sibyl, whose complex pose was prepared in an equally magnificent life study now in the Metropolitan Museum of Art, New York (Fig. 51). The model's right hand is not studied in any great detail in the latter work, and the Oxford drawing must have been drawn soon after to rectify this omission.[109] The lighting of this feature in the fresco is closely modelled on the Ashmolean detail, but Michelangelo reverted to the less involved position of the hand in the Metropolitan sheet.

With the end of the Sistine project in sight Michelangelo was thinking of returning to work on the tomb, and some time after making the red chalk studies on the sheet he filled up the remaining space around them with pen designs for the sculptures of *Slaves*. The description of the figures is more detailed than the near contemporaneous sketches in the Ashmolean Sistine sketchbook (Exh. Nos 20–3) and this refinement, as well as the lack of alterations to the outlines, makes it likely that he had already drafted their poses in earlier studies.[110] From the drawing it is clear that the *Slaves* were intended to be bound to caryatids (as they are shown in the finished design in the Uffizi, Fig. 52) and the artist's shorthand for their heads is also recognizable in his slightly later drawing in the same medium for the lower storey (Exh. No. 38). The figure second from left has a cuirass behind him and perhaps a helmet underfoot, familiar attributes of captured enemy soldiers in antique Roman art. This fits Vasari's interpretation of the *Slaves* as representing the provinces subdued by Julius and brought back under

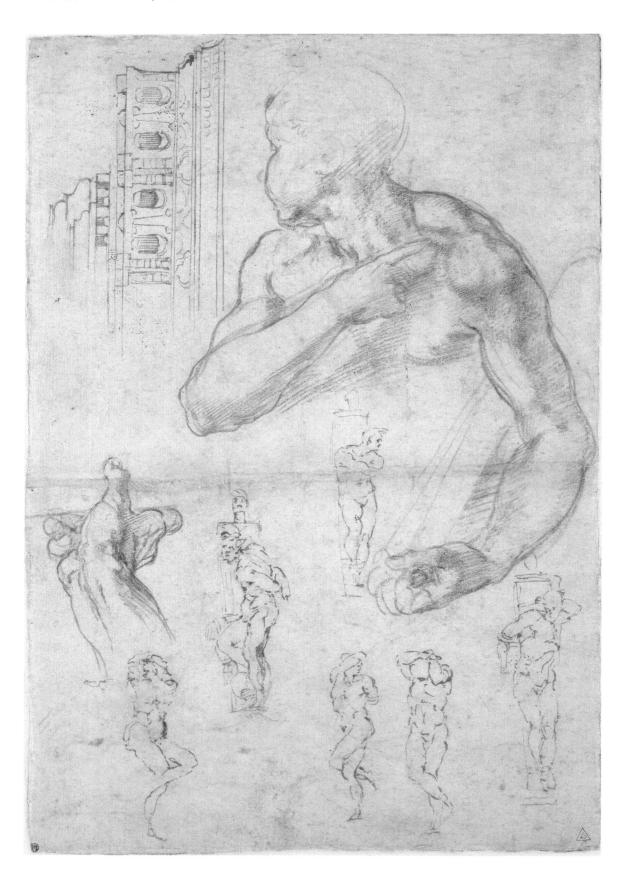

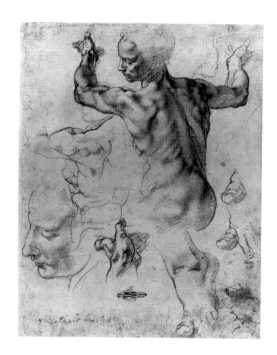

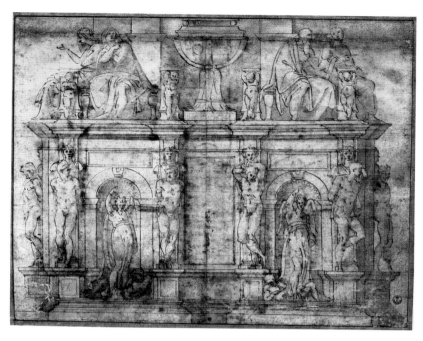

above left
Fig. 51 **Studies for the Libyan Sibyl**, *c*. 1511–12. Red chalk, made up section of the paper at the centre of right edge, 28.9 × 21.4 cm. The Metropolitan Museum of Art, New York (Joseph Pulitzer Bequest, 1924)

above right
Fig. 52 **Study for the Julius tomb**, 1513. Pen and brown ink, brown wash over black chalk, 29 × 36.1 cm. Galleria degli Uffizi, Florence

opposite
Exh. No. 28 **Studies for the Libyan spandrel and the *Slaves* for the Julius tomb**, *c*. 1511–12 (red chalk); *c*. 1512–13 (pen and ink), 28.5 × 19.4 cm. The Ashmolean Museum, Oxford

papal control.[111] This same figure is the only one of the six pen sketches on the sheet that can be connected to a sculpture, the so-called *Rebellious Slave* in the Louvre that Michelangelo had largely completed by 1516. The basic posture of the marble figure is close to that of the drawing, although Michelangelo eliminated the armour and increased the rightward rotation of his body. The faintly anthropomorphic and highly sculptural design for a cornice at the top left was drawn in the same ink as the *Slaves* and was presumably a fanciful idea for the Julius monument.[112]

Examination of the Sistine vault has shown that Michelangelo quickened the pace at which he painted in the second campaign of work on the vault. His *giornate* generally increased in scale and he was able to complete the scene of *God Separating Light and Darkness* in a single session. This change in tempo was due to a growing command of painting in fresco that allowed him to work with greater confidence and fluidity. Contributory factors may well have been his desire to finish such a physically exhausting project, not to mention the pressure almost certainly exerted on him by his impatient patron. Notwithstanding this acceleration in execution, Michelangelo's preparatory methods remained as rigorous and meticulous as before. This is demonstrated by two drawings for the crucified Haman painted on one of the pendentives of the altar wall (Fig. 53). The fresco's subject is taken from the Old Testament Book of Esther and depicts three episodes in the eponymous heroine's salvation of her fellow Jews from persecution by the Persians. Haman, the chief minister of Esther's Persian husband, King Ahasuerus, had instigated a campaign against the Jews, but in the end it was he who was condemned to be hanged on the gallows. (In Michelangelo's fresco he is shown crucified, a more pictorial form of execution that also foreshadowed Christ's.) The acutely foreshortened figure of Haman at the centre of the composition, posed so that he seems to stretch out his arm into the real space of the chapel was singled out for lavish praise by Vasari, and remains one of Michelangelo's most daring and influential figural creations.[113] The spiralling diagonal motion of the struggling Haman, loosely based on the pose of the central figure in the *Laocöon* marble (Fig. 54),

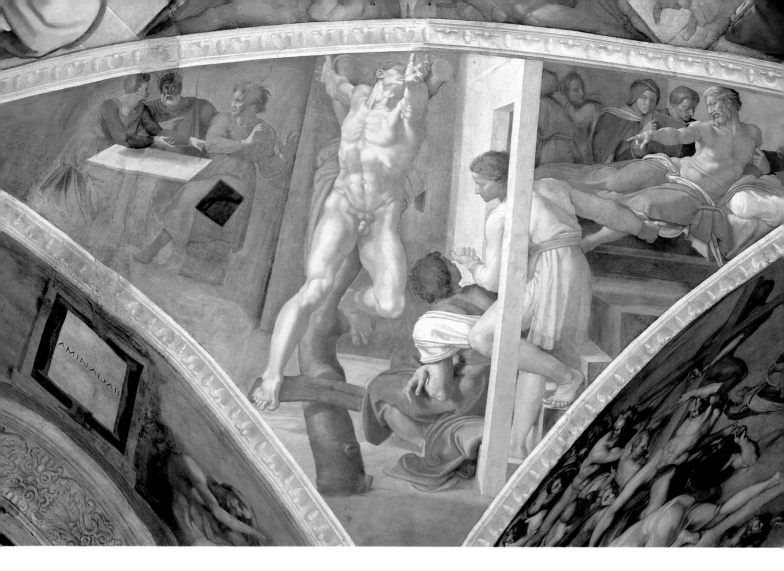

had already been established by the time that Michelangelo made the life drawing in the British Museum (Exh. No. 29). To maintain this dynamic pose for the considerable length of time needed to make such an acutely observed study, the model must have had his left leg supported in some way, perhaps by a loop suspended from the ceiling, and to have held on to ropes to keep his arms aloft.[114] The small circles visible on Haman's right thigh, and on the separate study of his bent left leg, are a notation used by Michelangelo to denote the most highlighted area, a method that he was still using over twenty years later for figure studies in the *Last Judgement* (see Exh. Nos 86–7).[115]

The Haarlem drawing for Haman (Exh. No. 30r) bears the scars of the study of the right arm having been cut out. This fragment was restored only in 1952.[116] The drawing underlines the complexity of the lighting of Haman's upper body, the tilted twist of his head allowing light to fall on the otherwise shadowy area beneath his arm in a way that is barely registered in the more generalized British Museum study that preceded it. The nuances of the light are detailed using two shades of red chalk in all the three main studies. (Michelangelo sketched the outline of the tree on which Haman was crucified in black chalk.) A darker stick was employed to pick out such details as the crease of skin on the right side of the neck on the main study, and to fix the contours of the right arm drawn with the sheet turned ninety degrees clockwise. In the main study the artist left out the left hand because it would have obscured the face, and comparison with the fresco shows that the head was fractionally lifted and the arm moved to the left so that the right part of his head is completely obscured.

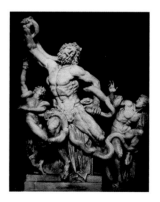

Fig. 54 *Laocoön*. **Roman marble copy, after a Hellenistic original of the second century BC, probably from the workshop of Hagesandros, Polydoros, and Athenodoros**, first century AD. Marble, h. 242 cm. Vatican Museums, Vatican City

opposite
Fig. 53 *The Execution of Haman*, 1511–12. Fresco. Corner pendentive, eleventh bay, Sistine chapel ceiling

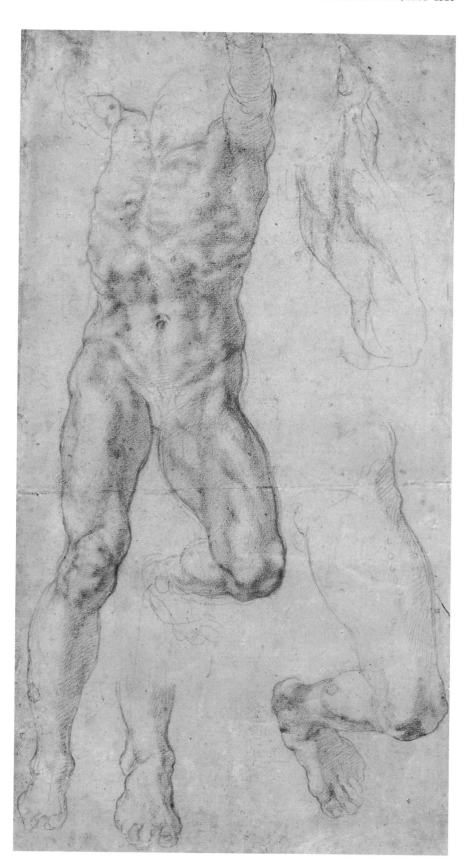

Exh. No. 29 **Studies for Haman**, 1511–12. Red chalk, made up section of the paper at upper right corner, 40.6 × 20.7 cm. The British Museum, London

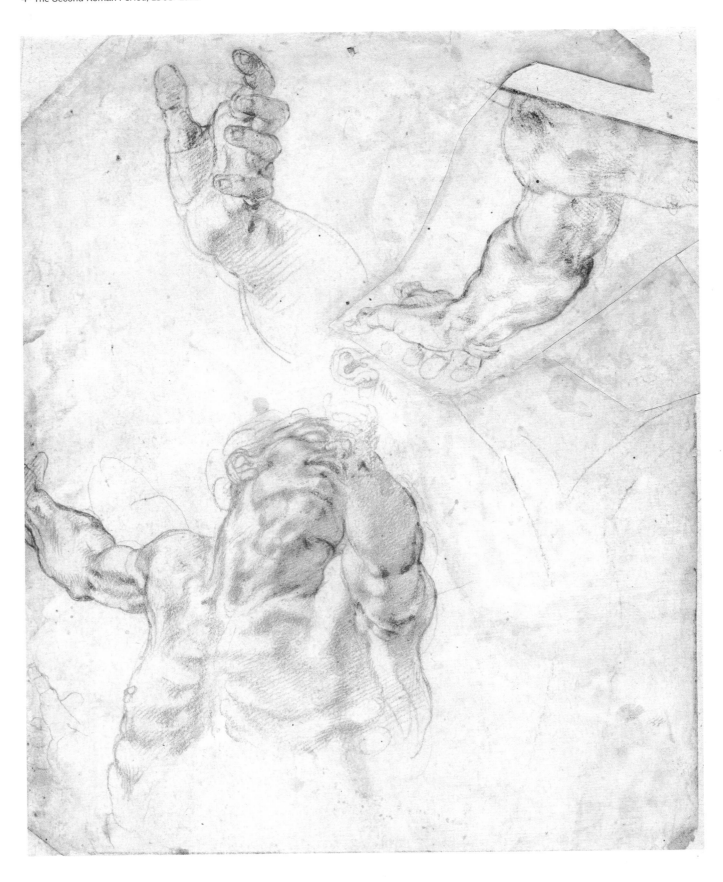

He seems to have run out of space on the left to put in the other hand, and made good this omission in a delicate outline study below. On the verso there is a fragment, unfortunately with the sheet turned upside down, of Haman's head hastily drawn with the line of the cheek, part of the mouth and the nose, complete with two nostrils, on exactly the same scale as the painted figure (the verso is illustrated on p. 121). The outlines of this have not been pricked or incised, so it is not strictly speaking a cartoon, although it is intimately connected to this last preparatory stage. Michelangelo must have had the Haarlem drawing to hand when he was preparing the cartoon, and it seems that he utilized the verso (blank except for a red chalk figure study and a faint tracing in black chalk of the main study on the other side) to experiment with an alternative position of the head that would have allowed the right side of the face to have been seen. The drawing powerfully evokes Michelangelo's relentless drive to perfect his work even at this final stage.

In a letter addressed to his father in October 1512 Michelangelo laconically mentioned that the ceiling was finished and that the pope was 'very well satisfied' (for the entire letter see Appendix II, no. 1, p. 295). Its completion was one of many successes that Julius enjoyed in the penultimate year of his pontificate. The military dominance of the Holy League made up of the papacy, Venice and the Emperor Maximilian had achieved that summer Julius' long-cherished goal of expelling the French from Italy. In turn this dealt a fatal blow to Julius' internal opponents: Soderini was forced into exile from Florence; the Bentivoglio abandoned Bologna; and Alfonso d'Este surrendered. Julius summoned the duke to Rome in July 1512 to have his excommunication lifted, and during his visit there Alfonso went on the Sistine scaffold where he remained at length in discussion with Michelangelo from whom he hoped to commission a painting.[117] This was the beginning of a long and ultimately unsuccessful pursuit (for the painting of *Leda* see pp. 186–9). A patron courting Michelangelo at this moment was wise to refuse, as did the wily duke, the invitation to follow up his viewing of the Sistine frescoes with a trip to see Raphael's work in the Stanza della Segnatura. In contrast to the rising fortunes of Raphael, who was successfully juggling his commitments in the Vatican palace with large-scale private commissions for patrons such as the wealthy Sienese banker Agostino Chigi, Michelangelo clearly felt depressed even after the critical acclaim of the Sistine ceiling.[118] He complained in the same letter to his father, quoted above, that things had not turned out as he had hoped: 'for this I blame the times, which are very unfavourable to our art'. The artist's nervousness that his involvement with Soderini would count against him with the newly established Medici regime in Florence is apparent from his letter to his father in autumn 1512 in which he vigorously denied rumours that he had ever spoken ill of the Medici (for the full text of this see Appendix II, no. 2, p. 295).

His anxieties can only have increased with the death of Julius in February 1513 and the election of Giovanni de'Medici, the son of his old patron Lorenzo the Magnificent, as Leo X. This appointment only magnified Raphael's ascendancy. Leo endorsed his continuing programme of decoration of the suite of rooms in the Vatican palace, and commissioned him to design magnificent Flemish-woven tapestries for the walls of the Sistine chapel. (Sebastiano reporting artistic affairs in Rome to Michelangelo in Florence in 1519 disparagingly mentions these works: see Appendix II, no. 3, p. 295.) The pontiff later candidly admitted to Sebastiano that he thought Michelangelo was the more original artist, astutely noting, perhaps with a hint of Florentine pride, how Raphael's early Peruginesque style had been abandoned after his exposure to Michelangelo's work; but that he found his compatriot's character off-putting ('he is terrible: one can't deal with him').[119] There is circumstantial

Exh. No. 30 Recto **Studies for Haman**, *c.* 1511–12. Red chalk; black chalk (outline of a tree), made up sections of paper at the corners, 25.2 × 20.5 cm. The Teyler Museum, Haarlem (verso illustrated on p. 121)

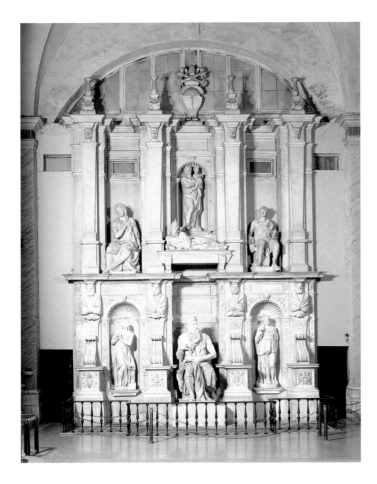

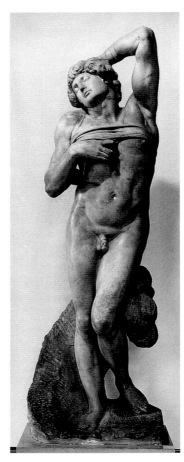

evidence to suggest that Michelangelo might have befriended Raphael in Florence *c.* 1504–5, but if such links ever existed they quickly evaporated once the painter had established himself at the papal court.[120]

Leo's initial lack of interest in employing the sculptor and his wish to maintain good relations with Julius II's nephew Francesco Maria della Rovere, duke of Urbino, meant that Michelangelo was given an almost interrupted period of three years to work on Julius' tomb.[121] A new contract for the work was agreed in May 1513 between the patron's executors – his nephew Leonardo Grosso della Rovere, cardinal of Agen, and the papal datary (treasurer) and later cardinal of Santi Quattro Coronati, Lorenzo Pucci. Following a new design submitted by Michelangelo, known through a fragmentary *modello* in the Uffizi (Fig. 52), and a damaged drawing in Berlin, the tomb was no longer free-standing but was to be attached to the wall.[122] That apart, the drawing shows no sign of Michelangelo scaling back the project to more manageable proportions. It was agreed that the artist should accept no other work that would impede his progress towards completing the commission within seven years.[123] During the next three years Michelangelo worked in rooms in a house lent to him by the della Rovere near Trajan's column at the foot of the Capitoline hill (the property was demolished in 1902 as part of the enlargement of Piazza Venezia).[124] Here he largely completed two *Slaves* now in the Louvre and the *Moses* that was to become the centrepiece of the much-reduced monument erected in S. Pietro in Vincoli in 1545 (Fig. 55). In addition he sub-contracted the stonemason Antonio da Pontassieve in July 1513 to sculpt the tomb's

above left
Fig. 55 **The Julius tomb**, 1513–45.
S. Pietro in Vincoli, Rome

above right
Fig. 56 ***The Dying Slave***,
c. 1513–16. Marble, h. 229 cm.
Musée du Louvre, Paris

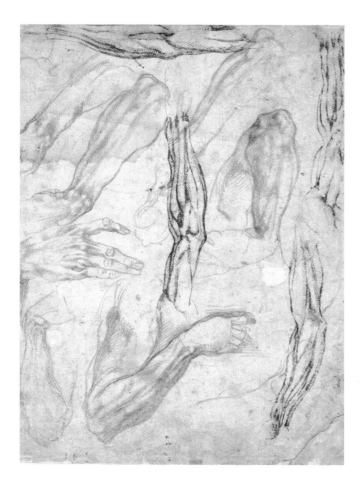

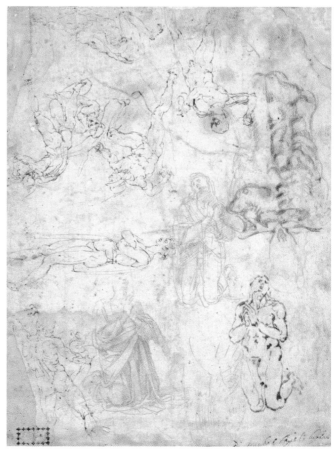

above left

Exh. No. 31 Recto **Studies for the *Dying Slave* and of flayed arms**, *c.* 1514. Pen and brown ink; red chalk over stylus, right corners made up, 28.5 × 20.7 cm. The Teyler Museum, Haarlem

above right

Exh. No. 31 Verso Michelangelo and pupils (?), **Study of a male torso; various figure studies**, *c.* 1510. Red chalk; pen and brown ink, the left corners made up, 28.5 × 20.7 cm. The Teyler Museum, Haarlem

architectural frame. These richly ornamented architectural sections were finished a year later and were also to form part of the final structure.

A double-sided drawing in Haarlem (Exh. No. 31) can be dated to the beginning of this period of work on the Julius tomb, as the red chalk studies from life of a right arm on the recto are preparatory for the *Dying Slave* (Fig. 56).[125] Since these are fitted around the four pen and ink studies of an outstretched left and right arm that has been flayed to reveal the muscles, it is fair to assume that the anatomical drawings were drawn first. These and the *écorché* drawing of a leg (Exh. No. 51r) are the only examples in the exhibition that document Michelangelo's study of anatomy, a vital field of interest for an artist so focused on exploring the expressive possibilities of the male nude. His biographers report that he began dissecting bodies in Florence in the 1490s, and he is said by Condivi to have wanted to distil his accumulated knowledge of the subject by writing a treatise for artists on the human body. This publication was never realized, but a group of around a dozen anatomical studies from the period 1515–25 document his investigations of the subject.[126] These show that Michelangelo's study of cadavers was driven by a desire to understand the workings of the skeleton and muscles, and there is no evidence to show that he was ever inclined to delve more deeply into the workings of the body like Leonardo. The anatomical drawings on the sheet were probably drawn at much the same period as the red chalk studies, for their short, regular internal hatching is closely paralleled in pen studies for the legs of the *Rebellious Slave* found on the verso of a drawing in Berlin related to the Julius monument.[127]

The eight drawings in red chalk over stylus of a right arm were drawn with the sheet turned one way and then the other. In these studies Michelangelo's anatomical interests are evident in the close observation of the shifts in the muscles and tendons of the arm and hand, each one studied from different positions and angles. In the five studies at the top of the sheet, Michelangelo began by concentrating on the articulation of the wrist and forearm with the position of the hand only outlined. He then flipped the paper the other way around to make a study of the entire arm resting on the chest, in a pose close to that of the marble. To the left of this the arm is studied in a more upright position, and above that there is a close-up study of the right hand. Michelangelo made ten further red chalk studies from life for the right arm of the marble on the verso of the drawing in the Uffizi (Fig. 52) related, like the aforementioned Berlin design, to the 1513 contract.

The studies on the verso of Exh. No. 31 had received little critical attention before the recent catalogue of Haarlem's fifteenth- and sixteenth-century Italian drawings, and prior to this only the red chalk torso had ever been accepted as autograph.[128] The outlines and some of the internal modelling in the latter study were sketched first in a lighter toned shade of chalk, and this underdrawing was then incompletely gone over and revised with a thicker, darker stick. The use of two chalks of the same tone is paralleled in some of the Sistine drawings, while the smudgy contours and the particularized treatment of the musculature is perhaps closer to some of the Windsor red chalk anatomical studies which have been dated c. 1518.[129] The red chalk kneeling figures, drawn with the sheet turned upside down, look from their upturned gazes to be figures in adoration for a painted composition of the Crucifixion. Whether they are by Michelangelo is debatable, as the figural types and the smooth blandness of the handling of the chalk seem foreign to his normal style. The same artist probably made the pen and ink study of a kneeling nude figure, as it is closely related to the ones in chalk. The wiry pen studies of animated battling figures present an even greater challenge of attribution. They are well drawn and lively, yet they lack the volumetric quality of Michelangelo's pen contours found even in his sparest pen drawings; compare Exh. Nos 13v and 15r.

Drawings made for Sebastiano del Piombo

Michelangelo's jealousy at Raphael's success found a more positive outlet in his collaboration with the Venetian painter Sebastiano Luciani, known as Sebastiano del Piombo because of his appointment in 1531 as holder of the Papal Seal (*Piombo* = lead, the metal used for the seals). Sebastiano had arrived in Rome in August 1511 at the invitation of the papal banker Agostino Chigi who set him to work painting fresco decorations in the villa now called the Farnesina.[130] Sebastiano was a superbly gifted painter in oil, and his technical mastery of the medium is shown in the subtleties of tone, evocative description of the twilight landscape and the yielding softness of flesh in works such as the half-length *Salome* or *Judith*, dated 1510, now in the National Gallery, London, painted in the period immediately preceding his departure from Venice. The tranquil poetic harmony of Sebastiano's style, derived from the aged Giovanni Bellini and the atmospheric works of Giorgione, was not readily adaptable to the expansive compositional grandeur and forceful action of Michelangelo and Raphael. The difficulties that he faced in transforming his style to this new idiom are apparent from his timid attempt to appropriate something of the physical vigour and power of the Sistine *ignudi* in his fresco of *Polyphemus*, painted in 1511 for a ground floor chamber in Chigi's Roman villa. The stiffness

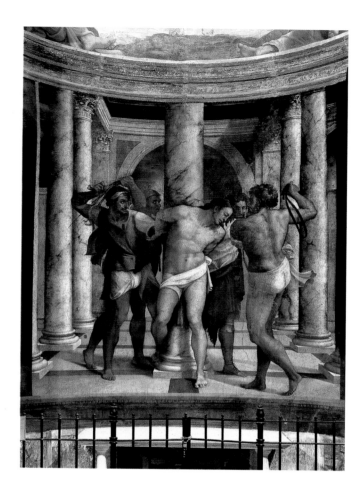

Fig. 57 Sebastiano del Piombo (1485/6–1547), **The Flagellation of Christ**, c. 1520. Oil mural. S. Pietro in Montorio, Rome

and lack of animation (not helped by his unfamiliarity with the technique of fresco) were brutally exposed by Raphael's fluent evocation of antique myth in the *Triumph of Galatea* painted in the same room a year or so later.

Sebastiano was helped out of this impasse by Michelangelo's willingness to supply him with compositional and figural designs. According to Vasari, Michelangelo's initial motive for helping Sebastiano was to combine their talents with the aim of undermining Raphael's domination of the Roman artistic scene.[131] How and when the Venetian became intimate with the isolated and diffident sculptor ten years his senior is not known. Their first collaboration occurred around 1513 when Michelangelo supplied a cartoon, now lost, for a painting of the *Pietà* commissioned from Sebastiano for the church of S. Francesco in Viterbo.[132] The huge initial gulf in their status, as well as their contrasting and complementary artistic talents, meant that Sebastiano did not arouse Michelangelo's jealousy, and as long as the Venetian painter was willing to play the subordinate role their relationship endured. Sebastiano possessed an engaging wit and charm, as can be seen from his gossipy letters keeping Michelangelo abreast of artistic developments in Rome while the sculptor was living in Florence (eg. Appendix II, no. 3, p. 295). The malicious reference to Raphael's Sistine tapestries in the British Library letter shows how Sebastiano exploited Michelangelo's dislike of his rival to ensure his continuing support. Their friendship outlived Raphael's death in 1520 but its twenty-year duration owed much to their rarely being in the same city, and they fell out irrevocably over the *Last Judgement*.

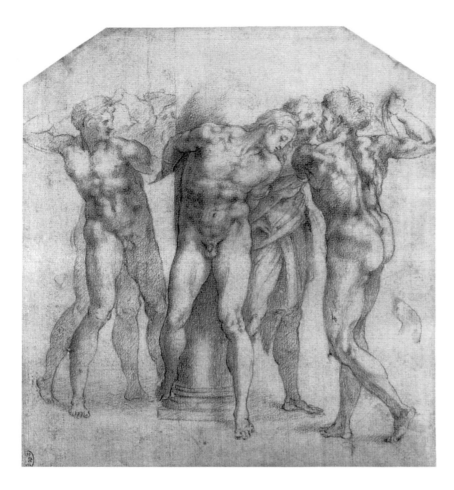

Fig. 58 Giulio Clovio (1498–1578),
The Flagellation of Christ,
after Michelangelo, *c.* 1545.
Red chalk over black chalk outlines,
20 × 18.2 cm. The Royal Collection,
Windsor Castle

The second project on which Sebastiano and Michelangelo collaborated was the decoration of a chapel in the Roman church of S. Pietro in Montorio, commissioned by the wealthy Florentine banker Pierfrancesco Borgherini. Vasari states that Michelangelo recommended Sebastiano for the job, and that Borgherini acceded in the knowledge that the sculptor would provide designs.[133] Michelangelo's involvement may in part have been inspired by his failure to honour an earlier promise to paint something for the banker.[134] The details of the work were probably agreed before Michelangelo left Rome for Florence in July 1516, while progress on the commission can be monitored with unusual precision through the letters addressed to Michelangelo from his and Sebastiano's mutual friend Leonardo Sellaio, who worked for the Borgherini bank in Rome. In the first of these letters, dated 9 August 1516, Sellaio reminded Michelangelo that he needed to send Sebastiano a drawing; Michelangelo responded swiftly and the study arrived in Rome by 16 August.[135] The 'piccolo disegno' mentioned by Vasari as having been sent by Michelangelo has not survived, but a copy of it by the Croatian miniaturist Giulio Clovio is in the Royal Collection at Windsor (Fig. 58).[136] This relates to the centrepiece of the chapel's decoration, the *Flagellation of Christ* (Fig. 57), painted on the curved surface of the wall directly above the altar.

Two autograph studies for this commission are in the British Museum (Exh. Nos 32–3), the earlier of which, executed in red chalk over stylus, shows a wider compositional field with more figures on either side, including the lightly indicated figure of Pilate in the left background. The extra figures around Christ and narrative touches in the drawing, such as the

Exh. No. 32 *The Flagellation of Christ*, 1516. Red chalk over stylus, 23.5 × 23.6 cm. The British Museum, London

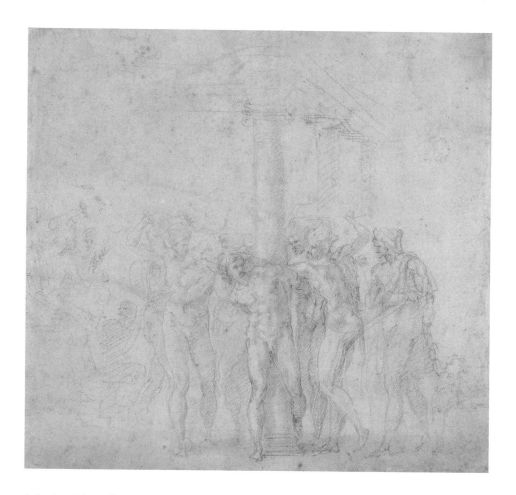

infant vainly pulling at the arm of a transfixed male spectator on the right, were dropped in favour of the far more focused treatment recorded in Clovio's copy. Michelangelo almost certainly knew the site he was designing for, as he had previously supplied a drawing in the 1490s for an altarpiece of the *Stigmatization of St Francis* for the opposite chapel.[137] Even so the fall of the shadows in the first of the British Museum studies indicates that he had temporarily forgotten that Sebastiano's painting would be lit from the entrance wall to the right. The figure of Christ in Clovio's copy, his slim build reminiscent of classical sculptures such as the *Apollo Belvedere* (Fig. 26), is closer in proportion to his counterpart in Exh. No. 32 than the more mature, thickset body of the central protagonist in the fresco. This physical transformation was instigated by Michelangelo as can be seen in his black chalk and stylus study of Christ (Exh. No. 33). This was probably drawn in the autumn of 1516 when Sebastiano was preparing the cartoon of the central mural, including modelling a small-scale clay model of Christ ('una fighurina di terra per Christo').[138]

Michelangelo's study would have been an invaluable aid to creating such a sculptural model, as his description of the muscled torso is intensely plastic. In order to help Sebastiano grasp what he was aiming for, Michelangelo deliberately adopted a style to resemble that of his friend. The Venetian character of the study, shown in the veiled softness of the modelling, is achieved through delicate stumping of the black chalk, an atmospheric style that is paralleled in some of Michelangelo's preliminary black studies for some of the figures in the Sistine chapel.[139] Despite the evidence of Michelangelo's adaptability as a draughtsman, past scholars

refused to accept that this study could be by him, despite the old attribution. Even Wilde, who championed the transfer to Michelangelo of a number of drawings previously given to Sebastiano on the strength of their link to his paintings, did not include this sheet in the 1953 British Museum catalogue, but was later persuaded by Gere and Pouncey's arguments that he had been mistaken.[140] The softness of the modelling is more pronounced in this study than in any other work in Michelangelo's oeuvre, and perhaps the most persuasive reason for accepting his authorship is the emotive power of the figure. The poignancy of Christ's suffering is expressed in the drawing with a subtlety that Sebastiano was unable quite to equal in the fresco. Christ's stoical refusal to call on his divine powers to save himself is underscored by the contrast between the physical potency of his pinioned body and the almost weary acceptance of his fate signified through the submissive, downcast position of his head. Michelangelo's incomparable ability to express different emotional states by slight adjustments to a pose can be seen from the defiance and resilience expressed in the near contemporaneous marble of the Louvre *Rebellious Slave*, a figure whose basic posture is quite close to that of Christ in the Borgherini chapel.

The murals in S. Pietro in Montorio were not completed until eight years after Michelangelo had sent his studies from Florence. One of the reasons why it took Sebastiano so long was the commission to paint an immense altarpiece of the *Raising of Lazarus* now in the National Gallery, London (Fig. 59). It was most likely Michelangelo who encouraged Cardinal Giulio de'Medici, the cousin and future successor to Leo X, to command Sebastiano in January 1517 to supply an altarpiece for his archiepiscopal church at Narbonne in France. The project had a special significance because Sebastiano's painting was intended to be the pendant to a *Transfiguration* ordered some months earlier from Raphael. This proved a shrewd pairing as Sebastiano (aided by Michelangelo) and Raphael (with his studio) strove to the utmost to outdo each other. Three drawings (two of them in the British Museum, Exh. Nos 34–5) demonstrate Michelangelo's attempts to devise the most effective pose for the key figure of Lazarus restored miraculously to life by Christ.[141] The pose of the figure in the earlier of the two British Museum studies (Exh. No. 34) is loosely based on the thematically related figure of Adam in the Sistine ceiling (Fig. 48). Two men attend to Lazarus; one sketched in with a few touches of chalk stands behind him, while a kneeling figure to the right is described with greater care. The latter's gaze was initially directed to the left, but was changed to concentrate his attention downwards on the task of removing the bands of drapery in which the corpse was shrouded. Michelangelo signalled his attempt to perfect the position of Lazarus' left foot and ankle by circling the area in the main drawing. The four slightly different studies of this detail below suggest that he had in mind to turn Lazarus slightly more frontally. His dissatisfaction with one of these is shown in his deletion of the toes with an imperious flick of the chalk.

The other study for this group (Exh. No. 35) is drawn over a small study of Lazarus begun at the top of the sheet with the paper turned the other way around. The irregular shape of both studies indicates that they must be fragments of larger drawings; in the case of Exh. No. 35 Michelangelo defined the perimeter of the composition by a vertical line. His earlier vital Lazarus has been replaced by a gaunter, sparer figure whose sharp angular pose suggests that his limbs still retain something of the cold stiffness of death. The positions of the three figures in the painting follow the drawing closely except that the gap on the right is filled by another figure (a squiggled form in the drawing perhaps anticipates this head), and the rightmost man is placed beside the tomb, not in it. The blending of the chalk modelling in the

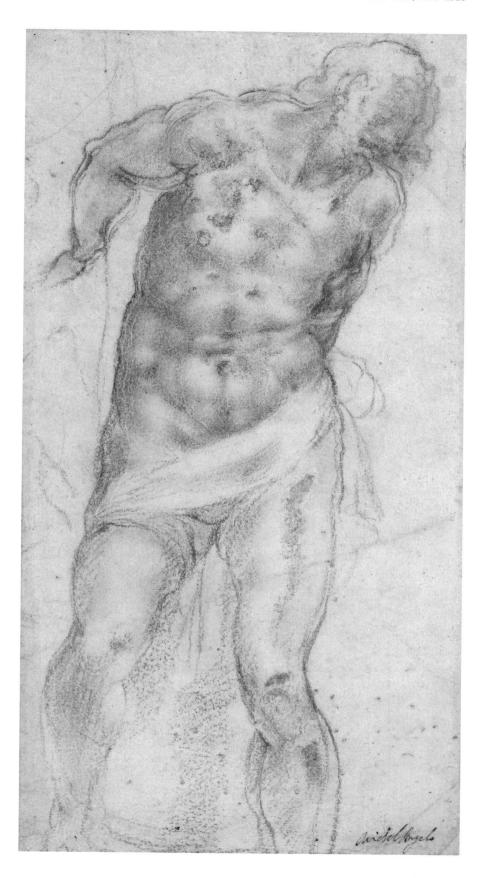

Exh. No. 33 **Christ at the Column**,
1516. Black chalk, heightened with
lead white (discoloured) over stylus,
27.5 × 14.3 cm. The British Museum,
London

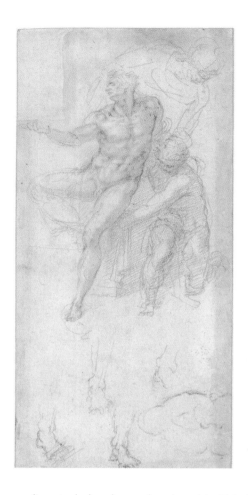

earlier study has been abandoned in Exh. No. 35 in favour of brisk parallel hatching, akin to that found in his pen studies. In all likelihood Michelangelo supplied drawings only for the group of figures around Lazarus and for the pose of Christ, although no studies for the latter survive. Vasari expressly says that Michelangelo was responsible for only part of the design, and a study by Sebastiano in Frankfurt for some of the women in the background demonstrates this to be true.[142] Sebastiano completed his painting in May 1519 and it was transported to the Vatican in December where it met with the approval of the patron (for the Venetian's letter reporting the success of his work see Appendix II, no. 3, p. 295). Raphael's *Transfiguration* was not quite complete when he died unexpectedly in April 1520. His much lamented demise invested his last work with a significance that Sebastiano's painting could not match, and it was decided that Raphael's panel should be kept in Rome at the high altar of S. Pietro in Montorio while the *Raising of Lazarus* was sent off to Narbonne.

above left
Exh. No. 34 **Lazarus**, 1516. Red and some black chalk, 25.2 × 11.9 cm. The British Museum, London

above right
Fig. 59 Sebastiano del Piombo (1485/6–1547), ***The Raising of Lazarus***, *c.* 1517–19. Oil on canvas (transferred from panel), 381 × 289 cm. The National Gallery, London

opposite
Exh. No. 35 **Lazarus**, 1516. Red chalk, the left side cut and made up, 25.1 × 14.5 cm. The British Museum, London

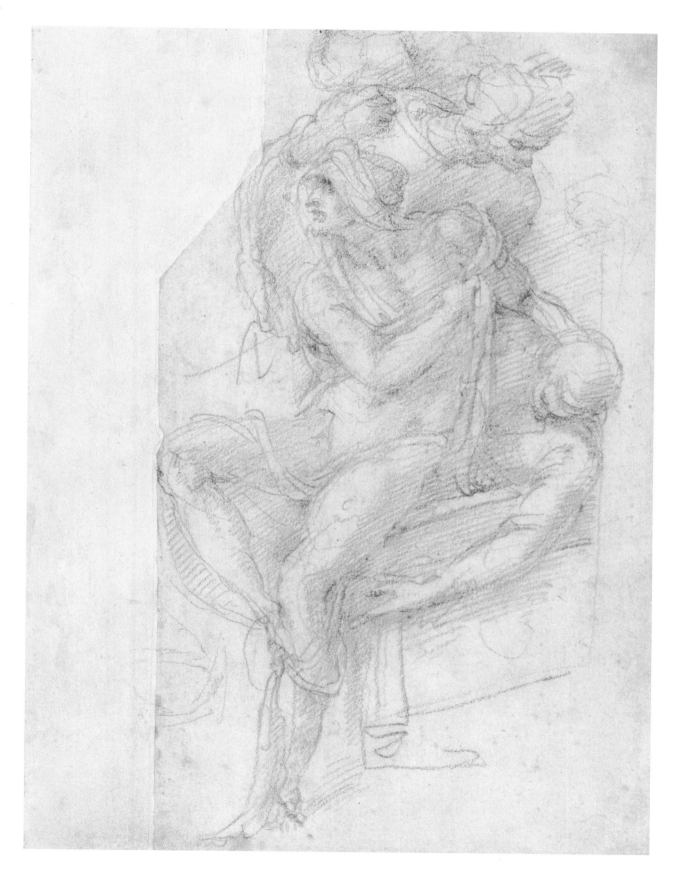

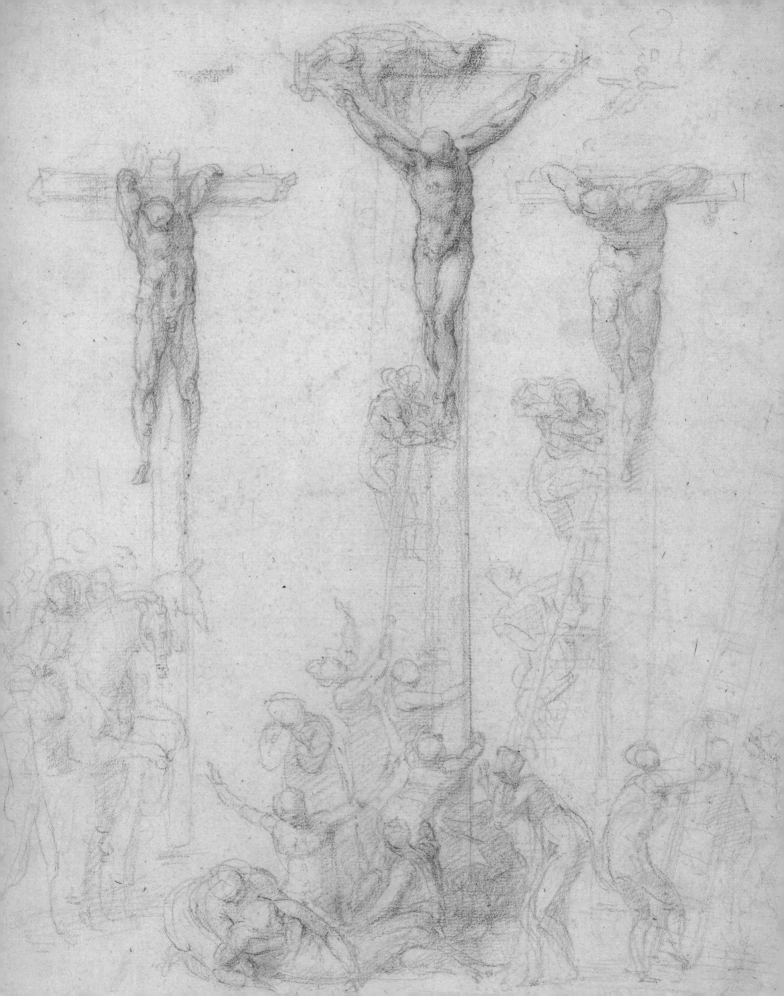

5

The Return to Florence
1516–1534

The sculptor's three-year reprieve from papal commitments ended in 1516 with Leo X's call for him to design the façade for the church of S. Lorenzo in Florence.[1] It is possible that this commission was hatched during the pope's stops in his native city in the autumn and winter of 1515–16 on his way to and from Bologna. Leo went to the Emilian city to negotiate with Francis I after the French victory over the imperial army at Marignano, and their recapture of Milan. The Medici pope's triumphal Florentine entry at the end of November had been celebrated with painted arches erected on the route, and, perhaps more significantly for Michelangelo's future project, the erection of a temporary façade made by the sculptor Jacopo Sansovino and the painter Andrea del Sarto covering the unfinished front of the cathedral.[2] At this time the Opera del Duomo also transported Michelangelo's *St Matthew* (Fig. 18) from the cathedral workshops to the courtyard of the Sala del Papa in S. Maria Novella where the pope resided.[3] The motive for this highly unusual public display of an unfinished work remains uncertain. If it was a ploy to persuade Leo to order Michelangelo's return to Florence so that he could recommence the Apostles project, it failed. It may, however, have played a part in making Leo ponder the advantages of using Michelangelo's talents away from Rome at a time when he was showering Raphael with lucrative commissions, including the highly sensitive one of designing tapestries to hang on the lower walls of the Sistine chapel. He had also chosen Raphael as the successor to Bramante in the well-paid office of papal architect, despite his negligible experience in the field.[4] The rancorous tone adopted by Sebastiano when referring to Raphael in his letters addressed to Michelangelo in Florence, gives a flavour of the poisonous atmosphere that Leo may have hoped to ease by engineering the sculptor's removal.[5] These practical considerations aside, the commission to clad the rough stone frontage of S. Lorenzo with marble would have been an appropriately grandiose way of honouring Leo's election as the first Florentine pope.

The project was also an expression of the dynastic continuity of Medici patronage. The family's involvement in the rebuilding of the church of their ancestral quarter began at the beginning of the fifteenth century, when Giovanni di Bicci de'Medici played a key role in its early development. The church took on even greater importance when Giovanni di Bicci's son, Cosimo, demonstrated his wealth and piety by taking the unprecedented step of organizing and financing its construction in the 1440s.[6] Condivi, followed by Vasari in the second edition of the *Lives*, claims that Michelangelo was forced to cease work on Julius' tomb in Rome but was promised he would be able to continue in Florence. This account has to be read in the light of Michelangelo's later campaign to clear his name over the tomb. In view of his subsequent single-minded pursuit of control over the façade, it is more than likely that he needed little persuasion to take on such an ambitious and lucrative undertaking. It is

perhaps significant that as early as June 1515 Michelangelo was anticipating soon entering Pope Leo's service.[7]

Michelangelo was free to break the terms of the 1513 tomb contract forbidding him to accept new work because the power of Julius' heirs had waned. Francesco Maria's refusal to fight the French invasion with a papal force under the command of Lorenzo de'Medici (the son of Michelangelo's former patron Piero and Leo's nephew) provided an ideal pretext for Leo to turn against his former ally. A Papal Bull of March 1516 stripped him of his dukedom, and his lands and title were handed to Lorenzo de'Medici. The deposed duke and duchess, along with the dowager duchess Elisabetta Gonzaga, were forced into exile in Mantua. Julius' executors had little choice but to accept a renegotiated contract concluded on 8 July 1516 that permitted Michelangelo to work in Florence, Pisa or Carrara on a scaled-down version of the monument. The 1513 contractual deadline of seven years was also extended by a further two years.[8] The same month Michelangelo was briefly in Carrara to select marble for the tomb, and he returned there in September for a period of almost a year. Despite his promise to keep working on the Julius monument, his attention inexorably shifted to the challenge of the new commission.

Michelangelo's competitors for the Medici project were, according to Vasari, the Florentine architects Baccio d'Agnolo, Andrea and Jacopo Sansovino, Antonio da Sangallo the Elder and Raphael. Surviving drawings also demonstrate that Michelangelo's old friend Giuliano da Sangallo had tried to secure the commission before his death in October 1516. The same month the project was awarded jointly to Michelangelo and the architect and wood-

Exh. No. 37 Bernardo della Volpaia (1475–1521/2), **The Codex Coner: details from the Arch of Constantine, and the Forum of Nerva, Rome**, finished c. 1515. Pen and brown ink, and brown wash, 23.5 × 16.8 cm and 23.2 × 16.8 cm. Sir John Soane's Museum, London

carver Baccio d'Agnolo. The two of them were summoned by Cardinal Giulio de'Medici's treas-
urer, Domenico Buoninsegni, to a secret meeting with the patrons at Montefiascone on the
shores of Lake Bolsena.[9] They were asked to pretend that the summons had nothing to do
with the façade, in order not to incur the opposition of 'the friend you know or other friends
of his', probably a veiled reference to Raphael and his faction at court. This proposed meeting
never took place, and Michelangelo was only finally persuaded to discuss his ideas for the
church in a brief visit to Rome in mid-December. As the façade was intended from the outset
to be liberally embellished with sculptural reliefs and free-standing figures in niches, the pair-
ing of Baccio d'Agnolo, a seasoned architect who had designed a number of Florentine
palaces, with a relative novice in the field, but an expert sculptor, made sound practical sense.

Michelangelo's desire to improve his architectural knowledge is shown by his copying
from a pattern-book of classical details (Exh. No. 37).[10] This volume, now in the Soane
Museum in London, was long thought to be the work of a sixteenth-century German priest in
Rome, Andreas Coner, on account of a letter of his bound among the drawings (for this
reason it is known as the Codex Coner). Thirty years ago it was persuasively attributed on
stylistic grounds to the obscure Florentine architect Bernardo della Volpaia who is known to
have been involved in the construction of the impressive classical Roman palace, the
Cancelleria, commissioned by Michelangelo's erstwhile patron Cardinal Riario.[11] Volpaia was
from a family of clockmakers, architects, cartographers and surveyors, several of whom
corresponded with Michelangelo. These ties probably explain how the sculptor was granted

access to the volume around a year after it had been completed.[12] Giulio de'Medici's close links with the clockmaker Benvenuto della Volpaia (perhaps Bernardo's brother) and with the Sangallo family may also have facilitated this study.[13] Volpaia is known to have been in the Roman architectural circle around Bramante and Giuliano and Antonio da Sangallo the Elder, whose antiquarian interests were directed to the study and recording of ancient buildings. The Codex is a compendium of finely rendered details derived from these sources (for further information see pp. 64–7).

Fig. 60 Bernardo della Volpaia (1475–1521/2), **The Codex Coner: details from the Temple of Vesta, Tivoli**, finished *c.* 1515. Pen and brown ink, and brown wash, 23.8 × 16.8 cm. Sir John Soane's Museum, London

The six surviving sheets after the Codex, divided between the British Museum and the Casa Buonarroti, reveal that Michelangelo's object was to extract a store of reference material of mainly profile views of architraves, capitals, bases and the like. The minimal level of detail in the copies underlines Michelangelo's view of them as a potential source of inspiration and not as a template. The profile view was the simplest and most economical method, both in terms of time and space, of recording the information he wanted. One of the British Museum pages (Exh. No. 36) exemplifies this economy, with seven simplified architraves and cornices squeezed on the recto by turning some of them on their sides. The most complete of these was based on Volpaia's study of the Arch of Constantine's architrave on the left-hand page of Exh. No. 37. Comparison between the two shows the extent to which Michelangelo left out the finer detail of the carved ornament that Volpaia meticulously recorded. The fluency of the freehand copies belies the difficulty of transforming Volpaia's mainly sectional studies into profile ones. Michelangelo's astonishing ability to picture in his mind the three-dimensional forms copied by Volpaia, underlies the effortless manner in which he was able to turn the cross-section elevation of an architrave on the left-hand side of Fig. 60 into the profile on the upper right of the recto of Exh. No. 36. His readiness to put the knowledge gleaned from the Codex into immediate practice is demonstrated on the verso. Here the column and architrave on the left taken from Volpaia's drawing of the Temple of Castor and Pollux (Fig. 61), inspired the rough sectional elevation sketch on the right related to the mezzanine level of his plan for S. Lorenzo (compare the wooden model in the Casa Buonarroti, Fig. 62).[14] The verso is of great importance in dating and authenticating this group of drawings which past critics were reluctant to accept as by Michelangelo.[15] The juxtaposition of the copy and the S. Lorenzo section in the same shade of chalk indicates that Michelangelo almost certainly copied the Codex Coner following his move to Florence, while the autograph inscriptions 'porta', 'pilastri' and two measurements at the bottom, written in the same shade of chalk as the drawings, prove beyond doubt his responsibility for the entire group.

Fig. 61 Bernardo della Volpaia (1475–1521/2), **The Codex Coner: details from the Temple of Castor and Pollux, Rome**, finished *c.* 1515. Pen and brown ink, brown wash, over stylus, 23.2 × 16.6 cm. Sir John Soane's Museum, London

Michelangelo's interest in Volpaia's drawings was almost certainly motivated by his desire to gain sufficient confidence in architecture to take sole command of the S. Lorenzo commission. This is exactly what transpired since within a year he had successfully orchestrated Baccio's removal. With the project in his control he promised his patrons in May 1517 that his design would be the 'mirror of architecture and sculpture of all Italy'.[16] Michelangelo's ruthlessness in ensuring his primacy is further revealed by a bitter letter of June 1517 sent to him by the sculptor Jacopo Sansovino. The latter denounced Michelangelo's duplicity after he had heard from a third party that he had been cast aside as a potential collaborator in favour of the young Baccio Bandinelli.[17] Paradoxically, within a few years Michelangelo was back on good terms with Sansovino, while Bandinelli became one of his most hated rivals. The enmity between the two arose from Bandinelli being assigned a colossal block of marble from which Michelangelo had long wanted to carve a *Hercules* as a pendant to his *David*, and was exacerbated by the younger sculptor's devotion to the Medici.[18]

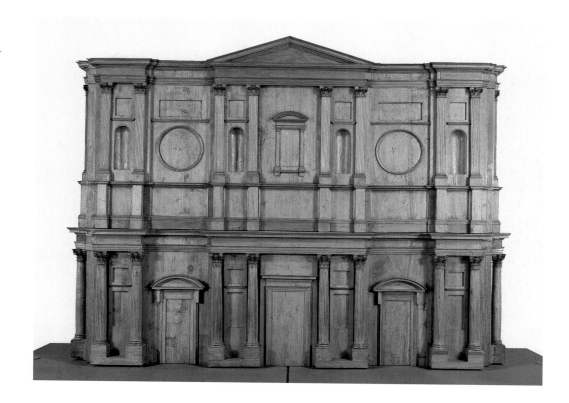

Fig. 62 **Wooden model for the façade of S. Lorenzo after a design by Michelangelo**, *c.* 1518. 216 × 283 cm. Casa Buonarroti, Florence

Progress on the commission was slow, with the final form of the design, represented by a wooden model (Fig. 62), only agreed between patron and artist in January 1518.[19] The proposed three-storey marble structure with the central section topped by a pediment would have been an imposing and impressively grandiose introduction to the church, the towering whiteness of the marble a dazzling addition to a city dominated by palaces constructed from the sober local *pietra forte*. Its purity would also have contrasted strikingly with the polychrome marble façades of earlier buildings, such as the Baptistery and S. Maria Novella. Although the scale and decoration of the proposed façade were far grander than the church it fronted, Michelangelo's design discreetly echoed the building's traditional triangular silhouette. Michelangelo planned for the façade to be richly embellished, like the Julius tomb, with sculpture in marble and bronze. This comprised six statues on each of the three sides of the tripartite structure; two circular reliefs at the upper storey of the lateral bays; and five rectangular ones. Only a pontiff as recklessly extravagant as Leo would have sanctioned such a project, the costs hugely increased by its intended construction out of solid marble with monolithic columns.

The immense quantities of marble required were to come from Carrara and relatively undeveloped quarries further south at Seravezza (see map Fig. 10), in a region disputed with Lucca which Leo had decreed to be Florentine in the first year of his pontificate.[20] Michelangelo's experience meant that his services were much in demand in exploiting this new resource, one which had the potential to fulfil the city's needs (hence the involvement of the Opera del Duomo) and to export supplies to other architectural projects like St Peter's. The copious correspondence from the period 1516–20 details the formidable logistical problems that Michelangelo had to overcome in his quest, as he put it, to 'domesticar questi monti' ('tame these mountains').[21] To this end Michelangelo organized a team of stone workers from

Settignano to work in the new quarries. He also had to oversee the construction in 1518 of a road to allow the blocks to be transported from the mountain to the sea where they could be loaded on boats bound for Pisa. His letters written at this period graphically recount the troubles he encountered in this undertaking: nearly losing his life when a column broke free, killing one of his workers; his desperation at the lack of rain during the winter months of 1518 that prevented the barges sailing upriver towards Florence; and the loss of months of labour when a precious column shattered because a poorly forged iron ring snapped.[22]

Michelangelo needed to find a suitably large area in Florence to store the hundreds of blocks for S. Lorenzo and for Julius' tomb (as regards quarrying the two commissions at this period are nearly impossible to distinguish). In 1518 he purchased a sizeable plot of land in the via Mozza (now via S. Zanobi) on the city's north-west edge, and here he built a studio that was substantially finished by March the following year. With the façade's foundations completed and shipments of marble beginning to arrive, Michelangelo was told in September 1519 by Cardinal Giulio de'Medici that he was to stop work. In March 1520 the contract was annulled.[23] Perhaps the chief reason for this sudden cessation was the parlous state of papal finances. A contributory factor may have been Leo's alleged irritation at Michelangelo's slow progress due to his refusal to delegate work to a studio of skilled assistants.[24] Vasari, in his biography of Bandinelli in the 1568 edition of the *Lives*, alleged that Domenico Buoninsegni engineered Michelangelo's dismissal, in revenge for the sculptor having rebuffed his scheme to defraud the Medici over the cost of the work.[25]

According to the testimony of one of the canons of S. Lorenzo, it was the death of the papal nephew Lorenzo, duke of Urbino, in early March 1519 that was instrumental in the Medici's decision to divert Michelangelo's energies to the New Sacristy or Medici chapel, a considerably smaller and less expensive undertaking.[26] The advent of this new commission driven forward by Giulio, the archbishop and *de facto* ruler of Florence, marked the end of Michelangelo's involvement in the façade. The façade project was never revived in spite of the continuing arrival over the next two years of marble intended for it at his studio.[27] Michelangelo was understandably disappointed by the cancellation, and in a draft of a letter, probably intended for Buoninsegni, he itemized what could never be recouped from the debacle including the loss of three years, and the 'vitupero grandissimo' ('enormous insult') to his reputation.[28] His efforts had not been entirely wasted, as the foundation of a studio in Florence and the organization of a reliable team of quarrymen and marble transporters were to prove of great practical importance for the Medici chapel. Equally, it had provided him with his first taste of large-scale architectural design, and this experience, especially regarding the successful integration of architecture and sculpture, was invaluable for the new project.

During the period when the sculptor was still engaged on the façade commission, he found time to work on the marble *Risen Christ* for the church of S. Maria sopra Minerva in Rome. This was the second version of a statue commissioned back in 1514, the first one having been abandoned due to a flaw in the marble. After a number of badgering letters from one of its patrons, Metello Vari, work on a new block began in 1519 and was finished two years later.[29] By contrast, he had made little progress on the Julius tomb, except perhaps to begin work on the four unfinished *Slaves* now in the Accademia, despite repeated encouragement from his friend Leonardo Sellaio. The latter had been entrusted with looking after the Roman studio (his letter in spring 1517 engagingly reports a crop of broad beans, peas and salad growing in the sculptor's vegetable garden).[30] As Michelangelo's Roman representative he had the less pleasant task of liaising with Julius' executor, Leonardo Grosso della Rovere.

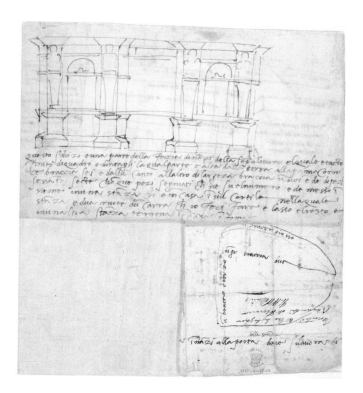

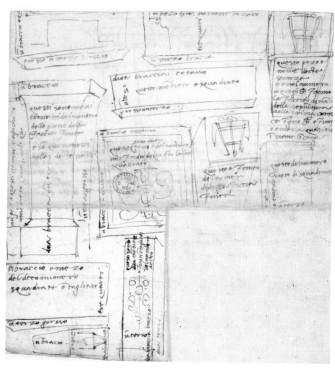

Exh. No. 38 Recto **Elevation of the lower storey of the Julius tomb**, 1518. Pen and brown ink, the lower left quarter of the sheet made up, 26 × 23.8 cm. The British Museum, London

above right
Exh. No. 38 Verso **Pieces of the lower storey of the Julius tomb**, 1518. Pen and brown ink, the lower right quarter of the sheet made up, 26 × 23.8 cm. The British Museum, London

This put him in the onerous position of being personal guarantor to the cardinal of Michelangelo's progress. He attempted to impress the awkwardness of this on the sculptor in a letter of November 1518, but this does not seem to have moved Michelangelo to return to work on the tomb.[31]

A double-sided pen drawing in the British Museum (Exh. No. 38) shows how much of the lower storey of the tomb's architectural framework had been completed before Michelangelo's departure to Florence in July 1516. The drawing was evidently made in response to Sellaio's request in February 1516 for a sketch of the monument's façade, if there were not time to provide a notebook with measurements of the individual elements.[32] It may well be a copy or draft, rather than the one sent to Rome, as the two pieces reunited in 1947 can both be traced back to the Casa Buonarroti (for the drawing's provenance see Appendix I, p. 287).[33] In the inscription below the sketch, Michelangelo recorded that the monument was made up of sixty-seven pieces and measured six *braccia* high from the ground to the first cornice and was eleven *braccia* wide (for the entire text see Appendix II, p. 294). His notes record that the pieces had been laid out in his house in Rome in a room off the courtyard containing two wagon wheels, and that the remaining parts of the tomb could be found in another ground floor space.[34] The drawing is an accurate record of the architectural elements that had been sculpted by Antonio da Pontassieve under Michelangelo's direction in 1513–16, except for the herms which were executed only when the monument was erected in the early 1540s. Michelangelo presumably added them to make the structure more comprehensible to a layman like Sellaio. He filled the rest of the sheet with diagrams of the remaining parts of the tomb with indications of their size and state of finish. A number of the pieces sketched on the verso can be identified in the finished work in S. Pietro in Vincoli (Fig. 55), such as the blocks decorated with flaming torches in the upper right which are two of the four reliefs located beside the herms on the lower storey of the monument.

The lower part of the tomb had been assembled for a visit in April 1516 of Elisabetta Gonzaga, the widow of Guidobaldo da Montefeltro, arranged by Cardinal Leonardo Grosso della Rovere.[35] She was in Rome on a doomed mission to persuade the pope to lift the charges against Francesco Maria della Rovere.[36] Her trip to Michelangelo's studio was significant since she would have seen there the *Moses*, and the two almost completed *Slaves* (now in the Louvre). Her report of these figures to Francesco Maria on her return to northern Italy in June, as well as of the almost finished state of the lower part of the structure, probably explains his fierce opposition to Michelangelo's suggestion in the mid-1520s that he should scrap these monumental sculptures in favour of a much more modest wall tomb.[37]

The project that was to preoccupy Michelangelo for a substantial part of his remaining time in Florence was the Medici chapel, a building also known as the New Sacristy because it mirrored Brunelleschi's Old Sacristy on the other side of S. Lorenzo. The latter building, completed in 1428, had a variety of functions. It served as sacristy or vestry (the place where sacred vessels and ecclesiastical vestments were stored); and as a burial chapel for the Medici, with the handsome *all'antica* marble tomb of the patron, Giovanni di Bicci, and his wife, fitted modestly beneath a marble vesting table in the centre. (Cosimo's sons, Giovanni and Piero, were also interred there in a sarcophagus by Verrocchio located in an arched opening cut in the wall between the transept.) Michelangelo's building on the north side of the church was, by contrast, designed solely as a funerary chapel where continuous services and prayers were to be offered on behalf of four members of the Medici: the *Magnifici*, Lorenzo the Magnificent, and his brother Giuliano, assassinated during the Pazzi conspiracy of 1478 (respectively the fathers of Leo X and his cousin, Giulio, later Clement VII); and the *Capitani*, Lorenzo's youngest son Giuliano, duke of Nemours and captain general of the church, and his eponymous grandson, captain general of the Florentines and briefly duke of Urbino.[38] The death of the latter aged twenty-eight in 1519 did not quite extinguish the dynastic aspirations of Leo and Giulio's branch of the family, as both *Capitani* had supposedly fathered illegitimate offspring. However, the duke of Urbino's passing did make Leo the last direct adult descendant of Lorenzo the Magnificent. The commissioning of a magnificent chapel by Leo and his cousin, modelled on Brunelleschi's, to honour their fathers was a richly symbolic way of marking the continued distinction of the family. There was even discussion in 1524 that space should be found in the chapel for Leo and Giulio to be buried there, a plan that was abandoned for want of space.[39]

The seamless continuity of the family's patronage is manifested by the manner in which the chapel's exterior blends in with the fifteenth-century church. The contextual nature of the external architecture, and its sometimes awkward relationship to the interior (seen most clearly in the semi-blocked up windows below the dome), has led some critics to suggest that the building was planned or partly built before Michelangelo came to it.[40] This is contradicted by both documentary evidence and contemporary testimony showing that he was in charge of the building work from the outset.[41] A crucial piece of evidence was the discovery of a memorandum in the Capponi archive detailing the history of the chapel and the Laurentian library composed by the canon, later prior, of S. Lorenzo, Giovanni Battista Figiovanni, who had been delegated by Giulio de'Medici to oversee the work.[42] The canon's reminiscence that Michelangelo was there right from the project's outset in November 1519 cannot be dismissed, since he had good reason to remember the start of his fractious relationship with someone whom he memorably described as 'quale Iob pazienzia havuto non harebbe con quello un giorno ('someone with whom Job would not have had patience with for a single day').[43]

Michelangelo's first surviving drawing for the scheme probably dates from soon after November 1519. It is a rough red chalk ground plan in the Casa Buonarroti showing five tombs, two in the side bays of the lateral walls and one in the centre of the entrance wall, executed on the back of a stonemason's estimate of the cost of reproducing the stonework in the Old Sacristy.[44] The inclusion of a fifth tomb in the design is puzzling. It may have been for Cardinal Giulio, although it anticipates by a year his expressed wish to be buried there. The costing has been interpreted as evidence that the Medici wanted the chapel's interior to mirror the old one, but a more prosaic explanation may be that it was done to provide a rough idea of the expense of the *pietra serena* elements in the new building.[45] Although Michelangelo's building became progressively less like Brunelleschi's, it did echo its quattro-cento counterpart in size, the use of Corinthian pilasters at the lower level and the archetypical contrast between the grey stone against the white stucco. The austere, unclut-tered nature of the chapel's marble decoration ostensibly seems to chime in with the purity of the previous interior; but this is misleading, as it is largely a consequence of it being left unfin-ished when Michelangelo left Florence in 1534, and Vasari's subsequent reorganization.

The death of Raphael in April 1520 left the way open for Michelangelo's return to Rome. However he ignored Sebastiano's fervent appeals and stayed in Florence, his preference swayed perhaps by the greater opportunities on offer there for his preferred occupation of sculpting, and the protection it afforded, with a Florentine on the papal throne, from being threatened by Julius' heirs. Due to Giulio de'Medici's frequent presence at the papal court from 1520 onwards, Michelangelo's plans for the chapel can be monitored to some extent through interpreting the letters that he received (and filed away) from Rome, commenting on drawings and written descriptions that he had dispatched from Florence. The earliest in the sequence dates from the end of November 1520 with news that the cardinal had received a study for the chapel with a free-standing four-sided tomb in the centre (see Exh. No. 39).[46] The worked up design (*modello*) mentioned in a letter of the following month is now thought not to relate to the Medici chapel, but to another project that Michelangelo had undertaken for the family: windows in a newly constructed part of their palace.[47] In the first half of April 1521 the sculp-tor was in Carrara ordering marble, and while there he was informed that the *pietra serena* membering in the lower storey had begun to be put up.[48] This was a crucial moment because it defined the area to be filled by the marble architectural and sculptural elements.

The stone he had ordered from Carrara began to arrive in Pisa in August 1521, but Leo X's death two months later and the election of the Utrecht-born Adrian VI impeded progress.[49] Giulio's finances were limited because he could no longer call on papal funds, and Michelangelo was preoccupied by renewed pressure from the della Rovere following the restoration of Francesco Maria's dukedom in March 1523.[50] Michelangelo rejoiced when Giulio de'Medici was elected as Clement VII in November 1523 following Adrian's death in September.[51] He left for Rome to consult with Clement in December, and returned with instructions to proceed with the chapel and to begin designing a library in S. Lorenzo. This was the realization of a plan, first mooted in 1519, to house the superb collection of manu-scripts and books assembled by Cosimo and Lorenzo de'Medici.

The new commission slowed Michelangelo's progress on the New Sacristy, especially as Clement's avid hunger to be kept abreast of developments through letters and drawings imposed an added burden. Nevertheless, Michelangelo heeded the advice of his closest ally at Clement's court, Giovan Francesco Fattucci, a chaplain of Florence cathedral, and of Sellaio, to 'always send drawings of what you are doing to please the pope'.[52] The exchange of letters in

the first three years of Clement's reign was often as frequent as every couple of days.[53] Such letters may have offered the highly cultivated pontiff a brief respite from the deepening political crisis. Alarmed by the Hapsburg emperor Charles V's stranglehold of Italy after his army's rout of the French and capture of Francis I at the Battle of Pavia in January 1525, Clement had joined Venice in forming an alliance against him. The diversionary pleasures afforded by these bulletins is captured by Fattucci's description of Clement reading five or six times to himself, before reading it out aloud to his court, the sculptor's suggestions for an inscription over the door of the Laurentian library.[54] Six weeks later in June 1526 Fattucci recounted that the pope had told him that the sculptor should proceed with the various works in S. Lorenzo as he saw fit (an expression of confidence frequently encountered in the replies from Rome). He added that the pope admitted that he wanted to be informed of progress because it gave him such great pleasure ('ne piglia piacere grandissimo').[55]

Clement's sympathetic understanding of Michelangelo's complex nature derived from a uniquely long familiarity with the artist, three years his senior, that began in the late 1480s when they were both members of Lorenzo de'Medici's household.[56] His admiration for Michelangelo frequently led him to ask too much: exemplified by Fattucci's letter of October 1525 detailing the pontiff's request for designs of a double tomb for himself and Leo; a ciborium to house Lorenzo the Magnificent's collection of urns and relics over the altar of S. Lorenzo; and a colossal statue by the church.[57] The last suggestion prompted a sarcastic flight of fancy from Michelangelo, and in his reply he suggested that the gigantic figure could house the square's existing barber shop, and have room for bells in his hollowed head so that he would seem to cry for mercy when they were rung.[58] The pope clearly took the hint and the plan was shelved, but it is perhaps a sign that Michelangelo at the age of fifty had begun to feel that his energy was not limitless. Twenty years earlier he had dreamed of sculpting a colossus of even greater scale from a marble mountainside at Carrara.[59] In 1523 he had complained to a friend that after a day's work he needed four to recuperate.[60] The substance of the letter concerns Michelangelo's acceptance of a request to create a small work for a cardinal (see Exh. Nos 71–2), and his admission of failing physical powers may have had more to do with dampening expectation of a speedy fulfilment of this obligation than with providing an accurate picture of his health.

In the early months of 1524 a full-size wooden model of one of the ducal tombs was built as a guide for the team of around twenty stone-carvers hired to execute the architectural and ornamental work in marble. For much of the rest of the year Michelangelo was occupied with creating same-size clay models of some of the tomb's figures (one of which, a *River God*, survives in the Casa Buonarroti; Fig. 68).[61] Over the next three years Michelangelo was busy overseeing the shifting roster of carvers employed on the two S. Lorenzo projects, and his own work on the chapel's marble figures. By mid-June 1526 Michelangelo reported that work on one of the ducal tombs was well advanced, generally agreed to be the more finely worked monument to Lorenzo.[62] In the same letter he added that in a fortnight he would begin work on the other *Capitano*, and that of the eleven figures he intended to carve personally (the two dukes, four allegorical figures on the sarcophagus lids, four River Gods and the Virgin and Child) he had started six. Clement was anxious for him to press on and asked more than once that he delegate some of the carving.[63] The pope's priorities were shown when he directed work on the library to be halted as military expenses forced him to cut his spending in the summer of 1526. Clement was at the same time exerting pressure on Francesco Maria to accept a pared down design for the Julius tomb.

Clement's financial woes were linked to the steadily worsening political situation. The ineffectiveness of the League of Cognac, an alliance between the papacy, Venice and France, as well as Rome's vulnerability, had been brutally exposed by the plundering of the Vatican by the forces of Charles V's Roman allies, the Colonna, in September 1526. Clement's dawning realization that the French king had no intention after the Battle of Pavia of returning to the fray in Italy placed him in a desperate situation. The French ambassador wrote of him in August 1526: 'I was with his Holiness yesterday, and I do not think that I ever before saw a man so distracted, depressed and careworn as he was. He is half-ill with disappointment.'[64] The military campaign in northern Italy was another cause of deep pessimism, as the League's commander, Francesco Maria della Rovere, was reluctant to commit troops to attack the imperial army because his overriding priority was to protect the Venetian Republic which employed him. Clement's hope that the disparate states of the peninsula would find common cause in his campaign had been dashed by the opportunism of shrewder leaders, such as Federico Gonzaga, marquis of Mantua, and Alfonso d'Este, who foresaw an imperial victory.

By the spring of 1527 the almost unchecked southward progress of the imperial army commanded by the duke of Bourbon threatened Florence. The city was a rich prize for troops that had not been paid for many months, and its capture was seen as a powerful political lever with which to force Clement's hand. Opponents of Medici rule in Florence, mindful of the parallels with the situation in 1494, took over the Palazzo della Signoria and declared Florence a republic on 26 April 1527. Their action proved premature, and the coup lasted a single day because della Rovere and his army were on hand to protect the city.[65] It was during the disturbances on the so-called *Tumulto di Venerdì* (Friday Rebellion) that a bench thrown from the window of the palace broke the left arm of Michelangelo's *David*. Vasari later claimed it was he and his fellow painter Francesco Salviati who saved the pieces from being trampled underfoot in the square below.[66] Michelangelo clearly expected further trouble, as three days later he allowed his *piagnone* friend Piero di Filippo Gondi to secrete certain family belongings in the relative security of the locked New Sacristy.[67]

The imperial army advanced to Rome, and at first light on 6 May they stormed the city. Bourbon's troops rampaged through the streets killing, raping, robbing and holding to ransom its terrified inhabitants. The sizeable contingent of German Lutherans in the imperial ranks wantonly defiled and pillaged churches, among them St Peter's, where 500 men were reportedly slaughtered at the high altar, its tombs smashed and its ancient relics stolen. Clement only just escaped to the relative safety of the ancient fortress of the Castel Sant'Angelo where he remained besieged, and at risk from the plague that had gripped the city, until he finally surrendered a month later on 7 June. Sebastiano joined his papal master in this refuge, and some measure of the lingering psychological effects from the horrors of the Sack of Rome can be appreciated from a passage in a letter written four years later to Michelangelo: 'Ancor non mi par esser quel Bastiano che io era inanti el sacco; non posso tornar in cervello ancora' ('I still seem unable to be that Sebastiano that I was before the sack, and I am still unable to think properly').[68] Clement remained for a further seven months a captive in Rome until the imperial commanders, anxious to encourage the troops to withdraw from the ravaged city, allowed him to escape to Orvieto in early December 1527.[69]

News of Rome's sack reached Florence on 11 May and a week later Filippo Strozzi negotiated with Clement's deputy, Silvio Passerini, the bishop of Cortona, to leave the city peacefully with the two Medici bastards: the sixteen-year-old Ippolito de'Medici (son of Giuliano, duke of Nemours) and his near-contemporary Alessandro, said to be Lorenzo, duke of Urbino's child,

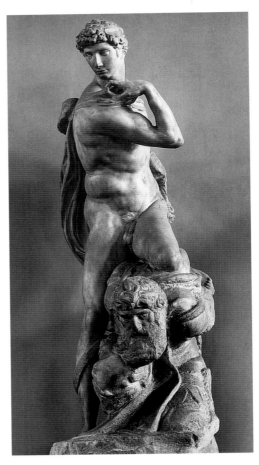

but widely rumoured to have been fathered by Clement. The city returned once more to the system of government in place when the Medici were expelled in 1494, and the Florentine patrician Niccolò Capponi was elected *Gonfaloniere* at the end of May. His moderate views were not shared by the new wave of radical young *arrabbiati* who ushered in a period of intense hostility to the Medici. This was manifested in the denunciation of those still loyal to the family, and the destruction of their arms throughout the city, even in churches such as S. Lorenzo.[70] In this atmosphere it would have been unwise for Michelangelo to keep working on Medici projects even if he had wanted to. In the event he showed no loyalty to his former papal patron and eagerly embraced the republican cause. Perhaps the most famous instance of Michelangelo's show of disrespect to the Medici is reported twice in the *Storia Fiorentina*, an unfinished work by Benedetto Varchi begun at the request of Duke Cosimo in the 1540s but not published until the eighteenth century. Varchi guardedly describes how he has heard tell, but had been unable to confirm, that Michelangelo suggested that the Medici palace should be razed to the ground and replaced by the *piazza dei muli* (the square of mules), a play on the other meaning of *mulo* to denote a bastard – an allusion to the pope and his younger relations' illegitimacy.[71] Varchi clearly could not resist recounting such a memorable insult from one of Florence's most famous sons, yet his prevarication suggests his disinclination to stir up too vigorously the spectre of Michelangelo's old anti-Medicean feelings in a work commissioned by Duke Cosimo, not least because he too had been a long-standing republican.

above left
Exh. No. 41 Verso **Vases; a male nude (*Victory*); portions of a sonnet**, *c.* 1520–1. Black chalk, 29.7 × 21 cm. The British Museum, London (recto illustrated on p. 172)

above right
Fig. 63 ***Victory***, *c.* 1519–34. Marble, h. 261 cm. Palazzo Vecchio, Florence

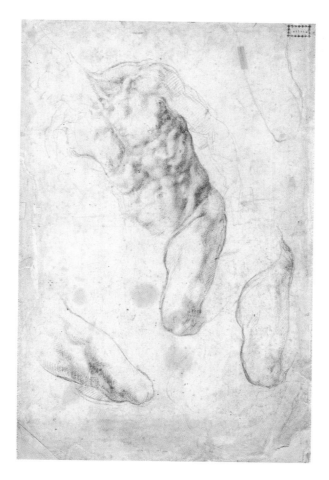

Exh. No. 10 Verso **A male nude** (**Victory**), c. 1527–30. Black chalk, the contours traced with a stylus, the lower corners made up, 40.4 × 25.8 cm. The Teyler Museum, Haarlem (recto illustrated on p. 83)

The brief presence in Florence of the murderous Francesco Maria della Rovere after the *Tumulto di Venerdì* may well have galvanized Michelangelo to return to the Julius tomb.[72] The duke may have taken the opportunity to meet the sculptor for the first time, although there is no documentary evidence of any such encounter. The suspension of Medici commissions during the three years of the Florentine Republic gave Michelangelo time to work on other projects. Earlier in the decade he may have begun the four *Slaves* for the lower part of the tomb (Accademia, Florence).[73] The chronology of these marbles is much contested, and the only certain fact about them is that they were executed in Florence and abandoned unfinished there in 1534. After Michelangelo's death his nephew diplomatically presented them to Duke Cosimo, and they were later placed in a grotto in the Boboli gardens. Part of the same gift was the more fully realized marble figure of *Victory* (Fig. 63; Palazzo Vecchio, Florence) also left behind in his studio. The most likely period of execution for this work was during these same years.[74] The *Victory* was almost certainly intended for the lower storey of the Julius tomb flanked by bound *Slaves*, as the garland on his head seems to be made of stylized oak leaves, a familiar device of the della Rovere.[75] A very schematic study in black chalk of the main figure's pose from the front is found on the reverse of one of the British Museum *Capitani* tomb designs (Exh. No. 41), along with sketches of vases and a fragmentary love sonnet ('Di te me veggo e di lontan mi chiamo'; for a translation of the whole poem see Appendix II, p. 294).[76] Michelangelo also made a life drawing in the same medium for the marble on the reverse of a much earlier *Bathers* nude in Haarlem (Exh. No. 10). Even though

the marble was intended for a niche and could not have been seen from the side, Michelangelo wanted to work out the dynamics of the pose from all angles before working on the block.

In the summer months of 1527 Florence was badly hit by plague. Michelangelo's worries about the disease are expressed in a postscript to a letter sent to Buonarroto in Settignano in September warning him not to touch the paper with his hand.[77] Despite these precautions, and warnings not to come to the city, Michelangelo's favourite sibling died from the plague in July 1528. The artist's immediate reaction to this blow is unrecorded as it coincided with a thirteen-month period when none of his letters survives. It is known that in August 1528 he received a commission for a colossal sculpture of Hercules that had been planned as a pendant to the *David* back in the early days of Soderini's rule in 1506.[78] The plan had been revived in 1525 when Clement assigned the Carrara block to Michelangelo's younger rival Bandinelli to carve a figure of Hercules triumphing over Cacus.[79] Michelangelo was bitterly disappointed by Clement's insistence that he concentrate on his ongoing work at S. Lorenzo. This reverse led him to fear that the infinitely less talented Bandinelli was threatening his position, an anxiety that is indicative of the self-doubt and paranoia that could easily overtake him.[80] When the Florentine Republican government reassigned the block to him, he had to adapt his design to work around Bandinelli's preliminary efforts, as had happened before with the *David*. Two designs of Hercules vanquishing Antaeus (see Exh. Nos 62r and 63r) most probably relate to Michelangelo's thoughts for the stone in the mid-1520s. Almost forty years later, he gave a wax model he had prepared for the marble to Leone Leoni. This was a token of his appreciation of Leoni's portrait medal of him, of which there is an example on view in the London exhibition (Exh. No. 110).[81]

As with the earlier *David*, the commissioning of a pendant *Hercules* came at a time when the Florentine Republic was under threat from powerful enemies. The reconciliation between Clement and Charles V, ratified at the Treaty of Barcelona in June 1529, meant that the imperial army was committed to restoring Medici rule. Florentine opposition was stiffened by the dismissal of Capponi in April 1529 after his secret negotiations with Clement had been discovered, and his replacement with Francesco Carducci, an implacable opponent of the Medici. Meanwhile, Michelangelo had been appointed in January to serve on a committee charged with defending the city, the Council of Nine of the Militia, and three months later he was elevated to the post of governor and procurator-general of fortifications. In this capacity he organized the fortification of the hill of S. Miniato on the south side of the Arno, made designs for bastions and in June he went to inspect the citadels of Pisa and Livorno. In late July 1529 he travelled to see the famed defences of Ferrara. Duke Alfonso gave him a personal tour, and in return he finally obtained Michelangelo's promise to execute something for him. The artist returned home the following month, but around three weeks before Philibert of Orange's imperial army commenced the siege he apparently experienced a premonition that the city would be betrayed. The Signoria dismissed his fears, but this did allay his anxieties and he departed the city northwards on 21 September with his pupil Antonio Mini and two others.[82] Four days later he reached Venice, where he wrote to Battista della Palla in Florence, a staunch republican and Francophile, asking him to journey together to France. The Signoria reacted to his desertion with the decree that he and his companions would be declared rebels and their property seized. Michelangelo duly returned around three weeks later.

Florence had already been under siege for over a month when Charles V and Clement met each other for the first time in Bologna in early November. Sebastiano was also in Bologna and he planned, but seems never to have executed, a painting to commemorate their reconcili-

Fig. 64 Sebastiano del Piombo (1485/6–1547), **Clement VII and the Emperor Charles V in Bologna**, *c.* 1530. Black and white chalk on grey-washed paper, 31 × 46.2 cm. The British Museum, London

ation. His loyalty to his papal master is shown by his study in the British Museum (Fig. 64) depicting Clement dominating the youthful emperor, a propagandistic reversal of the real balance of power. The fall of Florence finally occurred in August 1530, its end hastened by the city's Perugian mercenary captain, Malatesta Baglioni, switching sides. One of the agreed terms of surrender was an amnesty, but the Medici loyalists appointed to govern the city – Baccio Valori, Francesco Guicciardini and Roberto Acciaiuoli – paid little heed to this. Prominent members of the Republic were punished, and six of them, including Carducci, were beheaded. Michelangelo's friend Battista della Palla was also imprisoned by the new Medicean regime and two years later in 1532 was found dead, presumed poisoned, in his cell.[83]

According to Vasari, Michelangelo was on Valori's list of sympathizers to be imprisoned in the Bargello but he sought shelter with an unnamed friend.[84] The artist's nineteenth-century Italian biographer Aurelio Gotti related that, according to Buonarroti legend, Michelangelo hid for several days in the bell-tower of S. Niccolò on the other side of the river from his native S. Croce quarter.[85] Figiovanni almost certainly went too far in suggesting that Valori planned Michelangelo's assassination, but after having been absolved by Clement the sculptor certainly made a concerted effort to win Valori's favour.[86] He provided him with architectural designs and presented him with a smaller than life-size marble figure, variously identified as an *Apollo* or a *David*.[87] Valori was not alone in exploiting Michelangelo's precarious position at this time to obtain work from him. The mother of Philibert of Orange, whose son had been killed just before the conquest of the city, asked Michelangelo to help design a tomb; and the imperial general Alfonso d'Avalos, marquis of Vasto, managed to get him to make a cartoon of a *Noli me tangere* in 1531, from which the Florentine artist Jacopo Pontormo made a painting as a gift for Vittoria Colonna, the marquis' cousin's widow and his adopted mother.[88]

At the same time Michelangelo repaid Medici clemency by returning to work in the Sacristy, and for the next two years he concentrated his energies on S. Lorenzo. Towards the end of 1531 Michelangelo's friends feared that overwork had caused him to become ill.

Clement tried to shield him from further demands on his energy by issuing a papal brief that threatened him with excommunication if he worked on anything aside from Medici and della Rovere commitments.[89] Michelangelo belatedly realized the impossibility of fulfilling both these undertakings, and he resolved to hand over to Julius' heirs what he had done up to that time on the tomb: the finished marbles, drawings and models along with 2,000 ducats in reimbursement. He was dissuaded from making this offer, one that might have saved him a great deal of anguish, and instead a fourth contract was drawn up in April 1532 for a smaller monument to be erected in S. Pietro in Vincoli.[90]

The revival of the Julius tomb was a convenient pretext to spend time away from the young Alessandro de'Medici, appointed head of state in 1531 and duke of the Florentine Republic the following year, whose antipathy Michelangelo feared. Alessandro's despotic rule had driven numerous republican sympathizers into exile. Among them was the merchant-banker Bartolomeo Bettini, for whom Michelangelo had made a cartoon of a Venus and Cupid in c. 1532. The painting made by Pontormo after Michelangelo's design aroused the cupidity of the duke who subsequently seized it for the Medici collection.[91] The death of Michelangelo's father in 1531 meant he had less reason to stay in his native city, and his wish to return to Rome had been increased by his meeting with a handsome young Roman nobleman, Tommaso de'Cavalieri, during an extended break from Florence in August 1532. His eventual departure from Florence, without having completed either the Sacristy or the library, was prompted by Clement's wish to have him fresco the altar wall of the Sistine chapel. He arrived in Rome on 23 September 1534, two days before the pope's death. Michelangelo never returned to Florence, despite frequent offers to end his days there (for example the 1560 letter to him from the goldsmith and sculptor Benvenuto Cellini: see Appendix II, no. 11, p. 297).

Studies for the Tombs in the Medici Chapel

The earliest drawings for the commission in the exhibition relate to Michelangelo's plan in the winter of 1520 to place all four tombs in the centre of the chapel. The British Museum study (Exh. No. 39) was cut from a larger sheet of black studies with elevations and ground plans of a centralized tomb design, of which two smaller fragments in the Casa Buonarroti were once part.[92] That they belong together can be demonstrated by virtue of a red chalk column drawn with the aid of a ruler found on the versos of all three sheets.[93] This column was drawn as a template for the woodworker responsible for the model of S. Lorenzo, completed in late 1517 (Fig. 62), as the study's measurements accord closely with those in the lower storey.[94] The artist used the untouched side of the paper three years later when he was beginning work on the Medici chapel. The merit of a single central structure was that it avoided the problem of fitting four tombs on three walls; it also echoed the central sarcophagus in the Old Sacristy.[95] The idea of a free-standing monument can be linked back to his early design for the Julius tomb, but the two schemes were in fact very different. The papal monument was conceived as a gigantic backdrop to all kinds of sculptural decoration, whereas the modest scale of the Medici tomb would have allowed only a few small-scale figures.

Michelangelo's idiosyncrasies as a designer for sculpture are demonstrated in his preference for chalk rather than pen. Most of his contemporaries, and indeed most later sculptors, favoured pen often combined with wash.[96] The pen's flexibility and responsiveness to the slightest change of pressure or direction was a considerable asset in such designs, and the

Fig. 65 **The interior of the Medici chapel from the altar**

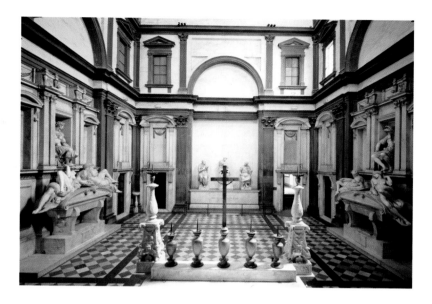

Exh. No. 39 **Studies for a free-standing tomb**, c. 1520–1. Black chalk, the upper right corner made up, 22 × 20.9 cm. The British Museum, London

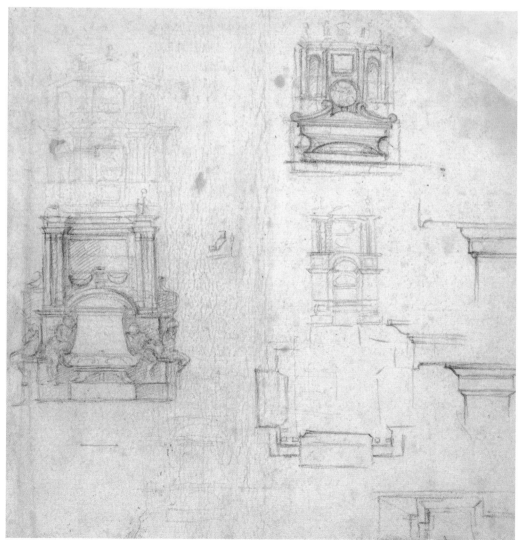

addition of washed shading helped to clarify the structure's various planes. Why Michelangelo chose to use chalk is perhaps linked to its versatility and also his impatience. It allowed him to sketch out a design very faintly, such as the octagonal structure in the upper left, which he could then choose to elaborate or not by adding lines of greater pressure. Unlike ink that required time to dry, the contours of a chalk study could be revised immediately. It is sometimes possible to glimpse Michelangelo's first draft beneath a later revision: for example, the study at the top right where the earlier outlines of the sarcophagus can be seen at a slightly lower level than the form that replaced it. Another characteristic feature of his designs of this kind is his preference for the orthogonal viewpoint with minimal perspectival recession. This brings to mind one of the aged sculptor's comments on Condivi's biography, noted down by Calcagni, relating to a passage stating that Michelangelo had dedicated himself to studying perspective and architecture. The sculptor admitted that he had neglected the former 'which seemed to me to make one lose too much time'.[97]

An unusual feature in the drawing is the inclusion of a scale, a 14 mm line corresponding to a Florentine *braccio* unit (58.6 cm or just under 2 feet) drawn between two compass points just below the most fully realized study at the lower left.[98] The tomb's size was all important as space was limited. In the lower left-hand study the tomb mixes the form of a classical sarcophagus in the lower part with a kind of wall monument capped by a segmental pediment above, a design first explored in the faint sketch to the right of the scale. By making the tomb so narrow he allowed sufficient space for smaller than life-size mourning figures to be seated on either side of it, but this was at the cost of making it too small credibly to be a repository for a body unless it was imagined as the slightly projecting end of a sarcophagus.[99] Michelangelo then sketched to the right an amendment to the upper storey, with the twinned columns reduced to a single one beside a bevelled corner. This alteration suggests that he was concerned by the block-like rectangularity of his design, and he also addressed this in the lightly sketched study in the top left corner of an octagonal structure. In the more worked-up design at the upper right the figural elements have been dropped, and instead the curving forms of an imposing sarcophagus dominate the lower part of the monument. A smaller-scale design below shows a taller triumphal arch-like structure with an end-on sarcophagus in an arched opening in the centre. Below this, he sketched a rough groundplan with a variant of the left-hand design monument and another, now truncated, below. The two drawings of a pillar supporting a cornice most likely relate to the upper storey of the design to the left, or to a similar structure.

As with Michelangelo's brilliant solution to the architectural framework of the Sistine ceiling, resolving practical restrictions that threatened to limit his powers of expression particularly fired his genius. This ingenuity is exemplified by the five variant designs for a central tomb in Exh. No. 39, and it should be remembered these constitute only half of the number on the fragments of a once much larger sheet. The concept was short lived, but Michelangelo's work on it was important in the development of his highly individualistic interpretation of the classical vocabulary.[100] For example, the curved sarcophagus lid with its elegant volutes in the upper study is an antecedent to the flipped over variant of the *Capitani* tombs; and the tension in the chapel's architecture between curved forms straining against vertical elements, seen most clearly in the remarkable tabernacles above the doors, is prefigured in the left-hand drawing in the vice-like grip of the paired pilasters on either side of the tomb's curved top.

Michelangelo subsequently returned to his first idea of placing the tombs on the walls, and the development of his ideas for the single *Capitani* and double *Magnifici* monuments can

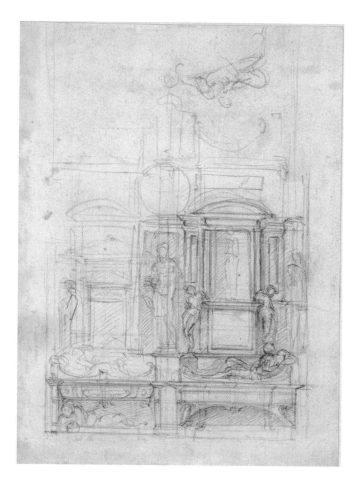

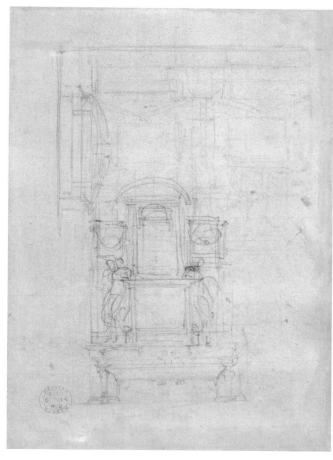

above left
Exh. No. 40 Recto **Studies for a double wall tomb**, *c.* 1520–1. Black chalk, 26.4 × 18.8 cm. The British Museum, London

above right
Exh. No. 40 Verso **Studies for a double tomb**, *c.* 1520–1. Black chalk, 26.4 × 18.8 cm. The British Museum, London

be traced in two black chalk studies in the British Museum (Exh. Nos 40–1). The study for the double tomb on the recto of Exh. No. 40 provides one of the best examples of how Michelangelo's creativity was stimulated by the actual process of drawing. The rapid evolution of his thinking is demonstrated most clearly in the metamorphosis of the left-hand niche that began as a small rectangle with a triangular pediment, to one twice as high with a segmental pediment. The architectural forms surge upwards with an unstoppable energy, their impetus reminiscent of time-lapse photographs of a seedling's ascent to the sunlight. The raising of the left-hand niche was developed further in its pair which is raised up on a square plinth flanked by mourning figures. The placement of the tombs on the sidewalls allowed greater scope for sculpture, but the figures had to be contained within the area bound by the grey stone piers. This restriction limited the space for the statues of River Gods, symbols of the territory over which the Medici had dominion. To get around this, Michelangelo experimented with using the blank space beneath the tomb with one such figure – identifiable as a River God because of the vase he leans on – included on the left. Close scrutiny shows that Michelangelo first sketched both the figures reclining on the tomb facing to the right, but he subsequently rejected this idea, and redrew the right-hand one facing the opposite direction. Other revisions to the sculptural decoration include the addition of a standing figure in the centre, as large as the representations of the deceased Medici on the tomb, drawn over an earlier thought to divide the two tombs by a column. This addition led him to squeeze a companion figure on the right. He probably intended these to supersede the smaller ones flanking the niche, because

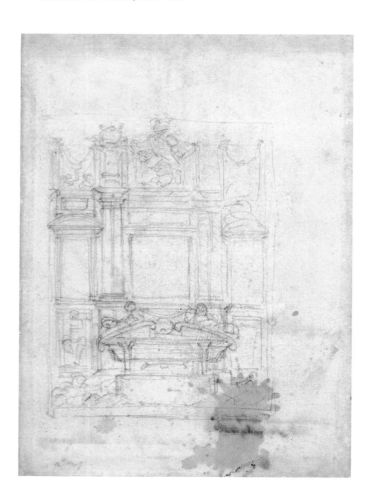

Exh. No. 41 Recto **Study for a single wall tomb**, *c.* 1520–1. Black chalk, 29.7 × 21 cm. The British Museum, London (verso illustrated on p. 164)

otherwise the disjunction of scale between the two sets of figures would have been jarring. Turning the sheet upside down he then drew a reclining figure balanced on the curved lid of a tomb, a technically challenging and entirely original feature of the finished design.

In the studies on the verso of Exh. No. 40 Michelangelo shifted the focus away from the figural sculpture that dominate the recto design.[101] He began with the sheet turned upside down in relation to the main study, by lightly drawing two tombs side by side with triangular lids. The space above them is divided by a column or pier, and on either side of this, a rectangular panel and a pair of small arched niches. He then turned the paper ninety degrees anti-clockwise to sketch a tomb with a curved segmental lid broken in the middle, a form close to that adopted for the *Capitani* monuments. The sobriety of these designs was taken up in the main study which is most likely one half of a double tomb rather than a single one, as the proportions are too narrow for a monument intended for the lateral walls.[102] The drawing is a modified version of the right-hand part of the double tomb on the other side, the two sharing in common a central niche, originally rectangular in shape and then altered to give it an arched top, below which are two figures leaning on its base mournfully looking down.

The study for the single tombs (Exh. No. 41r) must have been drawn at very much the same period as Exh. No. 40. The link between the two studies is shown by the shared motif of swags in the upper register, their looping form echoing that of the segmental pediments. While the design takes up ideas developed for the double tomb, it is significantly different in having at the centre what is presumably a blank square panel rather than a niche.

Notwithstanding the central void shown in the drawing, the figural element in the design has once more become a key element: River Gods at the lower part; seated figures at the ends of the tomb (only one of which is sketched in); reclining figures on the lids; and in the attic storey diminutive mourning figures placed on either side of a giant trophy of arms in the centre. The lateral niches in the middle tier are empty of sculptures but these must also have been intended to be filled. The classical trophy and the prominent shell at the backs of the flanking thrones would have extended the design upwards, had they been realized. The intervention of vertical marble elements to the horizontal bands of grey sandstone would have subtly modified the building, blurring the boundaries between the structural and the sculptural components of the design and making it resemble less Brunelleschi's chapel. The number of sculptures planned for each of the tombs is a further reminder that the austerity of the interior is due to it being unfinished.

Had the commission been completed as Michelangelo intended, the richness of the marble tombs would have been complemented by sculptural low reliefs in the lunettes (an element mentioned in the correspondence but never begun), and coloured gilded plasterwork of 'foliage, birds, masks and figures' in the coffered dome by Raphael's former collaborator Giovanni da Udine, left unfinished at Clement's death and later removed. The bases of the thrones were the only part of the upper section of the tomb to be completed. An even clearer idea of Michelangelo's intentions for the ducal tombs is provided by a highly finished black chalk and wash study in the Louvre, perhaps made as a finished design to win Clement's approval (Fig. 66). The neat regularity of its outlines has put off the majority of Michelangelo scholars, although the critical tide seems to be turning in favour of accepting it as auto-graph.[103] The Louvre drawing cannot be taken as an infallible guide to the finished design, as it includes some fantastical touches that would be impossible to render in marble, such as the bed of bulrushes behind the fierce River Gods at floor level.[104]

The architectural framework of the *Magnifici* tomb was hardly begun when Michelangelo left Florence in 1534, and an idea of its intended plan can be gained solely through his drawings. A double-sided study for the monument in the British Museum (Exh. No. 42) is drawn in pen and ink, a technique perhaps chosen deliberately in order to make him concentrate on the broad generalities of the design. Wilde's dating of this drawing to the same period as the black chalk tomb studies has been recently challenged in favour of a later dating when work resumed on the chapel after Clement's election in November 1523.[105] The difference in technique makes this question hard to resolve, especially when the pen study is so sketchy, but the similarity of conception between it and Exh. No. 40 favour them being from the same period. The sketchier, more unresolved design on the verso with the *Magnifici* seated above their tombs was drawn first, as is indicated by the repetition of the schematic standing Virgin on the recto that Michelangelo drew over to make her seated. In the recto the enthroned central sculpture is flanked by two standing ones, presumably the Medici saints, Cosmas and Damian.

The inscription below the design on the recto sheds some light on the much-debated issue of how Michelangelo intended the completed work to be interpreted: ('la fama tiene gli epitafi a giacere no[n] va ne ina[n]zi ne indietro/ p[er]ch[e] so[n] morti e a loro op[er]are e fermo' ('fame holds the epitaphs in position; she goes neither forward nor backward for they are dead and their work is done').[106] This refers to the lightly indicated figure of Fame seated in the centre with her arms outstretched towards the oblong panels of the podium. This figure was later dropped from the scheme to judge from a *modello* drawing known in a number of

versions, the best of which is in the Louvre (Fig. 67).[107] The two Louvre *modelli* starkly reveal how much still was to be done when Michelangelo abandoned work on the chapel. Personifications of Earth and Heaven are said by Vasari in his biography of Niccolò Tribolo, Michelangelo's collaborator in the chapel, to have been planned to flank Giuliano's effigy.[108] On a sheet of architectural studies connected to the chapel Michelangelo set down a short dialogue between Day and Night: with the two telling each other that they had brought about Giuliano's death by their swift course, but that the deceased had his revenge on them by sealing their eyes by taking his glory from the earth.[109] From this it seems that one of the chapel's themes was the notion of Fame stopping the destructive force of Time represented by the four allegorical figures on the lids of the tombs. In a celebrated but mysterious passage Condivi, whose muddled description betrays that he had never seen the chapel, added that Michelangelo was thwarted from realizing a mouse on one of the tombs to symbolize the ceaseless devouring nature of Time.[110] In truth neither duke had achieved very much in their short lives, and Michelangelo was aware that their posthumous fame would rest on his idealized representations of them. He is said to have decided against reproducing their actual features, pragmatically observing that after a thousand years no one would know what they actually looked like.[111]

The allegorical representations of Time (of which the four figures brought to various levels of finish on the ducal tombs are the only completed parts) would have been augmented by mourning figures at the top of the tombs along with symbols of their temporal power, such as the unrealized River Gods and the marble trophies currently found in the chapel's entrance hall. What the chapel lacks in its unfinished state is the overarching Christian theme that

below left
Exh. No. 42 Recto **Study for a double tomb**, *c.* 1520–1. Pen and brown ink, 21 × 16.2 cm. The British Museum, London

below right
Exh. No. 42 Verso **Study for a double tomb**, *c.* 1520–1. Pen and brown ink, 21 × 16.2 cm. The British Museum, London

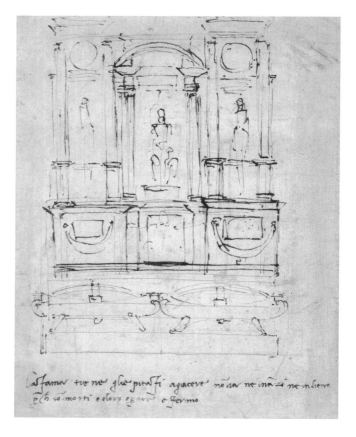

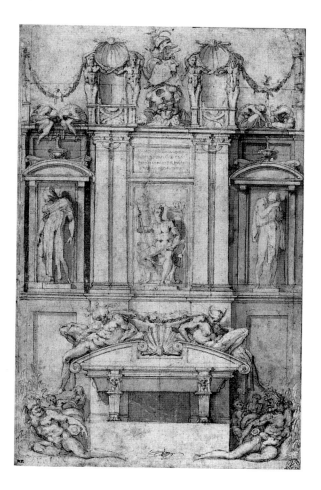

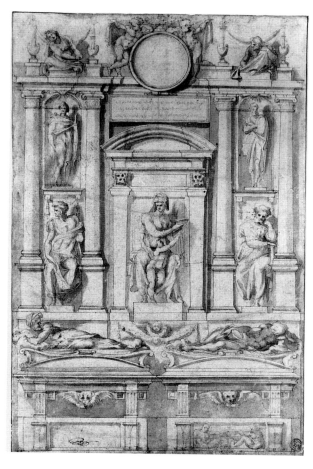

above left
Fig. 66 **Design for the tomb of Giuliano de'Medici**, *c.* 1520–1. Black chalk and brown wash, 32.1 × 20.3 cm. Musée du Louvre, Paris

above right
Fig. 67 Michelangelo or Studio, **Design for the tomb of the Magnifici**, *c.* 1520–1?. Black chalk and brown wash over stylus, 37.9 × 24.2 cm. Musée du Louvre, Paris

would have been provided by the sculptures of the *Magnifici* tomb. Had the ensemble been completed, the priest standing behind the altar would have been looking directly towards the Virgin and Child (Fig. 65) flanked by the Medici's favoured saints, Cosmas and Damian. The position of these statues explains the unexpected turn of the dukes towards the entrance wall rather than the principal altar (this visual link is marred in the chapel by the platform on which the three sculptures stand being too low). The chapel's function was to speed the souls of the deceased heavenward, and to this end in 1532 Clement ordered uninterrupted services for the dead to take place there. The belief that the Virgin was the most powerful intercessor in the soul's progress, her mercy frequently invoked in the ceaseless round of masses and recital of the psalter that continued for almost a century, explains why her statue was intended as the focal point of the interior.

Studies for the Tomb Sculpture

Having finalized the designs of the tombs by 1521, Michelangelo turned his attention to the individual figures. The most basic requirement for beginning work was a piece of marble of the requisite size. A pen sketch in the British Museum (Exh. No. 43) with measurements in his hand in Florentine *braccia* (abbreviated as *b[racci]*o in the singular or *b[racci]*a in the plural) give the dimensions of a River God intended for the lower part of the ducal tombs (see Fig.

66). He began the drawing with the paper turned the other way around, as an abandoned draft of the left-hand figure is visible at the bottom right. In common with the multitude of measured diagrams of marble blocks in the Casa Buonarroti, Exh. No. 43 was most probably a duplicate retained by the artist of an identical design sent to the quarrymen. The drawing can be dated thanks to the draft of a letter on the reverse, in which he mentions a false rumour that circulated in Florence during the autumn of 1525 that the captured Francis I was dying in Spain.[112] As Wilde observed, the measurements show that Michelangelo planned that these figures at floor level would be slightly larger than the allegorical figures on the tomb, a refinement in the relative scale of the sculptures that occurred to him after he had modelled a same-size terracotta model of one of them now in the Casa Buonarroti (Fig. 68).[113]

Before Michelangelo could order the marble for the River God, he must have worked out its pose by making studies on paper and small-scale sculptural models of wax or clay. Relatively few of these three-dimensional models have survived, as the materials of which they were made are very fragile. Moreover, the generally fragmentary nature of the figures and their lack of finish probably counted against their preservation, as these were qualities that generally came to be valued by collectors only much later. Vasari describes how Michelangelo used such works to prepare for his marble carving by placing the model in a vessel of water and then slowly lifting it out to familiarize himself with the points of greatest relief.[114] Whether he really needed to follow this procedure to visualize how to work the block is debatable, although it is certainly true that his preferred method of carving from the front

Exh. No. 43 **Marble block diagram for a River God**, *c.* 1525. Pen and brown ink, 13.7 × 20.9 cm. The British Museum, London

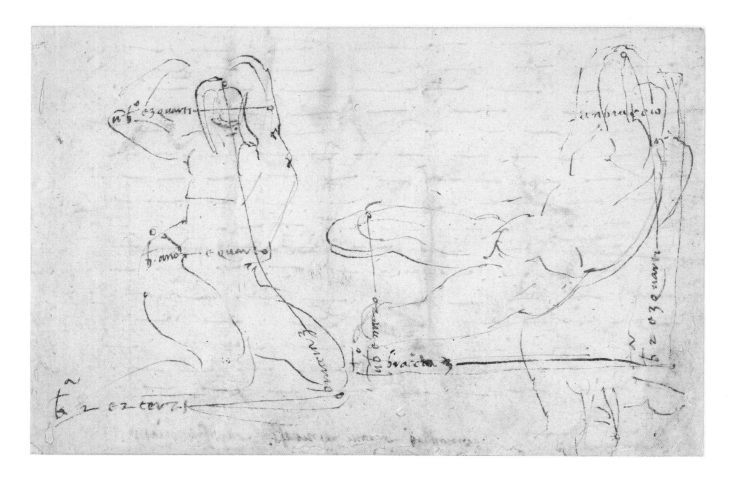

Fig. 68 Michelangelo and assistants, **Model of a River God**, c. 1525–6. Terracotta, oakum, wood and wool, l. 180 cm. Casa Buonarroti, Florence

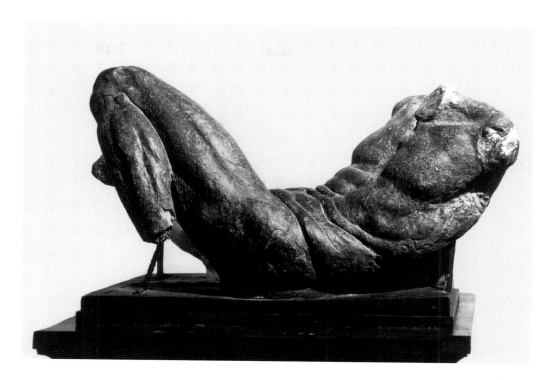

did mean that establishing the most forward projecting part of the figure (like the projecting knee of *St Matthew*, Fig. 18) was important in anchoring the pose. For all his careful preparation of the pose Michelangelo liked to keep his ideas fluid and make changes while carving. This is probably why he favoured cutting the face of the block, rather than the normal manner of working it from all sides, as it allowed him the greatest scope for alteration. Even though wax and clay models were clearly not templates to be followed slavishly, they had the advantage over drawings in enabling him to study the figure from all angles. Although it is probably safe to assume that the majority of drawings and sculptural models were made before work on the block began, his penchant for radical changes of mind mid-way through carving may have sometimes required further study.

The two British Museum sculptural models were acquired by Eastlake in 1859 from a cache of works discovered in the Casa Buonarroti. This provenance adds to the probability that they might have been executed by Michelangelo, as the largest group of works of this kind stem from there.[115] The status of these small-scale sculptures has been contested as keenly as the drawings, and they pose perhaps even more difficult questions of connoisseurship due to their scarcity.[116] The vexed question of authorship is reflected in the mixed critical fortunes of the two British Museum models (see Appendix I, pp. 287–8). The more immediately appealing of the two is a terracotta male torso, later painted green perhaps to simulate the aged patina of a classical bronze (Exh. No. 44). The clay has been worked against a wooden board and this explains the flatness of its back and the traces of wood graining in this area. The old, and possibly original, metal spike at the bottom might indicate that it was intended to stand upright. A small hole at the neck perhaps suggests that the head of the figure was separately modelled and joined to the body by a dowelling rod. The angle of the hole would preclude it being for a ring or hook, like the one found at the top of a wax model of a standing male nude in the Casa Buonarroti.[117] The figure has suffered what looks like firing damage in some areas, with some pieces of the thigh having been reattached and the hollow

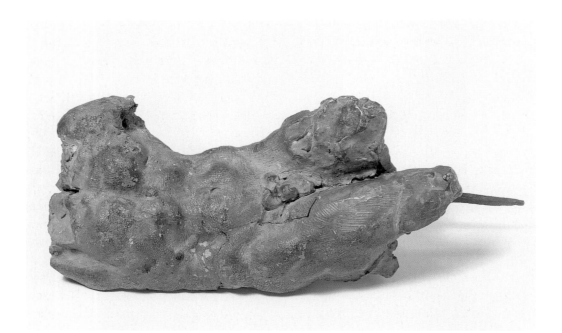

Exh. No. 44 **Model of a nude torso**, 1520s. Terracotta, later painted green, l. 28.5 cm. The British Museum, London

core later filled with plaster. The delicate condition of the model means that it now has to be exhibited on its side – old photographs record how it looked upright (Fig. 69).

The manner in which the figure's powerful musculature has been modelled is markedly expressive, especially in the key area of the torso that was so often the principal focus of Michelangelo's study. Close examination of the surface shows small-scale adjustments to the pose, such as the addition of a small lump of clay worked around the area of the right hip to give a greater sense of the bulging muscle caused by the twist of the body. The surface of the wet clay has been vigorously worked in some passages with a toothed modelling tool that recalls the marks of the claw chisel visible in the sculptor's unfinished marbles.[118] The way in which the length, density and direction of these strokes have defined the figure's form is also paralleled in the multi-directional hatching found in his pen drawings such as Exh. No. 11. The absence of limbs seems to have been intentional with just enough of the legs and shoulder to give a good idea of their general positions, as Michelangelo sometimes did in his figure studies (compare, for example, Exh. No. 18v). The model has been convincingly related to the so-called *Bearded Slave* now in the Accademia in Florence (Fig. 70). The two figures share a downward motion on the right side of the body registered in the position of the diaphragm, and the shifting planes of the pectoral and stomach muscles.[119] The incision made in the wet clay on the figure's left leg roughly corresponds to the lower border of the band of drapery in the marble. The fact that the back of the *Bearded Slave* would have been invisible in its intended location at the lower part of the Julius monument (see Fig. 52), may offer an explanation for the otherwise puzzling neglect of this area in the terracotta.

Fig. 69 **Exh. No. 44 displayed upright**

The other model in the British Museum (Exh. No. 45) is much smaller and executed in a brown wax with no metal armature. The high proportion of oil added to the wax has made it very pliable, and it would have needed only to be warmed in the hand to be manipulable.[120] The painter and writer Giovanni Battista Armenini, who was in Rome in the 1550s, described in his 1587 treatise on art how Michelangelo used wax models to prepare poses for the multitude of figures in the *Last Judgement*. Michelangelo would warm the wax to allow him fluidly

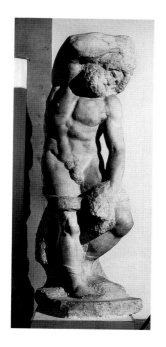

Fig. 70 **The Bearded Slave**, 1519–34. Marble, h. 255.5 cm. Galleria dell'Accademia, Florence

to twist the pose to give it torsion.[121] The material's malleability explains the block of wax at the bottom, as it allowed the figure to be picked up and turned without risking the warmth of the hand changing the pose. The model was shaped with the fingers and given a slight twist in the torso, while at the same time its surface has been worked over with a miniature gouge that has given it a slightly roughened appearance. In common with the terracotta model the most worked-up area is the torso. This contrasts to the impressionistic treatment of other parts of the body, like the flattened right leg. The lack of refinement perhaps explains the negative reaction of some Michelangelo scholars, but this is also true of the undoubtedly autograph drawing of a *River God* (Exh. No. 43) acquired from the Casa Buonarroti at the same time.[122] The wax figure cannot be firmly connected to any of Michelangelo's marbles, although the pose, especially the way in which the right leg is crossed over the left thigh, is not unlike that of *Dusk* on the left side of Lorenzo de'Medici's tomb (Fig. 72). Less persuasive is the suggestion that it is a model for a standing figure, the crossed legs linking it to the *Awakening Slave* (Fig. 73).[123]

Michelangelo must have made small three-dimensional models and numerous drawings of the figures in the chapel. As regards the latter, only those for the marble of *Day* below Giuliano's tomb have survived in sufficient numbers to give an insight into the intense preparation he undertook before beginning work. The early history of the block from which it was carved is known as its dimensions fit one recorded in a payment of October 1524.[124] This showed that that the stone was not quarried to order, but was taken from Michelangelo's store of marble in his studio. It has been convincingly argued that it was the lack of a specially ordered block that led to *Day* and its pendant *Night* having straight bases, as opposed to the curved ones on *Dawn* and *Evening* on the facing tomb (Figs 71–2).[125] The artist must have worked contemporaneously on the design of the two figures, as both depend so much for their visual effect on the contrast, one with the other: the pent-up physical energy and elemental force of *Day* intensified by the languid grace and torpor of *Night*. As was his normal practice Michelangelo researched the poses through life drawings, the majority of

Exh. No. 45 **Model of a reclining male nude**, 1520s. Brown wax, l. 12.2 cm. The British Museum, London

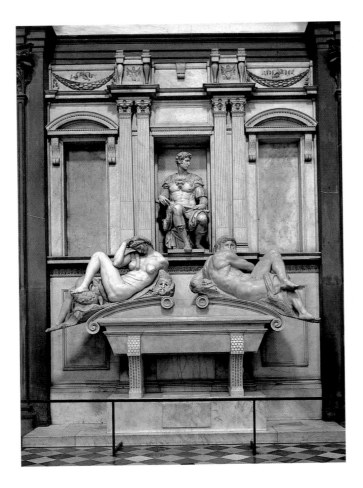

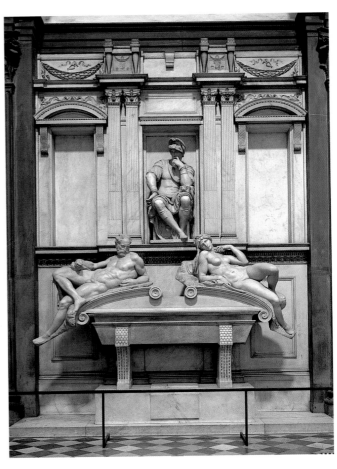

them executed in black chalk, unlike those in red chalk made a decade earlier for the Sistine chapel ceiling. The change in medium may have been influenced by the subdued lighting in the chapel (only four of the eight windows in the lower storey let in daylight), the illumination from above deepening the shadows beneath the projecting surfaces of the marbles.

A black chalk study in the Ashmolean (Exh. No. 46r) is the earliest known drawing for *Day*. It differs from others in the sequence in having been drawn from a more distant viewpoint, perhaps to appraise the figure's overall effect. The basic pose must already have been established as the figure's contours have been drawn with only minor revisions. The greatest difference from the marble is the position of the right arm with no indication of the twist to the shoulders that imparts such a powerful sense of muscular torsion. The placement of the other arm is mysterious, unless the faint outlines behind the back are read as a hand. The modelling of the torso is particularly soft and atmospheric with the tones smudged and blended together. Michelangelo concentrated on capturing the generalities of the top-lit forms, especially the heavily muscled shoulder and flank. In addition to studying the pose, the marks and lines on the right-hand side of the sheet, accompanied by the inscriptions '*Cos[c]ia*' (thigh) and '*S(?)p[alla]*' (shoulder), suggest that the sculptor was working out the figure's proportions and the size of the block needed to carve it. He used the other side of the sheet to make four life studies, initially in black and then in red chalk, of the arm of a lean lightly muscled male model seen from four different angles, related to the figure of *Night*.[126] The drawing is a textbook example of the greater expenditure of time and effort required by sculpture, even necessitating

above left
Fig. 71 **Tomb of Giuliano de'Medici**, 1524–34. Marble. Medici chapel, S. Lorenzo, Florence

above right
Fig. 72 **Tomb of Lorenzo de'Medici**, 1524–34. Marble. Medici chapel, S. Lorenzo, Florence

Michelangelo to study details of the pose that would be invisible to the viewer (such as the arm studied at the top left) in order to create a coherent whole.[127]

In another black chalk life drawing for *Day* in the Ashmolean (Exh. No. 47) Michelangelo viewed his model closer up, paying particular attention to the light ranging over the ribs and muscles of the torso. At first glance the figure seems to be kneeling, and from the position of the sixteenth-century inscription and Sir Joshua Reynolds' stamp in the upper right-hand corner it is clear that it was long thought to be an upright drawing. But the figure's true orientation is revealed by the position of his barely indicated left arm which is supporting the weight of the upraised torso. The position of the far arm emphasizes the broadness of the back, but because the near one is still angled downwards the shoulder muscles are, in contrast with the marble, still relatively relaxed. The head of the model is barely indicated although Michelangelo has playfully made a grinning ghoulish face from the folds of flesh on his belly, with the eye socket formed from a dimpled recess beneath his ribcage. A slightly rougher black drawing in the British Museum of a man's shoulders and upper back (Exh. No. 48) cannot be linked specifically to the chapel, although the arm studied in the upper left is not far from that of *Night*. Its stylistic similarities to studies for the marbles date it to the same period, and it is probable that it was made as part of Michelangelo's obsessively detailed examination of the shoulder region of *Day*. The reason why Michelangelo was so concerned with this part of the anatomy (Fig. 76) is related to the orientation of the tombs based on the viewpoint of the celebrants behind the altar (the chapel was never intended to house a congregation). From this spot alone all three of the tombs would have been visible, and from there the figure of *Day* is seen from the rear (Fig. 65).[128]

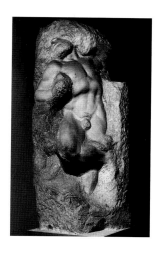

Fig. 73 **The Awakening Slave**, 1519–34. Marble, h. 267 cm. Galleria dell'Accademia, Florence

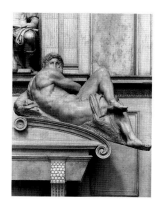

Fig. 74 **Day on the tomb of Giuliano de'Medici**, c. 1524–34. Marble, l. 185 cm. Medici chapel, S. Lorenzo, Florence

right
Exh. No. 46 Recto **Study for Day**, c. 1524–5. Black chalk, 25.8 × 33.2 cm. The Ashmolean Museum, Oxford (verso illustrated on p. 182)

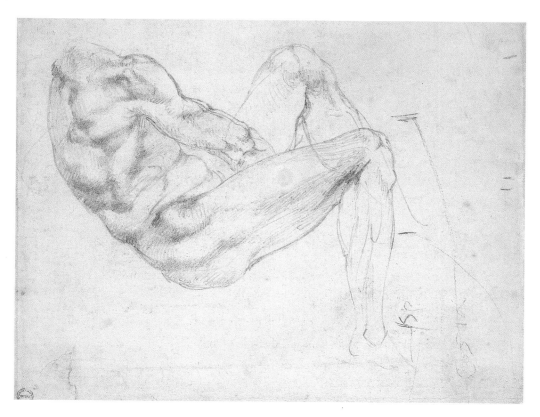

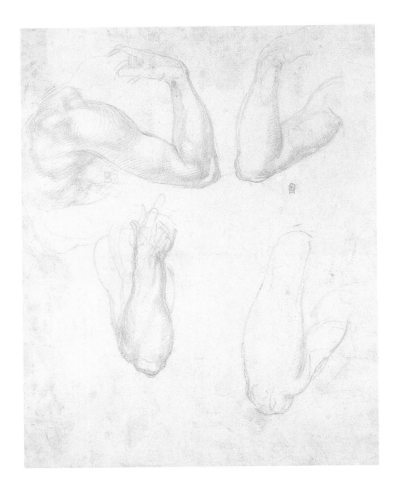

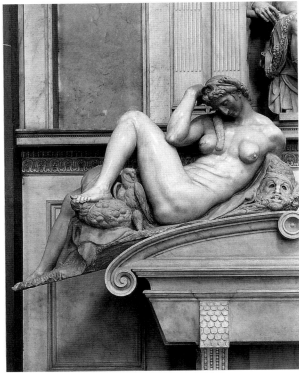

The most detailed, and certainly the most beautiful, of the suite of life drawings for this detail is a sheet in Haarlem (Exh. No. 49). The model, shown with a drapery around his waist, was presumably drawn seated with one arm behind his back and the other still facing downward, as can be seen from its faint outline in the main study. The complex turn of the left arm with the wrist parallel to the back, as in an arm lock, was studied three times, the drawing on the right overlapping the main study. The motif of one arm pinioned behind the back was one that Michelangelo explored for different expressive ends in a variety of sculptures beginning with the *Madonna of the Stairs*, and perhaps most memorably in the *Rebellious Slave* now in the Louvre. What is remarkable about the sheet is the intensity of Michelangelo's observation, shown by the inclusion of such details as the bulging veins on the underside of the forearm, a realistic touch found in the sculpted figure. Equally astonishing is his control of the varying tones of the black chalk, using his fingertips or the stump to blend them together to render the nuances of light and shade. Perhaps the most bravura examples of this are the delicate veils of chalk that have been touched in over areas of otherwise unmarked paper to suggest glistening highlights on the raised edge of a muscle. These details of lighting make plain that Michelangelo was already in his mind transposing the model's flesh into the polished reflective sheen of marble. The drawing's qualities are such that it requires some effort to keep in mind that it was made as a working study towards the production of the marble. In relation to this he made a now unintelligible note to himself regarding the void between the bicep and forearm 'in qua' ('up

above left
Exh. No. 46 Verso **Studies for the right arm of *Night***, *c.* 1524–5. Red chalk over touches of black, 33.2 × 25.8 cm. The Ashmolean Museum, Oxford (recto illustrated on p. 181)

above right
Fig. 75 ***Night* on the tomb of Giuliano de'Medici**, *c.* 1524–34. Marble, 194 cm. Medici chapel, S. Lorenzo, Florence

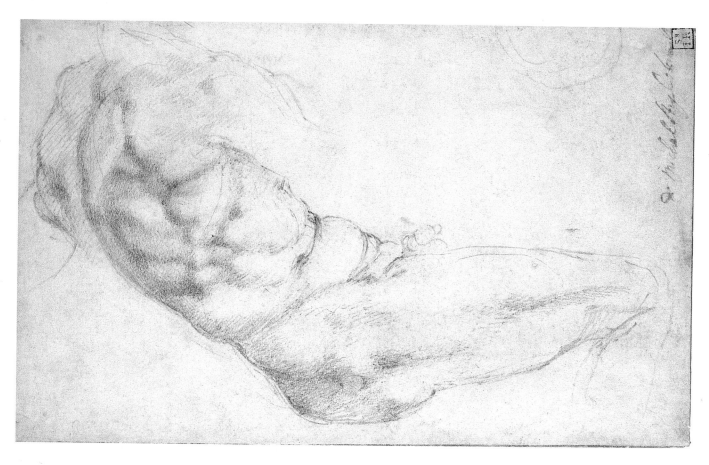

above
Exh. No. 47 **Study for *Day***,
c. 1524–5. Black chalk, 17.6 × 27 cm.
The Ashmolean Museum, Oxford

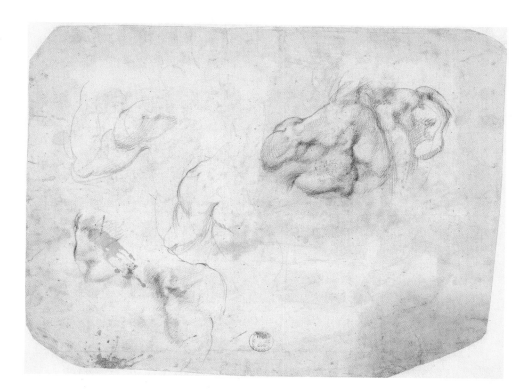

right
Exh. No. 48 **Study of shoulders**,
c. 1524–5. Black chalk,
27.5 × 35.9 cm. The British Museum,
London

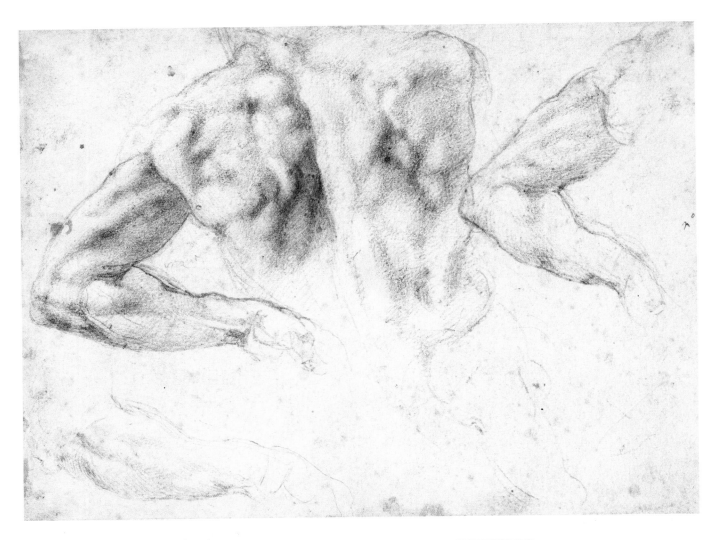

above
Exh. No. 49 **Studies for *Day***,
c. 1524–5. Black chalk,
19.2 × 25.7 cm. The Teyler Museum,
Haarlem

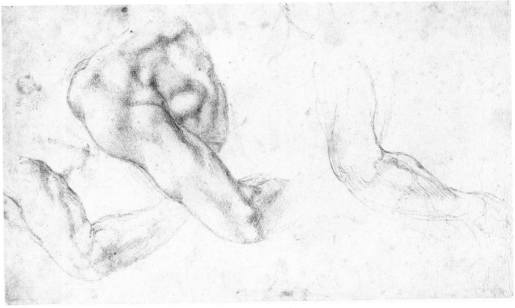

Exh. No. 50 **Studies for *Day***,
c. 1524–5. Black chalk,
26.6 × 16.2 cm. The Teyler Museum,
Haarlem

Exh. No. 51 **The left leg of *Day*;
head of a young man**, *c.* 1524–5.
Black chalk, 15 × 18.5 cm.
The British Library, London

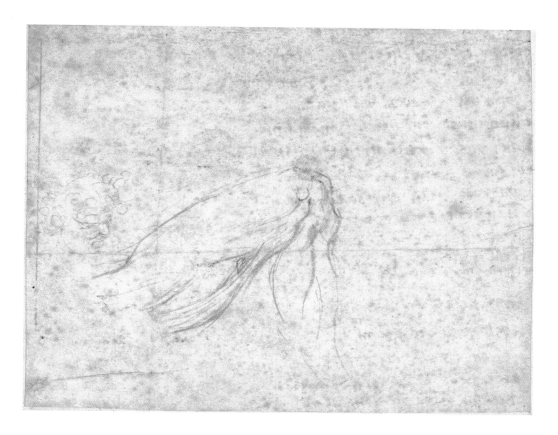

Fig. 76 *Day* (detail), 1524–34.
Marble. Medici chapel, S. Lorenzo,
Florence

to here' or 'in here'), and briskly deleted with a zigzagged line the outline of a muscle in the lower back that displeased him, as he had done with one of the studies of Lazarus's feet (Exh. No. 34). A second black chalk life drawing in Haarlem (Exh. No. 50) of three close-up studies of *Day*'s left shoulder is taken from an angle that no viewer of the sculpture once it was mounted on the tomb lid would ever see, a further reminder of the exacting preparation that preceded the carving of the block.

Three studies for the sharply bent left leg of *Day* survive to give a further indication of Michelangelo's relentlessly thorough examination of the marble's pose. The earliest of them is a little-known écorché study bought from the Samuel Rogers' sale in 1856 by the British Museum. It was transferred a year later to the Manuscripts Department, and as a consequence is now in the British Library (Exh. No. 51), because it has on the verso a pen and ink draft of a love madrigal that begins 'Ogni cosa chi veggio mi consiglia/ e prega e forza chi ti segua e ami...' ('everything I see advises, begs and forces me to follow you and love you').[129] The tiny black chalk figure of a nude blowing a horn to the right of the poem has been thought by some scholars possibly to relate to the Medici chapel decorations, but it is more likely a stray sketch, like the head of Bacchus (?) drawn on the other side of the paper. The two more substantial studies in the same medium in Haarlem (Exh. Nos 52–3) were most likely trimmed at an early date from a larger sheet, as both have similar architectural sketches in pen for the vestibule or *ricetto* of the Laurentian library (illustrated on p. 192). As with the studies of the left arm and shoulder, the leg and kneecap are studied from all viewpoints. Michelangelo again emphasized the surface reflection in anticipation of the effect of light on the polished surface of the marble.

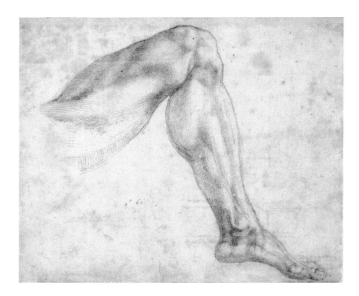

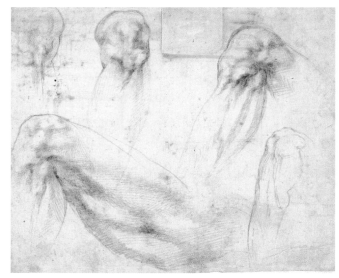

Leda and the Swan

Echoes of the Medici chapel Allegories can be found in a panel painting by Michelangelo executed during the siege of Florence in 1529–30. The lost painting of *Leda* was commissioned by Alfonso d'Este, the duke of Ferrara, who had wanted a work by Michelangelo since their meeting in the Sistine chapel in 1512. The artist finally promised to satisfy Alfonso's wish when he visited Ferrara in late 1529. According to Condivi, the duke gave Michelangelo a personal tour of the city's defences and of his art collection, which included the fabulous series of mythological paintings by Giovanni Bellini and Titian that hung together in the Castello Estense.[130] Alfonso was, like his sister Isabella d'Este in Mantua, a trophy collector who hungered to possess works by the greatest contemporary painters. The addition of a painting by Michelangelo would have been an enormous coup, especially as he already owned the sculptor's over-life-size bronze head of Julius II salvaged from the destroyed statue in Bologna. Up to that time the duke had had much more success obtaining work from Venetian artists than from their more distant counterparts in central Italy. Fra Bartolommeo and Raphael had both failed to deliver promised works in the preceding decade, although the latter had provided partial compensation by the gift of two cartoons. It has been suggested that Michelangelo's offer was part of the Florentine Republic's fruitless attempt to persuade Alfonso to provide military support.[131]

The choice of an erotic mythological subject was almost certainly the duke's since it fits the taste manifested in his earlier commission of three sensual bacchanals from Titian. The appearance of the *Leda* is known from copies in various media. These include an anonymous sixteenth-century painting on canvas in the National Gallery, London (Exh. No. 56) probably based on Michelangelo's preparatory cartoon, and a slightly different composition in an engraving by the Flemish printmaker Cornelis Bos (Exh. No. 55) including Castor and Pollux, the children born of Leda and Jupiter's union. The print is generally supposed to have been copied from the lost painting.[132] The close-up intimacy of Michelangelo's work was very different in mood from the exuberant multi-figured action of Titian's paintings, and he perhaps deliberately sought to distance his work even further by the choice of tempera,

above left
Exh. No. 52 Recto **The left leg of *Day***, *c.* 1524–5. Black chalk over stylus, 20.7 × 24.7 cm. The Teyler Museum, Haarlem (verso illustrated on p. 192)

below right
Exh. No. 53 Recto **A left leg and four studies of a knee (*Day*)**, *c.* 1524–5. Black chalk, made up section of the paper at centre of upper edge, 20.6 × 24.8 cm. The Teyler Museum, Haarlem (verso illustrated on p. 192)

below left

Exh. No. 56 Anonymous Artist, **Leda and the Swan**, after Michelangelo, *c.* 1540–60. Oil on canvas, 105.4 × 135 cm. The National Gallery, London

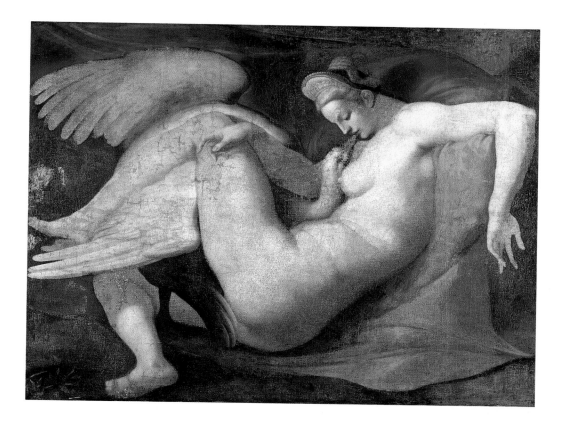

rather than the oil medium of which the Venetian was such a master.[133] The completion of the panel is documented in a letter written by Alfonso to the sculptor in November 1530 relaying his excitement at the news, and stating that his servant Pisanello would pick it up (see Appendix II, Exh. No. 6, p. 296).[134] The duke never received it because the tactlessness of his envoy apparently so enraged Michelangelo that he gave the painting, as well as the cartoon he had prepared for it, to his pupil Antonio Mini. (Another interpretation is that Michelangelo was punishing Alfonso for his failure to come to Florence's aid.)[135] Mini transported the panel and cartoon, along with other works given him by his master, to the court

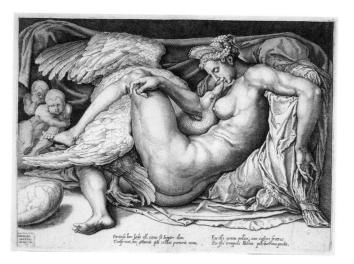

Exh. No. 55 Cornelis Bos (*c.* 1510–66), **Leda and the Swan**, after Michelangelo, *c.* 1530–50. Engraving, 30.2 × 40.1 cm. The British Museum, London

of Francis I the following year. Soon after Mini's departure from Rome, Michelangelo received a letter from Benvenuto della Volpaia relaying Pope Clement's interest in the painting.[136] Mini was later cheated of both works. After his death in France in 1533 the panel remained there, while the cartoon was returned to Florence by the early 1540s. Neither work has survived.[137]

Perhaps surprisingly, in view of Michelangelo's belief that sex was an unhealthy, life-threatening pursuit, his painting is unusually graphic in depicting the congress of Leda and her feathery lover. (The duke of Northumberland who donated Exh. No. 56 to the National Gallery in 1838 decreed that the copy should not be put on public display, and for many years it was deemed suitable only to be hung in the office of the evidently incorruptible director.[138]) Michelangelo almost certainly had his patron's taste in mind, both in the erotic treatment of the theme and in its derivation from classical art, another field of Alfonso's collecting.[139] The antique prototype of the reclining Leda with the swan on top of her was known from a now lost sarcophagus on the Quirinal in Rome, and an antique cameo, now in the Museo Archeologico in Naples. Lorenzo the Magnificent had been given the cameo by Sixtus IV in 1471, and Michelangelo may well have studied it when he was living in the Medici palace.[140] He had already used the pose of Leda from the cameo as a starting point for that of *Night*, and he did so again for the duke's painting.

The similarity of the two poses comes close to contravening Michelangelo's proud boast related by Condivi that he never, unlike his more practically minded contemporaries, recycled his figural inventions.[141] It is true that he did make changes to the pose of *Night* to emphasize Leda's ecstatic ardour shown by the way she pulls the swan closer to her with her legs,

and enfolds his sinuous neck by the gesture of her right arm. He certainly made new drawing in preparation for the painting rather than relying on those he had made for the marble, as can be seen from the spectacularly beautiful red chalk study of a young man's head in profile in the Casa Buonarroti that is preparatory for the head of Leda (Fig. 77).[142] Wilde's suggestion that the black chalk study in London drawn on unusually poor grade paper of a reclining male nude (Exh. No. 54) is also for the *Leda*, rather than for *Night* as was previously thought, is less certain.[143] The position of the legs, the right one just indicated by a short line to indicate the placement of the lower part of the thigh, is closer to the marble without the twist in the lower body that makes the buttocks of *Leda* visible in the painting.[144] On the other hand, the upright position of the torso is far closer to the pose of the painted figure than to the marble. The unprecedented number of Medici chapel studies in the exhibition might help to resolve whether it fits in better with works from this period or with those executed five or so years later.

The National Gallery painting is in poor condition but from what remains it is clearly a good quality, probably mid-sixteenth-century, copy after Michelangelo's cartoon. The Florentine painter Rosso, whose successful career at the court of Francis I from 1530 probably prompted Mini's departure from Florence the following year, also copied the painting in France. Some believe this to be the badly rubbed drawing in the Royal Academy (Fig. 78).[145] A more certain example of Rosso's draughtsmanship, drawn in the decade before he committed suicide at Fontainebleau in 1540, is a superbly inventive interpretation of the *Leda/Night* figure (Fig. 79).[146] The chilly eroticism of Michelangelo's work is transformed into something far more sensuous in the red chalk British Museum drawing by the younger painter's use of a female model, whose body is turned to the front and studied from a viewpoint that places the spectator in the voyeuristic position of gazing down on her sleeping form.[147]

Fig. 78 Attributed to Rosso Fiorentino (1494–1540), **Leda and the Swan**, after Michelangelo, *c.* 1538. Black chalk, 170.1 × 248.8 cm. The Royal Academy of Arts, London

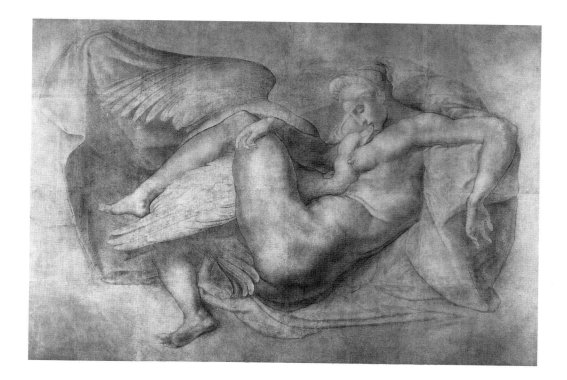

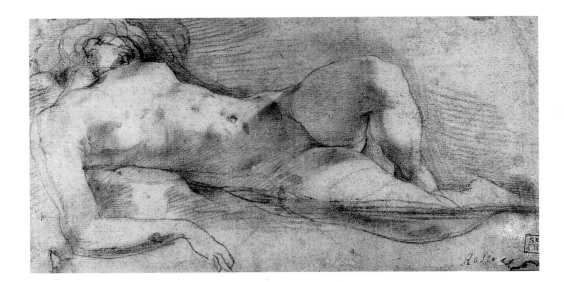

Fig. 79 Rosso Fiorentino (1494–1540), **Sleeping female nude**, c. 1530–40. Red chalk, 12.6 × 24.4 cm. The British Museum, London

The Laurentian Library

The idea of constructing a building at S. Lorenzo to house the library gathered by Cosimo and greatly enlarged by Lorenzo (hence 'Laurentian') was conceived in 1519, but work commenced on it only after Giulio's election as pope in November 1523.[148] As with the chapel, Clement's actions looked back to past Medicean patronage as he was following in the footsteps of his great-grandfather Cosimo, who had commissioned Michelozzo to design a library building at S. Marco. The pope's sense of responsibility in upholding this tradition can be felt in his comments relayed in Sebastiano's letter of 1533 that the library benches should be made of walnut. Michelangelo was told not to worry about the cost because what counted was that they should be 'a la cosimesca', that is they should be worthy of comparison with the buildings commissioned by Cosimo.[149] The traffic of letters between Rome and Florence demonstrate Clement's insatiable interest in every detail of the library's progress, and his impressively wide-ranging knowledge of the practicalities of construction and materials. The correspondence is one of the most fascinating records of a creative dialogue between a sixteenth-century patron and an architect, and the commodious functionality of the library and its highly innovative vestibule bear testament to the success of their partnership (Fig. 80).

Once the location of the library above the monastic quarters on the south side of S. Lorenzo had been finally settled on in the spring of 1524, Michelangelo was under intense pressure. He was simultaneously involved in the new building's design and the monitoring of its construction, while also having to find time to work in the Medici chapel. He was only able to juggle these two projects because the library's architectural features were to be carved from sandstone, a material for which there was a local pool of skilled workers whom Michelangelo could rely on to execute his designs. Meanwhile he could concentrate on the marble architecture and sculptures in the New Sacristy. In view of his workload it comes as little surprise that his designs for the library often arrived at the last moment. The pressure of keeping up with the huge team of craftsmen assigned to execute his orders was made more acute by his patron's wish to see his designs in advance. A graphic illustration of this pressure is shown by two Haarlem drawings that were once part of the same sheet. On one side he drew the legs of a model for the sculpture of *Day* (Exh. Nos 52–3) and on the reverse he

hurriedly sketched in ink designs for the *ricetto* of the library (illustrated on p. 192). These show that he had already come up with the arresting and profoundly unconventional idea of sinking the columns into recessed panels in the walls (Fig. 80).[150] One of the numerous differences with the finished work is the idea shown on the verso of Exh. No. 53 of having staircases running up the sidewalls. This helps to date the drawing since Fattucci mentioned Clement's approval of the double stairway ('salita di dua scale') in a letter written at the end of April 1524.[151] The staircase was one of the few major elements of the Laurentian library that was not completed by the time that Michelangelo moved to Rome, and the one constructed later was based on a clay model that Michelangelo sent from Rome in early 1559.

The double-sided sheet in London with a pen design for the two sides of the doorway between the vestibule and the library (Exh. No. 58) can also be dated with some precision thanks to a letter from Fattucci. He wrote on 18 April 1526 to thank Michelangelo for sending a 'drawing of the door', and the London sheet must be a study for the finished design mentioned in the letter.[152] The drawing on the recto is for the library side and the main study on the verso, alongside one for the external windows, is for the doorway from the vestibule. The latter had to be fitted into a narrower bay, hence the lack of columns at the side, because it was flanked by recessed paired pillars. The recto design was drawn first, as Michelangelo traced the central opening for the larger study on the other side of the sheet. In the main verso study he also incorporated, after some deliberation, the change shown in the recto from a segmental to a triangular pediment above the door. As has often been noted in regard to Michelangelo's architectural studies, his changes of mind as to the form of the pediment, with one superimposed over the other, might have been the inspiration for the library doorway leading to the vestibule that has a triangular pediment projecting forward from a segmental one behind it.[153]

A consistent element in all the sketches is the inclusion of a blank panel intended for a dedicatory inscription. In both of the main studies this is rather small. In the finished design

Fig. 80 **The vestibule (*ricetto*) looking towards the door of the Laurentian library**, S. Lorenzo, Florence

even more space had to be found, as Clement wanted a Latin inscription of between 100 to 140 letters and went to considerable trouble in finding one he liked.[154] The finished drawing that Michelangelo prepared from preparatory studies such as this one (an idea of the appearance of such *modelli* that he sent to Rome is provided by a refined pen and wash study in the Casa Buonarroti) must have included the papal arms, an element included as an afterthought on the recto.[155] This can be ascertained from Fattucci's comment in a letter of 6 June 1526 that Clement had decided he wanted only the Medici arms to be displayed.[156] By June Michelangelo was predicting that the vestibule would be ready by October, but this progress was halted by a funding crisis caused by the war. Michelangelo was subsequently instructed to concentrate on the tomb figures, and after the hiatus of the Republic it was not until 1533 that work on the doorway was commenced.

Michelangelo and his Pupils in Florence

Michelangelo actively encouraged the vision of himself as a solitary self-taught genius whose way of working did not encompass the vulgarity of running a workshop. This is rightly cited as one of the most significant differences between him and his rival Raphael. The latter established perhaps the most creative and productive studio in sixteenth-century Rome, the success of which was based on his ability to attract some of the best young talents who were eager to profit from his instruction and contacts. The acuity of Raphael's judgement can be gauged by the fact that a number of his pupils (Giulio Romano, Perino del Vaga and Polidoro da Caravaggio) went on to establish themselves as major painters in their own right after his

below left
Exh. No. 52 Verso **Studies for the Laurentian library vestibule (*ricetto*)**, *c.* 1524. Pen and brown ink; black chalk, 20.7 × 24.7 cm. The Teyler Museum, Haarlem (recto illustrated on p. 186)

below right
Exh. No. 53 Verso **Studies for the Laurentian library vestibule (*ricetto*)**, *c.* 1524. Pen and brown ink, made up section of the paper at centre of upper edge, 20.6 × 24.8 cm. The Teyler Museum, Haarlem (recto illustrated on p. 186)

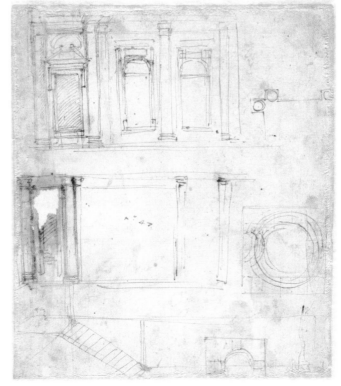

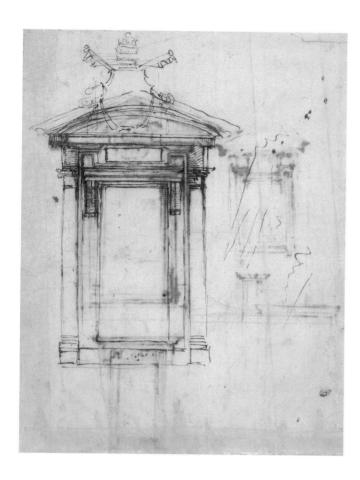

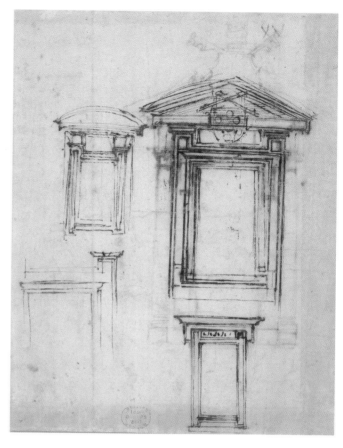

above left

Exh. No. 58 Recto **Design for the Laurentian library door**, *c.* 1526. Pen and brown ink over stylus; leadpoint, 28.4 × 20.9 cm. The British Museum, London

above right

Exh. No. 58 Verso **Designs for the Laurentian library door from the vestibule (*ricetto*) and an external window**, *c.* 1526. Pen and brown ink over stylus, 28.4 × 20.9 cm. The British Museum, London

death. By contrast Michelangelo's pupils were all mediocrities, and he was frequently jealous and paranoid in his behaviour towards his artistic contemporaries. Only late in his career, during the course of working in S. Lorenzo, did he run a workshop along the lines of the one he had been in as a youth. Both artists must have trained their assistants to draw, but Raphael's instructional studies have all perished while a handful by Michelangelo survive.157 Such pedagogical drawings can be shown through documentary evidence to have long been part of artistic education. In a contract of 1467 between the Paduan painter Francesco Squarcione and a certain Francesco, the artist promised to keep the boy 'with paper in his hand to provide him with a model, one after another, with various figures in lead white, and correct these models for him'.158

Michelangelo's repeated admonitions to his servant and pupil Pietro Urbano to draw have already been mentioned (p. 18), and with one of the latter's successors, Antonio Mini, who entered the sculptor's household in 1522 aged sixteen, there is even more tangible evidence of this encouragement in a sheet in the British Museum with two pen and ink studies of the Virgin and Child made as models for him (Exh. No. 59). These have sometimes been considered as studies for a putative picture or a Donatellesque relief rather than designs to copy, yet the latter seems a more likely explanation for the way in which the normally parsimonious artist turned the sheet around to make another study to leave space for Mini's efforts. To the right of the lower drawing he wrote in a beautiful hand, as though this too was intended to be copied as in Exh. No. 60r, 'Disegnia antonio disegnia antonio/ disegnia e no[n] p[er]der[e] te[m]po ('Draw Antonio draw Antonio, draw and don't waste time) which limited the space

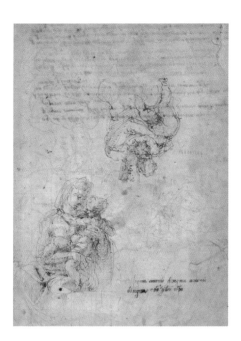

left

Exh. No. 59 Michelangelo and
Antonio Mini (d. 1533), **Studies
for a Virgin and Child**, *c.* 1522–6.
Pen and brown ink (the studies);
red chalk (the copies); black chalk
(the squaring and copy), made up
section of paper at upper right,
39.6 × 27 cm. The British Museum,
London

below

Exh. No. 60 Recto Michelangelo
and pupils, **Studies of profiles,
eyes and locks of hair**, *c.* 1525.
Red and black chalk, 25.4 × 33.8 cm.
The Ashmolean Museum, Oxford

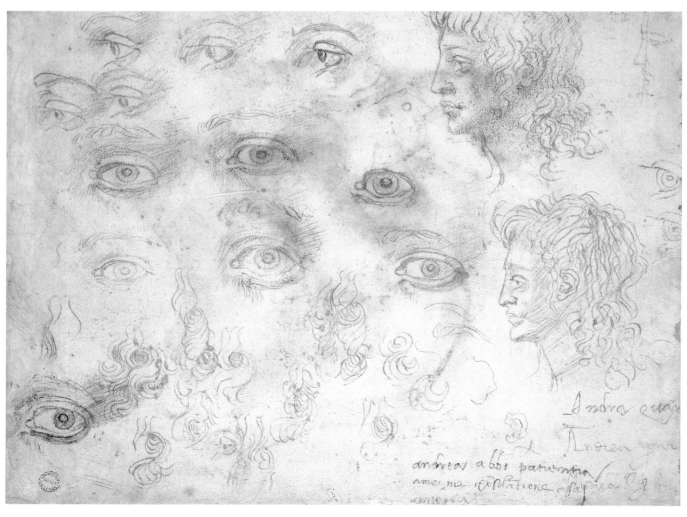

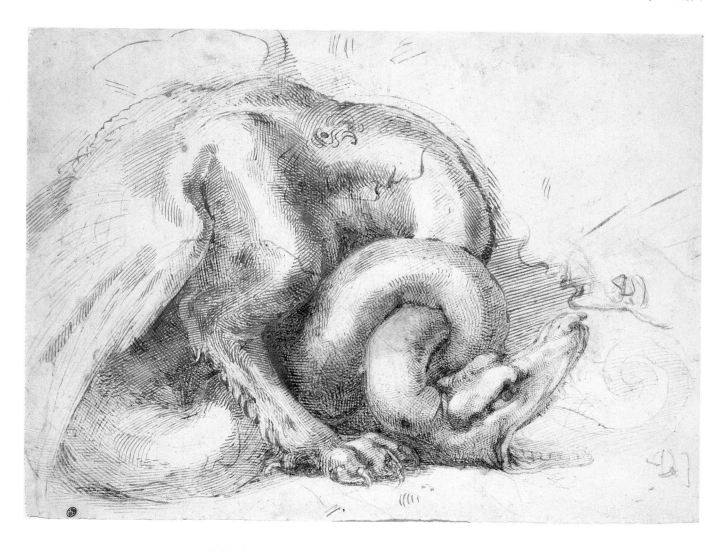

Exh. No. 60 Verso Michelangelo and pupils, **Dragon**, *c.* 1525. Pen and brown ink over black chalk (Michelangelo) over red and black chalk (pupil studies), 25.4 × 33.8 cm. The Ashmolean Museum, Oxford

available for Mini to make his drawing first in black chalk (the profile head of the Virgin in this medium is just visible to the right) before changing to red. The numbered squaring made with a ruler and black chalk of the lower drawing, most probably by Mini or another pupil (the numerals are not in Michelangelo's hand), would have facilitated the copying of the design with the lines in each square transcribed to a 5 × 7 grid drawn on another sheet. Mini's slightly larger, freehand chalk copies of his master's pen studies highlight his pedestrian talent; his control of chalk is far more incisive in the note of quantities of grain and beans ('grano 10 2/ fave 2½') that he later made over some of the contours of the lower copy. Admittedly the exercises he had been set were difficult to copy as Michelangelo's sketchy pen outlines are exploratory, and in some parts, such as the Virgin's hand in the upper study, unresolved. The sculptor displayed a similar inability to rein in his creative instinct in order to make a simplified model for a pupil two decades later in the *Epifania* cartoon (Exh. No. 95). Michelangelo used the back of Exh. No. 59 to make notes of payments dating from early October 1524 relating to the New Sacristy (including some concerning the construction of the terracotta models for the sculptures), and his instructional drawings are most probably from much the same period.[159]

A more endearing picture of Michelangelo's teaching emerges from a red and black chalk study sheet in the Ashmolean (Exh. No. 60). As with the previous drawing the sculptor

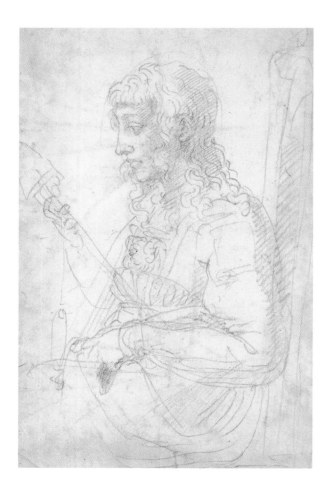

Exh. No. 61 Michelangelo and pupil,
Girl with a spindle, c. 1525.
Black chalk, the lower left corner
made up, 28.8 × 18.2 cm.
The British Museum, London

provided examples to copy, but working out which of the many studies on the page are by his hand and which are the copies is not straightforward. The most clear cut work by Michelangelo is the assured profile head of the youth at the top right after which there is a clumsy copy below. It has been recently suggested that the drawing was made with Michelangelo passing the sheet back and forth between two or more of his pupils to stimulate them to imitate his work.[160] One of the participants was almost certainly Andrea Quaratesi, a Florentine patrician born in 1512, whose name Michelangelo wrote at the bottom right in his typically elegant script that the youngster, perhaps no more than twelve or thirteen years old, copied below.[161] The encouraging inscription written by Michelangelo below in black chalk is also addressed to him, 'andrea abbi patientia' ('Andrea have patience'), to which one of his pupils, perhaps Mini, has added on the line below, 'ame me [dà?] co[n]solatione assai' ('it [gives] me great consolation')'.[162] Quaratesi, whose handsome features are recorded in Michelangelo's later portrait drawing (Exh. No. 70), was probably responsible for the lower profile head and some of the more faltering copies of eyes and curls of hair.

The sheet has provided an absorbing test of connoisseurship with most recent scholars agreeing that the eye in profile at the top left corner, and the eye seen from straight on in the middle of the top row of similar studies, are by Michelangelo.[163] Copying studies of an eye from various angles was a traditional exercise that continued well into the following century, and Michelangelo may well have been repeating lessons he remembered from Ghirlandaio's studio. His adherence to the practices of his youth is shown by his having sent his pupils to

study Giotto's work in S. Croce, as is shown by a copy of heads from the chapel by one of them found on the verso of one of his drawings in Haarlem (Exh. No. 72).[164] Assigning the studies of curling locks of hair inspired by those of the youth in the profile study is even more problematic, and perhaps only the one to the right of the eye childishly drawn in black chalk in the lower left corner could conceivably be by Michelangelo. On the other side of the paper Michelangelo covered over red chalk studies of a male head in profile, more likely by the older Mini than Quaratesi, with a pen and black chalk study of a dragon tying itself in knots and snarling menacingly, but impotently, at the profile head above.

The manner in which his pupils' feeble attempts to copy his work could inspire his creative imagination can also be seen in the black chalk study of a young woman holding a spindle in the British Museum (Exh. No. 61). He began the sheet by drawing a profile head much like the one on the recto of Exh. No. 60. One of his pupils, perhaps the young Quaratesi, made a partial copy of such ineptitude that Michelangelo was moved to cover it up by incorporating the spidery lines into the left sleeve of the now seated figure (the nose, eye and chin of the earlier study are the most discernible features).[165] This masking operation inspired him to use the profile head as the starting point for a rapidly sketched study of a woman seated in a high-backed chair, staring fixedly downwards towards the spindle held in her right hand. Such transforming sleights of hand were at least on one occasion applied to his own work, when on the verso of a presentation drawing now at Windsor he traced the outlines of a reclining Tityus from the recto to turn it into a figure of the Risen Christ.[166] As a poet Michelangelo

Exh. No. 62 Recto Michelangelo and pupils, **Hercules and Antaeus and other studies**, *c.* 1524–5. Red chalk, 28.8 × 42.7 cm. The Ashmolean Museum, Oxford (verso illustrated on p. 198)

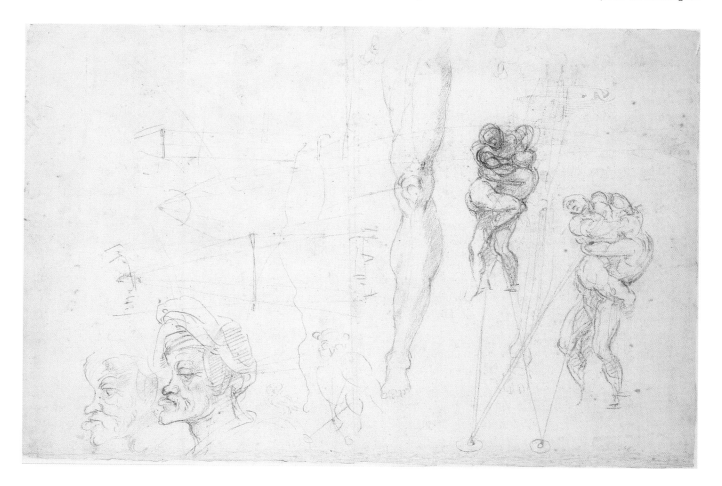

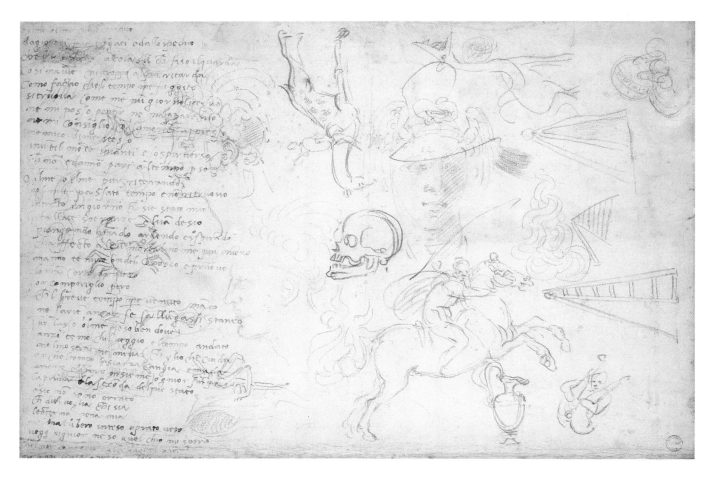

was also intrigued by the way in which profound changes in meaning could be affected through minor textual changes.[167]

Michelangelo's quickness of thought is also apparent in a double-sided study in the Ashmolean (Exh. No. 62) that shows him engaging in a jocular display of visual wit with his pupils. Michelangelo's neat copy of a long poem concerned with repentance and the imminence of death on the verso may well have preceded any of the drawings, 'Ohimè, ohimè, ch'i son tradito/ da'giorni mie fugaci e dallo specchio' ('Alas, alas, I have been betrayed by my fleeting days and by the mirror'). The red chalk sketches of a crab, grasshopper and the head of Mercury (copied by a pupil) certainly overlay the text.[168] Michelangelo was probably responsible for some of the more assured sketches to the right of the poem: including the head of Mercury seen full face; the horse and rider leaping over a vase; and the earthy thumbnail study of a male nude at the lower left with his legs over his shoulders. A comparable bawdiness is demonstrated in another of Michelangelo's instructional drawings on the verso of Exh. No. 66 that includes a sketch of a man defecating. One of the sketches on the Ashmolean sheet shows a giraffe, an animal that Michelangelo would have known as a child from the short-lived one presented to Lorenzo de'Medici by the sultan of Egypt in 1487. The savage version of the animal drawn to the right of it could either be Michelangelo deliberately drawing in an unsophisticated way (a mode that Vasari recounts he once adopted to win a bet in his youth), or perhaps more likely the work of a very young or incompetent pupil, like Quaratesi, whose level of skill is shown in the feebleness of the copies of the tripod/ ladder on the right.[169]

Exh. No. 62 Verso Michelangelo and pupils, **Figure and animal studies; a canzone**, c. 1524–5. Red chalk, 28.8 × 42.7 cm. The Ashmolean Museum, Oxford (recto illustrated on p. 197)

Similar questions of attribution are raised by the studies on the other side of the sheet which include a left leg, copied from a Michelangelo study in the same medium on an instructional sheet at Frankfurt, and crude optical diagrams by a pupil. There are also two deliberately simplified studies made by Michelangelo for his pupils to copy: the owl at the bottom, a bird that may have come to mind because of its inclusion as an attribute of *Night* (Fig. 75), of which there is a small and very poor copy to the left; and the right-hand carica-ture of an old crone in profile. The studies can be dated to 1524–5 because the two designs on the right relate to Michelangelo's abortive *Hercules and Antaeus*. The manner in which the two figures are locked together frontally is reminiscent of Antonio Pollaiuolo's expres-sive treatment of the subject more than sixty years earlier in a bronze statuette (Bargello, Florence) and in a small-scale panel in the Uffizi.[170] Michelangelo's knowledge of the earlier

Exh. No. 66 Verso Michelangelo and pupils, **Heads and figures**, *c.* 1525–8. Red chalk, a section of the paper made up at the lower left corner, 23.5 × 28.7 cm. The British Museum, London (recto illustrated on p. 203)

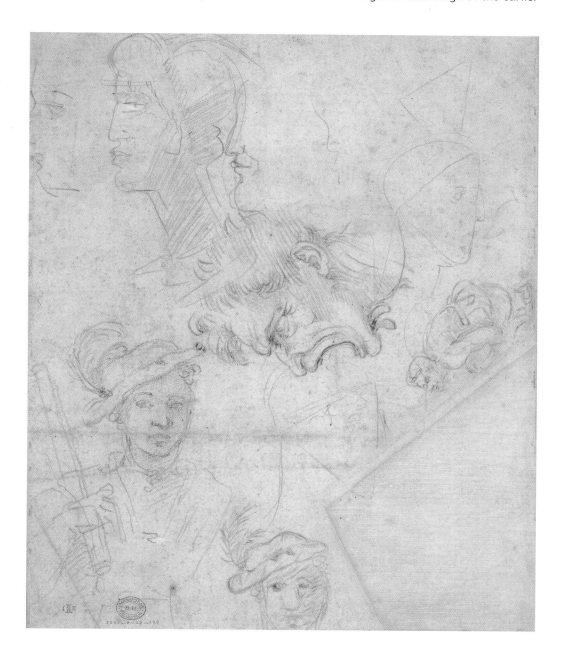

treatment is particularly evident from his borrowing of Antaeus' desperate push against the top of Hercules' head in his attempt to break free from his grip. He certainly would have known at least one of Pollaiuolo's versions of this subject because it featured in one of three huge paintings, now lost, by Antonio and his brother Piero in the Sala Grande in the Palazzo Medici.

Michelangelo made a further sketch of the group in black and then red chalk in the lower right corner of a sheet in the British Museum with three witty grotesque heads in red chalk (Exh. No. 63r). These curious creations, the upper two with leonine mouths and noses and highly expressive goatish ears, are of contrasting character: wide-eyed anxiety on the part of the bearded one to the left; half-witted puckish mischief of the laurel crowned figure to his right; and finally the overwhelming gloomy lethargy of the lower one expressed so eloquently by his drooping ears.[171] The beginning of a weak copy after the top right study on the left of the sheet suggests he may have made these drawings as amusing models for his pupils to copy. Michelangelo is not an artist usually associated with light-hearted diversion but such levity was appropriate for the subject. He is quoted as saying in the third of Francisco de Hollanda's *Dialogues* in a passage defending creative licence (for this literary work see p. 251) that such *grotteschi* should be a source of 'variation and relaxation of the senses'.[172]

Fig. 81 **Giuliano de'Medici (detail of breastplate)**, Medici chapel, S. Lorenzo, Florence

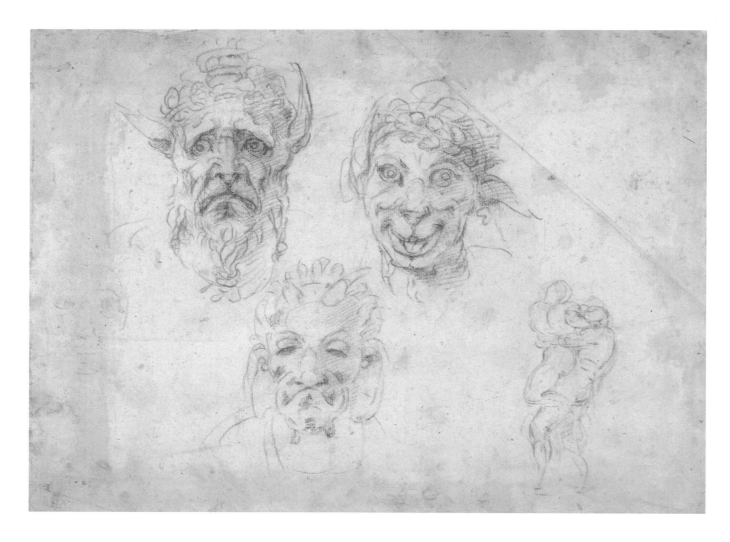

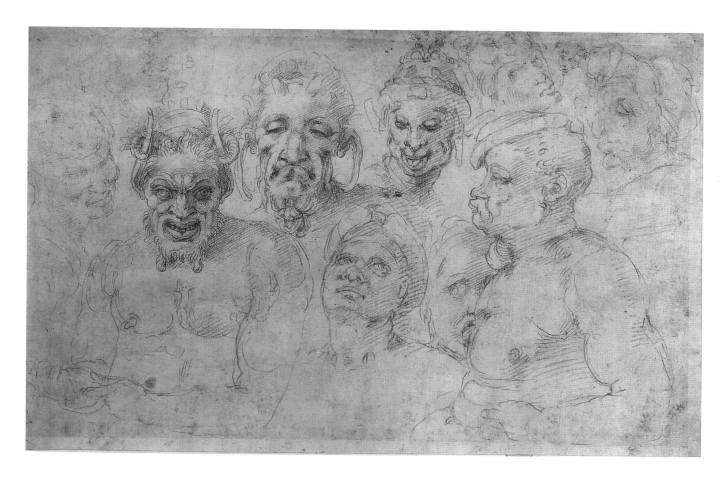

Fig. 82 Michelangelo and pupils, **Grotesque heads**, 1530s. Red chalk, 26 × 41 cm. Städelsches Kunstinstitut, Frankfurt

Michelangelo went on to use the three heads as the basis for further studies on a fascinating double-sided instructional drawing in red chalk now in Frankfurt (Fig. 82).[173] The attribution of this work has frequently been questioned because a few of Michelangelo's lightly sketched studies on the sheet have been overdrawn to deadening effect by one of his pupils, but the taste for the grotesque, evident in the figure suckling from the pendulous breast of the fat old man with a goitre, and the lively sketchiness of the untouched chalk lines are paralleled in drawings of comparable function such as Exh. Nos 62r and 66v. Similarly fantastic grotesque masks to those in Exh. No. 63 and in the Frankfurt study can be found in the interior of the New Sacristy with examples sculpted by Michelangelo, such as the one adorning the breastplate of Giuliano (Fig. 81), and on capitals and masks executed by marble carvers such as Francesco da Sangallo after his designs.[174]

Michelangelo's transformative powers are perhaps again displayed in a study in London (Exh. No. 64r) of a seated woman, drawn in pen and ink over red and a few lines at the bottom of black chalk. It has recently been suggested that the red chalk underdrawing was made by Mini, and that Michelangelo used this as a starting point for his drawing as he did with a study of a satyr's head in the Louvre.[175] Irrespective of whether the red chalk is by Michelangelo or a pupil, what is undeniable is the way in which the artist completely altered the initial sketch of the figure by the addition in pen of a vaguely classical cuirass and headgear. The woman's ill-defined right hand appears to rest on the back of a tiny man stretching forward, a figure that has been interpreted in a number of different ways: a St Christopher

opposite
Exh. No. 63 Recto **Grotesque heads; Hercules and Antaeus**, c. 1524–5. Red chalk, the Hercules sketch over black chalk, all contours traced with a stylus, 25.5 × 35 cm. The British Museum, London (verso illustrated on p. 216)

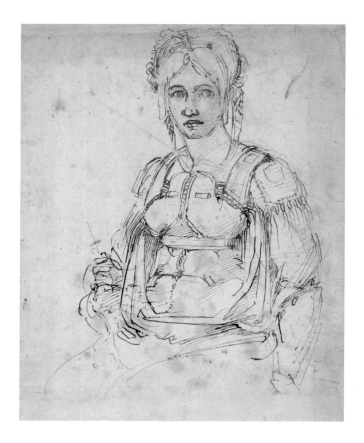

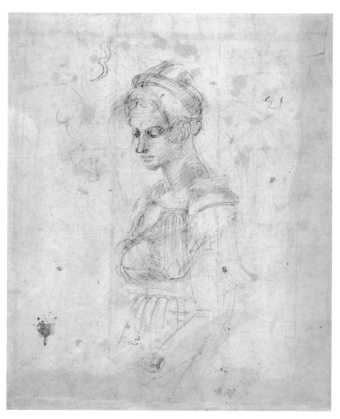

with the Infant Christ on his back, a Lilliputian artist shown drawing the gigantic figure, or a man reaching out to undress her.[176] Wilde was, however, almost certainly right to see it in a more prosaic light as an earlier and unrelated study that Michelangelo ignored and drew over. This view is supported by the way in which the hatching beneath her hand, and the outline of her drapery, cut across and cancel out the diminutive figure's form.[177] On the verso of the sheet he made a quick study of a woman in black chalk, the artist's disregard for the realities of the female form evident in the curious position of her breasts.

Studies of Heads

Michelangelo's didactic drawings of profile heads were perhaps the inspiration for him to make much more sophisticated finished studies that were created as works of art in their own right. The connection between the two is shown by a sheet in the British Museum (Exh. No. 66) that has an ideal female head on one side and red chalk studies on the verso, of which the bust-length boy, the screaming devilish head and the squatting man were drawn by him. The lower left corner of the sheet has been cut, perhaps because there was a desirable small study on the verso, and a small section of the top is also missing as is shown from old copies such as the one at Windsor (Fig. 83).[178] Michelangelo's head study on the recto is a masterful example of his extraordinary precise control of chalk rubbed across the surface of the paper to produce hatching of the utmost delicacy.[179] The intricate arrangement of the woman's plaited hair, which flows like rivulets of water out of the side and back of her bizarrely strapped

above left
Exh. No. 64 Recto **Half-length figure of a woman**, *c.* 1525. Pen and brown ink over red and black chalk, made up strip at upper edge and lower right corner, 323 × 25.8 cm. The British Museum, London

above right
Exh. No. 64 Verso **Half-length figure of a woman**, *c.* 1525. Black chalk, made up strip at the lower edge and upper right corner, 323 × 25.8 cm. The British Museum, London

opposite
Exh. No. 66 Recto **Ideal head of a woman**, *c.* 1525–8. Black chalk, a section of the paper made up at the lower left corner, 28.7 × 23.5 cm. The British Museum, London (verso illustrated on p. 199)

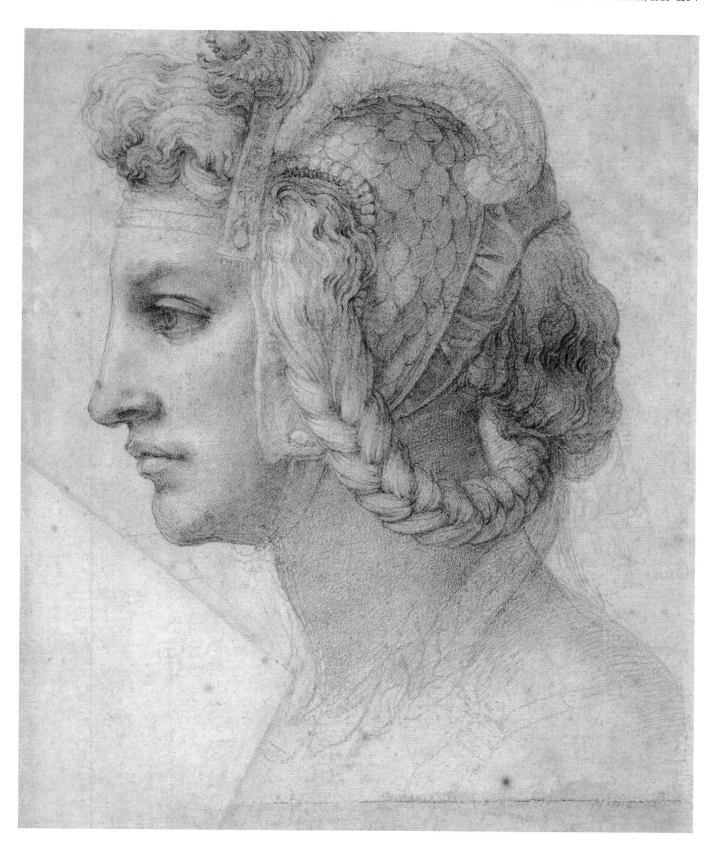

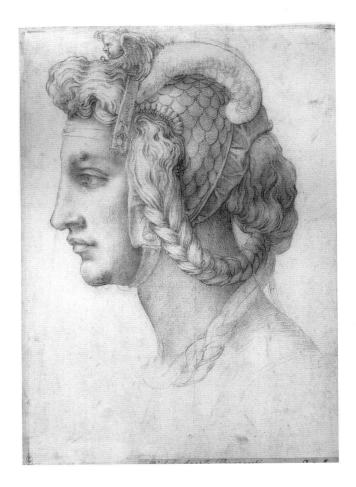

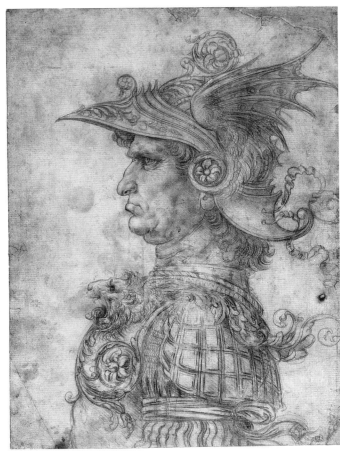

helmet, harks back to earlier Florentine models. These precursors include the black chalk study dating from the 1470s by the Florentine sculptor and painter Andrea del Verrocchio in the British Museum (Fig. 86), and Piero di Cosimo's painting of *Cleopatra* in Chantilly.[180] Verrocchio's love of elaborate female coiffure was passed down to his pupil Leonardo, as is demonstrated by the figure of *Leda* in his lost painting whose braided hair is the subject of a celebrated study at Windsor. Leonardo's exquisitely worked studies of heads, like his early metalpoint depiction of a leonine warrior executed in the mid-1470s and now in the British Museum (Fig. 84), may have been the inspiration for Michelangelo to reinvigorate the genre in the 1520s.[181]

The Leonardo warrior study is most likely an early example of a presentation drawing, a phrase coined by Wilde for the works on paper that Michelangelo made specifically as gifts.[182] Leonardo is documented as having made at least one such study, a lost drawing of Neptune for the Florentine Antonio Segni. Michelangelo took up this practice in the 1520s, beginning with three black chalk studies of heads for his friend Gherardo Perini that later passed to the Medici collection and from there to the Uffizi.[183] Leonardo was not the first artist to have made a drawing specifically to give away as a gift.[184] An earlier example is Pisanello's refined pen and wash study on vellum from the early 1430s (Fig. 85) that was almost certainly made for presentation because he elaborately signed it (Mantegna also made similarly elaborate drawings which must have been made for the same purpose).[185] Michelangelo's drawing of a female head (Exh. No. 66r) is as highly worked as any of the

above left
Fig. 83 Anonymous artist, **Ideal head of a woman**, after Michelangelo, *c.* 1540. Black chalk, 33.2 × 23.5 cm. The Royal Collection, Windsor Castle

above right
Fig. 84 Leonardo da Vinci (1452–1519), **Head of a warrior in profile**, *c.* 1475–80. Metalpoint, 28.7 × 21.1 cm. The British Museum, London

Fig. 85 Antonio Pisanello (*c.* 1395–1455), **Three elegantly dressed men**, *c.* 1433. Pen and ink and grey wash over black chalk on vellum, made up section of paper at upper left, 24.8 × 33.8 cm. The British Museum, London

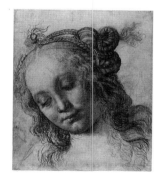

Fig. 86 Andrea del Verrocchio (1435–88), **Head of a woman**, *c.* 1475. Black and touches of white chalk, 32.5 × 27.3 cm. The British Museum, London

Perini presentation sheets and it too may have been drawn as a gift. The fact that the verso has a mix of autograph instructional studies and exercises by his pupils would not exclude this, because the same is true of one of the Uffizi sheets.[186] Michelangelo was content to allow such informal glimpses into his training of his pupils, as these drawings were made exclusively as tokens of his friendship, rather than as gifts to appease the many grandees who would have eagerly welcomed such exquisite works. If Michelangelo gave it away, then it must have been returned to the family's collection at some later point since it was one of the works that Wicar acquired from the Casa Buonarroti.

In 1613 the Florentine printmaker Antonio Tempesta made an engraving after Exh. No. 66r (Fig. 87) as a pendant to one taken from a lost Michelangelo drawing of a male warrior, identified as a portrait of his supposed kinsman, the count of Canossa. A good mid-sixteenth-century copy after the lost Canossa study is in the British Museum (Exh. No. 65). This was long thought to be by Michelangelo, a claim that has recently been revived by one scholar.[187] It was Robinson who first pointed out in print (in the 1876 catalogue of John Malcolm's collection) that the old tradition that it represented Michelangelo's presumed ancestor was supported by the visual pun or rebus on the helmet: a dog (*cane*) gnawing at a bone (*osso*).[188] The Canossa copy drawing is a reminder of the huge influence exerted by Michelangelo's finished black chalk studies on his younger Florentine contemporaries. Artists such as Bronzino and his pupil Alessandro Allori imitated the polished precision of the hatching of Michelangelo's drawings, and the chilly hauteur of their portraits of wealthy Florentines can be seen to echo works such as Exh. No. 66r.[189] When Woodburn exhibited Exh. No. 66 in 1836 among the pick of Lawrence's Michelangelo drawings, it was fancifully identified as a portrait of the Marchesa di Pescara, the aristocratic title of Vittoria Colonna, who became the artist's intimate friend in Rome in the second half of the 1530s.

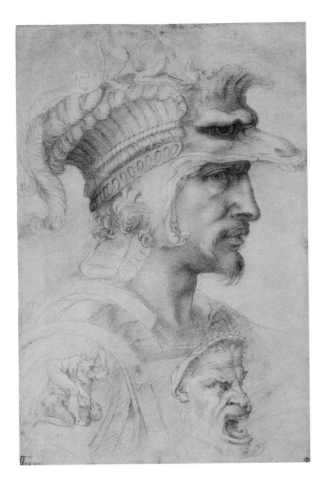

The androgynous quality of the British Museum female head is even more pronounced in a red chalk ideal head in the Ashmolean (Exh. No. 67). The figure's gender has been the source of much debate although the strongest likelihood is that it is of a young man.[190] Michelangelo brilliantly contrived a mood of dreamy melancholy by placing the right-hand side of the face in shadow, and choosing a highly original oblique viewpoint from behind. The dating of the drawing has fluctuated from the period of the Sistine chapel vault to around 1530, but perhaps the closest parallels to the soft feathery touch that Michelangelo employed in the description of the headdress and the shoulders are found in some of the passages of the two red chalk studies of Lazarus executed at the beginning of his time in Florence (Exh. Nos 34–5).[191] Michelangelo's gift for idealization, exemplified in Exh. No. 67, co-existed with a taste for the grotesque: the two poles of beauty and ugliness that had also fascinated Leonardo. The second inclination can be seen in the British Museum drawing of bestial heads (Exh. No. 63r), and in a less extreme form in a contemporaneous bust-length study of a young man in the Ashmolean (Exh. No. 68). The vaguely classical costume and the absurd hat perched on the side of the head are plainly fanciful, but it is less easy to determine whether the pugnacious character depicted in the drawing is a product of the artist's imagination, or a slightly exaggerated portrait of some Florentine coxcomb. The two Ashmolean drawings have points in common, such as the emphatic turn of the figures' heads and the use of light and shade for three-dimensional effect, but the later one is much bolder and more direct in its handling. This is particularly true of the multi-directional hatching, akin

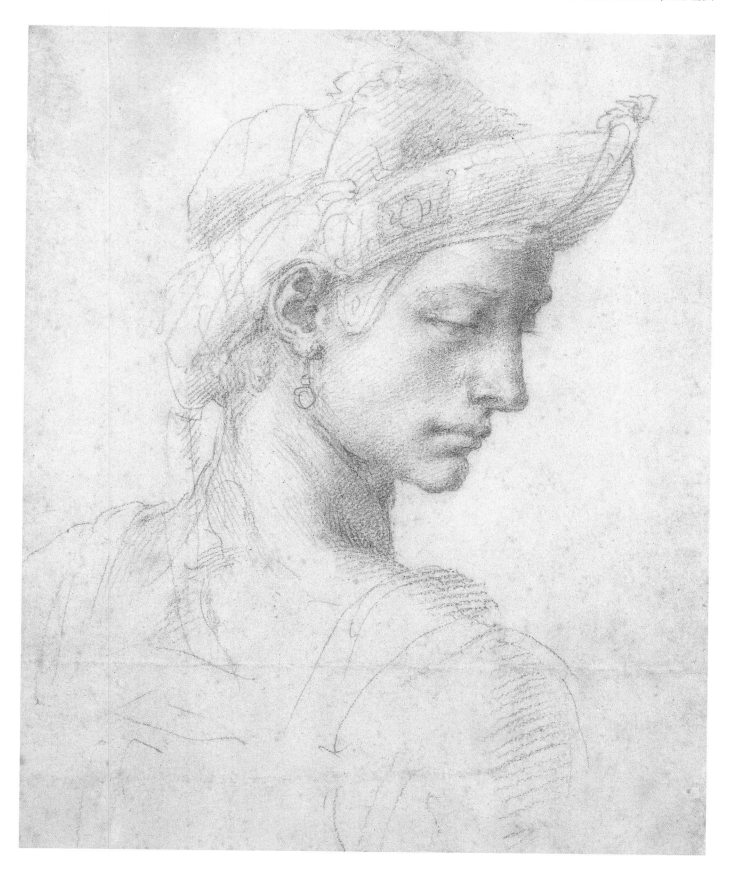

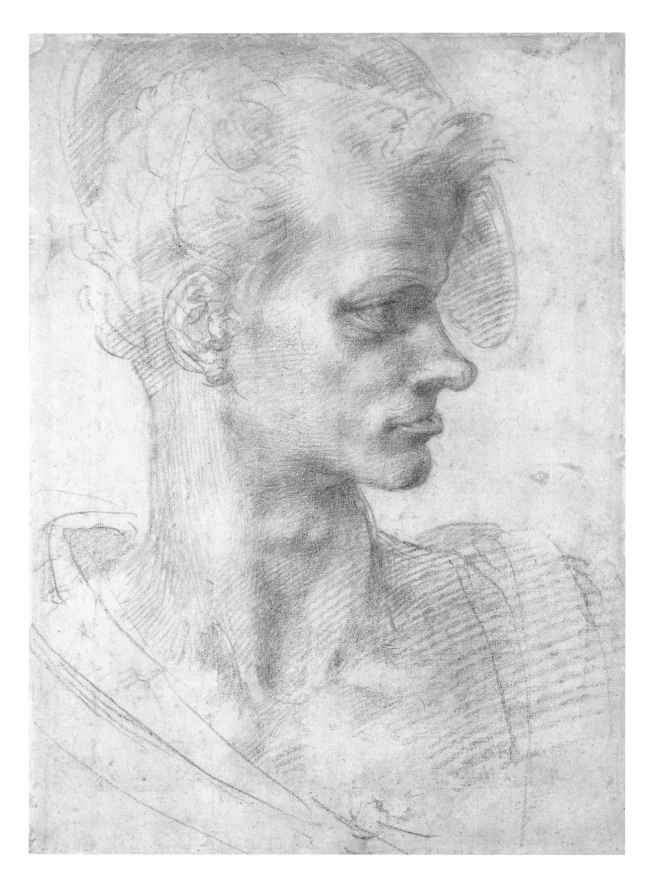

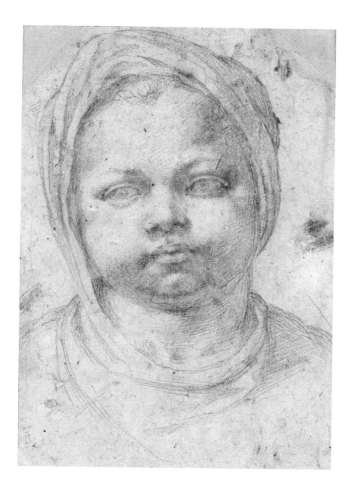

to a pen drawing, used to describe the columnar neck and the projecting tuft of hair that complements his jutting nose and lower lip.[192]

If the Ashmolean drawing is a kind of portrait it is a rarity, as Michelangelo generally managed to avoid making such works (the exceptions being the colossal bronze of Julius II and the marble of the same pontiff reclining on the S. Pietro in Vincoli tomb). The only portrait drawing that Vasari mentions in his biography is one of Tommaso de'Cavalieri which he described as his 'first and last, for he abhorred anything from life unless it was of the utmost beauty'.[193] It has recently been suggested that the latter might be the large and poorly preserved black drawing of a youth in the Musée Bonnat in Bayonne.[194] Michelangelo certainly made more than one portrait drawing, and Vasari's ignorance of them stems from their retention in the hands of the sculptor's friends. In the case of a black chalk drawing in Haarlem of a rather Herculean infant with a scarf, wrapped around his head like a turban (Exh. No. 69), the identity of the sitter will in all probability never be known.[195] The description of his chubby form through tonal chalk modelling, with touches of stumping in the most shaded areas, is paralleled in some of the studies of *Day* (compare Exh. No. 49), and it seems likely that it dates from the mid-1520s.[196]

The young man in the much more polished portrait in the same medium in the British Museum (Exh. No. 70) can be identified as the young Andrea Quaratesi, the scion of a Florentine banking family.[197] This is known from an inscription on a label written by one of the sitter's grandchildren attached to a red chalk copy from the mid-1640s, now in the Uffizi, by

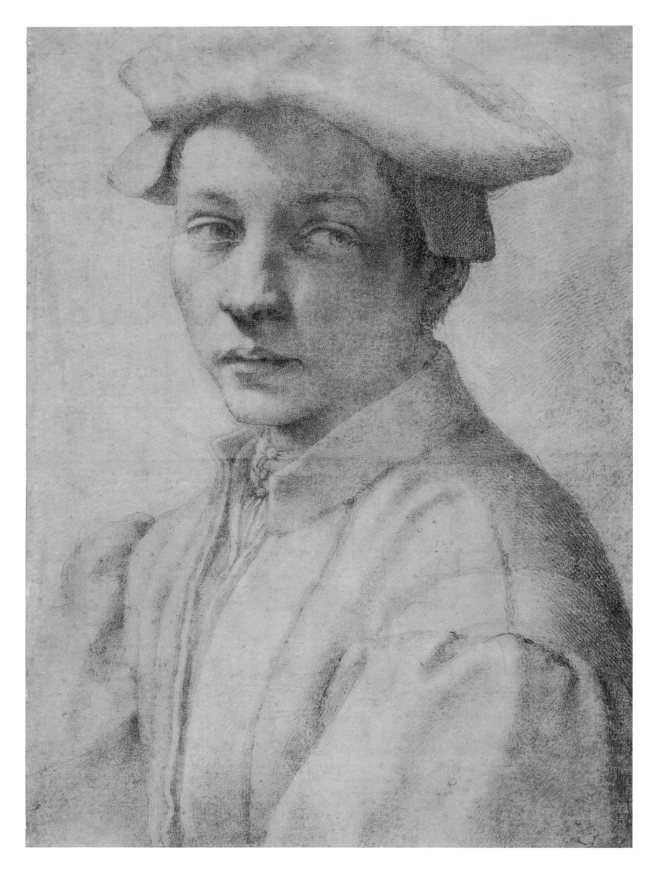

the Florentine Baroque artist Carlo Dolci.[198] The sitter, born in 1512, had been taught to draw by Michelangelo in the mid-1520s (see Exh. No. 60r), and his family may have sheltered the artist after the fall of the city in August 1530 (their main Florentine residence is next to S. Niccolò where is he supposed to have hidden). The drawing is sadly much abraded and has been extensively retouched. These damages have dulled the contrast between the untouched paper, used for the highlights on the left side of the face, and the shadows on the other. The sitter is studied from close range with his shoulders slightly turned to establish a sense of recession, but despite this proximity Michelangelo distances Quaratesi from the viewer by having him looking away to the right. The fixedness of this gaze gives him an anxious, watchful air. It is tempting to link this to Florence's uncertain fate during the early 1530s and to Michelangelo's musings on the fleetingness of youthful beauty in his poetry of the period.[199] The drawing cannot be dated with any certainty and a decision depends, in part, on the judgement of the likely age of Quaratesi. Wilde's dating of 1532 would make the sitter twenty, but he could well be younger. The fact that Vasari had no knowledge of the drawing, and that the only known copies of it are from the seventeenth century, suggest that the Quaratesi family did not advertise their ownership of the work, fearful perhaps that they would be pressured to give it away as happened to other recipients of Michelangelo's artistic gifts (see p. 266).

Unrelated Drawings from the Florentine Period

The following drawings (Exh. Nos 71–2, 75–80) from the 1520s and early 1530s cannot be securely linked to any of the projects that Michelangelo undertook in Florence. The likelihood is that some of them were made in response to the many requests that he received to supply designs for others. The artist's correspondence includes a number of such appeals, such as those written in 1529 by the prior of S. Martino in Bologna for a cartoon or painting of the Virgin and four saints.[200] He must also have received similar unwritten requests, and the impression given by Vasari and by Cellini in his autobiography is that Michelangelo was generous in providing designs for artists he liked, such as Bugiardini, a fellow pupil in Ghirlandaio's studio, and the obscure Domenico da Terranuova, called Menighella.[201] The latter was, according to Vasari, a clumsy painter but a very amusing man to whom Michelangelo gave drawings of religious subjects as models for paintings sold to country peasants and labourers.

Perhaps the most likely candidates for drawings made in response to requests for designs are the two red chalk drawings on the theme of the Crucifixion in the British Museum and Haarlem (Exh. Nos 71–2). Wilde suggested that these comparatively rare composition studies were related to Michelangelo's promise, referred to in his correspondence in June and July 1523, to execute a small work, in whatever medium he chose, for Cardinal Domenico Grimani.[202] The Venetian patrician was a noted collector of northern European paintings, with contemporary sources mentioning examples by artists such as Memling and Bosch, but he is also known to have owned some important Italian works, including a cartoon by Raphael of the *Conversion of St Paul*, a version of Sebastiano's *Christ Carrying the Cross* and some paintings, now lost, supposedly executed in Rome by Michelangelo.[203] If the drawings were made for a composition for the cardinal's study ('quadretto per uno studiolo'), Michelangelo must have heeded the request with unusual speed because Grimani died at the end of August 1523. Wilde's grounds for connecting the two drawings with Grimani was that their subject matter would have been appropriate as a devotional work. Rather than a painting, the compositions suggest a small-scale

Exh. No. 70 **Andrea Quaratesi**,
c. 1528–32. Black chalk,
two made up areas at upper edge,
41.1 × 29.2 cm. The British
Museum, London

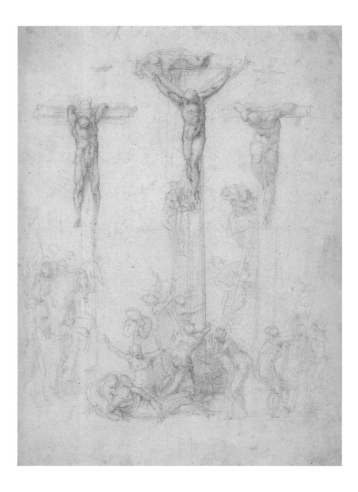

left
Exh. No. 71 **The Three Crosses**,
c. 1523. Red chalk, 39.4 × 28.1 cm.
The British Museum, London
(a larger illustration is on p. 152)

below
Exh. No. 72 Verso Michelangelo
and pupils, **Stooping woman,
and copies after Giotto**, *c.* 1523.
Red chalk, made up areas at the left
edge, 19 × 27.2 cm. The Teyler
Museum, Haarlem

relief, especially in the case of the Haarlem study which has parallel hatching behind the figures to denote a flat background. In date, the style of drawing fits well with the early Medici chapel studies from the beginning of the 1520s, especially as regards the stylized simplification of the figures (Exh. Nos 40–1).

The unusually well-preserved study in London (Exh. No. 71) depicts an earlier moment in the biblical narrative than the Haarlem drawing, as the soldiers clamber up Christ's abnormally tall Y-shaped cross at the centre to nail his arms and feet. Jesus' head is turned upward to the right to look at an ascending winged creature, perhaps a child-angel or the departing soul of the dead thief to the left. Wilde identified the crucified figure on the right as the Good Thief because his cross is level with that of Christ's, but more commonly this is the position of the Unrepentant Thief as it is on Jesus' ill favoured left side.[204] The centre of the drawing is dominated by the dramatic group of figures at the base of the cross: some attend to the gigantic figure of the collapsed, but still conscious Virgin, while others bewail the fate of Christ crucified above them. The image in the drawing of the suffering Virgin looking up at her dying son is strikingly different from her meditative composure in earlier works, such as the National Gallery's unfinished *Entombment* or in the marble *Pietà* in St Peter's. This change fits the suggestion that the drawing was a design for a private devotional work where such emotiveness would be appropriate.

The pared down Haarlem composition (Exh. No. 72r) may have been drawn after the London sheet with the aim of increasing the pathos by showing the Deposition, the scene of

opposite
Exh. No. 72 Recto **Studies
for a *Deposition***, *c.* 1523.
Red chalk, made up areas on lower
edge, 27.2 × 19.1 cm. The Teyler
Museum, Haarlem

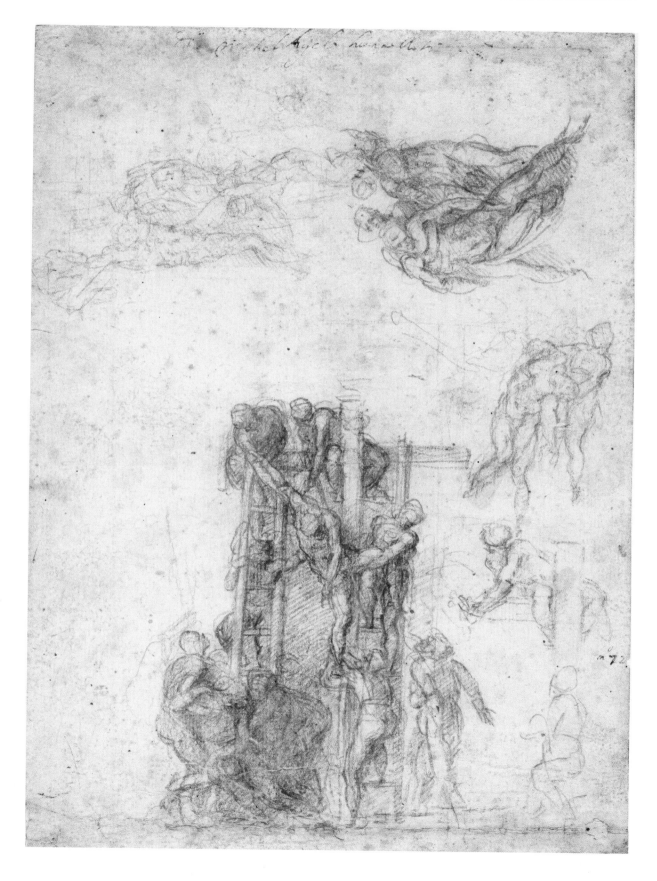

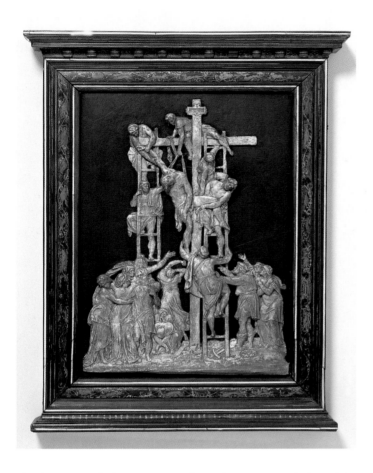

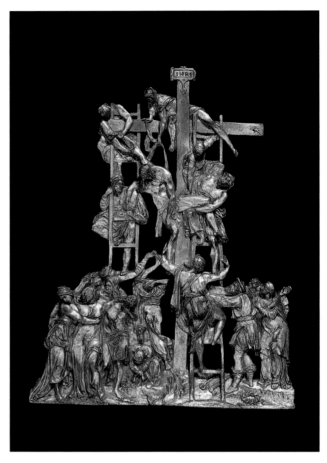

the lowering of Christ's corpse from the cross. Michelangelo's conception owes much to well-established Florentine models, such as Filippino Lippi's altarpiece (completed after his death in 1504 by Pietro Perugino) in SS. Annunziata, now in the Accademia, which has men lowering Christ's flopping, lifeless body from two ladders on either side of the cross.[205] Michelangelo's design adheres to the long-standing tradition of having the Virgin Mary swoon with grief below the cross, her sagging form mirroring that of her son. To the right of the main study in the lower corner he studied anew the attendant holding up the Virgin's left arm, and above that, the pose of the bearded man straddling the top of the cross like a mariner on a mast. Slightly higher up the sheet, he sketched a schematic figure supporting Christ's body, with the upper part of the cross and a loop of drapery faintly drawn behind. He then proceeded to make two further studies after rotating the sheet ninety degrees to the right. The lower one of these shows a simplified idea for the fainting Virgin with two attendant figures, one of whom looks up towards the right. A similar linking figure gazing at the Deposition is found in the group beneath the cross in the main study. Above this subsidiary study is a slightly oblique angle view of three bearers taking Christ down from the cross, his right arm hooked behind the horizontal crosspiece as with the right-hand thief in the British Museum drawing. On the verso the study of a heavily draped woman, partly drawn over a pupil's studies of some heads from Giotto, may possibly be a more developed idea for one of the women tending to the Virgin. The Haarlem and London drawings were long considered to be by either Sebastiano or by Michelangelo's much later associate Daniele da Volterra. Wilde's arguments for their stylis-

above left
Exh. No. 73 Anonymous Artist, **The Deposition**, after Michelangelo, second half of the sixteenth century. Relief in gilded gesso on a slate ground, 38.1 × 27.9 cm. The Victoria and Albert Museum, London

above right
Exh. No. 74 Anonymous Artist, **The Deposition**, after Michelangelo, seventeenth century. Relief in gilt bronze, 28.6 × 21.3 cm. The Victoria and Albert Museum, London

tic links with Michelangelo's drawings in the early 1520s, and the distinctly Florentine flavour of the two works, firmly disprove such suggestions.[206]

The Haarlem composition was later used as the basis for a small-scale relief sculpture of which there are a large number of examples in different media. It has recently been suggested that the earliest of these are the two wax reliefs in the Bargello and in the Munich Residenz that have been attributed to an artist in the circle of Daniele da Volterra, and dated around 1570.[207] These do not follow the Haarlem drawing exactly. The most obvious differences between them are the addition of more figures on the right, and a change made to the pose of the Virgin. It is possible that these adjustments reflect a lost prototype by Michelangelo, as there is a British Museum study from the 1540s for the standing Virgin and her attendants that is similar in many respects to their counterparts in the relief.[208] The wide circulation of the relief is shown by the fact that the Victoria and Albert Museum has four examples, two of which are included in the London exhibition (Exh. Nos 73–4).[209] The earliest of which (Exh. No. 73), made from gilded gesso on a slate ground, reproduces faithfully the composition of the two wax reliefs, and most likely dates from the second half of the sixteenth century. This has an extremely distinguished provenance which includes J.C. Robinson, the greatest English authority on drawings and works of art in the second half of the nineteenth century, and before him Thomas Lawrence and Samuel Woodburn. The popularity of the model is demonstrated by a seventeenth-century gilt

Exh. No. 75 **The Worship of the Brazen Serpent**, c. 1530. Red chalk, made up areas at left and lower edges, 24.4 × 33.5 cm. The Ashmolean Museum, Oxford

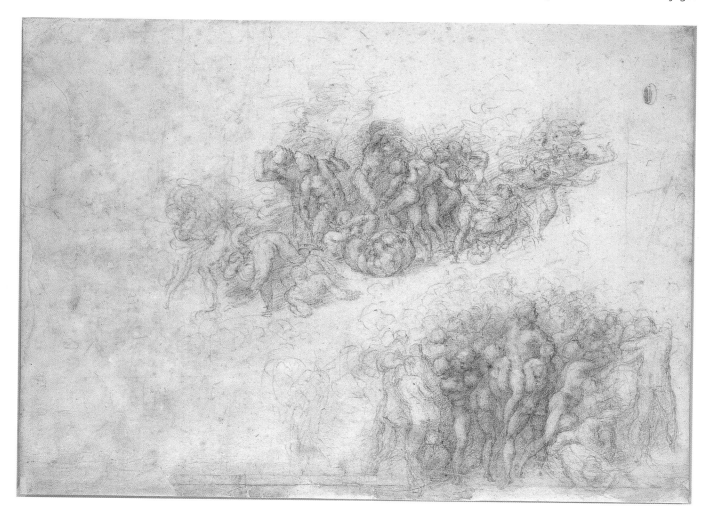

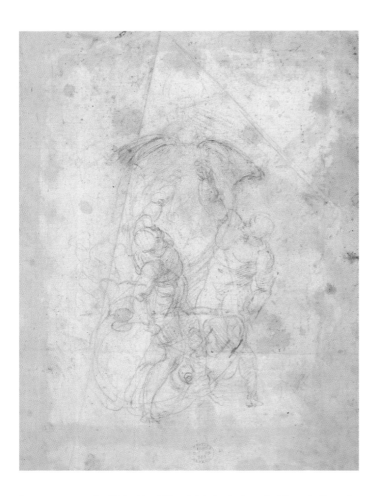

Exh. No. 63 Verso **Two men with spears**, *c.* 1530. Red chalk over earlier black chalk studies, 25.5 × 35 cm. The British Museum, London (recto illustrated on p. 200)

bronze example (Exh. No. 74) which includes slight variations from the earlier model, such as to the pose of the woman directly beneath the cross, to make it simpler to cast.

The refinement of the chalk in the Haarlem drawing is matched by an enigmatic sheet in the Ashmolean (Exh. No. 75) of the early 1530s, depicting two episodes in the Old Testament story of the Brazen Serpent (Num. XXI.4–9). In the upper study, drawn in a liverish shade of red chalk, the Israelites are shown unsuccessfully fending off a plague of serpents sent to punish them for speaking out against God and Moses. In a previous depiction of the subject in one of the Sistine chapel pendentives Michelangelo had shown some of the serpents flying, and he elaborated this vision in the drawing by giving them wings. The poses of the two figures on the left of the group defending themselves from airborne attack seem to have been the subject of a separate, larger-scale study in red chalk on the verso of Exh. No. 63.[210] In a slightly different shade of chalk from the study on the upper part of Exh. No. 75, the artist studied what appears to be the left-hand side of a composition devoted to the successive episode: the curing of the repentant Israelites by looking at a bronze serpent raised on a cross (hence the typological parallels with Christ's crucifixion). The surging motion of the close packed figures in the upper study is strongly reminiscent of the *Bathers* composition. The parallels are confirmed by his incorporation in the foreground of the lower composition of an unused motif for the Cascina project: the lookout lifted up by two companions studied in Exh. No. 14 (see Fig. 88). This adaptation is a rare exception to Condivi's boast that Michelangelo's 'tenacissima memoria' ensured that he never repeated the same pose.[211] The earlier motif

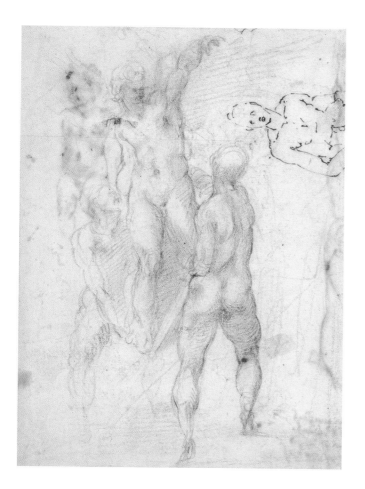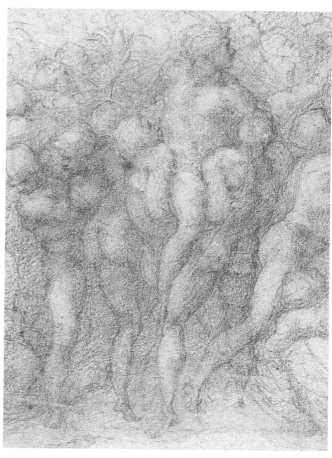

Fig. 88 **Details from Exh. Nos 14 recto and 75** (illustrated on pp. 76 and 215 respectively)

fitted well with the key element in the Old Testament narrative that salvation was granted only to those Israelites who were able to see the Brazen Serpent. Michelangelo's composition powerfully evokes the crowd's panic with a scrimmage of figures, including infants hoisted up by adults on the leftmost fringe of the group, desperately looking to the right, while those too weak to stand, like the man to the left of the Cascina group, implore their neighbours to lift them up.

Almost twenty years earlier Michelangelo had conflated the same two episodes in the Sistine chapel fresco, but the Ashmolean study cannot be so early, since in style it is close to the British Museum compositional study for the *Last Judgement* (Exh. No. 82). The Oxford drawing was almost certainly drawn before Michelangelo's move to Rome in 1534 because his collaborator in the Medici chapel, Raffaello da Montelupo, made copies after it.[212] The purpose of Exh. No. 75 has elicited much scholarly speculation, including the ingenious but certainly erroneous hypothesis that the two episodes were intended for the Medici chapel lunettes.[213]

A similarly unresolved question of destination is attached to a sizeable group of fourteen studies from the same period for a Risen Christ for a composition of the *Resurrection*. Three of these, all from London, are included in the present selection (Exh. Nos 76–8).[214] A plausible explanation for some of this group is that they were drawn to assist Sebastiano in designing an altarpiece of the subject for the Chigi chapel in S. Maria della Pace, Rome; a commission that was revived in 1530 after a decade-long interval but which the Venetian

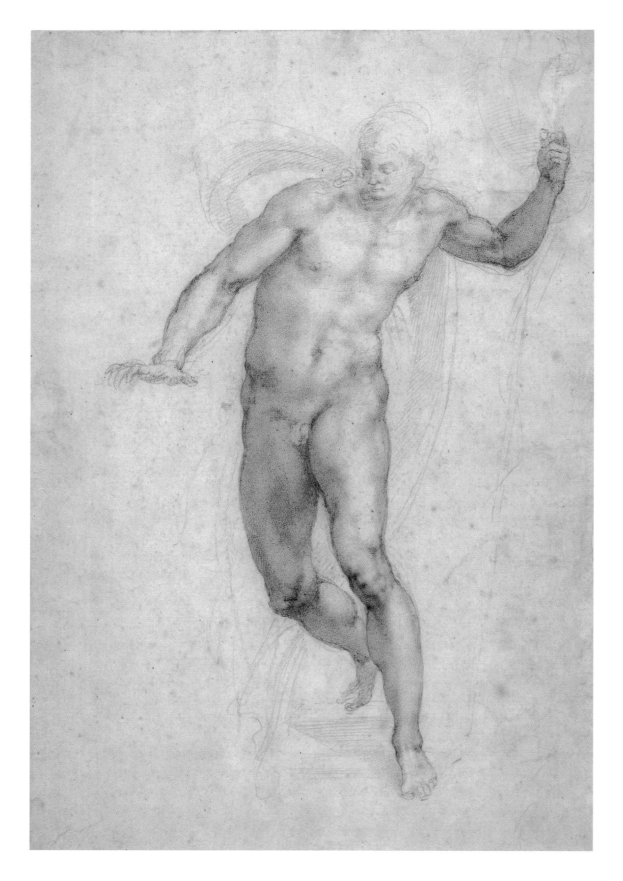

right
Exh. No. 76 Verso (detail)
**Fabulous monster and a nude
man holding a dish**, *c.* 1532–3.
Black chalk, 41.4 × 27.4 cm.
The British Museum, London

far right
Fig. 89 **The Risen Christ**,
c. 1532–3. Black chalk, 37.2 × 22 cm.
The Royal Collection, Windsor
Castle

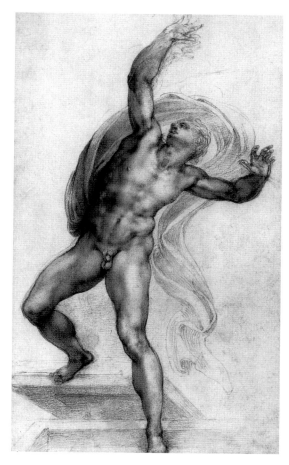

never fulfilled.[215] The impressive black chalk study of a lithe balletic Christ, holding a banner and standing poised with his eyes still closed on the edge of the opened sarcophagus (Exh. No. 76), may well have been made for Sebastiano's work on account of the unusual direction of the lighting from the right, as is the case with Raphael's *Prophets* and *Sibyls* frescoed above the intended position of the altarpiece.[216] The same direction of light is found in Michelangelo's study of the same figure at Windsor (Fig. 89).[217] Christ's head in Exh. No. 76 was originally drawn larger, the reduction in its size exaggerating his attenuated proportions. This change conforms to Vasari's observation that Michelangelo made his figures 'of nine, ten or twelve heads, endeavouring to realize a harmony and grace not found in Nature'.[218] On the verso are two unrelated drawings of a man holding a dish and a fabulous monster with a very human forearm. The action of Christ stepping out from the tomb shown in Exh. No. 76 is repeated in Exh. No. 77, but he is turned the other way and lit from the other side. In the latter, Christ is silhouetted against the mouth of the cave whose tear-shaped shape can be read as a kind of mandorla.

A similar setting for the narrative is shown in the most developed of the three drawings, a visionary and highly personal interpretation of Christ's ascent from the tomb (Exh. No. 78).[219] Conventionally this episode is depicted with Christ ascending vertically holding the banner of the resurrection while the astonished soldiers scatter in terror below. Michelangelo chose instead to express Christ's indeterminate state of being: caught in the hinterland between his soon to be discarded human body and his divine spiritual form. This hybrid state is conveyed

opposite
Exh. No. 76 Recto **The Risen
Christ**, *c.* 1532–3. Black chalk,
41.4 × 27.4 cm. The British
Museum, London

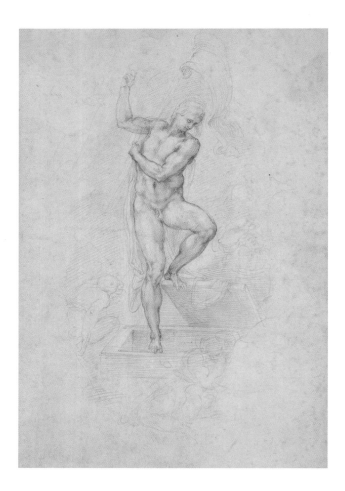

Exh. No. 77 **The Risen Christ**,
c. 1532–3. Black chalk,
40.6 × 27.1 cm. The British
Museum, London

through the weightless upward drift of his elongated, yet still three-dimensional, body. The idea that Christ after death was simultaneously material and immaterial was not new. For example, Dürer in his much circulated 1510 *Large Passion* woodcut series had shown the seemingly solid figure of the Risen Christ floating above the tomb, having passed through its lid without breaking the seal attached to its side. What is novel about Michelangelo's representation is Christ's passivity, his somnolent state registered by the lolling backward position of his head, as though he had not yet fully regained consciousness but was obeying an irresistible divine force that was drawing him softly, yet insistently upwards. His otherworldliness is also registered by the fact that he is considerably larger than the cowering soldiers sketched in with varying degrees of finish around the tomb, a displacement of scale in the representation of sacred figures that recalls the pictorial conventions of religious art of the trecento. Michelangelo had inherited from Ghirlandaio a reverence for earlier Florentine art, as witnessed by his copy after Giotto (Fig. 13), and it is clear that in the present instance he sought inspiration from medieval sacred paintings in which naturalistic conventions of scale and perspective were not followed. The 'severe simplicity' of such works, as they were described by one of the interlocutors in Francisco de Hollanda's *Dialogues*, imbued them with an authentic religiosity that inspired Michelangelo.[220]

The lighting of the scene conforms to Sebastiano's requirements for S. Maria della Pace, but the compactness of the design would have made it unsuitable for the upright rectangular format of an altarpiece without considerable revision. The drawing may instead have been an

Fig. 90 Attributed to Marcello Venusti (*c.* 1512–79),
The Resurrection of Christ,
after Michelangelo, *c.* 1550–78.
Oil on panel, 61 × 40 cm. The Fogg Art Museum, Harvard University Art Museums, Grenville L. Winthrop Bequest

independent spin-off from Michelangelo's work for his friend. The composition clearly was admired because there are a handful of drawn and painted copies after it, the best known of which is the small oil on panel in the Fogg Art Museum in Cambridge, Mass. (Fig. 90). The authorship of the painting has oscillated between the two painters of small-scale works after Michelangelo's drawing, the Croatian miniaturist Giulio Clovio and Marcello Venusti.[221] The Croatian's knowledge of Exh. No. 78 is demonstrated by his having borrowed the pose of Christ in his *Resurrection* miniature in the Townley Lectionary commissioned by Cardinal Alessandro Farnese in the early 1550s and now in the New York Public Library, but stylistically the panel fits better with Venusti's work.[222] Comparison with Exh. No. 78 reveals how the intensity and spirituality of the original has been reduced in the painting by the alteration to the scale and position of Christ.

Another religious theme that the artist explored in his drawings during the 1520s and early 1530s was that of the Virgin and Child. In common with the *Resurrection* studies none

Exh. No. 78 ***The Resurrection of Christ***, *c.* 1532–3. Black chalk, 32.6 × 28.6 cm. The British Museum, London

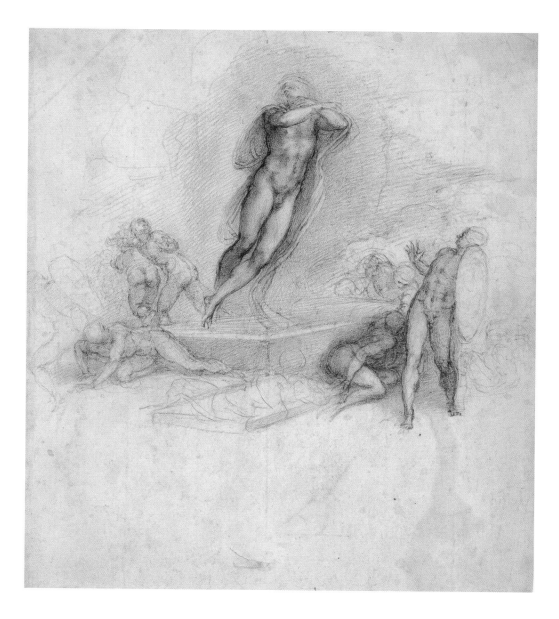

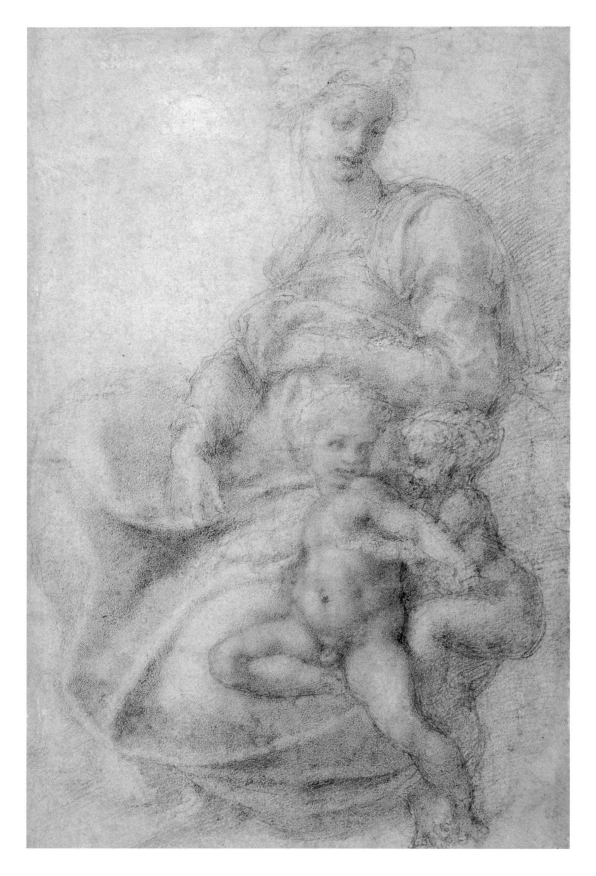

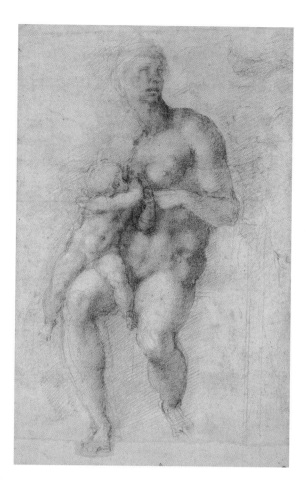

of these relates to a finished work by Michelangelo. The highly worked, but sadly considerably rubbed, black chalk study in the British Museum (Exh. No. 79) is one such work from the early 1530s. The pose of the Virgin is, as Wilde noted, based on that of the young mother in the Roboam and Abias lunette in the Sistine chapel. The inclusion of the Infant Baptist in a Virgin and Child composition as a playmate is conventional enough, but in the drawing he shows none of his usual deference and the two highly muscled infants are shown wrestling with each other.[223] The variety of finish in the drawing, ranging from the detailed description of Christ's torso and legs to little more than the outline of his right arm on the mountainous lap of his mother, is again found in a study in the same medium also in the British Museum's collection (Exh. No. 80). Wilde was inclined to date this to the period after Michelangelo's move to Rome in 1534, but if so it contains strong echoes of his Florentine work. The swivelling motion of the Christ Child to suckle from his mother's breast recalls, for example, his counterpart in the unfinished *Medici Madonna* marble (Fig. 91) in the Medici chapel inspired by a venerated trecento painting of the subject in S. Lorenzo known as the *Madonna di San Zanobi*.[224] The motif of the Infant seeking nourishment and comfort from his mother can be traced right back to his earliest marble relief, although a more direct forebear is a tiny sketch on the sheet of Cascina and Apostle studies of *c.* 1504 in the Uffizi (Fig. 28). In the London study the turning motion of the child is echoed in the twist of his mother's head towards the bearded figure of Joseph sketchily drawn to the right. The idea of giving the Virgin's movement a narrative impulse by the addition of her husband looks to have been an afterthought that followed the

completion of the Virgin and Child. The outlines of Joseph, like the gesturing figure of the Infant Baptist perched precariously on the side of the throne, are drawn over the hatching that Michelangelo used to push the main group into greater relief. The highly unconventional representation of the Virgin in the nude is hard to explain, unless the study was made to clarify her pose in preparation for a painting (as in the male nude used for the Bruges Madonna: Exh. No. 14r), but no such work is known.

A Study for a Presentation Drawing

A black chalk study of the Fall of Phaeton in the British Museum (Exh. No. 81) is inscribed at the bottom with a note written in Michelangelo's hand: '[Mess]e^r toma[s]o se questo scizzo no[n] vi piace ditelo a urbino [acci]o/ ch[e] io abbi tempo d averne facto un altro doma[ni]dassera/ [co]me vi promessi e si vi piace e vogliate ch[e] io lo finisca/ [rim]andate me lo' ('Messer Tommaso, if this sketch does not please you, say so to Urbino in time for me to do another tomorrow evening, as I promised you; and if it pleases you and you wish me to finish it, send it back to me'). The recipient of the drawing brought to him by Michelangelo's servant, Francesco d'Amadore, called Urbino, was Tommaso de'Cavalieri, a Roman aristocrat with whom the sculptor had fallen in love during a protracted visit to Rome in 1532. The fifty-seven-year-old artist's passionate attachment to the Roman nobleman more than forty years his junior (Cavalieri's date of birth is unknown but the likelihood is that he was only twelve on their first meeting) was to endure until his death. The artist expressed his feelings for Cavalieri in letters, poems and a handful of his most exquisitely finished presentation drawings.[225]

The first drawings that Michelangelo made for him were probably a *Tityus*, now at Windsor, and a lost *Ganymede* which Cavalieri acknowledged receipt of in a letter of January 1533.[226] The two works, inspired by Ovid's *Metamorphoses*, addressed two contrasting responses aroused by the artist's feelings for Cavalieri: the torment of passion, symbolized in the daily punishment of the shackled Tityus having his liver devoured by a gigantic bird; and the Platonic elevation of the twinned spirits of the artist and his younger love, manifested in the image of Jupiter in the guise of an eagle lifting heavenward the beautiful Ganymede. The latter subject was also unquestionably homoerotic. While Michelangelo's homosexuality is now almost universally acknowledged, opinion will probably forever remain divided as to whether these desires were expressed physically. Condivi later claimed that Michelangelo was able to extinguish in the young any 'incomposto e sfrenato desiderio' ('unseemly and unbridled desire'), but there is no way of knowing whether this had always been true of the sculptor's own behaviour.[227] The stress laid on the absence of earthly passion in Michelangelo's delight in human beauty in Condivi and Vasari's biographies is surely indicative of a certain defensiveness regarding this issue. Michelangelo's refashioning of his character goes even further in Francisco de Hollanda's third *Dialogue* where the elderly artist is reported as advising that a good painter should be like a saint for the Holy Spirit to inspire him. More earthy insinuation regarding his sexuality surface in Aretino's bitter gibe that only 'Gherardos and Tommasos' could count on receiving a drawing from him.[228] There is no firm evidence in Michelangelo's correspondence to support Aretino's intimation, although some interpret his stormy relationship with Febo di Poggio at the end of his time in Florence as evidence of a homosexual affair.[229] As regards Cavalieri, the very public nature of their relationship, thanks to the fame at the papal court of Michelangelo's dedicatory poems and drawings, perhaps make it less

Exh. No. 81 *The Fall of Phaeton*, 1533. Black chalk over stylus, 31.3 × 21.7 cm. The British Museum, London

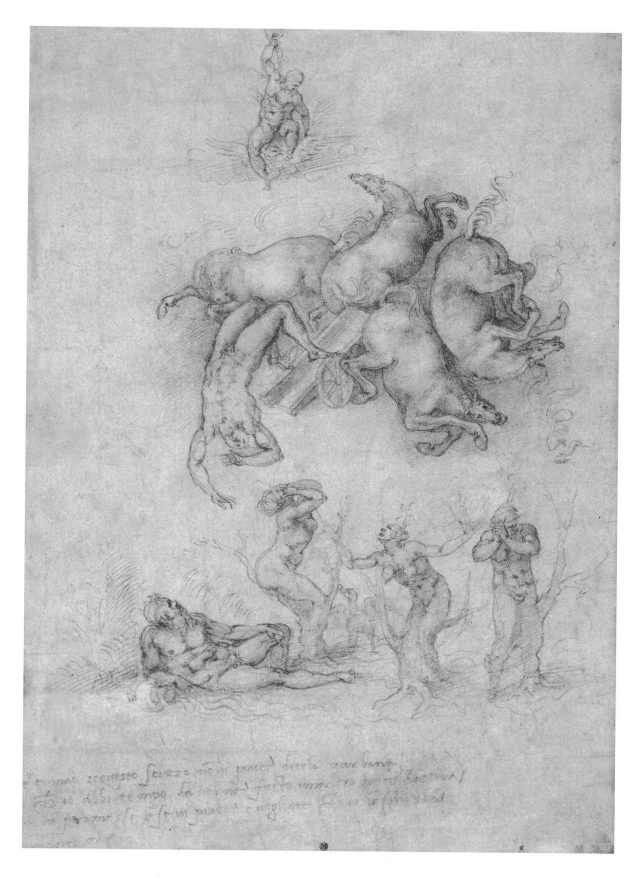

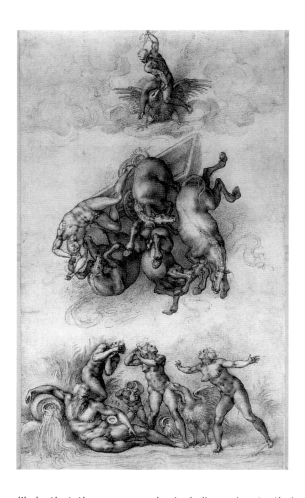

left
Fig. 92 **The Fall of Phaeton**, 1533.
Black chalk, 41.3 × 23.4 cm. The
Royal Collection, Windsor Castle

right
Fig. 93 After Giovanni Bernardi
(1494–1553), **The Fall of Phaeton**,
after Michelangelo, *c.* 1540–50.
Cast bronze plaquette, 8.5 × 7 cm.
The British Museum, London

likely that there was a physical dimension to their relationship.[230] Michelangelo's poems to Cavalieri were never published during his lifetime, but they did circulate in Roman and Florentine literary circles. Benedetto Varchi selected one of them as the subject for a lecture given to the Florentine Academy in 1547 published two years later as *Due lezzioni*.[231] For Varchi the friendship with Cavalieri was an example of Platonic love, and it should be born in mind that Michelangelo's devotion to a younger man was not abnormal in a very male-dominated society. A ready parallel is Luigi del Riccio's passion for his beautiful and short-lived nephew Cecchino Bracci, whose death in 1544 was lamented by Michelangelo in a series of poetic epigrams.[232]

A different aspect of love's dangers, again inspired by a subject from Ovid, is treated in the British Museum drawing. This depicts the story of Phaeton, the son of Apollo, who took advantage of his father's rash promise to grant him anything he wished by asking to drive the chariot of the sun. This act of hubris earned him a deadly lightning bolt from Jupiter, shown astride an eagle at the top of the drawing, when he lost control of the horses and threatened to incinerate the earth. His burning body fell into the Eridanus (the Po river) represented in the drawing by the reclining River God dispassionately watching Phaeton's descent. To his right are the young man's sisters, the Heliades, and his relation Cycnus whose grief at his loss was so intense that they were transformed respectively into poplar trees and a swan. Michelangelo identification with the plunging figure of Phaeton, punished for his presumptuousness in aspiring to the divine realm of his father, is echoed in his poetry of the period that

frequently equates love with fire and burning.[233] The middle section of the drawing pays homage in the representation of the headlong fall of Phaeton and the horizontal arrangement of the panic stricken horses and chariot to a well-known sarcophagus relief of the subject then found outside S. Maria in Aracoeli in Rome. This was a visual reference appropriate to the classical literary source, and to Cavalieri's upbringing among a distinguished collection of antiquities in his family's palace not far from the church.[234]

Michelangelo's inscription shows that the drawing was made when he was in Rome, but it was not worked up further. Instead the artist made a modified and slightly larger drawing of the subject in his most painstaking manner. This exquisite work, now at Windsor (Fig. 92), was sent from Florence and it was much admired by the Roman cognoscenti, headed by Pope Clement and Cardinal Ippolito de'Medici, who flocked to see Cavalieri's unrivalled hoard of three presentation drawings from his artistic admirer.[235] It is likely that Cavalieri also retained the British Museum sketch along with the Windsor presentation sheet, for a rock-crystal intaglio cut by Giovanni Bernardi of the *Fall of Phaeton*, now in the Walters Art Museum, Baltimore, inventively combines elements from both designs.[236] The intaglio was one of three based on Cavalieri's presentation drawings commissioned from Bernardi by Cardinal Ippolito, and probably completed before the latter's death in 1535 only a few years after the drawings had been made. Bernardi also made a slightly different adaptation of the two drawings for a set of rock-crystal intaglios commissioned by Pier Luigi Farnese in the early 1540s. Ippolito's original intaglio is lost but its composition is recorded in bronze plaquettes cast from it, of which there is an example in the British Museum (Fig. 93). A third drawing of the subject by Michelangelo, now in the Accademia, Venice, may, like Exh. No. 81, be a sketch for the Windsor sheet or a slightly later treatment made after his permanent move to Rome in 1534.[237]

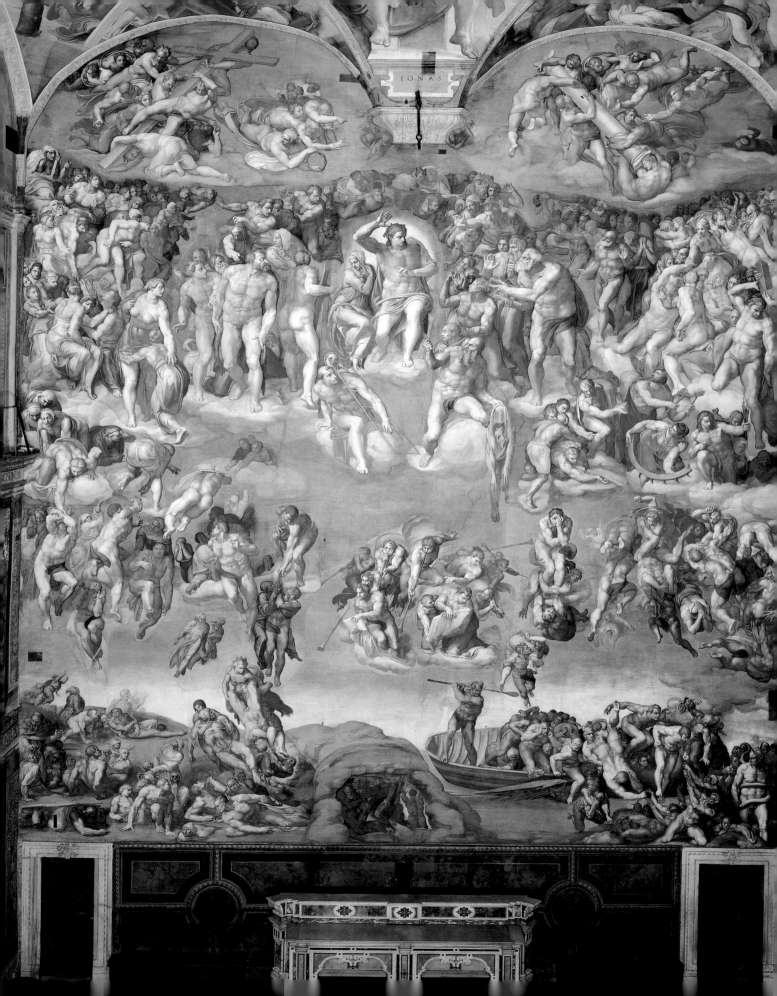

6

Rome
1534–1564

The Last Judgement

The first recorded hint that Clement VII was planning a major Roman commission for Michelangelo is contained in a letter to the artist from Sebastiano in mid-July 1533.[1] Michelangelo had just returned from an extended stay in Rome lasting from August 1532 to June 1533, and Sebastiano was writing in reply to a now lost letter detailing the progress that had been made at S. Lorenzo (a missive reportedly read so many times that Clement knew its contents by heart). In response to Michelangelo's expressed wish to return to Rome, Sebastiano reported that the pontiff had in mind an exciting project: 'farvi contrato de tal cossa che non ve lo sogniasti mai' ('to give you a contract for something beyond your dreams').[2] If Vasari's 1568 *Lives* is to be believed, Clement's ambitious plan encompassed Michelangelo painting at either end of the Sistine chapel: a *Fall of the Rebel Angels* at the entrance wall, and a *Last Judgement* behind the altar.[3] Michelangelo probably discussed the matter with Clement in September when they briefly met on the pontiff's way to France. Condivi and Vasari state that the sculptor was initially unwilling to take on such a large-scale project because he was anxious to fulfil the revised Julius tomb contract he had just agreed. This supposed reluctance may have more to do with his later attempts to placate the aggrieved della Rovere than with his actual sentiments at the time, but it is not impossible that he may have resisted returning to the chapel after a gap of more than twenty years, especially as he had not painted at all since 1512. However, the Sistine commission provided a welcome excuse to absent himself from the autocratic rule of Duke Alessandro in Florence, and in the following September he moved to Rome.

The death of Clement a few days after Michelangelo's arrival changed nothing, as his successor, Cardinal Alessandro Farnese, elected Paul III in October 1534 at the age of sixty-six, was equally keen on the plan. The new pontiff came from a distinguished family from the region north of Rome with a long history of loyalty to the papacy. He had been educated at the University of Pisa, and had also spent time in the circle of Lorenzo de'Medici in Florence. In 1491 he had entered the Roman curia (the papal bureaucracy), and two years later was made a cardinal by Alexander VI, who was said to have had Alessandro's older sister Giulia, known as 'la bella', as one of his mistresses. Farnese's canny intelligence and diplomatic guile were recognized by Julius II, and his Florentine link meant that his career blossomed further during Leo X's pontificate. He marked his growing success by commissioning Giuliano da Sangallo's nephew, Antonio, to design several buildings, including the remodelling of the family's Roman residence, the Palazzo Farnese, which Michelangelo was later to embellish (see Exh. No. 103). It was also during Leo's pontificate that Farnese's long delayed taking of holy

Fig. 94 *The Last Judgement*, 1536–41. Fresco. Sistine chapel

229

orders finally occurred in 1519, by which time he had already fathered four children. During his fifteen years as pope (1534–49), he flagrantly promoted his family interests, while at the same time beginning the process of reform that his predecessors had failed to instigate. His most important contributions to this cause were the confirmation of the Jesuit Order in 1540, the establishment of the Roman Inquisition to root out heresy and false doctrine two years later, and in 1545 the convening of the Council of Trent to redefine the church's doctrines and structures.

The choice of an apocalyptic subject matter for the chapel by Clement was not a response to the church's embattled position, because paradoxically it had been strengthened by the traumatic events of the Sack.[4] The confirmation of Hapsburg/Spanish dominance in Italy finally brought to a close more than thirty years of intermittent warfare on Italian soil started by the French invasion in 1494. Apart from occasional periods of crisis, like the invasion of the Papal States in 1556 by Spain's viceroy in Naples that precipitated Michelangelo's flight to Spoleto, the threat to Rome of a repetition of the slaughter and destruction of 1527 never arose. The resolution of the conflict meant that Clement could begin to rebuild the papacy's spiritual authority which had been so severely tarnished by its struggles to retain control of church territories in Italy. The fluctuating fortunes of the Hapsburg emperors and the Valois kings over this period had frequently wrong footed the incumbent pope, but it was the unfortunate Clement who paid most dearly for his political miscalculation. Both he and Charles V were keen to repair the damage done to the battered ideal of the *Imperium Christianum*, and their resolve to ensure that hostilities between them did not occur again was strengthened by the seriousness of the dangers from Protestantism in northern Europe and a growing threat on Europe's eastern margins from Ottoman invasion.

The end of France's territorial ambitions in the peninsula saved Clement's successors from repeating his mistake, and the rivalry of the two European powers was played out instead in Rome through diplomatic manoeuvring to win advantage at the papal court. The end of French ambitions in Italy virtually ended Florentine republican hopes that the Medicean regime would be toppled, especially after the attempts of the exiles (*fuorusciti*) to take advantage of Alessandro de'Medici's assassination in 1537 were crushed at the Battle of Montemurlo by forces loyal to the youthful Cosimo de'Medici, who soon after was made duke. The desperateness of the republican cause is highlighted by Michelangelo's 1544 offer, transmitted through the Florentine exile Roberto Strozzi, that he would reward Francis I's liberation of the city by erecting an equestrian sculpture at his own expense in the Piazza della Signoria.[5] Michelangelo's recognition of the political realities of his homeland (not to mention a fear of losing his extensive Florentine investments by continued support of the exile cause: see his letter in Appendix II, no. 8, p. 296) is neatly summed up by the fact that in the early 1560s he did design an equestrian sculpture to honour a French king, but it was at the behest of Catherine de'Medici to commemorate her husband Henry II.[6]

Michelangelo's fresco was, in any case, directed at an audience who thought of the Apocalypse in a very different way from our own age. According to Christian belief, the end of the world, when it is promised that all humanity will rise from the dead and be judged by divine justice, is a moment to be joyously welcomed not dreaded: 'look eagerly for the coming of the Day of God and work to hasten it on; that day will set the heavens ablaze until they fall apart, and will melt the elements in flames. But we have his promise, and look forward to new heavens and a new earth, the home of justice' (II Peter III.12–13).[7] The *Last Judgement* was a subject fairly frequently encountered in Italian churches, a favoured location for it being the

Fig. 95 Francesco Rosselli
(1448– before 1513),
The Last Judgement, c. 1470–85.
Engraving, 35.5 × 49.3 cm.
The British Museum, London

large expanse of the entrance wall where it would serve as an admonition to the faithful to heed the church's teachings as they turned towards the door at the end of the mass.[8] It was also a theme that could on occasion be depicted in altarpieces, like the highly influential example painted by Fra Angelico for S. Maria degli Angeli in Florence in 1431 (now in the Museo di S. Marco), or on the walls of a chapel, as in Signorelli's celebrated work in Orvieto cathedral which Michelangelo is known to have admired.[9]

Because the subject was so familiar (the sculptor's parish church in Florence, S. Croce, boasted a gigantic, and now almost destroyed, *Last Judgement* frescoed in the 1340s by the Florentine artist Orcagna), the commission presented Michelangelo with a severe test to find an innovative and arresting way to represent the narrative. The established iconographic pattern is exemplified by an engraving (Fig. 95) by the late fifteenth-century Florentine engraver Francesco Rosselli, inspired by Fra Angelico's aforementioned altarpiece. It shows the seated figure of Christ in judgment in Heaven surrounded on either side by orderly ranks of saints. The dead, raised up from their graves by the trumpets blown by the angels at the centre, are escorted either to Paradise on Christ's right or to Hell on his left. The burning pits in which the Damned are grouped according to their sins, were a well-known feature of Dante's description of the region in his *Divine Comedy*. Michelangelo acknowledged his debt to the Tuscan poet in an equally recognizable fashion in his own work by the inclusion at the lower left of the figure of Charon, a boatman famed in classical mythology for ferrying the souls of the dead across the River Styx. The congregation in the chapel would have immediately recognized the textual source of Michelangelo's depiction of him as a monstrous demon threatening his terrified passengers with his oar.

Michelangelo's composition – for all its differences of detail – remains broadly faithful to this traditional model, except that in the fresco the Blessed ascend upwards at the left and the Damned are actively beaten or pulled down on the right. More importantly the neat

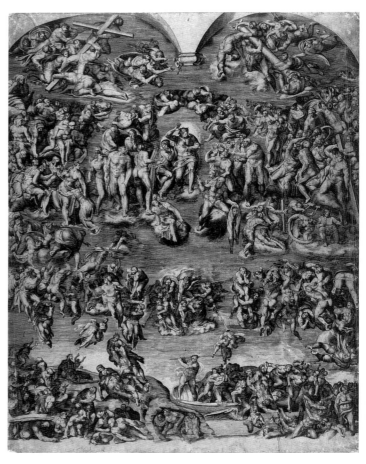

horizontal symmetry that governed previous representations has been replaced by a swirling compositional whirlpool centred around Christ, his right arm raised in judgment to the sinners and his left one discreetly drawing attention to the wound in his side. The five wounds visible on Christ's body in Michelangelo's work have a particular resonance in his placement directly above the altar, because it was there that the miraculous transformation of wine into his blood was believed to occur at every mass. Michelangelo represented the Saviour as a beardless Apollonian figure in his earlier drawings of the Risen Christ (Exh. Nos 76–7), but his repetition of this idealized type in the *Last Judgement* was a radical break from tradition and one that was criticized by later commentators. The figure's pose is a dynamic variant of that found in more orthodox depictions, such the fourteenth-century fresco in the Camposanto in Pisa (a city that the sculptor visited on a number of occasions in connection with marble shipments) or in Fra Bartolommeo's now ruined work in S. Maria Nuova, Florence (for which see Fig. 43).

As with Michelangelo's earlier work on the vault it is safe to assume that he consulted with theologians at the papal court regarding his treatment of the subject, although there is no documentary evidence of any such process. His preparatory drawings indicate that he was granted a certain degree of flexibility, as some of the changes recorded in the few surviving compositional drawings had an impact on the fresco's narrative. This is perhaps best illustrated by comparing the figure of the Virgin in the Casa Buonarroti study (Fig. 96) with her counterpart in the finished work. In the drawing she is shown in her role as mankind's most

above left
Fig. 96 **Study for *The Last Judgement***, c. 1534–6. Black chalk, some later pen retouchings, 41.8 × 28.8 cm. Casa Buonarroti, Florence

above right
Fig. 97 Giulio Bonasone (c. 1510–76), ***The Last Judgement***, late 1540s. Engraving, 58.3 × 44.7 cm. The British Museum, London

powerful intercessor, the fervency of her appeals for mercy to her son expressed by her outstretched arms. The Virgin's prominence was perhaps partly determined by the original intention to retain Perugino's *Assumption of the Virgin* altarpiece, represented as a blank space in the lower centre of Fig. 96, which would have meant that she appeared twice on the altar wall. In the fresco the Virgin is still in her customary position to the left of her son, yet in comparison with the drawing she is a much more withdrawn figure, her acceptance of his divine will signified by her closed eyes and arms crossed over her breast. This has generally been interpreted as signifying that the moment of her intercession has passed, and that the fresco represents the climactic moment when the majestic figure of Christ has commanded the angels to blow the trumpets to make the dead rise.

The Casa Buonarroti sheet is one of a handful of studies that relate to the preparation of a *modello*, now lost, made for Clement.[10] It was his successor who approved the design, but Michelangelo's idea for the composition continued to evolve during the year-long wait for the wall to be readied. During this time the windows were filled in, the cornices removed and, following Michelangelo's instruction, the wall was made to project slightly at the top to prevent dust from building up on the surface. The preparation of the wall's surface was the cause of an irrevocable rift between Michelangelo and Sebastiano. The Venetian wanted the Florentine to paint in the oil mural technique that he had pioneered for his work in S. Pietro in Montorio (Fig. 57). Following Sebastiano's instructions, apparently with Michelangelo's tacit acceptance, the wall was prepared for the work to be executed in oil. This preparation (*incrostatura*) was then removed in the first three months of 1536, and replaced with lime plaster suitable for conventional fresco painting. The sculptor may have had a genuine change of mind, or a more cynical interpretation of his behaviour is that he concurred with Sebastiano's suggestion merely as a delaying tactic. He is reported to have spoken dismissively of the Venetian's favoured oil method: 'era arte da donna e da persone agiate e infingarde, come fra 'Bastiano' ('an art for women and leisured-do-nothings like Fra Bastiano').[11] In the interim Michelangelo had begun to produce the cartoons for the painting which was finally begun in May 1536. The upper section of the fresco was completed by December 1540, and a little under a year later the work was finished (31 October 1541).

A densely worked double-sided drawing in the British Museum (Exh. No. 82) is one of only six extant compositional studies for the fresco. The recto is a palimpsest of studies that is not easy to decipher at first glance.[12] The earliest in the sequence are the studies in soft, and now somewhat rubbed, black chalk of a seated male looking down at the lower centre, and a small-scale variant of the pose to the right of centre drawn with the sheet turned upside down.[13] The upper part of the larger figure is overlaid by studies, made with a harder and sharper stick of black chalk, for a three-tiered group of figures on the right side of the composition. This arrangement of the figures, with the middle band echoing the line of the cornice below the windows on either side of the chapel, is not found in the other three extant compositional studies for the figures around Christ. This would suggest that it is the latest of Michelangelo's designs for this part of the fresco.[14] The artist began by drawing the three figures at the top left corresponding to the saints grouped immediately to the right of Christ. In the drawing two of the saints crane forward to watch the action below, a narrative touch that is missing in the fresco where almost all the figures in close proximity to Christ on the right are focused attentively on his actions. The scale of these figures is initially disconcerting because, as in the fresco, they are larger than those below them. Michelangelo's motives for this subversion of normal scale were perhaps partly practical, as it made the most important

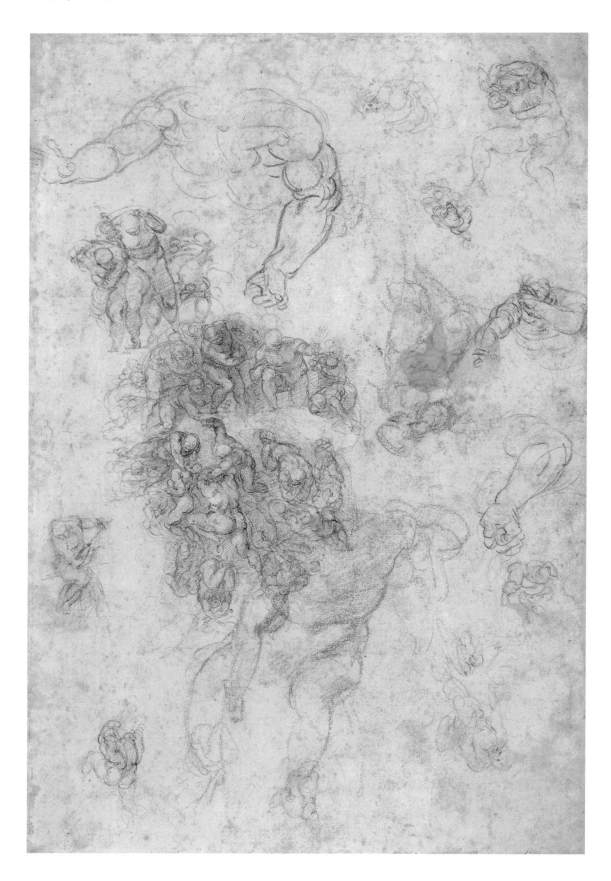

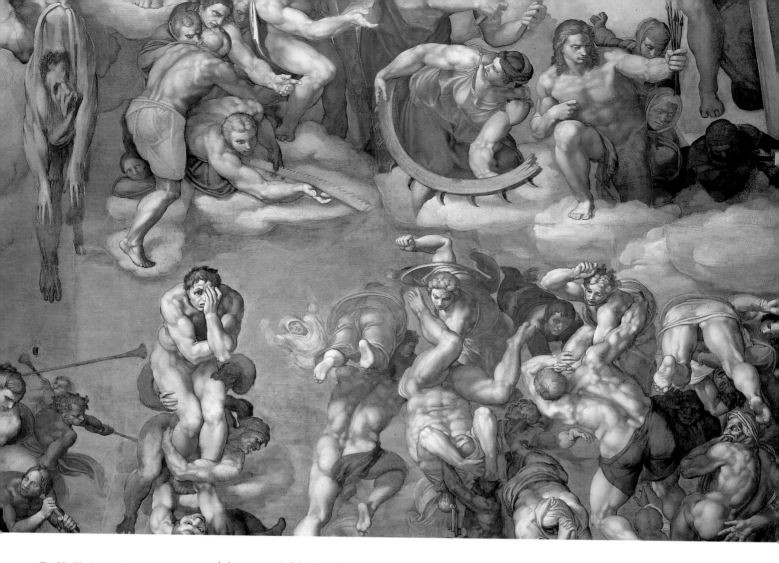

Fig. 98 **The Last Judgement**
(detail), 1536–41. Fresco.
Sistine chapel

saints more visible (Raphael had done the same in the divine figures in the upper tier of the *Disputa* in the Stanza della Segnatura in the Vatican). Visibility was an important consideration in a space as dark as the chapel, especially since the gloom had been deepened by the removal of the two altar wall windows. It was also a richly symbolic reversion to archaic pictorial convention, in which the size of figures was in proportion to their divinity. As with the limitless brilliant blue backdrop which sets the scene beyond normal time and space, like the gold background of early Christian mosaics and medieval paintings, the subversion of scale underlined the fresco's visionary nature.

The middle band of figures in the drawing corresponds to the group of Martyrs in the painting, only a minority of whom, like Blaise holding the combs with which his skin was removed, are identifiable through familiar attributes. In the drawing only St Catherine, reaching forward at the far right, holding her wheel and to her left the figure of St Sebastian holding a quiver of arrows can be identified on this basis (in the painting the position of the two figures is reversed). Apart from minor changes such as this, the general composition of this group, especially the cluster at the left huddled together and watching the sinners being repelled below them, matches that of the fresco fairly closely. Michelangelo was later criticized for Blaise's proximity to Catherine, and this was one of the details that was repainted by Daniele da Volterra in 1565. The alterations were predominantly directed to covering the nudity of the figures with draperies, but it also involved cutting out certain sections to revise the pose, as with the head of Blaise to make him look to the left and not down.[15] The drawing

opposite
Exh. No. 82 Recto **Studies for
The Last Judgement**, *c.* 1534–6.
Black chalk, 38.5 × 25.3 cm.
The British Museum, London
(verso illustrated on p. 237)

shows that Michelangelo had planned to have another saint in even more intimate contact with one hand resting on Catherine's back. A similar example of self-censorship is also found in the group below, where the leftmost angel is shown vigorously throttling with both hands one of the sinners. A number of these early figural ideas, such as the angel with his fist raised to pummel an interloper and the descending sinner with his hands joined pitifully in prayer, are found in the finished work. The remaining part of the sheet is filled with studies of varying sizes of individual figures, such as the two at the lower right corner of a devil straining to pull down one of the condemned, or of particular details like the left arm and clenched fist on the right side of the sheet. The shift in focus from the general to the particular is even more marked in a black chalk study for the lower left of the composition at Windsor (Fig. 99).[16]

Michelangelo traced through some of the figures of the lower group on the verso in black chalk, except for the angelic strangler where he used red chalk. The process of tracing reversed the poses of the figures, a change that might open up further variations to explore, although in this case the orientation of the figures in the fresco largely follows that on the recto. Armenini noted in relation to the *Last Judgement* how Michelangelo's figural invention had been aided by using wax models that could yield an almost infinite number of possible poses when studied from different angles; an observation that can partly be verified, albeit with a life model not a wax figurine, by the change in viewpoint observable in the two studies of a male head on the verso.[17] The same model seems to have been used for the St Lawrence study in Haarlem (Exh. No. 84), and it is likely that Michelangelo sought out someone whose powerful build matched the figure type that he had in mind for the bodies of the newly raised souls.[18] The notion that resurrected souls would be given bodies different from those that they had inhabited before depends on St Paul's description (I Corinthians xv.42–5): 'so also is the resurrection of the dead. The body is sown in corruption, it is raised in incorruption. It is sown in dishonour, it is raised in glory. It is sown in weakness, it is raised in power. It is sown a natural body, it is raised a spiritual body.'

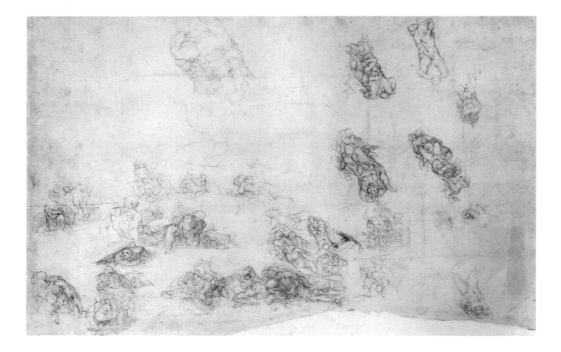

Fig. 99 **Studies for the lower left of *The Last Judgement*,** *c.* 1534–6. Black chalk, made up section of the paper at the lower right edge. The Royal Collection, Windsor Castle

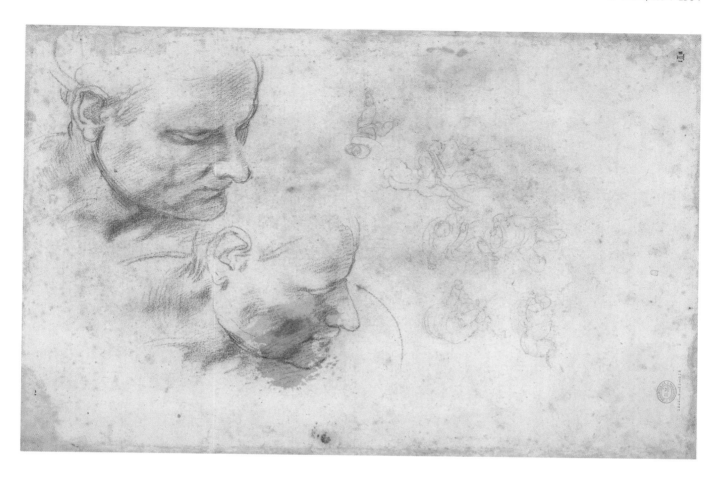

Exh. No. 82 Verso **Two heads and other studies**, c. 1534–6. Black and red chalk, 25.3 × 38.5 cm. The British Museum, London (recto illustrated on p. 234)

In his earlier drawings of the Risen Christ Michelangelo had visualized the appearance and nature of a single resurrected body in different ways, and the challenge of the *Last Judgement* was to find a manner of representing the 'spiritual body' that could be adapted for both sexes ranging from youth to old age. The nudity of the figures was anticipated by Signorelli's work, and indeed the latter's representation of the resurrected bodies is much more sensual than Michelangelo's. Another valid comparison is with another divinely raised figure – that of Adam painted a quarter of a century earlier on the vault (Fig. 48). The differences between the two works highlight how Michelangelo set out in the *Last Judgement* to create an abstracted idealized form, stripped of all sensuality and grace. What is also striking about the *Last Judgement* figures is that all of them, irrespective of their fate, are given the same ponderous muscular form, yet the angels and devils are manifestly able to differentiate between the blessed and the damned. (An exception to this is the ascending soul on the left whose hair is being pulled by a devil reluctant to let him go.) This raises the question of how the winnowing of souls worked, a topic that had taken on huge importance because it was one of the fault lines between Protestantism and the established church. Luther had argued for a bleakly deterministic Augustinian view of the matter, deriving from the notion that all of mankind was so inherently sinful that no one was worthy of salvation. It was only the divine gift of faith that brought about justification, the process by which a fallen human was made righteous, and thus saved (hence the doctrine's nomenclature of justification by faith).[19] Luther's and Calvin's idea that this occurred without man's

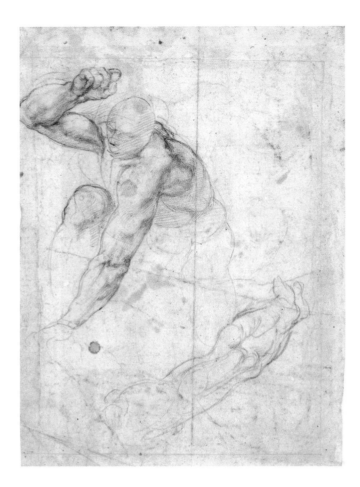

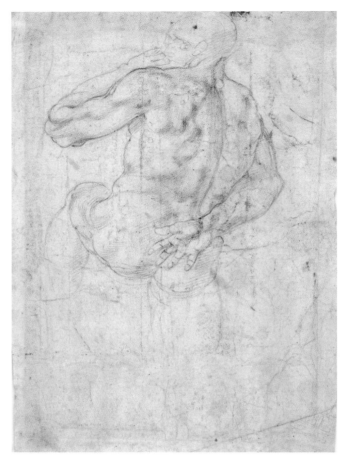

co-operation was opposed by Rome, who held that the individual was saved because of pious behaviour and good works.

What was envisaged for those who chose to be on the wrong side of this soteriological divide was represented in harrowing detail in the condemned souls dragged towards an eternity in Hell. The paradox at the heart of Michelangelo's work is that his call to the spirit is at the same time an artistic tour-de-force and perhaps the greatest demonstration of his genius for expressing the human condition through the nude figure. The astonishing variety and inventiveness of Michelangelo's figural language was recognized by his artistic contemporaries, and this quickly became one of his most copied and imitated works. However, it was also the most criticized, most frequently on the grounds that artistry and self-expression had been achieved at the expense of the sanctity of the subject.[20]

Some idea of the exacting nature of Michelangelo's preparation for the fresco can be gained from a double-sided black chalk drawing in the British Museum (Exh. No. 83) which has a life study of an angel on one side, and a condemned soul on the other. The recto study is related to the middle of the three angels beating down the damned (Fig. 98), and the quickly sketched arm below it is that of the victim vainly trying to push his persecutor away. The figure studied on the verso is for the sinner further to the right who is being pulled down to Hell by his scrotum. This is one of the figures that prompted Condivi's misleading generalization that the damned were shown in the fresco being pulled down by the parts of their body with which they had sinned.[21] The drawing exemplifies Michelangelo's remarkable consistency in his

above left
Exh. No. 83 Recto **A fighting angel**, c. 1534–6. Black chalk, 26.2 × 18.1 cm. The British Museum, London

above right
Exh. No. 83 Verso **A condemned sinner**, c. 1534–6. Black chalk, 26.2 × 18.1 cm. The British Museum, London

opposite
Exh. No. 84 Recto **Study for St Lawrence**, c. 1534–6. Black chalk, 24.2 × 18.2 cm. The Teyler Museum, Haarlem (verso illustrated on p. 241)

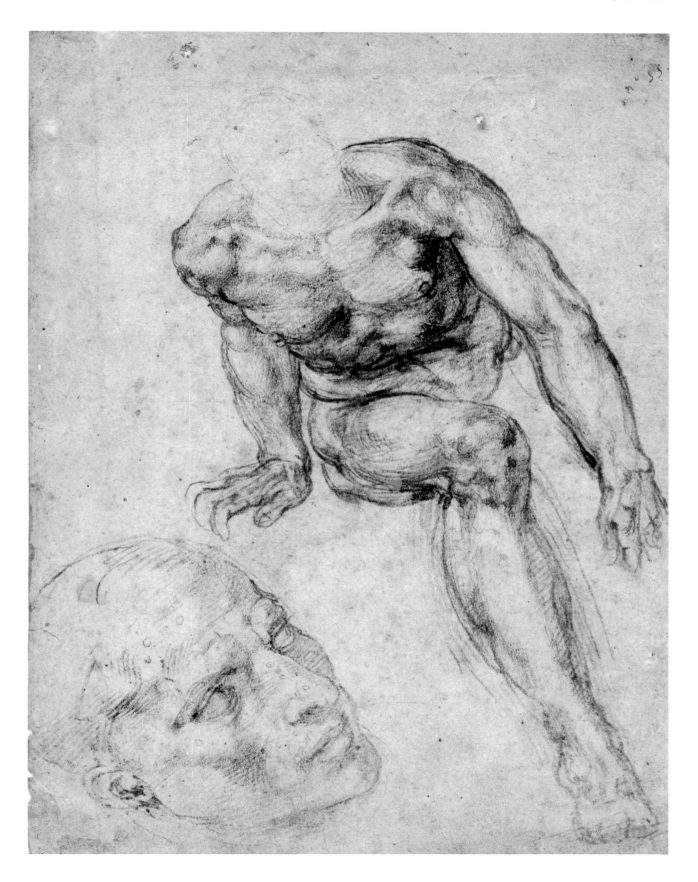

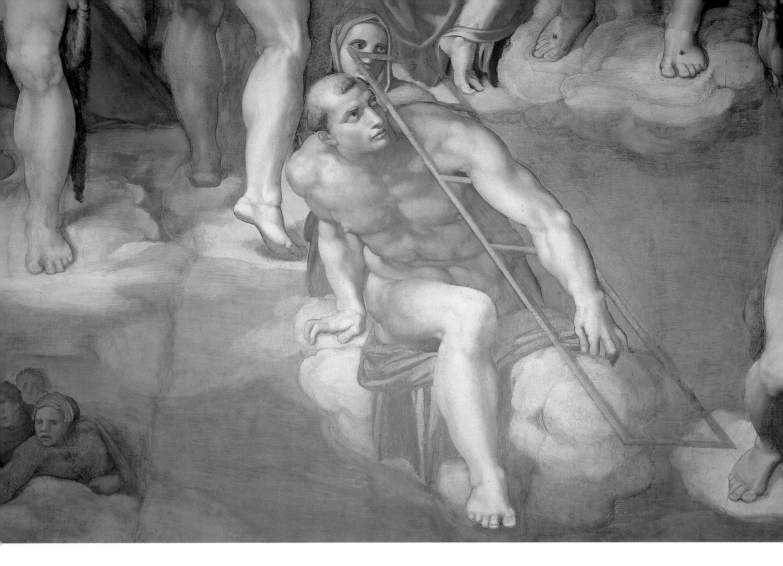

Fig. 100 **St Lawrence seated below Christ in *The Last Judgement***, 1536–41. Fresco. Sistine chapel

preparatory method. He always drew the principal figures from life, after making compositional studies that informed him of which parts of the model's anatomy needed to be examined in depth. His tendency to ignore the head, as in his life studies for the Cascina cartoon (Exh. Nos 9r and 10r) made thirty years earlier, suggests that he made specialized head studies akin to those found on the reverse of Exh. No. 82. Similarly the shorthand of small circles (also found on Exh. Nos 84, 86–7) to denote the areas to be highlighted was a notation that Michelangelo seems to have developed for studies for the Sistine vault (such as Exh. No. 29). The fact that he was studying on a single sheet two figures so close to each other in the work supports Wilde's idea that the cartoon was drawn in large sections, as it had been for the vault.[22]

Arguably the finest of Michelangelo's figure studies for the fresco is the one in Haarlem (Exh. No. 84) for St Lawrence seated on a cloud below Christ (Fig. 100). The prominence of Lawrence and the pendant figure of Bartholomew, neither of whom are identifiable in the artist's earliest compositional studies, has been ingeniously explained in relation to the chapel's history: the first mass to be held there had been on the vigil of St Lawrence's day, 8 August 1483, which was also the anniversary of Sixtus' election; the latter had personally celebrated mass in the newly built building on St Bartholomew's feast day, 24 August. Perhaps a more plausible suggestion is that they were to reinforce the Pauline message of the resurrection of the body.[23] Both saints' bodies had been destroyed through their martyrdom, as is true of many of the saints identified by an attribute, but their new spiritual forms are unmarked. It is instructive to see the way in which Michelangelo altered his drawing style to

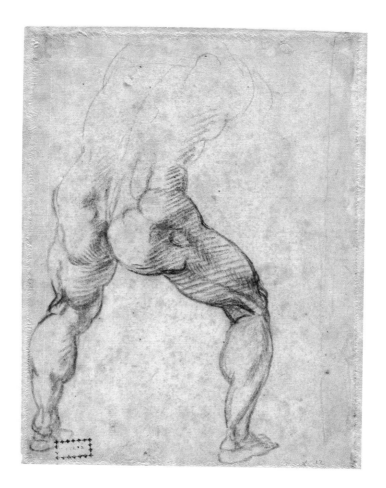

Exh. No. 84 Verso **Male nude seen from behind**, *c.* 1534–6. Black chalk, 24.2 × 18.2 cm. The Teyler Museum, Haarlem (recto illustrated on p. 239)

suit the visual effect of the finished work, as can be seen by comparing the modelling in black chalk of the Haarlem sheet with life studies, such as Exh. No. 50, related to *Day* in the Medici chapel around a decade earlier. The hulking build of the marble figure anticipates in many respects the physical type that he adopted for the *Last Judgement*. In the study for the marble, a work to be viewed from relatively close up and with indirect lighting from above, the outline is less important than the atmospheric, but subtly nuanced description of the surface. In the drawing for the frescoed figure almost the reverse is true. This is because the painted figure was destined for a high position on the wall, and the artist was therefore aware that it was the outline of the saint's muscular form that would be most visible to the viewer below. Highly detailed internal modelling was superfluous for a figure to be seen at this distance, especially as significant areas of the saint's body were bleached of surface detail because of his proximity to Christ's divine effulgence. As the saint is seated in front of Christ, his chest and stomach are largely in shadow and to model the form in these areas Michelangelo dampened the end of the chalk to darken its tone. The vigorous black chalk study of a male figure seen from behind on the verso of Exh. No. 84 cannot be related to any of the figures in the painting, but it may well have been drawn at much the same time as the more polished study on the other side.[24]

A double-sided study in the British Museum for a flying angel (Exh. No. 85) at the top right of the fresco is far less visually appealing than the St Lawrence study, and some critics have dismissed it as a copy after a lost drawing.[25] The pose of the swooping angel studied in the

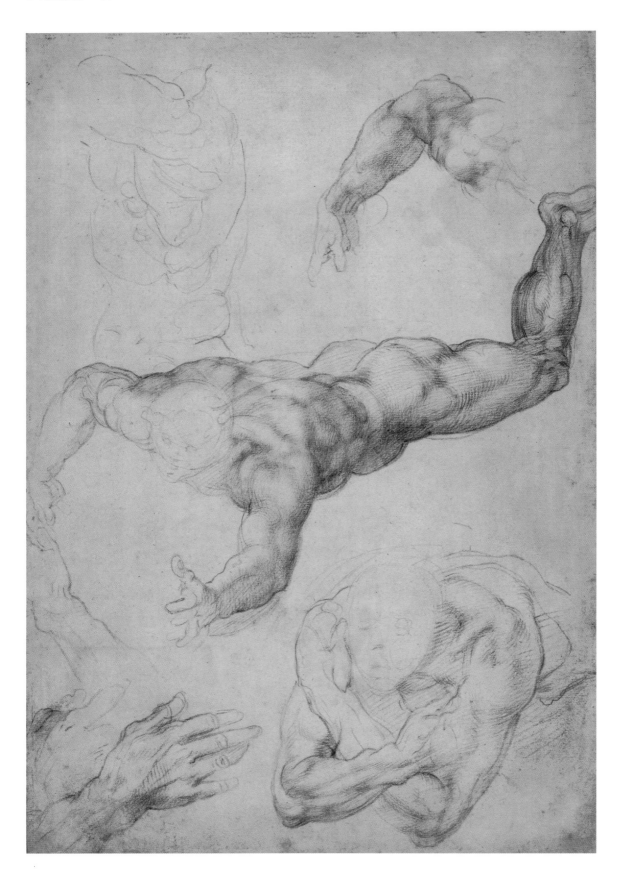

opposite
Exh. No. 85 Recto **A flying angel and other studies**, *c.* 1534–6. Black chalk, 40.7 × 27.2 cm. The British Museum, London

below left
Exh. No. 85 Verso **Flying angels**, c. 1534–6. Black chalk, 40.7 × 27.2 cm. The British Museum, London

below right
Fig. 101 **Angels from the top right lunette of *The Last Judgement***, 1536–41. Fresco. Sistine chapel

centre of the recto was worked out in two schematic studies on the verso, in one of which he is shown holding a crown of thorns – an attribute carried in the fresco by one of the angels in the other lunette. The sketchy pneumatic figures studied on the verso are executed in a brutally summary fashion with bulging contours, slashed hatching and reductive descriptions of hands and heads. For a draughtsman of such consummate touch as Michelangelo these studies are surprising, even shocking, yet from a functional viewpoint this fiercely economical drawing style is highly effective in establishing the fundamental elements of the various poses. Such inelegance is paralleled in studies from a comparable phase in his preparation for painting the vault, such as the highly simplified black sketch for the Erythraean Sibyl on the verso of Exh. No. 19, and it is made more extreme in Exh. No. 85 by his use of an unusually hard and unyielding piece of chalk. The flying figure was studied in greater detail on the recto and this pose, with slight differences, such as the turn of the head to the right, was retained in the fresco (Fig. 101). The broadness of modelling and the lack of precision in the outline of Exh. No. 85 that set it apart from Exh. Nos 83 and 86 might be due to it having been based on a sculptural model rather than from life.[26] The study of the steeply foreshortened right arm of the angel at the top right leaves out the tips of the fingers because this detail is obscured by an overlapping figure. The figure of the angel with his arms crossed drawn in lightly at the lower right (his hands are studied in greater detail on the left) does not appear in the finished work.

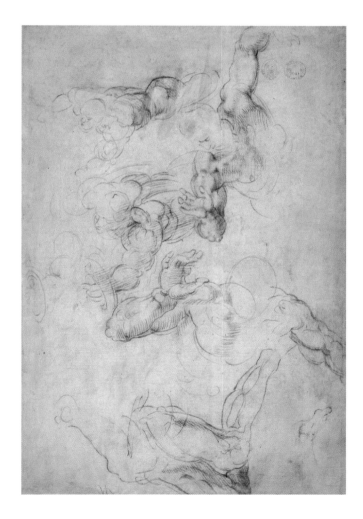

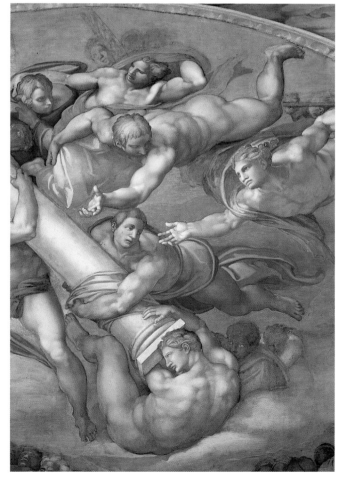

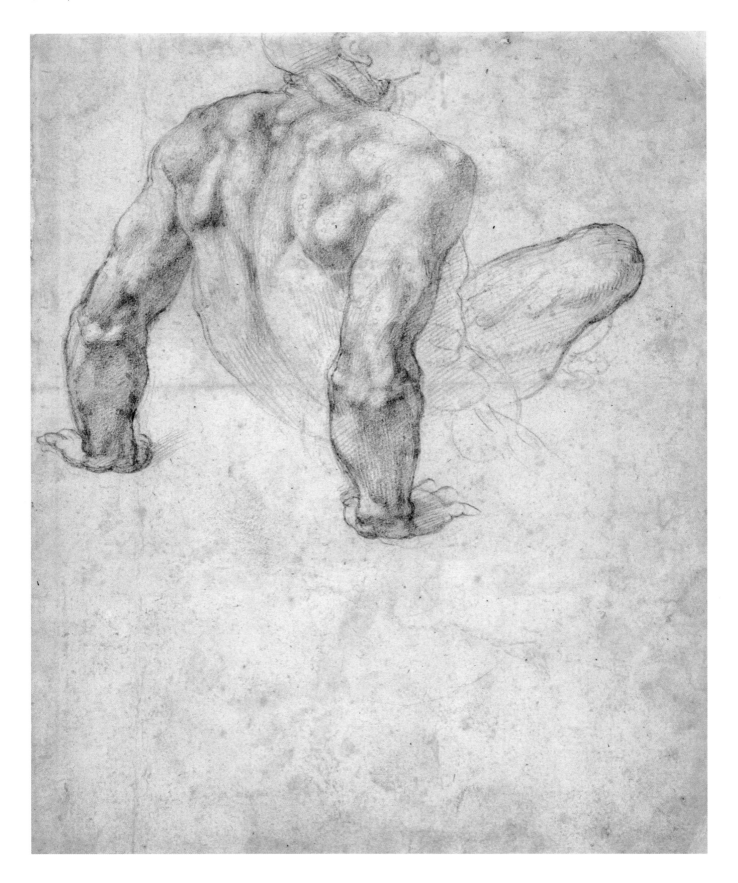

Exh. No. 86 Verso **A male nude in profile**, *c.* 1539–41. Black chalk, top corners and parts of the upper edge made up, 23.3 × 29.3 cm. The British Museum, London

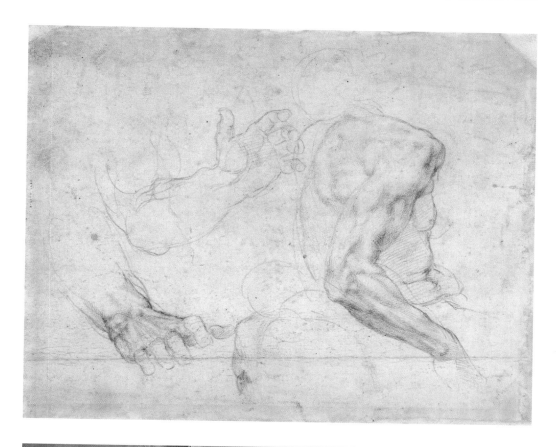

Fig. 102 **Figures in the lower left of *The Last Judgement***, 1536–41. Fresco. Sistine chapel

opposite
Exh. No. 86 Recto **A male nude seen from behind**, *c.* 1539–41. Black chalk, right corners and parts of edge made up, 29.3 × 23.3 cm. The British Museum, London

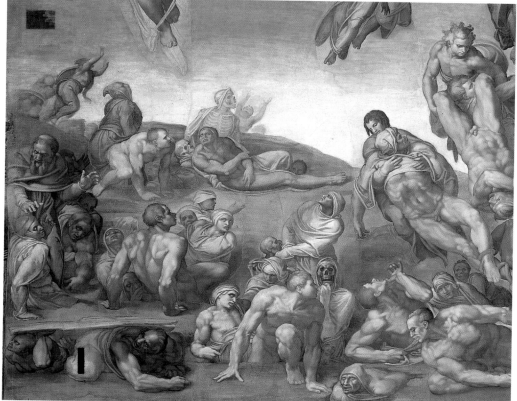

The final two studies (Exh. Nos 86–7) from London and Oxford respectively are connected to the group of figures emerging from graves at the lower left corner that was executed after the dismantling of the scaffolding in mid-December 1540 (Fig. 102). Because of their proximity to the chapel's floor these are the most visible figures, and this explains why Michelangelo made such detailed life studies for them. This is particularly true in the case of the recto study of Exh. No. 86 for the figure, seen from the rear, pushing himself upwards from the earth with huge muscular effort. On the verso Michelangelo prepared the pose of the figure shown wrapped in a shroud further to the left in the fresco, with the position of his head and shoulders studied again in a faint sketch below. The drawings of hands on the left are related to those of the monk directly above the seated figure studied on the right of the sheet. The figure emerging out from underneath a large flat stone directly in the foreground was studied in a life drawing in the Ashmolean (Exh. No. 87).

Vasari described how he was 'stupito' ('awestruck') when he first saw the *Last Judgement*, and both he and Condivi concur that the fresco had exhausted all possible variations for the human figure ('suffice it to say that, apart from the sublime composition of the narrative, we see represented here all that nature can do with the human body').[27] However, Vasari reports that one member of Paul's court felt that the nudity of Michelangelo's figures was improper for the pope's chapel, and it is known that this was not an isolated view.[28] Paul III had no such misgivings about Michelangelo's work, and he commissioned two further sizeable frescoes for the walls of his newly erected chapel in the Vatican. However, disquiet about the suitability of Michelangelo's *Last Judgement* did not dissipate, and the artist turned down a request by the austere Paul IV in the second half of the 1550s to make the work more

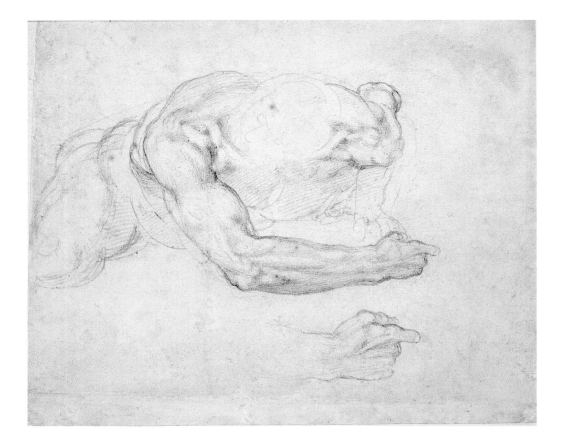

Exh. No. 87 **A male nude**, *c.* 1539–41. Black chalk, 21.6 × 26.6 cm. The Ashmolean Museum, Oxford

modest. The shift in perception was a manifestation of a growing mood of reform within the church that also touched on the need to purify sacred art of its perceived excesses. The controversy had been stirred up by Pietro Aretino's malicious letter addressed (but perhaps not sent) to Michelangelo in 1545 deploring the fresco's indecency (citing as an example the figure studied on the verso of Exh. No. 83), and criticizing him for putting artistic expression above devotion. A revised version of this letter was included in the fourth collection of Aretino's letters published in 1550.

Predictably the notoriety of a work that was located in a fairly inaccessible place created a booming market for reproductive engravings of the fresco. Bonasone's simplified rendering of the composition (Fig. 97) from the late 1540s, financed by the pope's art-loving nephew Alessandro Farnese, is one such print showing the fresco before it was changed by Daniele da Volterra.[29] Michelangelo did not collaborate with printmakers, unlike the cannier Raphael, but he could not prevent his finished works being copied by them. The wide dissemination of a composition that had been intended only for the educated circles of the Vatican palace added to the pressure for the fresco to be censored. The fresco was discussed at the last session of the Council of Trent in 1563, and the decision was taken to add loincloths and change some details. Following Michelangelo's death these alterations were made to his work, and for the most part they remain, since it was decided not to remove them during the last restoration (1990–4) because Daniele's revisions were considered such an integral part of the fresco's history.

A Design for a Salt-Cellar

Although the *Last Judgement* commission did not allow Michelangelo to work on the Julius tomb (Paul had issued a papal directive to that effect in 1536), the artist was keen to stay on friendly terms with Francesco Maria della Rovere. Early in 1537 he made the duke two minor works outside his usual sphere of artistic activity: a model for a horse to be cast in bronze and a design for a covered salt-cellar. The progress of the latter work is described in a letter written by the duke's Roman agent Girolamo Staccoli in July 1537:

> the three-dimensional model of the salt-cellar was finished a few months ago and some of the animals' paws, on which the body of the salt will be placed, have been begun in silver, and around this body there are some festoons and masks, and on the cover a figure wholly in the round with other foliage, as Michelangelo prescribed and as it appeared in the aforementioned finished model. Considering that he has spent as much as eight or ten ducats in its manufacture, and as it is going to cost more than this, I did not wish to proceed further without the knowledge and approval of Your Lordship.[30]

The resulting salt-cellar, like almost all Renaissance tableware of its kind, has not survived and all that remains is Michelangelo's crisply executed drawing acquired by the British Museum in 1947. Staccoli's description of the work tallies with the drawing (Exh. No. 88), except in regard to the falcons' heads on the lid that were substituted with foliage (perhaps della Rovere oak leaves). The function of the drawing as a blueprint for the silversmith explains why it is drawn with unusual precision, including the use of a ruler to draw a horizontal and vertical axis to ensure symmetry. His choice of black chalk has rightly been noted as an indicator of his faithfulness to this medium, because designs of this kind by his contemporaries are almost invariably in pen and ink, often with wash.[31] Giulio Romano, a gifted pupil of Raphael who left

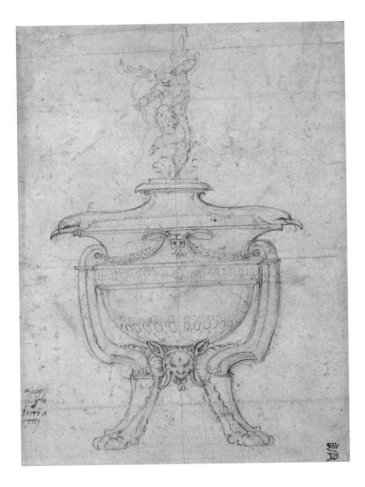

Exh. No. 88 **Design for a salt-cellar**, 1537. Black chalk, 21.7 × 15.5 cm. The British Museum, London

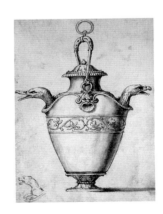

Fig. 103 Giulio Romano (c. 1499–1546), **A ewer with two spouts**, c. 1524–6. Pen and brown ink and brown wash, 23.8 × 17.6 cm. The British Museum, London

Rome for the Gonzaga court in Mantua in 1524, was a prolific designer of metalwork and his pen and wash study for a double-spouted ewer in the British Museum (Fig. 103) demonstrates the medium's advantages in describing the intended form of the work more fully.[32] Michelangelo's strictly orthogonal view without any shading is more sparing in its detail, and it does not even include the matching pair of feet at the far side of the circular vessel. (It has been assumed that it stood on three feet, but there is a case for it having been symmetrical with the central satyr mask repeated on the other side so that it could be viewed from all angles like a free-standing sculpture.)[33] There was perhaps no need to expend too much time making a more elaborate drawing, as the object was made in Rome and Michelangelo would have been able to explain his intentions to the silversmith or to Staccoli.

In common with most contemporary metalwork designs there are no measurements, and this again suggests that verbal instructions were given. Size was certainly an issue for such a *de luxe* item intended as a conspicuous show of the owner's wealth. One contemporary source records that salt-cellars came in three types: large ones for the *credenza* (sideboard), medium-sized for the banqueting hall and small ones for the patron's table.[34] From the description it is clear that the shaggy lions' feet that supported the circular vessel were cast separately (and the same would probably be true of the Cupid-crowned lid). This would have necessitated altering the swags on the sides of the vessel so that they were no longer attached to the volutes, a sign perhaps of Michelangelo's inexperience in designing such objects. His drawing wittily alludes to the differing nature of human passion with the winged

Cupid, lifted skywards when the lid is raised, threatening all who touch the salt-cellar with love's arrow, while below him the lascivious grin of the satyr suggests love's earthier physical expression.[35] Michelangelo mentions the actions of Cupid, the 'crudele arcier' (cruel archer), and his 'fero strale' (fierce arrow) in two poems from the 1530s, and he perhaps had these sentiments in mind when he mischievously included one of his darts in mid-flight, a detail that not even the most skilful silversmith could reproduce.[36]

The provenance of the drawing is known only as far back as a Scottish aristocratic collection, perhaps formed in the eighteenth century, that was acquired by a London dealer in the 1920s.[37] The drawing must have had a certain circulation in the sixteenth century as a facsimile copy from the period was owned by J.C. Robinson who held it to be the original (this is now in the Victoria and Albert Museum), and the lower part of the design was transformed into the basin of a fountain in a design for a niche in the Uffizi.[38] Michelangelo's normal reluctance to design decorative objects for patrons was, like his stance on portraiture, another mark by which he stood apart from his fellow artists, as both activities were undertaken by the majority of his contemporaries – even ones as exalted as Raphael.[39] There are a few other instances of Michelangelo supplying designs of this kind, including a lost model for a salt-cellar for Cardinal Alessandro Farnese, but the British Museum work is one of only three surviving studies for the decorative arts. The newest addition to this group was Timothy Clifford's discovery in the Cooper-Hewitt, National Design Museum in New York in 2002 of a study for a candelabrum probably executed towards the end of Michelangelo's stay in Florence.[40]

Michelangelo and Catholic Reform

An appreciation of Michelangelo's religious beliefs is vital to understanding his character and art, as his deeply held Christian faith infuses his work. This is particularly true of the last three decades of Michelangelo's life, when the Christian message of death and resurrection gained a particular resonance from his contemplation of his own mortality. His conflicting feelings of hope and dread in confronting the end of his life are explored in a series of drawings made in his last decade on the theme of the Crucifixion (Exh. Nos 105–7), and in some of his most affecting poems: 'Di morte certo, ma non già dell' ora/ la vita è breve e poco me n'avanza' ('Certain of death, but not yet of its hour, I know that life is short and little of it left for me').[41] His Catholicism was also expressed in more conventional shows of piety. These include discreet examples of 'good works', such as his offers of charity to impoverished Florentine nobles (see for example the letter of 1550 to his nephew: Appendix II, no. 10, p. 297), and in his own devotional practices that are sometimes appreciable in his letters. For example, Michelangelo admitted in a letter of 1560 that he felt too old at eighty-five to risk his health by giving up meat during the Lenten fast.[42] The sculptor lived at a period when some of the most fundamental tenets of the faith he had been brought up in were being questioned by clerics and laymen, some of whom he knew, even in Rome itself. The extent to which his spiritual beliefs were affected by his contact with these Catholic reformers in the 1530s and 1540s is one of the most intriguing questions of his later career.

The point of no return in the rift of the western church had yet to be reached when Michelangelo was working on the *Last Judgement* (1536–41), and there were those on both side of the religious divide who believed it might still be possible to seek compromise. The intense personal exploration of spirituality centred on Christ, and based on reading the Bible

and the theological writings of the early Church Fathers, advocated by Luther and other Protestant thinkers in northern Europe, struck a chord with a number of influential Catholics in Italy. Chief among them was the Spanish theologian Juan de Valdés, who had settled in Italy in 1530 to escape the Inquisition in his native land. The Spaniard's beliefs, articulated in his 1536 dialogue, *Alfabeto Cristiano* ('The Christian Alphabet'), leaned towards Protestantism in the emphasis on the subjective inner experience of faith. Valdés' belief in the doctrine of justification by faith was one held by some of the most spiritually minded and intellectually vigorous ecclesiastics in Rome. These included the Venetian nobleman Gasparo Contarini, whose religious crisis in 1511–12 had led to a mystical revelation of God's presence akin to that experienced by Luther some years later; the Englishman Reginald Pole, who had quit his native England when his cousin King Henry VIII had broken with Rome; and the charismatic Sienese Capuchin preacher Bernardino Ochino.[43] Paul III was quick to recognize the value of this movement of spiritual renewal, and he promoted to the cardinalship Contarini in 1535, and the following year Pole and the austere co-founder of the Theatine Order, Giovanni Pietro Carafa (the future Pope Paul IV). Pole and Contarini were leading members of a reformist tendency within the church identified by modern historians as the *spirituali*, because of their emphasis on personal revelation of God's grace through the working of the Holy Spirit.[44]

Among the best-known lay members of this reforming circle were the poet Vittoria Colonna, who became a confidante of Michelangelo, and her cousin by marriage, the beautiful Giulia Gonzaga.[45] Colonna came from an impeccable aristocratic lineage as a granddaughter of Federico da Montefeltro, duke of Urbino, and the daughter of Fabrizio Colonna, the head of one of Rome's most ancient and powerful clans. For political reasons Vittoria was betrothed at the age of seven in 1502 to the Spanish loyalist, Francesco d'Avalos, marquis of Pescara, whose stronghold on the island of Ischia off the Neapolitan coast became a refuge for the Colonna family when Alexander VI seized their lands.[46] The marriage took place in 1509, but the couple had little time together as d'Avalos' military career in Charles V's service meant he was mostly in northern Italy (her earliest poetry was occasioned by his brief capture by the French). His crowning achievement came in 1525 when he was one of the commanders of the army that crushed the French at the Battle of Pavia. That same year he died from the wounds he had received at the engagement, and Vittoria had to be dissuaded by her brother from mourning her heroic, if incompatible spouse by entering a convent. Her piety had won Clement's admiration and the Colonna clan were keen to use her influence to reduce papal anger over their Imperial loyalties. The poetess was extraordinarily well connected: her correspondents ranged from Charles V and later Paul III to leading literary figures including Aretino, Bembo, Castiglione, Giovio and Varchi. Her support for the *spirituali* cause derived from her own personal belief, but she was also interested in the practicalities of church reform.[47] In the period 1532–7 she was often in Rome, and it was during this time that her admiration for Michelangelo, which had earlier inspired the commission of a *Noli me tangere*, developed into a friendship.

Colonna left Rome for Ferrara in 1537, a centre of reform that had been visited by the Swiss Protestant Calvin the year before, on the way to a projected pilgrimage to the Holy Land. Poor health forced her to abandon this plan, and instead her spiritual yearnings fixed on Bernardino Ochino, the General of the Capuchins, whose famed sermons she travelled around Italy to hear. His emotive style can be appreciated from his *Dialoghi Sette* ('Seven Dialogues') published before 1540, which include vivid description of Christ's suffering on the cross. In the

publication Ochino does not enunciate the idea of justification by faith alone, but his emphasis on the individual's direct mediation with Christ had dangerous implications for the church. The newly formed Inquisition suspected him of heresy. Colonna was one of the people that Ochino wrote to in August 1542 to explain that he was going to flee Italy rather than obey the summons to Rome.[48] The Inquisition's suspicions were confirmed when he settled in Calvinist Geneva. The defection was a grave blow to the *spirituali* as they had already been weakened by Contarini's failure to gain backing for his compromise with the Protestants at the Diet of Regensburg in 1541.[49] Colonna's status protected her from the Inquisition, and she also swiftly repudiated Ochino's decision. During this difficult time she was sustained by her friendship with Pole, the intimacy between them deepened by her consolation of his grief at the execution of his mother for treason in England in May 1541. Pole in turn became her spiritual mentor and she left Rome, where she had renewed her contact with Michelangelo (see Exh. No. 91), when the Englishman moved to Viterbo at the end of 1541.

Michelangelo and Colonna feature in three of four dialogues (*Diálogo da pintura em a cidade de Roma*) written by the Portuguese painter and theorist Francisco de Hollanda in 1548. These purportedly record conversations on art that took place at S. Silvestro al Quirinale at the end of 1538.[50] During Hollanda's time in Rome (1538–40) he clearly had met Michelangelo, as is clear from the familiar tone of the letter he sent to the Florentine in 1553 asking for a drawing.[51] A black chalk figure study from the 1530s by Michelangelo inscribed with his name in Hollanda's writing may have been sent in response to this letter, or had been handed over earlier in Rome.[52] At the end of 1538 Colonna is also known to have been in Rome so the meetings described by Hollanda could have taken place.[53] Even so, the reliability of the *Roman Dialogues* as a source of information on Michelangelo's otherwise rarely stated and elliptical views on artistic matters is open to question.[54] The highly rhetorical conventions of the dialogue form make it hard to differentiate between the authentic voice of Michelangelo, and Hollanda's use of him as a persona to enunciate his own views and experiences.[55] Nonetheless, circumstantial evidence supports the view that parts of the dialogue depend on conversations Hollanda had had with the artist. It is unlikely, for example, that Hollanda would have learned of Michelangelo's pride in his protection of S. Miniato during the siege of Florence a decade earlier from anyone but the sculptor himself. Another convincing touch is the mutual respect and affection that characterizes the interaction between Colonna and Michelangelo, sentiments duplicated in their letters.

Colonna became a pivotal figure in Pole's circle in Viterbo alongside Valdés-inspired clerics such as Marcantonio Flaminio and Pietro Carnesecchi, both of whom, along with Pole, were condemned as heretics after Carafa's election to the papal throne in 1555.[56] The spiritual beliefs of this circle were articulated in the *Beneficio di Cristo* ('The Benefit of Christ'), a book published in 1543 written by a Benedictine monk Don Benedetto da Mantova (Benedetto Fontanini) and revised by Flaminio. Their arguments, heavily influenced by Calvin's in favour of justification by faith and the stress on private devotion, were extremely well received. Tens of thousands of copies sold in Italy over the next decade, but the book was subsequently suppressed with great rigour by the Inquisition.[57] Colonna remained a Catholic, but her exposure to the teachings of Ochino and her active participation in theological discussion in Pole's circle, which included the reading of some Lutheran Bible commentaries (as is known from the testimony of Carnesecchi's 1566 trial), coloured her devotional poetry. Yet her sympathies with the reformed Catholicism of the *Beneficio di Cristo* were never enunciated with sufficient clarity to condemn her writings as heretical.[58] The effect of

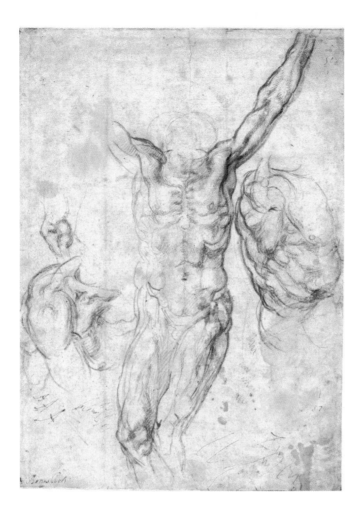

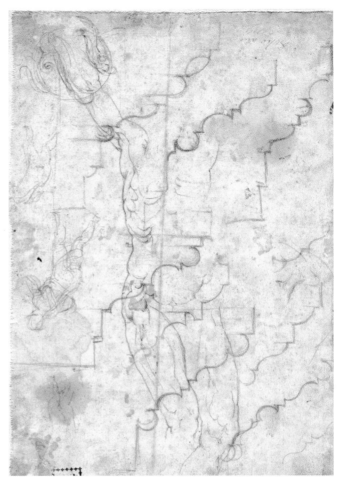

Michelangelo's study of her poetry and their relationship nourished by their shared piety – in her words 'stabile amicitia et ligata in cristiano nodo sicurissima affectione' ('a stable friendship and tied by a Christian knot with the most certain affection') – are reflected in the pietistic nature of the poems and drawings that the artist made in her honour (for an example of the latter see below).[59]

Michelangelo's friendship with Colonna was closest in the last three years of her life (1544–7) when she returned from Viterbo and was resident in Rome. His intimacy with Colonna led to a friendship with Pole, who owned a *Pietà* drawing by him, and the Englishman is one of the ecclesiastics listed by Condivi among the men of *virtù* known to the artist.[60] Michelangelo's correspondence provides evidence of his contact with other *spirituali* including Bartolommeo Stella, for many years Pole's major-domo and a founding member of the pioneering centre of Catholic reform, the Oratory of Divine Love founded in Rome around 1517, and with the English cardinal's biographer, the cultivated ecclesiastic Ludovico Beccadelli. Michelangelo and Beccadelli exchanged sonnets including one by the sculptor in 1556 lamenting the churchman's enforced exile from Rome, 'Per croce e grazia e diverse pene/ son certo, monsignor, trovarci in cielo' ('Through the cross and grace and through our various sufferings, I am certain, monsignor, that we shall meet in heaven').[61] Michelangelo is also known to have drawn a cartoon of *Christ Taking Leave of his Mother* for Cardinal Morone, an

Fig. 104 Master ES (active
1450–67), *The Lamentation*,
c. 1450–67. Engraving, 11.1 × 10.4 cm.
The British Museum, London

Fig. 105 **Studies for a *Pietà* and
a column**, *c.* 1530–5. Black chalk;
red chalk, made up section of the
paper at upper right, 25.7 × 22.1 cm.
The Royal Collection, Windsor Castle

enthusiast for Church reform imprisoned as a heretic by Paul IV. The cartoon, now lost, was listed in the posthumous inventory of Michelangelo's Roman studio.[62]

Some of Michelangelo's drawings from the period of the *Last Judgement* suggest that he may have been planning smaller-scale religious works, but frustratingly few can be related to finished work or linked to a particular patron. A case in point is the double-sided drawing from Haarlem (Exh. No. 89) with black chalk figure studies on both sides and some red chalk architectural profiles on the verso. Stylistically the soft chalk outlines of the figures and the reduction of the head to an oval with the lightest indication of the features can be paralleled with studies for the *Last Judgement* such as Exh. No. 87.[63] Michelangelo followed the life drawing for a Crucified Christ with studies of the model's torso from the side and of his knee. The lower left study is for another figure, as is shown by the position of the arm. He then traced part of the central figure to the verso but abandoned it unfinished. The red chalk free-hand sketches of profiles of mouldings cannot be linked to any architectural commission from the early 1530s, and neither can the studies for a figure leaning forward on the left be related to any sculptural project or painting.[64] No less mysterious is the project for a Crucifixion.[65]

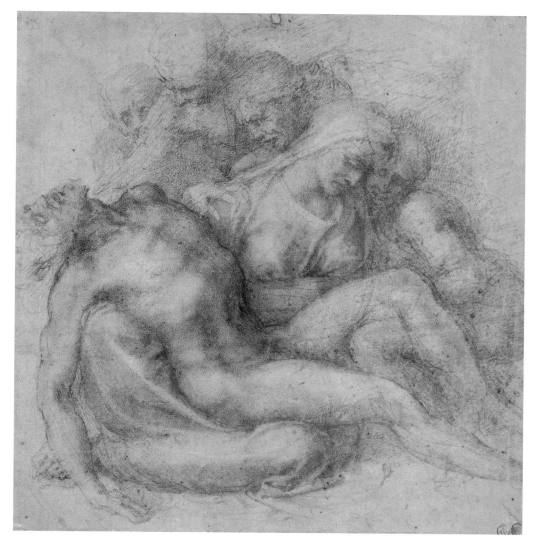

right
Exh. No. 90 *The Lamentation*,
c. 1530–5. Black chalk,
28.2 × 26.2 cm. The British
Museum, London

Suggestions for the sculptural commission include an unfulfilled commission for a roughly life-size three figure marble group of the *Crucifixion* recorded in a block design in the Casa Buonarroti, or a link with a bronze *Christ on the Cross* in the Metropolitan Museum of Art, New York, traditionally believed to be based on a lost wax model by the master.[66] A handful of black chalk studies of a figure in the same unusual crossed legs pose seem to record a more polished lost drawing by Michelangelo that followed on from Exh. No. 89.[67]

The emotional intensity of a finely worked, but rather rubbed black chalk study of the Lamentation in the British Museum (Exh. No. 90), from the first half of the 1530s, is far greater than any previous religious drawing in the exhibition. The uneven level of the finish rules it out as a presentation drawing, although it could be a preliminary study for such a work. The motif of the Dead Christ lying on his mother's lap was one that Michelangelo had memorably treated in his marble sculpture, now in St Peter's, more than three decades earlier, and there are obvious similarities between the two in the impassiveness of the Virgin and the unmarked body of her son. The Virgin's lack of expression may be linked to the objection of certain clerics, including Savonarola, to artists depicting the Virgin as grief-stricken at her son's death because it underestimated her understanding of the divine significance of his sacrifice.[68] The intimate bond between them is established in a more subtle way by having the Virgin seated on the ground with Christ propped up between her legs, an enclosing posture that intimates his miraculous incarnation inside her revealed at the Annunciation. Vittoria Colonna had such a pose in mind in her highly coloured description in the *Meditatione del Venerdì Santo* ('Meditation on Good Friday') of the Virgin cradling the Dead Christ so that her body became his bed and sarcophagus.[69] Many years ago it was suggested that the poses of Mary and her son show knowledge of an engraving by the pioneering fifteenth-century German printmaker known as Master E.S. (Fig. 104).[70] The contained emotions of the Virgin in Michelangelo's work, the turn of her head imparting the sense that she is unable to bear the sight of her son's broken body and lolling head, is counterposed by the fevered grief-stricken expressions of the three figures who press forward towards Christ's head. A black chalk drawing by Michelangelo at Windsor (Fig. 105) shows a subsequent development of the composition in which St John, the youthful figure pressed tight to the Virgin in the British Museum drawing, cradles Christ's head, while the heads of the Virgin and one of the Holy Women to the left are shown only in outline.[71]

Vasari in the 1568 edition mentions that Michelangelo made three drawings as tokens of his affection for Vittoria Colonna: a *Crucifixion*, a *Pietà*, and a *Christ and the Woman of Samaria*.[72] The first is in the British Museum (Exh. No. 91), the second in the Isabella Stewart Gardner Museum, Boston (Fig. 106), while the third is lost. Condivi makes no mention of *Christ and the Woman of Samaria*, but Exh. No. 91 elicits one of his most penetrating and perceptive passages of descriptive writing in the biography: 'for love of her [Vittoria Colonna] he also made a drawing of Christ on the Cross, not in the semblance of death, as is normally found, but alive with his face upturned to the Father, and he seems to be saying "Eli, Eli". Here we see that body not as an abandoned corpse falling, but as a living being, contorted and suffering in bitter torment'.[73] Vasari paraphrased this passage in his second edition with a slight alteration to the interpretation of the subject, describing it as Christ recommending his spirit to his Father just before his death rather than the earlier moment described in Matthew's Gospel (XXVII.46): 'My God, My God why hast thou forsaken me.' The most likely date of execution for the drawing on stylistic grounds is the late 1530s or early 1540s when Michelangelo was working on the final stages of the *Last Judgement*. The precise outlines and

Fig. 106 ***Pietà***, *c.* 1538–41.
Black chalk, made up along edges,
29.5 × 19.5 cm. Isabella Stewart
Gardner Museum, Boston

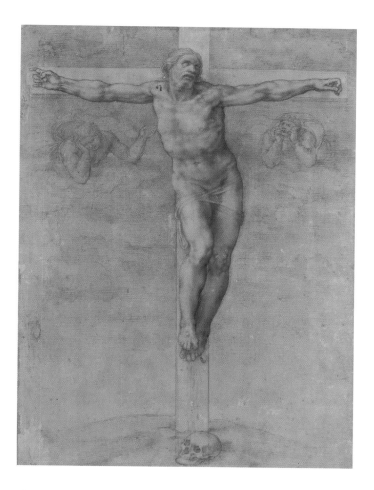

Exh. No. 91 *Crucifixion*,
c. 1538–41. Black chalk, 37 × 27 cm.
The British Museum, London

Fig. 107 Marcello Venusti
(*c.* 1512–79), ***Crucifixion***, after
Michelangelo, *c.* 1550–79. Oil on
panel, 51.6 × 33 cm. Galleria Doria
Pamphili, Rome

the superbly plastic rendering of Christ's torso are not far from the more impromptu mode of drawing he adopted in life studies for the lower part of the fresco such as Exh. No. 86.

The British Museum drawing also features in some of the scarce surviving correspondence between Michelangelo and Colonna, although frustratingly none of the eight letters is dated and their sequence is, as a consequence, impossible to establish firmly. Colonna's description of two of Michelangelo's gifts in her letters as having been 'depinto' ('painted') has been the source of much confusion, despite the clarification of Vasari and Condivi, both of whom were much better versed in artistic taxonomy.[74] Arguably the earliest of the letters that relates unequivocally to Exh. No. 91 is the request from Colonna for Michelangelo to allow her to borrow the *Crucifixion*, even if was still unfinished, to allow her to show it to unnamed members of Cardinal Ercole Gonzaga's retinue.[75] In what seems most likely a subsequent letter, Michelangelo light-heartedly chides Colonna for having left the *Crucifixion* with Tommaso de'Cavalieri while apologizing for not having time from the 'great task' (presumably the *Last Judgement*) to allow him to express his devotion to her personally.[76] At the end of the letter the artist mentions a surprise that he has been planning that has been ruined ('I was executing something I had not mentioned, in order to add something that was not expected. My plan has been spoilt'). The intriguing idea that Colonna may have suggested changes to the design of Exh. No. 91 (the artist's acceptance of these revisions was perhaps the surprise that had been ruined) is based on the opening sentence of another letter she wrote to the artist in which she mentions 'accrescer bontà alle cose perfetta' ('adding quality

to what is already perfect').[77] What she is referring to cannot be ascertained for certain, nor whether her admiration for the 'dolce Christo' ('sweet Christ'), to which she will address prayers, relates to the figure in Exh. No. 91 rather than that in the Boston sheet (Fig. 106).[78] An argument in favour of a connection to the London drawing is that she praises the right hand angel (a description that fits better the adult ones in Exh. No. 91 than the 'agnioletti' ('little angels') as termed by Condivi in the *Pietà*). Her allusion to this figure is an opening for her conceit that Michelangelo will be assigned a place on the favoured right side of God by his namesake St Michael at the Day of Judgement. The attractive hypothesis that the finished form of the design was arrived at after consultation with Colonna finds some support from the drawing itself, as it shows signs of having had additions made to it by Michelangelo. The two lamenting angels have been lightly drawn on top of the carefully drawn horizontal shading of the sky, and the skull at the bottom has also been added at the base of the cross with some hatching, to denote the bare earth of Golgotha, used to disguise the slight truncation of the ruled lines of the cross to accommodate it.[79]

The meaning of these letters associated with the gift of the *Crucifix* is often difficult to follow: the problematic task of unpicking Colonna's syntax is exacerbated by her dizzying changes in tone from high-flown theological abstraction to discussion of practicalities.[80] These shifts are nowhere more evident than in Colonna's letter in the British Library that details her gratitude at receiving the work, but then goes on to voice her worry that it was not hers to keep (for a translation of the whole letter see Appendix II, no. 7, p. 296). The author's poetical gifts are evident from the letter's captivating beginning: 'Unico maestro Michelagnelo et mio singularissimo amico, ho ha[v]uta la vostra et visto il Crucifixo, il qual certamente ha crucifixe nella memoria mia quante altre picture viddi mai' ('Unique master Michelangelo and my most particular friend, I have received your letter and seen the *Crucifix* which has certainly crucified itself in my memory more than any other picture I have ever seen'). On one level Colonna's wordplay is a witty response to Michelangelo's image, and such arresting metaphorical language is a feature of contemporary written expression. A more commonplace example of this is found, for example, in one of Cellini's letters (Appendix II, no. 11, p. 297) trying to lure Michelangelo to return to Florence. To express his devotion Cellini's language borrows from the relatively new technology of printmaking: 'Perché di continuo io vi tengo stampato inne'mia occhi et dentro al mio cuore' ('I keep you ever imprinted on my eyes and in my heart').[81] But Colonna's imagery also goes beyond a clever turn of phrase because her use of the word 'crucified' relates directly to the nature of Michelangelo's gift: a work that was both a precious example of his artistic skill, and a devotional image carefully shaped by the artist (and perhaps the recipient) to stimulate meditation on a particular moment of Christ's Passion. A possible clue to the way in which Colonna thought of the gift is contained in her praise at the end of the letter, 'no image better made, more alive, or finished could be seen', and her description of her having studied it 'using a lamp, a magnifying glass and a mirror: never did I see anything more finely executed'. Her description of studying it in a mirror is interesting. The reversal of the design, and the resulting image's disassociation from the drawing, was perhaps a means to move her attention away from aesthetic admiration of its merits as a work of art, to a devotional contemplation of its subject.

As Condivi rightly noted, Michelangelo's drawing did not show Christ dead but alive, the twist of his upper body and upturned face distantly echoing the death throes of Laocoön in the ancient marble (Fig. 54).[82] The stark simplicity of Michelangelo's drawing is reminiscent of Catholic *spirituali* writers and preachers' injunctions for the faithful to focus their devotions

Fig. 108 Marcello Venusti
(*c.* 1512–79), ***The Annunciation***,
c. 1550–79. Oil on panel,
45 × 30 cm. Galleria Nazionale
d'Arte Antica, Rome

on the image of Christ's Crucifixion. To help them to do so, writers like Ochino encouraged their readers to visualize the scene by precise descriptions, such as that in the fourth of his *Seven Dialogues* which recounts how the Good Thief had been converted because he witnessed 'Christ's burning tears falling on the ground and Christ's ardent fervent sighs going up to heaven'.[83] In Michelangelo's drawing, the skull, the blood dripping down from his nailed feet and the lamenting angels in the background are intended to act in a similar way, as visual clues prompting similar contemplation of Christ's sacrifice. It has been persuasively argued that Michelangelo's image of the living Christ reflects the emphasis in the writings of Ochino and other like-minded reformers of the duality of his nature.[84] The human aspect of Christ's incarnation is expressed in his desperate heavenward cry of anguish, while at the same time his divine nature, that part of him that accepted his suffering and sacrifice as the fulfillment of his mission to relieve mankind's sins, is shown by the majestic repose of his body. The potency of Michelangelo's image inspired a number of painted and engraved versions. One of the finest of these contemporary copies is Marcello Venusti's panel now in the Galleria Doria Pamphili, Rome (Fig. 107), which adds the figures of Mary and St John copied from Michelangelo drawings now in the Louvre.[85] Exh. No. 91 was also an inspiration to a younger generation of painters like El Greco charged with revivifying and purifying religious art in the light of the new spirit of the Counter-Reformation.[86]

Late Studies for Paintings by Other Artists

At the age of seventy-five, after completing the two frescoes in the Pauline chapel (1542–50: paintings not discussed here because there are no related drawings in the exhibition), Michelangelo's career as a painter ended. The physical demands of such work were now too onerous for his advanced years, especially as his health had deteriorated after two bouts of illness in the summer of 1544 and in the early part of 1546 when he had to be nursed back to health by his friend Luigi del Riccio in his apartment in the Palazzo Strozzi. (For the artist's state of health see the 1547 and 1549 letters to his nephew: Appendix II, nos 8–9, pp. 296–7.) His disinclination to pick up the brush, allied with the increasing demands on his time from his architectural responsibilities at St Peter's and the Palazzo Farnese from 1546 onwards, did not, however, end his involvement with painting. In the place of the spurned Sebastiano, Michelangelo had attracted around him a new generation of artistic collaborators who received help from him in the shape of compositional drawings. One of them was Marcello Venusti, a painter from Como in northern Italy almost forty years his junior. It is not known when their association began, although it has been plausibly suggested that it was triggered by the death of Venusti's master Perino del Vaga in 1547.[87] Venusti is known to have been an assiduous student of the *Last Judgement*, and in 1549 he painted a copy of it on panel now in the Galleria Nazionale di Capodimonte, Naples. Paul III paid for the copy, but its exquisite finish fits better with the taste of his nephew Alessandro, and it is possible that it was he who instigated the commission.[88]

Probably at the end of the 1540s, Cardinal Federico Cesi commissioned Venusti to paint an altarpiece of the Annunciation for the family's chapel in the Roman church of S. Maria della Pace. The Cesi painting was substituted by another altarpiece in the seventeenth century and has subsequently been lost, but its composition is known through several small-scale versions. These are of varying quality, but the best of them, such as that in the Galleria Nazionale d'Arte

Fig. 109 Marcello Venusti
(*c.* 1512–79), ***The Annunciation***,
c. 1550–79. Oil on panel, S. Giovanni
in Laterano, Rome

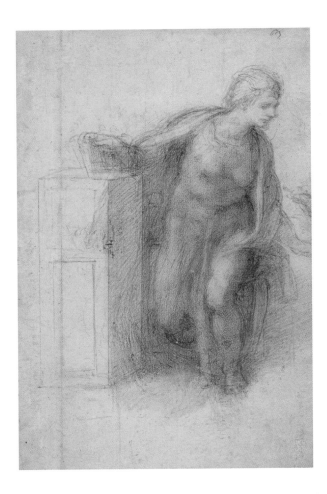

left
Exh. No. 93 Recto **The Virgin
Annunciate**, *c.* 1545–7. Black chalk,
34.8 × 22.4 cm. The British
Museum, London

above
Exh. No. 94 Verso **Annunciate
Angel**, *c.* 1545–7. Black chalk,
19.6 × 28.3 cm. The British
Museum, London

Antica in Rome (Fig. 108), have a strong claim to be by Venusti. According to Vasari it was Cesi's friend Tomasso de'Cavalieri who persuaded Michelangelo to help out with the design of the project, but Cesi may have approached him directly as the two were already familiar and the artist also knew his brother, Cardinal Paolo Emilio Cesi.[89] Michelangelo may even have recommended Venusti to Cesi for the commission as he had done with his protégé Sebastiano for the Borgherini chapel more than thirty years before. Around the same time Venusti executed a different horizontal rendering of the same subject for a panel painting that used to hang by the chapel of the Sacrament in S. Giovanni in Laterano, and is now in the Sacristy (Fig. 109). Michelangelo produced two finished drawings (*cartonetti*) as a guide for Venusti to paint the two altarpieces.[90]

Two preparatory studies by Michelangelo in the British Museum (Exh. Nos 93 and 94) must date from the beginning of his work on the two paintings. The two drawings were once part of a large sheet, as can be seen from the hand to the right of the Virgin on the recto of Exh. No. 93 that belongs (with a small strip missing) to the Angel Gabriel drawn on the verso of the other study.[91] The figure of the Virgin studied on the recto of Exh. No. 93 emerges out of a penumbra of corrections, her final form built up incrementally after many revisions.[92] Initially Michelangelo placed the Virgin further to the left and lower down the sheet. He managed almost completely to cover up this first attempt, except for the faint trace of a left arm holding a book placed on the top of a desk. The earlier desk was roughly half the size of the one that Michelangelo drew over it with the aid of a ruler. The alterations made to the

position of the Virgin's legs and feet demonstrate the care that Michelangelo devoted to creating the figure's fluid, upward turning motion to face her angelic visitor. The badly rubbed angel on the verso of Exh. No. 94 was subject to similarly radical revision, as the airborne figure was originally drawn further to the right, the outlines of his legs just visible over a lightly drawn canopied bed.

After turning the paper over, Michelangelo sketched out two variations of the theme with a more static seated Virgin, the earliest of which is probably the figure on the reverse of Exh. No. 93. This is difficult to read as it was drawn over a tracing from the other side of the Virgin's left leg and the hem of her dress (the more heavily drawn semi-circular form appears unrelated to the composition). With masterly economy Michelangelo delineated the Virgin's head in profile to the right and looking up, a pose very like that of her counterpart in the Cesi composition (Fig. 108). He then turned the piece of paper upright by rotating it rightward by 90 degrees to make space for another study on what was once the lower half of the sheet, but is now a separate sheet (Exh. No. 94). In common with his earlier study on the other side of Exh. No. 93, his drawing of the Virgin on the recto of Exh. No. 94 has been heavily worked and different conclusions have been reached as to the likely sequence of the changes. Following on from the earlier study made on the same side of the paper (Exh. No. 93v) Michelangelo initially drew the Virgin looking up in profile to the right, and with her left hand

below left
Exh. No. 93 Verso **The Virgin Annunciate**, *c.* 1545–7. Black chalk, 34.8 × 22.4 cm. The British Museum, London

below right
Exh. No. 94 Recto ***The Annunciation***, *c.* 1545–7. Black chalk, 28.3 × 19.6 cm. The British Museum, London

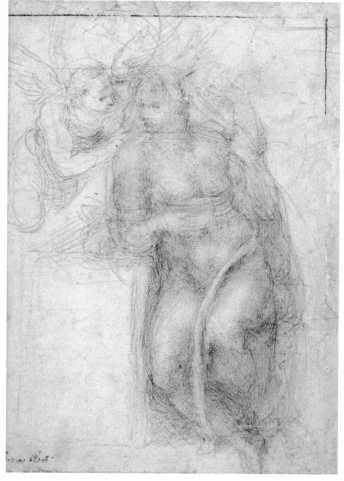

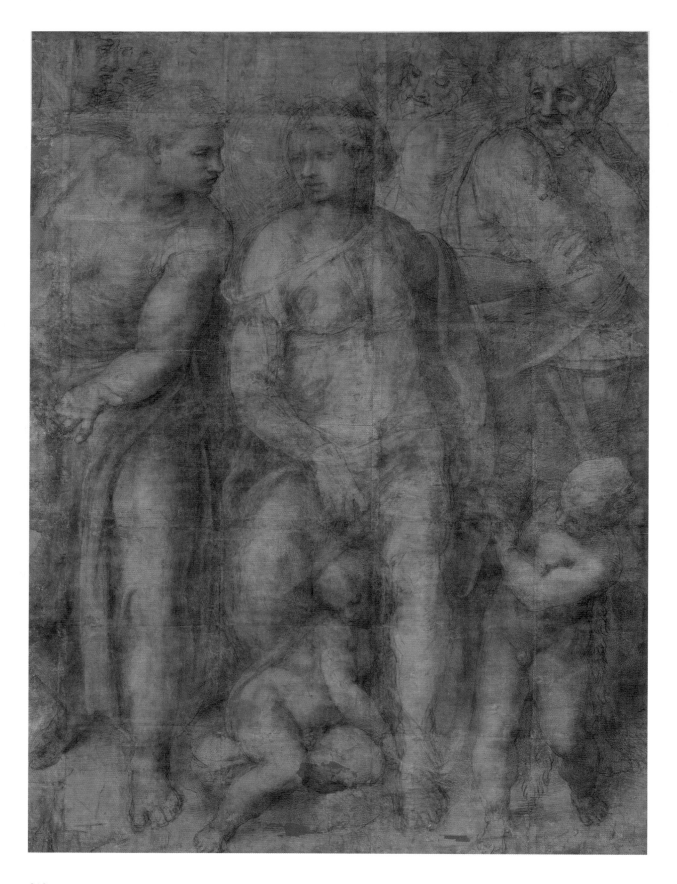

Fig. 110 Ascanio Condivi (1525–74), **The Holy Family and other figures**, after Michelangelo, 1550s. Oil on panel, 240 × 187 cm. Casa Buonarroti, Florence

raised in surprise. The much-revised position of her right arm originally followed that described in the first sketch, resting on the low desk to her right.

The pose of the Virgin is predicated on the angel approaching from the right as in the composition on the other side, but then Michelangelo completely changed his mind to develop a radical new interpretation with the angel hovering in mid-air, seemingly whispering the miraculous news in a conspiratorial fashion. This change entailed major revisions in which the Virgin's features were added to what had been the back of her head, and shading was added to the right side of the neck to create the sense of its rotation to the left. The proximity of the angel also made the alarmed gesture of the Virgin's left hand otiose, and the artist therefore drew another bent forearm lower down, rubbing away part of the shading to create a blank area for a highlight on her left hand.[93] As has been astutely noted, Michelangelo made the Virgin hold the edge of a veil, a gesture familiar from antique portrait sculpture (of which the Cesi were noted collectors) denoting modesty or chastity.[94] An added narrative touch is that the angel draws back the Virgin's veil to reveal her face, a gesture that could be read as symbolizing the revelation he is about to impart to her concerning the incarnation of Christ occurring inside her.[95] The compact intimacy of the two figures, and the unconventional nature of their interaction, made this later version of the theme unsuitable for an altarpiece, and Michelangelo reverted to the more traditional treatment as the basis for the two *cartonetti*.

The distinctive atmospheric quality of Michelangelo's late black chalk draughtsmanship found in Exh. Nos 93 and 94, with the outlines of the figures emerging from a fog of revisions, is repeated on a gigantic scale in one of his best-documented, but paradoxically also one of most enigmatic works, the cartoon known as the *Epifania* (Exh. No. 95). This gigantic drawing on twenty-six sheets of paper glued together was done in the first half of the 1550s as a model for Michelangelo's biographer Condivi to turn into a painting. It is one of only two surviving cartoons by the artist, the other being a fragment, now in Naples, made in preparation for the Pauline chapel *Crucifixion of St Paul*. The provenance of the British Museum drawing can be traced back to 19 February 1564 when it was listed as one of the works located in Michelangelo's studio after his death: 'Un altro cartone grande, dove sono designate et schizzate tre figure grande e dui putti' ('Another cartoon, where are drawn and sketched three large figures and two infants').[96] It is mentioned again in another list made a month later by the painter Daniele da Volterra as the cartoon that Ascanio painted, a reference that can be tallied with Vasari's disparaging reference in the 1568 edition of the *Lives* to Condivi's laboured efforts to paint a panel from a cartoon provided by Michelangelo.[97] Condivi's unfinished painting made after the painting has, since the seventeenth century, been in the collection of the Casa Buonarroti (Fig. 110). The panel reveals that the cartoon has been slightly cut on the left side.

Unfortunately none of these references to the cartoon give a descriptive title, and the only one that does – in an inventory of Michelangelo's studio made for the governor of Rome on 21 April 1564 – describes it wrongly as an '*Epifania*' (Epiphany or the adoration of the newborn Christ by the three kings).[98] The notary's guess as to the cartoon's subject cannot be right as the figure on the left is not dressed as a king, neither does he bear a gift and the inclusion of the Infant Baptist on the right dressed in skins would be unprecedented for an Adoration. The Baptist along with his cousin, the Christ Child, the Virgin and the bearded St Joseph (sometimes fancifully identified as a self-portrait) on the right are the only figures that are readily identifiable. The position of Christ between the Virgin's legs is strongly suggestive that one of the work's themes is his miraculous incarnation, and this led Thode to suggest that the announcing figure on the left was the Old Testament prophet Isaiah who foresaw the

opposite
Exh. No. 95 **The *Epifania* cartoon**, 1550s. Black chalk, 232.7 × 165.6 cm. The British Museum, London

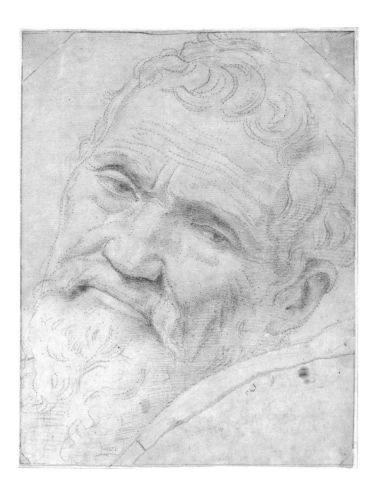

revelation of God's son to the world; the Virgin's gesture towards her husband behind her perhaps signifying that Christ was not his son.[99] Yet the large scale of Condivi's panel shows that it must have been commissioned for an altarpiece, perhaps in a church in Rome or in the painter's home region, and it is very improbable that any patron would have asked for such a unusual combination of Old and New Testament figures.[100]

Condivi's damaged panel is no help in resolving the enigma, and if anything adds to the confusion by turning Michelangelo's first draft of the Virgin's head into a completely new figure clumsily interposed between the two principal protagonists. In Condivi's defence concerning this and other misapprehensions of Michelangelo's design (see, for example, his version of the Infant Baptist's pose), the cartoon was a difficult model for an artist of his very limited talents to follow. It has numerous revisions to the outlines (sometimes clarified by darker black chalk accents), and in some passages quite major changes of mind – such as the alteration made to the Virgin's left arm. Michelangelo's initial thought seems to have been to have the Virgin's hand close to that of the Baptist but he then rethought this, and disguised the limb by making it into a piece of drapery.[101] Some passages, such as the two heads of the onlookers in the left background, betray that it was drawn at great speed (this is borne out by comparing it with the much more polished Naples fragment), the sketchiness of detail proving a major obstacle for Condivi's realization of the design on the panel.

Excuses aside, it has to be admitted that it would almost be impossible to infer from Condivi's laboured effort the solemn majesty of Michelangelo's original, in which the central

above left
Exh. No. 108 Daniele da Volterra (1509–66), **Portrait of Michelangelo**, 1550–2. Leadpoint and black chalk with traces of lead white, the outlines pricked, top corners and a section of the paper at lower right made up, 29.5 × 21.8 cm. The Teyler Museum, Haarlem

above right
Exh. No. 109 Daniele da Volterra (1509–66), **Portrait of Michelangelo**, c. 1564–66. Bronze with a brown patina, h. 28 cm. The Ashmolean Museum, Oxford

figure possesses something of the imposing presence and gravity of the enthroned Virgin in the central panel of Masaccio's Pisa altarpiece now in the National Gallery, London. While the sculptor made no concession to his pupil's pedestrian abilities, he was no more accommodating to the viewer for none of the figures looks outwards to engage our gaze. It is perhaps this austere hermetic quality, allied to its size, which makes the cartoon more than a little forbidding as a work of art. It is a relief to turn from puzzling over its mysterious content to enjoy the descriptive passages in the more worked figures at the front of the composition, where the chalk has not suffered too much rubbing. In areas such as the head and outstretched hand of the mysterious interlocutor on the left, it is still possible to glimpse something of the refinement of modelling and detail that has been lost. An additional factor to take into consideration is that Michelangelo's cartoon is recorded as having been framed and displayed in the sixteenth century, and the consequent exposure to light over so many centuries has turned what was probably blue paper to a dull grey-green. The flattening of the paper's surface, due to it having been mounted on panel, has obliterated any trace of the outlines having been incised, but as Condivi's figures are the same size as those in the cartoon some kind of transfer process must have taken place unless a tracing was used in order to preserve the drawing.

Michelangelo's creation of a cartoon for Condivi, perhaps in gratitude for the biography, was not unprecedented, as he had apparently done the same for Sebastiano at the beginning of their collaboration. However, such expenditure of effort went far beyond the designs he normally gave to help the small circle of artists who had gained his confidence. Undoubtedly the most gifted artistic member of his Roman circle at the end of his life was the Tuscan painter and sculptor Daniele da Volterra, who had come in the late 1530s to Rome where he worked with Perino del Vaga.[102] As with Venusti, Perino's death in 1547 may have stimulated Michelangelo to offer his support. Daniele's talents are testified by his sympathetic black chalk portrait study of the sculptor in Haarlem (Exh. No. 108). The contours of this have been carefully pricked to transfer the design onto another sheet of paper, and this was then used as a cartoon for one of the heads of the Apostles on the right side of Daniele's fresco of the *Assumption of the Virgin* painted in the early 1550s in the della Rovere chapel in Trinità dei Monti in Rome. He later used this portrait of Michelangelo in his mid-seventies as the basis of the posthumous bronze bust he mentions in a letter of June 1564 to the artist's nephew Leonardo (see Appendix II, no. 13, p. 298). An extremely fine cast of the head in Oxford

right
Exh. No. 110 Leone Leoni (*c.* 1509–90), **Portrait medal of Michelangelo**, *c.* 1560–1. Lead, 5.97 cm. The British Museum, London

far right
Exh. No. 111 Leone Leoni (*c.* 1509–90), **Portrait of Michelangelo**, *c.* 1560. Pink wax on black slate, h. 43 cm. The British Museum, London

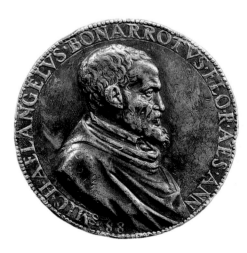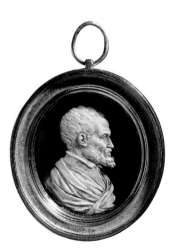

(Exh. No. 109) is perhaps one of the original two paid for by Leonardo.[103] The Oxford head was later turned into a bust (these accretions were subsequently removed), and in this form it appears in the print showing Lawrence's Drawing Room in his house (now demolished) in Russell Square around the corner from the British Museum (Fig. 7). Daniele's ruggedly naturalistic bronze can be compared to the classicizing profile portrait of the artist in a bronze medal by the gifted north Italian sculptor Leone Leoni (Exh. No. 110). The latter sent Michelangelo four copies of the medal (two silver and two in bronze) from Milan in March 1561.[104] The medal most probably depends on a delicately worked pink wax on slate portrait of the sculptor in the British Museum (Exh. No. 111); this bears an old inscription on the reverse stating that it was made from life by Leoni.[105] Although it is unsigned, the wax portrait's similarities with the medal, and its superlative quality support the old attribution.

As Daniele was a highly accomplished draughtsman and designer, Michelangelo's relationship with him differed from his collaboration with Venusti. In this case Michelangelo supplied the younger artist with figural ideas to be taken up and developed independently. Michelangelo's unparalleled ability to extemporize a stream of variations on a theme is exemplified in a sheet in the Ashmolean (Exh. No. 96) showing two unidentified males fighting.[106] Michelangelo's skill at imagining the tussling figures from all angles recalls the drawings he produced to help Daniele design in the mid-1550s an oil painting on slate, now in the Louvre, with depictions on both sides of *David and Goliath* seen from differing viewpoints (Fig. 111).[107] The unusual nature of the painting is explained by it having been commissioned by the Tuscan bishop and poet, Giovanni della Casa, as an aid to help him write an unrealized treatise on painting. This was to treat the question of *paragone*, the comparison between the relative

Fig. 111 Daniele da Volterra (1509–66), **David and Goliath**, *c.* 1555–6. Oil on slate, 133 × 172 cm. Musée du Louvre, Paris

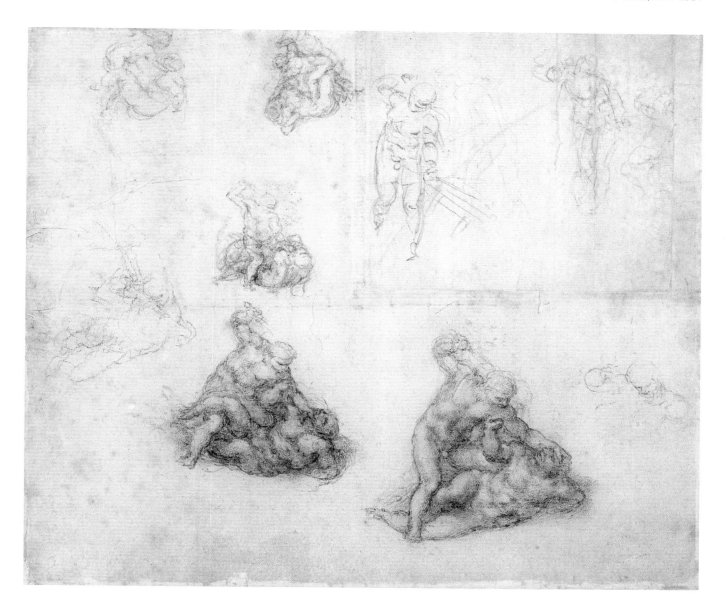

Exh. No. 96 **Studies of two
fighting men; and of *Christ
Purifying the Temple***, *c.* 1550–5;
c. 1555–60. Black chalk, the studies
of Christ on an inserted piece
of paper, 21 × 24.5 cm.
The Ashmolean Museum, Oxford

merits of painting and sculpture, a fashionable point of debate among art-minded intellectuals
like Varchi. The latter canvassed the views of notable artists including Michelangelo on the
subject.[108] The Ashmolean studies cannot be directly linked to the Louvre painting, although it
is probably from the same period, because the two figures in the drawing are the same size.
In the four Michelangelo studies in the Pierpont Morgan Library for Daniele's work, as well as
in the Louvre painting itself, the biblical text is followed in showing the gigantic Goliath being
vanquished by the youthful David.

The inserted section at the top right of Exh. No. 96 added by some later collector, may
well have been cut from a now dismembered sheet of studies for the *Purification of the
Temple* that Michelangelo prepared, in the second half of the 1550s, for a painting in the
National Gallery attributed to Marcello Venusti (Exh No. 100). The theme of Christ driving
out the traders out of the Temple in Jerusalem, a subject described most fully in the Gospel
of St John (II.13–16), was a particularly appropriate one for the reforming atmosphere of

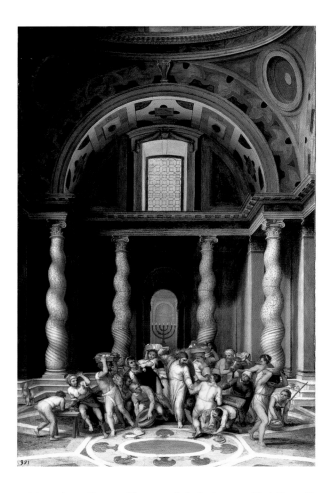

mid-century Rome. The parallels between Christ's actions and the cleansing of the church of its abuses by a succession of reform-minded pontiffs, explains the scene's popularity for the reverse of papal medals, among the earliest of which was issued by Paul III (Fig. 113). The patron of the National Gallery cabinet painting is not known as the provenance only stretches back to 1650, when it is recorded in the Borghese collection in Rome. A later owner was Thomas Lawrence who acquired it from Samuel Woodburn. The panel's intense colours and jewel-like finish are characteristic of Venusti's small-scale paintings that were designed to be examined at close quarters.[109] The involvement of Michelangelo gave these ultra-refined works an even greater lustre, their status enhanced by the near impossibility of collectors obtaining work by his own hand. Two Venusti paintings after Michelangelo belonging to the sons of the sculptor's deceased servant Francesco d'Amadore (nicknamed Urbino) were sequestered by Guidobaldo II della Rovere, duke of Urbino in 1557.[110]

More than half a dozen variants of the *Purification* composition are found on three double-sided sheets in the British Museum (Exh. Nos 97–9). The two larger pieces were once part of the same sheet, as can be seen from the composition trimmed at the top and side split between the versos of Nos 97 and 99 (see composite image Fig. 112). Michelangelo's first notion was to have Christ seen in profile upending a moneychanger's table with one hand, and scourging the traders with the whip in the other. He is shown in this attitude in the sketchiest of all the group compositional drawings on the verso of No. 97, and in some of the individual studies. A more frontal pose, not far from that of Christ in the *Last Judgement*, eventually

above left
Exh. No. 100 Attributed to
Marcello Venusti (*c.* 1512–1579),
Christ Purifying the Temple,
c. 1560–79. Oil on panel, 61 × 40 cm.
The National Gallery, London

above right
Exh. No. 97 Verso ***Christ
Purifying the Temple***, *c.* 1555–60.
Black chalk, 27.6 × 14.8 cm.
The British Museum, London

prevailed, probably because his forward motion meant that he could be placed in the middle of the traders, scattering them on either side. The collective motion of a group of densely packed figures was a compositional idea that had a particular appeal for Michelangelo, as can be seen by comparing these studies with the *Worship of the Brazen Serpent* (Exh. No. 75) drawn a quarter of a century earlier. In the most finely realized of the compositional studies on the recto of Exh. No. 99, he went over some of the central figure with a darker and more sharpened stick of chalk to elucidate the contours of the principal figures. The level of fine detail in the description of the nudes is remarkable for an artist approaching his eighties, and the study contains some rare depictions of animals – a lamb slung on the shoulder of one man on the left, a cow and a pair of chickens in a basket. The clothed figures in the National Gallery panel generally follow closely their drawn counterparts in pose and scale, although Venusti's protagonists lack the dynamic animation of the fleeing tradesmen in the study. The dramatic intensity is also much dissipated by the dwarfing effect of the lofty architectural setting which includes twisted columns, like those allegedly presented to St Peter's by the Emperor Constantine that were believed to have come from Solomon's

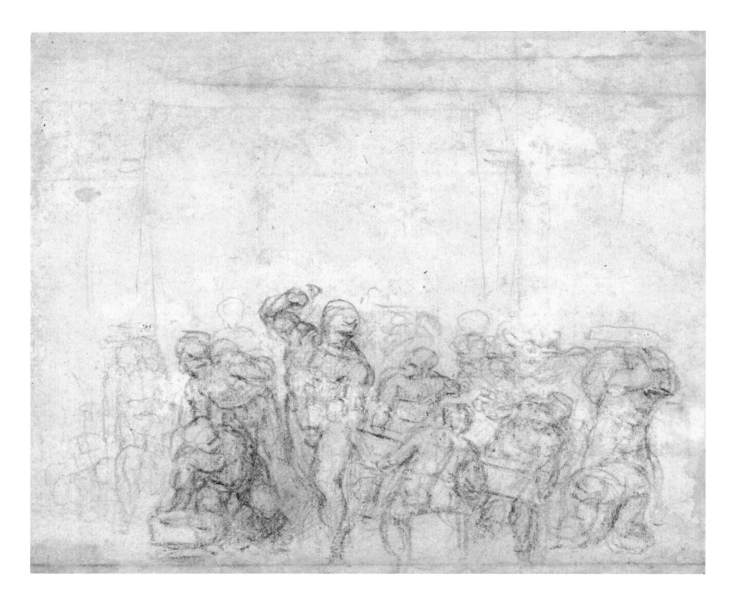

Temple in Jerusalem. This background is not prepared in any of the drawings (a double arched opening is shown behind the figures in the main sketch on Exh. No. 97v), and it may have been Venusti's invention.

Michelangelo's only allowance for his age in Exh. No. 99 was his use of scissors and paste. He cut out a section to the left of Christ that he was obviously unhappy with, and then inserted a fresh piece of paper to redraw this part of the composition. This form of editing to avoid having to start the whole design afresh is unique in his oeuvre, but it was a common enough method among his contemporaries.[111] Michelangelo also extended the sheet by gluing four strips of paper to the left, right and bottom of the main sheet, the piece used on the right is cut from another part of the sheet with an earlier idea for the figure of Christ, like those found on the fragment inset in Exh. No. 96. The rough uneven edge of the sheet running through the figure at the end of the table just about to be turned over by Christ, provides a clue to the original appearance of sixteenth-century drawing paper before the tidying up and trimming by later collectors.

Exh. No. 98 *Christ Purifying the Temple*, c. 1555–60. Black chalk, 13.9 × 16.7 cm. The British Museum, London

The last two drawings in this section cannot be related to any finished work, yet in date they fit the period of the *Epifania* and Michelangelo's drawings for Venusti. The first of these is a red chalk study of the *Descent from the Cross* or the *Carrying of Christ to the Tomb* in the Ashmolean (Exh. No. 101). The drawing's narrative is ill-defined as the action fits a *Descent* except there is no cross, and is perhaps more comprehensible as the transportation of the body to the tomb. If it does show the moving of Christ's body the inclusion of a female bearer in the foreground would be unusual. The contrast between the dense modelling of the foreground and the progressively sketchier definition of the figures behind is striking, and has led to suggestions that the drawing has been 'extensively reworked' or, more recently, that it was executed in two stages, with the loosely defined passages from the 1530s and the more finished areas added ten or fifteen years later.[112] The chalk and the paper have both certainly suffered, but when one thinks about how the drawing was executed it becomes clear that it cannot have been made in two stages. The first figure to have been drawn was Christ and the other figures are fitted around him. There is no evidence to show that the more finished parts of Christ's body are drawn over sketchier outlines. In fact one of the striking features of the drawing is the absence of hard outlines. The manner in which the figures merge into each other adds to the nightmarish, claustrophobic crush of bodies around Christ. Some of the

Exh. No. 99 Recto **Christ Purifying the Temple**, *c.* 1555–60. Black chalk, the sheet extended by the artist, 17.8 × 37.2 cm. The British Museum, London

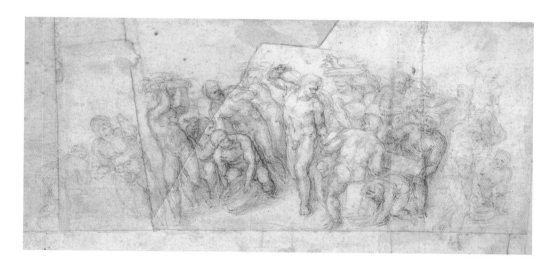

Exh. No. 99 Verso **Studies for Christ Purifying the Temple**, *c.* 1555–60. Black chalk, the sheet extended by the artist, 17.8 × 37.2 cm. The British Museum, London

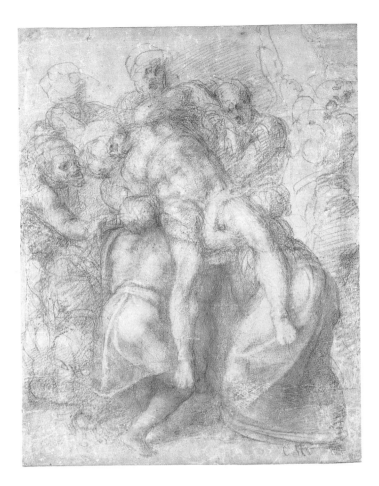

Exh. No. 101 **Carrying of Christ to the Tomb**, 1550s. Red chalk, made up sections of paper at right edge, 37.5 × 28 cm. The Ashmolean Museum, Oxford

Fig. 114 **Three fragments of a _Pietà_**, c. 1550–5. Black chalk, 16.5 × 18.9; 13.3 × 11.6; 7.5 × 8.1 cm. The Teyler Museum, Haarlem

tonal effects in the drawing are beautifully controlled, as in the bare paper used for the right leg of Christ with the contour defined by the shaded area behind; but the overall effect is uneven. The upper part of Christ's body has been left unresolved with his shoulders completely unaligned, and his acutely foreshortened head twisted to the left is unsatisfactorily muddled with that of an unfinished head of a bearer in profile (the pose of the latter can be ascertained from the position of the ear). The idea of placing the latter's hand and forearm on Christ's right thigh has also been left in an incomplete state, and this lack of definition, exacerbated by the chalk's rubbed condition, makes this passage difficult to interpret.

The dating of the Oxford drawing is problematic, in part because Michelangelo experimented with the sacramental representation of a frontally posed full-length Dead Christ throughout his career. His earliest treatment is the National Gallery panel of 1500–01, and the latest the unfinished marble _Rondanini Pietà_ (Fig. 121).[113] Robinson in his pioneering 1870 catalogue of the Ashmolean's Michelangelo and Raphael drawings placed the study as early as the 1510s, while Wilde was inclined to date it to the mid-1550s.[114] The latter dating would make it the last known example of Michelangelo's use of red chalk, a technique that he otherwise seems to have virtually eschewed from the 1540s onwards.[115] An earlier dating would fit the compositional similarities with drawings from the early 1530s, most notably a red chalk study of the Lamentation in the Albertina, Vienna.[116] On the other hand in terms of style, the inchoate haziness of the outlines and the smoky tonality that envelopes the forms in the Oxford work, the best matches are with works from the 1550s, like the _Annunciation_ studies

and the *Epifania* cartoon (Exh. Nos 93–5). Some support for this advanced dating is provided by compositional and stylistic similarities with a fragmentary black chalk *Pietà* in Haarlem that is generally agreed to be from the 1550s (Fig. 114).[117]

The doubts surrounding the subject matter in Exh. Nos 95 and 101 have yet to be satisfactorily resolved, whereas a black chalk study in the Ashmolean (Exh. No. 102), previously

Exh. No. 102 **The Risen Christ Appearing to his Mother**, *c.* 1555–60. Black chalk, 22 × 20 cm. The Ashmolean Museum, Oxford

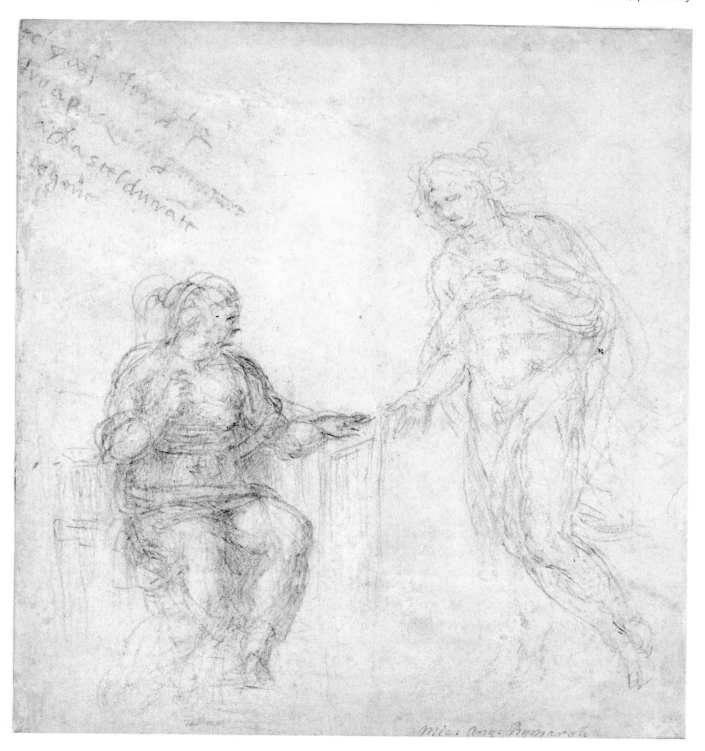

assumed to show the Annunciation, was correctly identified forty years ago as the Risen Christ appearing to the Virgin on Easter morning.[118] This episode, not mentioned in any of the Gospel accounts, had been gradually woven into the story of Christ's Passion to make the Virgin the first witness of his Resurrection. It was seen as a fulfilment of Christ's first incarnation at the time of the Annunciation, and the parallels between the two scenes were acknowledged in some artistic representations of the episode either by depicting the two in tandem, or, as with Exh. No. 102, echoing the imagery of the earlier narrative. In the drawing the floating figure on the right is clearly Christ, rather than an angel, his form still wrapped in his funeral shroud and showing the marks of the nail in his right palm to his mother. The contrast between the solidity of the Virgin's form and the spectral quality of her son (his ability to go through closed doors is mentioned in *John* xx.26) is the latest variation in Michelangelo's visualization of resurrected bodies beginning in the present exhibition in his studies of Lazarus from 1516 (Exh. Nos 34–5), and developed most fully in the Risen Souls in the *Last Judgement*.

Christ's appearance to the Virgin was not commonly depicted by Italian artists of the period, although it had featured in Dürer's hugely popular *Little Passion* woodcut series of around 1510, which was later engraved in a pirated edition produced by Raphael's collaborator Marcantonio Raimondi.[119] It is perhaps not coincidental that at much the same period Michelangelo was working on a lost cartoon of *Christ Taking Leave of his Mother*, another fairly obscure Marian subject included in the same Dürer series. The dating of Exh. No. 102 to the second half of the 1550s on stylistic grounds, is confirmed by the mention in the fragmentary inscription of '*pasquino*' and '*chasteldura*[n]*te*' which can be linked to Michelangelo's correspondence with the widow of his servant Urbino, Cornelia Colonelli. After the death of her husband in 1556 she had gone to live in Castel Durante (now called Urbania) in the duchy of Urbino, and the artist stayed in contact with them over the next six years via the muleteer Pasquino. The intimacy of the drawing's composition was one that would have well suited a small-scale devotional painting, but there is no evidence that it was ever taken any further.

Architectural Studies

From the mid-1540s onwards Michelangelo's energies were increasingly taken up by architectural projects in Rome. (This phase of Michelangelo's career is imperfectly covered in the exhibition because the holdings in Haarlem, London and Oxford have relatively few late architectural studies.) In 1546 Paul III asked him to take over the design of the Palazzo Farnese and appointed him chief architect of St Peter's. In both cases he took over from Bramante's pupil Antonio da Sangallo the Younger, who had died in September 1546, and thereby brought him into conflict with the Sangallo clan and their supporters, such as Nanni di Baccio Bigio. The pope's choice of Michelangelo ended the powerful hold that the Sangallo family had enjoyed over architectural commissions in Rome, and their resentment of the interloper was spiced by a disdain for the creative freedom with which he used the classical architectural vocabulary. These ideological differences came out in the vehement criticism of the trial wooden cornice on the façade of the Palazzo Farnese erected by Michelangelo in spring 1547. Giovanni Battista da Sangallo wrote to the pope to complain that it ran counter to the principles of classical architecture expounded in the treatise by the Roman first-century BC architectural theorist Vitruvius.[120] A Florentine friend of Michelangelo wrote to inform him in

May 1547 that Nanni di Baccio Bigio was spreading malicious rumours about him. These included the charge that the sculptor worked only at night; depended entirely on the architectural knowledge of a Spanish assistant (Juan Bautista de Toledo); his plan for the Farnese palace cornice would ruin the building; his plans were profligate; and his ideas for St Peter's were mad and child-like ('voi fare certe cose pazze e da bambini').[121] The pope, as he had done with criticism over Michelangelo's *Last Judgement*, simply ignored these detractors and remained faithful to the Florentine's artistic vision.

Michelangelo rewarded Paul III's faith in him by his masterly additions to Sangallo's nearly completed Palazzo Farnese façade: a massive sculptural cornice, the raising of the upper storey to accommodate it, and telling alterations to the design of the central window. These changes added an imposing authority to the building, and injected some much-needed variety to Sangallo's otherwise rather monotonous long horizontal elevation. Michelangelo had a freer hand in the central courtyard as he took it over halfway through its construction, and he was able to introduce greater plasticity to the design of the cornices, pilasters and windows. Michelangelo's desire to animate the wall surface, by introducing architectural elements of varied planar and textural relief, is highlighted by a marvellous study in the Ashmolean (Exh. No. 103) for the second floor windows of the courtyard of the Palazzo Farnese (Fig. 115). The decorative language that Michelangelo employed is still reminiscent of the Medici chapel in its inclusion of lion and goat masks, and also in the unorthodox transformation of a triglyph section of a frieze, complete with guttae, into the window surround. The final design follows the study fairly closely except in minor details, such as the reduction of the decorative detail in the lower part. Executed in thin black chalk, both freehand and ruled, this window design was probably made in the late 1540s before Michelangelo passed the project to the Bolognese architect Jacopo Vignola.

It has been recently convincingly argued that he returned to the drawing some twenty years later in the early 1560s, to adapt the design for the niche on the first floor landing of the Palazzo dei Conservatori, the right-hand building on the summit of the Capitol orientated around the bronze equestrian sculpture of Marcus Aurelius.[122] At this later date Michelangelo revised the study in a thicker black chalk, the medium handled with far less precision than in the window design he had made when in his sixties, twenty years before. His chalk additions are perhaps most evident in the roughly ruled horizontal lines added to the bottom to indicate that the inner moulding and the sill should be thickened, turning the window into a niche that would provide a suitable setting for a classical marble (Fig. 116). He applied wash and white heightening with a brush to cover up parts of the old design, and also to delineate new features. These include the lateral brackets seen in profile found in the finished work, and the just visible Doric column on the left that was later rejected from the design. The bold use of wash fits well with other architectural studies from the last period, like those for the Porta Pia of exactly the same time.[123] As there are substantial differences between the finished niche and the drawing, it is clear that Michelangelo must have gone on to develop the idea in subsequent studies. The use of an earlier idea as a starting point can be interpreted in different ways, yet in view of his ingenious adaptation it is perhaps fairer to see it as an attempt by Michelangelo, then in his mid-eighties, to accelerate the design process, rather than a sign of his diminishing inventive powers. His alacrity may have been inspired by Tomasso de' Cavalieri's involvement in the project in his role as one of the deputies of the fabric of the Palazzo dei Conservatori. (Cavalieri's name features in one of two inscription tablets, dated 1568, in the palace's vestibule commemorating its completion.)

Michelangelo's crowning achievement as an architect was St Peter's, a project that he worked on continually from his appointment in 1547 until his death seventeen years later. During this long period in control, he successfully re-established Bramante's principle of the church's spatial mass and volume growing out from the centre, and he brought to the plan an even greater coherence by simplifying the interior so that its constituent parts flowed together in a much more organic fashion. The most prominent exterior element in his design was the dome (Fig. 117), a double-sided black chalk study for which is in Haarlem (Exh. No. 104).[124] The evolution of this feature, and the extent to which the dome constructed almost twenty years later by the architect Giacomo della Porta depended on Michelangelo is highly contentious. From an early stage in his involvement in St Peter's Michelangelo was thinking about this feature, as is shown by his request to his nephew in July 1547 to send him measurements of Brunelleschi's dome and lantern of Florence cathedral.[125] However, it was not until 1557 that he actually completed a clay model (now lost) of the drum and dome, which then led to the construction of a large-scale wooden model finished in 1561. The model, substantially altered over successive centuries, survives in the Fabbrica di San Pietro in the Vatican (Fig. 119).[126]

Pre-existing the architectural studies of the dome and lantern were the studies of male figures, often shown standing in shallow upright niches, found on both sides of the Haarlem sheet. The greatest concentration of these are on the verso, with the two most finished designs, those on the left and the truncated one at the bottom, traced on to the other side of the sheet. The left-hand male on the verso, whose pose is studied various times on the sheet, has a saw propped up behind him, the attribute of St Simon Zelotes. The figure in the lower right corner of the verso is leaning on a staff or sword, but this is insufficient to identify him. Equally mysterious is the bearded thickset saint in the centre who leans pensively on a balustrade. The purpose of these figural sketches is unknown.[127] Above the figures Michelangelo drew a circular form that has either been interpreted as a C-shaped volute flanked by coffin-shaped panels seen from above, or as a view of the lantern's upper section from above.[128] Beside this Michelangelo wrote 'balmo' in black chalk (a miswritten form of the measurement 'palmo'), the ruled line below is perhaps a palmo scale.

His switch to architectural concerns is registered even more strongly on the recto where the traced figures have largely been obscured by studies of the dome and lantern. The main drawing is a section through the dome, drawn over some preparatory stylus work done with a compass, which shows it to consist of two shells of roughly equal thickness. The inner one is nearly hemispherical with steps ascending up its slope on either side, while the external one is slightly more elevated at the top, so that the gap between the two increases as they reach the lantern. In the top left study the two domes are both shown as hemispherical with just a narrow gap between them. Michelangelo abandoned the sectional view that he had adopted for the dome in his study of the lantern crowning it. Michelangelo went on to study the lantern's form in subsidiary larger-scale studies, partly drawn with the aid of the ruler, probably the last of which was made with the sheet turned to make it horizontal. These designs contain many elements inspired by Brunelleschi's lantern, such as the volutes at the base of the lantern and its conical top. These are features found in della Porta's lantern. Perhaps the most appreciable difference in all of the variants is the use of single columns between the windows. The subsequent doubling of the columns reinforced the visual impression of the dome's weight flowing down its external ribs to the drum, where paired columns on the buttresses below echo those on the lantern above.

Fig. 115 **Upper storey window of the courtyard of Palazzo Farnese, Rome**

Fig. 116 **Niche on the staircase leading to the first floor of Palazzo dei Conservatori, Rome**

opposite
Exh. No. 103 **A window**, 1547–9, reworked by Michelangelo in the early 1560s. Black chalk with lead white (discoloured), brown wash, 41.9 × 27.7 cm. The Ashmolean Museum, Oxford

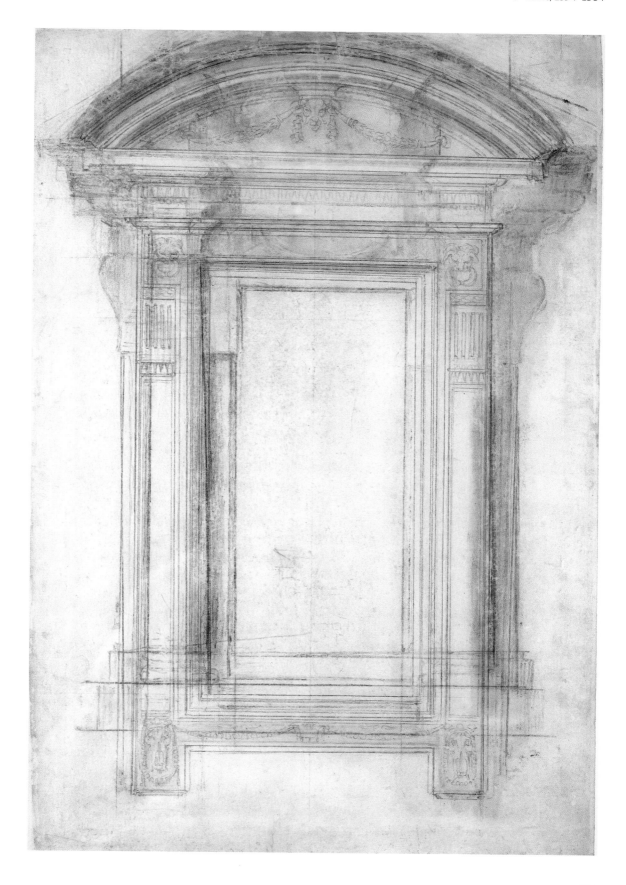

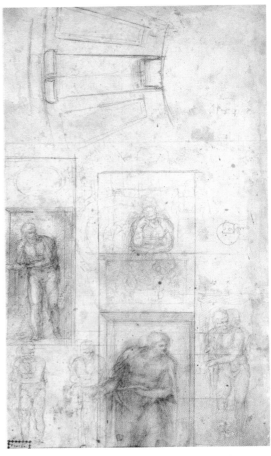

At what stage the Haarlem study was made in relation to the planning of the dome is not clear. The most likely alternatives are either from around the commencement of the drum's construction in 1554, or the beginning of the 1560s when the wooden model was being completed. The fact that the sheet contains studies for a raised and a hemispherical dome proves that Michelangelo kept both options in mind when he was working on the design, but it does not help to determine the vexed question of which one he ultimately fixed on. A hemispherical dome is reproduced in Etienne Dupérac's print (Fig. 118), generally dated to 1569, which is reckoned to record the original appearance of Michelangelo's wooden model finished in 1561, whereas Giacomo della Porta's final model and the constructed dome has a raised profile akin to Brunelleschi's design in Florence. A later dating for the drawing would bolster the argument that Michelangelo had not fixed on a hemispherical dome, and that his final intention not to follow the wooden model was followed in Giacomo della Porta's designs of a dome with a steeper curve more like that of Florence cathedral.[129]

above left
Fig. 117 **The dome of St Peter's**

above right
Exh. No. 104 Verso **Ground plan of the lantern's base; figure studies**, late 1550s. Black chalk over some stylus, three corners made up, 39.9 × 23.5 cm. The Teyler Museum, Haarlem

Three Late *Crucifixion* Drawings

In one of Michelangelo's most celebrated sonnets sent to Giorgio Vasari in 1554 and published by him in the second edition of the *Lives*, the sculptor admitted his earlier error in allowing his imagination to make art his idol and a tyrant, but that now it no longer soothed his anxieties

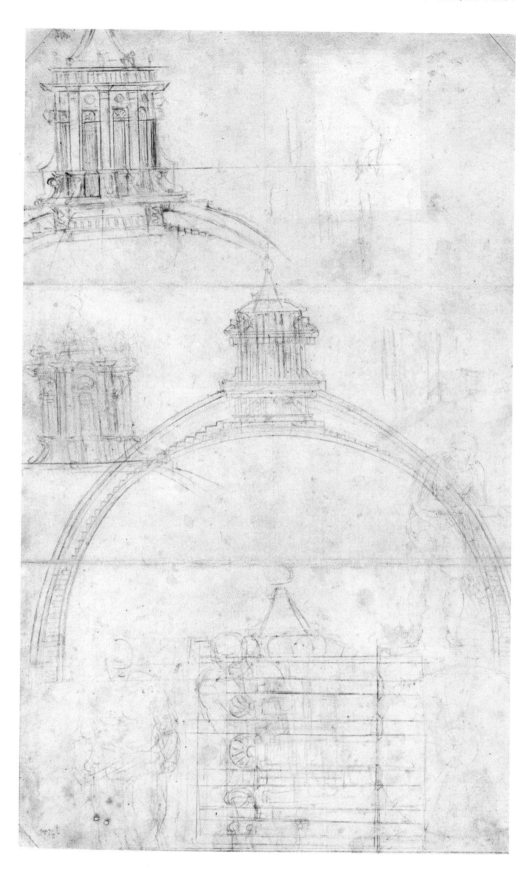

Exh. No. 104 Recto **Section through the dome of St Peter's; figure studies**, late 1550s.
Black chalk over some stylus, three corners made up, 39.9 × 23.5 cm.
The Teyler Museum, Haarlem

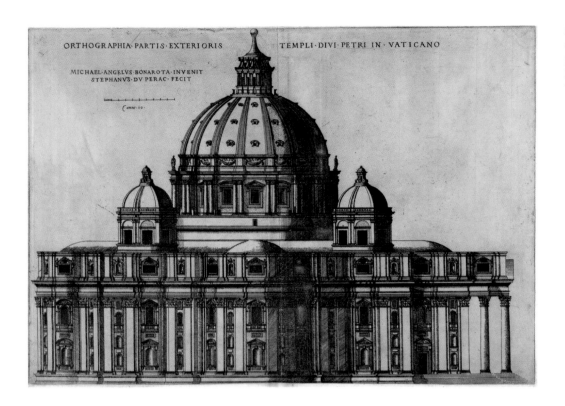

Fig. 118 Etienne Dupérac (c. 1525–1601), **Michelangelo's project for St Peter's**, c. 1569. Engraving, 33.3 × 46.5 cm. The British Museum, London

about his end: 'Né pinger né scolpir fie più quieti/ l'anima volta a quell'amor divino/ c'aperse, a prender noi, 'n croce le braccia' ('Neither painting nor sculpting can any longer quieten my soul, turned now to that divine love which on the cross, to embrace us, opened wide its arms').[130] Michelangelo's intensely felt meditations on Christ's sacrifice on the cross in his poetry is paralleled in a group of drawings of similar dimension and style from his very last period on the same theme. Two of these, both from the British Museum, are included in this exhibition (Exh Nos 106–7), two more are at Windsor and a single example is in the Louvre (Fig. 120).[131] Another rendering of the subject in Oxford is smaller and less heavily worked, and while it does not belong to the same group as the two London sheets it must be from much the same period (Exh. No. 105). The sculptor is known to have been planning to carve a wooden crucifix in 1562, and it has been suggested that the drawings might be related to that purpose.[132] While a projected sculpture may have been the impetus for Michelangelo to begin work on the theme, the pictorial nature of Exh. No. 106, with a hatched background and the undulating outline of Golgotha's outline behind the figures, would discount it being for sculpture unless for a relief.

The Ashmolean drawing is the least heavily worked of the three drawings with only a few strokes of white heightening (now discoloured) applied with a brush over the chalk (there are also some ruled horizontal stylus lines perhaps to indicate the horizon). The two figures are clearly not the Virgin and St John as in the two London studies, and there has been much discussion as to their identities.[133] The bearded male on the left, depicted nude except for a short cloak and a hat, seems too old to be St John, and is perhaps Longinus, the Roman centurion who purportedly stabbed Christ's side with a lance and was converted to Christianity. The gender of the other figure is more difficult to determine, but he/she is perhaps more likely female as the band of drapery above the waist is included in the costume of the Samaritan

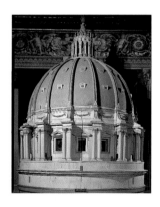

Fig. 119 **Wooden model of the dome of St Peter's**, 1558–61 with later additions. Vatican Museums, Vatican City

opposite

Exh. No. 105 **The Crucifixion with Two Mourners**, c. 1555–64. Black chalk, heightened with lead white (discoloured), 27.8 × 23.4 cm. The Ashmolean Museum, Oxford

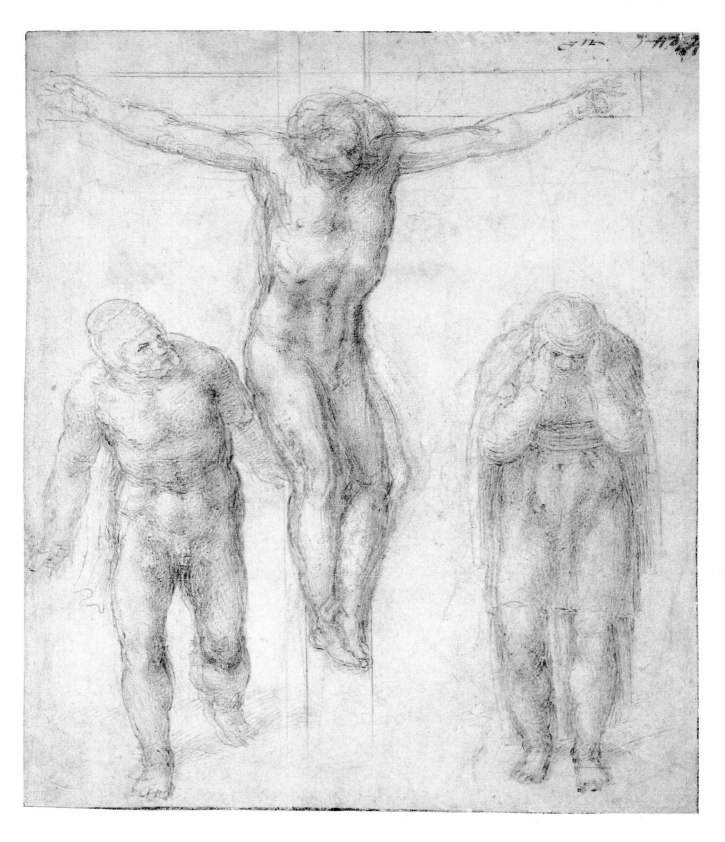

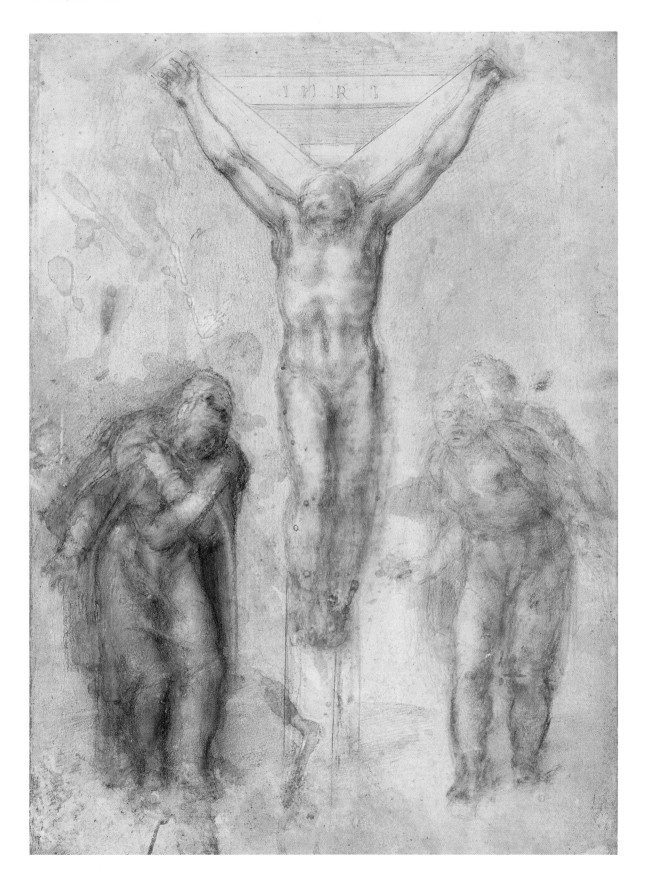

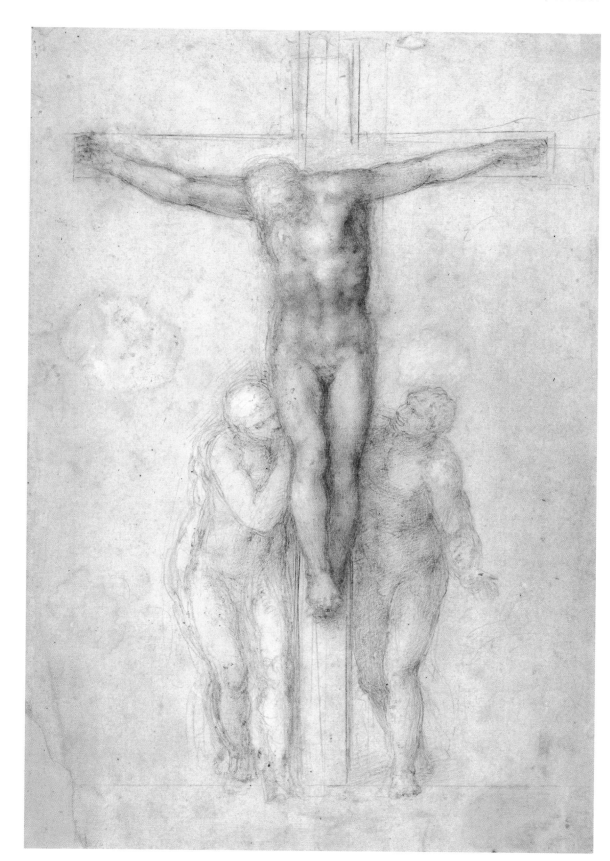

opposite
Exh. No. 106
The Crucifixion with the Virgin and St John,
c. 1555–64. Black chalk, heightened with lead white (discoloured),
41.3 × 28.6 cm.
The British Museum, London

right
Exh. No. 107
The Crucifixion with the Virgin and St John,
c. 1555–64. Black chalk, heightened with lead white (discoloured),
41.2 × 27.9 cm.
The British Museum, London

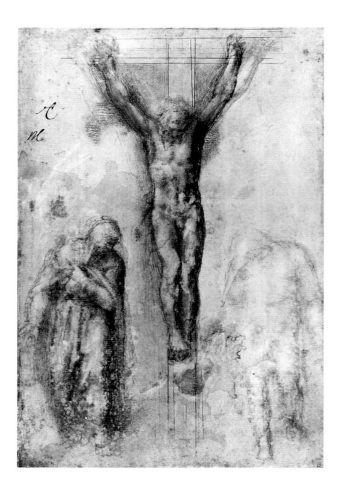

woman in a late Michelangelo drawing recently sold in New York.[134] It is unlikely to be the Virgin as she is almost invariably depicted on Christ's right side, but which one of the women present at the Crucifixion is intended cannot be determined (Mary Magdalene is perhaps the most likely candidate). The idea of one of the attendant figures advancing is repeated in Exh. No. 106, where the open-mouthed St John is shown striding forward, looking directly outwards. (An earlier pose with him looking up at the cross can be just made out beneath.) As in one of the Windsor drawings Christ is shown on a 'Y'-shaped cross, an archaic form that Condivi mentions in connection with one of the devotional drawings for Vittoria Colonna (Fig. 106). Michelangelo knew it from a crucifix in S. Croce in Florence that had been carried by the Bianchi, white-clad penitents, who had processed through the city at the end of the fourteenth century.[135] The blurring of the outlines caused by Michelangelo's reworking of them, and his use of diluted lead white pigment both to define form and to cover over areas is paralleled in his late architectural drawings, and it is likely that the group of *Crucifixion* drawings date from the last five years of his life.

The tremulous quality of the line and the reworking of the contours are powerfully suggestive of Michelangelo's failing eyesight and his faltering control of the chalk, although the fine detail of the description of Christ's hands in Exh. No. 106 belies his age.[136] The modelling of Christ's torso in both the London drawings is remarkably plastic: the artist blended the tones by rubbing the chalk with his fingers. The relative precision in the delineation of Christ's form contrasts to the tentativeness in the description of St John and the Virgin, and this

above left
Fig. 120 **The Crucifixion with two mourners**, *c.* 1555–64. Black chalk heightened with lead white (discoloured) and pen and brown ink, 43.2 × 28.9 cm. Musée du Louvre, Paris

above right
Fig. 121 ***Rondanini Pietà***, 1555–64. Marble, h. 195 cm. Castello Sforzesco, Milan

uncertainty of outline gives the mourners an evanescent quality heightened in Exh. No. 106 by the now translucent white heightening. The drawings' emotional intensity, and the sense that the obsessive reworking of their forms is an expression of Michelangelo's emotional investment in the subject, are paralleled in the pared down figures in the *Rondanini Pietà* (Fig. 121), a marble that we know he was working on just days before his death (see Appendix II, no. 13, p. 298). In the two drawings Michelangelo is able to conjure up two very differing emotional responses to Christ's death. In Exh. No. 106 Michelangelo first draws the Virgin looking dramatically up at the cross with one arm flung out behind her, the other gripping her cloak in place. Then he changes the position of her head, and crosses her left arm over her right to create a pose of huddled acceptance, as in the *Last Judgement*. In Exh. No. 107 both the Virgin and St John are brought close to the cross. Christ's mother is depicted with her eyes closed, perhaps in prayer, and her cheek pressed to her son's body. The proximity of the two mourners is powerfully suggestive of the magnitude of their loss and of their sense of desolation.

The *Crucifixion* drawings provide a fitting conclusion to the exhibition, as the themes explored in them with such fervency – death, loss, sacrifice and the hope of an afterlife – reverberate throughout Michelangelo's work. His search to find new ways of articulating the complexities of these issues in visual form almost always began with drawing, and his passionate commitment to the activity remained a consistent feature of his working life. His young assistant, Tiberio Calcagni, describes the aged Michelangelo in August 1561, drawing for three hours barefoot, with a concentrated exertion which later caused him to faint.[137] Irrespective of whether the finished work was to be God the Father's outstretched arm on the Sistine chapel vault, the modelling of the powerful shoulders of *Day* in the Medici chapel, or the form of a window in the Palazzo Farnese courtyard, it was through the process of drawing that Michelangelo honed and perfected his creative ideas. The insight into Michelangelo's mind and imagination at work is unique and thrilling. The sense in his preliminary sketches, like those for the Medici chapel and the *Last Judgement*, of a hand barely able to keep up with a surging flow of ideas is an experience which cannot be replicated when looking at works in any other media. His drawings also open up aspects of his career and personality which cannot readily be appreciated elsewhere: his engaging attempts to train his pupils; the use of his skills as a draughtsman to cement artistic alliances and friendships; his efforts, as in the *Crucifixion* series, to express his innermost feelings. And finally, quite apart from what can be learned about Michelangelo's life and artistic practice from his drawings, their vitality and dynamism make them some of his most immediate and enthralling creations.

Appendix I
List of exhibits

*All drawings and inscriptions on them are
by Michelangelo unless otherwise stated.
The exhibition history given for each drawing is
intended to be complete, while the bibliographical
references list just the main recent literature.
Fuller bibliographies can be found in the published
catalogues of the three collections. Short inscriptions
(excluding those written by later collectors) are
transcribed with an English translation. For longer
inscriptions – mainly drafts of poems – only the first
line is given, complete translations of all but one of
them can be found in Appendix II, pp. 294–8.*

*The page number in bold beneath the following entries
refers to the main discussion of the work in the
present publication. These references, along with
details of the illustrations, refer to the recto only
unless otherwise specified. Details of how the
drawings will be displayed relate solely to the London
exhibition.*

1
Giulio Bonasone (*c.* 1510–1576), **Portrait of
Michelangelo**, 1546
Engraving, 23.8 × 17.6 cm. The British Museum,
London (1868-8-22-63/Bartsch XV.170.345)
London only
Exh. Hist.: London 1964, no. 152
Illustrated p. 12

2
Domenico Ghirlandaio (*c.* 1448/9–1494), *The Birth
of the Virgin*, *c.* 1485–90
Pen and brown ink, 21.5 × 28.5 cm. The British
Museum, London (1866-7-14-9)
London only
Prov.: J. Richardson; J. Barnard; J. Reynolds;
W. Esdaile; T. Thane; H. Wellesley
Lit.: Popham and Pouncey 1950, no. 69; Cadogan
2000, no. 96
Exh. Hist.: Manchester 1857, no. 7; London 1960,
no. 502; London 1978, no. 202; Nottingham and
London 1983, no. 56; London 1994–5, no. 14
pp. 52, 54; illustrated p. 53

3
Domenico Ghirlandaio (*c.* 1448/9–1494), *The Naming
of St John the Baptist*, *c.* 1485–90
Pen and brown ink, parts of the right edge made up,
18.5 × 26.3 cm. The British Museum, London
(1895-9-15-452)
London only
Prov.: Count Moritz von Fries; J. Malcolm
Lit.: Popham and Pouncey 1950, no. 70; Cadogan

2000, no. 97
Exh. Hist.: London 1877–8, no. 775; London 1996,
no. 11
p. 54; illustrated p. 55

4
Domenico Ghirlandaio (*c.* 1448/9–1494), **Standing
woman**, *c.* 1485–90
Pen and brown ink, 24.1 × 11.7 cm. The British
Museum, London (1895-9-15-451)
London only
Prov.: J. Richardson; T. Lawrence; J. C. Robinson;
J. Malcolm
Lit.: Popham and Pouncey 1950, no. 71; Cadogan
2000, no. 98
Exh. Hist.: London 1994–5, no. 16; London 1996, no. 12
p. 55; illustrated p. 57

5
An old man wearing a hat (*Philosopher*),
c. 1495–1500
Verso: **Head of a youth and a right hand**,
c. 1508–10
Pen and brown ink. Verso: Red and black chalk over
stylus, gone over with pen and brown ink (the head);
black chalk (the hand), 33.1 × 21.5 cm. The British
Museum, London (1895-9-15-498)
Exhibited double-sided
Prov.: J. D. Lempereur; B. Constantine; T. Dimsdale;
T. Lawrence; S. Woodburn; J. C. Robinson; J. Malcolm
Lit.: Wilde 1953a, no. 1; Dussler 1959, no. 171; Hartt
1971, nos 21 and 245; Tolnay 1975–80, I, no. 6; Perrig
1991, pp. 21, 24–5, 67
Exh. Hist.: London 1836, no. 3; London 1953a, no. 1;
London 1964, no. 1; London 1975a, no. 1; Leningrad
and Moscow 1977, no. 28; New York 1979, no. 1;
Adelaide and Melbourne 1980, no. 28; London 1984,
no. 15; London 1986, no. 8; London 1994–5, no. 18;
London 1996, no. 21
**pp. 56, 58 (recto) and p. 117 (verso); recto
illustrated p. 59 and verso p. 117**

6
Three figures in adoration, *c.* 1495–1500
Verso: **Two figures leaning forward**, *c.* 1495–1500
Pen and brown ink, over black chalk, 26.9 × 19.4 cm.
The Teyler Museum, Haarlem (A 22)
Exhibited double-sided
Prov.: D. da Volterra; J. Sandrart; P. Spiering van
Silfvercroon; Christina of Sweden; Azzolini; Odescalchi
Lit.: Dussler 1959, no. 527 (rejected); Hartt 1971,
nos 163–4; Tolnay 1975–80, I, no. 10; Hirst 1988a,
p. 8; van Tuyll van Serooskerken 2000, no. 45
Exh. Hist.: Haarlem 1964, no. 1; Paris, Rotterdam and

Haarlem 1962, no. 84; Haarlem 1964, no. 1; Paris
1972, no. 7; Haarlem 1978, no. 4; Florence and Rome
1983–4, no. 5; Haarlem 2000 (unnumbered)
**p. 56 (recto and verso); recto and verso
illustrated p. 58**

7
Head of a man in profile, *c.* 1500–5
Pen and brown ink, cut at the top to a half-oval and
later made up to a square, 13 × 13 cm. The British
Museum, London (1895-9-15-495)
Prov.: J. Richardson (?); B. West; T. Lawrence;
S. Woodburn; J. C. Robinson; J. Malcolm
Lit.: Wilde 1953a, no. 2; Dussler 1959, no. 327
(ascribed); Hartt 1971, no. 157; Tolnay 1975–80, I,
no. 16
Exh. Hist.: London 1836, no. 36; London 1953a, no. 2;
London 1964, no. 2; London 1975a, no. 2; Florence
1980a, no. 7; London 1986, no. 9; Florence
1999–2000, no. 13
p. 67; illustrated p. 68

8
**Portrait bust of a bearded man dressed in
classical Greek attire**, Antonine, *c.* AD 130–150
Marble, h. 66 cm. The British Museum, London
(BM Cat. Sculpture 1949)
London only
p. 67; illustrated p. 69

9
A male nude, *c.* 1504–5
Verso: ***Judith and Holofernes***, *c.* 1508
Black chalk, heightened with lead white, the right
corners made up. Verso: Black chalk, 40.4 × 22.5 cm.
The Teyler Museum, Haarlem (A 18)
Exhibited double-sided
Prov.: D. da Volterra; J. Sandrart; P. Spiering van
Silfvercroon; Christina of Sweden; Azzolini; Odescalchi
Lit.: Dussler 1959, no. 524 (rejected); Hartt 1971,
nos 42 and 66; Tolnay 1975–80, I, no. 51; Hirst 1988a,
pp. 21, 25, 42, 45–6, 49, 66; van Tuyll van
Serooskerken 2000, no. 46
Exh. Hist.: London 1930, no. 524; Paris, Rotterdam and
Haarlem 1962, no. 77; Haarlem 1964, no. 4; London
1970, no. 70; Haarlem 1978, no. 5; Florence and Rome
1983–4, no. 6; Washington and Paris 1988–9, no. 7;
Washington 1992, no. 166
**pp. 81, 84, 86 (recto) and pp. 111, 112 (verso);
recto illustrated p. 82 and verso p. 110**

10
A male nude, *c.* 1504–5
Verso: **A male nude (Victory)**, *c.* 1527–30

284

Black chalk, heightened with lead white, the upper corners made up. Verso: Black chalk, the contours traced with a stylus, 40.4 × 25.8 cm. The Teyler Museum, Haarlem (A 19)

Prov.: J. Sandrart; P. Spiering van Silfvercroon; Christina of Sweden; Azzolini; Odescalchi

Lit.: Dussler 1959, no. 525 (rejected); Hartt 1971, nos 43 and 384; Tolnay 1975–80, I, no. 50; Hirst 1988a, pp. 21, 66; van Tuyll van Serooskerken 2000, no. 47

Exh. Hist.: Amsterdam 1934, no. 588; Paris, Rotterdam and Haarlem 1962, no. 78; Haarlem 1964, no. 5; Paris 1972, no. 8; Haarlem 1978, no. 6; Haarlem 1985, no. 3; New York and Chicago 1989, no. 1; Haarlem 2000 (unnumbered)

pp. 81, 84 (recto) and pp. 165–6 (verso); recto illustrated p. 83 and verso p. 165

11

A seated male nude twisting around, c. 1504–5
Verso: **Nude studies** (not by Michelangelo)
Pen and brown ink, brown and grey wash, heightened with lead white (partly discoloured) over leadpoint and stylus. Verso: Red chalk, 42.1 × 28.7 cm. The British Museum, London (1887-5-2-116)

Prov.: Casa Buonarroti; J. B. J. Wicar; T. Lawrence; S. Woodburn; H. Vaughan

Lit.: Wilde 1953a, no. 6; Dussler 1959, nos 324 (recto: ascribed) and 565 (verso: rejected); Hartt 1971, no. 41; Tolnay 1975–80, I, no. 52; Hirst 1988a, pp. 25–6, 67

Exh. Hist.: London 1836, no. 42; London 1953a, no. 4; London 1960, no. 535; London 1975a, no. 4; New York 1979, no. 3; London 1986, no. 13; Cambridge 1988, no. 2; London 2004–5, no. 56

pp. 86–8; illustrated p. 85

12

Maiolica plate with figures after the *Bathers* and the arms of Cardinal Bembo, Urbino, c. 1539–47, diam. 27.2 cm. The British Museum, London (MLA 1888-02-15-1)

London only

Prov.: H. Wallis; A. Fountaine

Lit.: Wilson 1987, no. 203; Syson and Thornton 2001, pp. 246–7

p. 88; illustrated p. 87

13

A youth beckoning; a right leg, c. 1504–5
Verso: **Studies of infants**, c. 1504–5
Pen and brown ink; black chalk. Verso: Pen and brown ink over black chalk, four infants not finished in pen and ink, 37.5 × 23 cm. The British Museum, London (1887-5-2-117)

Exhibited double-sided

Inscribed Recto: 'Ero ig[n]udo or son vestito ogni mal me...' ('I was nude and now I am clothed every ill me ...'); 'barba' ('beard'); in unknown hand: 'Charissimo sa ... chome abiano visto meno' ('Dearest sa ... as they have seen less ...'). Verso: '[a]lessandro manecti'; in unknown hand: 'chosse de bruges...' ('thing of Bruges')

Prov.: P. Crozat; P. J. Mariette; T. Dimsdale; T. Lawrence; S. Woodburn; H. Vaughan

Lit.: Wilde 1953a, no. 4; Dussler 1959, no. 169; Hartt 1971, nos 4 and 11; Tolnay 1975–80, I, no. 48; Perrig 1991, p. 26 (Cellini)

Exh. Hist.: London 1836, no. 13; London 1953a, no. 9; London 1964, no. 4; London 1975a, no. 8; London 1986, no. 11; Florence 1999–2000, no. 72

pp. 88, 90 (recto and verso); recto illustrated p. 89 and verso p. 90

14

A group of three nude men; the Virgin and Child, c. 1504–5
Verso: **Two putti; a nude; a left leg**, c. 1504–5
Black chalk (the nudes); pen and brown ink over leadpoint (the Virgin and Child), made up section of paper at centre of upper edge. Verso: Pen and brown ink; black chalk (the nude), 31.5 × 27.8 cm. The British Museum, London (1859-6-25-564)

Exhibited double-sided

Inscribed Verso: 'Amicho' ('friend'); a sonnet: 'sol io arde[n]do all ombra mi rima[n]go ...' (Girardi 1960, no. 2). Six lines of a sonnet in leadpoint, almost obliterated. See Appendix II for translations of poems

Prov.: B. Buontalenti; Casa Buonarroti

Lit.: Wilde 1953a, no. 5; Dussler 1959, no. 162; Hartt 1971, nos 27–8; Tolnay 1975–80, I, no. 46; Hirst 1988a, pp. 8, 27, 33–4, 43; Perrig 1991, p. 26 (Cellini)

Exh. Hist.: London 1953a, no. 6; London 1964, no. 6; London 1975a, no. 6; New York 1979, no. 2; London 1986, no. 12; London 1994–5, no. 20

pp. 75, 90–1 (recto) and pp. 90–1 (verso); recto illustrated p. 76 and verso p. 91

15

A battle-scene; two figures, c. 1503–4
Verso: **Capitals, smaller studies and lines from a sonnet**, c. 1503–4
Pen and brown ink, 18.6 × 18.3 cm. The British Museum, London (1895-9-15-496)

Exhibited double-sided

Inscribed Recto: '[d]olore sta[n]za nell inferno' ('pain resides in hell'; mistranscribed in Girardi 1960, Appendix of poetic fragments no. 7); 'dol'; 'dio devotame[n]te' ('God devotedly'); Deus in[n]omine / tuo salvu[m] me fac ...' ('God in your name save me ...'). Verso: six lines of a sonnet: 'Molti anni fassi qual felice in una ...' See Appendix II for translation.

Prov.: J. D. Lempereur; W. Dyce; J. C. Robinson; J. Malcolm

Lit.: Wilde 1953a, no. 3; Dussler 1959, no. 170; Hartt 1971, nos 22–3; Tolnay 1975–80, I, no. 36; Hirst 1988a, p. 3; Perrig 1991, pp. 19, 30 (Cellini); Weil-Garris, Acidini Luchinat, Draper et al. 1999, p. 176; Joannides 2003a, pp. 73–5

Exh. Hist.: London 1953a, no. 3; London 1964, no. 7; London 1975a, no. 3; London 1986, no. 10

pp. 75, 94–5 (recto) and pp. 73, 95 (verso); recto illustrated p. 74 and verso p. 73

16

A battle-scene, c. 1504
Pen and brown ink, made up sections at left and right edges, 17.9 × 25.1 cm. The Ashmolean Museum, Oxford (Parker 294)

Inscribed Recto: 'amis' (compare inscription found on another Ashmolean drawing Tolnay 1975–80, I, no. 39)

Prov.: Casa Buonarroti ?; W. Y. Ottley; T. Lawrence; S. Woodburn

Lit.: Parker 1956, no. 294; Dussler 1959, no. 190; Hartt 1971, no. 31; Tolnay 1975–80, I, no. 103; Hirst 1988a, pp. 45, 48

Exh. Hist.: Oxford 1846 no. 23; London 1953a, no. 10; London 1975a, no. 9; Florence 1980b, no. 305; Washington and Paris 1988–9, no. 8

p. 94; illustrated p. 94

17

Scheme for the Sistine chapel ceiling; studies of arms, c. 1508

Verso: **Drapery and figure studies**, c. 1508
Pen and brown ink over leadpoint and stylus (main study); black chalk (arm studies). Verso: Brush and brown ink; stylus, 27.5 × 38.6 cm. The British Museum, London (1859-6-25-567)

Prov.: Casa Buonarroti

Lit.: Wilde 1953a, no. 7; Dussler 1959, nos 163 and 318 (verso: ascribed); Hartt 1971, nos 62 and 82; Tolnay 1975–80, I, no. 119; Hirst 1988a, pp. 71, 80

Exh. Hist.: London 1953a, no. 16; London 1960, no. 536; London 1964, no. 8; London 1975a, no. 14; New York 1979, no. 4; Vatican 1990, no. 1

pp. 107–8; illustrated p. 106

18

One kneeling and three seated nude men, c. 1508
Verso: **A male torso**, c. 1508
Leadpoint and pen and brown ink. Verso: Black chalk, 18.8 × 24.5 cm. The British Museum, London (1859-6-25-568)

Prov.: Casa Buonarroti

Lit.: Wilde 1953a, no. 8; Dussler 1959, nos 164 and 319 (verso: ascribed); Hartt 1971, nos 96 and 100; Tolnay 1975–80, I, no. 139; Hirst 1988a, pp. 27–8, 67

Exh. Hist.: London 1953a, no. 25; London 1964, no. 9; London 1975a, no. 15; New York 1979, no. 5

p. 116 (recto) and pp. 116–17 (verso); recto and verso illustrated p. 114

19

The Erythraean Sibyl, c. 1508–9
Verso: **Sistine vault scheme; hand study; and Sibyl**, c. 1508–9
Black chalk, pen and brown ink, brown wash, made up section of the paper at the lower right corner. Verso: Black chalk, 38.7 × 26 cm. The British Museum, London (1887-5-2-118)

Exhibited double-sided

Prov.: Casa Buonarroti; J. B. J. Wicar; T. Lawrence; S. Woodburn; H. Vaughan

Lit.: Wilde 1953a, no. 10; Dussler 1959, nos 325 (verso: ascribed) and 566 (recto: rejected); Hartt 1971, nos 83–4; Tolnay 1975–80, I, no. 154; Hirst 1988a, p. 71

Exh. Hist.: London 1836, no. 12; London 1953a, no. 23; London 1964, no. 10; London 1975a, no. 17; New York 1979, no. 6

pp. 117, 119–20 (recto) and pp. 109–10, 120 (verso); recto illustrated p. 118 and verso p. 119

20

Sistine sketchbook, c. 1511
Verso: **Sistine sketchbook**, c. 1511
Pen and brown ink, 14 × 14.2 cm. The Ashmolean Museum, Oxford (Parker 302)

Exhibited double-sided

Prov.: W. Y. Ottley; T. Lawrence; S. Woodburn

Lit.: Parker 1956, no. 302; Dussler 1959, no. 607 (rejected); Hartt 1971, nos 110 and 123; Tolnay 1975–80, I, no. 169; Hirst 1988a, p. 36

Exh. Hist.: London 1953a, no. 19; London 1975a, no. 27

pp. 124, 126 (recto); recto and verso illustrated p. 124

21

Sistine sketchbook, c. 1511
Verso: **Sistine sketchbook**, c. 1511
Pen and brown ink, 13.8 × 14.3 cm. The Ashmolean Museum, Oxford (Parker 303)

Exhibited double-sided

Inscribed Recto: 'dagli bere' ('give him to drink')
Prov.: W. Y. Ottley; T. Lawrence; S. Woodburn

Lit.: Parker 1956, no. 303; Dussler 1959, no. 608 (rejected); Hartt 1971, nos 113, 120; Tolnay 1975–80, I, no. 170; Hirst 1988a, p. 36; Hirst 1986b, pp. 208–17
Exh. Hist.: London 1953a, no. 22; London 1975a, no. 28; Washington and Paris 1988–9, no. 12
pp. 124–5 (recto) and p. 125 (verso); recto and verso illustrated p. 126

22
Sistine sketchbook, *c.* 1511
Verso: **Sistine sketchbook**, *c.* 1511
Black chalk; pen and brown ink. Verso: Black chalk, 14 × 14.5 cm. The Ashmolean Museum, Oxford (Parker 305)
Exhibited double-sided
Prov.: W. Y. Ottley; T. Lawrence; S. Woodburn
Lit.: Parker 1956, no. 305; Dussler 1959, no. 610 (rejected); Hartt 1971, nos 115–16; Tolnay 1975–80, I, no. 172; Hirst 1988a, p. 36
Exh. Hist.: London 1953a, no. 22; London 1975a, no. 30
p. 125 (recto) and pp. 125–6 (verso); recto and verso illustrated p. 127

23
Sistine sketchbook, *c.* 1511
Verso: **Sistine sketchbook**, *c.* 1511
Black chalk, 14 × 14.5 cm. The Ashmolean Museum, Oxford (Parker 306)
Exhibited double-sided
Prov.: W. Y. Ottley; T. Lawrence; S. Woodburn
Lit.: Parker 1956, no. 306; Dussler 1959, no. 611 (rejected); Hartt 1971, nos 111–12; Tolnay 1975–80, I, no. 173
Exh. Hist.: London 1953a, no. 22; London 1975a, no. 31
p. 125 (recto); recto and verso illustrated p. 123

24
Josaphat (Iosaphat), *c.* 1511–12
Red chalk, 20.5 × 21.2 cm. The Ashmolean Museum, Oxford (Parker 298)
London only
Prov.: Borghese; T. Lawrence; S. Woodburn
Lit.: Wilde 1953a, p. 30; Parker 1956, no. 298 (ascribed); Dussler 1959, no. 612 (rejected); Hartt 1971, p. 390 (rejected); Joannides 1975, pp. 261–2; Tolnay 1975–80, I, no. 161 (copy)
Exh. Hist.: London 1836, no. 4; Oxford 1846 no. 47; London 1953a, no. 26
pp. 126–7; illustrated p. 128

25
Study for Adam, *c.* 1511
Verso: **Youthful head**, *c.* 1511
Red chalk, made up sections at lower edge. Verso: Red chalk, the contours traced with a stylus, 19.3 × 25.9 cm. The British Museum, London (1926-10-9-1)
Prov.: J. Richardson (?); J. Reynolds; W. Y. Ottley; T. Lawrence; S. Woodburn; F. Locker
Lit.: Wilde 1953a, no. 11; Dussler 1959, no. 580 (rejected); Hartt 1971, nos 77 and 107; Tolnay 1975–80, I, no. 134; Hirst 1988a, p. 2; Turner 1999, pp. 40–3
Exh. Hist.: London 1836, no. 79; London 1953a, no. 20; London 1964, no. 14; London 1975a, no. 18; Leningrad and Moscow 1977, no. 29; London 1978, no. 217; New York 1979, no. 7; Adelaide and Melbourne 1980, no. 29; Vatican 1990, no. 5; Tokyo and Nagoya 1996, no. 2; London 2000–1 (unnumbered); London 2003–4 (unnumbered)
p. 129 (recto) and p. 130 (verso); recto illustrated p. 129 and verso p. 130

26
A seated male nude, *c.* 1511
Verso: **Studies for God the Father and attendant angels**, *c.* 1511
Red chalk, heightened with lead white, the corners made up. Verso: Red chalk; leadpoint, 27.9 × 21.4 cm. The Teyler Museum, Haarlem (A 27)
Exhibited double-sided
Prov.: J. Sandrart; P. Spiering van Silfvercroon; Christina of Sweden; Azzolini; Odescalchi
Lit.: Dussler 1959, no. 530 (rejected); Hartt 1971, nos 74 and 103; Tolnay 1975–80, I, no. 136; Hirst 1988a, pp. 35, 72; van Tuyll van Serooskerken 2000, no. 48
Exh. Hist.: Amsterdam 1934, no. 589; Paris, Rotterdam and Haarlem, 1962, no. 80; Haarlem 1964, no. 14; Haarlem 1978, no. 5; Florence and Rome 1983–4, no. 7; Haarlem 2000 (unnumbered)
pp. 130–1 (recto) and pp. 133–4 (verso); recto illustrated p. 131 and verso p. 134

27
A male head in profile; studies of limbs, *c.* 1511
Verso: **Figure studies, including the hand of God**, *c.* 1511
Red chalk, the corners made up. Verso: Red chalk over stylus; leadpoint; black chalk, 29.6 × 19.5 cm. The Teyler Museum, Haarlem (A 20)
Exhibited double-sided
Prov.: J. Sandrart; P. Spiering van Silfvercroon; Christina of Sweden; Azzolini; Odescalchi
Lit.: Dussler 1959, no. 526 (rejected); Hartt 1971, nos 75–6; Tolnay 1975–80, I, no. 135; Hirst 1988a, p. 72; Joannides 1996a, p. 148; van Tuyll van Serooskerken 2000, no. 49
Exh. Hist.: Amsterdam 1934, no. 590; Paris, Rotterdam and Haarlem 1962, no. 81; Haarlem, 1964, no. 13; Paris 1972, no. 9; New York and Chicago 1989, no. 2; Haarlem 2000 (unnumbered)
pp. 132–3 (recto) and pp. 133–4 (verso); recto illustrated p. 133 and verso p. 135

28
Studies for the Libyan spandrel and the *Slaves* for the Julius tomb, *c.* 1511–12, red chalk (Libyan spandrel studies); *c.* 1512–13, pen and ink (Slaves)
Two studies of a left leg, *c.* 1512–13
Red chalk; pen and brown ink. Verso: Pen and brown ink, 28.5 × 19.4 cm. The Ashmolean Museum, Oxford (Parker 297)
Prov.: P. J. Mariette; marquis de Lagoy; T. Lawrence; S. Woodburn
Lit.: Parker 1956, no. 297; Dussler 1959, no. 194; Hartt 1971, nos 54 and 89; Tolnay 1975–80, I, no. 157; Hirst 1988a, pp. 25, 37–8; Echinger-Maurach 1991, pp. 239–46, 267–70; Perrig 1991, pp. 21–4, 50–1
Exh. Hist.: Oxford 1846, no. 51; London 1930, no. 511; London 1953a, no. 18; London 1975a, no. 19
pp. 134–5, 137; illustrated p. 136

29
Studies for Haman, 1511–12
Verso: **Studies for Haman's torso**, 1511–12
Red chalk, made up section of the paper at upper right corner. Verso: Red and black chalk, 40.6 × 20.7 cm. The British Museum, London (1895-9-15-497)
Prov.: Casa Buonarroti; J. B .J. Wicar; T. Lawrence; S. Woodburn; J. C. Robinson; J. Malcolm
Lit.: Wilde 1953a, no. 13; Dussler 1959, no. 569 (rejected); Hartt 1971, nos 90–1; Tolnay 1975–80, I, no. 163; Perrig 1991, pp. 21, 30, 51–2, 58 (copy)
Exh. Hist.: London 1836, no. 37; London 1953a, no. 2;

London 1960, no. 532; London 1964, no. 13; London 1975a, no. 23; Washington and Paris 1988–9, no. 17; London 1996, no. 22
pp. 137–8; illustrated p. 139

30
Studies for Haman, *c.* 1511–12
Verso: **Fragmentary study for the head of Haman and other figures**, *c.* 1511–12
Red chalk; black chalk (outline of a tree), made up sections of paper at the corners. Verso: Black chalk; red chalk (crouching figure), 25.2 × 20.5 cm. The Teyler Museum, Haarlem (A 16)
Prov.: J. Sandrart; P. Spiering van Silfvercroon; Christina of Sweden; Azzolini; Odescalchi
Lit.: Wilde 1953a, pp. 23, 26; Dussler 1959, no. 522 (rejected); Hartt 1971, nos 80 and 92; Tolnay 1975–80, I, no. 164; Bambach 1983, pp. 661–5; Hirst 1988a, pp. 2, 25, 70–1, 102; Bambach Cappel 1990, p. 494; Bambach 1994, pp. 85, 96–8; van Tuyll van Serooskerken 2000, no. 50
Exh. Hist.: Amsterdam 1934, no. 591; Paris, Rotterdam and Haarlem 1962, no. 79; Haarlem 1964, no. 10; Haarlem 1985, no. 4; Washington and Paris 1988–9, no. 18; Haarlem 2000 (unnumbered)
pp. 138, 141 (recto) and pp. 120, 141 (verso); recto illustrated p. 140 and verso p. 121

31
Studies for the *Dying Slave* and of flayed arms, *c.* 1514
Verso: Michelangelo and pupils (?), **Study of a male torso; various figure studies**, *c.* 1514
Pen and brown ink; red chalk over stylus, right corners made up. Verso: Red chalk; pen and brown ink, 28.5 × 20.7 cm. The Teyler Museum, Haarlem (A 28)
Exhibited double-sided
Prov.: J. Sandrart; P. Spiering van Silfvercroon; Christina of Sweden; Azzolini; Odescalchi
Lit.: Wilde 1953a, p. 3; Dussler 1959, no. 531 (rejected); Hartt 1971, nos 51 and 413; Tolnay 1975–80, I, no. 108; Joannides 1996a, p. 100; van Tuyll van Serooskerken 2000, no. 51
Exh. Hist.: Haarlem 1964, no. 15; Haarlem 2000 (unnumbered)
pp. 143–4 (recto) and p. 144 (verso); recto and verso illustrated p. 143

32
The Flagellation of Christ, 1516
Red chalk over stylus, 23.5 × 23.6 cm. The British Museum, London (1895-9-15-500)
Prov.: Casa Buonarroti; J. B. J. Wicar; T. Lawrence; William II of Holland; G. Leembruggen; J. Malcolm
Lit.: Wilde 1953a, no. 15; Dussler 1959, no. 570 (rejected); Freedberg 1963, pp. 253–8 (Sebastiano del Piombo); Tolnay 1975–80, I, no. 73; Hirst 1981, pp. 59–60; Hirst 1988a, pp. 6, 24, 47
Exh. Hist.: London 1836, no. 57; London 1953a, no. 32; London 1964, no. 15; London 1975a, no. 37; London 1996 (unnumbered); Mantua and Vienna 1999, no. 129
pp. 146–7; illustrated p. 147

33
Christ at the Column, 1516
Black chalk, heightened with lead white (discoloured) over stylus, 27.5 × 14.3 cm. The British Museum, London (1895-9-15-813)
Prov.: F. Cicciaporci ?; W. Y. Ottley; T. Lawrence; William II of Holland; G. Leembruggen; J. Malcolm
Lit.: Wilde 1953a, p. 28 (Sebastiano del Piombo);

Pouncey and Gere 1962, no. 276; Freedberg 1963,
pp. 253–8 (Sebastiano del Piombo); Hartt 1971,
no. 129; Tolnay 1975–80, I, no. 74; Hirst 1981, p. 61
Exh. Hist.: London 1964, no. 16; London 1975a, no. 38;
New York 1979, no. 8; London 1994, no. 26
pp. 147–8; illustrated p. 149

34
Lazarus, 1516
Red and some black chalk, 25.2 × 11.9 cm. The British
Museum, London (1860-7-14-2)
Prov.: Casa Buonarroti; J. B. J. Wicar; T. Lawrence;
William II of Holland; S. Woodburn
Lit.: Wilde 1953a, no. 16; Dussler 1959, no. 562
(rejected); Freedberg 1963, pp. 253–8 (Sebastiano del
Piombo); Tolnay 1975–80, I, no. 76; Hirst 1981, pp. 67,
69–70
Exh. Hist.: London 1836, no. 83; London 1953a, no. 36;
London 1964, no. 17; London 1975a, no. 40; London
1975b, no. 226; London 1979, no. 9
p. 148; illustrated p. 150

35
Lazarus, 1516
Red chalk, the left side cut and made up, 25.1 × 14.5 cm.
The British Museum, London (1860-7-14-1)
Prov.: Casa Buonarroti; J. B. J. Wicar; T. Lawrence;
William II of Holland; S. Woodburn
Lit.: Wilde 1953a, no. 17; Dussler 1959, no. 561
(rejected); Freedberg 1963, pp. 253–8 (Sebastiano del
Piombo); Tolnay 1975–80, I, no. 77; Hirst 1981, pp. 67,
69–70; Perrig 1991, pp. 10–11, 24, 27 (Sebastiano del
Piombo)
Exh. Hist.: London 1836, no. 87; London 1953a, no. 37;
London 1964, no. 18; London 1975a, no. 41; London
1975b, no. 225; Washington and Paris 1988–9, no. 21
pp. 148, 150; illustrated p. 151

36
Studies after the Codex Coner, c. 1516
Verso: **Studies after the Codex Coner and for the
façade of S. Lorenzo**, c. 1516
Red chalk, 28.8 × 21.7 cm. The British Museum,
London (1859-6-25-560/2)
Exhibited double-sided
Inscribed Verso: 'porta' ('door'); 'pilastri' ('pilasters');
'b[raccia] dieci' ('ten braccia'); 'b[raccio] uno e quarto
('one braccio and a quarter')
Prov.: Casa Buonarroti
Lit.: Wilde 1953a, no. 19; Dussler 1959, no. 316
(ascribed); Portoghesi and Zevi 1964, p. 50; Hartt
1971, nos 144–5; Tolnay 1975–80, IV, no. 511; Agosti
and Farinella 1987, nos 7–8; Argan and Contardi 1990,
pp. 154–60, 169
Exh. Hist.: London 1953a, no. 134; London 1964,
no. 57; London 1975a, no. 69
**p. 156 (recto and verso); recto and verso
illustrated p. 155**

37
Bernardo della Volpaia (c. 1475–1521/2), **The Codex
Coner: details from the Arch of Constantine, and
the Forum of Nerva, Rome**, finished c. 1515
Pen and brown ink, brown wash, 23.5 × 16.8 cm and
23.2 × 16.8 cm. Sir John Soane's Museum, London
(Soane Vol. 115, opening fols 88–89)
London only
Prov.: C. dal Pozzo; Albani; R. Adam; J. Soane
Lit.: Ashby 1904, p. 46; Buddensieg 1975, pp. 89–108;
Campbell 2004, I, pp. 39–40
pp. 65, 67, 156; illustrated p. 154

38
Elevation of the lower storey of the Julius tomb,
1518
Verso: **Pieces of the lower storey of the Julius
tomb**, 1518
Pen and brown ink, the lower left quarter of the sheet
made up, 26 × 23.8 cm. The British Museum, London
(1859-5-14-824; 1947-1-17-1)
Exhibited double-sided
Inscribed Recto: seven lines explaining the drawing
above, the measurements of an uncut block, and a cut
line of description below: 'Questo schizo e una parte
della faccia dinanzi della sepultura, el quale e tucto ...'
(Bardeschi Ciulich and Barocchi 1970, no. lii; see
Appendix II for translation). Verso: measurements and
descriptions of various marble blocks relating to the
Julius tomb in Michelangelo's Roman studio
Prov.: Casa Buonarroti (the fragment transferred from
the Dept of Manuscripts in 1947)
Lit.: Wilde 1928, p. 214; Wilde 1953a, no. 23; Dussler
1959, no. 152; Portoghesi and Zevi 1964, p. 78;
Hartt 1971, nos 126–7; Tolnay 1975–80, I, no. 57
Exh. Hist.: London 1953a, no. 138; London 1964,
no. 20; London 1975a, no. 36
**p. 159 (recto and verso); recto and verso
illustrated p. 159**

39
Studies for a free-standing tomb, c. 1520–1
Verso: **Youthful head**, c. 1520–1
Black chalk, the upper right corner made up, 22 × 20.9
cm. The British Museum, London (1859-6-25-545)
Prov.: Casa Buonarroti
Lit.: Wilde 1953a, no. 25; Dussler 1959, nos 155 and
306 (verso: ascribed); Hartt 1971, nos 78 and 212;
Tolnay 1975–80, II, no. 184; Ettlinger 1978b, pp.
287–304; Elam 1979, pp. 155–86; Hirst 1988a, pp. 97,
99, 103; Argan and Contardi 2004, pp. 175–81
Exh. Hist.: London 1953a, no. 141; London 1964, no. 21;
London 1975a, no. 48; London 1986, no. 71
**pp. 168, 170 (recto) and p. 168 (verso); illustrated
p. 169**

40
Studies for a double wall tomb, c. 1520–1
Verso: **Studies for a double tomb**, c. 1520–1
Black chalk, 26.4 × 18.8 cm. The British Museum,
London (1859-5-14-822)
Exhibited double-sided
Prov.: Casa Buonarroti
Lit.: Wilde 1953a, no. 26; Wilde 1955, pp. 54–66;
Dussler 1959, no. 150; Hartt 1971, nos 217–18; Tolnay
1975–80, II, no. 180; Ackerman 1986, pp. 82–94;
Perrig 1991, pp. 38–9; Argan and Contardi 2004,
pp. 175–81
Exh. Hist.: London 1953a, no. 146; London 1964,
no. 22; London 1975a, no. 49; New York 1979, no. 10;
Florence 1980a, no. 24; London 1986, no. 72;
Washington and Paris 1988–9, no. 25; Florence and
St Petersburg 2000, no. 17
**pp. 170–2 (recto) and p. 172 (verso); recto and
verso illustrated p. 171**

41
Study for a single wall tomb, c. 1520–1
Verso: **Vases**; **a male nude (Victory)**; **portions of
a sonnet**, c. 1520–1
Black chalk, 29.7 × 21 cm. The British Museum,
London (1859-5-14-823)
Inscribed Verso: 'de[n]tr a me gugnie al chor gia facto
tale' ('It reaches right inside me to my heart, already

made such'; Girardi 1960, Appendix of poetic
fragments, no. 21); 'd un ig[n]iecto leggiadro e
pellegrino/ d u[n] fo[n]te di pieta nasc[e] el mie male'
('From something lovely yet fleeting, from a fountain
of mercy my trouble is born'; Girardi 1960, no. 16).
Ten verses of a sonnet: 'Di te me veggo di lo[n]tan mi
chiamo ...' (Girardi 1960, no. 15; see Appendix II for
translation)
Prov.: B. Buontalenti; Casa Buonarroti
Lit.: Wilde 1953a, no. 27; Dussler 1959, no. 151; Hartt
1971, nos 220 and 291; Tolnay 1975–80, II, no. 185;
Hirst 1988a, p. 99; Argan and Contardi 2004,
pp. 175–81
Exh. Hist.: London 1953a, no. 143; London 1964,
no. 24; London 1975a, no. 50; Florence 1980a, no. 32;
London 1986, no. 73; Florence and St Petersburg
2000, no. 18
**pp. 172–3 (recto) and pp. 165–6 (verso); recto
illustrated p. 172 and verso p. 164**

42
Study for a double tomb, c. 1520–1
Verso: **Study for a double tomb**, c. 1520–1
Pen and brown ink, 21 × 16.2 cm. The British Museum,
London (1859-6-25-543)
Exhibited double-sided
Inscribed Recto: 'la fama tiene gli epitafi a giacere
no[n] va ne ina[n]zi ne indietro/ p[er]ch[e] so[n] morti
e el loro op[er]are e fermo' ('Fame holds the epitaphs
in position: she goes neither forward nor backward for
they are dead and their work is done'; Girardi 1960,
no. 13)
Prov.: B. Buontalenti; Casa Buonarroti
Lit.: Wilde 1953a, no. 28; Dussler 1959, no. 153;
Gilbert 1971, pp. 393–5; Hartt 1971, no. 224; Tolnay
1975–80, II, no. 189; Ackerman 1986, pp. 82–94;
Argan and Contardi 2004, pp. 175–85
Exh. Hist.: London 1953a, no. 144; London 1964,
no. 23; London 1975a, no. 51; New York 1979, no. 11;
Florence 1980a, no. 25; London 1986, no. 74
**pp. 173–4 (recto and verso); recto and verso
illustrated p. 174**

43
Marble block diagram for a River God, c. 1525
Pen and brown ink, 13.7 × 20.9 cm. The British
Museum, London (1859-6-25-544)
Inscribed Recto: Measurements in braccia . Verso: Last
line of the draft of a letter: 'Ver[o] se [i]l re di francia
mor[ir]a prigioniero ...' ('It is true, if the King of France
will die a prisoner ...')
Prov.: Casa Buonarroti
Lit.: Wilde 1953a, no. 35; Dussler 1959, no. 154;
Weinberger 1967, pp. 356–7; Hartt 1971, no. 252;
Tolnay 1975–80, II, no. 227; Hirst 1988a, p. 74; Perrig
1991, pp. 18–19, 40, 64
Exh. Hist.: London 1953a, no. 151; London 1964, no. 63;
London 1975a, no. 62; Florence 1980b, no. 307;
London 1986, no. 76; Saarbrücken 1997, no. 32;
Florence and St Petersburg 2000, no. 2
pp. 175–6; illustrated p. 176

44
Model of a nude torso, 1520s
Terracotta, later painted green, l. 28.5 cm. The British
Museum, London (1859-07-19-1)
London only
Prov.: Casa Buonarroti
Lit.: Popp 1936, pp. 202–13; Tolnay 1954, p. 157;
Weinberger 1967, p. 212, n. 48 (rejected); Hartt 1969,
p. 16; Baldini 1982, no. 68; Poeschke 1996, pp. 104–5;

Myssok 1999, no. 18
Exh. Hist.: London 1953a, no. 173; London 1964,
no. 107; London 1975a (ex cat.)
pp. 177–8; illustrated p. 177

45
Model of a reclining male nude, 1520s
Brown wax, l. 12.2 cm. The British Museum, London
(1859-07-19-2)
London only
Prov.: Casa Buonarroti
Lit.: Tolnay 1954, p. 158 (rejected); Goldscheider 1957,
pp. 9, 12, n. 11; Weinberger 1967, p. 354, n. 6
(rejected); Hartt 1969, p. 17; Baldini 1982, no. 70;
Myssok 1999, no. 14
Exh. Hist.: London 1953a, no. 174; London 1964,
no. 108; London 1975a (ex cat.)
pp. 178–9; illustrated p. 179

46
Study for Day, c. 1524–5
Verso: **Studies for the right arm of Night**, c. 1524–5
Black chalk. Verso: Red chalk over touches of black,
25.8 × 33.2 cm. The Ashmolean Museum, Oxford
(Parker 309)
Inscribed Recto: 'Cos[c]ia' 'S(?)p[alla]'('Thigh' and ?
'Shoulder')
Prov.: Casa Buonarroti; J. B. J. Wicar; T. Lawrence;
S. Woodburn
Lit.: Parker 1956, no. 309; Dussler 1959, no. 598
(rejected); Hartt 1971, no. 228; Tolnay 1975–80, II, no.
213; Hirst 1988a, pp. 62–3; Perrig 1991, p. 23 (Clovio)
Exh. Hist.: London 1836, no. 14; Oxford 1846, no. 13;
London 1930, no. 502; London 1953a, no. 42; London
1975a, no. 61; Washington and Paris 1988–9, no. 29
**p. 180 (recto and verso); recto illustrated p. 181
and verso p. 182**

47
Study for Day, c. 1524–5
Black chalk, 17.6 × 27 cm. The Ashmolean Museum,
Oxford (Parker 310)
Prov.: J. Reynolds; T. Lawrence; S. Woodburn
Lit.: Parker 1956, no. 310; Dussler 1959, no. 599
(rejected); Hartt 1971, no. 227; Tolnay 1975–80, II,
no. 212
Exh. Hist.: Oxford 1846, no. 28; London 1953a, no. 43;
London 1975a, no. 60
p. 181; illustrated p. 183

48
Study of shoulders, c. 1524–5
Verso: **The Massacre of the Innocents**
(not by Michelangelo)
Black chalk. Verso: Red chalk over stylus, outlined
in pen and brown ink, 27.5 × 35.9 cm. The British
Museum, London (1859-6-25-566)
Prov.: Casa Buonarroti
Lit.: Wilde 1953a, no. 46; Dussler 1959, no. 554
(rejected); Hartt 1971, no. 230; Tolnay 1975–80, II,
no. 214
Exh. Hist.: London 1953a, no. 48; London 1964, no. 71;
London 1975a, no. 100
p. 181; illustrated p. 183

49
Studies for Day, c. 1524–5
Verso: **Studies for Day**, c. 1524–5
Black chalk. Verso: Red chalk, 19.2 × 25.7 cm.
The Teyler Museum, Haarlem (A 30)
Inscribed Recto: 'in qua' ('up to here' or 'in here')

Prov.: J. Sandrart; P. Spiering van Silfvercroon;
Christina of Sweden; Azzolini; Odescalchi
Lit.: Wilde 1954, pp. 15–16; Dussler 1959, no. 532
(rejected); Hartt 1971, nos 229 and 232; Tolnay
1975–80, II, no. 216; Hirst 1988a, pp. 62–3; van Tuyll
van Serooskerken 2000, no. 56
Exh. Hist.: Amsterdam 1934, no. 592; Paris, Rotterdam
and Haarlem 1962, no. 82; Haarlem 1964, no. 20;
Stockholm 1966, no. 1096; Washington and Paris
1988–9, no. 28; Haarlem 2000 (unnumbered)
pp. 182, 185; illustrated p. 184

50
Studies for Day, c. 1524–5
Black chalk, 26.6 × 16.2 cm. The Teyler Museum,
Haarlem (A 36)
Prov.: J. Sandrart; P. Spiering van Silfvercroon;
Christina of Sweden; Azzolini; Odescalchi
Lit.: Dussler 1959, no. 534 (rejected); Hartt 1971,
no. 231; Tolnay 1975–80, II, no. 215; van Tuyll van
Serooskerken 2000, no. 57
Exh. Hist.: Haarlem 1964, no. 22
p. 185; illustrated p. 184

51
The left leg of Day; head of a man, c. 1524–5
Verso: **Draft of a sonnet; a man blowing a horn**,
c. 1524–5
Black chalk. Verso: Pen and brown ink (sonnet); black
chalk (figure), 15 × 18.5 cm. The British Library,
London (Add. MS 21907, fol. 1)
Exhibited double-sided
London only
Inscribed Verso: 'Ogni cosa chi veggio mi co[n]siglia ...'
(Girardi 1960, no. 81, draft III, p. 251; see Appendix II
for translation).
Prov.: W. Y. Ottley; S. Rogers
Lit.: Dussler 1959, no. 302 (ascribed); Hartt 1971,
nos 247 and 233; Tolnay 1975–80, II, no. 217
Exh. Hist.: London 1953a, no. 164; London 1975a,
no. 193
p. 185; illustrated p. 185

52
The left leg of Day, c. 1524–5
Verso: **Studies for the Laurentian library vestibule
(ricetto)**, c. 1524–5
Black chalk over stylus. Verso: Pen and brown ink;
black chalk, 20.7 × 24.7 cm. The Teyler Museum,
Haarlem (A 33)
Prov.: J. Sandrart; P. Spiering van Silfvercroon;
Christina of Sweden; Azzolini; Odescalchi
Lit.: Dussler 1959, no. 298 (ascribed); Hartt 1971, nos
234 and 262; Tolnay 1975–80, II, no. 218; van Tuyll
van Serooskerken 2000, no. 58
Exh. Hist.: Haarlem 2000 (unnumbered)
**p. 185 (recto) and pp. 190–1 (verso); recto
illustrated p. 186 and verso p. 192**

53
A left leg and four studies of a knee (Day),
c. 1524–5
Verso: **Studies for the Laurentian library vestibule
(ricetto)**, c. 1524–5
Black chalk, made up section of the paper at centre of
upper edge. Verso: Pen and brown ink, 20.6 × 24.8 cm.
The Teyler Museum, Haarlem (A 33 bis)
Prov.: J. Sandrart; P. Spiering van Silfvercroon;
Christina of Sweden; Azzolini; Odescalchi
Lit.: Wilde 1953a, pp. 82, 85; Dussler 1959, no. 298
(ascribed); Portoghesi and Zevi 1964, pp. 216–17,

858–9, 1005; Hartt 1971, nos 234 and 262; Tolnay
1975–80, II, no. 219; Ackerman 1986, p. 104; Morrogh
1992a, p. 595; van Tuyll van Serooskerken 2000,
no. 59; Argan and Contardi 2004, p. 187
Exh. Hist.: Paris, Rotterdam and Haarlem 1962, no. 83;
Haarlem 1964, no. 21; Florence 1980a, no. 51
**p. 185 (recto) and pp. 190–1 (verso); recto
illustrated p. 186 and verso p. 192**

54
Reclining male nude, c. 1524–30
Verso: **A naked man seen from behind** (not by
Michelangelo)
Black chalk, the contours partly traced with a stylus,
17.8 × 29.6 cm. The British Museum, London
(1859-6-25-569)
Prov.: Casa Buonarroti
Lit.: Wilde 1953a, no. 48; Dussler 1959, no. 555
(rejected); Hartt 1971, no. 235; Tolnay 1975–80, II,
no. 208
Exh. Hist.: London 1953a, no. 47; London 1964, no. 73;
London 1975a, no. 104
p. 189; illustrated p. 188

55
Cornelis Bos (c. 1510–1566), **Leda and the Swan**,
after Michelangelo, c. 1530–50
Engraving, 30.2 × 40.1 cm. The British Museum,
London (1874-8-8-332/Hollstein 1951, III, no. 54)
London only
Lit.: Schéle 1965, no. 59a; Carroll 1987, no. 102;
Falletti and Katz Nelson 2002, p. 177; Romani 2003,
p. 79
Exh. Hist.: London 1964, no. 92
p. 186; illustrated p. 187

56
Anonymous artist, **Leda and the Swan**, after
Michelangelo, c. 1540–60
Oil on canvas, 105.4 × 135 cm. The National Gallery,
London (1868)
London only
Prov.: J. Reynolds; duke of Northumberland
Lit.: Wilde 1957, pp. 270–80; Gould 1975, pp. 150–2;
Carroll 1987, no. 102; Hirst 1988b, p. 92; Falletti and
Katz Nelson 2002, pp. 174–6
Exh. Hist.: Vinci 2001, no. IV. 5
p. 189; illustrated p. 187

57
**Letter from Duke Alfonso d'Este to Michelangelo
concerning the painting of Leda and the Swan**,
22 October 1530. The British Library, London (Add.
MS 23139, fol. 4)
London only
Lit.: Barocchi and Ristori 1973, III, no. dcccciii
Exh. Hist.: London 1975a, no. 196
p. 187 (Appendix II, no. 6)

58
Designs for the Laurentian library door, c. 1526
Verso: **Designs for the Laurentian library door
from the vestibule (ricetto) and an external
window**, c. 1526
Pen and brown ink over stylus; leadpoint, 28.4 × 20.9 cm.
The British Museum, London (1859-6-25-550)
Exhibited double-sided
Prov.: Casa Buonarroti
Lit.: Wilde 1953a, no. 37; Dussler 1959, no. 157; Hartt
1971, nos 275–6; Tolnay 1975–80, IV, no. 554; Hirst
1988b, p. 78; Argan and Contardi 2004, p. 190

Exh. Hist.: London 1953a, no. 148; London 1964, no. 65; London 1975a, no. 67; London 1986, no. 80
pp. 191–2 (recto and verso); recto and verso illustrated p. 193

59

Michelangelo and Antonio Mini (d. 1533), **Studies for a Virgin and Child**, *c.* 1522–6
Verso: **Record of payments**, 4 October 1524
Pen and brown ink (studies); red chalk (copies); black chalk (squaring and copy), made up section of paper at upper right. Verso: Pen and brown ink, 39.6 × 27 cm. The British Museum, London (1859-5-14-818)
Inscribed Recto: 'Disegnia antonio disegnia antonio disegnia e no[n] p[er]der[e] te[m]po' ('draw Antonio draw Antonio, draw and don't waste time'); by Mini (?): 'grano 10 2/ fave 2½' ('grain 10 2/ beans 2½').
Verso: 'Ogí a di 4 d octobre 1524 o pagato al renaiolo ch[e] porta la rena a sa[n] Lorenzo p[er] segare e marmi ...' ('Today 4 October 1524 I paid the merchant who brings the sand to San Lorenzo to cut the marble ...'; Bardeschi Ciulich and Barocchi 1970, no. cxlix)
Prov.: Casa Buonarroti
Lit.: Wilde 1953a, no. 31; Dussler 1959, no. 149; Hartt 1971, no. 177; Tolnay 1975–80, II, no. 240; Hirst 1988a, p. 8, n. 10; Perrig 1991, pp. 24–7 (Mini); Wallace 1995f, p. 113
Exh. Hist.: London 1953a, no. 51; London 1975a, no. 59; Florence 1980a, no. 42; London 1986, no. 75
pp. 193, 195; illustrated p. 194

60

Michelangelo and pupils, **Studies of profiles, eyes and locks of hair**, *c.* 1525
Verso: **Dragon**, *c.* 1525
Red and black chalk. Verso: Pen and brown ink over black chalk (Michelangelo) over red and black chalk (pupil studies), 25.4 × 33.8 cm. The Ashmolean Museum, Oxford (Parker 323)
Inscribed Recto: 'andrea abbi patientia' ('Andrea be patient'); in another hand: 'ame me [dà ?] co[n]solatione assai' ('it [gives ?] me great consolation'), 'Andrea'; and by Michelangelo and Quaratesi: 'Andra Quar ...', 'Andrea Quar' and 'andrea qu ...'
Prov.: Baron Vivant-Denon; T. Lawrence; S. Woodburn
Lit.: Parker 1956, no. 323; Dussler 1959, no. 343 (ascribed); Hartt 1971, nos 191 and 311; Tolnay 1975–80, I, no. 96; Hirst 1988a, pp. 13–14; Wallace 1995f, pp. 118–20
Exh. Hist.: London 1836, no. 96; London 1930, no. 499; London 1953a, no. 52; Amsterdam 1955, no. 216; London 1975a, no. 106
pp. 195–7 (recto and verso) and p. 197 (verso); recto illustrated p. 194 and verso p. 195

61

Michelangelo and pupil, **Girl with a spindle**, *c.* 1525
Verso: Michelangelo and pupil, **Head of a youth**; **various studies**, *c.* 1525
Black chalk, the lower left corner made up. Verso: Red chalk, 28.8 × 18.2 cm. The British Museum, London (1859-6-25-561)
Prov.: Casa Buonarroti
Lit.: Wilde 1953a, no. 40; Dussler 1959, no. 553 (rejected); Hartt 1971, no. 368; Tolnay 1975–80, II, no. 315; Hirst 1988a, p. 10; Perrig 1991, recto illustrated fig. 51 (Mini)
Exh. Hist.: London 1953a, no. 46; London 1964, no. 31; London 1975a, no. 96; London 1986, no. 81
p. 197; illustrated p. 196

62

Michelangelo and pupils, **Hercules and Antaeus and other studies**, *c.* 1524–5
Verso: **Figure and animal studies**; **a canzone**, *c.* 1524–5
Red chalk, 28.8 × 42.7 cm. The Ashmolean Museum, Oxford (Parker 317)
Exhibited double-sided
Inscribed Verso: a 33-line canzone: 'Oilme oilme chi [che io] s[on] [t]radito ...' (Girardi 1960, no. 51; see Appendix II for translation)
Prov.: Casa Buonarroti; J. B. J. Wicar; T. Lawrence; S. Woodburn
Lit.: Parker 1956, no. 317; Dussler 1959, nos 196 and 622 (verso: by Mini); Hartt 1971, nos 302 and 312; Tolnay 1975–80, II, no. 237; Wallace 1995f, pp. 115–18; Joannides 2003c, p. 108
Exh. Hist.: London 1953a, no. 30; London 1975a, no. 92; Florence 1980a, no. 66
p. 198 (recto) and p. 199 (verso); recto illustrated p. 197 and verso p. 198

63

Grotesque heads; **Hercules and Antaeus**, *c.* 1524–5
Verso: **Two men with spears**, *c.* 1530
Red chalk, the Hercules sketch over black chalk, all contours traced with a stylus. Verso: Red chalk over earlier black chalk studies, 25.5 × 35 cm. The British Museum, London (1859-6-25-557)
Prov.: Casa Buonarroti
Lit.: Wilde 1953a, no. 33; Dussler 1959, no. 159; Hartt 1971, nos 186 and 496; Tolnay 1975–80, II, no. 236; Hirst 1988a, p. 74; Joannides 1996a, p. 50; Joannides 2003c, p. 108
Exh. Hist.: London 1953a, no. 27; London 1964, no. 62; London 1975a, no. 91; New York 1979, no. 12; London 1986, no. 79
p. 200 (recto) and p. 216 (verso); recto illustrated p. 200 and verso p. 216

64

Half-length figure of a woman, *c.* 1525
Verso: **Half-length figure of a woman**, *c.* 1525
Pen and brown ink over red and black chalk, made up strip at upper edge and lower right corner. Verso: Black chalk, 323 × 25.8 cm. The British Museum, London (1859-6-25-547)
Prov.: Casa Buonarroti
Lit.: Wilde 1953a, no. 41; Dussler 1959, no. 307 (ascribed); Hartt 1971, nos 366–7; Tolnay 1975–80, II, no. 320; Wallace 1995f, pp. 120–1
Exh. Hist.: London 1953a, no. 55; London 1964, no. 32; London 1975a, no. 113; Leningrad and Moscow 1977, no. 30; New York 1979, no. 14; Adelaide and Melbourne 1980, no. 30; London 1984, no. 16; London 1986, no. 82
pp. 201–2 (recto) and p. 202 (verso); recto and verso illustrated p. 202

65

Anonymous artist, **Ideal head of a warrior (count of Canossa)**, after Michelangelo, *c.* 1550–80
Black chalk, the upper corners made up, 41 × 26.3 cm. The British Museum, London (1895-9-15-492)
Prov.: J. Reynolds; T. Lawrence; S. Woodburn; J. C. Robinson; J. Malcolm
Lit.: Wilde 1953a, no. 87; Dussler 1959, no. 567; Joannides 1975, p. 258; Joannides 1996a, p. 48; Bonsanti 2001, pp. 513–18 (Michelangelo); Joannides 2003a, p. 219
Exh. Hist.: London 1836, no. 75; London 1975a, no. 115; London 1978, no. 218
pp. 30, 205; illustrated p. 206

66

Ideal head of a woman, *c.* 1525–8
Verso: Michelangelo and pupils, **Heads and figures**, *c.* 1525–8
Black chalk, a section of the paper made up at the lower left corner. Verso: Red chalk, 28.7 × 23.5 cm. The British Museum, London (1895-9-15-493)
Exhibited double-sided
Prov.: Casa Buonarroti; J. B. J. Wicar; W. Y. Ottley. T. Lawrence; H. Wellesley; J. Addington; J. Malcolm
Lit.: Wilde 1953a, no. 42; Dussler 1959, no. 568 (rejected); Hartt 1971, no. 365; Tolnay 1975–80, II, no. 316; Hirst 1988a, p. 117; Perrig 1991, pp. 67, 136–7, n. 6 (copy); Wallace 1995f, pp. 124–5; Joannides 1996a, p. 40; Ferino-Pagden 1997, pp. 116–17
Exh. Hist.: London 1836, no. 15; Manchester 1857, no. 18; London 1953a, no. 45; London 1964, no. 25; London 1975a, no. 114; New York 1979, no. 15; London 1986, no. 83; London 1996, no. 23
pp. 30, 202, 204–5 (recto) and pp. 198, 205 (verso); recto illustrated p. 203 and verso p. 199

67

Head of a young man (?), *c.* 1516
Red chalk, 20.5 × 16.5 cm. The Ashmolean Museum, Oxford (Parker 315)
Prov.: Casa Buonarroti; J. B. J. Wicar; T. Lawrence; S. Woodburn
Lit.: Parker 1956, no. 315; Dussler 1959, no. 342 (ascribed); Hartt 1971, no. 363; Tolnay 1975–80, II, no. 323; Hirst 1988a, p. 108; Perrig 1991, pp. 77–8, 139–40, n. 29 (Cavalieri)
Exh. Hist.: London 1836, no. 21; Oxford 1846, no. 24; London 1930, no. 503; London 1953a, no. 34; London 1953b, no. 46; London 1960, no. 533; London 1975a, no. 112; Washington and Paris 1988–9, no. 23
p. 206; illustrated p. 207

68

Head of a man in profile, *c.* 1520–4
Verso: **Hercules carrying a boar**, *c.* 1520–4
Red chalk, made up areas of the paper at the upper edge, 28.2 × 19.8 cm. The Ashmolean Museum, Oxford (Parker 316)
Prov.: Casa Buonarroti; J. B. J. Wicar; W. Y. Ottley. T. Lawrence; S. Woodburn
Lit.: Parker 1956, no. 316; Dussler 1959, no. 341 (ascribed); Hartt 1971, nos 161 and 303; Tolnay 1975–80, II, no. 328
Exh. Hist.: London 1836, no. 80; London 1930, no. 505; London 1953a, no. 28; London 1975a, no. 85; Florence 1980b, no. 309
pp. 206–7; illustrated p. 208

69

Head of a child, *c.* 1525
Verso: **Legs** (not by Michelangelo)
Black chalk, upper corners made up. Verso: Red chalk, 23.7 × 16 cm. The Teyler Museum, Haarlem (K I 53)
Prov.: Odescalchi
Lit.: Dussler 1959, no. 537 (rejected); Tolnay 1975–80, II, no. 330; Hirst 1988a, p. 11; van Tuyll van Serooskerken 2000, no. 69 (ascribed)
Exh. Hist.: Haarlem 1964, no. 28
p. 209; illustrated p. 209

70

Andrea Quaratesi, *c.* 1528–32
Black chalk, two made up areas at upper edge, 41.1 × 29.2 cm. The British Museum, London (1895-9-15-519)

Prov.: H. Wellesley; J. Malcolm
Lit.: Wilde 1953a, no. 59; Dussler 1959, no. 577
(rejected); Tolnay 1975–80, II, no. 329; Hirst 1988a,
pp. 11, 111; Joannides 2003a, p. 253; Romani 2003, p. 86
Exh. Hist.: London 1953a, no. 72; London 1964, no. 43;
London 1972, no. 152; London 1974, no. 45; London
1975a, no. 119; New York 1979, no. 17; London 1986,
no. 85; London 1996 (unnumbered).
pp. 209, 211; illustrated p. 210

71

The Three Crosses, *c.* 1523
Red chalk, 39.4 × 28.1 cm. The British Museum,
London (1860-6-16-3)
Prov.: Casa Buonarroti; J. B. J. Wicar; T. Lawrence;
William II of Holland; S. Woodburn
Lit.: Wilde 1953a, no. 32; Dussler 1959, no. 559
(rejected); Hartt 1971, no. 298; Tolnay 1975–80, I,
no. 87; Hirst 1988a, pp. 48–50; van Tuyll van
Serooskerken 2000, pp. 124–6
Exh. Hist.: London 1836, no. 29; London 1953a, no. 33;
London 1960, no. 537; London 1964, no. 29; London
1975a, no. 87; London 1986, no. 77
pp. 211–12; illustrated p. 212

72

Studies for a *Deposition*, *c.* 1523
Verso: Michelangelo and pupils, **Stooping woman,
and copies after Giotto**
Red chalk, made up areas on lower edge,
27.2 × 19.1 cm. The Teyler Museum, Haarlem (A 25)
Prov.: J. Sandrart; P. Spiering van Silfvercroon;
Christina of Sweden; Azzolini; Odescalchi
Lit.: Dussler 1959, no. 529 (rejected); Hartt 1971,
no. 452; Tolnay 1975–80, I, no. 89; Hirst 1988a,
pp. 48–50; van Tuyll van Serooskerken 2000, no. 60
Exh. Hist.: Amsterdam 1934, no. 594; Haarlem 1964,
no. 27; Stockholm 1966, no. 1095; London 1970, no. 71;
Florence and Rome 1983–4, no. 8; Washington and
Paris 1988–9, no. 24; Haarlem 2000 (unnumbered)
**pp. 211–15 (recto) and pp. 196–7 (verso); recto
illustrated p. 213 and verso p. 212**

73

Anonymous artist, ***The Deposition***, after
Michelangelo, second half of the sixteenth century
Relief in gilded gesso on a slate ground, 38.1 × 27.9 cm.
The Victoria and Albert Museum, London (A. 1–1941)
London only
Prov.: T. Lawrence; S. Woodburn; J. C. Robinson;
W. L. Hildburgh
Lit.: Pope-Hennessy 1964, no. 463; Ragionieri 2000,
pp. 74–7; Romani 2003, pp. 76–8
pp. 215–16; illustrated p. 214

74

Anonymous artist, ***The Deposition***, after
Michelangelo, seventeenth century
Relief in gilt bronze, 28.6 × 21.3 cm. The Victoria and
Albert Museum, London (A. 2–1941)
London only
Prov.: W. L. Hildburgh
Lit.: Pope-Hennessy 1964, no. 464; Ragionieri 2000,
pp. 74–7; Romani 2003, pp. 76–8
pp. 215–16; illustrated p. 214

75

The Worship of the Brazen Serpent, *c.* 1530
Verso: **A male chest**, *c.* 1530
Red chalk (some black chalk on the verso), made up
areas at left and lower edges, 24.4 × 33.5 cm.

The Ashmolean Museum, Oxford (Parker 318)
Prov.: Casa Buonarroti ?; J. B. J. Wicar; T. Lawrence;
S. Woodburn
Lit.: Parker 1956, no. 318; Dussler 1959, no. 195; Hartt
1971, nos 257 and 412; Tolnay 1975–80, II, no. 266;
Perrig 1991, pp. 31–2, 47 (Clovio studio); Joannides
1996b, pp. 155–62; Zentai 1998, pp. 64–8
Exh. Hist.: London 1836, no. 32; Oxford 1846, no. 37;
London 1953a, no. 318; London 1975a, no. 105
pp. 216–17; illustrated p. 215

76

The Risen Christ, *c.* 1532–3
Verso: **Fabulous monster and a nude man holding
a dish**, *c.* 1532–3
Black chalk, 41.4 × 27.4 cm. The British Museum,
London (1895-9-15-501)
Exhibited double-sided
Prov.: Casa Buonarroti; J. B. J. Wicar; T. Lawrence;
S. Woodburn; J. C. Robinson; J. Malcolm
Lit.: Wilde 1953a, no. 54; Dussler 1959, nos 328 and
571 (verso: rejected); Hirst 1961, pp. 178–83; Hartt
1971, nos 183 and 190; Tolnay 1975–80, II, no. 263;
Hirst 1988b, p. 98; Perrig 1991, pp. 21, 33–4, 42, 45
(copy); Joannides 1996a, p. 130
Exh. Hist.: London 1836, no. 26; London 1953a, no. 89;
London 1964, no. 35; London 1975a, no. 47
**p. 219 (recto and verso); recto illustrated p. 218
and verso p. 219**

77

The Risen Christ, *c.* 1532–3
Black chalk, 40.6 × 27.1 cm. The British Museum,
London (1887-5-2-119)
Prov.: Casa Buonarroti; J. B. J. Wicar; T. Lawrence;
William II of Holland; S. Woodburn; H. Vaughan
Lit.: Wilde 1953a, no. 53; Dussler 1959, no. 326
(ascribed); Hirst 1961, pp. 178–83; Hartt 1971, no. 132;
Tolnay 1975–80, II, no. 264; Joannides 1996a, pp.
64–5
Exh. Hist.: London 1836, no. 24; London 1953a, no. 87;
London 1964, no. 33; London 1975a, no. 45
p. 219; illustrated p. 220

78

The Resurrection of Christ, *c.* 1532–3
Black chalk, 32.6 × 28.6 cm. The British Museum,
London (1860-6-16-133)
Prov.: Casa Buonarroti; J. B. J. Wicar; T. Lawrence;
S. Woodburn
Lit.: Wilde 1953a, no. 52; Dussler 1959, no. 168; Hirst
1961, pp. 178–83; Hartt 1971, no. 350; Tolnay
1975–80, II, no. 258; Hirst 1988a, p. 15; Perrig 1991,
pp. 7, 32, 46–7 (Clovio); Joannides 1996a, pp. 128–9
Exh. Hist.: London 1836, no. 62; London 1953a, no. 77;
London 1960, no. 539; London 1964, no. 34; London
1975a, no. 42
pp. 219–21; illustrated p. 221

79

The Virgin and Child with the Infant Baptist,
c. 1530
Black chalk, 31.4 × 20 cm. The British Museum,
London (1860-6-16-1)
Prov.: Casa Buonarroti; J. B. J. Wicar; T. Lawrence;
William II of Holland; S. Woodburn
Lit.: Wilde 1953a, no. 58; Dussler 1959, no. 558
(rejected); Tolnay 1975–80, II, no. 245; Joannides
1981b, p. 683; Joannides 1996a, pp. 82–3
Exh. Hist.: London 1836, no. 73; London 1953a, no. 78;
London 1960, no. 530; London 1964, no. 44; London

1975a, no. 118; London 1986, no. 84; Tokyo and
Niigata 2003–4, no. 159
p. 223; illustrated p. 222

80

The Holy Family with the Infant Baptist, *c.* 1530–4
Black chalk, the lower edge (except for the Virgin's
right foot) made up, 31.7 × 19.1 cm. The British
Museum, London (Pp 1–58)
Prov.: P. J. Mariette; marquis de Lagoy; R. Payne
Knight Bequest, 1824
Lit.: Wilde 1953a, no. 65; Dussler 1959, no. 583
(rejected); Tolnay 1975–80, II, no. 248; Joannides
1996a, pp. 88–90
Exh. Hist.: London 1953a, no. 64; London 1975a,
no. 140; Florence 1980a, no. 43
pp. 223–4; illustrated p. 223

81

The Fall of Phaeton, 1533
Black chalk over stylus, 31.3 × 21.7 cm. The British
Museum, London (1895-9-15-517)
Inscribed Recto: '[Mess]er toma[s]o se questo scizzo
no[n] vi piace ditelo a urbino [acci]o/ ch[e] io abbi
tempo d averne facto un altro doma[ni]dassera/
[co]me vi promessi e se vi piace e vogliate ch[e] io lo
finisca/ [rim]andate me lo' ('Master Tommaso, if this
sketch does not please you, say so to Urbino in time
for me to do another tomorrow evening, as I promised
you; and if it pleases you and you wish me to finish it,
send it back to me')
Prov.: Moselli; P. Crozat; P. J. Mariette; marquis de
Lagoy; T. Dimsdale; T. Lawrence; S. Woodburn;
É. Galichon; J. Malcolm
Lit.: Wilde 1953a, no. 55; Dussler 1959, no. 177; Hartt
1971, no. 355; Tolnay 1975–80, II, no. 340; Frommel
1979, pp. 61–8; Hirst 1988a, pp. 113–14; Perrig 1991,
pp. 21, 24, 39, 65–6; Joannides 1996a, pp. 56–7;
Joannides 2003a, pp. 259–60
Exh. Hist.: London 1953a, no. 71; London 1964, no. 36;
London 1975a, no. 125; New York 1979, no. 16;
Washington and Paris 1988–9, no. 44
pp. 224, 226–7; illustrated p. 225

82

Studies for *The Last Judgement*, *c.* 1534–6
Verso: **Two heads and other studies**, *c.* 1534–6
Black and red chalk, 38.5 × 25.3 cm. The British
Museum, London (1895-9-15-518)
Exhibited double-sided
Prov.: F. Cicciaporci; B. Cavaceppi; W. Y. Ottley;
T. Lawrence; S. Woodburn; É. Galichon; J. Malcolm
Lit.: Wilde 1953a, no. 60; Dussler 1959, no. 333
(ascribed); Hartt 1971, nos 374–5; Tolnay 1975–80, III,
no. 350; Barnes 1988, pp. 243–5; Perrig 1991,
pp. 53–4, 62, 80–1, 83
Exh. Hist.: London 1836, no. 84; London 1953a, no. 66;
London 1960, no. 534; London 1964, no. 39; London
1975a, no. 131; New York 1979, no. 18; London 1996
(unnumbered)
**pp. 233, 235–6 (recto) and p. 236 (verso); recto
illustrated p. 234 and verso p. 237**

83

A fighting angel, *c.* 1534–6
Verso: **A condemned sinner**, *c.* 1534–6
Black chalk, 26.2 × 18.1 cm. The British Museum,
London (1980-10-11-46)
Exhibited double-sided
Prov.: A. Costoli; J. Sanford; Lord Methuen
Lit.: Hirst 1969, pp. 27–8; Tolnay 1971, p. 18; Dussler

1974, p. 119; Tolnay 1975–80, III, no. 359; Turner and Eitel Porter 1999, no. 355
Exh. Hist.: London 1975a, no. 134
pp. 238, 240 (recto and verso); recto and verso illustrated p. 238

84

Study for St Lawrence, *c.* 1534–6
Verso: **Male nude seen from behind**, *c.* 1534–6
Black chalk, 24.2 × 18.2 cm. The Teyler Museum, Haarlem (A 23)
Exhibited double-sided
Prov.: J. Sandrart; P. Spiering van Silfvercroon; Christina of Sweden; Azzolini; Odescalchi
Lit.: Dussler 1959, no. 295 (ascribed); Hartt 1971, nos 383 and 406; Tolnay 1975–80, III, no. 357; Hirst 1988a, pp. 30, 61, 68–9; van Tuyll van Serooskerken 2000, no. 64
Exh. Hist.: London 1930, no. 518; Paris, Rotterdam and Haarlem 1962, no. 76; Haarlem 1978, no. 7; Vienna 1997, no. IV. 51; Haarlem 2000 (unnumbered)
pp. 240–1 (recto) and p. 241 (verso); recto illustrated p. 239 and verso p. 241

85

A flying angel and other studies, *c.* 1534–6
Verso: **Flying angels**, *c.* 1534–6
Black chalk, 40.7 × 27.2 cm. The British Museum, London (1860-6-16-5)
Prov.: Casa Buonarroti; J. B. J. Wicar; T. Lawrence; S. Woodburn
Lit.: Wilde 1953a, no. 61; Dussler 1959, no. 560 (rejected); Hartt 1971, nos 378–9; Tolnay 1975–80, III, no. 352; Joannides 1981b, p. 685; Perrig 1991, pp. 131–2, n. 161 (rejected)
Exh. Hist.: London 1836, no. 40; London 1953a, no. 69; London 1964, no. 40; London 1975a, no. 132; Sydney 1999–2000, no. 63
pp. 241, 243 (recto and verso); recto illustrated p. 242 and verso p. 243

86

A male nude seen from behind, *c.* 1539–41
Verso: **A male nude in profile**, *c.* 1539–41
Black chalk, the right corners and parts of edge made up, 29.3 × 23.3 cm. The British Museum, London (1886-5-13-5)
Prov.: Casa Buonarroti; J. B. J. Wicar; T. Lawrence; S. Woodburn; J. P. Heseltine
Lit.: Wilde 1953a, no. 63; Dussler 1959, no. 563 (rejected); Hartt 1971, nos 390–1; Tolnay 1975–80, III, no. 360
Exh. Hist.: London 1836, no. 69; London 1964, no. 38; London 1975a, no. 137; Adelaide and Melbourne 1980, no. 31
p. 246 (recto and verso); recto illustrated p. 244 and verso p. 245

87

A male nude, *c.* 1539–41
Verso: **The legs of a recumbent male figure**, *c.* 1539–41
Black chalk, 21.6 × 26.6 cm. The Ashmolean Museum, Oxford (Parker 330)
Prov.: Casa Buonarroti; J. B. J. Wicar; T. Lawrence; S. Woodburn
Lit.: Parker 1956, no. 330; Dussler 1959, no. 625 (rejected); Hartt 1971, nos 380–1; Tolnay 1975–80, III, no. 361
Exh. Hist.: London 1953a, no. 70; London 1975a, no. 135
p. 246; illustrated p. 246

88

Design for a salt-cellar, 1537
Black chalk, 21.7 × 15.5 cm. The British Museum, London (1947-4-12-161)
Prov.: earl of Dalhousie; H. Oppenheimer; N. R. Colville
Lit.: Wilde 1953a, no. 66; Dussler 1959, no. 582 (rejected); Hartt 1971, no. 532; Tolnay 1975–80, III, no. 437; Hayward 1976, p. 343; Ward-Jackson 1979, p. 90; Hirst 1988a, pp. 7, 13, 24, 94; Syson and Thornton 2001, pp. 172–4; Clifford 2002, pp. 30–40
Exh. Hist.: London 1953a, no. 114; London 1964, no. 83; London 1975a, no. 139; New York 1979, no. 20; Florence, Chicago and Detroit 2002–3, no. 191
pp. 247–9; illustrated p. 248

89

Studies for a Crucified Christ, *c.* 1534–6
Verso: **A Crucified Christ**; **architectural profiles**, *c.* 1534–6
Black chalk. Verso: Black chalk; red chalk (profiles), 33.1 × 22.9 cm. The Teyler Museum, Haarlem (A 34)
Exhibited double-sided
Prov.: J. Sandrart; P. Spiering van Silfvercroon; Christina of Sweden; Azzolini; Odescalchi
Lit.: Dussler 1959, no. 299 (ascribed); Hartt 1971, nos 299–300; Tolnay 1975–80, II, no. 250; Coutts 1990, p. 215; Joannides 1996a, p. 96; van Tuyll van Serooskerken 2000, no. 62; Joannides 2003a, pp. 224–5, 236
Exh. Hist.: Haarlem 1964, no. 26; Stockholm 1966, no. 1093; London 1970, no. 73; Haarlem 1978, no. 8; Montreal 1992, no. 64; Vienna 1997, no. IV. 48; Haarlem 2000 (unnumbered)
pp. 253–4 (recto and verso); recto and verso illustrated p. 252

90

The Lamentation, *c.* 1530–5
Verso: **A nude man** (not by Michelangelo)
Black chalk. Verso: Red chalk with some corrections in black chalk, 28.2 × 26.2 cm. The British Museum, London (1896-7-10-1)
Prov.: C. M. Metz; earl of Warwick
Lit.: Wilde 1953a, no. 64; Dussler 1959, no. 578 (rejected); Hartt 1971, p. 388 (rejected); Tolnay 1975–80, II, no. 270
Exh. Hist.: London 1953a, no. 61; London 1975a, no. 141; New York 1979, no. 19
p. 254; illustrated p. 253

91

Crucifixion, *c.* 1538–41
Black chalk, 37 × 27 cm. The British Museum, London (1895-9-15-504)
Prov.: V. Colonna; king of Naples; M. Brunet; W. Y. Ottley ?; T. Lawrence; William II of Holland; Brooks; S. Woodburn; J. Malcolm
Lit.: Wilde 1953a, no. 67; Dussler 1959, no. 329 (ascribed); Hartt 1971, no. 408; Tolnay 1975–80, III, no. 411; Hirst 1988a, pp. 117–18; Perrig 1991, pp. 24, 32, 47–8, 114–15 (copy); Joannides 2003a, p. 263
Exh. Hist.: London 1836, no. 22; London 1953a, no. 57; London 1964, no. 37; London 1975a, no. 129; New York 1979, no. 21; Vienna 1997, no. IV. 27
pp. 254–7; illustrated p. 255

92

Letter from Vittoria Colonna to Michelangelo concerning Exh. No. 91, *c.* 1538–41? The British Library, London (Add. MS 23139, fol. 10)
London only

Lit.: Ramsden 1963, II, p. 238; Barocchi and Ristori 1979, IV, no. cmlxviii
Exh. Hist.: London 1953a, no. 171; London 1964, no. 106; London 1975a, no. 200; Vienna 1997, no. IV. 22
p. 256 (Appendix II, no. 7)

93

The Virgin Annunciate, *c.* 1545–7
Verso: **The Virgin Annunciate**, *c.* 1545–7
Black chalk, 34.8 × 22.4 cm. The British Museum, London (1900-6-11-1)
Prov.: Casa Buonarroti; J. B. J. Wicar; T. Lawrence; S. Woodburn; K. Radford
Lit.: Wilde 1953a, no. 71; Wilde 1959, pp. 374–7; Dussler 1959, nos 179 and 579 (verso: ascribed); Perrig 1962, pp. 279–86 (Venusti).; Hartt 1971, no. 431; Tolnay 1975–80, III, no. 394; Joannides 1981b, p. 684; Hirst 1988a, pp. 2, 54–8; Hirst 1988b, pp. 133–6; Perrig 1991, pp. 145–6, n. 45 (Venusti)
Exh. Hist.: London 1836, no. 60; London 1953a, no. 79; London 1960, no. 256; London 1964, no. 50; London 1975a, no. 145; New York 1979, no. 22
p. 258 (recto) and p. 259 (verso); recto illustrated p. 258 and verso p. 259

94

The Annunciation, *c.* 1545–7
Verso: **Annunciate Angel**, *c.* 1545–7
Black chalk, 28.3 × 19.6 cm. The British Museum, London (1895-9-15-516)
Prov.: Casa Buonarroti; J. B. J. Wicar; T. Lawrence; S. Woodburn; J. Malcolm
Lit.: Wilde 1953a, no. 72; Dussler 1959, no. 176; Wilde 1959, pp. 374–7; Hartt 1971, nos 432 and 436; Tolnay 1975–80, III, no. 395; Hirst 1988a, pp. 2, 54–6, 58; Perrig 1991, pp. 18, 20, 100, 115, 147, n. 29, 151, n. 52 (Venusti)
Exh. Hist.: London 1836, no. 65; London 1953a, no. 80; London 1964, no. 52; London 1975a, no. 144; Leningrad and Moscow 1977, no. 31
pp. 259, 261 (recto) and pp. 258–9 (verso); recto illustrated p. 259 and verso p. 258

95

The Epifania cartoon, 1550s
Black chalk, on 26 sheets, 232.7 × 165.6 cm. The British Museum, London (1895-9-15-518*)
London only
Prov.: F. Orsini; O. Farnese; S. Valenti; L. Buonaparte; prince of Canino; T. Lawrence; S. Woodburn; J. Malcolm
Lit.: Wilde 1953a, no. 75; Dussler 1959, no. 178; Hartt 1971, no. 440; Tolnay 1975–80, III, no. 389; Gombrich 1986, pp. 171–8; Hirst 1988a, pp. 77–8; Perrig 1991, pp. 86–93 (Condivi); Joannides 1992, p. 250; Bambach 1997, pp. 69–70; Bambach 1999b, pp. 268, 280–1, 287–9
Exh. Hist.: London 1836, no. 30; London 1953a, no. 82; London 1964, no. 26; London 1975a, no. 153; London 1996, no. 24
pp. 261–2; illustrated p. 260

96

Studies of two fighting men; **and of *Christ Purifying the Temple***, *c.* 1550–5; *c.* 1555–60
Verso: **Anatomical study of a man's left leg**, *c.* 1550–5
Black chalk, the studies of Christ on an inserted piece of paper, made up strip of paper upper right, 21 × 24.5 cm. The Ashmolean Museum, Oxford (Parker 328)

Prov.: T. Lawrence; S. Woodburn
Lit.: Parker 1956, no. 328 (verso: Montelupo ?);
Dussler 1959, nos 200 and 630 (verso: rejected); Hartt
1971, no. 473; Tolnay 1975–80, III, no. 374; Perrig
1991, pp. 105–7 (Daniele da Volterra); Thomas 2001,
pp. 50–1; Romani 2003, pp. 120–3
Exh. Hist.: London 1836, no. 67; Oxford 1846, no. 22;
London 1953a, no. 102; London 1975a, no. 164
pp. 264–5; illustrated p. 265

97
Christ Purifying the Temple, *c.* 1555–60
Verso: ***Christ Purifying the Temple***, *c.* 1555–60
Black chalk, 14.8 × 27.6 cm. The British Museum,
London (1860-6-16-2/2)
Exhibited double-sided
Prov.: Casa Buonarroti; J. B. J. Wicar; T. Lawrence;
William II of Holland; S. Woodburn
Lit.: Wilde 1953a, no. 76; Dussler 1959, no. 166; Wilde
1959, pp. 378–81; Hartt 1971, nos 442 and 446;
Tolnay 1975–80, III, no. 385; Perrig 1991, pp. 103,
105–8 (Daniele da Volterra)
Exh. Hist.: London 1836, no. 88; London 1953a,
no. 83a; London 1964, no. 47; London 1975a, no. 168
**pp. 266–8 (recto and verso); recto illustrated
p. 267 and verso p. 266**

98
Christ Purifying the Temple, *c.* 1555–60
Verso: **Figure studies for *Christ Purifying the
Temple***, *c.* 1555–60
Black chalk, 13.9 × 16.7 cm. The British Museum,
London (1860-6-16-2/1)
Exhibited double-sided
Prov.: Casa Buonarroti; J. B. J. Wicar; T. Lawrence;
William II of Holland; S. Woodburn
Lit.: Wilde 1953a, no. 77; Dussler 1959, no. 165; Wilde
1959, pp. 378–81; Hartt 1971, nos 444–5; Tolnay
1975–80, III, no. 386; Perrig 1991, pp. 103, 105–8
(Daniele da Volterra)
Exh. Hist.: London 1953a, no. 83b; London 1964,
no. 46; London 1975a, no. 169
p. 266; illustrated p. 268

99
Christ Purifying the Temple, *c.* 1555–60
Verso: **Studies for *Christ Purifying the Temple***,
c. 1555–60
Black chalk, the sheet extended by the artist, 17.8 ×
37.2 cm. The British Museum, London (1860-6-16-2/3)
Exhibited double-sided
Prov.: Casa Buonarroti; J. B. J. Wicar; T. Lawrence;
William II of Holland; S. Woodburn
Lit.: Wilde 1953a, no. 78; Dussler 1959, no. 167; Wilde
1959, pp. 378–81; Hartt 1971, nos 443 and 447;
Tolnay 1975–80, III, no. 387; Perrig 1991, pp. 20, 103,
105–8 (Daniele da Volterra)
Exh. Hist.: London 1953a, no. 85; London 1964, no. 48;
London 1975a, no. 167; London 1975b, no. 227; New
York 1979, no. 23; Tokyo and Nagoya 1996, no. 3
**pp. 266–8 (recto and verso); recto and verso
illustrated p. 269**

100
Attributed to Marcello Venusti (c. 1512–1579), ***Christ
Purifying the Temple***, *c.* 1560–79
Oil on panel, 61 × 40 cm. The National Gallery, London
(1194)
London only
Prov.: Borghese; Reboul; S. Woodburn; T. Lawrence;
Mainwaring; Denison

Lit.: Gould 1975, pp. 154–5; Perrig 1991, p. 107
(Clovio)
pp. 265–6; illustrated p. 266

101
Carrying of Christ to the Tomb, 1550s
Red chalk, made up sections of paper at right and left
edges, 37.5 × 28 cm. The Ashmolean Museum, Oxford
(Parker 342)
Prov.: Baron Vivant-Denon; T. Lawrence; S. Woodburn
Lit.: Parker 1956, no. 342; Dussler 1959, no. 616
(rejected); Hartt 1971, no. 456; Tolnay 1975–80, III,
no. 431; Hirst 1988a, p. 7; Nagel 1996, pp. 565–6;
Joannides 2003a, p. 167
Exh. Hist.: London 1836, no. 76; Oxford 1846, no. 34;
London 1953a, no. 95; Amsterdam 1955, no. 222;
London 1975a, no. 159; Florence 1980b, no. 311;
London 1994–5, no. 26
pp. 269–71; illustrated p. 270

102
The Risen Christ Appearing to his Mother,
c. 1555–60
Black chalk, 22 × 20 cm. The Ashmolean Museum,
Oxford (Parker 345)
Inscribed Recto: '[die]ci V al pictore p[er] dio/ [an]dro
a pasquino p[er] mandare/ a chasteldura[n]te/ legnie'
('ten [scudi] to the painter by god/ I will go to
Pasquino to send/ to casteldurante/ wood')
Prov.: F. Cicciaporci; W. Y. Ottley; T. Lawrence;
S. Woodburn
Lit.: Parker 1956, no. 345; Dussler 1959, no. 205;
Pfeiffer 1969, p. 227; Hartt 1971, no. 435; Tolnay
1975–80, III, no. 400; Hirst 1988a, p. 53; Perrig 1991,
pp. 72, 114–15
Exh. Hist.: Oxford 1846, no. 32; London 1930, no. 519;
London 1953a, no. 108; London 1975a, no. 174;
Washington and Paris 1988–9, no. 61
pp. 271–2; illustrated p. 271

103
A window, 1547–9, reworked by Michelangelo in the
early 1560s
Verso: **A man's right arm and various architectural
studies related to St Peter's**, 1547–9
Black chalk with lead white (discoloured), brown
wash. Verso: Black chalk, 41.9 × 27.7 cm.
The Ashmolean Museum, Oxford (Parker 333)
Prov.: Casa Buonarroti; J. B. J. Wicar; W. Y. Ottley;
T. Lawrence; S. Woodburn
Lit.: Parker 1956, no. 333; Dussler 1959, nos 352
(verso: ascribed), 634 (recto: rejected); Portoghesi
and Zevi 1964, p. 621; Hartt 1971, nos 483 and 495;
Tolnay 1975–80, IV, no. 589; Morrogh 1994, pp. 151–5;
Elam 2001, fig. 9; Argan and Contardi 2004, p. 270
Exh. Hist.: London 1836, no. 1; Oxford 1846, no. 11;
London 1953a, no. 154; London 1975a, no. 149; Oxford
2001 (unnumbered)
p. 273; illustrated p. 275

104
Section through the dome of St Peter's; **figure
studies**, late 1550s
Verso: **Ground plan of the lantern's base**; **figure
studies**
Black chalk over some stylus, three corners made up,
39.9 × 23.5 cm. The Teyler Museum, Haarlem (A 29)
Exhibited double-sided
Inscribed Verso: 'balmo' in black chalk (perhaps
a miswritten form of the measurement 'palmo')
Prov.: J. Sandrart; P. Spiering van Silfvercroon;

Christina of Sweden; Azzolini; Odescalchi
Lit.: Dussler 1959, no. 148; Hartt 1971, nos 498 and
503; Tolnay 1975–80, IV, no. 596; Hirst 1988a, p. 102;
Carpiceci 1991, pp. 50, 57–61; Perrig 1991, p. 104
(figure studies by Daniele da Volterra); van Tuyll van
Serooskerken 2000, no. 67; Argan and Contardi 2004,
p. 330
Exh. Hist.: Amsterdam 1934, no. 593; Paris, Rotterdam
and Haarlem 1962, no. 85; Haarlem 1964, no. 30;
Stockholm 1966, no. 1094; Haarlem 1978, no. 9;
Florence and Rome 1983–4, no. 9; Washington
1994–5, no. 437; Haarlem 2000 (unnumbered)
**pp. 274, 276 (recto and verso); recto illustrated
p. 277 and verso p. 276**

105
The Crucifixion with Two Mourners, *c.* 1555–64
Verso: **The Crucified Christ**, *c.* 1555–64
Black chalk, heightened with lead white over some
ruled horizontal stylus lines. Verso: Black chalk, 27.8 ×
23.4 cm. The Ashmolean Museum, Oxford (Parker 343)
Prov.: Casa Buonarroti ?; J. B. J. Wicar; T. Lawrence;
S. Woodburn
Lit.: Parker 1956, no. 343; Dussler 1959, no. 204; Hartt
1971, nos 426–7; Tolnay 1975–80, III, no. 415; Hirst
1988a, p. 58; Perrig 1991, pp. 94–8 (Venusti);
Joannides 1992, pp. 253–4; Paoletti 2000, pp. 58–9,
77
Exh. Hist.: London 1836, no. 23; London 1953a, no. 99;
London 1975a, no. 182
p. 278; illustrated p. 279

106
The Crucifixion with the Virgin and St John,
c. 1555–64
Black chalk, heightened with lead white (discoloured),
41.3 × 28.6 cm. The British Museum, London
(1895-9-15-509)
Prov.: Casa Buonarroti; J. B. J. Wicar; T. Lawrence;
William II of Holland; S. Woodburn; J. Malcolm
Lit.: Wilde 1953a, no. 81; Dussler 1959, no. 174; Hartt
1971, no. 424; Tolnay 1975–80, III, no. 417; Hirst
1988a, p. 58; Hirst 1988b, pp. 146–8; Perrig 1991,
pp. 25, 94–8 (Venusti); Joannides 1992, pp. 256–7;
Joannides 1996a, pp. 92, 94
Exh. Hist.: London 1836, no. 27; London 1953a,
no. 106; London 1960, no. 542; London 1964, no. 53;
London 1975a, no. 180; London 1996 (unnumbered)
pp. 282–3; illustrated p. 280

107
The Crucifixion with the Virgin and St John,
c. 1555–64
Black chalk, heightened with lead white (discoloured),
41.2 × 279 cm. The British Museum, London
(1895-9-15-510)
Prov.: Casa Buonarroti; J. B. J. Wicar; T. Lawrence;
S. Woodburn; J. Malcolm
Lit.: Wilde 1953a, no. 82; Dussler 1959, no. 175; Hartt
1971, no. 429; Tolnay 1975–80, III, no. 419; Hirst
1988a, p. 58; Hirst 1988b, pp. 146–8; Perrig 1991,
pp. 94–8 (Venusti)
Exh. Hist.: London 1836, no. 25; London 1953a,
no. 100; London 1960, no. 527; London 1964, no. 51;
London 1975a, no. 183; New York 1979, no. 24
p. 283; illustrated p. 281

108
Daniele da Volterra (1509–1566), **Portrait of
Michelangelo**, 1550–2
Leadpoint and black chalk with traces of lead white,

the outlines pricked, top corners and a section of the
paper at lower right made up, 29.5 × 21.8 cm.
The Teyler Museum, Haarlem (A 21)
Prov.: Odescalchi
Lit.: Barolsky 1979, pp. 85–6; Bambach 1999b,
pp. 108, 159–60; van Tuyll van Serooskerken 2000,
no. 142; Treves 2001, pp. 38, 44, n. 27
Exh. Hist.: Haarlem 1964, no. 17; London 1970, no. 75;
Haarlem 1978, no. 10; Haarlem 1985, no. 32; New
York and Chicago 1989, no. 5; Haarlem 2000
(unnumbered); Florence 2003–4, no. 27
p. 263; illustrated p. 262

109
Daniele da Volterra (1509–1566), **Portrait of
Michelangelo**, c. 1564–6
Bronze with a brown patina, h. 28 cm. The Ashmolean
Museum, Oxford (WA 1846.307)
London only
Prov.: R. Cosway ?; T. Lawrence; S. Woodburn
Lit.: Barolsky 1979, p. 112, no. 27; Murray 1984,
pp. 176–7; Penny 1992, I, no. 109; Romani 2003,
pp. 170–2
Exh. Hist.: London 1975a (ex cat.); Edinburgh 1995,
no. 212; London 1999, no. 32; Florence, Chicago and
Detroit 2002–3, no. 96
pp. 263–4; illustrated p. 262

110
Leone Leoni (c. 1509–1590), **Portrait medal of
Michelangelo**, c. 1560–1
Lead, 5.97 cm. The British Museum, London
(CM M 0161)
London only
Inscribed: MICHAELANGELVS.BONARROTVS.FLOR.[entius] .
AE[tatis] S[uae]. ANN 88.' Signed 'LEO' ('Michelangelo
Buonarroti from Florence aged 88')
Prov.: C. D. E. Fortnum
Lit.: London 1999, under no. 31; Attwood 2003,
no. 62a
Exh. Hist.: London 1953a, no. 175; London 1964,
no. 109; London 1975a, no. 202
p. 264; illustrated p. 263

111
Leone Leoni (c. 1509–1590), **Portrait of
Michelangelo**, c. 1560
Pink wax on black slate, h. 4.3 cm. The British
Museum, London (MLA 1893-10-11-1)
London only
Inscribed: on reverse: 'Ritratto di Michelangiolo
Buonaroti fatto dal Naturale da Leone Aretino suo
Amico' ('Portrait of Michelangelo Buonarroti done
from life by Leone from Arezzo his friend')
Lit.: Attwood 2003, p. 41
Exh. Hist.: London 1953a, no. 177; London 1964,
no. 111; London 1975a, no. 204; London 1999, no. 30
p. 264; illustrated p. 263

Appendix II
Translations of longer inscriptions and letters

Translated texts for Michelangelo's drafts for poems and one ricordo, *plus the selection of letters from the British Library, are included in the present Appendix (shorter inscriptions found on the drawings in the exhibition are given in Italian and English in Appendix I). The longer inscriptions in Italian have not, with one exception, been transcribed except for the first line, as they are readily available elsewhere: for the poetry see, among others, Girardi (1960), Saslow (1991), Ryan (1996), the latter two following Girardi's numerical sequence and with parallel translations; the texts of the British Library letters are found either in the five volumes of the artist's correspondence* (Carteggio) *or the two volumes of those sent to the artist or his family* (Carteggio Indiretto); *and Michelangelo's notes and memorandum are published in the* Ricordi. *The poetic draft on the verso of Exh. No. 51 is transcribed here because Laura Nuvoloni and Isabella Lodi-Fè have slightly amended Girardi's transcription of the text, and Ryan and Saslow only include the final version of the poem. The translations of the poems are taken, with kind permission from his publishers, from Christopher Ryan's 1996 book. The texts of the artist's letters differ slightly from those in Ramsden's invaluable two-volume translation of the artist's correspondence; nonetheless references to her 1963 work are provided for comparison.*

Exh. No. 14

Verso: *sol io arde(n)do all ombra mi rima(n)go ...*
I alone remain burning in the shadows, when the sun strips the world of rays: all others for pleasure, but I through suffering lie prostrate on the earth, lamenting and weeping (Girardi 1960, no. 2)

ch(e) febo alle ... nora
... which Phoebus to the ... you of its pleasant and beautiful rest ... I take refuge in the shade during the day, when with its light it makes the fields golden ... wherever it may be it makes me suffer over one ... discolours (Girardi 1960, Appendix no. 10)

Exh. No. 15

Verso: *Molti anni fassi qual felice in una*
One person passes many years in happiness, and in a single fleeting hour is brought to misery and grief; another shines brightly because of famous or ancient lineage, and in a single moment loses all lustre. Nothing mutable exists under the sun which death does not conquer and fortune change (Girardi 1960, no. 1).

Exh. No. 38

Recto: *Questo schizo e una parte della faccia dina(n)zi della sepultura el quale e tucto*
This sketch is one part of the façade before the tomb which is all finished in dressed and carved stone which rises six *braccia* from the floor to the first cornice and is eleven *braccia* from one end to the other and consists of sixty-seven pieces together with those pieces noted. And [these] are put together in a room beside the courtyard in which are also two wheels and a cart which I had made and the rest I leave in another ground-floor room in the house in Rome (Wilde's transcription in 1953a is corrected in *Ricordi* 1970, no. lii).

Exh. No. 41

Verso: *Di te me veggo di lontan mi chiamo*
I see that I am yours, and from afar I exhort myself to be so in order to come closer to heaven whence I derive; and drawn by the lure of your beauty I reach you, as a fish on the hook is pulled in by the line.

 And since a heart split in two shows little sign of life, to you are given both parts; so I remain, as you know, just what I am, of small account.

 And since a soul between two objects moves towards the more worthy, I am constrained, if I would live, to love you always: I am wood only, but you are wood and fire (Girardi 1960, no. 15).

Exh. No. 51

Verso: *Ogni cosa chi veggio mi co[n]siglia*
e prega e forza chi ti segua e ami
ch[e] quel ché no[n] e tè no[n] e elmie bene
ogni stupor e ogni maraviglia
de lluniverso par chacte mi chiami
e nel pe[n]sier miti dipinge etiene
e di questo me[n]tre maviene
mira[n]do le tua opre salde e ferme
u[n] venenoso verme
mi sempla e mi divora
ectuto il mondo a[n]cora
corroto da tuo pressioni parenti
odi nostri lame[n]ti
amor se tu sei dio
chel primo i[n]te[n]dermi mie desio

presta[n]do larme a questo orribil mostro
la colpa è tua di tucto el danno nostro

Everything I see advises/ and begs and forces me to follow you and love you/ for whatever is not you is not good for me/ Every wonder and marvel/ of the universe seems to call me towards you/ picturing your image in my head and holding on to it/ while I admire your steady and secure works/ a venomous worm/ corrupts and devours me/ and the whole world/ [is] corrupted by your apparent pressures/ hear our moans/ love if you are god/ as you are the first to understand my desire/ giving the weapon to this horrible monster/ all yours is the blame for our suffering (Girardi 1960, no. 81, draft III).

Exh. No. 62

Verso: *Ohime, ohime, chi s[on] [t]radito* (final form: *Oilmè, oilmè, ch'i'o son tradito*)
Alas, alas, I have been betrayed by my fleeting days and by the mirror that tells the truth to everyone who looks steadily into it! This is what happens to anyone who too long puts off thinking about his end, as I have done, while time has slipped me by: like me, he suddenly finds himself old. And I cannot repent, nor do I prepare myself, nor reconsider my ways, even with death near. My own worst enemy, I uselessly pour out tears and sighs, for there is no harm to equal that of wasted time.

 Alas, alas, though I keep going over my past life, I do not find a single day that has been my own! False hopes and vain desire have kept me weeping, loving, burning and sighing (for no mortal emotion is a stranger to me now), as I well know and daily prove again, far indeed from the true good. Now in danger I perish: time's short passage has run out for me, and even if it were to lengthen I should not tire of my ways.

 I go wearily on, alas, yet without really knowing where; or rather I fear I do, for I see where, and my past shows this to me, and it does me no good to close my eyes. Now that time is changing skin and moult, death and my soul are locked in battle every hour, one against the other, for my final state. And if I am not mistaken (God grant that I may be), I see the eternal punishment due for my having, in freedom, badly understood and acted on the truth, Lord; nor do I know what I may hope for (Girardi 1960, no. 51).

British Library letters
Exhibited only in London

1
Add. MS 23140, fol. 37
Michelangelo in Rome to his father Lodovico in
Florence
Early October 1512

*Michelangelo informs his father that he has completed
the painting of the Sistine ceiling.*

Dearest Father, I learnt from your last letter that
you've returned the forty ducats to the *Spedalingo*.[1]
You've done rightly, but should you hear that there's
any risk to the money please let me know of it. I have
finished the chapel I have been painting; the pope is
very well satisfied. But other things have not turned
out for me as I'd hoped. For this I blame the times,
which are very unfavourable to our art. I shall not be
home for All Saints [1 November], because I have not
the means to do what I want to do, and also it's not
the time for that.[2] Make the most of life and don't
bother yourself about anything else. That's all.
Michelangelo Sculptor in Rome

1 The warden of the Hospital of S. Maria Nuova in
Florence, an institution which in addition to its
medical and charitable functions also acted as
a bank deposit.
2 It is not clear what Michelangelo is referring to
here. The earlier mention of unfavourable times
may be a guarded reference to the return of Medici
rule to Florence the previous month.

Ramsden 1963, I, no. 83, pp. 75–6; *Carteggio* I, no. civ,
p. 137.

2
Add. MS 23140, fol. 13
Michelangelo in Rome to his father in Florence
October–November 1512

*Michelangelo defends himself from having spoken ill
of the Medici who had just been restored to power.
The letter shows Michelangelo's anxiety that his
pro-republican sentiments should not be known to
the Medici (for this see also No. 8 written over thirty
years later).*

Dearest Father, I learn from your last that I should be
careful not to keep money in the house or to carry it
about on me; and also that it's said in Florence that
I have spoken against the Medici.
 As to the money, what I have I keep in Balduccio's
bank; I do not keep it in the house nor on me, except
what I need from day to day. As regards the Medici,
I have never said anything against them, except what's
said generally by everybody, as it was in the case of
Prato; for if the stones could have spoken of it, they
would have done so.[1] Afterwards many other things
were said here, which, when I heard them, I said: 'If it
is true that they are doing those things they are doing
wrong'; not that I really believed them; and God grant
they didn't. Since a month ago someone who purports
to be a friend of mine has been speaking very ill of
them to me. But I replied saying that it was wrong
to talk like that and that he was not to say any more
to me about it. So I want Buonarroto[2] to see if he can

find out discretely from whom the fellow had it that
I had spoken against the Medici, in order to see if
I can find out where it came from, so that, if it came
from any of my supposed friends, I can be on my
guard.
 That's all I have to tell you. I am not doing anything
as yet, but am awaiting the Pope to tell me what to do.
Your Michelangelo Sculptor in Rome

1 Prato was brutally sacked by Spanish troops on
29 August 1512 on their way to exact revenge
on the Florentines for their support of the French.
The Medici were implicated because they were
supported by Julius II and the attack on Prato was
undertaken by troops in the Holy League, an anti-
French alliance formed by the pope. The Florentines
saved themselves from a similar fate by paying
a large fine, expelling the head of the republican
government, Piero Soderini, and accepting the
restoration of Medici rule.
2 Michelangelo's favourite brother.

Ramsden 1963, I, no. 85, pp. 81–2; *Carteggio* I, no. cvi,
p. 139.

3
Add. MS 23744, fol. 1
The Venetian painter Sebastiano del Piombo in Rome
to Michelangelo in Florence
29 December 1519

*Sebastiano urges Michelangelo to approve the bill for
his painting 'The Raising of Lazarus'.*

My dearest friend, your most gratefully received letter
arrived many days ago. I thank you enormously for
having deigned in the letter to accept to be my son's
godfather. The ceremony of the women[1] isn't
something we do in our house: the most important
thing for me is that you are a godfather. And for this
other matter, I will send you the water.
 Some days ago now, I had my child baptized and
gave him the name of my father, Luciano. It would
give me singular pleasure if Messer Domenico
Boninsegni[2] would deign to be a godfather, as I only
want men of standing to be godfathers.
 Other than that, I want to let you know that
I've finished the panel painting[3] and taken it to the
[Vatican] Palace where it was more quickly liked than
disliked, other than by the priests who don't know
what they're talking about. For me it is enough that
the most reverend Monsignor[4] said he is more pleased
with it than he'd expected to be. I believe that my
panel is better designed than the tapestries that have
arrived from Flanders.[5]
 Now, having completed my task, I have now sought
final payment and the most reverend Monsignor said
that, as he had agreed with Messer Domenico, he
wanted you to judge this work. Wanting a quick
conclusion, I would have let his Lordship decide the
price, but he would have nothing of it. I showed him
my bill, accounting for everything, but he wanted me
to send it to you for your approval nevertheless. This
I do, asking you to do me the favour of unhesitatingly
approving it, since both the most reverend Monsignor
and I leave it freely up to you. It's enough that you
saw the work at the beginning and it's forty figures in
total, not including those in the landscape. Included in
the bill is Cardinal Rangone's painting[6] which Messer
Domenico has seen and knows how large it is. I'll say

no more; my friend, I pray you to do this quickly,
before the most reverend Monsignor leaves Rome,
because, to tell you the truth, I'm broke. May Christ
maintain your health. My best regards to Messer
Domenico; and to you I remain ever yours,
On this day 29 December 1519
Your most faithful friend Sebastiano painter in Rome.
To Michelangelo sculptor in Florence

1 A reference to the Renaissance practice of female
visitors coming to see the newborn infant and
to present gifts to the mother during her period
of confinement after the birth (as is shown in
Ghirlandaio's *Birth of the Virgin*, Fig. 14).
2 The Florentine-born treasurer of Cardinal Giulio
de'Medici.
3 The *Raising of Lazarus*, now in the National Gallery,
London (Fig. 59), commissioned by Giulio de'Medici
for Narbonne cathedral.
4 Cardinal Giulio de'Medici.
5 A barbed reference to Raphael's Flemish-woven
tapestries for the Sistine chapel commissioned
by Leo X.
6 The *Martrydom of St Agatha*, now in the Palazzo
Pitti, Florence.

Carteggio II, no. cdxlviii, pp. 206–7.

4
Egerton MS 1977, fol. 8
Count Alessandro da Canossa in Bianello to
Michelangelo in Rome
8 October 1520

*Count Alessandro invites his 'relation' Michelangelo
to come and visit the Canossa's castle at Bianello
situated some 40km west of Modena. In reality the
firmly middle-class Buonarroti were unrelated to the
Canossa, and it is a mark of Michelangelo's fame that
Count Alessandro promoted this fiction. The exhibition
includes an old copy after a lost imaginary portrait
drawing by Michelangelo of his aristocratic forebear
(Exh. No. 65).*

Esteemed relation, I am very grateful for the visit paid
to me on your behalf by the painter Zoane da Regio;[1]
it would have pleased me even more, however, if you
yourself had been there to meet your relatives and see
your house. And if I had known that you were coming
to Carrara I would have come to force you over to
your house here, to see it and enjoy it for a few days
with us. I unreservedly offer you all that my brother,
Count Alberto, and I have. And if there was ever
something we could do for you, we would always be
ready to satisfy your every wish. We want you to
know that you can depend on us and that all that is
ours is yours also in the hope that one day you will
come to visit your home here.[2] Nothing else occurs
to me to say except to commend myself to your good
grace. Even if there's no need, I commend to you
Zoane the bearer of this letter.
At Bianello de le Quatro Castelle, on this day viii
October MDXX
Researching our family history, I have found that a
messer Simone da Canossa was *podestà*[3] of Florence,
something I have told Zoane.
Your true relation, Alexandro da Canossa, count etc
To my much loved and honoured relation messer
Michelle Angelo Bonaroto de [Cano]ssa, very great
sculptor, in Rome.

Appendix II

1 Michelangelo's assistant Giovanni da Reggio
2 There is no record that the sculptor ever took up this invitation.
3 Governor

Carteggio II, no. cdlxxiii, p. 245.

5
Add. MS 23140, fol. 43
Michelangelo in Florence to his father in Settignano
Second half of February or the beginning of March 1521

Michelangelo angrily rebuffs his father's claims that he had him thrown out of the family's house in Florence.

Dearest Father, I was amazed at your conduct the other day, when I did not find you at home; and now, when I hear that you are complaining about me and saying that I've turned you out, I'm still more amazed; for I'm certain that never to this day, since the day I was born, has it ever occurred to me to do anything, either great or small, opposed to your interest; and all the toils and troubles I've continually endured, I've endured for your sake. And you know that since I returned to Florence from Rome, I've always taken care of you and you know that I've assured you that what I have is yours. After all, it was only a few days ago, when you were ill, that I talked to you and promised you that to the best of my ability I would never fail you as long as I live, and this I reaffirm. I'm now astonished that you should so soon have forgotten everything. You have, besides, made trial of me, you and your sons, these thirty years and you know that I've always considered you and done well by you whenever I could.

How can you go about saying that I've turned you out? Don't you see what a reputation you give me, that it should be said that I've turned you out? This is the last straw, added to the worries I have about other things, all of which I endure for your sake. A fine return you make me! However, be it as it may, I'll try to imagine that I've thrown you out and that I've always brought shame and trouble upon you and thus, as if I'd done so, I ask your forgiveness. Imagine that you are forgiving a son of yours who has always led a bad life and has done you every possible wrong on earth. And thus again, I beg you to forgive me, like the wretch I am, and not to take away my reputation up there by saying that I've turned you out, for it matters more to me than you think. After all, I am your son!

The bearer of this will be Rafaello da Gagliano. I beg you for the love of God, and not for my sake, to come down to Florence, because I have to go away and I have something very important to tell you and I cannot come up there. And because, on his own telling, I've heard several things from my assistant Pietro,[1] which displease me, I'm sending him back to Pistoia this morning and he will not return to me any more, as I don't not wish him to be the ruin of our family. And you, who all knew what I did not know about his behaviour, should have informed me long ago and so much scandal would not have arisen.

I'm being urged to go away, but I'm not prepared to leave without talking to you and leaving you here at home. I beg you to put aside all rancour and to come. Your Michelangelo in Florence

1 Pietro Urbano, a live-in studio assistant, had been sent to Rome to install Michelangelo's marble figure of the *Risen Christ* in S. Maria sopra Minerva.

Inadvisedly Urbano decided to add some finishing touches which spoiled the statue in many areas. In September Urbano left Rome along with a ring worth forty ducats and the cape and hat stolen from a deceased friend.

Ramsden 1963, I, no. 149, pp. 137–40; *Carteggio* II, no. cdxciv, pp. 274–5.

6
Add. MS 23139, fol. 4
Alfonso I d'Este, duke of Ferrara in Venice to Michelangelo in Florence
22 October 1530

Concerning Michelangelo's painting of 'Leda'.

Dearest friend, it was with the greatest of pleasure that I received via my agent in Florence, Messer Alexandro Guarino, your message concerning the painting you have done for me. As I told you in person, I have desired for so long to own a work by you, that every hour more I wait seems to me a year. In this regard, therefore, I am sending you the bearer of this letter, my servant Pisanello, to whom I ask you to consign the work, giving him advice on how to transport it safely. And please do not be offended if I do not send payment with him since I have neither heard from you what you want for it, nor seen the work for myself to be able to judge. But I give you my firm promise that your devoted labour on my behalf will not have been wasted. And you would do me the greatest of favours if you wrote to let me know the amount you would like since I place much greater faith in your judgement in valuing it than my own. And in addition to this prize for your labour, I reaffirm to you that I shall always desire to please and help you, just as I believe your valour and rare virtue merit. And in the meantime and for always, I offer you my heartfelt wish to do anything that you require. Remain in good health.
Venice, 22 October 1530
Alfonso, duke of Ferrara etc.
Michelangelo Buonarroti, most excellent painter and sculptor.
In Florence

Carteggio III, no. dcccciii, p. 290.

7
Add. MS 23139, fol. 10
The poet Vittoria Colonna to Michelangelo
1538–1541?

Colonna upon receiving Michelangelo's drawing of the 'Crucifixion' (Exh. No. 91).

Unique master Michelangelo and my most particular friend, I have received your letter and seen the *Crucifix* which has certainly crucified itself in my memory more than any other picture that I have ever seen. No image better made, more alive, or finished could be seen. Certainly, I could never explain how subtlely and marvellously it is made, and for this reason I am resolved that I don't wish it to be in the hands of anyone else. And yet clarify this for me. If it does belong to someone else, never mind, but if it is yours I would definitely want to take it from you. If it isn't yours, and if you want to have it copied by that

man of yours, do let us talk about it beforehand since I realize how difficult it is to imitate and I would rather that he [the copyist] did something else. But if it is yours, please be patient since I won't return it. I've looked at it closely using a lamp, a magnifying glass and a mirror: never did I see anything more finely executed.
Your servant, the marchioness of Pescara

Carteggio IV, no. cmlxviii, p. 104.

8
Add. MS 23142, fol. 2
Michelangelo in Rome to his nephew Leonardo in Florence
22 October 1547

Michelangelo denies rumours that he has been associating with anti-Medici Florentine exiles.

Lionardo, I'm glad that you have informed me about the decree,[1] because if up till now I've been on my guard about talking to the exiles and associating with them, I'll be much more on my guard in future. As regards my being ill, in the Strozzi's house,[2] I do not consider that I stayed in their house, but in the apartment of Messer Luigi del Riccio,[3] who was a very great friend of mine; nor, since Bartolomeo Angiolini died, have I found anyone to look after my affairs better or more devotedly than he. But since he died I no longer frequent the said house, to which all Rome can bear witness, and to the kind of life I lead, as I am always alone; I go about very little and talk to no-one, least of all to Florentines; but if I'm greeted in the street I cannot but respond with a civil word and pass on – though, if I were informed as to which are the exiles, I would make no response at all.[4] But, as I've said, from now on I'll be very much on my guard, particularly as I have so many other anxieties that life is a burden.

As regards setting up a shop, do whatever you think will turn out successfully, because it's not my profession and I cannot give you any good advice. I only say this to you, that if you waste the money you have you may never be able to recover it.
Michelangelo in Rome.

1 Leonardo had evidently informed his uncle of rumours of the decree to be issued in a month's time by Duke Cosimo de'Medici against Florentines having any dealings with anti-Medici exiles. If the perpetrator remained outside Florentine territory punishment could be meted out on his family. The artist was clearly concerned that his family and his substantial property investments in and around Florence would be safe.
2 The Strozzi, a rich Florentine banking family, were perhaps the best-known opponents of Medici rule. Michelangelo had long-standing ties with the family: his early marble of *Hercules* was in the family's collection in Florence before they sold it to Francis I of France; and in 1546 he had given the two sculptures of *Slaves* (now in the Louvre) to Roberto Strozzi, then living in exile in Lyons, in gratitude for having been nursed back to health in the Strozzi palace in Rome.
3 Luigi del Riccio was Roberto Strozzi's agent and managing director of the Strozzi–Ulivieri bank in Rome. He took over the role of managing Michelangelo's affairs after the death of

Bartolomeo Angiolini in 1540. He died in 1546.
4 Michelangelo's professed ignorance of the status of Florentine exiles in Rome is mendacious as he was on friendly terms with some of the most prominent of them.

Ramsden 1963, II, no. 291, p. 82; *Carteggio* IV, no. mxcii, p. 279.

9
Add. MS 23142, fol. 37
Michelangelo in Rome to his nephew Leonardo in Florence
15 March 1549

Michelangelo details his ill health to his nephew and discusses the settling of his affairs.

Lionardo, there's no need to add anything further to what I told you in my last letter.

As regards my malady – being unable to urinate – I've been very ill with it since then, groaning day and night, unable to sleep or to get any rest whatever. As far as they can make out, the doctors say I'm suffering from the stone. They're still not certain. However, they continue to treat me for the said malady and are very hopeful. Nevertheless, as I'm an old man suffering from such a cruel malady, they're not making me any promises. I'm advised to go and take the baths at Viterbo, but one cannot go until the beginning of May. In the meantime I'll manage as best I can and perhaps it will turn out, mercifully, that the malady will prove not to be the stone, or that a cure will be found. I am therefore in need of God's help. So tell Francesca [Leonardo's older sister] to pray for me and tell her if she knew the state I have been in, she would see that she is not without companions in affliction. In other respects I am almost as I was at thirty years of age. This malady has come upon me through the hardships I have suffered and through taking too little care of myself. But there it is. Perhaps with God's help it will turn out better than I expected, and if otherwise I'll let you know, because I want to put my spiritual and temporal affairs in order, and for this it will be necessary for you to come here. When I think the time has come, I'll let you know. But without letters from me make no move, whatever anyone else says. If it is the stone, the doctors tell me that it is at an early stage and that it is a small one. They're therefore very hopeful, as I've said.

If you know of any noble family in a state of real need, which I think may well be the case, let me know about it, because I'll send you up fifty *scudi*, so that you may make a donation for the good of my soul. This will in no way diminish what I have arranged to leave you, so see to it without fail.
On the 15th day of March 1549
Michelangelo Buonarroti in Rome

Ramsden, II, no. 323, p. 102; *Carteggio* IV, no. mcxxiii pp. 315–16.

10
Add. MS 23142, fol. 66
Michelangelo in Rome to his nephew Leonardo in Florence.
20 December 1550

Michelangelo thanks his nephew for a gift of cheeses and gives advice on choosing a bride.

Lionardo, I got the *marzolini*, that is to say, twelve cheeses. They are excellent. I shall give some of them to friends and keep the rest for the household, but as I've written and told you on other occasions – do not send me anything else unless I ask for it, particularly not things that cost you money.

About your taking a wife – which is necessary – I've nothing to say to you, except that you shouldn't be particular as to the dowry, because possessions are of less value than people. All you need have an eye to is birth, good health and, above all goodness of character. As regards beauty, not being, after all, the most handsome youth in Florence yourself, you need not bother overmuch, provided she's neither deformed nor loathsome. I think that's all on this point.

I had a letter yesterday from Messer Giovan Francesco asking me whether I had anything of the marchesa di Pescara's.[1] Would you tell him that I'll have a look and will answer him this coming Saturday, although I don't think I have anything; because when I was away ill, many things were stolen from me.

I should be glad if you would let me know if you were to hear of any citizen of noble birth in dire need, particularly someone who has daughters in the family, because I would do them a kindness for the welfare of my soul.
On the 20th day of December 1550
Michelangelo Buonarroti in Rome

1 The Florentine canon Fattucci who has liased with Michelangelo over his work in S. Lorenzo (1519–34) wanted copies of poems sent to him by Vittoria Colonna. She had died in 1547.

Ramsden, II, 357, pp. 127–8; *Carteggio* IV, no. mclvii, p. 357.

11
Add. MS 23139, fol. 12
The sculptor Benvenuto Cellini in Florence to Michelangelo in Rome
14 March 1560

Cellini invites Michelangelo to end his days in Florence.

My most excellent and divine master Messer Michelangelo, I keep you ever imprinted on my eyes and in my heart, and if it's a long time since I last wrote, it's simply because no occasion to serve you has arisen and I didn't want to cause you unnecessary inconvenience.

But now, since maestro Giovanni da Udine[1] has been doing a few days' penance at my home on his way to Rome, it seemed appropriate to comfort myself a little by writing to your Lordship these numerous lines, reminding you how much I love you. It was with very great and marvellous pleasure that I heard in the past days that you were returning for certain to your native land, something that all this city greatly wishes, and most of all the duke himself[2] who is a great admirer of your marvellous virtues and the most benign and kind Lord ever seen on this earth. Come now and spend your last happy years in your homeland, surrounded by great peace and glory! Even if I have received some unfair treatment from this Lord, I believe undeservedly, I know for certain that

they were provoked neither by his Illustrious Excellency nor by me.[3] I tell you emphatically the truth that never was there a man in his homeland more cordially loved than me, and similarly in this most admirable court. And this displeasure, arrived without reason, can only be explained by some malign star, to whose effect I know of no remedy other than putting myself completely before the true and immortal God, whom I pray will keep you happy for some years to come.
Florence, on this day 14 March 1559
Always most ready to obey your lordship
Benvenuto Cellini
To the most excellent messer Michelangelo Buonarroti, greatly superior than myself and worthy of the highest repect.
In Rome.

1 The stuccoist, painter and architect (1487–1564) who had worked with Michelangelo in the Medici chapel in the early 1530s.
2 Duke Cosimo de'Medici.
3 Cellini was out of favour with the duke over accusations that he had appropriated bronze intended for the *Perseus* (1545–53) and he was also under house arrest after being convicted of sodomy in 1557.

Carteggio V, no. mcccxx, pp. 208–9.

12
Egerton MS 1977, fol. 18
Michelangelo's assistant, the sculptor Tiberio Calcagni, in Rome to the artist's nephew in Florence
14 February 1564

Calcagni recounts the last days of Michelangelo (he died on 18 February).

Most Magnificent m. Lionardo, if I haven't written to you before it's because the occasion has never arisen, and although it has now, it's not that important. Nevertheless, I didn't want to fail to warn you. This is because I heard from many people while in Rome today that Messer Michelangelo was ill. I immediately went over to his place where I found him walking outside – and this despite the fact it was raining! And when I saw him and said that it hardly seemed appropriate for him to be outside in this weather, he replied, 'And what would you rather have me doing? I am ill and can find peace nowhere.' And never before as much as then, what with his appearance and wavering words, had he caused me to fear so much for his life. I doubt very much that he has much longer left. However, one should never despair of divine grace by whose mercy we may be granted a little longer of his presence. And since your years and experience are greater than mine, words of consolation should come more appropriately from you and directed to me. It's enough and most important for me to know that my letter is not the one to bring bad news. And even though I don't enjoy communicating such things, I promise to go there more often and inform you day by day of events, this despite the fact that by some of his retinue, I know not precisely whom, I am not well-liked: however, he concedes to see me with pleasure.

There is no more to say. I will send this to Francesco Baldesi, mercer at the Colombe, or else with the taxed post. I remain yours, encouraging you to comfort yourself and be patient for what is to come.

In Rome, this day the 14 of February, at midnight – I say this because someone has said he is dead, and I've just left him and led him home! I am fearful however.

Yours, Tiberio Calcagni, sculptor

In reply you can give the letters to this Baldese.
To the very magnificent m. Lionardo Buonaruoti most worthy of the highest repect
In Florence

Carteggio Indiretto, II, no. 356, pp. 169–70.

13
Egerton MS 1977, fol. 20
The sculptor Daniele da Volterra (1509–1566) in Rome to Leonardo Buonarroti in Florence
11 June 1564

Concerning Daniele's posthumous bronze portrait busts of Michelangelo, a cast of which is in the exhibition (Exh. No. 109), a biographical note to pass to Vasari for his 'Lives of the Artists' and Michelangelo's tomb in the Florentine church of S. Croce.

Most Magnificent and Honorable m. Lionardo, I've received via our dear friend m. Diomede Leoni your letter of the 3rd of this month, by which I learn that my letter to m. Giorgio [Vasari] which you passed on to him was well received. A reply no longer being necessary, you can tell him that I've already absolved him of this sin. I'm very sorry to hear of his indisposition.

I can't remember if in all I wrote I mentioned how Michelangelo worked all the Saturday [12 February] of the Carnival weekend standing up over and carving the *Pietà*.[1] If I didn't mention it, tell him to add it to the biography. Do commend me to him. Concerning the *Madonna* it's fine to give the commission to Marignolle.[2] And concerning the cost of the plaster, if you could pay, we will reconcile our costs later. Let Marignolle do it as he pleases.

Regarding Michelangelo's tomb, I like the fact we're not rushing, since taking our time and consulting m. Giorgio, I am certain we'll find the right solution.

As for the metal portraits [of Michelangelo], up to now I've only made a wax model for them. I continue to do what I can, and with due application, the task should be completed in the quickest time possible.

Having said enough, I will finish telling you of my injury, which, because of the heat, is improving a little. Nevertheless, the doctors are agreed that it would be good for me to come and visit the baths at Lucca. And things improved, God willing, it shouldn't be long before we see each other there.

The pope's people[3] have tried hard to get the house. I put up such a fight that I don't think they'll try again. And to be sure that the house is occupied, I've installed Jacopo and his women in the rooms that were occupied by Antonio's women. And I'm continuing to sleep in the tower with one of my family. Keep well and let God bring you happiness.
Rome, on this day 11 June 1564
Your affectionate friend and servant,
Daniele Ricciarelli
To my most magnificent and honourable M. Lionardo Buonarroti worthy of the highest respect
In Florence

1 The unfinished marble *Rondanini Pietà* (Fig. 121)

now in the Castello Sforzesco, Milan.

2 Perhaps a reference to Michelangelo's early *Madonna of the Stairs* relief that Leonardo was soon to present to Duke Cosimo I. The Florentine sculptor Leonardo (or Lorenzo) Marignolli has been asked to make a gesso copy of it.

3 Julius II's heirs tried unsuccessfully to take back possession of Michelangelo's house and studio in Rome in Marcel dei Corvi that had been initially lent to him by the della Rovere to work on the tomb.

Carteggio Indiretto II, no. 370, pp. 198–200.

Notes

Notes to Chapter 1

1 *Carteggio* II, no. cdlxxi, pp. 242–3.
2 Condivi's story of Paul's reaction is one of the many unacknowledged borrowings that appear in Vasari's second edition (1568) of Michelangelo's biography: see Condivi (Nencioni ed.) 1998, p. 46; Condivi (Wohl ed.) 1999, p. 75 and Vasari (Bettarini and Barocchi ed.) 1987, VI, pp. 66–7.
3 Hatfield 2002 is the best guide to Michelangelo's wealth. While this rightly stresses Michelangelo's huge earnings over the course of his long career, the author perhaps exaggerates the uniqueness of his earning power. Comparable financial records for Raphael do not survive, but as he was planning to build a Roman palace in the most fashionable area of the city he too must have earned huge sums.
4 *Carteggio* III, no. dccxxvii, pp. 184–5.
5 *Carteggio* III, no. dcccxxxiv, pp. 348–9.
6 Both are documented in the artist's letters; Condivi's claim that Michelangelo contemplated leaving for a Genoese abbey or Urbino in 1534 in order to work on Julius' tomb can be discounted as later fabrications to placate the aggrieved della Rovere: Condivi (Nencioni ed.) 1998, p. 46; Condivi (Wohl ed.) 1999, p. 75.
7 Michelangelo beautifully articulated this in his poem about the limitless possibilities offered by a block of marble ('non ha l'ottimo artista alcun concetto'): Girardi 1960 , no. 151; Ryan 1996, pp. 139–40, 301.
8 Barocchi 1971–7, I, pp. 133–51.
9 For this event see Wittkower 1964 and Varchi 1564.
10 The Latin text with an Italian translation is given in Barocchi 1971–7, I, pp. 10–13.
11 Parallel texts from the 1550 and the 1568 can be compared in the Bettarini and Barocchi edition of Vasari's *Lives*, 1987, VI, pp. 3–141 and with an extensive commentary in Barocchi's 1962 edition of Vasari's biography of Michelangelo.
12 For Vasari and Condivi's biographies see Hirst 1996a.
13 For a recent Italian edition see Condivi (Nencioni ed.) 1998; and in translation Condivi (Wohl ed.) 1999. For Michelangelo's artful manipulation of his biography see Barolsky 1991.
14 *Carteggio* V no. mccxxiv, p. 61.
15 For Caro's involvement – first intimated by Wilde – see Hirst 1996a.
16 For the identification of the marginal annotations and discussion of their significance see Elam in Condivi (Nencioni ed.) 1998, pp. xxiii–xlvi.

17 Vasari's biography of Michelangelo was also issued as a separate publication, an example of which is in the British Museum's Prints and Drawings departmental library.
18 For a brief introduction in English to the history and foundation of the Casa Buonarroti see Ragionieri 1997. The artist's correspondence is published in five volumes edited by Barocchi and Ristori 1965–83; English translations of Michelangelo's letters are given by Ramsden 1963. For the *ricordi* see Bardeschi Ciulich and Barocchi 1970.
19 Shearman 2003, I, pp. 112–18 and 180–4.
20 These difficulties are summed up by Vasari's description of Michelangelo as both solitary and gregarious: Vasari (Bettarini and Barocchi ed.) 1987, VI, p. 109.
21 For a helpful guide to the topic see K.-E. Barzman, *Perception, Knowledge, and the Theory of 'Disegno' in Sixteenth-Century Florence*, in Feinberg 1991, pp. 37–48.
22 See Vasari (Bettarini and Barocchi ed.) 1987, VI, p. 164.
23 See his 1547 letter to Varchi on the issue of the *paragone*: *Carteggio* IV, no. mlxxxii, pp. 265–6.
24 Vasari mentions that he owned a drawing of draped women after Ghirlandaio made by a fellow student of Michelangelo in the painter's workshop. One of the figures had been transformed and 'made perfect' by corrections in a thicker pen by Michelangelo: Vasari (Bettarini and Barocchi ed.) 1987, VI, p. 7.
25 *Carteggio* I, no. cclxix, p. 336; Ramsden 1963, no. 121, pp. 110–11.
26 The only lacuna is a drawing combining red and black chalk with white heightening as he does in the cartoon of the *Virgin and Child* in the Casa Buonarroti: *Corpus* II, no. 239.
27 For a fuller explanation of the technique see James, Corrigan, Enshaian et al. 1997, pp. 63–4.
28 Metalpoint drawings by Ghirlandaio include examples in the British Museum and the Louvre: Cadogan 2000, nos 99–100 and 105.
29 For Granacci's metalpoint drawings see Holst 1974, nos 5, 13–16, figs 12, 31–4.
30 Raphael's example probably inspired Parmigianino to use the technique in Rome in the 1520s such as the *Head of a Girl* in the Fitzwilliam: Popham 1971, I, no. 46, II, pl. 80.
31 A point made in Hirst 1988a, p. 8.
32 In Wilde's 1953 catalogue the technique is described as black chalk, but the thinness of the line is more like leadpoint. Another example of Michelangelo's use of the technique in the 1530s is in a fragmentary drawing in the British

Museum: Wilde 1953a, no. 51; *Corpus* II, no. 252bis.
33 In Wilde's entry for a leadpoint drawing in the British Museum (Wilde 1953a, no. 51) he noted its presence in four pen drawings in the Casa Buonarroti: *Corpus* I, nos 79–82.
34 A study of two arms in red chalk drawn before the principal study in pen after Masaccio is found on a drawing in Munich: *Corpus* I, no. 4r. Ghirlandaio also employed black chalk as in his study for the head of an old woman at Chatsworth: Cadogan 2000, no. 79.
35 Condivi (Nencioni ed.) 1998, p. 18; Condivi (Wohl ed.) 1999, p. 21.
36 James, Corrigan, Enshaian et al. 1997, pp. 76–7.
37 I am grateful to Janet Ambers, Philip Fletcher and Duncan Hook of the Department of Conservation, Documentation and Science, the British Museum. The drawings were investigated using Ramen and XRF.
38 For cartoons on blue paper see Bambach 1999b, p. 36. The British Museum Raphael drawing is no. 26 in Pouncey and Gere 1962.
39 *Corpus* I, no. 31. Later examples of the paper having been given a light coloured wash – as in the Albertina *Lamentation* (*Corpus* III, no. 432) – look from the silhouetting of the figures to have been done after the chalk, perhaps to obscure damages to the paper.
40 Popham and Pouncey 1950, no. 24.
41 Such as in the double-sided study of the *Virgin and Child with a Cat* in the British Museum: Popham 1946, no. 9; Popham and Pouncey 1950, no. 97.
42 *Corpus* IV, nos 550, 555, 564–83 and 612r.
43 Rare examples of Michelangelo using pen in his later architectural projects are the drawing in the Vatican with profiles of mouldings associated by Tolnay with the bases of the *River Gods* on the Campidoglio (*Corpus* IV, nos 607r), and the few details added in pen to the Casa Buonarroti plan for S. Giovanni dei Fiorentini, nos 610r and 612r.
44 Described in ch. 34, Cennini 1899, p. 29.
45 See also *Corpus* I, nos 37v and 53v.
46 Popham 1946, nos 166–7 and 199.
47 The most elaborate example is the large Virgin and Child in the Casa Buonarroti: *Corpus* II, no. 239. Other red and black chalk combination drawings include a study of a grotesque mask at Windsor (*Corpus* II, no. 263bis; Joannides 1996a, p. 51) and the J.P. Getty Museum *Rest on the Flight to Egypt*: Turner, Hendrix and Plazzotta 1997, no. 28.

48 The *Corpus* was reviewed by Joannides (1981b) and Hirst 1983.

49 Hirst 1984 (it is now in the J.P. Getty Museum); the Castle Howard drawing was sold at Sotheby's, London, on 11 July 2001; the Cooper Hewitt drawing was published by Clifford 2002; the Belgian drawing was published by Joannides 2001: the two Madrid drawings are in Nicholas Turner's new catalogue of the Italian drawings: Turner and Matilla 2004, nos 1–2.

50 The most common drawings that bear the signatures of the artist who made them are contractual designs.

51 Thode in his 1913 catalogue of Michelangelo's drawings was the first twentieth-century scholar to argue in favour of the traditional attribution of the Oxford sketchbook. In recent times the most persuasive advocates of the drawings have been Wilde in the 1953 exhibition, Parker in his 1956 catalogue and Hirst (1986b). The case is also well argued in Joannides' forthcoming Ashmolean catalogue.

52 This tradition has been upheld in recent times by Perrig's elevation of Quaratesi, Cavalieri and Condivi to account for drawings that do not concur with his restrictive view of Michelangelo's canon.

53 For Wilde's biography see Hirst's obituary in *The Burlington Magazine* 113, 1971, pp. 155–7 and Dennis Farr's entry in the *Oxford Dictionary of National Biography,* Oxford, 2004.

54 For a very different assessment of Michelangelo's graphic corpus see Perrig 1991.

55 Vasari (Bettarini and Barocchi ed.) 1987, VI, p. 7.

56 For the measurements see Bambach 1999, fig. 6.

57 An exception to this are the six trimmings in the Casa Buonarroti from a single sheet of studies for a *Transfiguration. Corpus* I, nos 78–83.

58 Examples of sixteenth-century cut-and-paste editing of drawings include Raphael (Pouncey and Gere 1962, no. 27) and Vasari (Turner 1986, no. 123).

59 This, like much else in the following analysis of Michelangelo's surviving corpus, is taken from Hirst 1988a, pp. 16–21.

60 Paul Joannides suggested (2003a, p. 61) that a red chalk study on the verso of a Louvre drawing might be for the *David: Corpus* I, no. 3v.

61 Hirst 1988a, p. 17.

62 *Corpus* III, nos 358r, 383 and 384.

63 *Carteggio* I, no. cclv, p. 318.

64 For the use of the word *cartone* or *chartone* in the artist's letters see Bambach [Cappel] 1990, p. 498, n. 41. Vasari reports that the heirs of Girolamo degli Albizi owned four cartoons from the Sistine vault with figures of *ignudi* and prophets and that the Florentine banker Bindo Altoviti had been presented by Michelangelo with the cartoon of the *Drunkeness of Noah.* Vasari (Bettarini and Barocchi ed.) 1987, VI, pp. 64 and 109. The date of Michelangelo's gift of the cartoon is given as *c.* 1535 in Chong, Pegazzano and Zikos 2003, p. 395. None of these cartoons survives.

65 *Carteggio* IV, nos cmlvii and mlxii, pp. 90–1 and 238.

66 Frey 1923–30, II, nos cdxxxv and cdxlix, pp. 53–5 and 82.

67 Both Uffizi, Florence (*Corpus* III, nos 393 and 409).

68 Vasari (Bettarini and Barocchi ed.) 1987, VI, p. 108.

69 *Carteggio* I, no. vii, pp. 11–12; Ramsden 1963, I, no. 6, pp. 11–13.

70 For Michelangelo's letter to his father: *Carteggio* I, no. lxxxix, p. 121; Ramsden 1963, I, no. 63, p. 62; the storage of the marbles is reported by Sellaio in a letter of August 1516: *Carteggio* I, no. cxlviii, p. 190.

71 There are two letters to Michelangelo from Sebastiano describing the state of the house after this disaster in February and June 1531: *Carteggio* III, nos dcccxi and dcccxv, pp. 299–300 and 308–10.

72 The theft is recorded in a note in Mini's hand: *Ricordi* pp. 371–2. The names of the perpetrators are given by Vasari (Bettarini and Barocchi ed.) 1987, VI, p. 82.

73 For a copy of a lost Parmigianino drawing inspired by Exh. No. 14r see Popham 1971, I, no. O.C.2, p. 233, II, pl. 267.

74 For the watermarks on Michelangelo's drawing see Roberts 1988.

75 For a provocative enquiry into the Casa Buonarroti provenance see Perrig 1999.

76 Wilde 1953a, no. 34.

77 This is expounded in chapter IV of Hirst's study of Michelangelo's drawings (1988a, pp. 22–31).

78 Bonsanti 2001, pp. 513–18.

79 The relevant references are given in the entry for the drawing in the Haarlem catalogue: van Tuyll van Serooskerken 2000, no. 48.

80 For the history of the Teyler drawings see van Tuyll van Serooskerken 2000, pp. 13–29.

81 For Christina's drawing collection see Bjurström 1997, pp. 123–9.

82 A list of these is given in Martin Clayton's appendix to Joannides 1997, pp. 208–9, with some additional items given in van Tuyll van Serooskerken 2000, p. 28, n. 69.

83 Van Tuyll van Serooskerken 2000, no. 31. Joannides in the forthcoming Ashmolean catalogue tentatively suggests that the group may have belonged to one or other of Daniele da Volterra's pupils, Michele degli Alberti or Feliciano di San Vito.

84 Passavant 1836, II, pp. 97–8. The registration numbers and present attributions of the works listed are as follows: 1. Pp. 1–59 (Attributed to Clovio); 2. Ff.1–13 (After Michelangelo); 3. Pp. 1–61 (Bandinelli); 4. Pp. 1–58 (Michelangelo); 5. Pp. 2–123 (Franco); 6. Ff. 4–2 (Follower of Michelangelo). He also attributed to Andrea del Sarto a red chalk drawing from Cracherode's collection then listed as Michelangelo (Ff. 4–4). This study is by the later Florentine artist Matteo Rosselli.

85 Gere and Pouncey 1983, I, no. 123, II, pl. 107.

86 For discussion of the provenance of the Michelangelo drawings in the Royal Collection see Martin Clayton's appendix to Joannides 1996a, pp. 205–9.

87 The Christ Church drawings are *Corpus* nos 86 (I), 280 and 282 (II), and 421 (III).

88 Ottley's activities as a collector are discussed in Gere 1953, pp. 44–53 and in greater detail in Joannides' forthcoming Ashmolean catalogue. My discussion of provenance is hugely indebted to his research.

89 *Corpus* II, no. 327r.

90 Paul Joannides, in his study of the provenance of the Michelangelo drawings at Oxford in his forthcoming catalogue, has noted that at least three of Ottley's Michelangelo drawings were later specified by Woodburn as having previously belonged to Wicar.

91 This figure is quoted in Joannides' Introduction to the Ashmolean Michelangelo catalogue (forthcoming) and is taken from that given at the end of the ninth exhibition of the Lawrence Gallery devoted to Raphael.

92 Quoted in Gere 1953, n. 22.

93 For this transaction and the Oxford purchase see Parker 1956, pp. xvi–xx.

94 Waagen 1854–7, I, p. 225.

95 The fascinating circumstances of the acquisition are discussed by Thornton and Warren 1998, pp. 9–29.

96 For Malcolm see Coppel in Royalton-Kisch, Chapman and Coppel 1996, pp. 7–20.

97 Turner 1999.

98 1993-4-3-10 and 11; Turner and Eitel-Porter 1999, nos 353–4.

Notes to Chapter 2

1 A letter of December 1547: *Carteggio* IV, no. mxcvi, p. 284.

2 Details of the political careers and offices held by the Buonarroti family are given in Hatfield 2002, pp. 201–10.

3 He served three times as *podestà* in small Tuscan towns and once as *castellano* (keeper of the castle) of Facciano in the Romagna: Hatfield 2002, pp. 205–6.

4 The artist's financial dealings and land deals are investigated in Hatfield 2002. A fine example of this kind of letter is the one written by Michelangelo to his errant brother Giansimone in the summer of 1509: *Carteggio* I, no. lxvii, pp. 95–6; Ramsden 1963, I, no. 49, p. 52.

5 *Carteggio* IV, no. mlxx, p. 249; Ramsden 1963, II, no. 272, p. 64.

6 *Carteggio* II, no. cdlxxiii, p. 245.

7 *Carteggio* IV, no. mcix, p. 299; Ramsden 1963, II, no. 306, pp. 91–2.

8 *Carteggio* IV, no. mlxxxviii, pp. 274–5; Ramsden 1963, II, no. 287, p. 79.

9 An example being the lowly sculptor Donato Benti who supervised the quarrying of marble for the S. Lorenzo façade: see Wallace 1994, pp. 29–31.

10 Lodovico's letter: *Carteggio* I, no. vi, pp. 9–10; Michelangelo's poem: Girardi 1960, no. 86; Ryan 1996, pp. 79–83, 286–7.

11 Condivi (Nencioni ed.) 1998, p. 8; Condivi (Wohl ed.) 1999, p. 6.

12 A conservative estimate is that complications related to childbirth accounted for the death of a fifth of the young married Florentine women in the early fifteenth century: Musacchio 1999, p. 25. For a psychoanalytic view of the effects it had on Michelangelo's art see Liebert 1983, pp. 13–28.

13 Condivi (Nencioni ed.) 1998, p. 8; Condivi (Wohl ed.) 1999, p. 6 and in the 1568 edition of Vasari (Bettarini and Barocchi ed.) 1987, VI, p. 5. The various types of *macigno* are described by Wallace 1994, pp. 147–50.

14 For the connections with Settignano: Wallace 1994, pp. 27–38.

15 The argument in favour of Michelangelo being able to read Latin is presented by Summers 1981, p. 463, n. 23. The probability that he didn't (an impediment to those seeking to portray Michelangelo as an assiduous reader of Latin texts: see the postscript to Hall 2005, pp. 240–1) is indicated by his need to have contracts translated from Latin: Hirst 1985, p. 159. Further

evidence is provided by Michelangelo's refusal to write even the simplest Latin phrase; see the 1518 letter sent by the Florentine literati petitioning for the return of Dante's remains to Florence: Gotti 1875, app. I, p. 84.

16 An example being the inscription, *tempo verra ancor*, on the back of the Getty *Rest on the Flight* (Turner, Hendrix and Plazotta 1997, no. 28) that Carol Plazzotta identified as coming from the third stanza of a canzone by the poet (*Canzoniere*, no. 126).

17 The painting is in an English private collection, see Weil-Garris Brandt, Acidini Luchinat, Draper et al. 1999, pp. 329–30.

18 Poeschke 1996, pp. 68–71, pls 1–6.

19 Piero's involvement was suggested by Hirst 1985, p. 155 and Elam 1992b, p. 60; for the 1495 document see Caglioti 2000, pp. 262–4.

20 The reference to the marble is in a letter of June 1506 from Lorenzo Strozzi to Michelangelo's brother Buonarroto: *Carteggio Indiretto* II, no. 2, pp. 323–4.

21 Elam 1993, pp. 58–60.

22 For the history and possible appearance of the *Hercules* see Joannides 1977, pp. 550–5 and 1981a, pp. 20–3.

23 The work was first identified by Lisner 1963; Poeschke 1996, pp. 71–2, pls 7–9.

24 Condivi (Nencioni ed.) 1998, p. 62; Condivi (Wohl ed.) 1999, p. 105. For the links between Savonarola and Michelangelo's future patron Giuliano della Rovere, and the influence of the friar's follower Sante Pagnini on the Sistine vault, see Wind 2000, pp. 1–22.

25 Girardi 1960, no. 10; Ryan 1996, pp. 7–9, 262–3. This is generally dated to Michelangelo's second period in Rome; for a suggestion that it is earlier see Bardeschi Ciulich 1989, pp. 17–18.

26 For Savonarola's sermons of the period see Ridolfi 1959, pp. 78–9. Vasari in the first edition of the *Lives* makes no mention of Michelangelo's flight nor of his subsequent period in Bologna. Michelangelo's visions of future calamities and his instinct to heed them was not abnormal for the period: see Wind 2000, pp. 23–33.

27 The comments on Piero de' Medici's reaction to Michelangelo are contained in a letter to the sculptor Adriano Fiorentino from his brother Ser Amadeo quoted in Elam 1992b, p. 58.

28 Later the following year the Bentivoglio also purchased the Medici Garden as a favour to Piero and his family: see Elam 1992b, pp. 51–2. See also L. Ciammitti, *Note biografiche su Giovan Francesco Aldrovandi* in Weil-Garris Brandt, Acidini Luchinat, Draper et al. 1999, pp. 139–40.

29 Poeschke 1996, pp. 72–3, pls 10–12.

30 Life of Ercole Ferrarese, Vasari (Bettarini and Barocchi ed.) 1971, III, p. 422.

31 For the brothers see Brown 1979, pp. 98–103 and Baldini 2003.

32 A well-known contemporary example of this is Leonardo having designed equestrian monuments in Milan to honour his Sforza patrons and then later for one of the architects of their downfall, the mercenary captain Giovanni Giacomo Trivulzio.

33 Shearman 1975a, pp. 12–27.

34 For Lorenzo's purchase of a gem in 1487 denounced a year later as a fake by Caradosso see Agosti in Barocchi 1992, pp. 22–3.

35 For a stimulating discussion of Michelangelo's activities as a forger and his response to the art

of the past see Nagel 2000, pp. 1–22.

36 The best account of this episode and of the subsequent history of the marble is given by Hirst in Hirst and Dunkerton 1994, pp. 21–8. For further information on Baldassare del Milanese and Galli see the essay of Baldini, Lodico and Piras in Weil-Garris Brandt, Acidini Luchinat, Draper et al. 1999, pp. 149–62.

37 *Carteggio* I, no. i, pp. 1–2.

38 Poeschke 1996, pp. 73–5, pls 13–16.

39 For the arguments in favour of the sculpture see Weil-Garris Brandt, Acidini Luchinat, Draper et al. 1999, pp. 84–97, 300–7 and Joannides 2003d. For a dissenting voice see Heikamp 2000.

40 Michelangelo's letter to his father: *Carteggio* I, no. iii, pp. 4–5; for the painting, often known as the *Manchester Madonna* because of its inclusion in a famous nineteenth-century exhibition of Italian treasures held in the city, see Hirst in Hirst and Dunkerton 1994, pp. 37–46.

41 Agosti and Hirst 1996, pp. 683–4.

42 Poeschke 1996, pp. 75–77, pls 17–19.

43 The timing of this was established in Hirst 1985, pp. 154–9.

44 *Carteggio* I, no. v, pp. 7–8.

45 As Hirst noted, transfer of money from Rome to Florence suggests that Michelangelo's move took place in March 1501: Hirst and Dunkerton 1994, n. 14, p. 79.

46 For the painting see Hirst in Hirst and Dunkerton 1994, pp. 57–71 and Nagel 2000, pp. 23–48. Doubts about identifying the S. Agostino commission with the London panel are raised in Hatfield 2002, pp. 13–14.

47 Quoted in Cadogan 2000, p. 3.

48 Dacos 1962.

49 *Corpus* I, no. 3; Joannides 2003a, no. 1. For an appreciation of Michelangelo's sympathetic interpretation of Giotto's figures see Nagel 2000, pp. 4–8.

50 For comparison of Michelangelo and Ghirlandaio's painting techniques see Dunkerton in Hirst and Dunkerton 1994, pp. 83–126.

51 'Ghirlandaio was the man who first put a pen in Michelangelo's hand and taught him how to use it', Berenson 1970, I, p. 187.

52 For a study of the two transfer methods see Bambach 1999b, pp. 56–80.

53 An excellent analysis of Ghirlandaio's compositional methods is given in Cadogan 1984, pp. 159–72.

54 For the critical history of these see van Tuyll van Serooskerken 2000, no. 45 and Wilde 1953a, no. 1. Wilde dated the British Museum drawing slightly later because of the parallels he perceived with Michelangelo's sculpted apostles for the Piccolomini altar (1501–4).

55 *Corpus* I, no. 5r.

56 Wilde 1953a, p. 2.

57 For example, the altarpiece originally in the Tornabuoni chapel now in Munich, Cadogan 2000, no. 38.

58 Tolnay's comparison (1943, p. 67) of the figure with an alchemist drawn by Dürer on a sheet in the Albertina (Strauss 1974, I, no. 1496/16) seems to confirm that the featureless object held by Michelangelo's figure cannot be a skull.

59 For example in Benozzo Gozzoli's depiction of the Magi's exotic retinue in the Medici palace chapel fresco.

60 The letter is cited in Elam 1992b, p. 58.

61 Vasari (Bettarini and Barocchi ed.) 1976, IV, pp. 125–6.

62 The circumstances and form of the service are described in Wittkower 1964, pp. 92–3. For the address: Varchi 1564.

63 Elam 1992b, pp. 41–84.

64 Frey 1892, p. 110.

65 Kent 2004, especially ch. 4.

66 For Cosimo's patronage see Kent 2000, especially chapters 10 and 12.

67 Bober and Rubinstein 1986, p. 72.

68 On Verrocchio's training see Butterfield 1997, pp. 9–10.

69 Bertoldo is documented as having carved wooden angels for Florence Cathedral: Draper 1992, pp. 25–6, doc. 9. Hirst's suggestion (1999b) that the Manhattan *Cupid* is by Bertoldo was rejected by Draper (1997, p. 400).

70 Kent 1993. Bertoldo's date of birth is also discussed in Draper 1992, pp. 3–4.

71 Draper 1992, pp. 7–12.

72 *Corpus* I, exh. no. 37v is copied from Donatello's marble *David* in the Bargello. Luke Syson has pointed out to me the similarity between the Christ Child in Michelangelo's *Taddei Tondo* and a child in Donatello's *Feast of Herod* bronze relief in the Siena baptistery.

73 In the 1479 letter to Lorenzo: Draper 1992, pp. 7–12.

74 Bertoldo's relief is now in the Bargello: Draper 1992, no. 11, pp. 133–45.

75 For further discussion of Bertoldo's influence see Draper in Weil-Garris Brandt, Acidini Luchinat, Draper et al. 1999, pp. 57–63.

76 Wallace notes that the two were distantly related through Michelangelo's Rucellai mother: Wallace in Marani 1992, pp. 152–3.

77 It is described as such in a letter dated March 1527 written by the Mantuan ambassador in Florence, Giovanni Borromeo, to Federico II Gonzaga. Borromeo was hoping to acquire the work for his employer; the relevant passage is quoted in Tolnay 1943, I, p. 133.

78 See Hankins 1991 and his essay in Weil-Garris Brandt, Acidini Luchinat, Draper et al. 1999, pp. 25–9.

79 *Carteggio* II, no. cdlxxvii, pp. 252–3.

80 *Carteggio* III, no. dccxxxii, pp. 194–5.

81 *Carteggio* V, no. mccciii, p. 181.

82 For a good introduction to this topic see Agosti and Farinella 1987, pp. 12–13, n. 3

83 For the histories of these works see Bober and Rubinstein 1986, nos 28, 132 and 122 respectively. For Lorenzo's collection of cameos see Dacos, Giuliano, Grote et al. 1973.

84 Vasari (Bettarini and Barocchi ed.) 1987, VI, p. 21.

85 Folio 1 verso and folio 2 of London II: Bober 1957, pp. 77–8, fig. 108. For the dating of the sketchbook see Faietti and Scaglietti Kelescian 1995, p. 70.

86 *Carteggio* I, no. i, pp. 1–2; Ramsden 1963, I, no. 1.

87 Hirst in Hirst and Dunkerton 1994, p. 35.

88 For an introduction to Florentine collections of antiquities see Agosti in Barocchi 1992, pp. 21–8.

89 For the album: Egger, Hülsen and Michaelis 1906.

90 Condivi (Nencioni ed.) 1998, p. 10; Condivi (Wohl ed.) 1999, p. 10.

91 Vasari (Bettarini and Barochi ed.) 1971, III, p. 492.

92 *Corpus* II, nos 231–4. A sketchy drawing after the same marble is found on the verso of a drawing in the Louvre: *Corpus* II, no. 230v (Joannides 2003a, no. 22) that has on the recto a female figure seen from behind inspired by the same sculpture.

93 Hirst 1988a, p. 61.
94 *Corpus* I, no. 99r, the history of the relief is given in Bober and Rubinstein 1986, no. 94. For the Louvre drawing made for Sebastiano see *Corpus* I, no. 92; Joannides 2003a, no. 38.
95 Joannides 1983, no. 398.
96 The attribution to della Volpaia was made in Buddensieg 1975. For further information on della Volpaia see Pagliara in *DBI* 1989, XXXVII, pp. 795–7.
97 For the volume's connection with dal Pozzo, see Campbell 2004, I, pp. 37–40.
98 For the dal Pozzo insertions see Campbell 2004, II, pp. 597–655.
99 *Corpus* IV, nos 511–12, 516–20.
100 Michelangelo's copies are reproduced alongside the relevant pages from the Codex Coner in Agosti and Farinelli 1987, pp. 86–129.
101 For Michelangelo's reliance on his own judgement in matters of proportion see Vasari (Bettarini and Barocchi ed.) 1987, VI, p. 109.
102 The relevant pages are reproduced in Agosti and Farinelli 1987, p. 105.
103 *Carteggio* IV, pp. 243–5 and no. mlxxxiii, pp. 267–8.
104 Ackerman 1986, p. 45.
105 The consensus was breached by Hartt (1971, no. 157) who eccentrically believed Exh. No. 7 to be a study of 1517–18 for a statue of John the Baptist for the façade of S. Lorenzo.
106 An even better example is the child studied on the verso of a drawing in the Louvre: *Corpus* I, no. 20v; Joannides 2003a, no. 13.
107 Details of the bust, exhibited in London only, are given in Appendix I, p. 284. Weinberger 1967, p. 123 noted that the inclusion of drapery pointed against the drawing being a satyr.
108 *Corpus* I, no. 24r; the identification of the model and its location was made by David Ekserdjian in his 1993 article.

Notes to Chapter 3

1 For details of the payment that shows Michelangelo's move to Florence: Hirst in Hirst and Dunkerton 1994, n. 14, p. 79.
2 For an account of Savonarola's fall see Pastor 1898, VI, pp. 3–51.
3 For the political fortunes of Savonarola's followers after his death see Polizzotto 1994, ch. 1.
4 Rubinstein 1995, p. 40.
5 For the Florentine political scene of the period see Butters 1978.
6 Accounts of Soderini's election and his tenure in office are given in Pesman Cooper 1967, pp. 145–85 and 1978, pp. 71–126; Butters 1978.
7 In the *Deliberazione* of the Opera del Duomo of 2 July 1501 (Poggi 1988, no. 455) the block is described as 'male abbozzatum et supinum'; the correct reading of this is given in Hirst 2000, n. 35.
8 Hirst's suggestion for the destination of this marble (Hirst and Dunkerton 1994, pp.70–1) is questioned by Hatfield (p. 14, n. 53).
9 Hirst 2000.
10 Hirst notes that as late as April 1504 the destination seems not to have been decided, 2000, p. 490. Two differing interpretations of the January 1504 meeting and of the sculpture's symbolism are presented in Levine 1974 and Parks 1975, pp. 560–70.
11 For the anti-Medici interpretation see Tolnay 1964, p. 10; for the perpetrators see Hirst 2000, n. 30.

That vandalism was a problem in Renaissance Florence is demonstrated by two documents relating to the Opera del Duomo. The first is a payment for a guard to protect Bandinelli's marble *Dead Christ with an Angel* before it was installed in 1552, and the second a report in late December 1582 that cloth hangings behind Benedetto da Maiano's *Crucifix* in the choir of the cathedral had been deliberately set alight 'per dispetto': Waldman 2004, nos 896 and 1551, pp. 503 and 848.
12 Caglioti 2000, I, pp. 334–8.
13 Hirst in Hirst and Dunkerton 1997, pp. 84–5.
14 Argentina's letter to her brother sent by Soderini to Michelangelo on 7 August 1516 (*Carteggio* I, no. cxlvii, pp. 188–9); the tabernacle project is first mentioned in a letter from Piero Rosselli in May 1518 (*Carteggio* II, no. cclxxx, p. 2); Soderini thanked the artist for the design in October 1518 (*Carteggio* II, no. ccclx, p. 102).
15 *Carteggio* II, no. dxxxvi, p. 323.
16 The questions as to which bronze *David* Rohan wanted copied, and the relevant locations at this period of Donatello and Verrocchio's bronze figures of *David*, are exhaustively discussed in Caglioti 2000, pp. 313–16. The location of the two works is clarified in Paolozzi Strozzi and Vaccari's essay, *Verrocchio's 'David': New Facts, New Theories* in Radke 2003, pp. 14–16.
17 Agosti 1993, pp. 68 and 78–9, n. 32.
18 *Corpus* I, no. 175; Joannides 2003a, no. 4.
19 Amy 2000, pp. 493–6.
20 The Spanish artist Alonso Berruguete utilized the pose of the figure in Michelangelo's drawing for a sculpture of St John the Evangelist in Vallodolid in 1526–32: for details of this see Joannides 2003a, no. 5.
21 Poeschke 1996, pp. 79–81, pls 26–7. The marble seems only to have been given to the church in 1514.
22 Details of payment and shipment are given in Mancusi-Ungaro 1971, pp. 35–40.
23 Poeschke 1996, pp. 81–4, pls 28–33.
24 Henry, Kanter and Testa 2001, pp. 112–13.
25 For the history of the building see Rubinstein 1995.
26 For the dimensions of the room, see Newton and Spencer 1982, p. 48 and Bambach 1999a, pp. 107–8, n. 5.
27 For Leonardo's activities in Florence at this period see Kemp 1981, pp. 213–77; Zöllner 2003, pp. 143–74.
28 Wilde's argument in favour of the frescoes by Leonardo and Michelangelo being located on the east wall (Wilde 1944) was challenged by Rubinstein (1995, pp. 70–5) who argued in favour of the opposite side. For a guide to the literature regarding this question see Bambach 2003, p. 485, n. 1.
29 Morozzi 1988–9, p. 320.
30 Bambach 1999a, p. 130.
31 In a letter to Fattucci of December(?) 1523: *Carteggio* III, no. dxciv, pp. 7–9; Ramsden 1963, I, no. 157. The date of Michelangelo's summons to Rome is given in Hirst 1991, p. 762.
32 For the *Battle of Anghiari* see Kemp 1981, pp. 234–47.
33 Villani 1846, pp. 493–7.
34 For a discussion of Michelangelo's sources for the narrative see Cecchi 1996.
35 Bruni (Hawkins ed.) 2004, II, pp. 461–5.
36 Rubinstein 1995, p. 75.
37 Vasari gives two differing account of the cartoon's

destruction, one naming the unpopular Florentine sculptor Bandinelli as the culprit: cf. Vasari (Bettarini and Barocchi ed.) 1984, V, p. 241, and 1987, VI, p. 25.
38 Cellini 1981, p. 31.
39 Vasari (Bettarini and Barocchi ed.) 1984, V, pp. 393–4.
40 *Corpus* I, nos 50–4. The last of these, a black chalk study in the Louvre of a soldier seen from the back, was considered a copy by Tolnay; but Joannides is surely right in claiming it to be autograph: Joannides 2003a, no. 6.
41 See Hirst 1986a, I, pp. 43ff. and 1988a, p. 44.
42 Hirst 1988a, pp. 43–4.
43 Exh. No. 10r was used for a frieze of a Roman triumph in the Palazzo dei Conservatori, Rome; Exh. No. 9r for a figure in the *Baptism of Christ* over the altar of the Ricci chapel in S. Pietro in Montorio, Rome: see van Tuyll van Serooskerken 2000, p. 100, n. 3 and p. 98.
44 Wilde 1932–4, p. 59.
45 Parker 1956, no. 27.
46 A good example of Raphael imitating such studies is his black chalk nude study of a soldier in the Ashmolean: Joannides 1983, no. 306r. The Florentine artist Andrea del Sarto was another artist who was inspired by Michelangelo's example.
47 *Corpus* I, no. 53r.
48 This observation is made by Ames-Lewis in his essay on Raphael and Michelangelo in Ames-Lewis and Joannides 2003, p. 19.
49 Wilde (1953a, p. 8) suggested that a faint leadpoint sketch on a drawing in the Ashmolean (*Corpus* I, no. 39) was related to the figure, a connection that Parker denied (Parker 1956, p. 139).
50 The British Museum registration number for the Cigoli drawing is 1986-6-21-42; on the recto there is a study for the 1594 altarpiece in S. Marco, Florence, the *Emperor Heraclius Carrying the True Cross*.
51 *Corpus* I, no. 49r.
52 Another explanation for the number of nude studies from this period is that Michelangelo was planning an undocumented composition of the *Martyrdom of the Ten Thousand*, Joannides 1994. While I remain to be convinced of this idea, I should acknowledge that I accept Paul Joannides' dating of the British Museum pen studies of the two crucified men (*Corpus* I, no. 162; Wilde 1952a, no. 12) to the same period as the Cascina cartoon. Wilde believed this to be related to the figure of Haman in the Sistine vault.
53 The inscription on the verso 'chosse de Bruges', not in Michelangelo's hand, must be a reference to the marble *Bruges Madonna* (Fig. 19) which he was working on at that time.
54 The most famous example of a Raphael drawing in this mould is the sheet of Virgin and Child studies in the British Museum: Pouncey and Gere 1962, no. 19.
55 Popham and Pouncey 1950, no. 238; Henry 1998, no. 14.
56 The 1513 meeting with Signorelli is related in Michelangelo's letter of 1518: *Carteggio* II, no. cclxxxv, pp. 7–8.
57 *Corpus* I, nos 37r and 47r. The Louvre drawing is Joannides 2003a, no. 9.
58 Hirst 1988a, p. 43. He noted that the Uffizi drawing must post-date the invention of this group as it includes a figure, also found in the cartoon, whose

59 She was intended to look slightly to the right: see Wilde 1953, p. 13, n. 1

60 The estimate of the size of the *Bathers* is taken from Wilde 1944, pp. 80–1.

61 The tubular shorthand used in the description of the horsemen is reminiscent of studies by Jacopo Zucchi (c. 1540–96), although the quality of the British Museum drawing is much beneath him. For Zucchi as a draughtsman see Pillsbury 1974, pp. 3–33.

62 The most revealing study of the connection between the two artists remains Wilde 1953b. Further confirmation of the mutual interest the two artists had in each other's work has emerged in a study of Leonardo's ideas for a colossal sculpture of Hercules: see Bambach 2001, pp. 16–23.

63 Wilde 1953a, p. 70.

64 *Corpus* I, no. 102r.

65 Dominique Cordellier's discovery of the Louvre drawing (Joannides 2003a, no. 5) verified Popp's view on the placement of the statue: Popp 1925–6, p. 138. For Michelangelo's insistence on making profile views of statues even when they could not be seen from that angle see Hirst 1988a, pp. 3–4.

66 Girardi 1960, nos 1–2; for English translations see Ryan 1996, pp. 3 and 259.

Notes to Chapter 4

1 See Hirst 1991, pp. 763–4.

2 For Julius' career Pastor's history (1898, vol. VI) has yet to be bettered; a recent biography of the pontiff is Shaw 1993.

3 Bauman 1990, p. 55.

4 Sections of this building, including some of Pinturicchio's decorations, were incorporated into the Palazzo Colonna and are still extant: Scarpellini and Silvestrelli 2004, pp. 107–9.

5 For the palace and its collection of antiquities see Brown 1986, pp. 235–8; Bauman 1990, pp. 103–22; and Magister 2002, pp. 393–587. For the sculpture court created by Julius at the Vatican see Brummer 1970.

6 Vasari (Bettarini and Barocchi ed.) 1976, IV, pp. 144 and 146–7. The relevant passage in Francesco Sangallo's 1567 letter to Vincenzo Borghini is quoted in *Carteggio* I, p. 365.

7 Hirst 1976, pp. 376–7.

8 See, for example, the reference to Giuliano in Piero Rosselli's letter to Michelangelo of May 1506: *Carteggio* I, no. x, p. 16. For a translation of this see Robertson 1986, p. 98.

9 Such as Bramante's reported attempt to discourage Julius from commissioning Michelangelo to paint the Sistine chapel reported in Rosselli's letter cited above, n. 8. Rosselli's motives are discussed in Robertson 1986, pp. 98–9.

10 Vasari (Bettarini and Barocchi ed.) 1987, VI, p. 37.

11 *Carteggio* IV, no. mi, pp. 150–5; Ramsden 1963, II, no. 227, pp. 26–32.

12 The relationship between Bramante and Michelangelo is analysed in Robertson 1986, pp. 91–105. Arguably the least convincing part of his discussion is the suggestion that Michelangelo approached the architect for advice on the Sistine chapel vault.

13 Condivi (Nencioni ed.) 1998, p. 58; Condivi (Wohl ed.) 1999, pp. 99–101.

14 Disparaging remarks about Bramante are reported in Vasari (Bettarini and Barocchi ed.) 1987, VI, p. 37 and in Condivi (Nencioni ed.) 1998, pp. 23–4, 29–30; Condivi (Wohl ed.) 1999, pp. 30–3 and 39.

15 *Carteggio* IV, no. mlxxi, pp. 251–2; Ramsden 1963, II, no. 274, pp. 69–70.

16 For an assessment of the financial aspects of the commission see Hatfield 2002, pp. 30–4, 126–38.

17 *Carteggio* II, no. ccclxxxii, pp. 129–30; Ramsden 1963, I, no. 134, p. 121.

18 *Carteggio* III, no. dcclx, pp. 239–40; Ramsden 1963, I, no. 178, pp. 166 and 169.

19 Letter to Luigi del Riccio: *Carteggio* IV, pp. 148–9; Ramsden 1963, II, no. 226, pp. 24–6.

20 *Carteggio* IV, no. mi, pp. 150–5; Ramsden 1963, II, no. 227, pp. 26–31.

21 *Carteggio* III, no. dxcv, pp. 10–11; Ramsden 1963, I, pp. 191–2.

22 For the Metropolitan drawing see Hirst 1976, pp. 375–82. The latter's original suggestion that the New York drawing was related to the 1513 contract was revised to 1505 in his entry in Hirst 1988b, pp. 26–8. For the Louvre drawing see Joannides 1991b, pp. 32–42 and Cordellier 1991, pp. 43–8. A montage of the two drawings is illustrated by them on p. 46. The two drawings are nos 14v and 15v in Joannides 2003a.

23 Elevations and plans of the 1505 tomb reconstructed from Condivi and Vasari's descriptions by Panofsky (1937), Weinberger (1967), Hartt (1969) and Frommel (1977) are illustrated in Argan and Contardi 2004, pp. 50–2.

24 The agreed sum may have been 10,500: see Hatfield 2002, p. 18, n. 5.

25 *Carteggio* I, no. vii, pp.11–12; Ramsden 1963, I, no. 6, pp. 11–13.

26 For the suggestion that the Sicilian sculptor Antonello Gagini was in Michelangelo's studio at that time see Kruft 1975. Even if he did not work for Michelangelo (Argan and Contardi 2004, p. 49, describe Kruft's hypothesis as 'improbable') Gagini's quotation of a relief from the Julius tomb in his decoration of the choir of Palermo cathedral in 1507 shows that some of the decorative elements had been carved by the time that the Sicilian left Rome, probably in autumn 1505.

27 *Carteggio* I, no. viii, pp. 13–14; Ramsden 1963, I, no. 8, pp. 13–15.

28 *Carteggio* I, no. x, p. 16.

29 For Michelangelo's relations with Alidosi see Beck 1990 and Hirst 1991, p. 765. Correspondence between Florence and Rome with regard to Michelangelo's return is published in Gaye 1839–40, II, pp. 83ff.

30 See Hirst 1991, pp. 762–6.

31 Gaye 1839–40, II, no. xxix, p. 83.

32 According to Calcagni's marginal notes: see Condivi (Nencioni ed.) 1998, no. 13, p. 27; further confirmation is provided by the letter written from Adrianople (mod. Edirne) by Tommaso di Tolfo in 1519 recalling Michelangelo's wish some fifteen years earlier to visit Turkey: *Carteggio* II, no. cdxxiv, pp. 176–7.

33 *Carteggio* III, no. dxciv, pp. 7–9.

34 *Carteggio* I, nos xii–xliv, pp. 18–61. For the letters relating to the Aldobrandini dagger see Wallace 1997. During his time in Bologna in July 1507 Michelangelo was asked to submit designs for the completion of Brunelleschi's drum of the dome of Florence cathedral: see Marchini 1977.

35 *Carteggio* I, nos xli and xliv, pp. 57 and 61;

36 The papal *breve* summoning Michelangelo to Rome is mentioned in a letter written by Piero Soderini at the end of June 1508: Gaye 1839–40, II, p. 101.

37 Hatfield 2002, p. 22.

38 *Ricordi* no. 2, pp. 1–2.

39 *Carteggio* I, no. xlvii, pp. 66–7; Ramsden 1963, I, no. 42, p. 45. Caroline Elam informs me that the Gesuati were glass makers, hence their supply of pigments to painters. As Ramsden notes, Gozzoli is recorded as having bought azurite from the monks in 1459.

40 For Michelangelo's hiring of painting assistants see *Ricordi* no. 1, p. 1 and Granacci's letter to him: *Carteggio* I, no. xliv, pp. 64–5 and 375–8.

41 For the Sistine chapel's history prior to Julius see Shearman 1986, pp. 22–87; a shortened version of this essay incorporating new observations based on findings gathered during the restoration of the building was published in Mancinelli, Morello, De Strobel et al. 1990, pp. 19–27. Shearman's article amends certain details given in Wilde's examination of the chapel's decoration in a 1958 lecture to the British Academy (republished in Wallace 1995a, pp. 37–57).

42 For the construction of the chapel see Pagliara's contribution to Weil-Garris Brandt 1994, pp. 15–19.

43 The newly restored fifteenth-century decorations are illustrated and discussed in Buranelli and Duston 2003. Particularly valuable are the essays by Nesselrath and Pagliara, which provide an excellent summary of the findings that they and other scholars have gleaned from the recently completed restoration of the frescoes and the chapel.

44 Now in the Albertina, Vienna: Scarpellini 1984, fig. 40.

45 Gabinetto Disegni e Stampe, Uffizi (711A). The drawing is discussed and reproduced, along with an illustration of its stylus underdrawing, in Weil-Garris Brandt 1992, pp. 60–1, 82–3, figs 12–13. It is not known how the lunettes above the windows were decorated prior to Michelangelo.

46 The best-known chapel with this kind of vault decoration is Giotto's Arena chapel in Padua.

47 *Carteggio* III, no. dxciv, pp. 7–9; Ramsden 1963, I, no. 157, pp. 148–9. Michelangelo actually described the Apostles as having been intended for the lunettes, but he meant the spandrels, as is shown by the British Museum and Detroit drawings.

48 This observation was made by Weil-Garris Brandt (1992, pp. 68–73) in her revealing study of Michelangelo's early drawings for the vault.

49 A more developed study in leadpoint for the pose of a seated Apostle with his head turned the other way appears on the verso of the sheet. When Michelangelo subsequently used the remaining part of the verso to make a drapery study he seems to have roughly brushed over this figure drawing in brown wash, perhaps to make it more visible, before rubbing charcoal or black chalk over the surface to create a dark grey ground. The connection that Wilde made between the stylus underdrawing to the right of the leadpoint study of the Apostle with one on the verso of the Detroit drawing is now impossible to verify as it is so faint.

50 *Carteggio* III, no. dxciv, pp. 7–9; Ramsden 1963, I, no. 157, pp. 148–9.

51 Scarpellini and Silvestrelli 2004, pp. 241–3.

52 Bramante's comments relayed to Michelangelo in Pietro Rosselli's letter of 1506: *Carteggio* I, no. x, p. 16.

53 Pouncey and Gere 1962, no. 208.

54 The connection is rightly downplayed in Wilde 1953a, p. 19.

55 *Corpus* I, no. 120.

56 Wilde (1953a, p. 10) thought that the plan was drawn after the Sibyl but I have not been able to verify this. The study of a hand is certainly later.

57 *Carteggio* III, no. x, pp. 7–9; Ramsden 1963, I, no. 157, pp. 148–9.

58 On the reliability of the letter see Hirst 1986b, p. 211. The scholarly consensus that Michelangelo was not solely responsible for the ceiling's programme was challenged by Hope 1987, pp. 203–4.

59 Egidio da Viterbo and Sante Pagnini are just two of the theologians that have been suggested as possible advisers. The theological programme of the vault has elicited a vast amount of scholarship of which the most recent major contributions are Dotson 1979; O' Malley 1986; and Bull 1988.

60 Vasari in the first edition identified the fresco as the *Sacrifice of Noah* but then followed Condivi's description of it in the 1568 edition as a *Sacrifice of Cain and Abel*. Beck (1991), unlike most recent scholars, is in favour of the latter identification.

61 Wind's argument that Michelangelo used woodcuts in a Bible translated into Italian by Niccolò Malermi for the imagery of some of the bronze medallions has been taken up by Hope and Hatfield, both of whom argue that the artist used it more extensively as a source of inspiration: see Wind 1960; Hope 1987; and Hatfield 1991. The latter demonstrated that Michelangelo consulted the 1490 and 1493 editions of the book.

62 Mancinelli 1994, I, p. 38.

63 *Carteggio* I, no. vii, p. 11–12; Ramsden 1963, I, no. 6, pp. 11–13.

64 Vasari (Bettarini and Barocchi ed.) 1987, VI, pp. 33–4; Condivi (Nencioni ed.) 1998, p. 58; Condivi (Wohl ed.) 1999, pp. 99–101.

65 *Corpus* I, no. 133r. This schematic drawing has been the subject of a number of interpretations which have reached widely different conclusions: see for example, Mancinelli and Gilbert's contributions to Weil-Garris Brandt 1994, pp. 43–9 and 61–5 respectively.

66 Wölfllin 1890; a modified version of this chronology is presented in Tolnay 1945, pp. 105–12.

67 *Corpus* I, no. 174.

68 Girardi 1960, no. 5; Ryan 1996, pp. 5 and 260–1. Michelangelo's biographers record that his eyesight was temporarily affected after finishing the vault.

69 Hatfield (2002, p. 28) suggests that the *arriccio* was applied by Rosselli in three sections in 1508, 1509 and 1510.

70 Tolnay 1945, no. 7, p. 219.

71 Mancinelli in Mancinelli 1994, I, pp. 15–28.

72 A very different interpretation of the chronology of the vault based on the artist having used a moveable tower to paint the main part is given in Gilbert 1994b, pp. 191–219.

73 Wilde 1953b, p. 23.

74 There are also technical changes in the second part of the ceiling related to Michelangelo painting at greater speed with fewer *giornate*: Mancinelli in Mancinelli 1994, I, p. 18.

75 The marble is now in the Vatican: Bober and Rubinstein 1986, no. 132.

76 *Corpus* I, no. 143r; Joannides 2003a, no. 19r.

77 For drapery studies of this kind in Renaissance Florentine studios: Dalli Regoli 1976.

78 For drawings of this kind see Viatte, Monbeig Goguel and Pinault 1989 and Viatte's contribution to Bambach 2003, pp. 110–19.

79 Ghirlandaio's drawing in this technique is in Berlin: Cadogan 2000, no. 75.

80 For squaring see Bambach 1999b, pp. 128–33.

81 The only squared grid overlaid over one of his drawings in the exhibition, Exh. No. 59, was most likely added by a pupil to facilitate his copying of it.

82 None of the Sistine chapel studies is squared so one must assume that the enlargement of the design was done by eye.

83 See n. 64, chapter 1, for the Vasari references to these gifts.

84 Carmen Bambach astutely spotted this connection: see Bambach 1983.

85 A useful summary of this information is given in Mancinelli 1994, I, pp. 15–28 with helpful diagrams of the methods of transfer used, pp. 143–98.

86 The letter to his father dates from January 1509: *Carteggio* I, no. lxii, pp. 88–9; Ramsden 1963, I, no. 45, pp. 48–9.

87 *Carteggio* I, no. xlvi, pp. 64–5.

88 Vasari (Bettarini and Barocchi ed.) 1987, VI, p. 35.

89 For recent discussion of this question in favour of workshop participation see Wallace 1987, pp. 203–16; evidence that Michelangelo did not employ a team of assistants is given in Hatfield 2002, pp. 24–6.

90 *Carteggio* I, no. lxx, pp. 101; Ramsden 1963, I, no. 51, p. 54.

91 Their hatred was demonstrated by Francesco Maria arresting Alidosi in Modena on charges of corruption and of having colluded with the French in October 1510. He was released by Julius and rewarded with the bishopric of Bologna: Pastor 1898, VI, pp. 335–6.

92 In the biography of Raphael, Vasari (Bettarini and Barocchi ed.) 1986, IV, pp. 175–6. Vasari mistakenly dates this incursion to the period when Michelangelo was in Florence. John Gere suggested that a red chalk drawing at Christ Church, Oxford, copied from the pair of putti by Isaiah painted in the second campaign was by Raphael: Joannides 1983, no. 292. Paul Joannides kindly informs me that he no longer believes this drawing to be by Raphael.

93 A recent advocate of this is Goffen 2002, pp. 121–2.

94 Guicciardini 1984, p. 227.

95 For his letter to Michelangelo see *Carteggio* I, no. lxxii, p. 104.

96 I have made much use of Hirst's study of the sketchbook: Hirst 1986b. Further codicological information is given in Elan 1995, pp. 287–8.

97 *Corpus* I, no. 166r.

98 For an abbreviated critical history see the drawings' entries in Appendix I, pp. 285–6.

99 The pose is similar to a figure in a sarcophagus in the Louvre: see Hirst 1986, II, p. 211.

100 Parker, Hartt, and Tolnay all doubted the attribution in print (the bibliographical references are given in Appendix I, p. 286). Michael Hirst and Carel van Tuyll have both expressed their misgivings about the attribution to me in conversation. Wilde accepted it as autograph in the British Museum Michelangelo catalogue (1953a, p. 30) and in his 1953 exhibition (no. 26), as does Paul Joannides in his forthcoming Ashmolean catalogue.

101 Perhaps the best comparison is supplied by the black chalk lunette figure studies in Turin: *Corpus* I, no. 155v.

102 It may be one of the works by Michelangelo listed in a 1601 inventory of a drawing collection assembled by Antonio Tronsarelli; unfortunately the description ('a seated prophet in red chalk by Michelangelo') is not sufficiently precise to make the connection certain: Lafranconi 1998, no. A48, p. 548.

103 In his dialogue *Ragionamento sulla lingua*: Gelli 1967, pp. 308–9.

104 Wilde believed it to be a study from life and likened it to a black chalk drawing for the head of the Cumaean Sibyl in Turin (*Corpus* I, no. 155r), a view also shared by Hartt (1971, no. 107). To my eyes this comparison only shows that it cannot have been made from a model.

105 Evidence for the two sheets having been one is the divided anchor watermark. The two halves must have been separated at an early date but kept together as is shown by the sequential numbers inscribed on both. The position of the watermark and the light it sheds on the unified sheet can be seen in the two comparative illustrations of the recto and verso of the two drawings: van Tuyll van Serooskerken 2000, figs. 3 and 4, p. 535.

106 Raffaello da Montelupo in his autobiography claimed that Michelangelo was naturally left handed: Gatteschi 1998, pp. 120–1. There is, however, no evidence of this is any of his drawings.

107 For a recent proponent of the Eve identification as well as even more startling ones in the same fresco see Steinberg 1992.

108 Popham and Wilde 1949, no. 449; Joannides 1996a, no. 46.

109 The two drawings are sometimes thought to have formed a single sheet, but if so they must have been separated within Michelangelo's lifetime as the Oxford drawing seems to have been one of the works taken to France by Mini.

110 This follows Joannides' analysis of the drawing in his forthcoming Ashmolean catalogue.

111 'questi Prigioni erano tutte le provincie soggiogate da questo Pontefice e fatte obediente alla Chiesa Apostolica': Vasari (Bettarini and Barocchi ed.) 1987, VI, p. 27.

112 On the verso (*Corpus* I, no. 137v) there are two pen studies of legs related to the two Louvre *Slaves*.

113 'figura certamente, fra le dificili e belle, bellisima e dificilissima': Vasari (Bettarini and Barocchi ed.) 1987, VI, pp. 47–8.

114 Hettner (1909, p. 84) suggested that the model was on the floor or on a low bench with his left arm outstretched and kept aloft with a sling.

115 This observation is due to Hirst who noted that the compiler of the 1836 Lawrence catalogue had reached the same conclusion: Hirst 1988a, pp. 67–8.

116 For its previous appearance see van Tuyll van Serooskerken 2000, fig. 2, p. 534.

117 Reported in a letter from Grossino to Isabella d'Este: Tolnay 1945, II, no. 76, p. 243.

118 His black mood is shown in an undated sonnet plausibly related to this period ('Signor, se vero è alcun proverbio antico, questo è ben quel, che chi può mai non vuole'): Girardi 1960, no. 6; Ryan 1996, pp. 5 and 261–2.

119 *Carteggio* II, no. cdlxxiv, pp. 246–7.

120 For this suggestion see Henry and Plazzotta's essay in Chapman, Henry and Plazzotta 2004, p. 38.

121 The only Roman project that Leo may have commissioned from Michelangelo was the marble façade of his chapel in the Castel Sant'Angelo; see Argan and Contardi 2004, pp. 64–6.

122 The Uffizi drawing is *Corpus* I, no. 56r (as a studio work). The case for the drawing being by Michelangelo and related to the 1513 contract is made by Hirst 1988b, pp. 52–4; Joannides (1991b, pp. 39–42) does not doubt the attribution but he dates it to the beginning of the artist's work on the Sistine chapel. The Berlin drawing is *Corpus* I, no. 55

123 For the contract see Milanesi 1875, nos xi–xii, pp. 635–9.

124 Details of this property and the wrangling over Michelangelo's ownership of it are given in Hatfield 2002, pp. 98–103.

125 The drawing was first published by Wilde (1953a, p. 3) who noted the connection to the marble.

126 The largest groups of these are at Haarlem and Windsor Castle: *Corpus* I, nos 106–9, 111–15. Tolnay did not include in the group a sheet of red chalk studies of legs that belonged to the Gathorne-Hardy collection (sold Sotheby's, London, 28 April 1976, lot 16). This little-known drawing is now in the collection of the Wellcome Institute Library in London.

127 *Corpus* I, no. 55v.

128 Hartt 1971, no. 413 where it is dated to the mid-1540s. For the critical history of the drawing see van Tuyll van Serooskerken 2000, pp. 108–11.

129 *Corpus* I, nos 112–13; Joannides 1996a, pp. 134–7.

130 The following account of the relationship between the two artists is reliant on Hirst's 1981 monograph on Sebastiano, esp. chs 3–6.

131 Vasari (Bettarini and Barocchi ed.) 1984, v, p. 88.

132 Hirst 1981, pp. 41–8, pls 53–4.

133 Vasari (Bettarini and Barocchi ed.) 1984, v, p. 89.

134 For the relationship with Borgherini see Michelangelo's letters to Buonarroto: *Carteggio* I, nos cxxviii and cxlii, pp. 166 and 182; Ramsden 1963, I, nos 97 and 110. For the possible intervention of Andrea del Sarto in the fulfilment of this promise, see Shearman 1965, II, pp. 309–10.

135 *Carteggio* I, nos cxlviii and cl, pp. 190 and 192.

136 As was first noted by Wilde in Popham and Wilde 1949, no. 263–4; the most extensive recent discussion of the drawing is by Joannides 1996a, pp. 120–2.

137 For this early example of Michelangelo supplying a design see Agosti and Hirst 1996.

138 This detail is known from Sellaio's letter of October 1516: *Carteggio* I, no. clxi, p. 203.

139 Such as *Corpus* I, no. 143v; Joannides 2003a, no. 19v. I am grateful to Paul Joannides for this observation.

140 Pouncey and Gere 1962, no. 276. Wilde's acceptance of the attribution is reported in the 1975 British Museum exhibition entry (no. 38).

141 The earliest of the three is at Bayonne: *Corpus* I, no. 75r.

142 Hirst 1981, pl. 103.

Notes to Chapter 5

1 The clearest account of this commission is given in Millon and Hugh Smyth 1988, pp. 3–15. Millon's

dating for some of the drawings is slightly amended in Elam 1992.

2 Buonarroto described the festivities in a letter to Michelangelo written at the end of the month: *Carteggio* I, pp. 184–5. For the decoration of the cathedral see Shearman 1975, p. 147, n. 33.

3 This document was first published by Ciulich in Bardeschi and Bardeschi Ciulich 1994, no. xxx, p. 133. I am grateful to Caroline Elam for alerting me to this.

4 Raphael boasted of his salary as papal architect in a letter to his uncle in 1514: Shearman 2003, I, no. 1514/6, pp. 180–2.

5 The angelic connotations of Raphael's name were, for example, maliciously twisted by the Venetian to the 'the prince of the synagogue' in a letter of 2 July 1518: *Carteggio* II, pp. 32–3; for discussion of the term see Shearman 2003, I, no. 1518/51, p. 353. Buonarroto's letter to his brother in April 1517 is another example of Michelangelo's paranoia: *Carteggio* I, no. ccxix, pp. 274–5. Raphael's reaction to Michelangelo and his camp is unfortunately not documented.

6 For Cosimo's patronage of the church see Kent 2000, pp. 179–97.

7 *Carteggio* I, no. cxxviii, p. 166; Ramsden 1963, I, no. 97. For the implications of this letter see Hirst 2004b, pp. 39–40.

8 For the contract see Milanesi 1875, nos xvi–xvii, pp. 644–51.

9 *Carteggio* I, pp. 204–5.

10 The connection between the two was made by Ashby in his 1904 publication on the Codex.

11 For the Codex see Buddensieg 1975; Brothers 2000, pp. 96–101. For della Volpaia see also *DBI* 1989, XXXVII, pp. 795–7.

12 For references to Michelangelo's contact with the family see Agosti and Farinella 1987, p. 25, n. 4.

13 For this suggestion see *DBI* 1989, XXXVII, p. 795.

14 The connection with S. Lorenzo was first made by Thode. The two-tiered arrangement of the mezzanine in the drawing, but not the choice of classical order, is comparable to Michelangelo's pen profile of the façade in the Casa Buonarroti (*Corpus* IV, 504r), a drawing that Elam (1992a, p. 109) notes should be dated to post-January 1517 rather than the previous autumn as Millon (1988, p. 62) had suggested.

15 The critical history of the group is given in *Corpus* IV, pp. 44–5.

16 Letter from Michelangelo to Buoninsegni, May 1517: *Carteggio* I, pp. 277–9; Ramsden 1963, I, no. 116, pp. 105–7.

17 *Carteggio* I, no. ccxxxi, p. 291.

18 Jacopo later spread rumours of Michelangelo idleness to Leonardo Grosso della Rovere in December 1518 (*Carteggio* II, nos ccclxxx and cccxcvi, pp. 127 and 146). The rift between the sculptors had been repaired by 1525 when Michelangelo helped Sansovino obtain a commission for the tomb of the imperial ambassador in Rome, the duke of Sessa and his wife: see *Carteggio* III, nos dclxxxiii and dcxci, pp. 127 and 136.

19 Milanesi 1875, nos xxxiii–iv, pp. 671–5.

20 The best account of the quarrying of marble in Seravezza is found in the first chapter of Wallace 1994, pp. 9–74.

21 Letter from Michelangelo to Buonarroto, 18 April 1518: *Carteggio* I, no. cclxxvi, pp. 346–7; Ramsden 1963, I, no. 123, p. 112.

22 *Carteggio* II, nos cccxliii, ccclxxxii, cdxxxi, pp. 82–3, 129–30, 185–6; Ramsden 1963, I, nos 129, 134, 139, pp. 117–18, 121, 124–5

23 *Ricordi* no. xcviii, p. 102.

24 Bandinelli later claimed in a 1547 letter to Duke Cosimo that Clement VII had told him that Michelangelo's failure to complete the S. Lorenzo projects was due to his solitary working methods, the relevant passage is cited in Barocchi 1962, II, p. 687.

25 Vasari (Bettarini and Barocchi ed.) 1984, v, pp. 247–8.

26 For Figiovanni's account see Corti 1964.

27 Wallace 1994, pp. 75–81.

28 *Carteggio* II, no. cdlviii, pp. 218–21.

29 Poeschke 1996, pp. 99–101, pls 50–1; the reworked first version of the sculpture was discovered in S. Vincenzo Martire, Bassano Romano by Irena Baldriga and Silvia Danesi Squarzina: Baldriga 2000, pp. 740–5 and Danesi Squarzina 2000, pp. 746–51. The reappearance of the work shows that the ex-Brinsley Ford study for the figure (*Corpus* I, no. 21) is related to the second version.

30 Letter of 15 April 1517, *Carteggio* I, no. ccxvii, p. 272.

31 *Carteggio* II, nos ccclxvii and cdxxxii, pp. 111 and 187.

32 *Carteggio* I, no. cclv, p. 318. This connection was first noted by Wilde.

33 The small section lower right was reunited with the larger piece following its transfer from the Department of Manuscripts in 1947. The missing piece was said in an article in *Die Weltkunst* (15 July 1955, p. 6) to be in the Leningrad, now St Petersburg, Academy of Sciences, but the reproduction from their catalogue shows this to be an autograph, but unrelated block drawing. As the smaller piece is inscribed 'Presented to me by Signor Buonaroti [sic] of Florence H.W. Williams' one can only presume that the other half was also trimmed away by Michelangelo's descendant to provide a suitable gift.

34 The transcription of the main recto inscription in Wilde 1953a is slightly inaccurate; this is corrected in *Ricordi* no. LII, pp. 59–60.

35 The cardinal's letter is dated 21 April 1516: *Carteggio* I, no. cxlv, p. 186. I owe the correct identification of the duchess to Michael Hirst.

36 For her biography see the entry in the *DBI* 1993, XLII, pp. 494–9.

37 See Michelangelo's letter of 4 September 1525 ('Del fare decta supultura di Iulio al muro, chome quello di Pio, mi piacie'): *Carteggio* III, no. dccxiii, p. 166; Ramsden 1963, I, no. 173, p. 162.

38 For Clement's liturgical arrangements for the chapel and their impact on its structure, see Ettlinger 1978b, pp. 294–301.

39 The idea is outlined in Fattucci's letter of 23 May 1524: *Carteggio* III, no. dcxl, pp. 76–7.

40 For the most detailed discussion of this opinion see Saalman 1985. For recent bibliography on this issue see Elam in Gouwens and Reiss 2005, p. 204.

41 The key article is Elam 1979.

42 Published by Corti 1964.

43 Corti 1964, p. 28.

44 *Corpus* II, no. 178v. For this drawing see Wilde 1955 and Elam 1979, pp. 163–4. Paul Joannides informs me that in his view Michelangelo must have envisaged tabernacle tombs on the lateral walls to avoid blocking the doorways.

45 Joannides has most recently expressed the idea

46 *Carteggio* II, no. cdlxxxiii, p. 260.

47 This was proposed by Hirst (2004b, pp. 40–2).

48 Letters from Stefano Lunetti and Fattucci, 20 and 21(?) April 1521: *Carteggio* II, nos dvii and dx, pp. 288 and 292.

49 Detail of the marble shipments are given in Wallace 1992, n. 62, p. 139.

50 Pastor 1910, IX, p. 162.

51 See Michelangelo's letter to Topolino, 25 November 1523: *Carteggio* III, no. dlxxxix, p. 1; Ramsden 1963, I, no. 156, p. 146.

52 *Carteggio* III, no. dciii, p. 21.

53 See Wallace 1994, p. 136.

54 *Carteggio* III, no. dccxlvii, pp. 220–1.

55 *Carteggio* III, no. dccl, pp. 224–5.

56 The most famous example of Clement's personal attention to Michelangelo is the encouraging postscript to a letter written and signed in his own hand: *Carteggio* III, no. dccxxxii, pp. 194–5. An English translation of this postscript is given by Hughes 1997, p. 179. For the relationship between Michelangelo and Clement see the essays by Wallace and Elam in Gouwens and Reiss 2005, pp. 189–98 and 199–225.

57 *Carteggio* III, no. dccxvii, pp. 170–1.

58 *Carteggio* III, no. dccxxx, pp. 190–1; Ramsden 1963, I, no. 176, pp. 164–5.

59 Condivi (Nencioni ed.) 1998, p. 23; Condivi (Wohl ed.) 1999, pp. 29–30.

60 Letter to Bartolomeo Angiolini, July 1523: *Carteggio* II, no. dlxxxvi, p. 384; Ramsden 1963, I, no. 154, pp. 144–5.

61 Poeschke 1996, pl. 88.

62 *Carteggio* III, no. dcclii, pp. 227–8.

63 Clement's views were relayed in letters from Fattucci in July and September 1526: *Carteggio* III, nos dcclvi and dcclvii, pp. 232–4.

64 Quoted in Pastor 1910, IX, p. 323.

65 See Roth 1925, pp. 23–31; Hook 2004, pp. 152–3.

66 Vasari (Bettarini and Barocchi ed.) 1984, V, pp. 512–13.

67 *Ricordi* p. 228. The Palazzo Gondi was one of the few buildings damaged in the riots, but Piero's link to the main branch of the family is uncertain: see Calì 1980, p. 104, n. 3.

68 *Carteggio* III, no. dcccxi, pp. 299–300.

69 Banditry meant that few letters got to or from the much reduced papal court at Orvieto; but one written in early March 1528 by Clement's treasurer, Leonardo Niccolini, did reach Michelangelo in Florence: *Carteggio* III, no. dcclxxiv, p. 255.

70 For the destruction of Cosimo's epitaph see Stephens 1983, p. 234. The new regime's hostility to the Medici is discussed in Polizzotto 1994, pp. 353–6.

71 Varchi 2003, I, p. 403, II, p. 562.

72 I am grateful to Michael Hirst for this suggestion. For Francesco Maria della Rovere's part in quelling the uprising in Florence see Clough in Gouwens and Reiss 2005, pp. 103–4, n. 132.

73 Poeschke 1996, pp. 103–5, pls 56–65. The suggestion that Michelangelo began the *Slaves* before the spring of 1523 was made by Wilde 1954, p. 12 (reprinted in Wallace 1995c, pp. 437–58).

74 Poeschke 1996, pp. 101–3, pls 52–5. Wilde's dating to this period (1954, p. 14) is followed

75 For the destination see Wilde 1954.

76 Girardi 1960, no. 15; for an English translation see Ryan 1996, p. 11.

77 *Carteggio* III, no. dcclxxi, p. 252; Ramsden 1963, I, no. 182, p. 171.

78 Hirst 2000, pp. 490–2 and Joannides 2003c.

79 The antagonism between the two sculptors is shown by a comment in a letter from Sellaio to Michelangelo of January 1525: *Carteggio* III, no. dclxxxiii, p. 127.

80 Michelangelo's exaggerated reaction to Bandinelli having won the commission can be inferred from the attempts to dispel his 'vane fantasie' by the Florentine banker Jacopo Salviati in a letter of October 1525: *Carteggio* III, no. dccxxii, pp. 178–9.

81 Vasari (Bettarini and Barocchi ed.) 1987, VI, p. 101.

82 Varchi 2003, II, p. 193.

83 Elam 1993, p. 71.

84 Vasari (Bettarini and Barocchi ed.) 1987, VI, p. 63. See also Varchi 2003, II, p. 562.

85 Gotti 1875, p. 199.

86 For Figiovanni's version of events see Corti 1964, p. 29.

87 For the marble Poeschke 1996, pp. 117–18, pls 92–3. News of Valori's palace is given in the letter he wrote to Michelangelo in April 1532 in which there is also a reference to the sculpture ('mia fighura'): *Carteggio* III, no. dccclvi, pp. 386–7.

88 The princess of Orange's request came through a letter of 29 January 1531 from Orlando Dei (*Carteggio* III, no. dcccx, p. 298). For the *Noli me tangere* commission see Hirst 2004a, pp. 5–29.

89 The report of Michelangelo's poor health is given in a letter of 29 September 1531 by Giovanni Battista Mini, the uncle of the sculptor's assistant, to Bartolommeo Valori: published in *Carteggio* III, pp. 328–31.

90 For the state of the tomb in the early 1530s see Echinger-Maurach 2003.

91 For this painting see Nelson in Falletti and Nelson 2002, pp. 187–90.

92 *Corpus* II, nos 182–3.

93 An illustration of the reconstructed sheet is in Hirst 1988a, pl. 201. In the present example Michelangelo drew a male head over part of the column: *Corpus* II, 184v.

94 As was first noted in Hirst 1988a, p. 103.

95 The link between the two is clear from Michelangelo's fragmentary draft of a letter to Giulio de'Medici: *Carteggio* II, no. cdlxxxii, p. 259. For the suggestion that Michelangelo took inspiration from Raphael's Francesco Gonzaga tomb design see Morrogh 1992b, pp. 145–50.

96 Compare, for example, the pen tomb designs by Antonio da Sangallo the younger recently offered at Christie's, London, 7 July 1998, lots 50–3, and at Christie's, Paris, 27 November 2002, lot 22.

97 Condivi (Nencioni ed.) 1998, p. 58 and *postilla* no. 19, p. xxii Condivi (Wohl ed.) 1999, n. 115, p. 143.

98 Other examples of drawings with a scale include *Corpus* IV, nos 508r and 560r.

99 The observation of a 'symbolic' sarcophagus is taken from Wilde 1955, pp. 59–60.

100 Michelangelo's inventive interpretation of classical forms in the chapel's architecture prompted a celebrated passage in Vasari (now thought to have been penned by Cosimo Bartoli): Vasari (Bettarini and Barocchi ed.) 1987, VI, pp. 54–5.

101 Wilde (1953, p. 53) thought that the drawings on

by Hirst who kindly shared his thoughts with me on the work's chronology.

the verso preceded those on the recto, a sequence supported by Joannides (1991b, p. 255). Morrogh (1992b, pp. 152–3) proposed a more involved sequence beginning with the double tomb on the verso followed by that on the recto with the tomb on the verso drawn last.

102 Prior to Wilde this was always regarded as a study for a free-standing monument.

103 The drawing has been championed by Joannides and he gives its critical history up to 1998 in his Louvre catalogue (2003a, no. 27).

104 An observation made by Hughes 2004, p. 767.

105 See Morrogh 1992a. This change in chronology is rebutted by Joannides (2003a, pp. 134–5).

106 For a different interpretation of this inscription see Gilbert 1971, pp. 393–5 (reprinted in Wallace 1995c, pp. 105–7).

107 Joannides 2003a, no. 26. This is less appealing than the other Louvre *modello* and Joannides championing of its autograph status has generally not been accepted. In a review of an exhibition to celebrate the publication of Paul Joannides' Louvre catalogue (Chapman 2003, p. 470) I supported the latter's suggestion that both Louvre Medici tomb *modelli* were autograph. While I remain convinced that the drawing for the Giuliano de'Medici monument (fig. 66) is by Michelangelo, I am now less confident that the other one is by him (fig. 67).

108 Vasari (Bettarini and Barocchi ed.) 1984, V, pp. 204–5.

109 *Corpus* II, no. 201r. An English translation of the passage is in Poeschke 1996, p. 114. For the interpretation of Michelangelo's note see Hughes 1981, pp. 202–6.

110 Condivi gets the number of the tombs and the chapel's location wrong.

111 Michelangelo's words are quoted in a 1544 letter by Niccolò Martelli: Tolnay 1948, p. 68. Michelangelo may have exaggerated the obscurity of the two *Capitani* as their appearances are recorded in contemporary portraits, see Hughes 1997, figs 119–20.

112 Wilde 1953a, p. 70.

113 Wilde 1953a, p. 70.

114 Vasari (Bettarini and Barocchi ed.) 1987, VI, p. 110.

115 See Ragionieri 2000.

116 I am extremely grateful to Dora Thornton and Jeremy Warren for taking the time to look at the British Museum models with me. I have ruthlessly exploited their long experience of such works and sharp eye for detail in the following discussion.

117 Ragionieri 2000, pp. 26–31.

118 The impression of rough textured cloth like sacking can be seen in some areas, such as around the groin. After working on the figure the artist would have wrapped it up in material to keep in the moisture so it could be worked over an extended period.

119 The sculpture's existence was noted by Thode (1913, III, no. 599, p. 282) but the connection with the *Slave* and a fuller appreciation of the work was first made by Popp in 1936.

120 For recipes for making and colouring the wax see Vasari 1960, pp. 148–9.

121 Armenini (Olszewski ed.) 1977, p. 169; Armenini (Gorreri ed.) 1988, p. 118.

122 'Weak in execution and not in the style of Michelangelo': Tolnay 1954, p. 158.

123 Most recently by Myssok 1999; see Appendix I, p. 288.

124 As noted by Wilde (1954, pp. 15–16, n. 3) in

reference to *Ricordi*, p. 124.

125 Hirst 1988a, pp. 62–3 and 1988b, p. 70.

126 Hirst was the first to recognize this connection.

127 A point elegantly made by Hirst in the previously cited references to the drawing.

128 Hirst 1988a, p. 63.

129 Girardi 1960, no. 81 (III). For a translation of the final poem see Ryan 1996, pp. 73 and 284–5. The drawing is still on an Ottley mount. A handwritten note in the British Museum's copy of the Rogers' sale catalogue records it was bought as part of a parcel of eight drawings, 8 May 1856, lot 1212.

130 Condivi (Nencioni ed.) 1998, p. 43; Condivi (Wohl ed.) 1999, p. 70. For Alfonso's collection see Hope 1971.

131 The suggestion was first made by Wilde in his 1957 essay (pp. 270–1) on the commission, and was taken up by Wallace 2001. Wilde's essay is reprinted in Wallace 1995c, pp. 418–36.

132 For the National Gallery painting see Falciani's entry in Dalli Regoli, Nanni and Natali 2001, pp. 164–5.

133 The technique of the work is given in Vasari (Bettarini and Barocchi ed.) 1987, VI, p. 56. It is known to have been on panel from Mini's letters to Michelangelo from France: for example *Carteggio* III, no. dcccxli, p. 361.

134 Alfonso had already known of the painting's completion in October as he had sent his ambassador Jacopo Laschi to fetch the work: see Tolnay 1948, p. 190.

135 Wallace 2001, pp. 497–8.

136 *Carteggio* III, no. dcccxxxiv, pp. 348–9. Wallace's suggestion that this was made on behalf of Alfonso seems implausible, as Clement was bitterly opposed to the duke: see Hook 2004, p. 287.

137 A good account of the *Leda* and the painted and drawn copies made after it by Mini, Rosso and others in France is in Carroll 1987, pp. 318–27. This includes the fullest analysis of the cartoon in the Royal Academy which Carroll is inclined to believe is by Rosso.

138 Michelangelo's views on sex are recorded in Condivi and reiterated in the marginal annotations or *postille* of his comments recorded by Calcagni: Condivi (Nencioni ed.) 1998, p. 65 and *postilla* no. 23, p. xxii; Condivi (Wohl ed.) 1999, p. 108. For the painting's history see Gould 1975, pp. 150–2.

139 See Costabili's 1517 letter to the duke with reference to Raphael's inability to acquire from the Ghiberti collection in Florence the *Amor and Psyche* (or the *Bed of Polycleitus* as it was then known) but the promise that he could send from Rome another relief: Shearman 2003, I, no. 1517/6, pp. 285–6.

140 Bober and Rubinstein 1986, no. 5 and 5b; for Lorenzo's collection of ancient cameos and gems see Dacos, Giuliano and Pannuti 1973.

141 Michelangelo reiterated this claim in one of the *postille*: Condivi (Nencioni ed.) 1998, p. 64 and *postilla* no. 22, p. xxii; Condivi (Wohl ed.) 1999, p. 107.

142 *Corpus* II, no. 301r. The connection with the *Leda* is due to Wilde (1957, p. 277).

143 Details of the scholarly divide are given by Wilde (1953a, p. 83) and in the *Corpus* entry (II, no. 208). Tolnay followed Wilde but the drawing is confusingly separated from other studies for *Leda*.

144 The differences in pose were noted by Gere and Turner in the 1975 catalogue (p. 86).

145 For differing views on the Rosso attribution see

146 Carroll 1987, p. 321 and Cox-Rearick in Falletti and Katz Nelson 2002, pp. 174–6.

146 Pp. 5–132: see Turner 1986, no. 111, p. 154.

147 Rosso's highly unusual practice of drawing nude female models can be documented from twenty years earlier in a drawing in the Uffizi: Carroll 1987, no. 3, pp. 58–60. The masculinity of Michelangelo's rendering of the female nude is discussed in Jonathan Katz Nelson's essay in Falletti and Katz Nelson 2002, pp. 27–63.

148 For the commission see Wittkower 1934; Ackerman 1986, pp. 97–122; Argan and Contardi 2004, pp. 186–97; Wallace 1994, pp. 135–85.

149 *Carteggio* IV, no. cmx, pp. 17–19.

150 For discussion of these with the relevant bibliography see van Tuyll van Serooskerken 2000, pp. 121–3.

151 The drawings connection with Fattucci's letter (*Carteggio* III, no. dcxxxvi, p. 71) was first noted by Wittkower (1934, pp. 189–90).

152 *Carteggio* III, no. dccxlvii, pp. 220–1. Fattucci reports in the letter that Clement said that he had never seen a more beautiful door, neither ancient nor modern ('della porta disse che e' nonn aveva veduta mai la più bella, né antica né moderna').

153 For example in Elam 2001.

154 *Carteggio* III, nos dccxlvii and dccl, pp. 220–1 and 224–5.

155 For the Casa Buonarroti drawing see *Corpus* IV, no. 555r.

156 *Carteggio* III, no. dccl, pp. 224–5.

157 For Michelangelo's drawings of this kind see Wallace 1995f.

158 Gilbert 1980, pp. 33–4.

159 As Wilde noted, a fair copy of the British Museum note (*Ricordi* no. cxlix, pp. 157–8) is in the Casa Buonarroti (no. cxxiii, p. 132).

160 Wallace 1995f, pp. 118–20. The profile head is similar to one on a drawing at Princeton attributed to Michelangelo by Michael Hirst (1983, p. 556).

161 It was on the basis of this inscription that Berenson created his fictional pupil of the sculptor, 'Andrea di Michelangelo'. These inscriptions show that the sheet has been trimmed on the right side.

162 Wilde (1953a, p. 77) ascribed the second line of the inscription to Mini, but Caroline Elam informs me that his handwriting is different.

163 This is the position of Hartt, Wallace and Joannides; for Hirst (1988a, pp. 13–14) a further eye study is autograph but he does not divulge which of them he considers right ('of the eleven, I believe, three to be by Michelangelo'). The leftmost one at the lower register is perhaps the next best candidate to be by Michelangelo.

164 Hirst 1988a, p. 14. A description of the eye also features in a poem by Michelangelo of the period: Girardi 1960, no. 35; Ryan 1996, pp. 27–9, 273. Michelangelo also set his pupils to copy engravings as he had done in Ghirlandaio's workshop: Joannides 1988.

165 Wilde's account of the drawing (1953a, pp. 76–7) is fleshed out further by Summers 1981, p. 125.

166 *Corpus* II, no. 345v.

167 As in the much discussed alternative version of one of his quatrains lamenting the death of Cecchino Bracci: Girardi 1960, no. 197; Ryan pp. 173 and 310–11.

168 Girardi 1960, no. 51; Ryan 1996, pp. 39–41, 278.

169 The anecdote, Vasari (Bettarini and Barocchi ed.)

1987, VI, p. 115, is mentioned in Wallace's study of the drawing (1995f, pp. 115–18). He thinks that the savage giraffe is by Michelangelo.

170 Ettlinger 1978a, nos 10 and 18, pls 92 and 79–82.

171 Wittkower (1937–8) suggested that Michelangelo was demonstrating how an expression could be changed by altering a given feature, like the mouth, into its opposite.

172 For this passage see Summers 1981, pp. 135–7.

173 *Corpus* II, no. 322r and v. The leg on the verso is the model copied on no. 62r.

174 For the grotesque masks and capitals see Wallace 1994, pp. 124–6.

175 *Corpus* I, no. 95.

176 The interpretations are those respectively of Tolnay (*Corpus* II, no. 320r), Wallace (1995f, pp. 120–1) and Joannides (1981b, p. 684).

177 Wilde 1953a, p. 77. In a private communication Paul Joannides observed that it is rare to find Michelangelo making a small study in the middle of a large sheet, and he still believes that the drawing of a woman preceded the smaller sketch.

178 For the dating of the Windsor copy see Joannides 1996a, p. 40.

179 Wilde (1953a and 1959) wrongly described the technique as stippling, a description amended by Hirst (1988a, pp. 56, 115–16) and in greater detail by Rosand (2002, pp. 200–7).

180 Popham and Pouncey 1950, no. 258; Bambach 2003, pp. 249–50. The Piero di Cosimo *Cleopatra* is described by Vasari as in Francesco da Sangallo's collection: Vasari (Bettarini and Barocchi ed.) 1976, IV, p. 71. It is likely to have been owned by his father Giuliano da Sangallo, whose portrait Piero di Cosimo painted, which would signify that Michelangelo would have almost certainly known of it.

181 Popham and Pouncey 1950, no. 96.

182 The best analysis of these drawing is Hirst 1988a, pp. 105–18.

183 *Corpus* II, nos 306–8.

184 For recent discussion of precedents see Joannides 1996a, p. 54.

185 Popham and Pouncey 1950, no. 219; Syson and Gordon 2001, p. 74.

186 *Corpus* II, no. 307v.

187 Bonsanti 2001, pp. 513–18.

188 Robinson 1876, no. 55.

189 For the influence of such ideal heads on Florentine art see Joannides 1996a, pp. 32, 34–53.

190 Following Hirst 1988b, p. 60. A further argument is the absence of hair which Michelangelo seldom resisted including in his fanciful depictions of young women.

191 Berenson in the second edition of his corpus of Florentine drawings suggested 1518–20, a dating followed by Hirst. Joannides in his forthcoming Ashmolean catalogue places it later, c.1530.

192 The cast of features led to the drawing being identified as a portrait of Lorenzo de'Medici: see *Corpus* II, no. 328r.

193 Vasari (Bettarini and Barocchi ed.) 1987, VI, p. 110.

194 Joannides 1995a, pp. 4–5 and 2003a, under no. 107, p. 253. His suggestion that the Bayonne drawing is a portrait of Tomasso de'Cavalieri was made in the latter publication.

195 Tolnay's identification in the *Corpus* (II, no. 330r) and very late dating are, as Hirst noted, untenable.

196 This dating follows that proposed by Hirst 1988a, p. 11.

197 For Michelangelo's friendship with Quaratesi see Wilde 1953a, pp. 97–8.

198 The Uffizi drawing is one of two copies made by Dolci: see Baldassari 1995, p. 73. The Quaratesi were major patrons of the artist hence his access to the portrait.

199 Such as the unfinished sonnet from the late 1520s, 'Che fie doppo molt'anni di costei', Girardi 1960, no. 50; Ryan 1996, p. 39.

200 *Carteggio* III, nos dccxci and dccxciv, pp. 272 and 275–6.

201 Vasari (Bettarini and Barocchi ed.) 1984, IV, p. 282 and 1987, V, pp. 120–1.

202 The relevant letters are *Carteggio* II, nos dlxxix and dlxxxiv–vi, pp. 376, 381–4.

203 For references to Grimani and his collection see *DBI* 2002, LIX, pp. 599–604.

204 The Unrepentant Thief on the right is seen, for example, in Donatello's relief of the *Crucifixion* in S. Lorenzo. In the drawing the right-hand figure still looks to be alive which would also contradict Wilde's suggestion that his soul is ascending.

205 See Franklin 2001, pp. 6–8.

206 Wilde 1953a, p. 65. Nagel, in his stimulating analysis of Michelangelo's development of the motif, is keen to make the Haarlem drawing later (1996, p. 553), but his reasons for doing so are not persuasive.

207 Romani 2002, p. 76.

208 Wilde 1953a, no. 69; Hartt 1971, no. 451. It is not included in the *Corpus*.

209 Pope-Hennessy and Lightbown 1964, II, nos 463–5. Jeremy Warren kindly alerted me to a fourth version of the composition in the same collection, not mentioned in the 1964 catalogue, by the Augsburg goldsmith Melchior Gelb (inv. M362-1856). It is made of silver and is dated 1608.

210 Two red chalk studies in Düsseldorf seem also to be further developments of the theme of the Brazen Serpent: Joannides 1996b, figs 8 and 9.

211 For the Condivi reference see n. 135.

212 Details of the copies in the Uffizi and in Budapest are given in Joannides forthcoming Ashmolean entry.

213 Popp 1922, pp. 96–100, 158–63. The objections to this hypothesis, chief of which is that the lunettes were intended to be filled with relief sculpture, is given by Joannides (1996b, p. 155).

214 The *Resurrection* drawings are listed in Wilde 1953a, p. 89 and more recently by Joannides 2003a, p. 168.

215 The contract was published by Hirst (1961, pp. 161–85).

216 The inclusion of the sarcophagus discounts Perrig's suggestion that the drawing is related to Sebastiano's painting of the *Descent into Limbo* (Prado, Madrid). In regard to matching the fictive and real illumination of an altarpiece see Sebastiano's letter of May 1532 to Michelangelo: *Carteggio* III, no. dccclxix, pp. 405–6.

217 *Corpus* II, no. 265.

218 Vasari (Bettarini and Barocchi ed.) 1987, VI, p. 109.

219 Hirst plausibly suggested that Michelangelo had in mind the floating figure of Eve on the east door of the Baptistery in Florence: Hirst 1988a, p. 15.

220 For Michelangelo's appreciation of medieval art, see Joannides 1992 and Nagel 2000, pp. 1–22.

221 For other copies see Wilde 1953a, p. 87. The painting and Exh. No. 78 are attributed to Clovio by Perrig; currently in the Fogg it is labelled as 'Attributed to Marcello Venusti'. I am grateful to

Paul Joannides for sharing his knowledge of this work with me.

222 The miniature is illustrated in Perrig 1991, fig. 85.

223 Joannides (2003b, p. 71) noted a red chalk copy by Salviati in the Uffizi (594F.) and a painted version in a private collection illustrated in Perrig 1991, fig. 57 (as Mini).

224 Reiss 1987, pp. 394–400.

225 For varying estimates of Cavalieri's age see Ramsden 1963, I, pp. 298–9 and Panofsky-Soergel 1984, pp. 399–405. The latter argues convincingly that he was born c. 1519/20.

226 *Corpus* II, no. 345r. For the letter see *Carteggio* III, no. dcccxcviii, pp. 445–6.

227 Condivi (Nencioni ed.) 1998, p. 62; Condivi (Wohl ed.) 1999, p. 105.

228 This is contained in Aretino's famous 1545 letter on the impiety of the *Last Judgment*: *Carteggio* IV, no. mxlv, pp. 215–17. The writer's complaint about the impossibility of obtaining a drawing was left out of the published version of the letter in 1550.

229 For the two letters see *Carteggio* IV, nos cmxli–ii, pp. 66–7. The Fogg drawing of this subject published by Hirst in 1975 (Corpus II, no. 344) is a variant of Michelangelo's lost original.

230 See Hughes' typically level-headed discussion of this issue, 1997, pp. 325–7.

231 Barocchi 1971–7, I, pp. 493–544.

232 Girardi 1960, nos 179–228; Ryan 1996, pp. 165–85, 307–15.

233 Such as Girardi 1960, no. 73; Ryan 1996, p. 67.

234 Bober and Rubinstein 1986, p. 70, fig. 27. Michael Kwakkelstein pointed out to me that the pose of Lazarus in Exh. No. 35 may have been inspired by a figure in this same relief.

235 This is reported in Cavalieri's letter to Michelangelo: *Carteggio* IV, no. cmxxxii, p. 49.

236 Syson and Gordon 2001, pp. 174–81.

237 *Corpus* II, no. 342r. For the dating of the Venice drawing see Hirst 1988b, pp. 110–12; Joannides 1996a, p. 56.

Notes to Chapter 6

1 *Carteggio* IV, no. cmx, pp. 17–19. The connection between the letter and the commission was made by Wilde.

2 *Carteggio* IV, no. cmx, pp. 17–19.

3 Vasari (Bettarini and Barocchi ed.) 1987, VI, p. 65. None of the drawings that Vasari mentions Michelangelo making for the *Fall of the Rebel Angels* survive. The most recent discussion of this puzzling reference is Shearman in Weil-Garris Brandt 1994, pp. 29–36. Shearman's acceptance of Vasari's report is countered by Hirst (1996a, pp. 81–4).

4 A good short introduction to the historical context is provided by Thomas Mayer's essay in M. Hall 2005, pp. 76–94.

5 *Carteggio* IV, pp. 183–4.

6 This lost work executed by Daniele da Volterra is discussed in Romani 2003, pp. 158–9.

7 For a lucid short introduction to the biblical origins of the Apocalypse see Norman Cohn's essay in Carey 1999, pp. 28–41.

8 See Chapter 1 of Barnes 1998 for the pictorial tradition of the subject.

9 Michelangelo's admiration is described in Vasari's life of Signorelli (Bettarini and Barocchi ed.) 1971, III, p. 637.

10 The design is known through drawn copies discussed in Barnes 1988.

11 Vasari (Bettarini and Barocchi ed.) 1984, V, p. 102.

12 Wilde's entry (1953a, no. 60) with a numbered key of the various studies is, as ever, an invaluable key to unpicking the various layers.

13 A general similarity in pose to a figure studied in a badly rubbed black chalk drawing in the British Museum strengthens Wilde's proposition (1953a, no. 62) that it relates to the *Last Judgement* rather than the Medici chapel, as de Tolnay and others averred: *Corpus* II, no. 221r.

14 The others are *Corpus* III, nos 346r, 347r and 349r.

15 One of the speakers (the doctor M. Pulidoro Saraceni) in Giovanni Andrea Gilio's *Dialogo nel quale si ragiona degli errori e degli abusi de'pittori circa l'istorie* ('Dialogue concerning the errors of painters'), published in 1564, voices this criticism, reprinted in Barocchi 1960–2, II, p. 81.

16 *Corpus* III, no. 351. The verso is illustrated in Joannides 1996a, p. 170.

17 Armenini (Olszewski ed.), 1977, p. 169; Armenini (Gorreri ed.), 1988, p. 118.

18 With reference to artists seeking to study well-muscled men, I am grateful to David Ekserdjian for pointing out a reference to the sixteenth-century Netherlandish artist, Hendrick Goltzius, choosing to travel by sea from Naples to Rome in order to see the naked slaves rowing the papal galley: see van Mander 1994, I, p. 393.

19 For a useful guide to the theology of the period see MacCulloch 2004, pp. 106–21.

20 Most famously by Gilio. For the author and a guide to the extensive literature on the 1564 dialogue see *DBI*, 2000, LIV, pp. 751–4.

21 Condivi (Nencioni ed.) 1998, p. 50; Condivi (Wohl ed.) 1999, p. 84. As Wilde noted (1953a, p. 100, n. 1) the prominence of the Deadly Sins overthrown by angels may be linked to Vasari's statement that Clement VII wanted Michelangelo to portray such a group in bronze on the tower of the Castel Sant' Angelo as a fulfilment of a vow.

22 Wilde 1953a, p. 103. This observation was made by Hirst in his 1969 article on the newly discovered work.

23 This is proposed by Marcia Hall in the volume dedicated to the *Last Judgement*: M. Hall 2005, pp. 104–6.

24 Different dates for the verso are noted in van Tuyll van Serooskerken 2000, p. 134.

25 Berenson, Frey and A.E. Popp rejected the attribution: Wilde 1953a, p. 101. Tolnay included it in the *Corpus* (III, no. 352) but he was not in favour of the attribution. Hartt (1971, nos 378–9) enthusiastically endorsed Wilde's positive reaction.

26 This contradicts Hartt's view that the main study was taken from a 'muscular model of great strength' studied in a prone position.

27 Condivi (Nencioni ed.) 1998, p. 51; Condivi (Wohl ed.) 1999, p. 87.

28 Less than a month after the fresco was unveiled Nino Sernini, an agent of Cardinal Ercole Gonzaga, reported that the nudity had been criticized by the Theatines (perhaps a synonym for ultra-conservative Catholics). For this and other reactions to the fresco see Barnes 1998, pp. 71–101 and M. Hall 2005.

29 For this print see Bury 2001, no. 93. Ironically Gilio's attack on the fresco was also dedicated to Cardinal Farnese.

30 The translation is taken from Clifford 2002,

pp. 32–3; the whole document is published in Vasari (Milanesi ed.) 1881, VII, pp. 383–4.

31 Hirst 1988a, p. 13.

32 For the drawing see Pouncey and Gere 1962, no. 127.

33 Hayward 1976, p. 343.

34 Hayward 1976, p. 25.

35 The latter observation is taken from Joannides' excellent entry on the drawing in Chiarini, Darr and Giannini 2002, pp. 324–5.

36 Girardi 1960, nos 74 and 131; Ryan 1996, pp. 69 and 123.

37 The drawing bears the collector's mark of the earl of Dalhousie: Lugt 1956, no. 717a.

38 For the Victoria and Albert Museum copy see Ward-Jackson 1979, no. 193; the Uffizi drawing is published by Clifford 2002, p. 32, fig. 9.

39 For this area of artistic activity see Syson and Thornton 2001, pp. 135–81.

40 Clifford 2002. A third drawing of this kind is in the Fogg Museum, Cambridge; Corpus IV, no. 438r.

41 Girardi 1960, no. 295; Ryan 1996, pp. 239 and 335.

42 Carteggio V, no. mcccxxii, p. 212; Ramsden 1963, II, no. 455, p. 194.

43 For biographies in English of Contarini and Pole see respectively Gleason 1993 and Mayer 2000. An outline of Ochino's life is given in the Introduction to Belladonna's translation of the Seven Dialogues (Ochino 1988, pp. vii–xxiv).

44 For a useful short guide to the defining characteristics of this group see Collett 2000.

45 The most extensive study of Vittoria Colonna is the Vienna exhibition (Ferino-Pagden 1997); biographies of Colonna and Gonzaga are in the DBI 1982, XVII, pp. 448–57 and 2001, LVII, pp. 783–7.

46 According to his sixteenth-century biographer Paolo Giovio, d'Avalos's devotion to Spain extended to insisting on communicating with his wife in Spanish: see Hook 2004, p. 54.

47 In March 1539 the Mantuan agent in Rome relayed how she had questioned Pole and Contarini on why measures to address long-standing abuses were not being implemented: see Gleason 1993 p. 169.

48 For this letter see Ochino 1985, pp. 123–4.

49 The belief that Ochino visited the cardinal on his deathbed just before his flight northward is dismissed by Gleason 1993, p. 301.

50 For an English translation see de Hollanda (Folliero-Metz ed.) 1998.

51 Carteggio V, no. mclxxix, pp. 9–10.

52 The drawing is at Darmstadt: Corpus II, no. 334r. For the Hollanda provenance see Deswarte 1988–9.

53 In a letter to Aretino of September 1538 from Lucca, Colonna mentions she is returning to Rome on the pope's orders and another letter of 5 March 1539 records her presence there: see Ferrero and Müller 1892, pp. 163 and 171.

54 For discussion of the reliability of the Roman Dialogues see Bury 1981.

55 The best-known example of the latter tendency is Michelangelo's praise for works of art that he had never seen, but were known to Hollanda from his travels through Italy.

56 Pastor 1924, XIV, pp. 289–311. For the Viterbo circle see Calì 1980, pp. 116–54 and Mayer 2000 pp. 113–33.

57 A useful synopsis of recent studies on the Beneficio is found in Calì 1980, pp. 119–22. The

first copy of the original Italian publication only came to light in the 1840s in an English university library: MacCulloch 2004, p. 215.

58 For the links between Colonna's poetry and Ochino, see Campi 1994, pp. 39–54. Carnesecchi's riveting testimony of his memory of the marchesa, including the detail that she had read with interest one of Luther's commentaries on the Psalms, is published in Ferrero and Müller 1892, pp. 331–42.

59 The influence of Ochino on Michelangelo's poetry is examined in Campi 1994, pp. 55–8, 61–5.

60 Condivi (Nencioni ed.) 1998, p. 60; Condivi (Wohl ed.) 1999, p. 102. Pole's intimacy with Michelangelo led Cardinal Gonzaga to ask him to help in obtaining a drawing in 1546: see Frey 1907, p. 139.

61 For Beccadelli's letters see Carteggio V, nos. mccxxix, mccxlvii, and mcclxviii, pp. 66–7, 89–90 and 127; Stella's letter: Carteggio IV, no. mclxxiii, p. 378. There is also a letter from Bartolommeo's nephew Giovan Francesco, who was also in Pole's circle, to whom Michelangelo had sent a draft of a poem (Carteggio IV, no. cmxliv, p. 71).

62 For this see Hirst 2004a, pp. 25–9.

63 In Hartt's 1971 corpus it is associated with Exh. No. 71.

64 I am grateful to Michael Hirst for pointing out that Wilde's notes in the Courtauld Institute show that he thought the profiles might relate to Michelangelo's design for the base of the Marcus Aurelius on the Capitoline in Rome.

65 A diminutive study in the British Museum of the Crucified Christ may be related (Corpus II, no. 249).

66 For this connection with the Casa Buonarroti drawing see Wilde 1953a, p. 107. The latter's dating fits neither Joannides' suggestion (1972, p. 551) that the Casa Buonarroti drawing is for a Crucifix for the cappelletta of the Medici chapel nor Tolnay's hypothesis that it was prepared for a sculpture planned for the tomb of Vittoria Colonna who died in 1547 (Corpus III, no. 486r). The link with the bronze was made by Tolnay in the Corpus.

67 The copies are in the Louvre, Windsor Castle and the Victoria and Albert Museum: see Joannides 1996a, p. 96 and Coutts 1990, p. 215.

68 Nagel 2000, pp. 37–8.

69 Colonna's text is printed in Campi 1994, pp. 117–22.

70 Warburg's 1903 article is published in English in the recent collection of his writings (Warburg 1999, p. 310). Another possible source is Donatello's bronze relief of the Pietà in the Victoria and Albert Museum which has the Virgin seated on the ground and supporting her son in her lap: Janson 1963, pp. 206–8. Whether the work was accessible is not known, as its provenance is unrecorded prior to the museum buying it in the nineteenth century.

71 Corpus III, no. 271r. Morrogh (1994, p. 152) links the outline of a column on the right with those of the Palazzo dei Conservatori designed in the 1560s. The figures cannot be so late in date and it seems another case of Michelangelo reusing an old sheet for architectural designs on both sides.

72 Vasari (Bettarini and Barocchi ed.) 1987, VI, pp. 111–12. In the first edition Vasari only mentions Michelangelo's gift of the Pietà.

73 Condivi (Nencioni ed.) 1998, p. 61; Condivi (Wohl ed.) 1999, p. 103.

74 Redig de Campos' 1964 paper (Il Crocifisso di Michelangelo per Vittoria Colonna) at a Michelangelo conference in Rome (valuable for his

interpretation of the meaning of Colonna's letters) is an example of this confusion: Gronchi 1966, pp. 356–65 (republished in Cimino 1967, pp. 103–11). The two references in her letters are Carteggio IV, nos cmlxix and mxii, pp. 105 and 169. As anyone who works in the graphic field will attest, many people still have a hazy awareness of the difference between a painting and a drawing. I am hugely indebted to my wife, Isabella Lodi-Fè, and to Caroline Elam for their help in translating the British Library letter. The interpretation of the letter concurs with that of Michael Hirst who also generously shared his thoughts on the matter.

75 Carteggio IV, no. cmlxvi, p. 101.

76 Carteggio IV, no. cmlxvii, p. 102; Ramsden 1963, II, no. 202.

77 Carteggio IV, no. cmlxix, p. 105. Thode (1908–13) and Wilde (1953a, p. 107) both favour Colonna's involvement in shaping the design.

78 Wilde (1953a, p. 107, n. 1) was, for example, more inclined to think the marchesa was referring to the Pietà while Hirst (1988a, p. 118) believes that her comments relate to the British Museum sheet.

79 As was first noted by Hirst 1988a, p. 118.

80 This exchange of letters and the theological implications of gift giving are analysed by Nagel (1997, pp. 649–55).

81 Carteggio V, no. mcccxx, pp. 208–9.

82 Michelangelo is reported by J.J. Boissard (Romanae urbis topographiae et antiquitatum, Frankfurt, 1597–1602) to have particularly admired this marble, cited in Barocchi 1962, IV, p. 2101.

83 Ochino 1988, p. 44. Another example of this highly visual approach to sacred texts is found in Colonna's Meditatione del Venerdì Santo ('Meditation on Good Friday') published in Campi 1994, pp. 117–22.

84 Campi 1994, pp. 58–60.

85 Corpus III, nos 412r and 413r; Joannides 2003a, nos 39 and 40.

86 For the drawing's influence on El Greco's painting in the Louvre see Davies 2003, pp. 132–5.

87 The best synopsis of Venusti's relations with Michelangelo is that provided by Wilde 1953a, p. 113. See also Wallace 2003.

88 Robertson 1992, p. 158.

89 For Michelangelo's links with the Cesi see Wallace 2003, pp. 139–40 and 155, n. 15.

90 Pierpont Morgan Library, New York and Uffizi: Corpus III, nos 393r and 399r. The classic study of this class of drawings remains Wilde's 1959 article.

91 Wilde (1953a, p. 111) suggests that Michelangelo may have cut the sheet himself, but there seems no compelling reason to support this.

92 I am much indebted to Gere and Turner's excellent entry on Exh. No. 92 (1979, pp. 98–100) and Hirst's analysis of these drawings (1988a, pp. 54–5). The sequence described here is slightly different from that of the latter.

93 Similar rubbing was made for the new position of her other hand.

94 Hirst 1988a, p. 55. For the Cesi collection of antiquities see Bober and Rubinstein 1986, p. 472.

95 For the veil symbolizing Christ's incarnation see Hebrews x.19–20: 'Having therefore, brethren, boldness to enter into the holiest by the blood of Jesus, by a new and living way, which he hath consecrated for us, through the veil, that is to say his flesh.'

96 It was a mistake in the provenance given for this drawing in the 1836 Woodburn catalogue of the

Lawrence collection that inspired Perrig (1999) to question the veracity of the dealer's claim that many of the drawings were bought from the Casa Buonarroti. Despite the cartoon's provenance and contemporary citations to the contrary, Perrig attributes it to Condivi.

97 Vasari (Bettarini and Barocchi ed.) 1987, VI, p. 111.

98 Gombrich's suggestion that the title alludes to the Greek monk Epithanias seems most implausible, as makers of inventories then, as now, describe the subject of works not their textual sources.

99 Thode 1908-13, II, pp. 439–43.

100 Perhaps the only chance of finding the subject would be if the contract for the painting came to light.

101 This suggestion was made by a Martin Hutner in 1992 (note in British Museum file).

102 For Daniele see Barolsky 1979 and Romani 2003.

103 The most extensive analysis of Daniele's bust is in the entry on the one in Romani 2003, pp. 170–24.

104 Carteggio V, no. mcccxlvii, pp. 244–5.

105 There is an old pen inscription on a piece of paper stating that it was made from life by Leoni; this is illustrated in Warren 1999, p. 94.

106 Tolnay and others have interpreted the object held by the aggressor in the two lower studies as the jawbone of an ass, hence his identification as Samson. I find the weapon too indistinct to be sure of this.

107 Corpus III, nos 370–3. For the painting: Barolsky 1979, no. 17.

108 For the responses to Varchi see Barocchi 1971-7, I, pp. 493–523.

109 Gould (1975, p. 154) demonstrates characteristic caution in leaving the panel under Michelangelo's name in the National Gallery catalogue while acknowledging the likelihood that it is by Venusti.

110 This is recounted in Cornelia Colonelli's letter of December 1557: Carteggio V, no. mcclxv, pp. 120–2.

111 Examples of this method are given in n. 58 in chapter 1.

112 Parker in the Ashmolean catalogue (1956, p. 179) proposed that it had been reworked. For it having been drawn in two stages see Nagel 1996, pp. 565–6 and 2000, pp. 204–5.

113 Poeschke 1996, pp. 120–2, pls 104–5.

114 Wilde's dating of the drawing was given in the 1953 British Museum Michelangelo exhibition he organized. This late date was accepted by Tolnay and Hirst (Hirst and Dunkerton 1994, p. 139).

115 The Madonna del Silenzio from the 1540s in the duke of Portland's collection (Corpus III, no. 388) is another notable late red chalk drawing.

116 Corpus II, no. 269r. Exh. No. 101 is dated to c. 1530 in Joannides' forthcoming Ashmolean catalogue.

117 Corpus III, no. 434v; van Tuyll van Serooskerken 2000, no. 65.

118 Pfeiffer 1966. For a discussion of the subject and its textual sources see Breckenridge 1957, especially pp. 26–8.

119 Bartsch VII.46 and XIV.614.

120 Argan and Contardi 2004, p. 265.

121 Carteggio IV, no. mlxxxiii, pp. 267–8; Sangallo's letter is found on pp. 242–4. Information on Michelangelo's successful campaign to oust Nanni di Baccio Bigio from working at St Peter's is provided in correspondence of one of the deputies supervising the construction: Saalman 1978.

122 Elam 2001 and Joannides (in forthcoming Ashmolean catalogue) based on the proposals of d'Ossat and Pietrangeli 1965, pp. 106–9 and

Morrogh (1994, pp. 151–2) that the drawing should be related exclusively to the Palazzo dei Conservatori. The latter noted 'a faintly drawn standing figure in the opening suggests that the aedicule frames, not a window, but a niche for statuary'. This is impossible to see in reproduction but the faint outlines of the head and shoulders of a figure can just be made out when the drawing is examined closely. Paul Joannides informs me that there is a facsimile copy of Exh. No. 103 in the Fogg Museum. The Ashmolean has a similar design for a window and/or door related to the Palazzo dei Conservatori: Corpus IV, no. 605r.

123 Corpus IV, no. 619r.

124 My discussion of this much contested work is hugely reliant on Carel van Tuyll van Serooskerken's exemplary entry in his catalogue of Haarlem's Italian drawings.

125 Carteggio IV, no. mlxxxvi, pp. 271–2; Ramsden 1963, II, no. 285, p. 78.

126 The most extensive recent study of the dome with extensive references to previous literature is Millon and Smyth 1988, pp. 93–187.

127 For the various suggestions as to their destination see van Tuyll van Serooskerken 2000, p. 143.

128 The circular form obscured by the seated saint may be a view of the lantern above, as Carpiceci (1991, p. 61) suggested.

129 For the later dating see Joannides 1981c, pp. 621–2; Carpiceci 1991, pp. 50 and 57, and Joannides 1995b, pp. 5–6.

130 Girardi 1960, no. 285; Ryan 1996, pp. 230–3, 332–3.

131 Corpus III, nos 414, 416 and 418.

132 For the fullest discussion of this hypothesis see Joannides, 1996a, p. 92. The triangular line drawn around Christ's form on the verso of one of the Windsor drawings (illustrated in Hartt 1971, fig. 422) was interpreted by de Tolnay as indicating a block of marble or a piece of wood from which the figure was to be carved. I have no better explanation of this, but I wonder why any sculptor, let alone one as experienced as Michelangelo, would need to make such a simplistic diagram to visualize the material needed to carve the figure.

133 See Parker 1956, p. 181.

134 The drawing was first published by Annesley and Hirst 1981 and was later sold at Sotheby's, New York, in January 1998.

135 Condivi (Nencioni ed.) 1998, p. 61; Condivi (Wohl ed.) 1999, pp. 103 and 145, n. 120. This is one of a number of connections with ducento art discussed in Joannides 1992, pp. 252–7. Faint lines indicate that Michelangelo's first thought was to have a conventional-shaped cross.

136 Michelangelo's failing vision is alluded to in a letter of October 1537 from Staccoli to Francesco Maria della Rovere: Gronau 1906, p. 9. According to Staccoli, Michelangelo was unhappy with the model of a horse he had made for the duke because its small scale made it difficult for him to see. Once again I am grateful to Michael Hirst for alerting me to this reference.

137 In a letter from Calcagni to Leonardo Buonarroti: Daelli 1865, no. 23, pp. 34–5.

Bibliography

Ackerman, J. S. (1986) *The Architecture of Michelangelo*, 2nd edn, Harmondsworth.

Agosti, G. (1993) 'Su Mantegna 2. (All'ingresso della "maniera moderna")', *Prospettiva* 72, pp. 66–82.

Agosti, G. and V. Farinella (1987) *Michelangelo, studi di antichità dal Codice Coner*, Turin.

Agosti, G. and M. Hirst (1996) 'Michelangelo, Piero d'Argenta and the *Stigmatisation of St Francis*', *The Burlington Magazine* 138, pp. 683–4.

Ames-Lewis, F. and P. Joannides (eds) (2003) *Reactions to the Master: Michelangelo's effect on art and artists in the sixteenth century*, Aldershot.

Amy, M. J. (2000) 'The dating of Michelangelo's *St Matthew*', *The Burlington Magazine* 142, pp. 493–6.

Androsov, S. and U. Baldini (2000) *L'Adolescente dell'Ermitage e la Sagrestia Nuova di Michelangelo*, exh. cat., Casa Buonarroti, Florence and Hermitage Museum, St Petersburg.

Annesley, A. and M. Hirst (1981) '*Christ and the woman of Samaria* by Michelangelo', *The Burlington Magazine* 123, pp. 608–14.

Argan, G. C. and B. Contardi (2004) *Michelangelo Architect*, English language edn, Milan.

Armenini, G. B. (1977) *On the True Precepts of the Art of Painting*, trans. and ed. E. J. Olszewski, New York.

Armenini, G. B. (1988) *De'Veri Precetti della Pittura*, ed. M. Gorreri, Turin.

Ashby, T. (1904) 'Sixteenth-century drawings of Roman buildings attributed to Andreas Coner', *Papers of the British School at Rome* 2, pp. 1–96.

Attwood, P. (2003) *Italian Medals c. 1530–1600 in British Public Collections*, 2 vols, London, 2003.

Baldassari, F. (1995) *Carlo Dolci*, Turin.

Baldini, N. (2003) 'In the shadow of Lorenzo the Magnificent: the role of Lorenzo and Giovanni di Pierfrancesco de'Medici', in *In the Light of Apollo: Italian Renaissance and Greece*, exh. cat., ed. M. Gregori, National Gallery, London, and Alexander Soutzos Museum, Athens, 2 vols, I, pp. 277–82.

Baldini, U. (1982) *The Complete Sculpture of Michelangelo*, London, 1982.

Baldriga, I. (2000) 'The first version of Michelangelo's *Christ* for S. Maria sopra Minerva', *The Burlington Magazine* 142, pp. 740–5.

Bambach, C. (1983) 'A note on Michelangelo's cartoon for the Sistine ceiling: Haman', *Art Bulletin* 65, pp. 661–5.

Bambach [Cappel], C. (1990) 'Review of M. Hirst, *Michelangelo and his Drawings*', *Art Bulletin* 72, pp. 493–8.

— (1994) 'Problemi di tecnica nei cartoni di Michelangelo per la Cappella Sistina', in *Michelangelo, la Cappella Sistina: Atti del Convegno Internazionale di Studi, Roma, marzo 1990*, ed. K. Weil-Garris Brandt, Rome, pp. 93–117.

— (1997) 'Review of A. Perrig, *Michelangelo's Drawings: The science of attribution*, *Master Drawings* 35, pp. 69–70.

— (1999a) 'The purchase of cartoon paper for Leonardo's *Battle of Anghiari* and Michelangelo's *Battle of Cascina*', in *I Tatti Studies: Essays in the Renaissance*, ed. W. Kaiser, Florence, pp. 105–33.

— (1999b) *Drawing and Painting in the Italian Renaissance Workshop, theory and practice*, Cambridge.

— (2001) 'A Leonardo drawing for the Metropolitan Museum of Art: studies for a statue of *Hercules*', *Apollo* 153 (March), pp. 16–23.

— (2003) *Leonardo da Vinci Master Draftsman*, exh. cat., The Metropolitan Museum of Art, New York.

Bardeschi Ciulich, L. (1989) *Costanza ed evoluzioni nella scrittura di Michelangelo*, Florence.

Bardeschi Ciulich, L. and P. Barocchi (1970) *I Ricordi di Michelangelo*, Florence.

— (2002) *Michelangelo: Grafia e biografia. Disegni e Autografi del Maestro*, exh. cat., Rome, Palazzo di Venezia, Fondation Baula, Biel-Bienne, 2002.

Bardeschi, M. D. and L. Bardeschi Ciulich (1994) *A-Letheia 5, La difficile eredità: Architettura a Firenze dalla Repubblica all'assedio*, exh. cat., Accademia delle Arti del Disegno di Firenze, Florence.

Barnes, B. (1988) 'A lost *modello* for Michelangelo's *Last Judgement*', *Master Drawings* 26, pp. 239–48.

— (1998) *Michelangelo's 'Last Judgement', the Renaissance Response*, Berkeley, Los Angeles and London.

Barocchi, P. (ed.) (1960–2) *Trattati d'arte del Cinquecento: fra manierismo e controriforma*, 3 vols, Bari.

— (1962) *G. Vasari: La vita di Michelangelo nelle redazioni del 1550 e del 1568*, 5 vols, Milan and Naples.

— (1971–7) *Scritti del arte del Cinquecento*, 3 vols, Milan and Naples.

— (1992) *Il Giardino di San Marco: Maestri e compagni del giovane Michelangelo*, exh. cat., Casa Buonarroti, Florence.

Barocchi, P. and R. Ristori (1965) *Il Carteggio di Michelangelo*, vol. I, Florence.

— (1967) *Il Carteggio di Michelangelo*, vol. II, Florence.

— (1973) *Il Carteggio di Michelangelo*, vol. III, Florence.

— (1979) *Il Carteggio di Michelangelo*, vol. IV, Florence.

— (1983) *Il Carteggio di Michelangelo*, vol. V, Florence.

Barocchi, P. K. L. Bramanti and R. Ristori (1988–97) *Il Carteggio Indiretto di Michelangelo*, 2 vols, Florence.

Barolsky, P. (1979) *Daniele da Volterra: A catalogue raisonné*, New York and London.

— (1991) *Michelangelo's Nose: A myth and its maker*, University Park and London.

Bauman, L. P. (1990) *Power and Image: Della Rovere patronage in late quattrocento Rome*, Ph.D. thesis, Northwest University.

Bean, J. (1960) *Inventaire Général des Dessins des Musées de Province: Bayonne, Musée Bonnat. Les dessins Italiens de la collection Bonnat*, Paris.

Beck, J. (1990) 'Cardinal Alidosi, Michelangelo and the Sistine Chapel', *Artibus et Historiae* 22, pp. 63–77.

— (1991) 'Michelangelo's "sacrifice" on the Sistine ceiling', in *Renaissance Society and Culture: Essays in honor of Eugene F. Rice Jr.*, ed. J. Monfasani and R. G. Musto, New York, pp. 9–22.

Berenson, B. (1970) *The Drawings of the Florentine Painters*, reprint of 1938 edn, 3 vols, Chicago and London.

Bjurström, P. (1997) 'Christina's collection of drawings reconsidered', in *Politics and Culture in the Age of Christina*, ed. M.-L. Rodén, Wenner-Gren Centre, Stockholm, pp. 123–9.

Bober, P. P. (1957) *Drawings after the Antique by Amico Aspertini: Sketchbooks in the British Museum*, London.

Bober, P. P. and R. Rubinstein (1986) *Renaissance Artists and Antique Sculpture*, London and Oxford.

Bonsanti, G. (2001) 'Per un riesame del "Conte di Canossa" ', in *Opere e giorni: Studi su mille anni di arte europea dedicati a Max Seidel*, ed. K. Bergdolt and G. Bonsanti, Venice, pp. 513–18.

Breckenridge, J. D. (1957) '*Et Prima Vidit*: the iconography of the appearance of Christ to his Mother', *Art Bulletin* 39, pp. 9–32.

Brothers, C. (2000) 'Architecture, texts, and imitation in late fifteenth- and early sixteenth- century Rome', in *Architecture and Language*, ed. G. Clarke and P. Crossley, Cambridge, pp. 82–101.

Brown, A. (1979) 'Pierfrancesco de'Medici 1430–1476: a radical alternative to elder Medicean supremacy', *Journal of the Warburg and Courtauld Institutes* 42, pp. 81–103.

Brown, D. (1986) 'The *Apollo Belvedere* and the garden of Giuliano della Rovere at SS. Apostoli', *Journal of the Warburg and Courtauld Institutes* 49, pp. 235–8.

Brummer, H. H. (1970) *The Statue Court in the Vatican Belvedere*, Stockholm.

Bruni, L. (2001–4) *History of the Florentine people*, 3 vols, trans. and ed. J. Hankins, Cambridge (Mass.) and London.

Buddensieg, T. (1975) 'Bernardo della Volpaia und Giovanni Francesco da Sangallo: Der Autor des Codex Coner und seine Stellung im Sangallo-Kreis', *Römisches Jahrbuch für Kunstgeschichte* 15, pp. 89–108.

Bull, G. (1995) *Michelangelo, a Biography*, New York.

Bull, M. (1988) 'The iconography of the Sistine Chapel ceiling', *The Burlington Magazine* 130, pp. 597–605.

Buranelli, F. and A. Duston (eds) (2003) *The Fifteenth-Century Frescoes in the Sistine Chapel: Recent restorations of the Vatican Museum*, vol. IV, Vatican City State.

Bury, J. B. (1981) *Two Notes on Francisco de Hollanda*, ed. J. B. Trapp, Warburg Institute Surveys, London.

Bury, M. (2001) *The Print in Italy 1550–1620*, exh. cat., British Museum, London.

Butterfield, A. (1997) *The Sculptures of Andrea del Verrocchio*, New Haven and London.

Butters, H. (1978) 'Piero Soderini and the Golden Age', *Italian Studies* 33, pp. 56–71.

Cadogan, J. K. (1984) 'Observations on Ghirlandaio's method of composition', *Master Drawings* 22, pp. 159–72.

— (1993) 'Michelangelo in the workshop of Domenico Ghirlandaio', *The Burlington Magazine* 135, pp. 30–1.

— (2000) *Domenico Ghirlandaio, Artist and Artisan*, New Haven and London.

Caglioti, F. (2000) *Donatello e i Medici, storia del 'David' e della 'Giuditta'*, 2 vols, Florence.

Calì, M. (1980) *Da Michelangelo all'Escorial*, Turin.

Campbell, I. (2004) *The Paper Museum of Cassiano dal Pozzo, Series A – Antiquities and Architecture: Ancient Roman topography and architecture*, 3 vols (series A, part IX-1/3), London.

Campi, E. (1994) *Michelangelo e Vittoria Colonna*, Turin.

Carpiceci, A. C. (1991) 'Progetti di Michelangelo per la Basilica Vaticana', *Bollettino d'arte* 76 (68–9), pp. 23–106.

Carey, F. (ed.) (1999) *The Apocalypse and the Shape of Things to Come*, exh. cat., British Museum, London.

Carroll, E. A. (1987) *Rosso Fiorentino: Drawings, prints, and decorative arts*, exh. cat., National Gallery of Art, Washington.

Carteggio = Barocchi and Ristori (1965–83), 5 vols, Florence.

Carteggio Indiretto = Barocchi, Bramanti and Ristori (1988–97), 2 vols, Florence.

Cecchi, A. (1996) 'Niccolò Machiavelli o Marcello Virgilio Adriani? Sul programma e l'assetto compositivo delle *Battaglie* di Leonardo e Michelangelo per la Sala del Maggior Consiglio in Palazzo Vecchio', *Prospettiva* 83–4, pp. 103–15.

Cecchi, A. and A. Natali (1996) *L'Officina della Maniera*, exh. cat., Uffizi, Florence.

Cellini, B. (1981) *Autobiography*, trans. G. Bull, London.

Cennini, C. (1899) *The Book of the Art of Cennino Cennini: A contemporary practical treatise on quattrocento art*, trans. C. J. Herringham, London.

Chapman, H. (2003) 'Review of the Louvre's Michelangelo drawings exhibition', *The Burlington Magazine* 145, pp. 468–70.

Chapman, H., T. Henry and C. Plazzotta (2004) *Raphael from Urbino to Rome*, exh. cat., National Gallery, London.

Chiarini, M., A. Darr and C. Giannini (eds) (2002) *L'ombra del genio: Michelangelo e l'arte a Firenze 1537–1631*, exh. cat., Palazzo Strozzi, Florence, The Art Institute of Chicago, Chicago, and The Detroit Institute of Arts, Detroit.

Chong, A., D. Pegazzano and D. Zikos (eds) (2003) *Raphael, Cellini and a Renaissance Banker: The patronage of Bindo Altoviti*, exh. cat., Isabella Stewart Gardner Museum, Boston, and Museo Nazionale del Bargello, Florence.

Cimino, G. (1967) *Il 'Crocifisso' di Michelangelo per Vittoria Colonna*, Rome.

Clifford, T. (2002) 'A candelabrum by Michelangelo, a discovery at the Cooper-Hewitt, National Design Museum in New York', *Apollo* 156 (September), pp. 30–40.

Collett, B. (2000) *A Long and Troubled Pilgrimage: The correspondence of Marguerite D'Angoulême and Vittoria Colonna 1540–1545*, Studies in Reformed Theology and History, Princeton.

Colonna, V. (1982) *Rime*, ed. A. Bullock, Bari.

Condivi, A. (1998) *Vita di Michelagnolo Buonarroti*, ed. G. Nencioni (with essays by M. Hirst and C. Elam), Florence.

Condivi, A. (1999) *The Life of Michelangelo*, trans. A. S. Wohl, ed. H. Wohl, Pennsylvania.

Cordellier, D. (1991) 'Fragments de jeunesse: deux feuilles inédites de Michel-Ange au Louvre', *Revue du Louvre* 2, pp. 43–55.

Corpus = Tolnay (1975–80), 4 vols, Novara.

Corti, G. (1964) 'Una ricordanza di Giovan Battista Figiovanni', *Paragone* 175, pp. 24–31.

Coutts, H. (1990) 'A copy of a lost drawing by Michelangelo (letter)', *The Burlington Magazine* 132, p. 215.

Dacos, N. (1962) 'Ghirlandaio et l'antique', *Bulletin de l'Institut Historique Belge de Rome* 34, pp. 419–55.

Dacos, N., A. Giuliano, A. Grote, et al. (1973) *Il Tesoro di Lorenzo il Magnifico, repetorio delle gemme e dei vasi*, Florence.

Daelli, G. (1865) *Carte Michelangiolesche inedite*, Milan.

Dalli Regoli, G. (1976) 'Il piegar de'panni', *Critica d'Arte* 22 (November–December), pp. 35–48.

Dalli Regoli, G., R. Nanni and A. Natali (2001) *Leonardo e il mito di Leda: modelli, memorie e metamorfosi di un'invenzione*, exh. cat., Palazzina Uzielli del Museo Leonardiano, Vinci.

Danesi Squarzina, S. (2000) 'The Bassano "Christ the Redeemer" in the Giustiniani collection', *The Burlington Magazine* 142, pp. 746–51.

Davies, D. (ed.) (2003) *El Greco*, exh. cat., National Gallery, London.

Deswarte, S. (1988–9), '*Opus Micaelis Angeli*: le dessin de Michel-Ange de la collection de Francisco de Holanda', *Prospettiva (Scritti in ricordo di Giovanni Previtali I)* 53–6, pp. 388–98.

DBI, Dizionario Biografico degli Italiani, vol. I– , Rome, 1960– (in progress).

Dotson, E. G. (1979) 'An Augustinian interpretation of Michelangelo's Sistine ceiling', *Art Bulletin* 61, pp. 223–56, 405–29.

Draper, J. D. (1992) *Bertoldo di Giovanni, sculptor of the Medici household: Critical reappraisal and catalogue raisonné*, Columbia and London.

— (1997) 'Ango after Michelangelo', *The Burlington Magazine* 139, pp. 398–400.

Dussler, L. (1959) *Die Zeichnungen des Michelangelo*, Berlin.

Dussler, L. (ed.) (1974) *Michelangelo-Biographie 1927–1970*, Wiesbaden, 1974.

Echinger-Maurach, C. (1991) *Studien zu Michelangelos Juliusgrabmal*, Hildesheim, 1991.

— (2003) 'Michelangelo's monument for Julius II in 1534', *The Burlington Magazine* 145, pp. 336–44.

Egger, H., C. Hülsen and A. Michaelis (1906), *Codex Escurialensis, ein Skizzenbuch aus der Werkstatt Domenico Ghirlandaios*, 2 vols, Vienna.

Ekserdjian, D. (1993) 'Parmigianino and Michelangelo', *Master Drawings* 31, pp. 390–4.

Elam, C. (1979) 'The site and early building history of Michelangelo's New Sacristy', *Mitteilungen des Kunsthistorischen Institutes in Florenz* 23, pp. 155–86.

— (1992a) 'Drawings as documents: the problem of the San Lorenzo façade', in *Studies in the History of Art 33, Center for Advanced Study in the Visual Arts, Symposium Papers XVII: Michelangelo drawings*, ed. C. Hugh Smyth, Hanover and London, pp. 99–114.

— (1992b) 'Lorenzo de'Medici's sculpture garden', *Mitteilungen des Kunsthistorischen Institutes in Florenz* 36, pp. 41–84.

— (1993) 'Art in the service of liberty – Battista della Palla, art agent for Francis I', *I Tatti Studies: Essays in the Renaissance* 5, pp. 33–109.

— (2001) *Design into Architecture*, exh. cat., Christ Church Picture Gallery, Oxford.

Elan, A. J. (1995) *Italian Late Medieval and Renaissance Drawing – Books from Giovanni de'Grassi to Palma Giovane: A codicological approach*, Leiden.

Ettlinger, L. D. (1978a) *Antonio and Piero Pollaiuolo*, London.

— (1978b) 'The liturgical function of Michelangelo's Medici chapel', *Mitteilungen des Kunsthistorischen Institutes in Florenz* 22, pp. 287–304.

Faietti, M. and D. Scaglietti Kelescian (1995) *Amico Aspertini*, Modena.

Falletti, F. and J. Katz Nelson (eds) (2002) *Venere e Amore: Michelangelo e la nuova bellezza ideale*, exh. cat., Galleria dell'Accademia, Florence.

Feinberg, L. J. (1991) *From Studio to Studiolo*, exh. cat., Allen Memorial Art Museum, Oberlin College.

Ferino-Pagden, S. (ed.) (1997) *Vittoria Colonna: Dichterin und Muse Michelangelos*, exh. cat., Kunsthistorisches Museum, Vienna.

Ferrero, E. and G. Müller (eds) (1892) *Vittoria Colonna Marchesa di Pescara, Carteggio*, Turin.

Franklin, D. (1994) *Rosso in Italy: The Italian career of Rosso Fiorentino*, New Haven and London.

— (2001) *Painting in Renaissance Florence 1500–1550*, New Haven and London.

Freedberg, S. J. (1963) ' "Drawings for Sebastiano" or "Drawings by Sebastiano"?: The problem reconsidered', *Art Bulletin* 45, pp. 253–8.

Frey, K. (1907) *Michelagniolo Buonarroti: Quellen und Forschungen zu seiner Geschichte und Kunst*, vol. I, Berlin.

— (1923–30) *Der Literarische Nachlass Giorgio Vasaris*, 2 vols, Munich.

Frey, K. (ed.) (1892) *Il Codice Magliabechiano*, Berlin.

Frommel, C. L. (1977) ' "Capella Iulia": Die Grabkapelle Papst Julius II. in Neu-St. Peter', *Zeitschrift für Kunstgeschichte* 40, pp. 26–62.

— (1979) *Michelangelo und Tommaso dei Cavalieri*, Amsterdam.

Gatteschi, R. (ed.) (1998) *Vita di Raffaello da Montelupo*, Florence.

Gaye, G. (1839–40) *Carteggio inedito d'artisti dei secoli XIV, XV, XVI*, 3 vols, Florence.

Gelli, G. B. (1967) *Dialoghi*, ed. R. Tissoni, Bari.

Gere, J. A. (1953) 'William Young Ottley as a collector of drawings', *British Museum Quarterly* 18, pp. 44–53.

Gere, J. A. and P. Pouncey (1983) *Italian Drawings in the Department of Prints and Drawings in the British Museum: Artists working in Rome c.1550 to c.1640*, 2 vols, London.

Gere, J. A. and N. Turner (1975) *Drawings by Michelangelo*, exh. cat., British Museum, London.

— (1979) *Drawings by Michelangelo from the British Museum*, exh. cat., Pierpont Morgan Library, New York.

Giacometti, M. (ed.) (1986) *The Sistine Chapel: Michelangelo rediscovered*, London.

Gilbert, C. E. (1971) 'Texts and contexts of the Medici chapel', *Art Quarterly* 34, pp. 391–409.

— (1980) *Sources and Documents: Italian art 1400–1500*, New Jersey.

— (1994a) 'Lo schizzo della scala', in *Michelangelo, la Cappella Sistina: Atti del Convegno Internazionale di Studi, Roma, marzo 1990*, ed. K. Weil-Garris Brandt, Rome, pp. 61–5.

— (1994b) *Michelangelo on and off the Sistine Ceiling*, New York.

Girardi, E. N. (1960) *Michelangiolo Buonarroti, Rime*, Bari.

Gleason, E. G. (1993) *Gasparo Contarini: Venice, Rome, and reform*, Berkeley LA and Oxford.

Goffen, R. (2002) *Renaissance Rivals: Michelangelo, Leonardo, Raphael, Titian*, New Haven and London.

Goldscheider, L. (1957) *Michelangelo's Bozzetti for Statues in the Medici Chapel*, London, 1957.

Gombrich, E. (1986) *New Light on Old Masters: Studies in the art of the Renaissance: 4*, Oxford.

Gotti, A. (1875) *Vita di Michelangelo Buonarroti*, Florence.

Gould, C. (1975) *National Gallery Catalogues: The sixteenth-century Italian schools*, London.

Gouwens, K. and S. E. Reiss (eds) (1995) *The Pontificate of Clement VII, History, Politics, Culture*, Aldershot and Burlington VT.

Gronau, G. (1906) 'Die Kunstbestrebungen der Herzöge von Urbino', *Jahrbuch der Königlich Preuszischen Kunstsammlungen* 27 (Supplement), pp. 1–44.

Gronchi, G. (ed.) (1966) *Atti del Convegno di Studi Michelangioleschi Firenze–Roma 1964*, Rome.

Guicciardini, F. (1984) *The History of Italy*, trans. S. Alexander, Princeton.

Hale, J. R. (2004) *Florence and the Medici*, London.

Hall, J. (2005) *Michelangelo and the Reinvention of the Human Body*, London.

Hall, M. B. (ed.) (2005) *Michelangelo's 'Last Judgment'*, Cambridge.

Hankins, J. (1991) 'The myth of the Platonic Academy of Florence', *Renaissance Quarterly* 44, pp. 429–75.

Hartt, F. (1969) *Michelangelo, the Complete Sculptures*, London.

— (1971) *The Drawings of Michelangelo*, London.

— (1982) 'The evidence for the scaffolding of the Sistine chapel', *Art History* 5, pp. 273–86.

— (1994) 'Lo schizzo degli Uffizi, il suo significato per il ponteggio e la cronologia', in *Michelangelo, la Cappella Sistina: Atti del Convegno Internazionale di Studi, Roma, marzo 1990*, ed. K. Weil-Garris Brandt, Rome, pp. 51–5.

Hatfield, R. (1991) ' "Trust in God": the sources of Michelangelo's frescoes on the Sistine chapel', *Occasional Papers Published by Syracuse University, Florence, Italy*, pp. 1–23.

— (2002) *The Wealth of Michelangelo*, Rome.

Haussherr, R. (1971) *Michelangelos Kruzifixus für Vittoria Colonna. Bemerkungen zu Ikonographie und theologischer Deutung*, Opland.

Hayward, J. F. (1976) *Virtuoso Goldsmiths and the Triumph of Mannerism*, London.

Heikamp, D. (2000) 'The youth of Michelangelo: The New York *Archer* reconsidered', *Apollo* 151 (June), pp. 27–36.

Henry, T. (1998) *Signorelli in British Collections*, exh. cat., National Gallery, London.

Henry, T., L. Kanter and G. Testa (2001) *Luca Signorelli*, Turin.

Hettner, O. (1909) 'Zeichnerische Gepflogenheiten bei Michelangelo. Mit einem Anhage über Signorelli und Correggio', *Monatschefte für Kunstwissenschaft* 2, pp. 71–87, 134–48.

Hirst, M. (1961) 'The Chigi chapel in Santa Maria della Pace', *Journal of the Warburg and Courtauld Institutes* 25, pp. 161–85.

— (1963) 'Michelangelo drawings in Florence', *The Burlington Magazine* 105, p. 166–71.

— (1969) 'Two unknown studies by Michelangelo for the *Last Judgement*', *The Burlington Magazine* 111, pp. 27–8.

— (1975) 'A drawing of the *Rape of Ganymede* by Michelangelo', *The Burlington Magazine* 117, p. 166.

— (1976) 'A project of Michelangelo for the tomb of Julius II', *Master Drawings* 14, pp. 375–82.

— (1981) *Sebastiano del Piombo*, Oxford.

— (1983) 'Review of de Tolnay's *Corpus*', *The Burlington Magazine* 125, pp. 552–6.

— (1984) 'A further addendum to the Michelangelo *Corpus*', *The Burlington Magazine* 126, p. 91.

— (1985) 'Michelangelo, Carrara, and the marble for the cardinal's *Pietà*', *The Burlington Magazine* 127, pp. 154–9.

— (1986a) 'I disegni di Michelangelo per la *Battaglia di Cascina* (ca.1504)', in *Tecnica e Stile: esempi di pittura murale del Rinascimento italiano*, ed. E. Borsook and F. S. Gioffredi, Milan, vol. I, pp. 43–58.

— (1986b) ' "Il modo delle attitudini": Michelangelo's Oxford sketchbook for the ceiling', in *The Sistine Chapel: Michelangelo rediscovered*, ed. M. Giacometti, London, vol. II, pp. 208–17.

— (1988a) *Michelangelo and his Drawings*, New York and London.

— (1988b) *Michelangelo Draftsman*, exh. cat., National Gallery of Art, Washington.

— (1991) 'Michelangelo in 1505: an altar-piece and the *Bacchus*', *The Burlington Magazine* 133, pp. 760–6.

— (1996a) 'Michelangelo and his first biographers', *Proceedings of the British Academy* 94, pp. 63–84.

— (1996b) 'The New York "Michelangelo": a different view', *Art Newspaper* 7, 61, p. 3.

— (2000) 'Michelangelo in Florence: *David* in 1503 and *Hercules* in 1506', *The Burlington Magazine* 142, pp. 487–92.

— (2004a) *Tre saggi su Michelangelo*, Florence.

— (2004b) 'Two notes on Michelangelo in Florence: the façade of S. Lorenzo and the "kneeling" windows of the Palazzo Medici', *Apollo* 159 (February), pp. 39–43.

Hirst, M. and J. Dunkerton (1994) *Making and Meaning: The young Michelangelo*, exh. cat., National Gallery, London.

— (1997) *Michelangelo giovane. Pittore e scultore a Roma 1496–1501*, National Gallery catalogue in Italian edn, Modena.

Hollanda, F. de (1998) *Diálogos em Roma (1538): Conversations on art with Michelangelo Buonarroti*, ed. G. D. Folliero-Metz, Heidelberg.

Hollstein, F. W. H. *Dutch and Flemish Etchings, Engravings and Woodcuts* c. 1450–1700, vol. I–, Amsterdam, 1949– (in progress).

Holroyd, C. (1903) *Michael Angelo Buonarroti*, London and New York.

Holst, C. von (1974) *Francesco Granacci*, Munich.

Hook, J. (2004) *The Sack of Rome 1527*, 2nd edn, Basingstoke and New York.

Hope, C. (1971) 'The "Camerini d'Alabastro" of Alfonso d'Este – I & II', *The Burlington Magazine* 113, pp. 641–50, 712–21.

— (1987) 'The medallions on the Sistine chapel', *Journal of the Warburg and Courtauld Institutes* 50, pp. 200–4.

Hugh Smyth, C. (ed.) (1992) *Studies in the History of Art, 33, Center for Advanced Study in the Visual Arts, Symposium Papers XVII: Michelangelo drawings*, Hanover and London.

Hughes, A. (1981) 'A lost poem by Michelangelo?', *Journal of the Warburg and Courtauld Institutes* 44, pp. 202–6.

— (1997) *Michelangelo*, London.

— (2004) 'Review of Joannides Louvre catalogue', *The Burlington Magazine* 146, pp. 766–8.

James, C., C. Corrigan, M. C. Enshaian, et al. (1997) *Old Master Prints and Drawings: A guide to preservation and conservation*, trans. M. B. Cohn, Amsterdam.

Janson, H. W. (1963) *The Sculpture of Donatello*, 2nd edn, Princeton.

Joannides, P. (1972) 'Michelangelo's Medici chapel: some new suggestions', *The Burlington Magazine* 104, pp. 541–51.

— (1975) 'Review of exhibition 'Michelangelo Drawings in the British Museum', *The Burlington Magazine* 117, pp. 257–62.

— (1977) 'Michelangelo's lost *Hercules*', *The Burlington Magazine* 119, pp. 550–5.

— (1981a) 'A supplement to Michelangelo's lost *Hercules*', *The Burlington Magazine* 123, pp. 20–3.

— (1981b) 'Review of de Tolnay's *Corpus*', *Art Bulletin* 63, pp. 679–87.

— (1981c) 'Review of Wittkower *Idea and Image: Studies in the Italian Renaissance* and Wilde's *Michelangelo. Six Lectures*', *The Burlington Magazine* 123, pp. 620–2.

— (1983) *The Drawings of Raphael*, Oxford.

— (1988) 'A Michelangelesque copy after Raphael', *The Burlington Magazine* 130, pp. 530–1.

— (1991a) 'A newly unveiled drawing by Michelangelo and the early iconography of the *Magnifici* tomb', *Master Drawings* 29, pp. 255–62.

— (1991b) 'La chronologie du tombeau de Jules II, à propos d'un dessin découvert', *Revue du Louvre* 41, pp. 32–42.

— (1992) ' "Primivitism" in the late drawing of Michelangelo: the master's construction of an old-age style', in *Studies in the History of Art, 33, Center for Advanced Study in the Visual Arts, Symposium Papers XVII: Michelangelo drawings*, ed. C. Hugh Smyth, Hanover and London, pp. 245–61.

— (1994) 'Bodies in the Trees: a mass martyrdom by Michelangelo', *Apollo* 140 (November), pp. 3–14.

— (1995a) 'On the recto and on the verso of a sheet of drawings by Michelangelo at Princeton', *Record of The Art Museum Princeton University* 54, no. 2, pp. 3–11.

— (1995b) 'A drawing by Michelangelo for the Lantern of St Peter's', *Apollo* 142 (November), pp. 3–6.

— (1996a) *Michelangelo and his Influence: Drawings from Windsor Castle*, exh. cat., National Gallery of Art, Washington, and Kimbell Art Museum, Fort Worth.

— (1996b) 'Michelangelo: the *Magnifici* tomb and the *Brazen Serpent*', *Master Drawings* 34, pp. 149–67.

— (2001) 'On Michelangelo's *Stoning of St Stephen*', *Master Drawings* 39, pp. 3–11.

— (2003a) *Musée du Louvre Département des Arts Graphiques, Inventaire Général des Dessins Italiens: Michel-Ange, élèves et copistes*, Paris.

— (2003b) 'Salviati and Michelangelo', in *Reactions to the Master*, ed. F. Ames-Lewis and P. Joannides, Aldershot, pp. 68–92.

— (2003c) 'Two drawings related to Michelangelo's *Hercules and Antaeus*', *Master Drawings* 41, pp. 105–18.

— (2003d) 'Michelangelo's *Cupid*: a correction', *The Burlington Magazine* 145, pp. 579–80.

Kemp, M. (1981) *Leonardo da Vinci: The marvellous works of nature and man*, London, Melbourne and Toronto.

Kent, D. (2000) *Cosimo de'Medici and the Florentine Renaissance*, New Haven and London.

Kent, F. W (1993) 'Bertoldo "sculptore" again', *The Burlington Magazine* 135, pp. 629–30.

— (2004), *Lorenzo de'Medici and the Art of Magnificence*, Baltimore and London.

Kruft, H.-W. (1975) 'Antonello Gagini as co-author with Michelangelo on the tomb of Julius II', *The Burlington Magazine* 117, pp. 598–9.

Lafranconi, M. (1998) 'Antonio Tronsarelli: A Roman collector of the late sixteenth-century', *The Burlington Magazine* 140, pp. 537–50.

Levine, S. (1974) 'The location of Michelangelo's *David*: the meeting of January 25, 1504', *Art Bulletin* 65, pp. 31–49.

Lisner, M. (1963) 'Der *Kruzifixus* Michelangelos im Kloster S. Spirito in Florenz', *Kunstchronik* 16, pp. 1–2.

Lugt, F. (1921) *Les Marques de Collections de Dessins et l'Estampes*, Amsterdam.

— (1956) *Les Marques de Collections de Dessins et l'Estampes: Supplément*, The Hague.

MacCulloch, D. (2004) *Reformation: Europe's house divided 1490–1700*, London.

Magister, S. (2002) 'Arte e politica: la collezione di antichità del Cardinale Giuliano della Rovere nei palazzi ai Santi Apostoli', *Atti della Accademia Nazionale dei Lincei* 14, no. 4, pp. 389–631.

Mancinelli, F. (1986) 'Michelangelo at work: the painting of the ceiling', in *The Sistine Chapel: Michelangelo rediscovered*, ed. M. Giacometti, London, pp. 218–59.

— (1992) 'La progettazione della volta della cappella Sistina di Michelangelo', in *Studies in the History of Art, 33, Center for Advanced Study in the Visual Arts, Symposium Papers XVII: Michelangelo drawings*, ed. C. Hugh Smyth, Hanover and London, pp. 43–55.

— (1994) 'Il ponteggio di Michelangelo per la cappella Sistina e i problemi cronologici della volta', in *Michelangelo, la Cappella Sistina: Atti del Convegno Internazionale di Studi, Roma, marzo 1990*, ed. K. Weil-Garris Brandt, Rome, pp. 43–9.

Mancinelli, F. (ed.) (1994) *Michelangelo, the Sistine Chapel: The restoration of the ceiling frescoes*, 2 vols, Treviso.

Mancinelli, F., G. Morello, A. M. De Strobel, et al. (1990) *Michelangelo e la Sistina: la tecnica, il restauro, il mito*, exh. cat., Musei e Gallerie Pontificie, Vatican.

Mancusi-Ungaro, H. R. (1971) *Michelangelo: The 'Bruges Madonna' and the Piccolomini altar*, New Haven and London.

van Mander, K. (1994–9) *The Lives of the Illustrious Netherlandish and German Painters from the First Edition of the 'Schilder-boeck' (1603–1604)*, trans. and ed. H. Miedema, 6 vols, Doornspijk.

von Marcuard, F. (1901) *Die Zeichnungen Michelangelos im Museum Teyler zu Haarlem*, Munich.

Marani, P. C. (ed.) (1992) *Le génie du sculpteur dans l'oeuvre de Michel-Ange*, exh. cat., Musée des Beaux-Arts de Montréal, Montreal.

Marchini, G. (1977) 'Il ballatoio della cupola di Santa Maria del Fiore', *Antichità Viva* 16, 6, pp. 36–48.

Maurenbrecher, W. (1938) *Die Aufzeichnungen des Michelangelo Buonarroti im Britischen Museum in London und im Vermächtnis Ernst Steinmann in Rom*, Leipzig.

Mayer, T. F. (2000) *Reginald Pole, Prince and Prophet*, Cambridge.

— (2002) *The Correspondence of Reginald Pole*, vol. I, *A Calendar, 1518–1546: Beginnings to legate of Viterbo*, Aldershot.

Meder, J. (1978) *The Mastery of Drawing*, trans. W. Ames, 2 vols, New York.

Milanesi, G. (1875) *Le lettere di Michelangelo Buonarroti, publicate coi ricordi ed i contratti artistici*, Florence.

Millon, H. A. and C. Hugh Smyth (1988) *Michelangelo Architect: The façade of San Lorenzo and the drum and dome of St Peter's*, exh. cat., National Gallery of Art, Washington.

Morozzi, L. (1988–9) '*La Battaglia di Cascina* di Michelangelo: nuova ipotesi sulla data di commissione', *Prospettiva (Scritti in ricordo di Giovanni Previtali: I)* 53–6, pp. 320–4.

Morrogh, A. (1992a) 'The *Magnifici* tomb: a key project in Michelangelo's architectural career', *Art Bulletin* 74, pp. 567–98.

— (1992b) 'The Medici chapel: the designs for the central tomb', in *Studies in the History of Art, 33, Center for Advanced Study in the Visual Arts, Symposium Papers XVII: Michelangelo drawings*, ed. C. Hugh Smyth, Hanover and London, pp. 143–61.

— (1994) 'The palace of the Roman people: Michelangelo at the Palazzo dei Conservatori', *Römisches Jahrbuch der Biblioteca Hertziana* 29, pp. 129–86.

Murray, L (1984) *Michelangelo: His life, work and times*, London.

Musacchio, J. M. (1999) *The Art and Ritual of Childbirth in Renaissance Italy*, New Haven and London.

Myssok, J. (1999) *Bildhauerische Konzeption und plastiches Modell in der Renaissance*, Münster.

Nagel, A. (1996) 'Observations on Michelangelo's late *Pietà* drawings and sculptures', *Zeitschrift für Kunstgeschichte* 59, pp. 548–72.

— (1997) 'Gifts for Michelangelo and Vittoria Colonna', *Art Bulletin* 79, pp. 647–68.

— (2000) *Michelangelo and the Reform of Art*, Cambridge.

Newton, T. H. and J. R. Spencer (1982) 'On the location of Leonardo's *Battle of Anghiari*', *Art Bulletin* 64, pp. 45–52.

O' Malley, J. (1986) 'The theology behind Michelangelo's ceiling', in *The Sistine Chapel: Michelangelo rediscovered*, ed. M. Giacometti, London, pp. 92–148.

Ochino, B. (1985) *I 'Dialoghi Sette' e altri scritti del tempo della fuga*, ed. U. Rozzo, Turin.

— (1988) *Seven Dialogues*, trans. R. Belladonna, Ottawa.

d'Ossat, G. de Angelis and C. Pietrangeli (1965) *Il Campidoglio di Michelangelo*, Rome.

Panofsky, E. (1937) 'The first two projects of Michelangelo's tomb of Julius II', *Art Bulletin* 19, pp. 561–79.

Panofsky-Soergel, G. (1984) 'Post-scriptum to Tommaso Cavalieri', in *Scritti di storia dell'arte in onore di Roberto Salvini*, ed. C. de Benedictis, Florence, pp. 399–405.

Paoletti, J. T. (2000) 'The Rondanini *Pietà*: ambiguity maintained through the palimpsest', *Artibus et Historia* 21, 42, pp. 53–80.

Parker, K. T. (1956) *Catalogue of the Collection of Drawings in the Ashmolean Museum*, vol. II, *Italian Schools*, Oxford.

Parks, R. N. (1975) 'The placement of Michelangelo's *David*: a review of the documents', *Art Bulletin* 57, pp. 560–70.

Passavant, M. (1836) *Tour of a German Artist in England with Notices of Private Galleries, and Remarks on the State of Art*, 2 vols, London.

Pastor, L. (1891–1953) *The History of the Popes*, ed. R. F. Kerr and E. Graf, 40 vols, London.

Penny, N. (1992) *Catalogue of European Sculpture in the Ashmolean Museum: 1540 to the present day*, 3 vols, Oxford.

Perrig, A. (1962) 'Michelangelo und Marcello Venusti: Das Problem der Verkündigungs- und Ölberg Konzeption Michelangelos', *Wallraf-Richartz-Jahrbuch* 24, pp. 261–94.

— (1991) *Michelangelo's Drawings: The science of attribution*, trans. M. Joyce, New Haven and London.

— (1999) 'Räuber, Profiteure, "Michelangelos" und die Kunst der Provenienzen-Erfindung', *Städel Jahrbuch* 17, pp. 209–86.

Pesman Cooper, R. (1967) 'L'elezione di Pier Soderini a gonfaloniere a vita', *Archivio storico italiano* 125, pp. 145–85.

— (1978) 'Piero Soderini: aspiring prince or civic leader', *Studies in Medieval and Renaissance History* 1 (New Series), pp. 71–126.

Pfeiffer, H. (1966) 'On the meaning of a late Michelangelo drawing', *Art Bulletin* 48, p. 227.

Pillsbury, E. (1974) 'Drawings by Jacopo Zucchi', *Master Drawings* 12, pp. 3–33.

Poeschke, J. (1996) *Michelangelo and his World*, trans. R. Stockman, New York.

Poggi, G. (1988) *Il Duomo di Firenze: documenti sulla decorazione della chiesa e del campanile tratti dall'archivio dell'opera*, ed. M. Haines, Florence.

Polizzotto, L. (1994) *The Elect Nation: The Savonarolan movement in Florence 1495–1545*, Oxford.

Pope-Hennessy, J. and R. Lightbown (1964) *Catalogue of Italian Sculpture in the Victoria and Albert Museum*, 3 vols, London.

Popham, A. E. (1946) *The Drawings of Leonardo da Vinci*, London.

— (1971) *The Drawings of Parmigianino*, 3 vols, New Haven and London.

Popham, A. E. and P. Pouncey (1950) *Italian Drawings in the Department of Prints and Drawings in the British Museum: The fourteenth and fifteenth centuries*, 2 vols, London.

Popham, A. E. and J. Wilde (1949) *The Italian drawings of the XV and XVI centuries in the Collection of His Majesty the King at Windsor Castle*, London.

Popp, A. E. (1922) *Die Medici Kapelle Michelangelos*, Munich.

— (1925–6) 'Bemerkungen zu einigen Zeichnungen Michelangelos', *Zeitschrift für Bildende Kunst* 59, pp. 134–46.

— (1936) 'Two torsi by Michelangelo', *The Burlington Magazine* 69, pp. 202–13.

Portoghesi, P. and B. Zevi (1964) *Michelangelo architetto*, Turin.

Pouncey, P. and J. A. Gere (1962) *Italian Drawings in the Department of Prints and Drawings at the British Museum: Raphael and his circle*, 2 vols, London.

Ragionieri, P. (1997) *Casa Buonarroti*, Florence.

Ragionieri, P. (ed.) (2000) *I bozzetti michelangioleschi della Casa Buonarroti*, Florence.

Radke, G. M. (2003) *Verrocchio's 'David' Restored, a Renaissance Bronze from the National Museum of the Bargello, Florence*, exh. cat., High Museum of Art, Atlanta, and National Gallery of Art, Washington.

Ramsden, E. H. (1963) *The Letters of Michelangelo, Translated from the Original Tuscan, Edited and Annotated*, 2 vols, London.

Reiss, S. E. (1987) 'A medieval source for Michelangelo's *Medici Madonna*', *Zeitschrift für Kunstgeschichte* 50, pp. 394–400.

Ricordi = Bardeschi Ciulich and Barocchi (1970), Florence.

Ridolfi, R. (1959) *The Life of Girolamo Savonarola*, trans. C. Grayson, London.

Roberts, J. (1988) *A Dictionary of Michelangelo's Watermarks*, Milan.

Robertson, Ch. (1986) 'Bramante, Michelangelo and the Sistine ceiling', *Journal of the Warburg and Courtauld Institutes* 49, pp. 91–105.

Robertson, Cl. (1992) *'Il Gran Cardinale': Alessandro Farnese, patron of the arts*, New Haven and London.

Robinson, J. C. (1870) *A Critical Account of the Drawings by Michel Angelo and Raffaello in the University Galleries, Oxford*, Oxford.

— (1876) *Descriptive Catalogue of Drawings by the Old Masters, Forming the Collection of John Malcolm of Poltalloch, Esq.*, London.

Romani, V. (2003) *Daniele da Volterra, amico di Michelangelo*, exh. cat., Casa Buonarroti, Florence.

Rosand, D. (2002) *Drawing Acts: Studies in graphic expression and representation*, Cambridge.

Roth, C. (1925) *The Last Florentine Republic*, New York.

Royalton-Kisch, M., H. Chapman and S. Coppel (1996) *Old Master Drawings from the Malcolm Collection*, exh. cat., British Museum, London.

Rubinstein, N. (1995) *The Palazzo Vecchio 1298–1532: Government, architecture, and imagery in the civic palace of the Florentine Republic*, Oxford.

Ryan, C. (ed.) (1996) *Michelangelo, the Poems*, London.

Saalman, H. (1978) 'Michelangelo at St Peter's: the Arberino correspondence', *Art Bulletin* 60, pp. 483–93.

— (1985) 'The new sacristy of San Lorenzo before Michelangelo', *Art Bulletin* 67, pp. 199–228.

Saslow, J. M. (1991) *The Poetry of Michelangelo*, New Haven and London.

Scarpellini, P. (1984) *Pietro Perugino*, Milan.

Scarpellini, P. and M. R. Silvestrelli (2004) *Pintoricchio*, Milan.

Schéle, S. (1965) *Cornelis Bos: A study of the origins of the Netherland Grotesque*, Uppsala.

Shaw, C. (1993) *Julius II: The warrior pope*, Oxford and Cambridge MA.

Shearman, J. (1965) *Andrea del Sarto*, 2 vols, Oxford.

— (1972) *Raphael's Cartoons in the Collection of Her Majesty the Queen and the Tapestries for the Sistine Chapel*, London.

— (1975a) 'The collections of the younger branch of the Medici', *The Burlington Magazine* 117, pp. 12–27.

— (1975b) 'The Florentine *Entrata* of Leo X', *Journal of the Warburg and Courtauld Institutes* 38, pp. 136–54.

— (1986) 'The chapel of Sixtus IV and the fresco decorations of Sixtus IV', in *The Sistine Chapel: Michelangelo rediscovered*, ed. M. Giacometti, London, pp. 22–87.

— (1994) 'Una nota sul progetto di Papa Giulio', in *Michelangelo, la Cappella Sistina: Atti del Convegno Internazionale di Studi, Roma, marzo 1990*, ed. K. Weil-Garris Brandt, Rome, pp. 29–41.

— (2003) *Raphael in Early Modern Sources*, 2 vols, New Haven and London.

Silvan, P. (1994) 'Il ponteggio di Michelangelo per la decorazione della volta della cappella sistina', in *Michelangelo, la Cappella Sistina: Atti del Convegno Internazionale di Studi, Roma, marzo 1990*, ed. K. Weil-Garris Brandt, Rome, pp. 37–41.

Steinberg, L. (1992) 'Who's who in Michelangelo's *Creation of Adam*: a chronology of the picture's reluctant self-revelation', *Art Bulletin* 74, pp. 552–66.

Stephens, J. N. (1983) *The Fall of the Florentine Republic*, Oxford.

Summers, D. (1981) *Michelangelo and the Language of Art*, Princeton.

Strauss, W. L. (1974) *The Complete Drawings of Albrecht Dürer*, 6 vols, New York.

Syson, L. (2004) 'Bertoldo di Giovanni, Republican court artist', in *Artistic Exchange and Cultural Translation in the Italian Renaissance City*, ed. S. J. Campbell and S. J. Milner, Cambridge, pp. 96–133.

Syson, L. and D. Gordon (2001) *Pisanello, Painter to the Renaissance Court*, exh. cat., National Gallery, London.

Syson, L. and D. Thornton (2001) *Objects of Virtue: Art in Renaissance Italy*, London.

Thode, H. (1908–13) *Michelangelo: Kritische Untersuchungen über seine Werke*, 3 vols, Berlin.

Thomas, B. (2001) ' "The lantern of painting": Michelangelo, Daniele da Volterra and the *paragone*', *Apollo* 154 (August), pp. 46–53.

Thornton, D. and J. Warren (1998) 'The British Museum's Michelangelo acquisitions and the Casa Buonarroti', *Journal of the History of Collections* 10, 1, pp. 9–29.

Tolnay, C. de (1943) *Michelangelo I: The youth of Michelangelo*, vol. I, Princeton.

— (1945) *Michelangelo II: The Sistine ceiling*, vol. II, Princeton.

— (1948) *Michelangelo III: The Medici chapel*, vol. III, Princeton.

— (1954) *Michelangelo IV: The tomb of Julius II*, vol. IV, Princeton.

— (1960) *Michelangelo V: The final period*, vol. V, Princeton.

— (1964) *The Art and Thought of Michelangelo*, New York.

— (1971) *Alcune recenti scoperte e risultati negli studi michelangeschi*, Rome.

— (1975–80) *Corpus dei disegni di Michelangelo*, 4 vols, Novara.

Treves, L. (2001) 'Daniele da Volterra, a collaborative relationship', *Apollo* 154 (August), pp. 36–45.

Turner, N. (1986) *Florentine Drawings of the Sixteenth Century*, exh. cat., British Museum, London.

— (1999) 'The Creation of Adam', *National Art Collections Fund Quarterly*, Summer 1999, pp. 40–3.

Turner, N., L. Hendrix and C. Plazzotta (1997) *The J. Paul Getty Museum: European drawings 3, catalogue of the collections*, Los Angeles.

Turner, N. and R. Eitel Porter (1999) *Italian Drawings in the Department of Prints and Drawings at the British Museum: Roman baroque drawings c. 1620 to c.1700*, 2 vols, London.

Turner, N. and J. M. Matilla (2004) *Museo del Prado Catálogo de Dibujos, Tomo V: Dibujos Italianos del Siglo XVI*, Madrid.

van Tuyll van Serooskerken, C. (2000) *The Italian Drawings of the Fifteenth and Sixteenth Centuries in the Teyler Museum*, Haarlem, Ghent and Doornspijk.

Varchi, B. (1564) *Orazione funerale di M. Benedetto Varchi fatta, e recitata da Lui pubblicamente nell'essequie di Michelagnolo Buonarroti in Firenze, nella chiesa di San Lorenzo*, Florence.

— (2003) *La Storia Fiorentina*, ed. L. Arbib, 3 vols, Rome.

Vasari, G. (1878–85) *Le vite de'più eccellenti pittori, scultori ed architettori*, ed. G. Milanesi, 8 vols, Florence.

— (1960) *Vasari on technique*, trans. L. S. Maclehose, New York.

— (1962) *La Vita di Michelangelo nelle redazioni del 1550 e del 1568*, ed. P. Barocchi, 5 vols, Milan and Naples.

— (1966–) *Le vite de'più eccellenti pittori, scultori e architettori nelle redazioni del 1550 e 1568*, ed. R. Bettarini (commentary vols 2, 4, 6 by P. Barocchi), Florence.

Viatte, F., C. Monbeig Goguel and M. Pinault (1989) *Léonardo de Vinci: Les études de draperie*, exh. cat., Musée du Louvre, Paris.

Villani, F. (1846) *Cronica di Matteo Villani*, 2 vols, Florence.

Waagen, G. (1854–7) *Treasures of Art in Great Britain*, 4 vols, London.

Waldman, L. A. (2004) *Baccio Bandinelli and Art at the Medici Court*, Philadelphia.

Wallace, W. E. (1987) 'Michelangelo's assistants in the Sistine chapel', *Gazettes des Beaux-Arts* 110, pp. 203–16.

— (1992) 'Drawings from the *Fabbrica* of San Lorenzo during the tenure of Michelangelo', in *Studies in the*

History of Art, 33, Center for Advanced Study in the Visual Arts, Symposium Papers XVII: Michelangelo drawings, ed. C. Hugh Smyth, Hanover and London, pp. 117–41.

— (1994) Michelangelo at San Lorenzo: The genius as entrepreneur, Cambridge.

Wallace, W. E. (ed.) (1995a) Michelangelo Selected Scholarship in English, 5 vols, Volume I: Life and early works, New Haven and London.

— (1995b) Michelangelo Selected Scholarship in English, 5 vols, Volume II: The Sistine chapel, New York and London.

— (1995c) Michelangelo Selected Scholarship in English, 5 vols, Volume III: San Lorenzo, New York and London.

— (1995d) Michelangelo Selected Scholarship in English, 5 vols, Volume IV: Tomb of Julius II and other works in Rome, New York and London.

— (1995e) Michelangelo Selected Scholarship in English, 5 vols, Volume V: Drawings, Poetry, and Miscellaneous Studies, New York and London.

— (1995f) 'Instruction and originality in Michelangelo's drawings', in The Craft of Art, ed. A. Ladis and C. Wood, Athens GA and London, pp. 113–33.

— (1997) 'Manoeuvring for patronage: Michelangelo's dagger', Renaissance Studies 11, pp. 20–6.

— (2001) 'Michelangelo's Leda: the diplomatic context', Renaissance Studies 15, pp. 473–99.

— (2003) 'Michelangelo and Marcello Venusti: a case of multiple authorship', in Reactions to the Master: Michelangelo's effect on art and artists in the sixteenth century, ed. F. Ames-Lewis and P. Joannides, Aldershot.

Warburg, A. (1999) The Renewal of Pagan Antiquity, trans. D. Britt, Los Angeles.

Ward-Jackson, P. (1979) Victoria and Albert Museum Catalogues. Italian Drawings I: Fourteenth–Sixteenth century, London.

Warren, J. (1999) Renaissance Master Bronzes from the Ashmolean Museum, Oxford: The Fortnum collection, exh. cat., Daniel Katz Ltd, London.

Weil-Garris Brandt, K. (1992) 'Michelangelo's early projects for the Sistine ceiling: their practical and artistic consequences', in Studies in the History of Art, 33, Center for Advanced Study in the Visual Arts, Symposium Papers XVII: Michelangelo drawings, ed. C. Hugh Smyth, Hanover and London, pp. 57–87.

— (1996) 'A marble in Manhattan: the case for Michelangelo', The Burlington Magazine 138, pp. 644–59.

Weil-Garris Brandt, K. (ed.) (1994) Michelangelo, la Cappella Sistina: Atti del Convegno Internazionale di Studi, Roma, marzo 1990, vol. III, Rome.

Weil-Garris Brandt, K., C. Acidini Luchinat, J. D. Draper, et al. (1999) Giovinezza di Michelangelo, exh. cat., Palazzo Vecchio and Casa Buonarroti, Florence.

Wilde, J. (1928) 'Zwei Modelle Michelangelos für das Julius-Grab', Jahrbuch der Kunsthistorischen Sammlungen in Wien 2, pp. 199–218.

— (1932–4) 'Eine Studie Michelangelos nach der Antike', Mitteilungen des Kunsthistorischen Institutes in Florenz 4, pp. 41–64.

— (1944) 'The Hall of the Great Council of Florence', Journal of the Warburg and Courtauld Institutes 7, pp. 65–81.

— (1953a) Italian Drawings in the Department of Prints and Drawings in the British Museum: Michelangelo and his studio, 2 vols, London.

— (1953b) 'Michelangelo and Leonardo', The Burlington Magazine 95, pp. 65–77.

— (1954) Michelangelo's 'Victory', Charlton Lectures on Art, Oxford.

— (1955) 'Michelangelo's designs for the Medici tombs', Journal of the Warburg and Courtauld Institutes 18, pp. 54–66.

— (1957) 'Notes on the genesis of Michelangelo's Leda', in Fritz Saxl, 1890–1948: A volume of memorial essays from his friends in England, ed. D. J. Gordon, Oxford, pp. 270–80.

— (1958) 'The decoration of the Sistine chapel', Proceedings of the British Academy 44, pp. 61–81.

— (1959) 'Cartonetti by Michelangelo', The Burlington Magazine 101, pp. 370–81.

— (1978) Michelangelo: Six lectures, Oxford.

Wilson, T. (1987) Ceramic Art of the Italian Renaissance, London, 1987.

Wind, E. (1960) 'Maccabean histories in the Sistine ceiling', in Italian Renaissance Studies: A tribute to the late Cecilia M. Ady, ed. E. F. Jacob, London, pp. 312–27.

— (2000) The Religious Symbolism of Michelangelo: The Sistine chapel, Oxford.

Wittkower, R. (1934) 'Michelangelo's Biblioteca Laurenziana', Art Bulletin 16, pp. 123–218.

— (1937–8) 'Physiognomical experiments by Michelangelo and his pupils', Journal of the Warburg Institute 1, pp. 183–4.

— (1964) The Divine Michelangelo, the Florentine Academy's Homage on his Death in 1564: A facsimile edition of the Esequie del Divino Michelagnolo Buonarroti Florence 1564, London.

Wölfflin, H. (1890) 'Die Sixtinische Decke Michelangelos', Reportorium für Kunstwissenschaft 13, pp. 264–72.

— (1901) 'Die Zeichnungen Michelangelos in Haarlem herausgegeben von F. Marcuard (München 1901)', Reportorium für Kunstwissenschaft 24, pp. 318–20.

Woodburn, S. (1836) The Lawrence Gallery, Tenth Exhibition: A catalogue of one hundred original drawings by Michael Angelo collected by Sir Thomas Lawrence, late president of the Royal Academy, London.

Zentai, L. (1998) Sixteeth-Century Central Italian Drawings: An exhibition from the museum's collection, exh. cat., Szépművészeti Múzeum, Budapest.

Zöllner, F. (2003) Leonardo da Vinci 1452–1519: The complete paintings and drawings, Cologne.

Exhibition catalogues

Adelaide and Melbourne (1980) Leonardo, Michelangelo and the Century of Genius, Master Drawings from the British Museum, Art Gallery of South Australia, Adelaide, and National Gallery of Victoria, Melbourne (exh. cat. by N. Turner and M. Royalton-Kisch).

Amsterdam (1934) Italiaansche Kunst in Nederlandsch Bezit, Stedelijk Museum, Amsterdam.

Amsterdam (1955) De Triomf van het Maniërisme. De Europe stijl van Michelangelo tot El Greco, Rijksmuseum, Amsterdam.

Cambridge (1988) Baccio Bandinelli 1493–1560: Drawings from British collections, Fitzwilliam Museum, Cambridge (exh. cat. by R. Ward).

Edinburgh (1999) Richard and Maria Cosway: Regency artists of taste and fashion, Scottish National Portrait Gallery, Edinburgh (exh. cat. by S. Lloyd).

Florence (1980a) Michelangelo e i Medici, Casa Buonarroti, Florence, 1980 (exh. cat. by C. de Tolnay and P. Squellati Brizio).

Florence (1980b) Firenze e la Toscana dei Medici nell'Europa del Cinquecento: il primato del disegno, Palazzo Strozzi, Florence (exh. cat. ed. L. Berti).

Florence (1985) Michelangelo e i maestri del Quattrocento, Casa Buonarroti, Florence (exh. cat. ed. C. Sisi).

Florence (1999–2000) Giovinezza di Michelangelo, Palazzo Vecchio and Casa Buonarroti, Florence (exh. cat. ed. K. Weil-Garris Brandt).

Florence (2001) Vita di Michelangelo, Casa Buonarroti, Florence (exh. cat. ed. L. Bardeschi Ciulich and P. Ragionieri).

Florence (2003–4) Daniele da Volterra, amico di Michelangelo, Casa Buonarroti, Florence (exh. cat. ed. V. Romani).

Florence, Chicago and Detroit (2002–3) L'ombra del genio. Michelangelo e l'arte a Firenze 1537–1631, Palazzo Strozzi, Florence, The Art Institute of Chicago, and The Detroit Institute of Arts (exh. cat. ed. M. Chiarini, A. P. Darr, and C. Giannini).

Florence and Rome (1983–4) Disegni italiani del Teylers Museum Haarlem provenienti dalle collezioni di Cristina di Svezia e dei principi Odescalchi, Istituto Universitario Olandese di Storia dell'Arte, Florence, and Istituto Nazionale per la Grafica, Rome (exh. cat. by B. W. Meijer and C. van Tuyll van Serooskerken).

Haarlem (1964) Tekeningen van Michelangelo, Teyler Museum, Haarlem (exh. cat. by J. Q. van Regteren Altena).

Haarlem (1978) Teylers Museum. 200 jaar verzamelen. Hoogtepunten der tekenkunst, Teyler Museum, Haarlem (exh. cat. by J. H. van Borssum Buisman).

Haarlem (1985) Italiaanse Tekeningen, Teyler Museum, Haarlem, 1985 (brochure by C. van Tuyll van Serooskerken).

Haarlem (2000) De eeuw van Michelangelo: Italiaanse tekeningen uit de collectie van Teylers Museum, Teyler Museum, Haarlem.

Leningrad and Moscow (1977) The Italian Renaissance, The Hermitage, Leningrad, and the Pushkin Museum, Moscow (exh. cat. by N. Turner and M. Royalton-Kisch).

London (1836) The Lawrence Gallery, Tenth Exhibition: A catalogue of one hundred original drawings by Michael Angelo, Messrs Woodburn Gallery, London.

London (1877–8) Winter Exhibition, Grosvenor Gallery, London.

London (1930) Exhibition of Italian Art 1200–1900, The Royal Academy of Arts, London (exh. cat. by A. E. Popham).

London (1953a) An Exhibition of Drawings by Michelangelo belonging to H.M the Queen, the Ashmolean Museum, the British Museum and other Collections, The British Museum, London (exh. cat. by J. Wilde).

London (1953b) Drawings by Old Masters, The Royal Academy of Arts, London (exh. cat. by J. Byam Shaw and K. T. Parker).

London (1960), Italian Art in Britain, The Royal Academy of Arts, London (exh. cat. by E. K. Waterhouse and A. E. Popham).

London (1964) Michelangelo Buonarroti 1475–1564: An exhibition to commemorate the 400th anniversary of his death, The British Museum, London (exh. cat. by J. A. Gere).

London (1970) *Drawings from the Teyler Museum, Haarlem*, The Victoria and Albert Museum, London (exh. cat. by J. Q. van Regteren Altena and P. Ward-Jackson).

London (1974) *Portrait Drawings XV–XX Centuries*, The British Museum, London (exh. cat. ed. by J. A. Gere).

London (1975a) *Drawings by Michelangelo*, The British Museum, London (exh. cat. by J. A. Gere and N. Turner).

London (1975b) *The Renaissance*, The National Gallery, London.

London (1978) *Gainsborough and Reynolds in the British Museum*, The British Museum, London (exh. cat. by T. Clifford, A. Griffiths and M. Royalton-Kisch).

London (1984) *Master Drawings and Watercolours in the British Museum*, The British Museum, London (exh. cat. ed. J. Rowlands).

London (1986) *Florentine Drawings of the Sixteenth Century*, The British Museum, London (exh. cat. by N. Turner).

London (1990) *Treasures of Prints and Drawings*, The British Museum, London.

London (1994) *The Study of Italian Drawings: The contribution of Philip Pouncey*, The British Museum, London (exh. cat. by N. Turner).

London (1994–5) *Making and Meaning: The young Michelangelo*, The National Gallery, London (exh. cat. by M. Hirst and J. Dunkerton).

London (1996) *Old Master Drawings from the Malcolm Collection*, The British Museum, London (exh. cat. by M. Royalton-Kisch, H. Chapman and S. Coppel).

London (1999) *Renaissance Master Bronzes from the Ashmolean Museum, Oxford: The Fortnum collection*, Daniel Katz Ltd, London (exh. cat. by J. Warren).

London (2000–1) *The Human Image*, The British Museum, London (exh. cat. ed. by J. C. H. King).

London (2003–4) *'Saved!' 100 Years of the National Art Collections Fund*, Hayward Gallery, London (exh. cat. ed. R. Verdi).

London (2004–5) *Raphael: from Urbino to Rome*, The National Gallery, London (exh. cat. by H. Chapman, T. Henry and C. Plazzotta).

Manchester (1857) *The Art Treasures of the United Kingdom*, Museum of Ornamental Art, Manchester (the drawings section of the exh. cat. by G. Scharf).

Mantua and Vienna (1999) *Roma e lo stile classico di Raffaello*, Palazzo Te, Mantua and Albertina, Vienna (exh. cat. by K. Oberhuber and A. Gnann).

Montreal (1992) *Le génie du sculpteur dans l'oeuvre de Michel-Ange*, Musée des Beaux-Arts de Montréal, Montreal (exh. cat. ed. P. C. Marani).

New York (1979) *Drawings by Michelangelo from the British Museum*, Pierpont Morgan Library, New York (exh. cat. by J. A. Gere and N. Turner).

New York and Chicago (1989) *From Michelangelo to Rembrandt: Master Drawings from the Teyler Museum*, The Pierpont Morgan Library, New York, and The Art Institute of Chicago (exh. cat. by C. van Tuyll van Serooskerken).

Nottingham and London (1983) *Italian Drawings*, University Art Gallery, Nottingham, and Victoria and Albert Museum, London (exh. cat. by F. Ames-Lewis and J. Wright).

Oxford (1842) *Original Designs by Michael Angelo and Raffaelle, proposed to be purchased by Subscription*, New University Galleries, Oxford.

Oxford (1846) *Original Designs by Michael Angelo and Raffaelle*, New University Galleries, Oxford.

Oxford (2001) *Design into Architecture*, Christ Church Picture Gallery, Oxford (exh. cat. by C. Elam).

Paris (1972) *Cent dessins du Musée Teyler Haarlem*, Musée du Louvre, Paris (exh. cat. by J. Q. van Regteren Altena and R. Bacou).

Paris, Rotterdam and Haarlem (1962) *Italiaanse Tekeningen in Nederlands Bezit*, Institut Néerlandais, Paris, Boijmans van Beuningen, Rotterdam, and Teyler Museum, Haarlem (exh. cat. by F. Lugt and J. Q. van Regteren Altena).

Saarbrücken (1997) *Zeichnungen aus der Toskana. Das Zeitalter Michelangelos*, Saarland Museum, Saarbrücken (exh. cat. ed. by E. G. Güse and A. Perrig).

Stockholm (1966) *Christina Queen of Sweden: A personality of European civilisation*, Nationalmuseum, Stockholm.

Sydney (1999–2000) *Michelangelo to Matisse: Drawing the figure*, Art Gallery of New South Wales, Sydney (exh. cat. ed. T. Maloon and P. Raissis).

Tokyo and Nagoya (1996) *Italian 16th and 17th Century Drawings from the British Museum*, National Museum of Western Art, Tokyo, and Aichi Prefectural Museum of Art, Nagoya (exh. cat. by M. Koshikawa and H. Kurita).

Tokyo and Niigata (2003–4) *Treasures from the World's Cultures: the British Museum after 250 years*, The Metropolitan Art Museum, Tokyo, and Prefectural Museum of Fine Arts, Niigita (exh. cat. ed. M. Caygill).

Vatican (1990) *Michelangelo e la Sistina: la tecnica, il restauro, il mito*, Vatican Museums, Vatican City (exh. cat. ed. F. Mancinelli).

Vienna (1997) *Vittoria Colonna: Dichterin und Muse Michelangelos*, Kunsthistorisches Museum, Vienna (exh. cat. ed. S. Ferino-Pagden).

Vinci (2001) *Leonardo e il mito di Leda*, Museo Leonardiano, Vinci (exh. cat. ed. G. Dalli Regoli, R. Nanni and A. Natali).

Washington (1992) *Circa 1492: Art in the age of exploration*, National Gallery of Art Washington (exh. cat. ed. J. A. Levenson).

Washington (1994–5) *Italian Renaissance Architecture: Brunelleschi, Sangallo, Michelangelo – the cathedrals of Florence and Pavia, and St Peter's Rome*, National Gallery of Art, Washington.

Washington and Paris (1988–9) *Michelangelo Draftsman*, National Gallery of Art, Washington, and Musée du Louvre, Paris (exh. cat. by M. Hirst).

Index of names and works by Michelangelo excluding drawings

Illustration Acknowledgements

All objects belonging to the Ashmolean Museum,
 the British Museum and the Teyler Museum are
 reproduced with the permission of the respective
 institutions. Other objects are reproduced with the
 following copyrights:

Figs 11, 68, 77, 96, 110 © Casa Buonarroti, Florence
Figs 13, 111 © Photo RMN – Gérard Blot
Figs 14, 117 © Photo Scala, Florence, 1990
Figs 18, 19, 56, 63, 70–5, 81, 91, 121 © Hirmer
 Verlag München
Figs 20, 78 © The Royal Academy of Arts, London
Fig. 21 By kind permission of the earl of Leicester and
 the trustees of the Holkham Estate. Photograph:
 Photographic Survey, Courtauld Institute of Art
Figs 22, 28, 52 Gabinetto Fotografico,
 Soprintendenza Speciale per il Polo Museale
 Fiorentino
Figs 29, 66–7 © Photo RMN – Michèle Bellot
**Figs 33, 39, 40, 42, 44, 46–8, 50, 53, 94, 98,
 100–2, 119** Vatican Museums, Vatican City
Fig. 35 © The Detroit Institute of Arts
Fig. 36 © Photo Scala, Florence / Fondo Edifici
 di Culto – Ministero dell' Interno, 1999
Figs 49, 58, 83, 89, 92, 99, 105 © 2004,
 Her Majesty Queen Elizabeth II
Fig. 51 The Metropolitan Museum of Art, New York
Fig. 55 © Photo Scala, Florence – courtesy of the
 Ministero Beni e Att. Culturali, 1990
Fig. 57 © Photo Scala, Florence, 1998
Exh. Nos 56, 100, Fig. 59 © The National Gallery,
 London
Exh. No. 37, Figs 60–1 By courtesy of the trustees
 of Sir John Soane's Museum
Fig. 62 © Photo Scala, Florence, 2004
Fig. 65 Supplied by the Bridgeman Art Library,
 London; copyright holder untraced
Figs 76, 80 Conway Library, Courtauld Institute
 of Art, London
Exh. No. 51 By permission of the British Library
Fig. 82 © Ursula Edelmann, Frankfurt
Exh. Nos 73–4 © V&A Picture Library
Fig. 90 Photographic Services © 2004 President and
 Fellows of Harvard College
Fig. 106 © Isabella Steward Gardner Museum,
 Boston
Fig. 107 © APD / Management Fratelli Alinari
Figs 108–9, 115 © Archivi Alinari
Fig. 116 © Gemeinnützige Stiftung Leonard von Matt
Fig. 120 © Photo RMN